MW00851241

# THE LIVING TRADITION OF YUP'IK MASKS

Dearest- Aunty Joyce
To remember some good
years here in Alaska
full of spirit! Love
Ward

You're the Dearest
Auntie In the
WORLD!
Love,
Pierre C.O.

Dear Auntie!,

I'm so glad
You're here to
stay! CEven if
it is for only
6 or 5 days.)
Well love you
LOTS!
Love,

Joyce-
Thanks for all your
support and friendship
over these many years -
both to Wanda and I
and to Emile and Pierre.
Your closeness to us is
most precious! Jerry

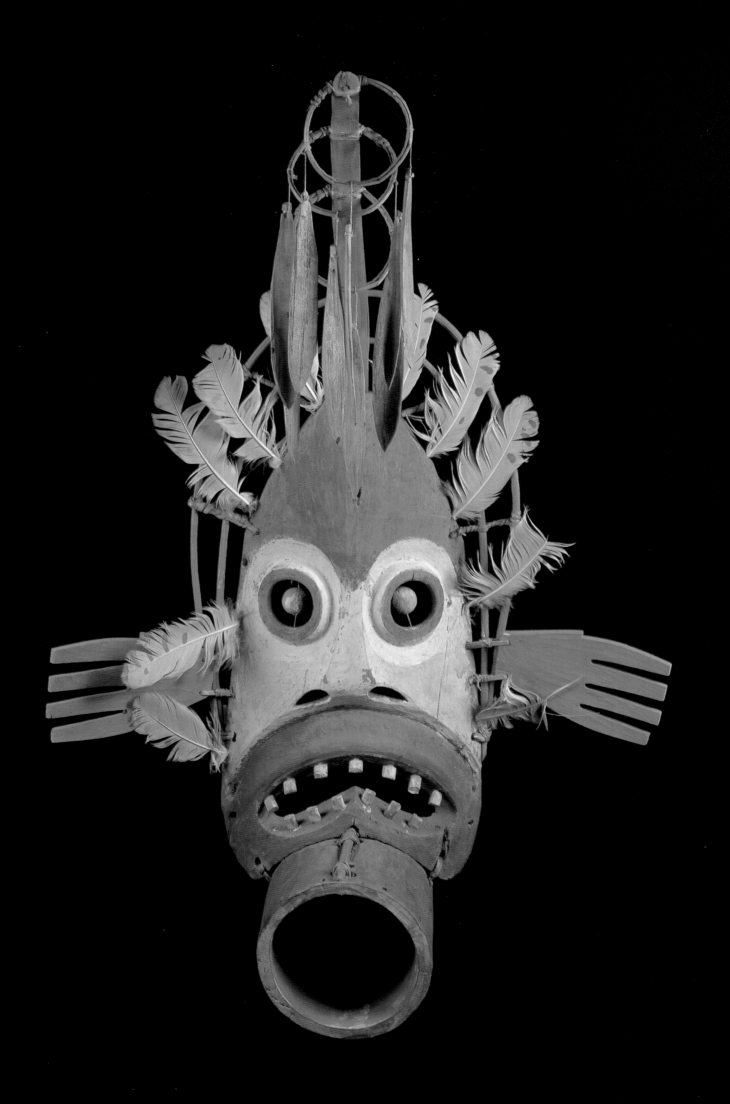

# THE LIVING TRADITION OF YUP'IK MASKS

## *Agayuliyararput*
### *Our Way of Making Prayer*

## Ann Fienup-Riordan

*Translations by Marie Meade / Photography by Barry McWayne*

Joyce —
I hope you enjoy the book. It was an exciting project to be a part of.
Barry McWayne

UNIVERSITY OF WASHINGTON PRESS   *Seattle & London*

*in association with the* ANCHORAGE MUSEUM OF HISTORY AND ART

*and the* ANCHORAGE MUSEUM ASSOCIATION

Published in conjunction with the exhibition *Agayuliyararput* (Our Way of Making Prayer): The Living Tradition of Yup'ik Masks, curated by Ann Fienup-Riordan and organized by the Anchorage Museum of History and Art and the Coastal-Yukon Mayors' Association.

EXHIBITION SCHEDULE

Toksook Bay, *Nelson Island, Alaska*
*January 1996*

Yupiit Piciryarait Cultural Center, *Bethel, Alaska*
*February–March 1996*

Anchorage Museum of History and Art
*May–October 1996*

Alaska State Museum, *Juneau*

University of Alaska Museum, *Fairbanks*

National Museum of the American Indian, *New York*

National Museum of Natural History, Smithsonian Institution, *Washington, D.C.*

The exhibition and publication were made possible in part by a generous grant from the National Endowment for the Humanities, a federal agency.

This book was published with the assistance of the Getty Grant Program and the Rockefeller Foundation.

Copyright © 1996 by the University of Washington Press
FIRST EDITION
03 02 01 99 98 97 96   6 5 4 3 2 1
Designed by Audrey Meyer
Printed by Toppan Printing Company, Inc., Tokyo, Japan
Unless otherwise noted, color photographs are by Barry McWayne. Color map (pp. 44–45) is by Ayse Gilbert, Anchorage.
Illustrations on pp. 20 and 170 copyright © 1979 and 1978 by the Metropolitan Museum of Art. James H. Barker photographs (JHB) copyright © 1996 by James H. Barker

All rights reserved. No portion of this publication may be reproduced or transmitted in any form or by any means, electronic or mechanical, including photo-copying, recording, or any information storage or retrieval system, without permission in writing from the publisher.

Library of Congress Cataloging-in-Publication Data
Fienup-Riordan, Ann.
The Living Tradition of Yup'ik masks: Agayuliyararput (our way of making prayer) / Ann Fienup-Riordan; translations by Marie Meade; photography by Barry McWayne.
p.  cm.
"In association with the Anchorage Museum of History and Art and the Anchorage Museum Association."
Published in conjunction with an exhibit organized by the Anchorage Museum of History and Art.
Includes bibliographic references and index.
ISBN 0-295-97501-6 (cloth), 0-295-97523-7 (paper) (alk. paper)
1. Yupik masks—Exhibitions.   2. Yupik art—Exhibitions.   3. Yupik Eskimos—Religion—Exhibitions.   4. Alaska—Antiquities—Exhibitions.   I. Anchorage Museum of History and Art.   II. Title.
E99.E7F435   1996
731'.75'089971—dc20   95-23296   CIP

The paper used in this publication meets the minimum requirements of American National Standard for Information Sciences–Permanence of Paper for Printed Library Materials, ANSI Z39.48–1984. ∞

Page 2: Mask representing "Negakfok," the cold weather spirit, collected by Bethel trader A. H. Twitchell in the early 1900s. *NMAI 9/3430 (91 cm high)*

Page 6: Asymmetrical pair of owl masks collected by Sheldon Jackson on the lower Yukon in the 1890s. Similar masks were collected by H. M. W. Edmonds at St. Michael (Ray 1967:193), J. H. Turner on the lower Yukon (see p. 227), and Edward Nelson (1899:197) at Sabotnisky (which he identifies as the "inua of the short-eared owl"). *SJM, IIH11 (15.8 cm) and IIH14 (16.5 cm)*

*Quyanarpiit-lli ciulirnemteni*

With thanks to our elders

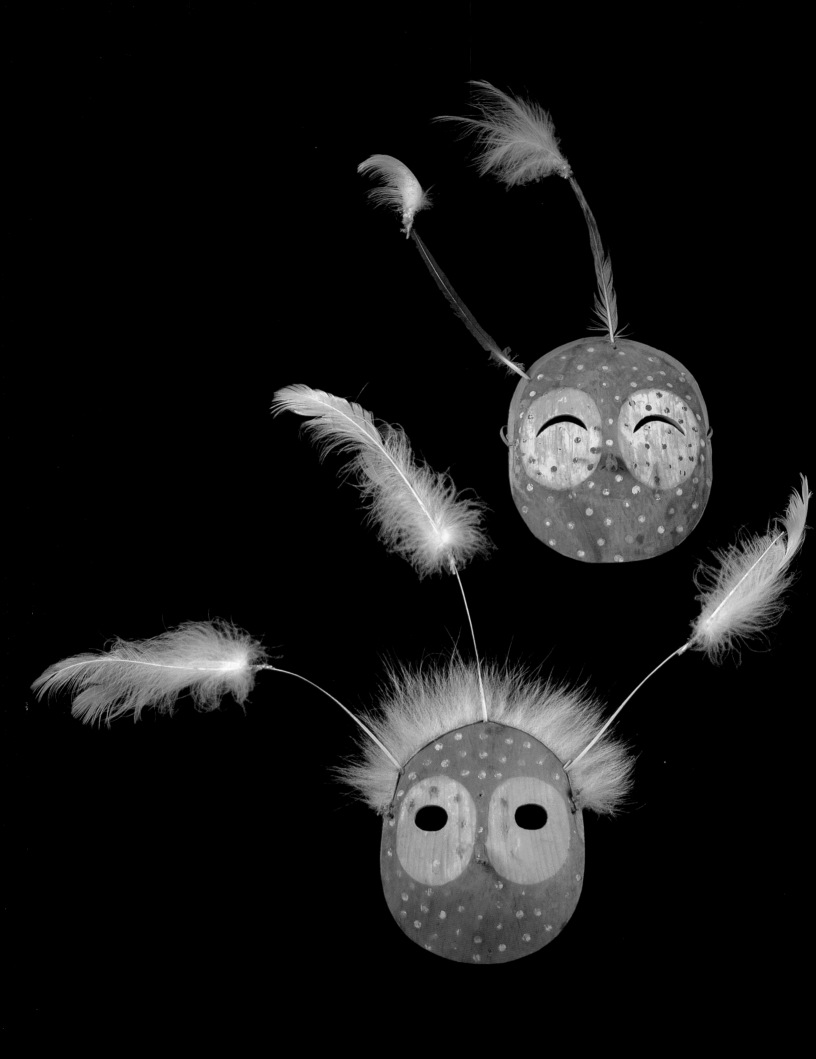

# Contents

# Abbreviations

Chevak dancers using a comic half-face mask in a 1989 performance. *JHB*

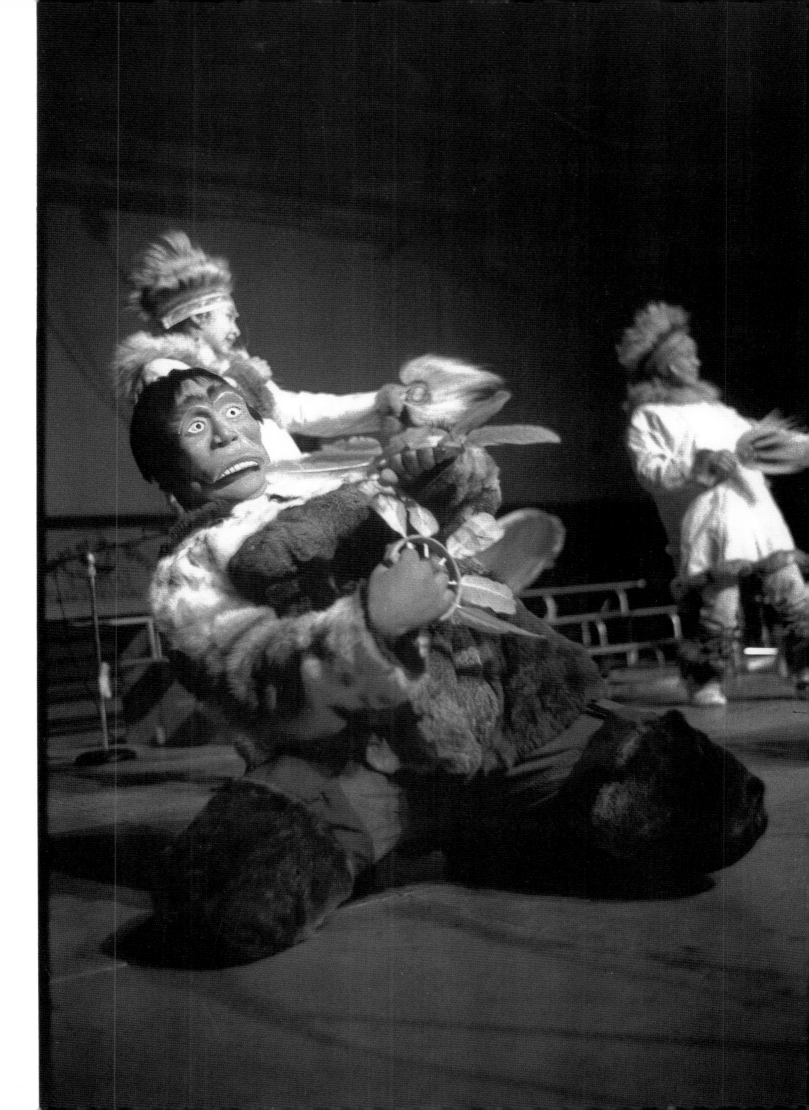

# Una Ayagneqluku Ciumek

**M**akut maani wangkuungramta mikelnguaraput taringesqumaaput ciuliat catullritnek. Tua-i-wa maa-i watua wangkuungramta irniaput, tutgaraput, kinguqlirkait-llu ciuliameng callritnek, tua-i-w' nallullrat man'a elpekesqumayaaqngamegteggu, wangkuta waten pitarilriani makut maa-i ak'a ciuliamta atullrit tangrresqumaaput. Cali-llu man'a yuraryaraq arulairesqumavkenaku cali nutem avaken ciuliamtenek pikngamteggu, imutun tua angelriaruluku cakneq yuraryaraq man'a avaken ciuliamtenek atulriaruan.

Cali man' yuraq pitekluku yuut waten quyurtaalallrat nunanun, tuani tua-i yurarvigkaatni waten ullagalug' naken quyurtaalallrat ikayuurpalliniuq. Ilakuyucim imutun nallunriutekelriatun ayuqluku. Tua-i ilakuyutnguqapiaralliniluni yugnun avaken ayagluta ciuliamtenek. Cali-llu ilakuyutnguami tungayiit, ilakutat nalluyaaqerraarluk' waten yuraq pitekluk' quyurtaqata nallunriraqluki. Tua-i ilakuyutngulliniami man' yuraq avaken ayagluni, pimiutauluni, kenkutauluni.

Quliriqaqernaurtua ilakutellrata yuut tua-i-w' ayagneqelriatun ayuqiitnek. Tamaani yuut ayagassuutaicaaqellruut makunek cukaluteng ayagalrianek. Una-ll' cali waten ciuliamtenek ayagluni qaneryaraq: Ella-gguq allamek yuituq. Tamakut ella allamek yuitnilallermeggni, man'a maa-i nunateng imutun direct-arluku pilriatun qantullrulliniut. Ayagassuutaileng'ermeng waten imumek, angutem ilii naken yaaqvaarnek tekillun' arnamek tegullun' ayautaqluni, wagg'uq nuliqsagulluku. Cali-llu angun naken tekilluni tuavet nunanun tekitaqami utertevkenani arnamek cali aipangluni taukumiungurtaqluni.

Taumek waniw' Yupiit yuuyaraacetun ayuqelria una. Tua-i ilumun ilakutlinilriit tamaaggun tamaa-i waten avaken ciuliamtenek tuatnallratgun. Wiingallu tan'gurraulua tuaten qanraqata ella allamek yuitniluku umyuarteqtullruyaaqua yaaqvanelnguut cakumanricukluki. Maa-i watua ayagalqa murilkelluku pingrraanemnek tan'gurraunriama, una nani nunani yaaqvaarni uitang'ermi imumek apqemtenek kangirqaqami ciuliani augkut kangirqelluki, apaaluki, niicugniurallra cali wangkuta kingunemteni qanlallrat ciuliamta umyuaqluku piaqamteggu elitaqnaurput, tauna ima tanem tamaavet ayallrani tamaaken utertenritnilaqiit. Wall'u tuaten pinrilkuni, tauna ima tam tamaaken tekitaulriarullrunilaqiit. Cunaw' tamaa-i ilumun waten ilakut'luugtellinilriit ataucimek taqestengqengramta imutun cagingayaaqellemtenek tuarpiaq ilaksagulluta waten tua-i pillemteggun.

Paul John, Nunakauyaq
*April 15, 1994*

# Foreword

We are eager to have our children learn and understand the ways of our ancestors. We elders would like our children and our grandchildren to become aware of their lack of knowledge about the ways of our ancestors, and we would like them to see what our ancestors used so they can pass it on to their descendants. Also, because Yup'ik dancing has been passed down to us through our ancestors from time immemorial, unchanged from its original form and as important to us now as it was to our ancestors, we do not want to see it discontinued.

The tradition of dance in its many forms was a uniting force in bringing people from villages together in the larger Yup'ik community. It was supportive of the extended kinship system of the people. Gathering for dancing often enabled distant family members to meet each other, in many cases, for the first time. For a long time this tradition, based on our long-standing value system of compassion and love for each other, has been a system for perpetuating kinship ties.

Let me give you an example from the past that illustrates why people maintained the old kinship system. At that time the people did not have fast modes of transportation. There is an adage that has been around since the time of our ancestors: *Ella-gguq allamek yuituq* [The world contains no others, only our human selves]. Those who follow the principle behind the adage conduct their lives accordingly—that is, showing respect for all people. Though our people did not have fast modes of transportation, a man would come from a distant place in pursuit of a wife and would take her back with him. And sometimes a man would go to a certain village to get married and settle down, becoming a member of that community.

This example illustrates the practice of the Yup'ik people. By following this practice, people have been connected since the time of our ancestors. When I first heard people saying the aforementioned adage, I thought people who lived far away were not connected to me in any way. Now that I'm older I pay more attention when I travel. During my travels when I meet people and they begin to talk about their genealogies, and when a person mentions a relative, we find ourselves recognizing names that our elders mentioned. When a certain person is mentioned, suddenly we remember that it is one who left and didn't return home. Or you might recognize the name of someone who came from far away to live in your village. And since we all come from one Creator, we are related though we live far apart.

Paul John, Toksook Bay
*April 15, 1994*

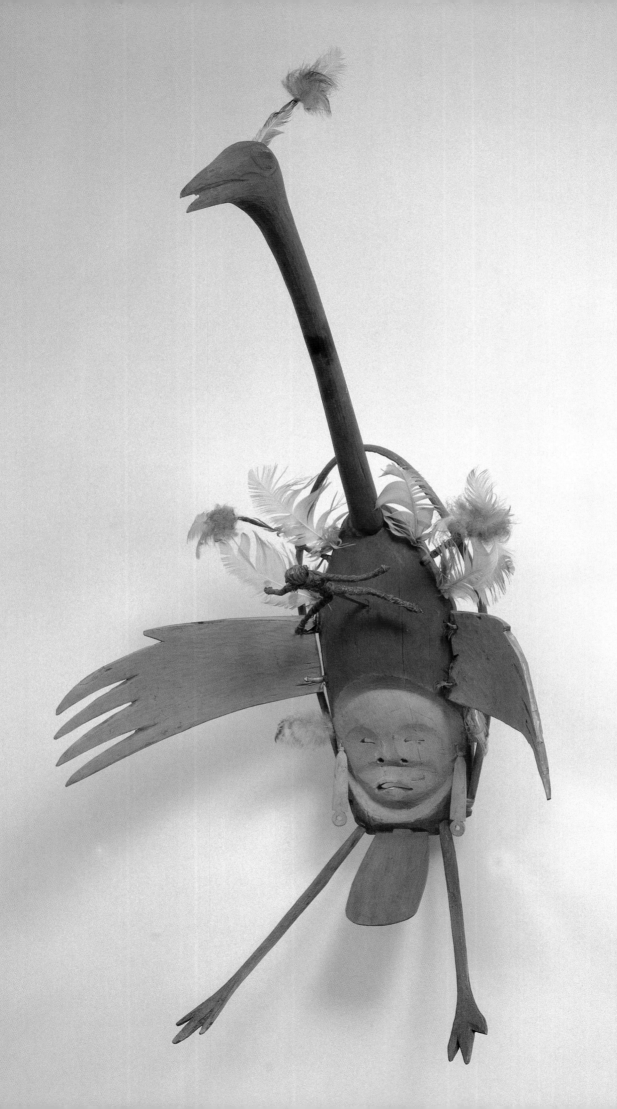

# Preface

One of a pair of Kuskokwim masks representing a crane that carried a sick *angalkuq* to his home. Carlebach purchased the other from Heye in 1944. *NMAI, 9/3417 (99 cm). David Heald*

**M**y interest in Yup'ik masks and museum collections began in earnest in 1989 when Wendell Oswalt sent me photographs of masks collected along the lower Kuskokwim River by Adams Hollis Twitchell, a turn-of-the-century Bethel trader. The photographs portrayed masks unlike anything I had come to associate with Yup'ik art and ceremony. Unlike the hooped faces encircled with appendages common in museum collections, these were enormous mobiles with dangling slivers of wood, and wind tunnels projecting from their chins and foreheads—and, according to accession records, many had Yup'ik names.

The masks, it turned out, had been purchased from Twitchell by George Gustav Heye, the wealthy New York collector and founder of the Museum of the American Indian. They were housed along with seven hundred thousand other Native American artifacts at the Heye Foundation in the Bronx. I visited the museum in 1990. Located in a neighborhood to which New York cabbies will not go, the Heye (now the National Museum of the American Indian) looks like a small Bastille, with boarded-up windows and iron and barbed-wire fencing. I came away amazed, both by the masks' vitality and by their inaccessibility.

Two things impressed me. First, most of the masks were paired. The single mask is the exception, not the rule. Two masks labeled "Andlu" depict a pair of muskrats emerging from their holes. Two masks represent "Tomanik," or Wind-maker, with a white tube for winter and a black tube for spring. Two more depict "Negakfok" (*negeqvaq,* "north wind"),[1] said by Twitchell to be a "cold weather spirit . . . used in dances in March" with "a sad expression on account of the approach of spring." Records showed that where I spotted one-of-a-kind masks hanging on the wall, originally there had been pairs, but that expendable "doubles" had been sold in the 1940s and 1950s for $40 and $50 each.

Of the original fifty-five masks Twitchell sent Heye in the early 1900s, all but twenty-nine were "exchanged" with the New York dealer Julius Carlebach between 1944 and 1946. Carlebach found buyers for the masks all over the world, including Surrealist artists André Breton, Roberto Matta, Yves Tanguy, and Robert Lebel (Carpenter 1991:16). Some remain in private collections in the United States and

1. All Yup'ik definitions and etymologies given in the text derive from the *Yup'ik Eskimo Dictionary,* compiled by Steven Jacobson (Alaska Native Language Center, 1984).

abroad, and some have since made their way back into museums. For example, in 1961 John D. Rockefeller bequeathed a Twitchell mask to New York's Metropolitan Museum of Art, where it remains classified as a "class 1 art object." But I am getting ahead of my story.

The second thing that impressed me that day in the Bronx was one small mask that broke all the rules I knew. The masks I had seen were wooden or skin coverings for the face, some ringed and some not. And I had read repeatedly that Yup'ik masks were worn only by men. But way back on a dusty shelf I pulled out four bentwood hoops joined at the base and decorated with tufts of caribou hair.

The curator asked what it was. Well, it looked like a mask without a face. I checked the accession files. Twitchell described it as a "dance ornament of four wooden circles . . . tied on face." Moreover, the faceless mask was not alone. A second pair of hoops, one with four rings and one with five, were on the same shelf. They had been collected by George Byron Gordon, who described them as "women's dancing headgear." Thanks perhaps to their simplicity, Carlebach and the Surrealists had passed them by. They were as eloquent as they were unexpected. I had been drawn to the Heye by photos of one-of-a-kind masterpieces worn by men and instead found pairs of everything, including faceless masks worn by women.

That first visit to the Heye and subsequent forays into collections of Yup'ik material revealed a range of objects that, it seemed to me, Yup'ik friends and colleagues would find exciting. What I did not expect was interest from the Yup'ik community more generally. Here again I was in for a surprise.

## "Opening the Book": The 1989 Mountain Village Dance Festival

*When the Eskimo between Yukon and Kuskokwim rivers become so sophisticated by contact with white men that mask festivals fall into disuse, it will be but a short time until all the wealth of mythological fancy connected with them will become a sealed book.*—Edward Nelson, *The Eskimo about Bering Strait*

The same year I was discovering the contents of Mr. Heye's attic, Yup'ik elders and community leaders from villages along the Yukon River were planning their own expedition into museum country, and for their own reasons. The idea for such a trip started

when Andy Paukan, mayor of the Yukon village of St. Marys, and Tim Troll, a former administrator for the city of St. Marys, met with elders to plan a multivillage dance festival. Paukan and Troll suggested to the communities that the festival could be an opportunity to show and share traditional Yup'ik things. Paukan (May 1994) recalled, "We pondered and finally got the idea to go to some museums and find out what should be shown."

Why bring back these old things, relics of a nearly forgotten past? Andy Paukan continued, "One of the ideas was that the generation after me is the one that is not really educated in our culture, and therefore they don't have too much understanding of what our ancestors did. Their heritage has been forgotten." Through bringing back and displaying old things, they hoped to show "how our ancestors survived and had their own culture, and before the new technology was introduced, how they themselves had survived, too."

Indeed, Yup'ik life had changed dramatically since the early 1900s, when the oldest living community members were born. The tools and artifacts elders saw and used in their childhood—wooden bowls, seal-gut rain parkas, skin-covered kayaks—have since been replaced by plastic, nylon, and mechanical innovations.

This "looking back" by Yukon residents is not a frivolous concern but an active effort to shape their future. The Coastal-Yukon Mayors' Association, the group sponsoring the Yukon dance festivals and exhibit, hoped to achieve three things: to bring Yup'ik people into contact with the tools of their past; to gather information from elders viewing the exhibit about how the tools were used; and—perhaps most important, yet most difficult to obtain—to "help offset the plague of alcohol-related deaths and suicides in the region by instilling in the young people pride in what they have been and help them understand the essence of what it is to be Yup'ik. Just possibly the exhibit can give them a vision of a future in which they can remain Yup'ik and survive in a changing world" (Troll 1989).

From the Yup'ik point of view, a dance festival provides the perfect place to act on these concerns. The paradigmatic "museum experience," in which objects are segregated from life and put on a pedestal to confront the viewer, is out of place in contemporary Yup'ik village life. Out of context an object is meaningless; but at a dance festival elders would gather and talk both publicly and privately about the objects' meaning and their makers. Contemporary Yup'ik dancing is itself a living link to the past, wherein the youngest community members bring old songs and stories to life.

Every group in this world has its own style of dancing. In those days people didn't travel around the world . . . and a person couldn't go to a far-off place to show his ways. Though we couldn't do that, God, apparently, created us with our own traditions. Now dancing is the

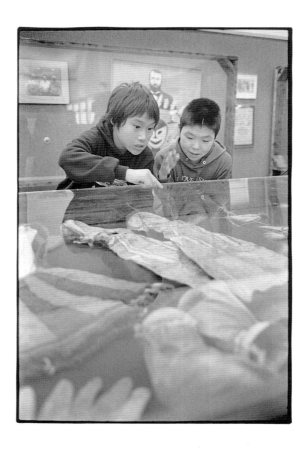

Children examining fishskin boots exhibited at Mountain Village, 1989. *JHB*

only custom remaining from the ways of our own culture. (Paul John, April 15, 1994)

In preparation for the dance festival and exhibit Andy Paukan, Tim Troll, and two elders chosen from their communities traveled to the Sheldon Jackson Museum in Sitka to choose objects from the massive collection the renowned Presbyterian missionary and government agent for whom the museum is named had acquired from the area in the 1890s. Tim Troll (1989:11) noted, "Most of the great collections of Eskimo artifacts are housed in museums outside Alaska. Fortunately for the people of the lower Yukon, the Jackson artifacts belong to the State of Alaska. But the artifacts are in Sitka, and most have never been seen by the people for whom they would be most relevant." Andy Paukan (May 1994) described what followed:

Since they knew Yukon masks they had used in the past and had knowledge of makers, we took two elders—Wassilie Evan [from Pilot Station] (the poor guy died last year) and Willie Beans from Mountain Village—down to Sitka with us. Before we went down we didn't know how it was going to work, but [museum director] Peter Corey met and welcomed us, including Tim Troll, and took us down to the museum.

When we first went into the Sheldon Jackson Museum I got disappointed, thinking, "Is this all we are going to see?" Apparently, there were many, many more things in storage. Not knowing there was a lot more to see, I got disappointed at first.

We looked at Yup'ik things in the storage room for two days. We looked for Yukon and coastal things. Wassilie Evan and Willie Beans would recognize them.

Wassilie Evan (holding a *nep-cetaq* mask), Tim Troll, Andy Paukan, and Willie Beans during their visit to the Sheldon Jackson Museum in 1989.
*Timothy E. Troll*

They would know who had made them. After two days, of things the elders had picked, we decided what to take home to Mountain Village. We took home over one hundred Yup'ik things and masks at that time.

All were deeply moved by what they saw. When asked what he thought about the collection of such things, Wassilie Evan responded:

Because they have taken good care of them, without much disturbance, that is why we can see them today. If no one took care of them, they would not be available. We would not have seen them.

Because they are in such a place and being taken care of in good condition, even though they are old they are not broken. I am thankful that I am able to witness them in their present condition. . . .

We are very thankful to be able to be in a place where our ancestors' implements are and see them with our own eyes. (KYUK 1989, tape 2)

Gratitude, rather than resentment, characterized Willie Beans's attitude toward the museum's protection of his ancestors' creations:

I was able to come, and that made me extremely thankful. . . .

Some of the things that are here I have seen before. . . . I recognized the pipes and tobacco containers that used to be filled with chewing material. We do not see them anymore back at our village. I see they are kept here. They are very old. If the *kass'at* [white people] did not arrive in our area we would still be using parkas like the ones that can now be seen in the museums, including ones made of fishskin leather. We would have had those materials for clothing. I was very amazed by what I saw in this museum. (KYUK 1989, tape 2)

No comparable loan had ever been requested of the museum, let alone approved. The 112 artifacts would eventually travel one thousand miles from their climate-controlled storage vault in Sitka to the Yup'ik community of Mountain Village, population six hundred, on the banks of the Yukon River. Curator Peter Corey (1989) recalled the enormity of the request: "By museum standards there was no way possible to lend the items because of lack of climate controls, security, and trained personnel to properly handle the artifacts and insurance concerns." Finally, however, Corey and Tom Lonner, the director of the state museum, agreed that the request was legitimate and exciting in concept and approved a limited loan.

At Mountain Village Andy Paukan and Peter Corey unpacked the crates while elders watched and commented. They found nothing broken or damaged. The elders then arranged the things for display in the manner they thought most appropriate. Explanatory labels were unnecessary, as elders were there to talk about the artifacts' significance and use. More important than any single object brought for the exhibit was the local significance of having the exhibit come to Mountain Village. For most of the objects, it was the first time in more than a hundred years that Yup'ik hands touched them and Yup'ik eyes viewed them.

At first, everyone talked quietly among themselves. Soon, however, the voice of Pilot Station's Noel Polty, among the oldest people present, rose above the crowd. He was excited and insistent as he marveled at an *angalkuq*'s ["shaman"; pl., *angalkut*] mask that had been returned:

NOEL POLTY: I used to see the masks used by those who requested them! It was spread with squirrel skin and put on. It did not have strings. It just stuck to the face and was danced with. The masks were large. The people dug a hole in the ground alongside the hill and buried them.

WASSILIE EVAN: Because they were not going to use them again.

NOEL: Yes

UNIDENTIFIED ELDER: That was what they did. They were gathered and buried all together.

NOEL: The mask that he used at our village—[Dan Green] knows the song for it. (KYUK 1989, tape 2)

Polty spoke for a long time. He was not the only one moved by what he saw. Andy Paukan (May 1994) recalled, "There were some elders who had emotional feelings when they saw those artifacts, and I said, by golly, this is really good, what our ancestors really did! And that made me believe this must be shared with the younger generation so they, too, can carry on our tradition and heritage."

Younger people flocked to the community hall. More than the complicated and delicately carved masks, they were impressed by simple, everyday objects, such as a pair of grass socks or a wooden bird spear. The use of some items had to be explained to them. Wassilie Evan remarked, "Those kids are amazed when they see old things, and a lot of times they ask me questions. Even my grandchildren,

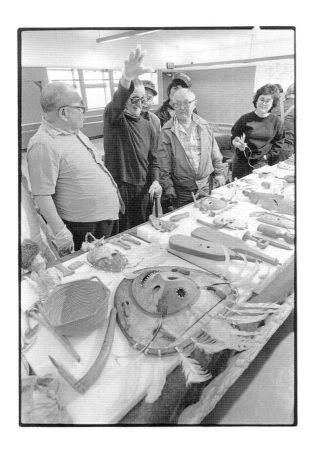

the first time how this tradition was going to be carried out. . . . When her children understood, they decided that they were going to begin to push and encourage the practice of Yup'ik tradition. It's already evident in people; instead of being ashamed of it, they are beginning to participate in it. It's because they have understood it for the first time.

After a silence of more than thirty years, the drums beat again, and dancing and dance festivals have been resurrected as a regular part of village life.

The decision to work collaboratively on this book and the exhibit it accompanies grew out of neither museum policy nor precedent, but out of a unique combination of players interested in bringing the masks back to Alaska. Although neither I nor the Yup'ik men and women involved in the exhibit knew much about the world of museums before planning began, we were all aware of the power of objects to evoke the past and influence the future. The support and interest that we found in the museum community was extraordinary. We hope that the book and exhibit can show how the right to own one's past can work for everyone's benefit.

Noel Polty speaking to Yup'ik elders and KYUK's Rhonda McBride at the 1989 Mountain Village Dance Festival. *JHB*

because they were born into these modern conveniences" (KYUK 1989, tape 1).

I had traveled to East Coast museums as an ignorant individual, and I came away amazed by what I'd seen.[2] Tim Troll and Andy Paukan had looked into their communities—to elders whose knowledge of the past was dying with them and to young people living with little comprehension of where they came from. Our experiences would have remained discrete events were it not for a third interested party.

Ironically, the Catholic Church, which had been instrumental in causing the old masks and dances to be put away in the 1930s, helped bring them back together. Father René Astruc, a Jesuit who has worked with Yup'ik communities for more than thirty years, deserves the name "Dancing Priest," as in the 1960s it was he who spread the word that the Church no longer frowned on that activity so valued in Yup'ik community life today. This new openness has helped create an atmosphere of rediscovery and reinvention. Dance festivals like the one held at Mountain Village in 1989 and that planned for Toksook Bay in 1996 would have been inconceivable twenty years ago. Across the delta, people are acting out what they have long suppressed, in both small ways and large. For example, at St. Marys, eighty-two-year-old Justina Mike spoke openly about the past and inspired a small-scale cultural revival on the part of her children. Andy Paukan (April 15, 1994) recalled:

This winter when they were going to have a gift-giving festival in St. Marys, when they were going to honor her grandchildren, she explained to her children for

## YUPIIT YURARYARAIT

## PILINGUARIT-LLU PAIVTAIT

Cenarmiut, Kuipagmiut, Ciuliqagtaita Umyuallgutekluteng

Mountain Village, Alaska 1989

Logo (featuring a *nepcetaq* mask) for the 1989 Mountain Village Dance Festival and exhibit. *Ray Troll*

2. I shouldn't have been surprised at what I found. Any museum anthropologist knows that 90 percent of the great nineteenth-century collections—Eskimo and otherwise—remain unresearched (Stocking 1985:9).

# Acknowledgments

We owe our greatest debt, both for this book and the exhibit, to the Yup'ik elders who generously and openly shared their knowledge with us, especially William Tyson, Mary Mike, Andy Kinzy, Jasper Louis, Willie Kamkoff, Kay Hendrickson, and Paul John. Marie Meade spent hundreds of hours interviewing these elders in their language and transcribing and translating their detailed accounts. They provided the information on which the text is built. Both the Anchorage Museum and the Yupiit Piciryarait Cultural Center in Bethel will house copies of the taped interviews and transcripts so that this touchstone will not be lost. Moreover, the University of Washington Press has published a separate volume of selected accounts, in both Yup'ik and English, to accompany the Toksook and Bethel mask exhibits.

A committee of Yup'ik men and women—including Paul John and his daughter Teresa John, Andy Paukan, Elsie Mather, Cecelia Martz, John Pingayak, Mary Stachelrodt, and Alexie Isaac—worked with me to ensure that the exhibit reflects Yup'ik community knowledge. Father René Astruc and Tim Troll were also full participants from the beginning. A group of anthropologists much more knowledgeable than I am about the way museums work—including William Fitzhugh, Susan Kaplan, Jonathan King, and Jim VanStone—helped guide the planning for the book and exhibit, which would have been impossible without the knowledge they shared.

Dorothy Jean Ray's pioneering research on Eskimo masks provided the cornerstone on which I built this book. I stand on the shoulders of Elsie Mather and Phyllis Morrow in my summary account of the Yup'ik ceremonial cycle. Betty Issenman, Phyllis Morrow, and Mike Yarborough contributed comments in the section on the human hand. I would know nothing about the influence of the Twitchell masks on the Surrealists were it not for Edmund Carpenter and Jean-Jacques Lebel. In 1985 I watched Nick Charles, Sr., transform wood to mask and wrote down what I saw as part of his biography (Fienup-Riordan 1986b). That information is included here in the chapter on maskmaking. Karin Berning and Peter Bolz of the Museum für Völkerkunde generously provided source material on Johan Adrian Jacobsen and his collection, including German articles, translated correspondence, and a biographical summary. Father René Astruc, Lydia Black, Bill Fitzhugh, Nelson Graburn, Margaret Lantis, Elsie Mather, Chuna McIntyre, Tim Troll, and Jim VanStone read manuscript drafts and gave many useful comments.

In the 1970s the bilingual education effort in southwestern Alaska incorporated a standard Yup'ik orthography established at the University of Alaska Fairbanks under the direction of Michael Krauss. That orthography is used throughout this book, making it possible to present accurate transcriptions and translations. Continuing their commitment to the Yup'ik language, Irene Reed and Anna Jacobson contributed dozens of hours working with Marie Meade, refining her translations. Judith Brogan, as always, provided fine editing of the manuscript. The mistakes that remain are mine.

Institutions that generously made Yup'ik masks and ceremonial objects available for the exhibit and to photograph for this book include the Alaska State Museum, Juneau; the Metropolitan Museum of Art, New York; the Moravian Historical Society, Nazareth, Pennsylvania; the Museum für Völkerkunde, Berlin; the National Museum of the American Indian, New York; the Seattle Art Museum; the Sheldon Jackson Museum, Sitka; the Smithsonian Institution, Washington, D.C.; the Thomas Burke Memorial Washington State Museum, Seattle; and the University of Alaska Museum, Fairbanks. Special thanks to the Alaska State Museum, the Burke Museum, the Moravian Historical Society, the National Museum of the American Indian, the Sheldon Jackson Museum, and the University of Alaska Museum, which helped us realize the promise of visual repatriation, allowing masks from their collections to travel to southwestern Alaska for Yup'ik people to see.

Masks in museums are objects divorced from context. This book could only begin to give them a human face thanks to James H. Barker's fine black-and-white photographs. Our thanks to Barry McWayne, who photographed the masks themselves, traveling to six major museums to do so, and to Aldona Jonaitis, who, as director of the University of Alaska Museum, enabled Barry to contribute his time and expertise to this project. Additional photographs were provided by the Alaska State Library, Juneau; Margie Brown; Edmund Carpenter; Arnold De Heus; the Field Museum, Chicago; the Institute of Alaska Native Arts, Fairbanks; the Library of Congress;

Chuna McIntyre; the Metropolitan Museum of Art; the Moravian Archives, Bethlehem, Pennsylvania, and Herrnhut, Germany; the Museum für Völkerkunde; the National Museum of the American Indian; the Oregon Province Archives at Gonzaga University, Spokane, Washington; the Peter the Great Museum of Anthropology and Ethnography, St. Petersburg; the Smithsonian Institution; Sotheby's, New York; Ray Troll; the Special Collections Division, University of Washington Library, Seattle; and the University Museum, Philadelphia. Matt O'Leary helped locate historic sites, and Patrick Jankanish and Ayse Gilbert prepared the maps.

A dozen German-speakers in Anchorage volunteered to translate 230 accession notes handwritten in the 1880s by Johan Adrian Jacobsen for the Museum für Völkerkunde in Berlin: André Appel, Annamarie Brunhart, Gabriel Dietrich, Margritt Engel, Melissa Hankins, Jeff Hittson, Janet Kaps, Sam Ozer, Adelheid Pauls, Dagmar Phillips, and Andrew Zartmann. Cornelia Feye of the San Diego Museum of Man at Balboa Park translated also. Had they not donated their time to this task, we would have been unable to include details on the Yup'ik masks Jacobsen collected.

Major sources of funding for both the book and exhibit include the National Endowment for the Humanities, the National Bank of Alaska, the Rockefeller Foundation, the National Endowment for the Arts, the Alaska Humanities Forum, the Lila Wallace Reader's Digest Community Folklife Program, Lewis S. Ranieri, the Anchorage Museum Foundation, the Kreielsheimer Fund of the Anchorage Museum Foundation, the ARCO Foundation, ARCO Alaska, Inc., the Getty Grant Program, the Wilson & George Meyer & Company, the Anchorage Hilton/Bristol Bay Native Corporation, and the Anchorage Daily News. Numerous smaller donors also contributed, and we are deeply grateful for their support. Thanks to the Coastal-Yukon Mayors' Association and the communities of St. Marys and Toksook Bay for sponsoring the festival that welcomed the masks back to Alaska and to the Yupiit Piciryarait Cultural Center in Bethel, which not only hosted the exhibit but helped publish the Yup'ik counterpart to this book.

Last, my gratitude to the staff of the Anchorage Museum as well as lending institutions, especially Rebecca Andrews, Lynn Binek, Peter Bolz, Diane Brenner, Gordon Chun, Jerrie Clarke, Peter Corey, Susan Dreydoppel, Vera Espinola, Barbara Geib, Walt Hays, Steve Henrikson, Mina Jacobs, Lori Johnson, Aldona Jonaitis, Janet Klein, Dinah Larson, Mary Jane Lenz, Molly Lee, Janelle Matz, Elena Mikhalovna, Dave Nicholls, Susan Steen, Walter Van Horn, and Patricia Wolf. Thanks also to the team at the University of Washington Press, including editors Lorri Hagman and Marilyn Trueblood and designer Audrey Meyer. And thanks to my family, especially my father and Dick, who have lived with this book and exhibit along with me every step of the way.

Ann Fienup-Riordan
*January 1996*

# Yup'ik Contributors

| Name | Residence | Birthplace | Year of Birth |
|------|-----------|-----------|---------------|
| William Tyson | Anchorage | Pastuli River | 1916 |
| Andy Kinzy | St. Marys | Qissunaq River | 1911 |
| Mary Mike | St. Marys | Uksuqalleq | 1912 |
| Justina Mike | St. Marys | Caniliaq | 1912 |
| Jasper Louis | St. Marys | Anagciq | 1916 |
| Pauline Akaran | St. Marys | | 1920 |
| Johnny Thompson | St. Marys | Tuutalgaq | 1923 |
| Andy Paukan | St. Marys | Akulurak | 1939 |
| Wassilie Evan | Pilot Station | | 1907 |
| Noel Polty | Pilot Station | | 1919 |
| Willie Beans | Mountain Village | | 1908 |
| Henry Bighead | Stebbins | Nelson Island | 1903 |
| Anatole Bogeyaktuk | Stebbins | | 1908 |
| Cecilia Foxie | Kotlik | Penguq | 1912 |
| Alma Keyes | Kotlik | Pastuli River | 1922 |
| Willie Kamkoff | Kotlik | Nunapiggluugaq | 1923 |
| Ivan Hamilton | Emmonak | | 1900 |
| Agnes Waskie | Emmonak | | 1903 |
| Jasper Joseph | Emmonak | | 1912 |
| Sophie Lee | Emmonak | | 1922 |
| Agnes Tony | Alakanuk | | 1930 |
| Joseph Tuluk | Chevak | Qissunaq River | 1914 |
| Billy Andrews | Chevak | | 1922 |
| David Boyscout | Chevak | | 1922 |
| John Pingayak | Chevak | Qissunaq | 1948 |
| Elsie Tommy | Newtok | Kayalivik | 1922 |
| Mike Angaiak | Tununak | | 1910 |
| Billy Lincoln | Toksook Bay | Kayalivik | 1906 |
| Cyril Chanar | Toksook Bay | Nelson Island | 1909 |
| Brentina Chanar | Toksook Bay | Chefornak | 1912 |
| Theresa Moses | Toksook Bay | Chefornak | 1926 |
| Paul John | Toksook Bay | Chefornak | 1929 |
| Dennis Panruk | Chefornak | | 1910 |
| Martha Mann | Kwigillingok | Kipnuk | 1910 |
| Charlie David | Kongiganak | Anuuraaq | 1915 |
| Julia Azean | Kongiganak | Urutuq | 1918 |
| Joe Beaver | Goodnews Bay | | 1909 |
| Nick Lupie | Tuntutuliak | Qinaq | 1921 |
| Peter Lupie | Tuntutuliak | | 1923 |
| Joseph Evan | Napaskiak | Paingaq | 1906 |
| Nickolai Berlin | Nunapitchuk | Qikertaq (Iik Island) | 1912 |
| Nastasia Kassel | Kasigluk | | 1910 |
| Dick Andrew | Bethel | Kayalivik | 1909 |
| Nick Charles, Sr. | Bethel | Nelson Island | 1912 |
| Kay Hendrickson | Bethel | Ciguralegmiut, Nunivak Is. | 1910 |
| Fannie Waski | Bethel | | 1918 |
| James Lott | Tuluksak | | 1908 |
| Joshua Phillip | Tuluksak | | 1909 |

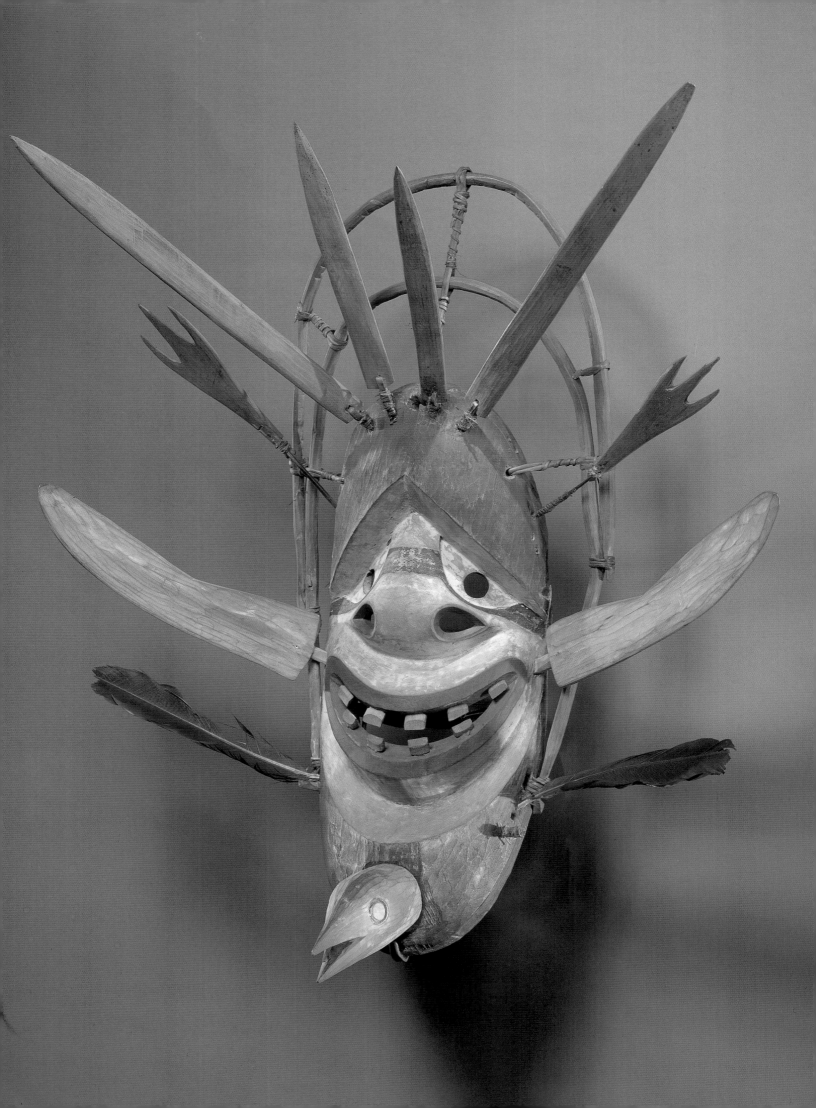

# Introduction

Formerly in the collections
of the Museum of the Ameri-
can Indian, Heye Founda-
tion, and Claude Lévi-
Strauss, this mask is now a
valued art object of the Met-
ropolitan Museum of Art. It
was one of a pair of "Anvik"
masks purchased by Heye in
1927. Its mate was pictured
in the Nushagak photo-
graph "Working to Beat the
Devil," taken between 1906
and 1908 (see p. 189).
*MMA, Michael C. Rockefeller
Collection, bequest of
Nelson A. Rockefeller.
1979.206.1120 (orig.
no. 15/4343) (68 cm)*

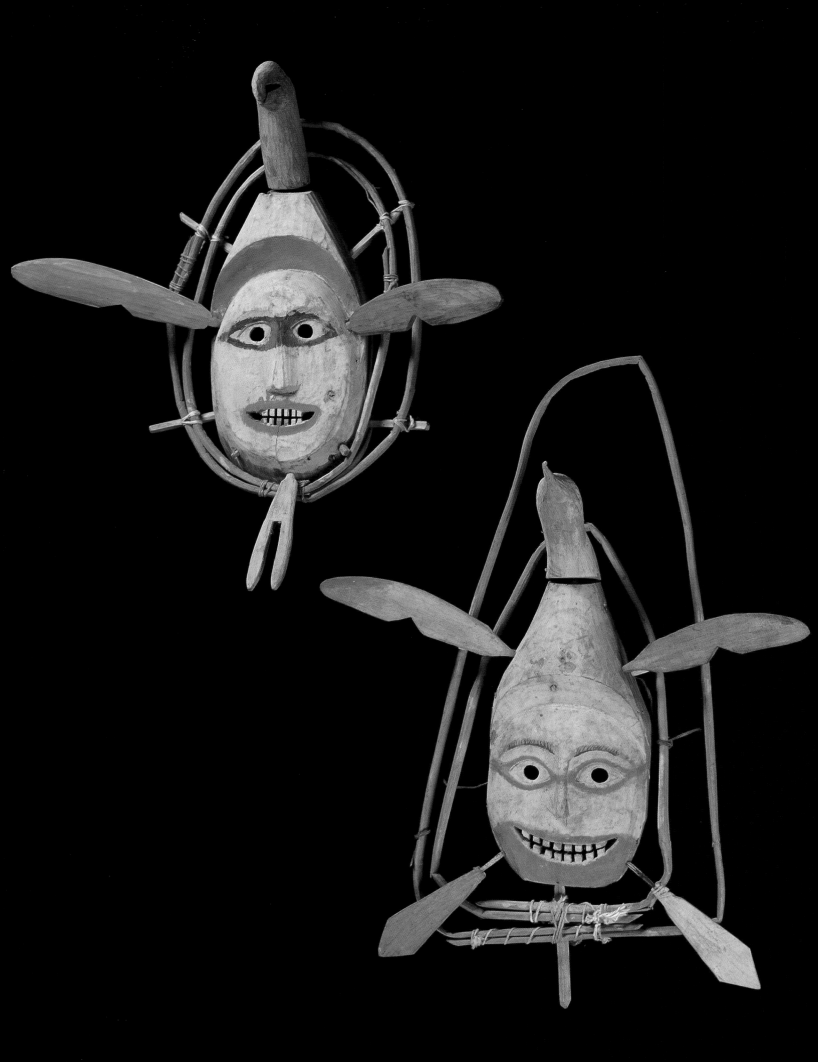

# Our Way of Making an Exhibit

Paired masks collected by Robert Gierke on the Kuskokwim in the 1920s. *Burke, 1.2E651 (45 cm) and 1.2E652 (31.5 cm)*

## "Visual Repatriation" and the Living Tradition of Yup'ik Masks

In 1992 the Coastal-Yukon Mayors' Association and the Anchorage Museum of History and Art began organizing their exhibit of nineteenth- and early twentieth-century Yup'ik masks. Members of three very different groups collaborated on the project—anthropologists, the Yup'ik community in southwestern Alaska, and the museum community, especially the Anchorage Museum—and brought very different perspectives and expectations to the process. The exhibit evolved through the synergy of their dedicated efforts.

The depth of feeling that the return of the masks evokes for the Yup'ik community is apparent in the title they gave the exhibit: *Agayuliyararput: Our Way of Making Prayer*. On Nunivak Island the word *agayu* originally meant "mask," and the verb phrase *agayuliluteng* meant "they making masks" for use in requesting that animals be plentiful in the coming year. After Christian contact and missionaries' suppression of masked dancing at the end of the nineteenth century, the verb base *agayu-* ("to request" or "to participate in a ceremony") evolved to mean "to pray" or "to worship." *Agayuliyararput,* as applied to the return of the masks, evokes in a single phrase both the old and new meanings of the word.

The exhibit opens at Toksook Bay, then travels to the new Yupiit Piciryarait Cultural Center in Bethel, then to Anchorage, and finally to Seattle and New York—a geographic trajectory very different from that of other cultural exhibits. The masks' return to Alaska is an act of "visual repatriation" that illuminates the worldview of their creators. Elders' involvement as consultants and the selection of items from collections from around the world are first steps in the two-way process of Yup'ik people owning their past and museum curators better understanding the contents of their attics. This book provides a map to dozens of Yup'ik mask collections worldwide. Yupiit have only recently become aware of the extent of these collections, and such knowledge can be empowering. Their grandparents were prolific carvers, and the most prestigious museums in the world are proud to include their creations. Yupiit can share this pride as they learn about the contents of these collections.

The context of the exhibit in Alaska is the display of the masks in their native settings, as people gather for large dance festivals and elders' memories are stirred. The Yupiit involved, including Marie Meade, Andy Paukan, Paul and Teresa John, Mary Stachelrodt, Cecelia Martz, Elsie Mather, Alexie Isaac, and John Pingayak, see the exhibit as an opportunity to better understand the Yup'ik past still present in innumerable contexts. The most lasting exhibit remnant will be the exchange of information with Yup'ik elders who view and talk about the masks.

Yup'ik elders can help us understand different kinds of masks from the Yup'ik point of view. When Willie Beans of Mountain Village and Wassilie Evan of Pilot Station looked at and handled the Sheldon Jackson Museum's collection in 1989, they identified one large, plaque mask as a *nepcetaq. Nepcetat* (plural), they said, were masks made and used by shamans, and they were distinguished from *kegginaqut,* or dancing masks (singular, *kegginaquq*). The men noted that there were many kinds of *nepcetat.* The one they were handling was but a single example. In 1991 William Tyson described *nepcetat:*

Now there's a mask in the old days they used to make that gets stuck to your face. I saw that one once. I was wondering how he did it. He put the mask on the floor and put the rain parka over it. And then another parka facing this way, muskrat parka facing that way [opposite], and there are four parkas about [two feet] thick. And he goes like that [*bends down*] and stands up with the mask stuck to his face. . . . And the parka's still there. . . .

We call it a *nepcetaq,* something that gets stuck to your face.

For the first time since the masks' creation, Yup'ik people can view many of the masks in pairs. Nineteenth- and twentieth-century collectors were understandably reluctant to transport masks in twos. Even when a trader such as A. H. Twitchell acquired paired masks, deaccessioning of collections split them apart. One was enough, George Heye contended, and he sold off what he considered extras. The *Agayuliyararput* exhibit puts these pairs—some of which have been separated by continents—back together again, and not just the extraordinary paired masks, such as those collected by Twitchell on the lower Kuskokwim

and by Edward Nelson on the lower Yukon. Robert Gierke, another Bethel trader, acquired twenty-six masks in the 1920s, which his son gave to Seattle's Burke Museum in 1978. These masks are also paired, but their craftsmanship is rough and the painting is sloppy. This inattention to detail may reflect intense missionary suppression and the decline of masked dancing in the region dating from the early 1900s. It may also reflect the character of masks as stage props rather than as family heirlooms. Their creators did not intend them to survive the performance. Most masks were simpler, more diverse, and cruder than the stunning examples usually chosen for exhibit.

Most exhibits have ignored the fact that each Yup'ik mask was integral to telling a story. Masks never stood alone, nor were they mute. When people saw them in performance, their makers often made their stories known. When St. Marys elders saw photographs of the masks Otto William Geist collected at Old Hamilton in 1934, each mask elicited a story. Mary Mike (May 29, 1993) of St. Marys spoke about the masked dancing she observed when she was young: "During those two years I watched and paid close attention to them when they were dancing with masks. They would explain what the masks were about. This happened when many guests arrived for the event. When the song ended and they removed the masks, the owners of the masks would come forward and explain the stories behind them."

Mary Mike gave detailed accounts of the masked dances she observed and the stories associated with them, in each case describing masks used in pairs. For example, she remembered her uncle's story of the time he and his brother were on ice that broke off and began to drift away into the ocean (see pp. 117–19). They were saved by two loons who guided their kayak to shore, after which they suddenly vanished. Mary Mike concluded, "Year after year, he would make those two loon masks and present them to the people. He would tell everyone that those two had saved them. . . . That was the way he explained the masks."

The connection between masks and the tales they tell is fundamental. Even contemporary masks made for the art market continue this tradition. When Wendell Oswalt bought masks from the Nelson Island carver Cyril Chanar in 1970, Chanar told him the story of the warrior Apanuugpak, whom the mask represented. Likewise, when Yup'ik maskmaker Noel Polty sold a mask, he recorded its story on tape and attached it to the mask in a plastic bag. Bob Charles of Bethel also names and attaches written narratives to the masks he makes and sells.

Masks often were collected without attention to the stories they embodied, and today they hang in museums all over the world divorced from their original meaning, accompanied only by an accession number and place of origin. The *Agayuliyararput* exhibit aims to bring at least some masks and their stories together again and to ask new questions about others whose stories have been lost. For example, the discovery of women's masks raises intriguing questions. Did only women use them? How often? How were they used? Were they worn with plain or painted faces? Collectors may have observed them frequently but only occasionally brought them home, just as they may have been reluctant to buy two of a kind.

These masks still have stories to tell. Bringing them out of storage for exhibit may injure a feather in transit, but will increase tenfold what the masks can teach of ways of viewing the world very different from our own.

## Yup'ik and Museum Collaboration: A Powerful Partnership

An idea needs a place to develop and grow if it is to turn into a reality. The *Agayuliyararput* exhibit found such a place at the Anchorage Museum of History and Art. Established only twenty-five years ago, the Anchorage Museum has a small collection of Yup'ik items, and only a few masks, but it is keenly interested in hosting and developing exhibitions of all kinds that bring back to Alaska the treasures created here that are spread throughout the world. Pat Wolf, the museum's energetic and visionary director, was as excited by the idea of an exhibit of Yup'ik masks as was Andy Paukan. Although the communities they represent are very different, their shared status as residents of the Last Frontier gives them more in common than one would think.

To understand the unprecedented character and significance of this cross-cultural collaboration, one need only look back on the historical relationship between Inuit and museums. Although up-to-date displays have in most cases replaced the pejorative label "Eskimo" with the people's generalized self-designation "Inuit," the tendency to show them snowbound in fur clothing continues. Inuit remain iconic of distant peoples and times. A natural history museum without an igloo is like a donut without a

Andy Kinzy, Laurentia Green, and Agnes Polty examining women's dance fans at Mountain Village, 1989. *JHB*

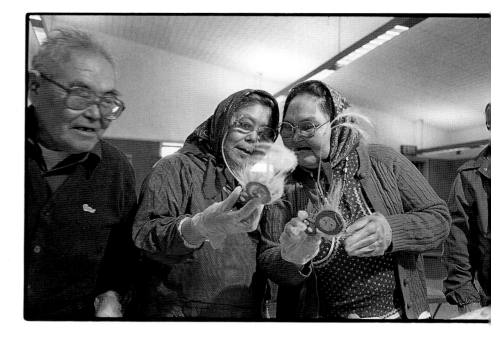

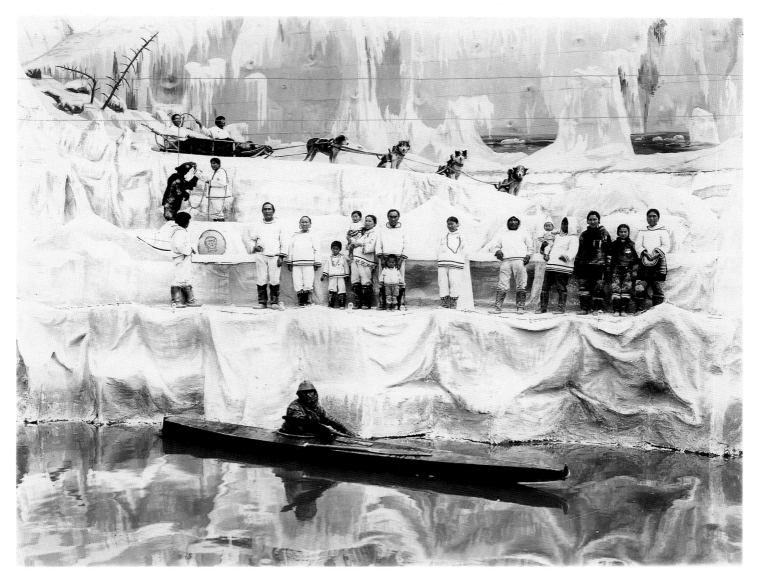

Inuit on display in papier-mâché grotto at the 1904 St. Louis Exposition. *FMNH, Carpenter Collection, neg. no. 13329*

hole. The cover of the March 1990 issue of *Smithsonian,* featuring an article on the $225 million state-of-the-art Canadian Museum of Civilization near Ottawa, pictures a brown-eyed girl, her face rimmed in fur, standing in front of a foam igloo holding a toy kayak. The caption: "A young visitor learns about Inuit life at Canada's newest museum."

Nineteenth-century exploration literature introduced the American public to Inuit peoples, primarily those of central Canada and Greenland, but as early as the sixteenth century Inuit occasionally had accompanied explorers south. Exhibits of living Inuit catered to the long-standing Euro-American interest in exotic peoples and consistently depicted them as being at a purer, though lower, stage of civilization. Alaska natives generally played no part in these displays, which routinely disregarded the diversity and cultural complexity of life in the Arctic.

During the 1800s the Inuit venue gradually improved from sideshows and occasionally zoos to major exhibitions, such as the 1893 World's Columbian Exposition in Chicago and the 1909 Alaska-Yukon-Pacific Exposition in Seattle. The former featured fifty-nine Labrador Inuit and their thirty-five dogs in an elaborately contrived papier-mâché

grotto, where they danced, chanted, played games, and otherwise entertained visitors. The exhibit portrayed neither hunting nor domestic activities, and the effect was to present the Inuit as simultaneously simple, childlike, entertaining, and quaint. Inuit life was completely decontextualized and trivialized (King 1990:8). The theme of progress was implicit in the organization of these displays—a theme that would die hard. It was visual confirmation of the metaphoric "ladder of civilization," a low rung of which Inuit occupied while the top was reserved for the sons and daughters of the Industrial Revolution.

More permanent Inuit exhibits could be found in museum display cases. The establishment of major anthropological museums began with the founding of the Peabody Museum of Archeology and Ethnology in 1866, and the "museum age" was born (Sturtevant 1969:622; Stocking 1985:7). Museum anthropology, including the development of systematic collection strategies and display techniques, flourished between 1880 and 1920, and examples of the tools and trappings of Inuit life were put on public view in all major natural history museums. Under the direction of Franz Boas, New York's American Museum of Natural History opened a small Eskimo

hall in 1907. In the central aisle several life-sized groups, functioning as "glorified stop signs," drew the visitor's gaze while larger cases held the museum's primary collections (Jacknis 1985:100). This scientific exhibit was designed to bring home to the observer "not only the ethnological facts involved, but also other facts, such as the austerity of Eskimo life, its enforced simplicity, and the limitations set upon civilization for the people of the Arctic" (American Museum 1909:211). The exhibit simultaneously elicited admiration of Inuit fortitude and ambivalence toward their "primitive," childlike state. With tools of stone and bone, they appeared as an inferior culture on the verge of extinction, necessarily and inevitably overwhelmed by progress.

Boas's original Eskimo hall remained virtually intact until the mid–1960s, when Stanley Freed designed and installed its replacement. The new exhibit reduced the overwhelming plentitude of artifacts by half but retained an updated diorama depicting a Canadian Inuit snowhouse. The captions make no distinction between the Yup'ik and Iñupiaq peoples of Alaska, referring to them with the then-acceptable summary term "Western Eskimo." Freed was by no means unique in constructing such a cultural conglomerate. Many contemporary exhibits continue to mix Yup'ik and Iñupiaq art and artifacts in a single case.

Every museum that attempts to depict the diversity of world cultures contains its variation on the Eskimo theme. In San Francisco's Golden Gate Park, the California Academy of Sciences devotes the large Wattis Hall of Human Cultures, opened in 1976, to a half-dozen representative groups. In the hall, which uses native dwellings to focus displays, Alaska natives are represented by a log structure constructed to approximate Edward Nelson's photograph of a St. Michael storehouse on page 243 of his 1899 publication *The Eskimo about Bering Strait*. Any Yup'ik or Iñupiaq viewer would recognize the replica for what it is—a food cache—but nowhere is this noted in the unlabeled exhibit. Many a Californian must go away disabused of the notion that all Inuit live in igloos but firmly convinced that their log homes are on stilts. Pointing this out to the collections manager, I was reassured that plans are under way to renovate the hall's cultural dioramas: "The plan is to somehow combine the Yup'ik and Netsilik Eskimo dioramas into a single, more general scene relating to a polar or subpolar environment" (Russell Hartman, personal communication).

Thanks to its proximity to the people represented, the Anchorage Museum of History and Art has done a better job than most in constructing Yup'ik and Iñupiaq dioramas. The museum's cutaway reconstruction of a semisubterranean sod house is accurate in all its particulars. It shows a family scene consisting of a seated woman, standing hunter, and playful child—the stereotypic nuclear family group. The frozen moment is true as far as it goes. Yes, women and children lived in small sod houses like the one

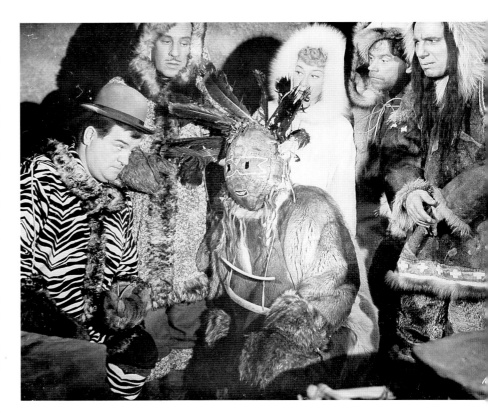

The pure primitives meet their "civilized" counterpart: Abbott and Costello confront a masked Eskimo in the 1952 film *Lost in Alaska*. *Universal Pictures*

displayed. Yup'ik hunters, however, lived together in a large, communal men's house (*qasgiq;* pl., *qasgit*), in which they ate, slept, danced, worked, and entertained visitors. The man in the diorama is just visiting.

All over the world Inuit still appear in natural history museums, never far from stuffed polar bears and moose. When Yup'ik and Iñupiaq artists are asked to exhibit their work in such museums, many are understandably uncomfortable with this positioning. As Inuit, they are still more closely aligned with a primitive past than a civilized present. The label "primitive art" has only recently been set aside, and its shadow still falls across their work.

For decades, museums large and small assumed they could interpret Yup'ik and Iñupiaq cultural material in isolation from the people whose heritage their displays portrayed. Designers consulted scholarly texts and historic photographs but only rarely the living descendants of the makers. This pattern has been challenged more and more frequently since the early 1980s. Issues of representation and ownership, although not new, are increasingly taking center stage in the social sciences. In the aftermath of the colonial era, the traditional relationship between "objects and others" is being called into question. Both the physical ownership of objects and the right to represent their meaning have become issues of contention (Stocking 1985:10).

The museum community, with its public presence, has been directly affected by this new self-consciousness. Working relationships with the native peoples represented in exhibits and displays are no longer luxuries museums cannot afford, but necessities they cannot do without. In the exhibition of Arctic peoples, Canadian institutions have led the way in

forging such partnerships. Since 1980 there have been numerous examples where Canadian Inuit have conducted research, recorded their history, and sponsored exhibitions on their own or in alliance with nonnative people, including *Things Made by Inuit,* an exhibit organized in 1980 by La Fédération des Coopératives du Nouveau Québec; *Inuit Annuraangit/Our Clothes,* prepared by the Inuit Cultural Institute; and the *Trapline/Lifeline* exhibition of the Prince of Wales Northern Heritage Center, planned by a group composed of Dene, Métis, Inuit, and nonnatives (Issenman 1991:4). Canadian museums have also been subject to misunderstandings, as when the Lubicon Cree called for a boycott of the exhibition *The Spirit Sings,* sponsored by Calgary's Glenbow Museum in 1988–89.

Alaska natives have not been as involved as their Canadian cousins in exhibiting their past. Older Alaska material increasingly draws interest, but curators of major collections have controlled research and exhibition decisions. Although Alaska native artists have actively organized showings of their work, including the recent *Bending Traditions* by the Institute of Alaska Native Art (IANA) and *Arts from the Arctic* by IANA and the Anchorage Museum, the focus has been on contemporary pieces.

By 1904 Yup'ik masks were stored in glass cases at the Sheldon Jackson Museum. *Merrill Collection, ASL, PCA 57–122*

Two major exhibits of nineteenth-century Iñupiaq and Yup'ik material were sponsored by the Smithsonian Institution in the 1980s—*Inua: Spirit World of the Bering Sea Eskimo* and *Crossroads of Continents: Cultures of Siberia and Alaska.* Both broke new ground and traveled widely in the Lower Forty-eight states and to major urban centers in Alaska. Smaller versions of both exhibits traveled not only to Alaska's regional centers, but also to Europe, Canada, and Greenland. *Crossroads* celebrated and symbolized Americans' shifting interest from the Atlantic, European-dominated view of art, history, and culture to a new appreciation of the importance of the Pacific Rim. Drawing on collections in the United States and Russia, it involved international scholarly collaboration unprecedented in northern-exhibit history. *Crossroads* gave viewers an up-to-date picture of what nonnatives know about the native peoples of Alaska and Siberia.

*Crossroads'* strength was the academic collaboration it set in motion, bringing together information on a dozen Pacific Rim societies. Building directly on *Crossroads, Agayuliyararput* takes the next step and frames the windows through which the public can view the "objects of others" as did the people who made them. *Agayuliyararput* is the first major exhibit of Yup'ik material planned by Yup'ik men and women in collaboration with the museum community. For many nonnative viewers, both in and outside Alaska, it will be their first opportunity to learn something about Yup'ik people in Yup'ik terms.

Each perspective—scholarly and native—is essential and interdependent, and each advances understanding of contemporary Arctic peoples. It has taken museums almost one hundred years to include the native point of view in planning exhibits and docu-

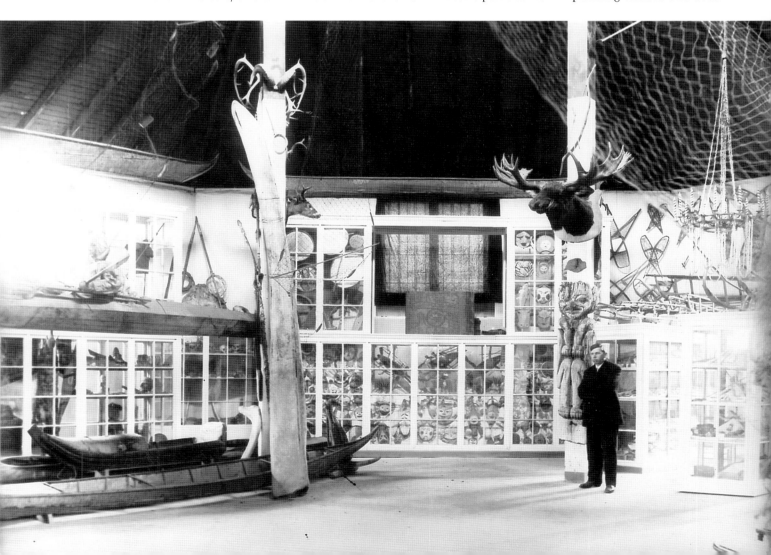

menting collections. The door to the past of western Alaska is closing fast, as the last generation of men and women who grew to adulthood in the *qasgiq* and participated in the old ceremonies passes away. Today these elders are willing to share their memories, in part due to interest stirred by exhibits such as *Inua* and *Crossroads*. But by the year 2000 most of these elders will be gone. The 1990s is a critical and exciting decade in which the collaborative exchange between the "makers" and the "keepers" can take place.

Some Native Americans view the museums that store and study artifacts and the native perspective as essentially incompatible. The issue of repatriation, however, is having unexpected results in Alaska, opening communication between historically separate groups and turning plunder into a rich resource (McDaniel 1994:F1). Because museums must learn more about their collections—what is sacred and what is not—to comply with the law, a potential problem has become an asset to understanding. The *Agayuliyararput* exhibit has allowed native and nonnative Alaskans to work together to gain control of the representation of their shared history. Both groups represent local communities, and both seek to increase their community's understanding of others and themselves.

Ironically, Anchorage is simultaneously Alaska's largest urban center and its largest native village. More Alaska natives live in Anchorage than in any other community in the state. These eighteen thousand men, women, and children, as well as their visiting friends and relatives from Bush Alaska, are part of the audience the Anchorage Museum is trying to reach. They are also a rich resource on whom the museum can and does draw, both during their annual summer performance series and native heritage festival as well as under more personal circumstances. In 1980 King Island elder Paul Tiulana worked to build a walrus-hide umiak for the museum's Alaska Gallery. He subsequently celebrated his grandson's first polar bear hunt at the museum, dancing and feasting members of the Anchorage native community as well as hundreds of nonnative visitors. Time and again the Anchorage Museum has shown itself close enough to the diverse community it represents to retain some of the density of local meanings and memories and "reinvented histories" normally lost in the cosmopolitan milieu of major metropolitan museums (cf. Clifford 1991:223).

Along with entering the world of urban museums, Alaska natives are creating museums of their own. Although it may appropriately be regarded as an invention of modern Western culture, the museum is no longer exclusively a Euro-American preserve (Karp and Lavine 1991:5). Regional attempts to have control over heritage have resulted in the formation of a handful of cultural centers all over the state, including Bethel's new Yupiit Piciryarait (Real People's Lifeway) Cultural Center and Museum. Through these organizations, Alaska natives can participate in inter-

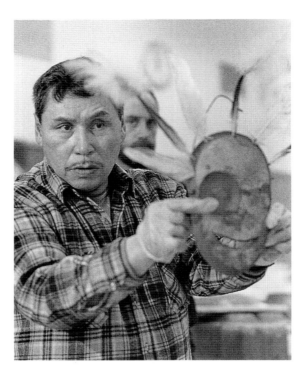

Andy Paukan presenting a mask to the people at Mountain Village, 1989. *JHB*

pretation, increase access to collections, and gain authority to manage cultural property. They may also develop distinctive exhibition techniques, reflecting different ways of organizing experience.[3] All challenge majority institutions with an oppositional thrust to their "universalizing narrative" (Clifford 1991).

## "We Have Not Vanished": Masks as Stories of Survival, Signs of Heritage

*This project is important for me and, I believe, all Yup'ik people, not because it brings the past back to us but because it may help preserve our future. . . . I consider it fortunate that so many well-regarded museums have fine collections of Yup'ik materials collected at an important time in our history. Certainly those who collected these items may have thought they were collecting the artifacts of a vanishing culture. However, among those of us whose forefathers were the craftsmen, these items demonstrate that we may be different, but we have not vanished.—Andy Paukan, May 1994*

In May 1994 Andy Paukan explained to a primarily nonnative audience the importance of bringing the masks home. He emphasized not problems of the past, but possibilities for the future, and gave a strong statement of identity, concluding, "We have not vanished." Paukan knows what museum professionals are only now directly confronting—that exhibitions can be places for defining who people are as well as places for challenging these definitions (Lavine and Karp 1991:4). Yupiit come into museums not contentiously or antagonistically, but with energy to share and elaborate and with the patience to correct. They have taken masks—objects judged alternately "primitive art" or evidence of the low evolutionary rung Inuit occupy—and turned them into signs of heritage.

Paul John, traditional chief of Toksook Bay and well known throughout the region, is one of the most

3. Distinctive security measures are also possible. At a planning meeting museum personnel raised the problem of security during the Toksook Bay mask exhibit. Andy Paukan stated simply, "All you do is say 'No touching' before [people] enter the exhibit, and nobody will touch [anything]. And that's how it works."

outspoken proponents of the need to look to the past to shape the future. When he spoke at planning meetings, he said little about the masks themselves—their beauty, their complexity, their presence. Rather, he focused on the dance in which they were traditionally embedded. Dancing, he explained, "is the only custom remaining in our culture. . . . supportive of the extended kinship system of the people." Dancing was a system that perpetuated the kinship ties from way back in time, advocating love and compassion between people. For Paul John, the masks were iconic of this connectedness, as they had been part of dances that simultaneously linked families and identified them.

Like Willie Beans and Wassilie Evan during their visit to the Sheldon Jackson Museum, Paul John was moved by the collections he viewed in storage at the Anchorage Museum. It was not, however, merely the objects that impressed him, but the memories and stories they evoked:

Yesterday, though I'm a grandfather, I was filled with awe when I saw the things they had used before I was born. I was overwhelmed seeing what I had imagined in stories I had heard. I was especially struck with fascination when I saw the stone *uluaq* [woman's semi-lunar knife] and the carving tools they used before metal was introduced. . . .

When I saw the stone *uluaq,* a story I heard came to mind. Long before the time the white people's material was seen in this area, the character in the story was a scientist of our ancestors. They say he would get up in the morning and drum all day long. When he was done drumming he would say that he had finished drumming upon reaching the time of shiny material [metal] of future generations. Yesterday I was reminded of the scientist of our ancestors who was able to foresee the time we would be using metal and other shiny material.

Paul John's reaction to these "old things" turns the dominant practice of collecting and display on its head: "the master narratives of cultural disappearance and salvage" are replaced by "stories of revival, remembrance, and struggle" (Clifford 1991:214).

To begin to retrieve their stories, elders throughout the region were queried about the meaning of the masks they had seen when they were young. As people from lower Yukon villages gathered at St. Marys in February 1993 for their annual winter dance festival, Andy Paukan greeted two dozen elders with pictures of masks brought from far-flung museums:

Thank you for coming and listening for a while. When we gather to dance at Toksook Bay in 1996, these masks will be shown to people. If you know it you should tell the story behind a mask. You are doing that right now. The future generations will learn about it. And we would like these people who are giving information on stories they know to do that when they gather at Toksook Bay. Since our children are beginning to forget the traditions, we would like to start bringing it out for them. We would like for our children to understand who they are and to maintain their identity in the years to come.

After recording individual recollections Marie Meade began the time-consuming job of translating their stories. The exhibit committee also met to discuss details such as which masks to request and how they would be shown. Three fundamental issues surfaced.

First, people wanted to communicate the ceremonial and social context in which Yup'ik people used masks in the past and are beginning to use them again today. The masks, they pointed out, were not originally created to hang on walls or rest quietly in glass cases. They were not made to be treasured as heirlooms but to be used in elaborate and exuberant ceremonies and destroyed after use. Showing the conditions under which masks were made, used, collected, and finally displayed reduces the isolation of individual "masterpieces" (Greenblatt 1991:43). The postbase *-li* (to make) in the title suggests the process of "making" in its fullest sense—making masks, making songs, making motions, making dance groups, making requests, making everything needed for prayer.

How can we exhibit Yup'ik meanings in a historically non-Yup'ik form? Are museums Western cultural institutions that inevitably transform Yup'ik creations, past or present, into "exotic" objects? Is the Euro-centered way of seeing masks so central to the "museum effect" that inclusion of Yup'ik masks in a museum display can be meaningful only in relation to that tradition? Yes and no. We can never see these nineteenth-century masks as their creators viewed them. Over the last century each has acquired its own thick history, including unique circumstances of collection and salvage. At the same time, surrounding the circumstances of their exhibition with the sounds, sights, and dances of the past reduces their isolation and evokes their original context of use.

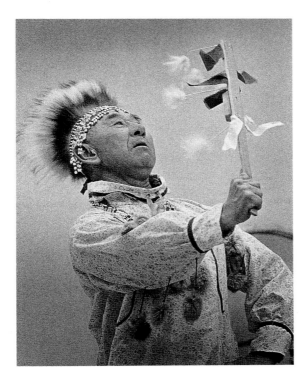

Paul John dancing at a Bethel dance festival, 1987. "From a long time past they did wear masks. It was a way of praying so the animals would come when they hunted them." JHB

In many ways masks are well suited to museum appropriation. The theatricality of museums, including their intense visual focus, has much in common with the traditional Yup'ik ceremonial setting in which all the senses were stirred, in contrast to the rigorous circumspection of daily life. Like theater, both provide the "opportunity of experiencing imaginative truth as present truth" (Cole 1975:5). The *Agayuliyararput* exhibit strives to create an event where the masks live again for the viewer.

Second, the Yup'ik steering committee gave a clear mandate to group the masks by region. This insistence made clear a major interpretive principle for them—place has meaning. Repetition of interpretive themes was judged acceptable and would give viewers multiple opportunities to confront ideas central to understanding mask design and use.

The third issue discussed concerned style of presentation. Yup'ik members of the exhibit team regarded *Agayuliyararput* as an opportunity to teach their children, as well as nonnative visitors, something about the Yup'ik way of life: "Let us make our ancestors' ways known to our younger generation with the help of our elders. Let them see the elders talk about how these things were used and how they were made" (Andy Paukan, May 1994). The question was how to do this. Yupiit typically learn by watching or by taking part in an activity, not through lectures. Traditionally, people chose words carefully, as they believed spoken words had the power to evoke that which they described. They recounted their own experiences and those of their parents but refrained from generalizing (Morrow 1990). Even today, a narrator often ends an account saying, "I know this from my own experience. Someone else may have experienced it differently," or "They did it this way here in our area, but it was different in other places."

In both design and content, the exhibit and book reflect this attitude toward information. Within regional groupings, elders' statements describe particular experiences related to the objects, grounding them and giving them meaning. The Yup'ik experts—the elders—provide the information available to viewers in a recognizably Yup'ik way. This "new" approach gives remarkably "traditional" results.

But the book is not a Yup'ik monologue; rather, it juxtaposes elders' statements with different understandings of the objects to create an international dialogue. Yupiit made the masks, but over the years their creations passed through many hands. Mission-

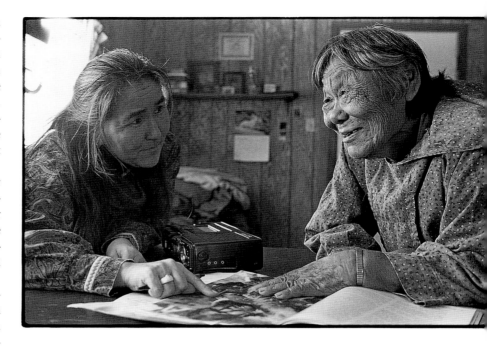

Marie Meade working with Edna Kolerak, Mekoryak, 1995. *JHB*

aries derided them as "heathen idols," while French Surrealists studied them as a source of inspiration. Each meaning has a place in the masks' histories, according to the "cubist approach" advocated by David Hurst Thomas: "Just as Renaissance painters believed that they were depicting reality, some . . . groups persist even today in pursuing and promoting their single-point version of the 'truth'—the way it really was. But the only truth is the artificiality of our perspectives because, to one degree or another, all views of the human past are created by those telling the story" (West 1993:39).

Multiple perspectives on these objects exist within as well as beyond the Yup'ik community. Teresa John recalled one elder describing a certain mask that could not be shown to the people because it was too powerful. Talking about her visit to the Smithsonian storage facility in Maryland, Cecelia Martz remembered, "When I looked at masks in the Smithsonian, I couldn't touch some of them. But some of the masks I touched with ease." Andy Paukan said that when he visited the Sheldon Jackson Museum, "I didn't feel anything, I touched them all." In spite of their differences in perspective (which are repeated throughout the region) all three support the exhibit and its presentation of masks as "our way of making prayer." Their intent is not for the exhibit's "voice" to oppress others, but to express one view without denying the others' existence.

# THE MASKS' HISTORY

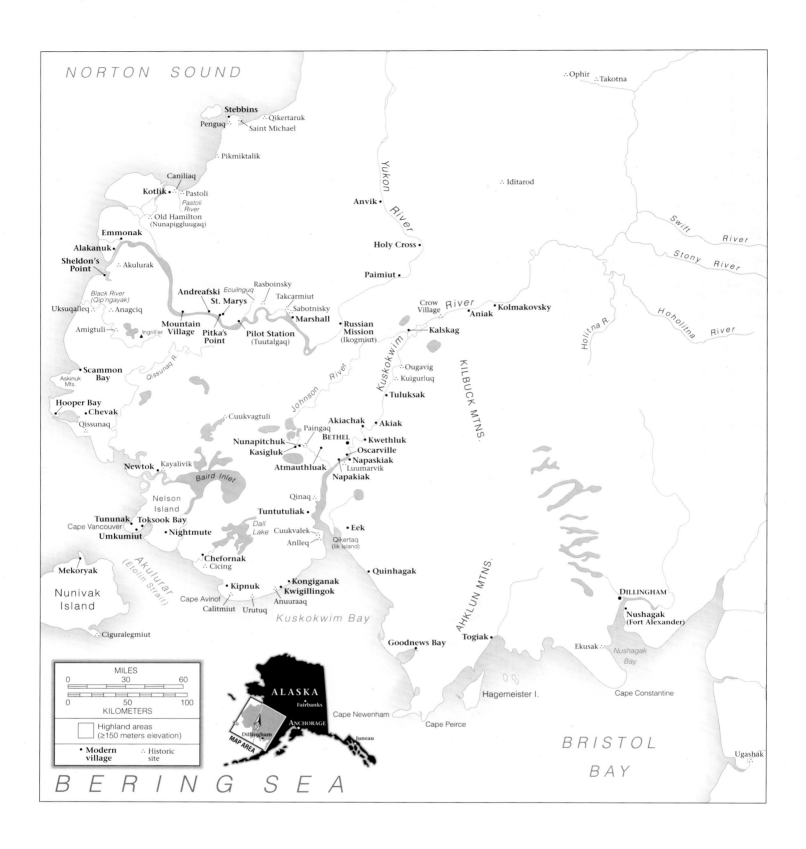

NORTON SOUND

Ophir
Takotna

Stebbins
Penguq
Qikertaruk
Saint Michael

Pikmiktalik

Caniliaq
Kotlik
Pastoli
Pastoli River

Old Hamilton
(Nunapiggluugaq)

Emmonak
Alakanuk
Sheldon's Point
Akulurak

Yukon River

Iditarod

Anvik

Holy Cross

Paimiut

Andreafski
Eculinguq
Rasboinsky
Takcarmiut
St. Marys
Sabotnisky
Marshall

Black River
(Qip'ngayak)
Uksuqalleq
Anagciq

Mountain Village
Pitka's Point
Pilot Station
(Tuutalgaq)

Russian Mission
(Ikogmiut)

Crow Village
Aniak
Kolmakovsky

Kalskag

Amigtuli
Ingrill'er

Scammon Bay
Askinuk Mts.

Qissunaq R.

Johnson River

Kuskokwim

Ougavig
Kuigurluq

KILBUCK MTNS.

Holitna R.

Hoholitna River

Swift River

Stony River

Hooper Bay
Chevak
Qissunaq

Cuukvagtuli

Tuluksak

Akiachak
Paingaq
Nunapitchuk
Kasigluk
BETHEL
Akiak
Kwethluk
Oscarville
Napaskiak
Luumarvik
Napakiak

Newtok
Kayalivik
Baird Inlet

Atmauthluak

Nelson Island

Qinaq

Tununak
Cape Vancouver
Toksook Bay
Umkumiut
Nightmute

Dall Lake
Cuukvalek
Anlleq

Tuntutuliak

Eek
Qikertaq
(Ik Island)

Mekoryak

Akulurar
(Etolin Strait)

Chefornak
Cicing

Quinhagak

Nunivak Island

Kipnuk
Cape Avinof
Calitmiut
Urutuq

Kongiganak
Kwigillingok
Anuuraaq

DILLINGHAM

Nushagak
(Fort Alexander)

Ciguralegmiut

Kuskokwim Bay

Goodnews Bay
Togiak

Ekusak
Nushagak Bay

AHKLUN MTNS.

Hagemeister I.

Cape Constantine

BRISTOL
BAY

MILES
0        30        60

0          50          100
KILOMETERS

Highland areas
(≥150 meters elevation)

• Modern village    ∴ Historic site

ALASKA
Fairbanks
Anchorage
MAP AREA
Dillingham
Juneau

Cape Newenham
Cape Peirce

Ugashak

B E R I N G   S E A

Yukon-Kuskokwim
Delta region, 1990. *Patrick
Jankanish and Matt O'Leary*

# The Yup'ik People of Western Alaska

The name Yup'ik is the self designation of the Eskimos of western Alaska and is derived from their word for "person" (*yuk*) plus the postbase *-pik,* meaning "real" or "genuine." Like many indigenous people throughout the world, they consider themselves "real people" in contrast to presumably less-real outsiders. They are members of the larger family of Inuit cultures extending from Prince William Sound on the Pacific coast of Alaska to Bering Strait and from there six thousand miles north and east along Canada's Arctic coast and into Labrador and Greenland. Within that extended family, they are members of the Yup'ik-speaking, not Inuit/Iñupiaq-speaking, branch.

The Yup'ik people of western Alaska and the Inuit of northern Alaska and Canada claim a common origin in eastern Siberia and Asia. The ancestors of modern Yupiit originally settled on the coastal headlands of western Alaska as many as three thousand years ago (Shaw 1982:59–73). By the late nineteenth century Yup'ik territory extended upriver to the vicinity of Paimiut on the Yukon River and Crow Village on the Kuskokwim River, at which point they came into contact with Athapaskan people.

The coastal landscape consists of a broad, marshy plain, the product of thousands of years of silting action by the Yukon and Kuskokwim rivers. The sea is shallow and the land is flat. Innumerable sloughs and streams criss-cross this seemingly endless alluvial prairie, covering close to half the surface of the land with water and creating the traditional highways of its native population. Low volcanic domes on Nelson and Nunivak islands and outcroppings of metamorphic rock in the vicinity of Cape Romanzof provide the only relief.

Frequent storms gather force as they race uninhibited across the delta landscape. Wind chill can drive temperatures to the equivalent of −80°F in winter. At the other extreme, a sunny, windless day in July can reach temperatures of +80°F. Precipitation averages no more than twenty inches a year, including fifty inches of snow. Even during the darkest months of the year, the sun rises above the horizon for at least five hours a day.

## The Bounty of Land and Sea

The subarctic tundra environment nourishes a rich array of vegetation, including numerous edible greens and berries harvested by the local people. Shrubs and trees, mostly willow and alder, crowd streambanks. River drainages sustain a mixture of spruce and birch from Aniak on the Kuskokwim and Pilot Station on the Yukon. Breakup releases an ample drift of logs downriver every spring. Though living beyond the reach of the dense forests of the Interior, the Yupiit were well supplied with wood, which they used to build their homes, boats, tools, and elaborate ceremonial accoutrements.

The Bering Sea coast supports rich fauna. An impressive variety of animals and fish appears and disappears as part of an annual cycle on which the Yup'ik people focus both thought and deed. Far from seeing their environment as the insentient provider of resources available for the taking, they continue to this day to view it as responsive to their own careful action and attention.

Winter begins to give way by the end of February. In the lengthening light, hunters emerge to replenish depleted stores of food. As leads begin to open in the nearshore ice, men set out to hunt seals, protected by shifting floes from the treacherous open sea.

Daylight stretches to a full twelve hours by April. Rock ptarmigan begin to flock in the willow and alder, their white-plumed bodies contrasting with the brown tundra and making them an easy target. Women and children hook tomcod and sculpin through the ice. Children range the nearby tundra in search of last year's berries. Young men and boys venture farther, hunting for Arctic fox and snowshoe and Arctic hare. On Nunivak and Nelson islands they may harvest an occasional musk ox from the herd introduced in 1963.

The Yup'ik term for April is Tengmiirvik, translating literally as "Bird Place." Millions of birds annually make the long journey north to nest and breed in the wetlands of western Alaska. These include four species of geese, black brant, sandhill cranes, whistling swans, and numerous varieties of ducks and seabirds, including pintails, old-squaws, and king eiders.

The inexorable melting persists throughout May, and the shore ice begins to dissipate. Men continue to hunt seals in open water. The smaller ringed (hair) seals, spotted (harbor) seals, and ribbon seals follow the bearded seals on their way north. Hunters also occasionally take sea lions, walrus, and beluga whales.

The ringed and spotted seals are small, and

women cut them up on the kitchen floor. Men butcher the larger bearded seals, which can reach 750 pounds, out on the ice to facilitate transport back to the village. The real work begins in mid-May, when women adjourn to their storehouses to prepare for drying the thousands of pounds of meat that have accumulated between the beginning of hunting and the time when the weather warms enough to defrost the frozen carcasses. They will also cut the seals' blubber and store it in a cool place, where it gradually renders into the oil that accompanies every meal.

As men continue to harvest from the sea, women venture into the nearby tundra. There they pursue a varied quarry, supplementing the meat-rich spring diet with the greens of marsh marigold and wild celery and the roots and shoots of wild parsnips. Although egg gathering from the thousands of nearby nests made by gulls, cranes, geese, and ducks today is restricted by law, coastal residents continue to harvest fresh clams and mussels from the tidal flats.

The fishing season begins in earnest by early June, and modern coastal communities bustle with twenty-four-hour activity. The first arrivals are herring, which residents harvest in abundance and dry for winter use. Like bird hunting, the herring fishery has undergone dramatic changes over the last decade due to government management decisions and resulting regulations.

Herring breed along the coast and do not enter the Yukon and Kuskokwim rivers. The riverine summer harvest focuses on the regular succession of five major species of salmon: king (chinook), red (sockeye), coho (silver), pink (humpback), and chum (dog). From June through August, millions of these fish struggle up the major waterways to spawn. As they begin their ascent, thousands are taken in gill nets, dried, smoked, and stored away as winter food for both people and dogs.

Herring and salmon are only two of the many fish species taken by the Yup'ik people of the Bering Sea coast. Throughout summer, boats come and go with the tides. Fishermen harvest halibut and flounder with long lines and four-pronged jigging hooks. As summer comes to a close, men also use dip nets, spears, and traps to harvest an impressive variety of freshwater fish, including sheefish, northern pike, Dolly Varden (char), burbot, and blackfish. Various species of whitefish also populate the tundra lakes.

Fishing slows by the first of August as the berries ripen, and families disperse over the soggy tundra to harvest salmonberries, crowberries, and blueberries. Later in the season, women whip the stored berries together with seal oil or shortening and sugar to make the festive *akutaq,* or "Eskimo ice cream," which remains to this day a requisite to hospitality during winter entertaining.

The wind blows mostly from the east during early autumn, and temperatures regularly drop below 35°F at night. The seals return to the river mouths where hunters await them in open water into December if

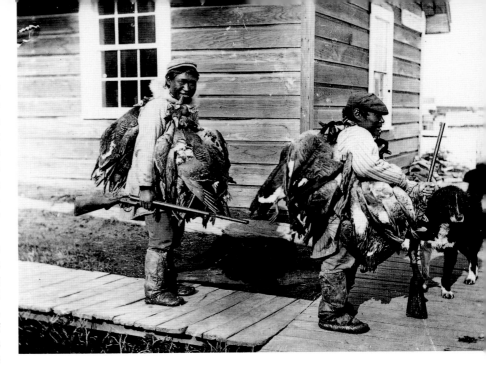

Goose hunters returning to Bethel, circa 1920. *MA (Ger.)*

the winter is mild. Schools of beluga whales enter river mouths and are sometimes beached, butchered, and shared throughout the village.

Men stay busy before freezeup, checking nets and traps on day trips away from the village or leaving in pairs on overnight hunting ventures. Some travel upriver to hunt for moose and bear. Women tend to the last of their annual harvesting activities. On clear days they search the tundra for caches of "mouse food"—the stock of small roots and underground stems of sedges and cotton grass gathered by unsuspecting tundra lemmings. They also gather rye grass blade by blade and dry it to use for weaving baskets during the long winter. This gathering used to be a major fall task, as winter boot insoles and household mats required a huge supply. Less important now, the gathering of grass remains part of the fall routine.

Men travel out to nearby sloughs and streams during September to set wooden or wire traps for the small but tenacious blackfish and the more substan-

Teresa and Agie John gathering smelt (*cikaat*) from the Nelson Island coast, 1981. *JHB*

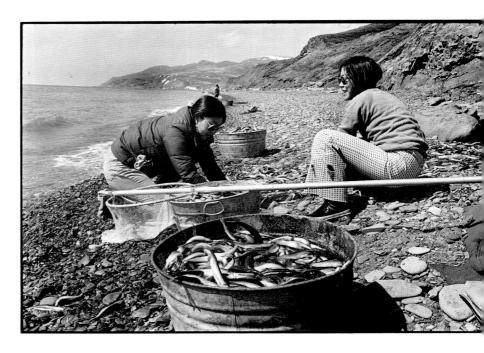

tial burbot. These cone-shaped, spirally bound traps are set with their mouths upstream and rely on underwater barriers to channel the fish. If checked once or twice a week, they can provide hundreds of pounds of fresh fish through the fall and early winter.

Fall is also a time for bird hunting, though less so today than in years past, due to declining bird populations and increasing state and federal restrictions. From mid-August through mid-September, geese, cranes, and swans begin their journey south after their summer nesting season. By mid-October the ducks are gone as well, and the berry-fattened ptarmigan remain the only fresh fowl available for the table. Except for processing the daily catch of fish and fowl, the major gathering and butchering tasks end with the frost in early October, and women retire into their houses for the winter. Men continue regular hunting and fishing trips away from the village.

November solidifies freezeup. Tomcod continue to run upstream, and men fish for them through the ice with barbless hooks. They also net thousands of sticklebacks through the ice with large dip nets. As the rivers freeze and the first snows cover the ground, some of the men alternate setting and checking traps for mink, muskrat, and beaver. Later in winter they may visit traplines within snowmobile distance from the villages.

December temperatures often dip to −20°F, too severe for ocean hunting. No birds fly, and the ice is too thick for tending fish traps and nets. Only an occasional gust from the south mitigates the cold north winds of January and February. This is the season of indoor work, when villagers mend nets, repair motors, tan skins, and sew new parkas. On clear, calm days, young men and boys pack water, pump stove oil, and shovel the snow that has blown into porchways and covered windows.

Fresh food is scarce through February, and in the past famine was an all-too-common antecedent to spring renewal. Though tomcod, needlefish, and blackfish remain available, a rainy summer season during which few fish are put away combined with prolonged cold weather the following winter still can produce real hardship.

Freezeup in western Alaska corresponds to a marked social thaw. While blizzards gather force across the tundra, men tighten walrus-stomach or plastic coverings over the circular wooden frames of large hand-held drums. Women and children join them in the community hall, bringing their dance fans out of storage. Community leaders may also invite neighboring villages for an intervillage dance. Such celebrations traditionally required months, even years, to prepare the food and gifts. Even now, residents strip bare their food caches and store shelves to ensure their guests' satisfaction. Women whip berries and fat together into *akutaq* and boil fresh-caught seal meat and store-bought turkeys into rich soups. Families give away what they have gathered during the previous seasons, and by the close of winter they are ready to begin the process again.

Potluck dinner during the 1989 Mountain Village Dance Festival, with large bowls of *akutaq* in the foreground. *JHB*

## Changes from Without

The Yup'ik people built on their rich resource base, developing a complex cultural tradition prior to the arrival of the first Euro-Americans in the early 1800s. Sometimes referred to as the "cradle of Eskimo civilization," the Bering Sea coast traditionally supported and continues to display a cultural diversity and vitality unsurpassed in the Inuit world. As many as fifteen thousand people may have lived on the Yukon-Kuskokwim delta in the early 1800s.

The abundance of fish and game available in western Alaska allowed for a more settled life than that enjoyed by Inuit peoples in other parts of the Arctic. Like the northern Inuit, the coastal Yupiit were nomadic, yet their rich environment allowed them to remain within a relatively fixed range. Each of at least a dozen regional groups demarcated a largely self-sufficient area within which people moved freely throughout the year in their quest for food.

Interregional relations were not always amicable. Prior to the arrival of the Russians in the early 1800s, intermittent skirmishes regularly interrupted delta life. Ironically, death itself brought this killing to an end in the form of a dramatic population decline resulting from the diseases that accompanied contact with Euro-Americans. Although few Russians settled in western Alaska, the larger Russian trade network to the south introduced smallpox into the region, devastating the native population. Entire villages disappeared. As much as 60 percent of the Yup'ik population with whom the Russians were familiar in Bristol Bay and along the Kuskokwim was dead by June 1838 (Oswalt 1990:51).

The effects of the smallpox epidemic of 1838–39, combined with subsequent epidemics of influenza in 1852–53 and 1861, produced both a decline and a shift in the population and undercut interregional social distinctions. Although the introduction of communicable diseases damaged traditional social groups and patterns of intergroup relations, it largely left intact the routines of daily life throughout the remainder of the nineteenth century. Small bands of extended family groups continued to move over the landscape, seeking the animals they needed to support life and gathering in winter villages for the elaborate annual ceremonial round.

Significant Euro-American settlement did not occur in western Alaska until the end of the nineteenth century. Though rich in the resources necessary to support a scattered and seasonally nomadic native population, the Bering Sea coast is notoriously lacking in the commercially valuable resources that first attracted nonnative argonauts and entrepreneurs to other parts of Alaska. Because of its geographical isolation and dearth of commercial resources, the Yukon-Kuskokwim delta was virtually ignored by outsiders during the first three-quarters of the nineteenth century. Russian traders and Orthodox priests migrated inland along the delta's major rivers beginning in the 1830s, but the people living along the Bering Sea coast between the Yukon and Kuskokwim rivers did not experience extended contact until nearly one hundred years later.

The arrival of missionaries dramatically altered village life. First came the Russian Orthodox priests in 1845 to work out of Ikogmiut (Russian Mission) on the Yukon River. Orthodox hegemony was challenged in 1885 by the establishment of a Moravian mission at Bethel on the Kuskokwim River and three years later by the founding of a Catholic mission on Nelson Island, which moved to Akulurak at the mouth of the Yukon a year later. These two missions made a much more sustained bid to convert the "baptized heathen" to whom the Russian Orthodox laid claim. Moreover, both made concerted efforts to alter the Yup'ik way of life, especially along the Yukon and Kuskokwim rivers near their mission stations.

The year 1900 constitutes a major demographic marker in the region. The influenza epidemic that arrived that year in western Alaska with the annual supply vessels in just three months halved the native population. Although coastal communities were not as severely affected, numerous winter villages on the Yukon and Kuskokwim rivers were abandoned. A sharp increase in the region's white population matched the decline of the native population, the gold rush at Nome having spawned a concerted effort to locate mineral deposits along the upper Yukon and middle Kuskokwim rivers.

The Yup'ik people supplied fish and cordwood to miners and steamship captains and participated in an expanding fur market, bringing substantial changes to their domestic economy. In 1916 the regional superintendent for the U.S. Bureau of Education, John Henry Kilbuck, wrote with satisfaction that most Kuskokwim natives lived in log cabins heated with cast iron stoves, ate homegrown turnips and potatoes from graniteware dishes, possessed at least some Western clothing, which they mended on treadle machines, and received education, health care, and Christian teachings from federal employees and missionaries.

Much had changed in western Alaska by statehood in 1959, but much remained the same. The continuities between past and present were as significant as the innovations. The people continued to speak the Central Yup'ik language, enjoy a rich oral tradition, participate in large ritual distributions, and focus their lives on extended family relations that were bound to the harvesting of fish and wildlife. They never converted to gardening or reindeer herding, regardless of sustained missionary and federal encouragement to do so. The coastal population had declined dramatically, but its geographical isolation and commercial insignificance had inhibited change. The seasonal cycle of activities remained much the same as that of their ancestors.

## Turn-of-the-century Coastal Village Life

The Yup'ik people were left largely to their own devices into the early decades of the twentieth century. When the elders cited in this book were born, their parents, scattered in dozens of seasonal camps and winter villages, still followed the seasonal round of their forebears. Travel was still by skin boat, including both the single-man kayak and the larger *angyaq*.

The bilateral extended family, numbering up to thirty persons, was the basic social unit. Spanning two to four generations, including parents, offspring, and parents' parents, the group might also encompass siblings of parents or their children. An overlapping network of family ties, both fictive and real, joined people in a single community. In larger villages most marriage partners came from within the group, though regional recruitment also occurred.

Extended family groups lived together most of the year, but normally they did not live in family compounds. Rather, winter villages were divided residentially between a communal men's house or houses and smaller sod houses (*enet*) occupied by women and young children. Married couples or groups of hunters often moved to outlying camps for fishing and trapping during spring and fall. Families gathered when temperatures dropped below freezing and, in some cases, during the spring seal-hunting and summer fishing seasons. Winter villages ranged in size from a single extended family to three hundred people. In these larger settlements there might be as many as three men's houses with up to fifty men and boys living in each.

All men and boys older than five years ate their meals and slept in the *qasgiq*, the social and ceremonial center of village life. In winter men rose between three and four in the morning to begin their day's

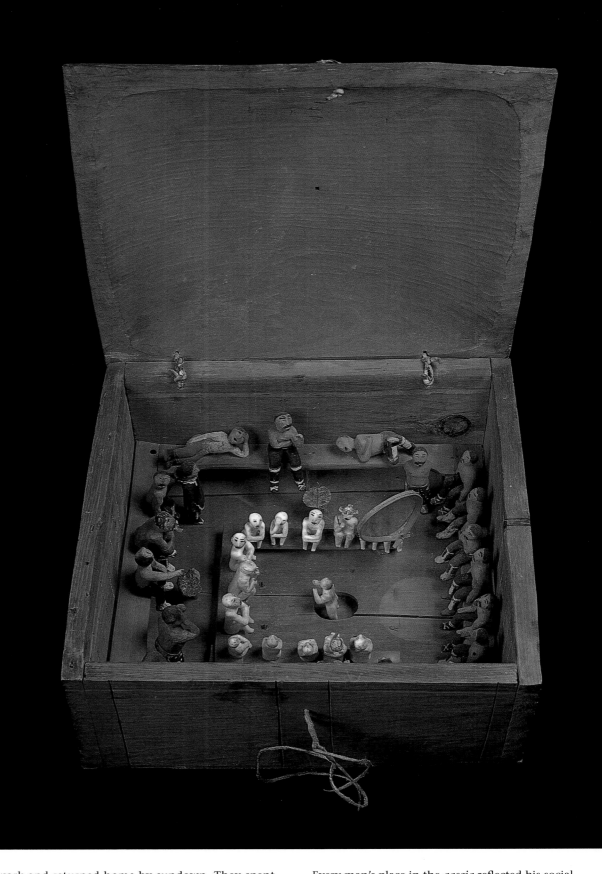

Model *qasgiq* showing men observing a performance. One man holds a drum while another emerges from the underground entryway. The performers are made of ivory and the audience of wood. *SJM, IIH31* (30 cm square)

work and returned home by sundown. They spent their spare time together in the *qasgiq* talking and carving tools, weapons, bowls, kayaks, and elaborate ceremonial equipment. Their daughters and wives brought their meals, waiting demurely by their sides while each man emptied his personal bowl. The *qasgiq* was also the scene of the ubiquitous sweat bath, in which occupants alternately endured intense heat and luxuriated in its aftermath.

Every man's place in the *qasgiq* reflected his social position, and the men's house framed a number of internal distinctions, including that between young and old, married and unmarried, and host and guest. The social structure of the *qasgiq* mirrored that of the natural world. The Yupiit believed that sea mammals lived in huge underwater *qasgit* (pl.), where they ranged themselves around a central firepit in ranked fashion. From these underwater homes they viewed

their treatment by people and, based on what they observed, chose whether to give themselves to human hunters.

The hunters who gave the most thought and care toward the animals they sought were richly rewarded, both socially and materially. The *nukalpiaq,* or good provider, was a man of considerable importance in village life. Not only did he contribute wood for the communal sweat bath and oil to keep the lamps lit, he also figured prominently in midwinter ceremonial distributions, during which local extended families vied with each other to gather and redistribute surplus.

Social status and power accrued to those who could afford to give. Without a central authority figure, political integration was loose at best. Although the prowess and generosity of the *nukalpiaq* was a primary focus of both political and economic integration, the counsel of elders, who not only advised when to harvest but when distribution was appropriate, mitigated his authority.

Contemporary elders had as youths listened in the *qasgiq* to their fathers and grandfathers discuss the hunt and talk about the rules for right living. This tradition of oral recitation continues, but the elders' generation was the last to be raised within the *qasgiq.* Young men received essential education as they listened to and observed the older men at work. Elders encouraged them to try their hand at carving and fixing tools. They also admonished young men and women to perform helpful acts, while keeping their minds filled with thoughts of the animals on whose good will their lives depended. People believed that thoughtful actions cleared a path for the animals they would someday hunt.

## The Traditional Ceremonial Cycle

Into the early decades of the 1900s, the Yupiit gathered after freezeup in winter villages, where they enjoyed a varied and elaborate ceremonial season.[4] Masked performances were only a part of this "round of pleasure," although an important one. The Yupiit traditionally performed six major ceremonies, three of which focused on the creative reformation of the relationship between the human community and the spirit world on which they relied. In the Bladder Festival, the Feast for the Dead, and the annual masked dances, spirits of the human and animal dead were drawn back into view to be feasted, hosted, and sent away supplied for the coming year. This ritual movement effectively recreated the relationship between the human and spirit worlds and placed each in the proper position to begin the year again.

### Ingulaq

Ingulaq was a harvest festival celebrated in many coastal and Kuskokwim villages at the end of the berry season. After families returned to their winter villages, they worked together to refurbish the *qasgiq*—cleaning it, mending benches, weaving new grass mats, preparing a new gut skylight, fumigating

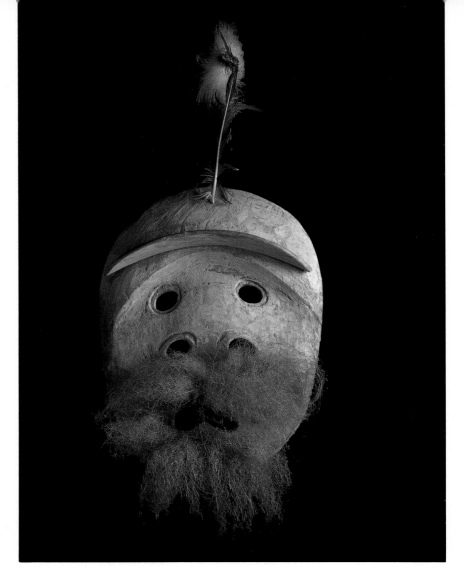

it, and generally readying it for occupancy. After these preparations, people gathered for a celebration and feast. Women danced to *ingulautet*—slow, old-style songs—and presented the men with bowls of *akutaq*. Ingulaq marked the end of the summer harvest and the formal renewal of community life.

### The Bladder Festival

The celebration of the Bladder Festival (Nakaciuryaraq, literally, "way of doing something with bladders") marked the opening of the winter ceremonial season. At the time of the winter solstice the bladders of seals killed that year were inflated and brought into the *qasgiq.* These bladders, believed to contain the animals' souls, were hung across the back wall and treated as honored guests.

The primary function of the Bladder Festival was to reverse the separation of body and soul effected at the time of the seal's death. According to Paul John (February 15, 1994), "They treat the seal's body as if it is their kayak. And when they catch it, its soul can go into its bladder. People said to themselves that the animal they caught was alive, saying its soul was inside its bladder. This was according to our understanding."

In some places ceremonies preceded the Bladder Festival proper, including Qaariitaaq, Qengarpak, and Aaniryaraq. Men might paint the faces of village chil-

Small Napaskiak mask representing "Kaarenta" (Qaariitaaq). According to Dick Andrew (January 5, 1994), once when people were going house to house receiving food during the Qaariitaaq ceremony, some of them "got lost underground. One of the people had done something against the advice of the elders. Though he was given words of guidance, he would ignore them. One of them had not followed the traditional law, and that caused the people to go under." The mask may represent the one giving the advice, as a beard commands respect in Yup'ik iconography. *NMAI, 9/3405 (39.4 cm)*

4. Elsie Mather (1985) and Phyllis Morrow (1984) did groundbreaking work on this

subject, and I build on their findings in what follows. Readers should be aware that the ceremonial cycle varied a great deal from region to region and village to village. These summary accounts describe the ceremonies in their most general form. For details of coastal Yup'ik ceremonies see Fienup-Riordan (1994).

"False-face" mask collected by Charles L. McKay at Bristol Bay in 1882. An outer mask of four concentric hoops and a small hoop supporting a nose and mustache intended to hang over the dancer's face are worn at the same time. The wooden nose recalls the false noses used during Qengarpak. According to Dick Andrew (January 5, 1994), "They would wear big wooden

dren during Qaariitaaq and then lead them house to house, receiving food from the women. Through this ritual circuit, the children opened the community to the spirits of their animal guests and may have represented the spirits' gradual approach. Parents advised children not to remove the paint from their faces, and when they awoke with the paint worn off, assured them that Qaariitaaq had come in the night and licked them clean.

Qengarpak ("Proboscis Festival," from *qengaq,* "nose," plus *-pak,* "big") followed Qaariitaaq in some communities. The men and children again painted their faces with a combination of white clay and lamp soot. Participants also wore small nose-shaped wooden face masks, pretend eyes, and special painted marks around their mouths. They further disguised themselves by dressing in other people's clothing (Mather 1985). Nelson Islanders said the nose masks represented animal spirits.

Some communities held Aaniryaraq ("the process of providing a mother") directly after Qaariitaaq and Qengarpak, and it introduced the Bladder Festival proper. During Aaniryaraq two older men, dressed in gutskin parkas and referred to as "mothers," led a group of boys, whom they termed their dogs, around the village. The men collected newly made bowls filled with *akutaq* from the women—a reversal of the usual pattern of women bringing food to their men

in the *qasgiq.* In some areas these preliminary ceremonies and the Bladder Festival each lasted for five days, corresponding with the five steps that separated the world of the living from that of the dead.

During the Bladder Festival the men ritually purified themselves with sweat baths and the smoke from wild celery plants. They set routine activities aside and devoted their days to athletic competitions, instruction in and performance of commemorative songs, and presentation of special foods and gifts. They performed all these activities to please and honor the souls of the seals residing in the bladders hung along the *qasgiq* wall.

On the last night of the Bladder Festival, the entire village and invited guests from nearby villages gathered in the *qasgiq.* Parents celebrated their children's accomplishments with lavish gifting. They distributed to young girls the wooden dolls of the young women who had recently come of age. Finally, there occurred a huge villagewide distribution of items such as frozen and dried fish and sealskin pokes full of seal oil. Donors were quick to say that everything they offered had been given to them. In a number of ceremonial distributions people gave gifts in someone else's name, particularly that of a deceased relative. Even today in western Alaska, social ties between the living are maintained through the relationship between the living and the dead.

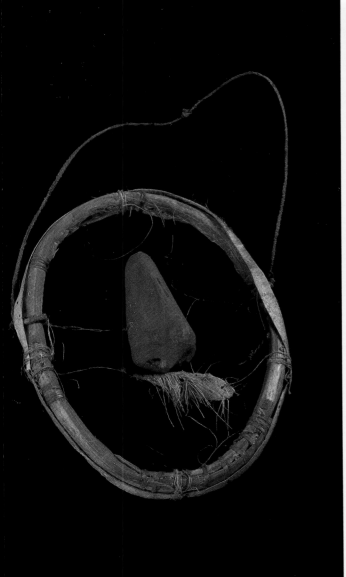

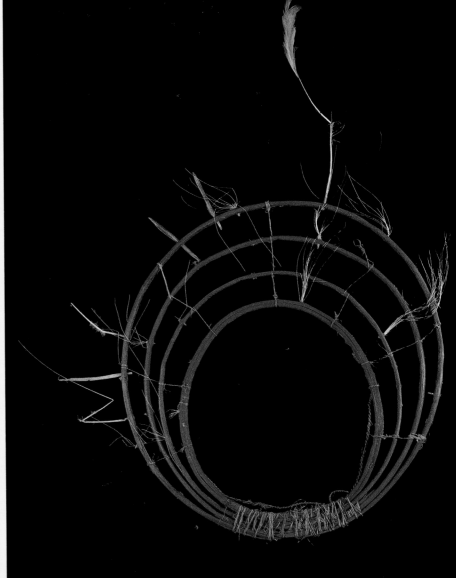

Finally, at the close of the Bladder Festival, pairs of young men took the inflated bladders, along with bunches of wild celery, out through the central smoke hole and down to a hole in the ice. There they deflated the bladders and returned them to their underwater home, where the seals' spirits would boast of their good treatment and subsequently allow themselves to be taken by the villagers the following season.

### The Feast for the Dead

The annual Feast for the Dead (known in some areas as Merr'aq, from *meq,* "water") was the public occasion on which people invited the spirits of the human dead into the community and presented them with the food, water, and clothing they required. Men placed stakes at the graveside to initiate the feast, signaling the spirits to enter the village as in the ceremonies prior to the Bladder Festival. People ritually cleansed the community in preparation for the arrival of the spirits and throughout the ceremony carefully limited activities (such as sewing or chopping wood) that might injure the souls as they entered the village or cut their path.

The Great Feast for the Dead, Elriq, was a much more complex and elaborate event, which attracted hundreds of people from the far corners of the Yukon and Kuskokwim deltas and continued for four to six days. Elriq was sequentially hosted by different villages within a subregion. An individual, aided by his relatives, hosted the feast within each village. The major gift distributions took place on the fourth and fifth days of the ceremony, when first women and then men ritually clothed living namesakes according to the sex of the deceased relative being honored. The hosts brought their gifts into the *qasgiq* through the gut skylight, reversing the route they used to remove the human body at death.

### Petugtaq, the "Tie-On"

Another important winter ceremony was the "commercial play" known as Petugtaq (lit., "something tied on," referring to the attachment of small models of the requested gifts to a stick). This event is usually described as an exchange of small gifts between the men and women of one village. The men might begin by making tiny replicas of things they desired, such as grass socks, bird-skin caps, or fish-skin mittens, which were hung from a wand or stick and taken to the women of the village. Each woman then chose one of the images and prepared the item requested. When all was ready the women brought their gifts to the *qasgiq* and presented them to the men, who were duty-bound to provide a suitable return.

In some areas, the pairing of both biologically and socially unlikely couples in the exchange added to the enjoyment, as no one knew who had made a specific request until the actual distribution. In this context people considered the pairing of cross-cousins[5] particularly delightful. Yup'ik speakers refer to cross-sex cross-cousins with the terms *nuliacungaq* ("dear little wife") and *uicungaq* ("dear little husband"). Though tradition did not dictate marriage between cross-cousins, teasing, complete with sexual innuendo, characterized their relationship.

### The Messenger Feast

Another major event during the winter season was the Messenger Feast (Kevgiryaraq), named for the two messengers (*kevgak*) sent to invite the guest village to the festival. The Messenger Feast was characterized by a mutual hosting, whereby one village would go to another to dance and receive gifts. To initiate the feast the host village presented its guests with a long list of wants, and the guests subsequently reciprocated with a list of their own. Besides collecting the articles they would give, villagers composed songs describing the articles they desired in return and naming the individual from whom they requested each object.

Considerable rivalry surrounded the quality and quantity of gifts given during the Messenger Feast. In some areas the guests were designated *curukat,* or challengers. A calculated ambiguity circumscribed the Messenger Feast, as a fine line existed between friend and foe. Although the Messenger Feast shared common features with the other ceremonial distributions, it stands out as a particularly elaborate display and distribution of the bounty of the harvest, providing a clear statement of respect to the spirits of the animals. The massive gift-giving that the Messenger Feast entailed served both to redistribute wealth within and between villages and to express and maintain status distinctions.

### Agayuyaraq: Dancing with Masks

The final major winter ceremony, and the one most closely associated with masks, was Agayuyaraq ("way [or process] of requesting"), also referred to as Kelek, Itruka'ar, the "Inviting-In" Feast, or the Masquerade. This complex ritual event involved singing songs of supplication to the animals' *yuit* ("their persons"), accompanied by the performance of masked dances under the direction of the *angalkuq.* Ritually powerful masks were created especially for the event, including representations of the animals' *yuit* and *tuunrat,* the *angalkuq*'s spirit helpers (sing., *tuunraq*). In preparation for Agayuyaraq, the *angalkuq* directed the construction of the masks through which the spirits revealed themselves as simultaneously dangerous and helpful. Used in enactments of past spiritual encounters, they had the power to evoke them in the future.

Each ceremony emphasized a different aspect of the relationships among humans, animals, and the spirit world. The Bladder Festival, along with related ceremonies, ensured the rebirth and return of the animals in the coming harvest season. During the Feast for the Dead people elaborately fed and clothed living namesakes to provide for and honor the souls of their departed relatives. The Great Feast for the

noses they had made. They would paint their faces with red ocher, by adding blood to ash, and put on big fake noses. Then the young people from the *qasgiq* would go around to the different houses." *SI, 56040 (53.3 cm) and 56038 (25.4 cm)*

5. Cross-cousins are related through a cross-sex relationship in the ascending generation. Thus the children of a sister and a brother are cross-cousins, while the children of two sisters or two brothers are parallel cousins.

Dead served the same function within human society as the Bladder Festival within animal society, expressing and ensuring continuity between the living and the dead. The intravillage Petugtaq and the intervillage Messenger Feast played on, exaggerated, and reversed normal social relationships between husband and wife and between host and guest. The Messenger Feast also served important social functions, including display of status, social control, and redistribution of wealth. At the same time it provided a clear statement to the *yuit* of the animals that the hunters were once again ready to receive them. Finally, Agayuyaraq dramatically recreated past encounters with spirits to elicit their participation in the future. Together the ceremonies embodied a cyclical view of the universe whereby right action in the past and present reproduced abundance in the future.

### Yupiit Enter the Modern World

Village life has changed considerably since the turn of the century. Following the epidemics of the nineteenth and early twentieth centuries, improved health care and the decline of infant mortality during the last seventy years have allowed population to surpass its aboriginal number. Today, nearly twenty thousand Yupiit live in western Alaska, scattered among seventy small communities of 150 to 600 inhabitants. Each of these modern villages has both an elementary and a secondary school, city government or traditional council, clinic, church or churches, airstrip, electricity, and, in a few places, running water and flush toilets. The residential separation of men and women has been abandoned in favor of single-family dwellings, and children divide their time between public school, video movies, and playing basketball in high school gymnasiums rather than listening to elders tell stories in the *qasgiq*.

During the decade after statehood, Alaska natives generally were viewed as extremely disadvantaged, and the Yupiit of the Yukon-Kuskokwim delta region as one of the most impoverished groups among them. Relative to other areas of rural Alaska, the availability of Western material goods was minimal, modern housing nonexistent, educational levels low, and tuberculosis—as destructive as earlier influenza and smallpox epidemics—ran rampant. The Great Society dispatched scores of VISTA volunteers to the region as soldiers in President Johnson's War on Poverty.

Events in the 1970s began a new era in the Yukon-Kuskokwim delta and throughout rural Alaska. Passage of the Alaska Native Claims Settlement Act (ANCSA) in 1971 transformed land tenure in the state and is the major determinant of land status in Alaska today. It extinguished aboriginal land claims statewide, giving in return fee-simple title to forty-four million acres of land and nearly one billion dollars to twelve regional and one nonresident profit corporations and more than two hundred village corporations. These organizations administer the land and money received under ANCSA. The Calista Corporation (lit., "the worker," from *cali-,* "to work") was established to manage the corporate resources of southwestern Alaska.

The "Molly Hootch decision" in 1976 mandated sweeping educational reform. Local high schools sprang up in all of the smaller communities of the region, which had previously sent their children to boarding schools in Bethel, St. Marys Catholic Mission, or outside the region.

ANCSA paved the way for construction of the trans-

Village of Chevak, 1995. *JHB*

Alaska pipeline, and the state's share of the profits gushed into public works projects and social programs. Supported by ANCSA village corporation activity and state services, the coastal communities of western Alaska experienced steady growth during the 1970s and 1980s. Villages have burgeoned in both population and modern facilities, and employment income and cash transfers of other kinds provided some support for local subsistence harvesting activity.

The regional economy shifted radically as the delta's population coalesced at permanent sites. Along with the continued importance of subsistence harvesting activities, the most significant feature of village economy in western Alaska today is its dependence on government. Commercial fishing and trapping, craft sales, and local service industries provide only a small portion of the aggregate local income. As much as 90 percent flows through the village economies from the public sector, including both wages and salaries and various state and federal transfer payments. Most local service and distribution businesses in the private sector consequently depend on purchases made by persons and organizations who themselves rely on public-sector income transfers.

Men and women in contemporary communities participate in the economy as clerks, welfare recipients, commercial fishermen, and bureaucrats but also maintain themselves partially through subsistence hunting and fishing. Integration into the larger economy is marginal, and domestic activities focus on extraction and consumption rather than investment and production. Dependence on public sources of income limits economic diversity. The combination of wage employment and the harvest of local resources for both commercial and subsistence use dominates.

High rates of alcoholism, child abuse, sexual assault, suicide, violent crime, and mental health problems plague the region. Infant mortality has dramatically declined during the last twenty years, but the suicide rate has increased from 5.5 to 55.5 per 100,000 people during the same period—five times the national toll. Alcohol is a contributing factor in nearly all cases (Lenz 1986:4, 5).

Residents struggle to find solutions to village problems and ways to continue to live in their traditional homeland. Men and women still see themselves as living in a highly structured relationship with the resources of their environment, not merely surviving off them. Central Yup'ik continues as the primary language for most people living in the coastal and tundra villages. Public housing programs have dictated the construction of single-family housing, yet elaborate patterns of interhousehold sharing, adoption, and hunting partnerships continue to nourish extended family relationships. People remain strongly committed to traditional harvesting activities and continue to share products of the hunt.

The passage of ANCSA and, more recently, heightened awareness of domestic problems has created a diffuse yet important cultural reformation in much of western Alaska. Consciousness-raising has concentrated contemporary Yup'ik efforts on maintaining control of land, resources, and local affairs; improving residents' health and sense of well-being; and adhering to cultural and linguistic traditions. This renaissance reflects a certain nostalgia for the "old ways," which in political and economic terms refer to times after many technological improvements had been introduced but before the Yup'ik people had experienced subordination to federal and state control and related dependency.

Increasing articulation of issues of native cultural identity and political control indicate a growing awareness of the value of being a Yup'ik person in the modern world. This book and the exhibit it accompanies owe their existence to men and women dedicated to preserving and communicating the nineteenth-century Yup'ik view of the world. Their efforts reflect the desire of many Yup'ik people to gain recognition of their unique past, parts of which they hope to carry into the future.

# Masks in Museums: Collecting the Past for the Future

Turn-of-the-century Yup'ik masks have acquired long and convoluted histories and meant many things to many people—shaman's vision, heathen idol, primitive art, priceless antique, and, most recently, symbol of original spirituality and distinct identity. Traded for the equivalent in firewood, many moved first to walls in the back of traders' stores and then south to museum vaults. There, artists and art aficionados found them and blew the dust away, fascinated by what lay beneath a half-century's neglect. They could only guess at the meaning the masks had for their creators, but they valued them nonetheless.

During the late nineteenth and early twentieth centuries, museums built up large inventories of Yup'ik masks contributed by explorers, traders, mis-

sionaries, teachers, federal agents, and natural scientists. Some routes were direct and some circuitous. A native owner or a nonnative might sell or give a mask to a visitor, who sold it to an agent, who sold it to a museum. Many masks must have been lost along the way, but several thousand reside in museums throughout the United States, Canada, and Europe (especially Germany).

Unlike Northwest Coast ceremonial regalia, Yup'ik masks were not family or clan property. The maker could dispose of a mask as he saw fit. Edward Nelson (1899:359) mentioned that in some places natives did not object to selling a mask as long as the person who bought it supplied enough wood for the sweat bath. Men made masks for use in specific ceremonies and normally destroyed them after use in the ritual

*Yup'ik masks hanging from the rafters of the Sheldon Jackson Museum, between 1891 and 1897. ASL, Case and Draper neg. no. 39-193*

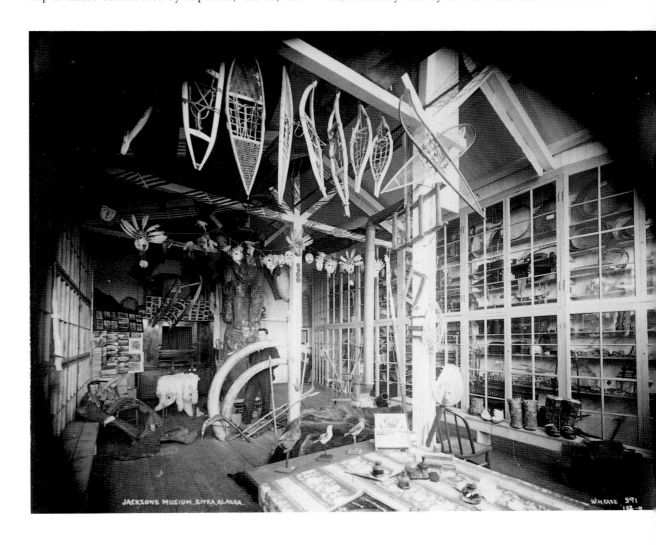

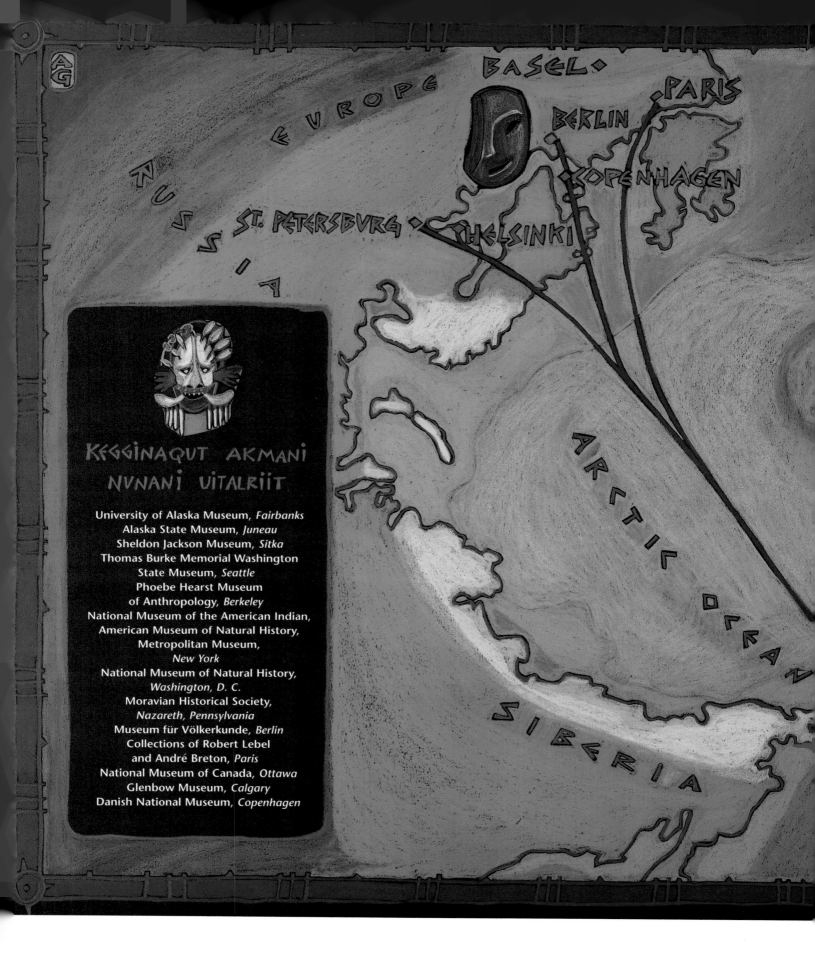

KEGGINAQUT AKMANI
NUNANI UITALRIIT

University of Alaska Museum, *Fairbanks*
Alaska State Museum, *Juneau*
Sheldon Jackson Museum, *Sitka*
Thomas Burke Memorial Washington
State Museum, *Seattle*
Phoebe Hearst Museum
of Anthropology, *Berkeley*
National Museum of the American Indian,
American Museum of Natural History,
Metropolitan Museum,
*New York*
National Museum of Natural History,
*Washington, D. C.*
Moravian Historical Society,
*Nazareth, Pennsylvania*
Museum für Völkerkunde, *Berlin*
Collections of Robert Lebel
and André Breton, *Paris*
National Museum of Canada, *Ottawa*
Glenbow Museum, *Calgary*
Danish National Museum, *Copenhagen*

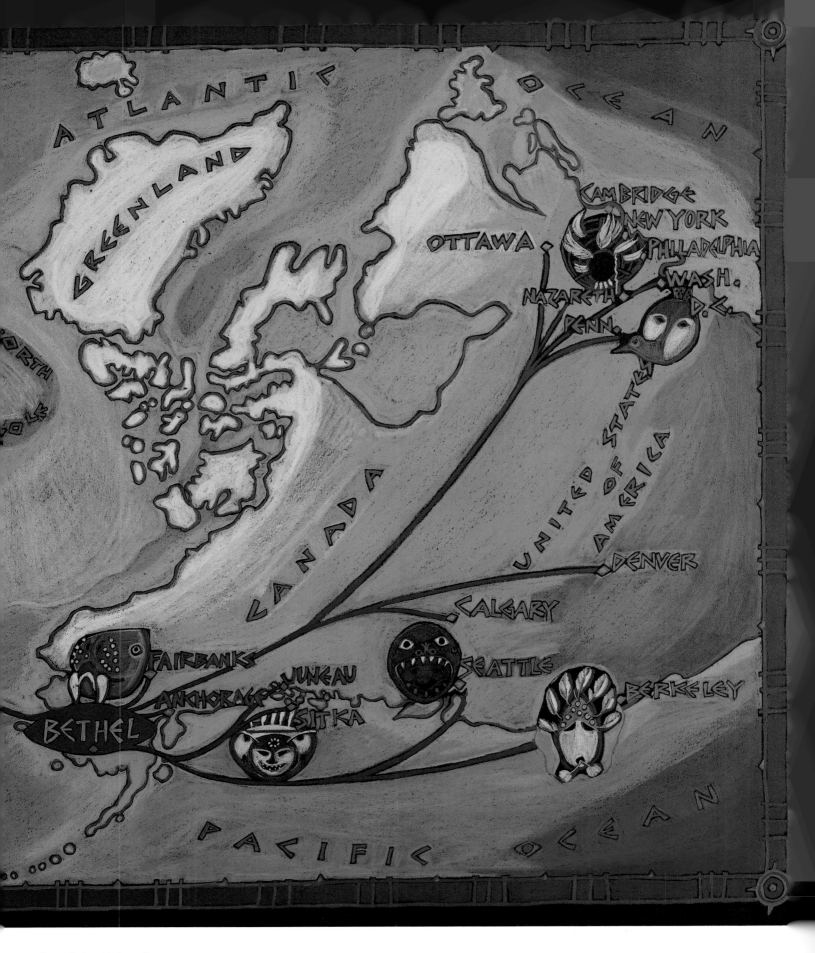

A traveler's guide to major
collections of Yup'ik masks
worldwide. *Ayse Gilbert*

MASKS IN
MUSEUMS

cleansing that followed all masked performances. In retrieving masks from the tundra or sweatbath fire, nonnative traders and collectors simultaneously extended the life of these objects and fundamentally transformed their meaning, turning them into "captured heritage," trophies of a primitive past.

Museums have divided masks according to their own designations of what they are—"art" or "science." Yup'ik masks came from a variety of sources and were gathered for a multitude of reasons: Norwegian entrepreneur Johan Adrian Jacobsen came to Alaska specifically to collect "rare specimens" for Berlin's Museum für Völkerkunde; Kuskokwim trader A. H. Twitchell saw the masks as marketable commodities and sent them east to the highest bidder; Alfred and Elma Milotte came to Hooper Bay in 1946 to film, not collect, and only at the end of their visit retrieved masks people had discarded.

Most nineteenth-century collectors saw themselves as preserving for posterity the relics of primitive peoples whose culture was dying (Issenman 1991:2). At a 1911 meeting to decide their long-term collecting strategy, the Committee for the American Section of Philadelphia's University Museum unanimously agreed on supporting further fieldwork in the Americas "to secure ethnological data and artifacts from native groups that they feared were vanishing at an 'accelerated speed'" (Kaplan and Barsness 1986:40). Like so many others before and since, they viewed this "ethnological data" as past production, the creations of a ruined world, thus justifying their collecting as salvage and redemption (Clifford 1988:202).

Ironically, the materialist perspective of nineteenth-century collectors made masks precious to them. To collect was to elevate. Masks were simultaneously removed from the ceremonial context for which Yup'ik carvers made them and "re-sacralized" as ethnologic artifacts in the domain of researchers and conservators (Stocking 1985:6). Two general types of collections and collecting emerge: ethnographic collections, in which masks were acquired in the context of a larger effort to document the material culture of native peoples; and specialty collections, in which masks and their contexts of use were the focus of interest.

Once collected, Yup'ik masks were valued first as ethnographic fact and later as objets d'art. The masks subsequently found homes in natural history and art museums, and the *Agayuliyararput* exhibit borrows from both. "Science can be aestheticized, art made anthropological," James Clifford writes (1988:203). Applying this principle to the history of translation of Native American literature, Arnold Krupat (1992:4) stated, "When literary people aestheticize science, accuracy and authenticity are inevitably lost in some degree; when the anthropologists scientize art, its charm, force, beauty are inevitably lost in some degree." Can Yup'ik curators avoid this conflict? For them, the aesthetic power and meaning of the masks are inseparable. Perhaps they can help defuse the oppositional relation the masks' divergent collection histories have set in motion.

Late nineteenth- and early twentieth-century ethnographic collections were systematically organized as "data" in a natural history paradigm. Following contact, the purity of distant peoples was progressively compromised, making it essential to amass representative collections as well as to record texts and cultural inventories as quickly as possible. Every major museum tried to acquire a representative sample of Inuit material, including domestic utensils, hunting equipment, clothing, children's toys, and ceremonial paraphernalia.

Much of this material came from regional centers, including Nushagak and St. Michael, where natives gathered from the surrounding area to trade. The point of origin is sometimes hard to determine, as visiting natives brought objects from hundreds of miles away to trade for tea and tobacco. Moreover, native traders sometimes painted and refurbished the masks to increase their market value. William Healy Dall (1884:125), who collected for the Smithsonian throughout western Alaska, described the "brightening up" of Prince William Sound masks for trade:

It is a curious fact that some one had made an attempt to furbish up the old painting by daubing on a little vermilion and by sticking a few new feathers into the holes, whence the old ones had rotted away. I suppose that these masks were old dancing masks, which, as was sometimes the custom, were thrown away after the festival was over into some convenient and perhaps habitual rock-shelter. There they had lain many years, for wood decays with great slowness in this climate. . . . When the agent had appealed for 'curios' to the natives of the adjacent villages, some one had thought of these old masks as a means of procuring some tobacco, and having brought them in supposed a little brightening up would not make the price any smaller, and so . . . added the vermilion and new feathers.

Yupiit also carved masks explicitly for sale in the new artifact market.

Since the 1880s the Jesuits and the Moravians have been the most prominent missionary groups in southwestern Alaska. Although Jesuit priests such as Francis Barnum (1901), John Fox (1972), and Francis Menager (1962) recorded their observations about the people they worked among, they were not interested in acquiring mementos of the way of life they were transforming. The Jesuits left the region as they had arrived—unencumbered by material items. The Moravians, who had more interest in collecting, assembled substantial collections of Yupik material in the early 1900s. As a matter of church policy, they were mandated by their governing board to "collect among the heathen," and the first objects were sent back to headquarters in Herrnhut, Germany, from Dutch Guiana (now Suriname) in 1778. Subsequent proclamations in 1818 and 1891 instructed missionaries to acquire tools and hunting implements, house and boat models, money, and ceremonial items,

Ivan Demientieff wearing a mask in a humorous pose, circa 1930, on the Yukon River near Holy Cross. *Jules Jette, S.J., OPA*

Although Moravian missionaries kept the board's instructions in mind, in practice they collected what came their way. In 1911 Adolf Stecker sent home to his native Germany the single largest Moravian collection, including 171 objects. Along with tools and a model *qasgiq*, he sent a cribbage board, toothpick, crochet hook, and fork and spoon—all carved from ivory. The only ceremonial pieces he acquired were a pair of dance mittens decorated with puffin beaks and two wooden "idols." Joseph Herman Romig also collected three "idols" in 1896. Traditionally, people kept small carved dolls such as these as personal amulets, or *iinrut* (sing., *iinruq*), which they fed and clothed during winter festivals (Nelson 1899:494–97; Fienup-Riordan 1994:201–202).

Along with missionaries and museum collectors, local traders amassed numerous collections of Yup'ik material, both small and large. Like the Moravian Church, the Alaska Commercial Company sent a general order to its numerous agents requesting collections of "specimens," many of which were subsequently sent to the company's main office in San Francisco. In 1904 the company gave them to the University of California. Unfortunately, the fire following the 1906 San Francisco earthquake destroyed the documentation that came with the collections.

Although some federal agents and traders regarded themselves as preserving natural history, many more scrambled to acquire native curios for the tourist trade. The early 1900s saw an upswing in the purchase of native artifacts, including masks. Whereas during the Victorian era collecting had been the domain of the rich, at the turn of the century owning and displaying Native American artifacts of all kinds became an increasingly widespread expres-

including *Gotzen* (gods or idols), which are housed today at Herrnhut's Völkerkunde (Folk) Museum. Salvage of "idolatrous" artifacts contrasted sharply with the practices of other churches, which summarily destroyed such objects. Religious items form a small but significant part of Moravian collections.

"Curios of a trader. Bethel. 1901." The drum on the left may be the one George Heye purchased in 1946, now in the National Museum of the American Indian (no. 20/9343). *Joseph Herman Romig, MA (Pa.)*

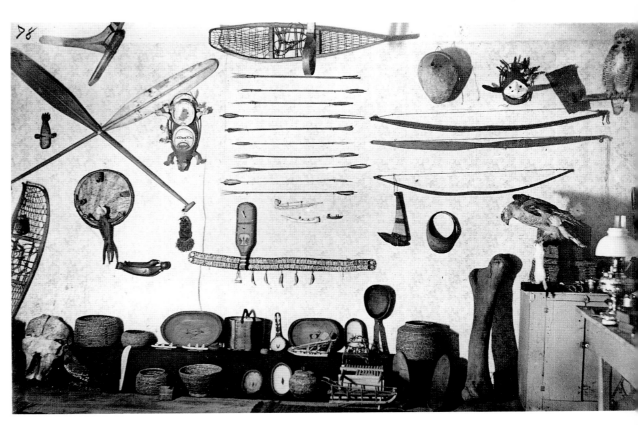

sion of the antimodernism that arose in the United States. Baskets and carvings neatly arranged in a corner cabinet of many middleclass homes served to remind "civilized" owners of their own lost innocence. Native Americans were viewed as vanishing, and everyone wanted a piece of their past before they went. The salvage paradigm spawned hundreds of modest collections of artifacts in attics and parlors all over the world. In many of these collections, a wooden mask was the central icon.

Both longtime residents of and casual visitors to the region were responsible for smaller collections of masks, many of which have come to light only in the last two decades. Typically, they remain family property until the collector's death, following which the heirs sell or donate the pieces to a museum. As they surface they not only confirm but add to what we know.

The majority of Yup'ik masks in American museums were obtained between 1877 and 1900. The Russian I. G. Voznesenskii and the Frenchman Alphonse Pinart collected magnificent Alutiiq masks in the 1840s and 1870–72, respectively, but few Yup'ik pieces left Alaska before Edward Nelson arrived in 1877. Over the next twenty years, however, more than six hundred masks were boxed up and shipped to museums all over the world. By the early 1900s, missionary activity in western Alaska had extinguished most traditional ceremonies in which masks played a prominent part. Occasional masked dances still occurred, and a half-dozen discrete collections represent these increasingly infrequent events.

Collecting Yup'ik artifacts for American museums began as soon as Alaska was purchased by the United States. William Healy Dall came to Alaska with the Western Union Telegraph Expedition in 1866 and was among the first to collect in the newly acquired territory. He left his finds with the Smithsonian Institution, and the Smithsonian's assistant secretary Spencer Fullerton Baird subsequently encouraged others working in Alaska to collect for the museum. Baird well knew that the Smithsonian could not afford the field-workers the study of Alaska would require. His solution was to work with amateur collectors already living in Alaska and to encourage government agencies with job openings in Alaska to appoint people willing to collect for the Smithsonian in their spare time (Fitzhugh 1983:10–11). The Smithsonian acquired small collections of Yup'ik objects during the late 1800s from federal agents, including J. Henry Turner of the U.S. Coast and Geodetic Survey at St. Michael, I. Applegate of the U.S. Army Signal Corps from Togiak, and J. W. Johnson and Charles L. McKay (also of the Signal Corps) from Nushagak.

By far the most productive naturalist and collector Baird sent to Alaska was Edward Nelson, who shipped nearly ten thousand objects, including two hundred masks, back to the Smithsonian during his four-year tenure with the Signal Corps in St. Michael between 1878 and 1881. Nelson replaced Lucien M. Turner,

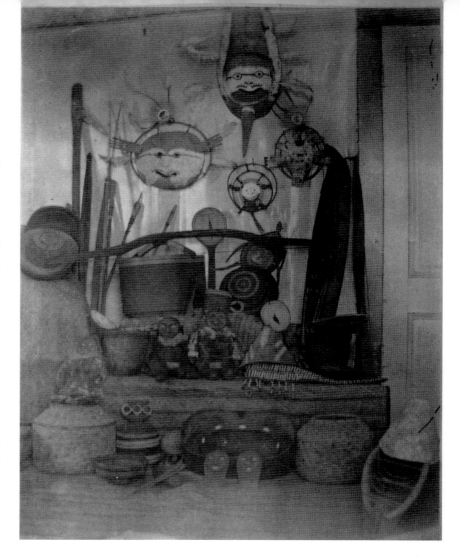

Missionary collection, early 1900s. The fur-clad wooden images in the center foreground may be *iinrut* (amulets) confiscated from Yup'ik converts. *MA (Pa.)*

another Smithsonian naturalist whose meager collections pale in comparison to Nelson's—the single richest collection of nineteenth-century Yup'ik material anywhere in the world. As important as Nelson's collection was the detailed documentation of the artifacts he published in his 1899 Bureau of Ethnology report, *The Eskimo about Bering Strait*.

Second only to Nelson's is the enormous collection of Alaska artifacts amassed by Johan Adrian Jacobsen. Jacobsen arrived at St. Michael from Berlin in spring 1882, the year after Nelson left. In journal entries written during his travels on the Yukon River, Jacobsen repeatedly complained that "Mr. Nielsen" had already collected everything, leaving him little of value. In spite of such laments, in six months Jacobsen collected more than seven thousand Athapaskan, Iñupiaq, and Yup'ik specimens. Western scholars have long believed that the bulk of this collection was destroyed during World War II (Ray 1987:33). However, the collection has been reassembled in the Museum für Völkerkunde in Berlin, including more than 130 Yup'ik masks.

In a five-year period between 1877 and 1882, Nelson and Jacobsen amassed the world's two largest and most important collections of nineteenth-century Yup'ik masks. Both are regionally diverse, including masks from Yukon, coastal, and Kuskokwim communities. For any Yup'ik person with time and money to visit museums, these are the "must see" collections.

Short of traveling to the Smithsonian, photographs and drawings of the masks Nelson collected are free for the looking in the 1983 reprint of his five-hundred-page report, as well as in *Inua*, William Fitzhugh and Susan Kaplan's well-illustrated catalog of the 1982 Smithsonian exhibit of Nelson's collection. The Jacobsen masks, however, have been virtually invisible to the general public, and it is one of the primary goals of this exhibit and book to illustrate and describe the Yup'ik pieces he acquired.

The first agent for the U. S. Bureau of Education in Alaska, Sheldon Jackson, was the next most prodigious collector. During his annual trips to Arctic Alaska between 1890 and 1900 on the revenue cutter *Bear*, Jackson gathered ethnographic specimens from every port of call. He also commissioned teachers to send him specimens when the opportunity arose. Like Nelson and Jacobsen, Jackson was collecting for a museum, the first in Alaska, which he founded in 1888 in Sitka specifically to house his numerous acquisitions (DeArmond 1987:3–19). Also, like Nelson and Jacobsen, he collected pieces from all over western Alaska. Of the one hundred masks in his collection, the majority come from Andreafski, on the Yukon, with a handful from St. Michael and Nushagak.

The years following Nelson, Jacobsen, and Jackson's collecting trips engendered high interest in and fierce competition for Yup'ik and Iñupiaq art and artifacts. Arriving in Nome on a collecting expedition in 1914, William Van Valin discovered that he had no less than four competitors in the antiquities business. These men were no match for Van Valin, however, and he cleverly outflanked them in the acquisition of a Siberian graveyard collection, stolen by guests while their hosts slept. Van Valin (1941:139) wrote: "Of course, had I known that these articles had been extracted in such a manner, I would have had serious misgivings about buying them; although I might have been influenced by the reflection that it would have been only a matter of years until the elements had ruined these priceless relics, especially the pottery." In all, Van Valin came home with 4,500 objects from "Eskimoland," including six masks from Hooper Bay now housed in the University of Pennsylvania's University Museum.

Along with the major collections of Yup'ik masks put together by Nelson, Jacobsen, and Jackson, two dozen additional collectors gathered Yup'ik masks between 1870 and 1946. In most cases the masks are part of a larger collection. Several collections, however, contain only masks. Although museums originally supported the collecting in only a few cases, today museums have either purchased or received as gifts all but a handful of these masks.

Lucien Turner, the weather officer stationed at St. Michael between 1871 and 1877, sent nine masks to the Smithsonian during his tenure. They appear to have been made for the souvenir market, and the quality is poor. As Nelson's collecting would show, what was going on at St. Michael was very different from that in villages to the south. In contrast to the roughly constructed masks Lucien Turner collected, J. Henry Turner acquired a superb collection of masks while surveying the international boundary between Alaska and Canada. In 1892 and 1893 he sent Baird 235 items from the northern part of the Yukon delta, including twenty-three masks. Turner died shortly after shipping the collection to the Smithsonian, without providing additional docu-

Iñupiaq face masks nailed to the rafters of the Sheldon Jackson Museum, Sitka, 1904. To this day, each mask has a hole in its forehead. *Merrill Collection, ASL, PCA 57–123*

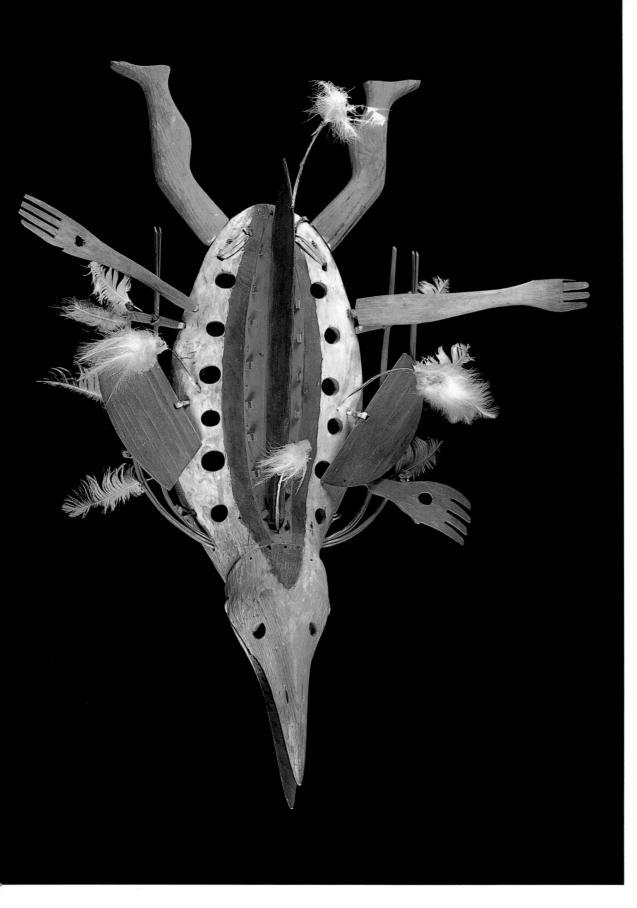

Diving loon mask from St. Michael collected by Sheldon Jackson in 1892. The wooden loon is painted white, black, and red, with snowy owl feathers attached. The loon's *yua* is indicated by its human arms and legs. The thin rods encircling the upper half of its body may indicate its ability to move between worlds. Behind the neck is a horizontal bar, which the dancer holds in his teeth, carrying the mask at a 45 degree angle above his forehead. The face of the loon's *yua* is hidden inside the moveable outer head at the base of the neck. *SJM, IIG11 (80 cm)*

mentation. Although we know roughly where these delicate pieces were made, we know little else about them.

During 1890–91 and 1898, H. M. W. Edmonds worked as a physician for the U.S. Coast and Geodetic Survey at St. Michael. There he collected objects of daily use, including tools and clothing, as well as several dozen masks. In the early 1900s he gave his collection to the University of California at Berkeley, where it remains in the Phoebe Hearst Museum of Anthropology. Dorothy Jean Ray (1966, 1967) published Edmonds's detailed notes about the use of the objects he collected as well as photographs of most of the masks in her ground-breaking book *Eskimo Masks: Art and Ceremony.*

The Hearst Museum also houses the Alaska Com-

Finely carved mask, simultaneously a bird and a human face, collected by J. H. Turner from the lower Yukon, 1891. The eyes and mouth are rimmed in red.
*SI, 153616 (27.9 cm)*

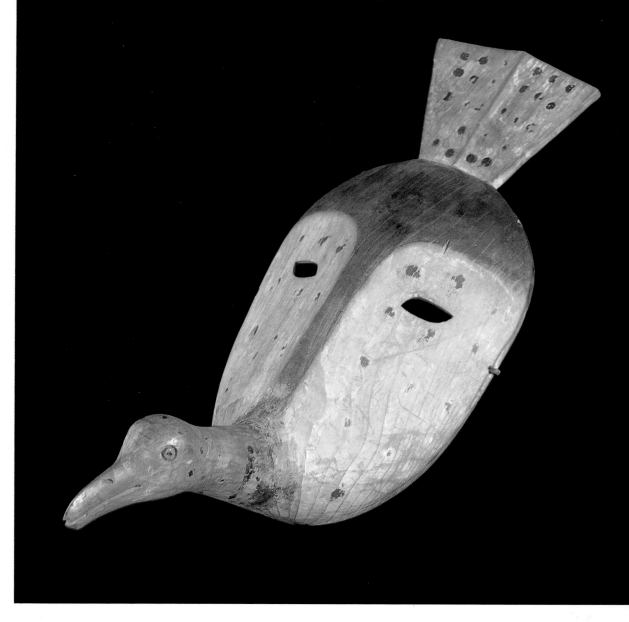

mercial Company's huge collection of artifacts from western Alaska (Graburn, Lee, and Rousselot 1995). All of the approximately 5,300 ethnographic specimens were collected by the company's agents in the field between 1868 and 1898 and were donated to the museum in 1904. Rudolf Neumann, the agent at St. Michael for many years, was one of the most active company collectors. Thanks to the combined efforts of Neumann and Edmonds, the Hearst Museum has forty-two Yup'ik and Iñupiaq masks.

Ernest W. Hawkes collected another nine masks and related ceremonial paraphernalia at St. Michael during the winter he taught school there. In January 1912 he witnessed an "Inviting-In" Feast, "Aithukagak" (probably Itruka'ar), and received the masks as a gift after the feast. Hawkes later sold the masks to the National Museum of Canada in Ottawa, and they are illustrated in the description of the feast he published in 1913.

Dr. Daniel S. Neuman, a U.S. Bureau of Education contract doctor, collected in Nome between 1910 and 1920. In 1921 he sold his collection, including seventy Yup'ik and Iñupiaq masks, to the Territory of Alaska, and it eventually formed the cornerstone of the Alaska State Museum collection in Juneau (Wal-

len 1994). In all, Neuman collected thirty masks from the vicinity of St. Michael and an additional sixteen from Hooper Bay and Katalac Island. The collection includes some striking pieces, including several paired masks, but in 1954 the museum curator decided to brighten them with commercial paint, radically changing their appearance.

Otto William Geist obtained another interesting collection from the Yukon community of Old Hamilton in 1934. Geist was an avid collector, largely sponsored by the University of Alaska. His collections remain at the University of Alaska Museum in Fairbanks as well as New York's American Museum of Natural History. Although most of his work was in northern Alaska, he had contacts all along the Bering Sea coast and made brief visits to Nelson Island and Yukon delta communities in the early 1930s. The fifteen masks Geist obtained at Old Hamilton are on the surface poor relations to the finely carved pieces J. Henry Turner obtained from the same area fifty years before. But thanks to the local schoolteacher, Pauline Kameroff, a native elder was recorded telling the stories the masks were made to illustrate—the only stories that accompany a mask collection anywhere in the world.

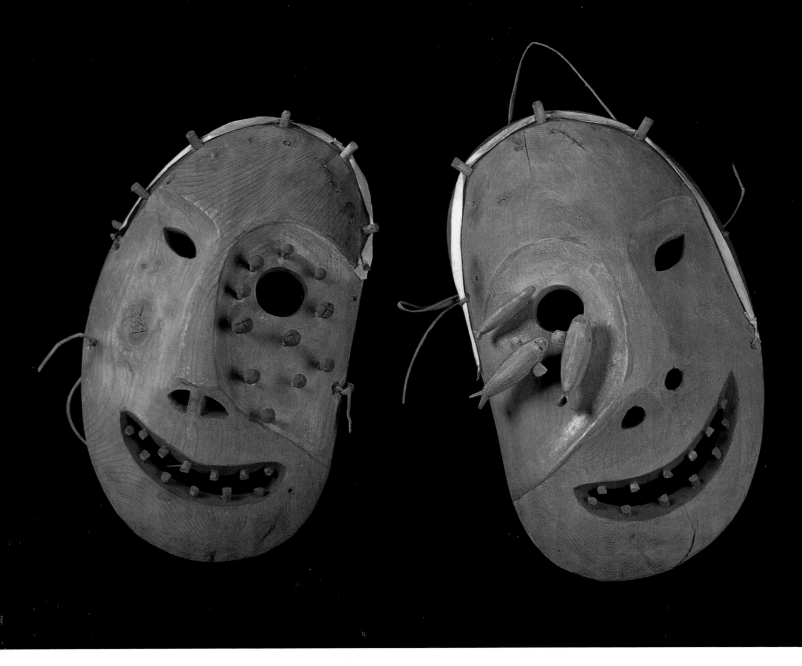

Moving down the coast, two unique collections of masks come from the community of Hooper Bay and another from nearby Qissunaq. Ralph and Anna Sullivan, schoolteachers at Hooper Bay between 1916 and 1918, acquired three dozen masks after village dances. Following a circuitous route, eight of the original masks were purchased by Canada's Glenbow Museum in Calgary, one by the Anchorage Museum of History and Art, and a tenth remains in private hands (Wallen 1990).

The newest major collection of Yup'ik masks is a group of twenty-four dance masks that Alfred and Elma Milotte brought home from Hooper Bay after filming sequences for the Walt Disney production *Alaskan Eskimo.* Hooper Bay carvers made the masks in spring 1946 to use in a masked dance being filmed in the village. After the dancing and filming were done, the villagers were going to destroy the masks, but the filmmakers interceded and purchased them, later selling them to the Alaska State Museum in Juneau. That same spring men in nearby Qissunaq carved masks for a dance, after which Frank Waskey, a well-known trader in the region, purchased ten,

later selling them to the University of Alaska Museum in Fairbanks. The Milottes' black-and-white photographs and film footage provide unique images of masks in use and document the rebirth of masked dancing, which had not occurred in either village since the Jesuits established a year-round mission at Hooper Bay in the 1920s. Father John Fox had given the villagers special permission to make masks for the Milottes' filmmaking project. Carvers at Hooper Bay and Qissunaq responded enthusiastically and set about preparing the first masked dances in more than two decades.

Nunivak carvers have produced numerous masks for sale since the 1920s, and many museums have isolated examples. The most valuable collection of Nunivak masks was made for the famous Arctic explorer Knud Rasmussen in 1924. While in Nome, Rasmussen met ten Nunivakers who had been called to witness at court proceedings against a Nunivak shaman accused of murder (Sonne 1988:10). Rasmussen interviewed them with the help of the native trader Paul Ivanoff and commissioned them to make twenty-eight dance masks, which were sent to the

Paired masks with asymmetrical features collected by Dr. Daniel S. Neuman on Katalac Island near St. Michael in the early 1900s. Red-topped wooden bird-arrow points surround the left eye of one mask and three seals the right eye of its partner. The strips of skin pegged around the faces show that they were originally framed in fur. *ASM, IIA1451 (37 cm) and IIA1452 (33.3 cm)*

Danish National Museum in Copenhagen in 1925. In 1988 Birgitte Sonne published Rasmussen's and Ivanoff's detailed notes on the masks, along with drawings and photographs.

In 1907 George Byron Gordon, the longtime director of the University of Pennsylvania's University Museum in Philadelphia, put together a small but valuable collection of objects from the lower Kuskokwim, including two masks. Gordon, along with his brother Maclaren, began his expedition on the Yukon River, crossed the Kantishna portage, and canoed on into the Kuskokwim River. During this trip Gordon revitalized his collecting networks so that although he never returned to Alaska, the University Museum continued to receive Yup'ik artifacts long after he returned home (King and Little 1986:31).

Probably the most important Kuskokwim collection is the group of fifty-six masks collected by the trader Adams Hollis Twitchell in the early 1900s. The masks sat in storage at the Heye Foundation in the Bronx for forty years. Expatriate Surrealists discovered them in the 1940s, and half the collection was quietly deaccessioned. Although books on primitive art have illustrated several of the most extraordinary of these masks, the collection as a whole has never been published or exhibited until now.

Another Kuskokwim trader, Robert Gierke, collected 350 objects during his tenure in southwestern Alaska between 1905 and 1940. He acquired twenty-six masks, probably from a single ceremony and the work of one or two carvers. These rough-cut masks, now housed at the University of Washington's Thomas Burke Memorial Washington State Museum, provide a sharp visual contrast to the finely crafted mobiles Twitchell acquired from the same area.

Moravian missionary Ferdinand Drebert bequeathed the Moravian Historical Society in Naza-reth, Pennsylvania, a small but significant collection of Yup'ik material, including four masks. Drebert obtained the masks—originally part of a group of nineteen pictured in a photograph taken in the 1920s, entitled "Heathen Masks"—during his years working along the Kuskokwim and lower coast between 1912 and 1954.

Hans Himmelheber, a German art historian, came to the Kuskokwim in 1936 to observe Yup'ik carvers at work. In the fall he traveled as far as Point Barrow on the *North Star,* eventually returning to Nunivak Island for the winter. Himmelheber is best known for his published description of Yup'ik carvers and painters at work, entitled *Eskimokünstler* (Eskimo Artists) (1938). He also collected several Yup'ik masks, presently housed at the Ethnographic Museum in Basel, Switzerland.

In 1912 Ellis Allen obtained from Goodnews Bay, below the mouth of the Kuskokwim, an unusual collection of seven masks, which the Burke Museum eventually acquired. This collection includes several enormous masks that were suspended from the ceiling during the dances, with performers standing behind them. Although almost nothing is known about the circumstances of their creation or collection, they represent a distinctive "Goodnews Bay style."

A number of the major collections of Yup'ik masks have been either exhibited or published, and they are relatively well known. Masks from the Sheldon Jackson Museum were included in the 1973 exhibit *The Far North,* curated by C. Douglas Lewis of the National Gallery of Art. Nelson's extraordinary collection, including forty masks, was featured in the Smithsonian's 1982 exhibit *Inua,* curated by William Fitzhugh and Susan Kaplan, and another ten masks appeared in *Crossroads of Continents.* Several of the

Masked dancers performing in the *qasgiq* in Qissunaq, spring 1946. Note the grass mats covering the back wall and the carved drum handle. The white fox mask (see p. 298) on the left, purchased by Frank Waskey after the performance, is now in the University of Alaska Museum, Fairbanks. *AM, neg. no. 1098, MC, ASM*

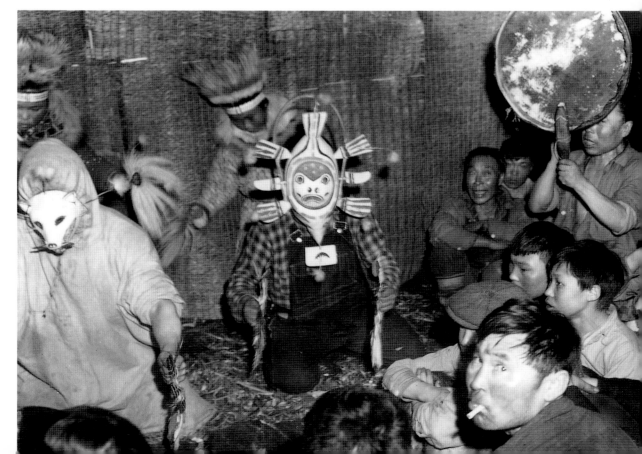

masks collected by Gordon and Van Valin were displayed in the University Museum's 1986 exhibit *Raven's Journey,* curated by Susan Kaplan and Kristin Barsness. In 1988 Birgitte Sonne exhibited Rasmussen's Nunivak masks at the Danish National Museum in Copenhagen. And in 1990 the ten masks collected by the Sullivans at Hooper Bay were featured in a small, well-received exhibit, *The Face of Dance,* curated by Lynn Ager Wallen at the Glenbow Museum. Photographs of the masks that Hawkes collected at St. Michael appear in his published account of the "Inviting-In" Feast, and photographs of the masks Edmonds and Rudolf Neumann collected at St. Michael are included in Dorothy Jean Ray's book *Eskimo Masks.*

In spite of these excellent exhibits and publications, 50 percent of the masks remain virtually unknown. No exhibit or publication has featured the diverse masks collected by J. H. Turner, Twitchell, Gierke, Geist, Waskey, Drebert, or Allen. Nor have the Yup'ik masks of southwestern Alaska ever received detailed, focused treatment comparable to that Dorothy Jean Ray gave to Eskimo masks in general in the 1960s. In fact, although Ray mentions lower coastal and Kuskokwim masks, she was more familiar with the people and the pieces from St. Michael and communities to the north. Although Ray and others have published occasional photos, little has been written about these lesser-known collectors or their collections. Furthermore, until now Yup'ik maskmakers have never had the opportunity to describe in their own words the meaning and uses of their works.

The hundreds of unattributed Yup'ik masks in collections all over the world also merit mention. Every major museum has its Yup'ik trophy, most dating from after the turn of the century, but some from the

These appendages belonged to a Quinhagak mask collected by G. B. Gordon that entered the collection of the Museum of the American Indian in 1908. The body of the mask was later deaccessioned, leaving its appendages behind. *NMAI, 1/6808 (40 cm; large hands, 11.3 cm each)*

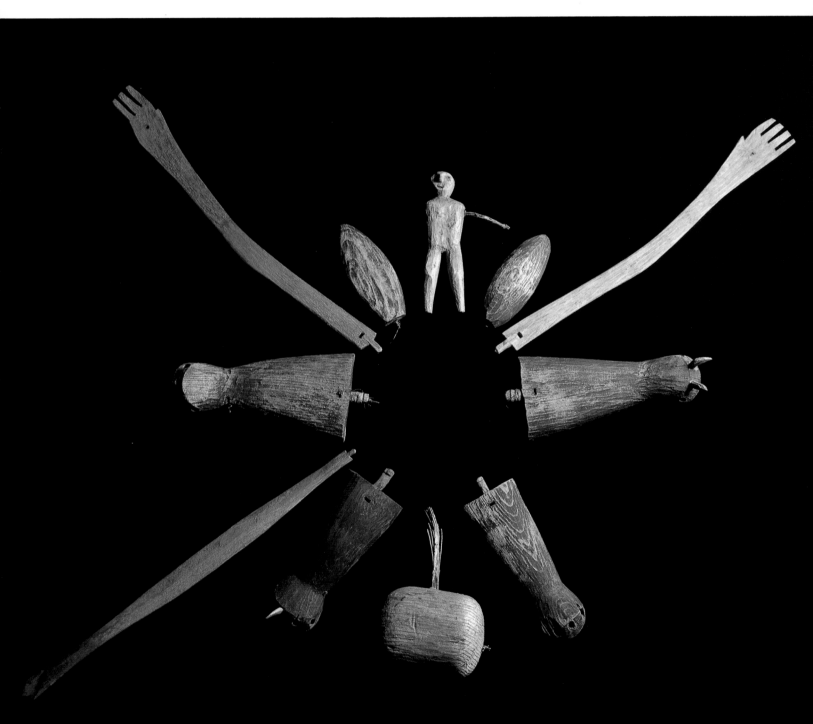

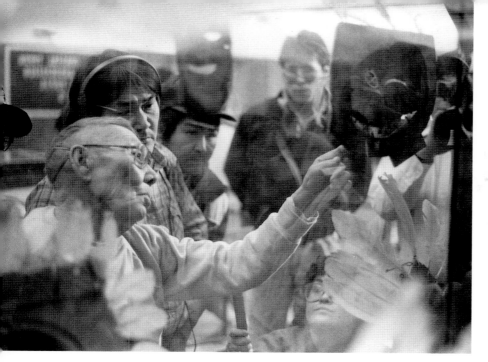

Chevak elder Joe Friday explaining the meaning of a mask at the 1989 Mountain Village Dance Festival exhibit. *Ray Troll*

1880s and 1890s. The desire to possess representative collections that inspired museums to collect a range of objects from many areas also inspired them to trade or sell their "duplicates" to less-well-endowed museums to round out their collections. The once-acceptable practice of deaccessioning objects from collections spread masks all over the globe. For example, the Musée de l'Homme in Paris received fifteen Iñupiaq and Yup'ik items from the Smithsonian in 1885, taken from the collections of Nelson, Turner, Dall, and McKay. In all, the Smithsonian deaccessioned five hundred specimens from the Nelson collection (Fitzhugh 1983:41). Into the 1970s the gift shop at the Museum of the American Indian in New York sold pieces from the museum's collections, including an occasional Yup'ik mask.

Most of the extraordinary Kuskokwim masks that Heye allowed to leave his New York collection in the 1940s and 1950s remain in private collections in France and the United States, but some have since reentered the museum world. Often, however, their venue has changed. Instead of ethnographic specimens embedded in an area-specific collection, the masks stand on their own, exhibited devoid of context in such world-class institutions as the Metropolitan Museum of Art. Many masks made since 1900 remain in private collections. In Bethlehem, Pennsylvania, home to retired Moravian missionaries, Yup'ik masks are still displayed in homes. Washington State alone probably contains several hundred Yup'ik masks owned by men and women who have retired to Alaska's closest neighbor in the Lower Forty-eight states after living in Yukon or Kuskokwim communities.

Yup'ik masks today mean different things to different people. For museums, the masks are valued ethnographic specimens. In the context of their original collections they can tell us not only about the

people from whom they were gathered, but also something about the collectors, their limitations and their strengths, their prejudices and their vision. The scattered masks retain a different meaning. In some cases they have become part of the owners' personal histories, reminding them more of the adventures of their own forebears than of the masks' Yup'ik carvers. Other masks have been embraced by the international community as artistic masterpieces beyond price. The fact that their makers are nameless and their original meanings unknown only adds to their mystique.

But what of the Yup'ik community, which is just beginning to know these collections? In 1844 Russian explorer Lavrentiy Zagoskin (Michael 1967:231) noted the urgency of recording in Alaska:

A wide field lies open, after our meager harvest, to anyone with better means and opportunity to describe the disposition and habits of these people—we have only raised the curtain. If we wish to preserve the memory of their primitive life, it is well to hurry: with the spread of Christianity and the contact with our way of living, the natives so quickly lose their native character that in a decade or so the old people will be ashamed to recount and will conceal their former customs, beliefs, and other habits, and their whole social life will change. We observed this at the present time among the newly baptized on the Kuskokwim.

Speaking about the masks he collected during the winter of 1878–79, Nelson (1899:395) wrote:

Unfortunately, I failed to secure the data by which the entire significance of customs and beliefs connected with masks can be solved satisfactorily. I trust, however, that the present notes, with the explanations and descriptions of the masks, may serve as a foundation for more successful study of these subjects in the future; the field is now open, but in a few years the customs of this people will be so modified that it will be difficult to obtain reliable data.

In 1981 Ray wrote that the time had passed: "Unfortunately, no one did follow through with serious inquiry. . . . and even the few persons who had attended semi-traditional ceremonies in the 1910s could remember very little of what they saw or did. They were unable to tell me why the masks were made, nor could they repeat the songs and stories." But Ray worked primarily in the Bering Strait region, and the elders she interviewed in the 1960s may have been reluctant to discuss masked dances many still considered heathen superstition. Had she spoken with Yup'ik elders in Yukon or coastal communities in the 1990s, her prognosis might have been more optimistic. Here, even pictures of these masks still evoke powerful images in the minds of many Yup'ik elders. Much has been lost, but much can still be learned from elders' recollections.

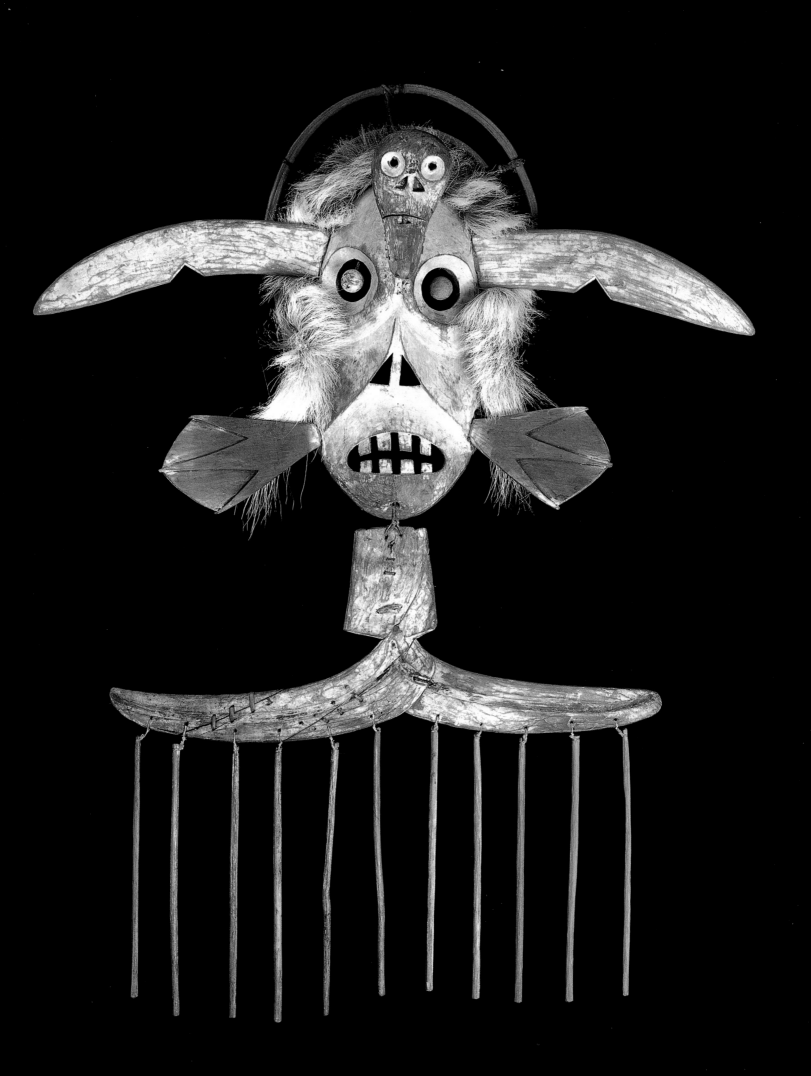

# THE MASKS' MEANING

Large flying-swan mask
collected by J. A. Jacobsen
on the Kuskokwim and
designated "Korreyorreoak"
(*qugyuguaq,* "pretend or imi-
tation swan"). He wrote that
it was an *angalkuq*'s dance
mask used during the last
feasts of winter: "The face
shows the shaman's helping
spirit. It brings the swans,
geese, ducks, and other
birds back to the coast in
the spring to give nourish-
ment to the people (espe-
cially the eggs and young
birds). The mask represents
the swan spirit." A caribou
ruff originally encircled the
face, and the head stood
upon a piece of baleen
so that it trembled at the
lightest touch. An enlarged
*caqiqsak* (woman's labret)
is attached to the chin; the
wooden rods dangling from
its base appear on many
Kuskokwim masks. The mask
was featured as the center-
piece of the Museum für
Völkerkunde's Eskimo exhibit
in the 1920s (see p. 218)
but was badly damaged
during World War II. The cur-
rent caribou ruff was added
during restoration in 1994.
*MV, IVA5147 (85 cm)*

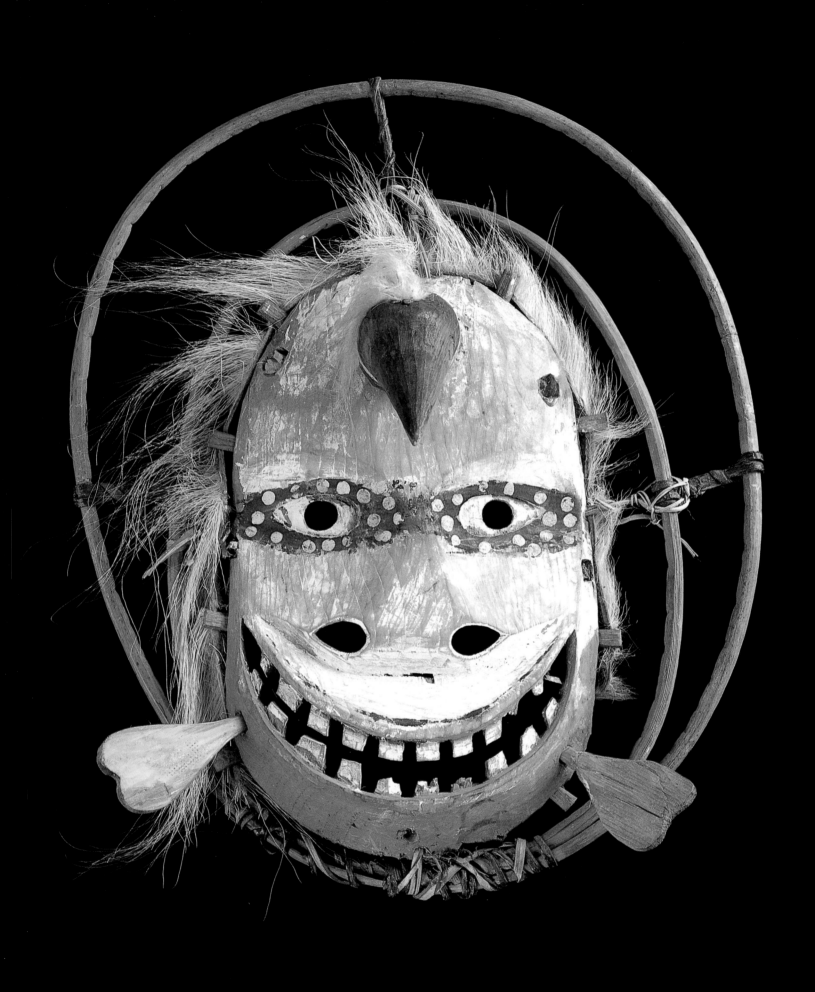

# Making the Unseen Seen

A loon mask J. A. Jacobsen collected between Cape Vancouver and the mouth of the Kuskokwim, describing it as a "dance mask representing a loon, probably the messenger of the shaman, so the mask is a shaman mask." The inside of the mouth still shows traces of red. *MV, IVA5190 (25.7 cm)*

A first encounter with Yup'ik masks may leave the viewer overwhelmed by their varied abundance and imaginative force. Masks in museums today range from the comparatively simple animal or human faces favored by Yukon carvers to enormous and elaborate Kuskokwim mobiles. They vary in size as much as shape, ranging from tiny forehead "maskettes" measuring three to four inches in diameter to monstrous twenty-pound constructions that no dancer could wear without external support. The Yupiit, who are known for their tolerance of multiple perspectives on the way the world works (Morrow 1990), remained open to individual variation among maskmakers and the *angalkut* who directed them.

Masks presented a wide range of beings and experiences through performances and stories. One told of an *angalkuq*'s journey under the sea or into the skyland, and included appended parts representing the creatures he encountered. Others represented animal *yuit*. Carvers made masks depicting insects, berries, wood, ice, and myriad creatures of everyday life.

Yup'ik masks' formal continuity is also impressive. Carvers creatively appropriated and transformed a common set of design elements, including toothy mouths, thumbless hands, "goggled" eyes, and feather halos. The majority of Yup'ik masks in museum collections today are rough-cut and simpler than the elegant and ephemeral masterpieces usually chosen for exhibit. Expert Yup'ik carvers, of whom there were hundreds during the last half of the nineteenth century, each had a recognizable vision and style. In most cases we are not left with the corpus of a Picasso, only his *Guernica*. What are we to make of it?

Carvers strove to represent the helping spirits or animal *yuit* they, or the *angalkut* who directed them, encountered in vision, dream, or experience. Although some, such as *angalkut*, were recognized as having more direct contact with the spirit world than others, through masks and masked dances everyone could vividly experience it.

Masks, in essence, were stage props, special but not sacred, and most were destroyed after use. Sometimes a group of masked dancers took the floor, but at other times a single performer focused attention. The masks' appearance shifted as the dancers moved in the dimly lit space. Masked performers tran-scended themselves in the audience's eyes, but the mask also transformed the performer's experience. Dancing behind the wooden barrier simultaneously restricted physical sight and enhanced spiritual vision. Some masks were believed to actually imbue the dancers with the spirits represented. The unsteady, changeable character of these past performances is hard to imagine in the quiet, carefully lit atmosphere of museum storage rooms and exhibit cases.

## Classifying Yup'ik Masks

The dozen or so scholars who have seriously studied Yup'ik masks over the last hundred years have typecast them in different ways. Edward Nelson (1899:394–95), the first and the most perceptive Yup'ik ethnographer, distinguished shaman masks (representing either a "tunghak," *inua*, or *yua*) from masks representing "totemic animals" (animal helpers). In all cases the wearer was infused with the spirit of the creature represented. In his discussion of the St. Michael "Inviting-In" Feast, Hawkes (1913:12), like Nelson, noted two general mask types—those "intended to excite merriment and good feeling among the guests, and those worn to honor the inua of the animals in whose honor the dance is given." Complaining that it was difficult to get reliable information, Edward Curtis (1930:38–39) nonetheless classified Nunivak masks into two groups—"those of the medicine men and those of the people in general." Visiting southwestern Alaska six years later, Himmelheber (1993:31) reported that the Kuskokwim Yupiit recognized three types of masks according to function: animal and plant masks for the purpose of influencing the harvest; "actors masks" for the performance of humorous stories; and "masks of the helper-spirits of the shamans." Admitting the limitations of a formal classification, Lynn Wallen (1990:14) divides Yup'ik masks into two categories: realistic/secular and surrealistic/spiritual.

Older Yupiit also speak of different kinds of masks observed in their youth. Kay Hendrickson (January 1, 1994), born on Nunivak Island in 1910 and a talented maskmaker, spoke at length about the masks he observed, including *angalkut*'s masks, animal masks, and contemporary masks made for sale: "The *angalkut* made many different kinds of masks. An *angalkuq* would make a mask depicting his *tuunraq*. A mask

would depict an *irciq* [semihuman being]. . . . Some of them would make carvings of birds. . . . Some had human faces carved on them. They were all men's faces. . . . This is a modern piece—made for sale."

Yup'ik men and women continue to make some of the same distinctions. Many speak about both *angal-kut* masks, made to reveal extraordinary experiences, and animal masks, made to elicit the animals' return in the future. Yet these "animal masks" were also often considered "of the *angalkut*." No hard-and-fast typology is possible because it is unlikely that Yup'ik maskmakers divided their creations into rigid types. We cannot read back from the unmarked masks in museum collections to general functional categories.

Apparent types of masks overlap. In the few cases that stories are known, they teach caution in categorizing. It is risky at best at this distance in time to classify a mask as *inua* or "tunghak" based on appearance. The shape of a mask can be deceptive. The simplest, most "realistic" mask may be iconic of a complicated experience or spirit journey. Alternately, some scholars describe the typical *yua* mask as an animal face or body in which a human face (the face of the animal's person) is embedded (either in its eye or on its back). This human face, however, may also represent the *angalkuq* and the animal, his or her helping spirit. The only sure way to interpret a mask's features is to know the story it was created to represent.

Although an external, formal mask typology is impossible, other ways of looking at masks shed light on their multiple meanings. One is to listen to Yup'ik elders who saw the last masked dances. This is not so much a solution to the issue of classification as a change in perspective. The focus shifts from the objects themselves to how people remember them. Just as there are limits in the classifications of nonnative experts (most of whom never saw the masks in use), there are limits to elders' recollections. Many echo the late William Tyson (February 27, 1993), who said, "That was what I observed. Things I remember are from the recent time. I cannot imagine about things and speak, but I can talk about things I heard about." Any expert view—whether native or nonnative—is partial. What marks the real experts is recognition of the limits of their knowledge.

## Masks as Revelation, Masked Dancing as Prayer

*I think they revealed as masks the animals' beings that helped them.*—Mary Mike, *St. Marys, February 25, 1994*

Today elders most often describe masks as vehicles for experiencing and, in some cases, influencing the beings they relied upon but did not normally encounter in day-to-day life. The masked performances both highlighted extraordinary past events and foreshadowed hopes for the future. Paul John (February 22, 1994) described the face masks he saw used on Nelson Island when he was young as "examples of what people can catch . . . representing what people might not have had":

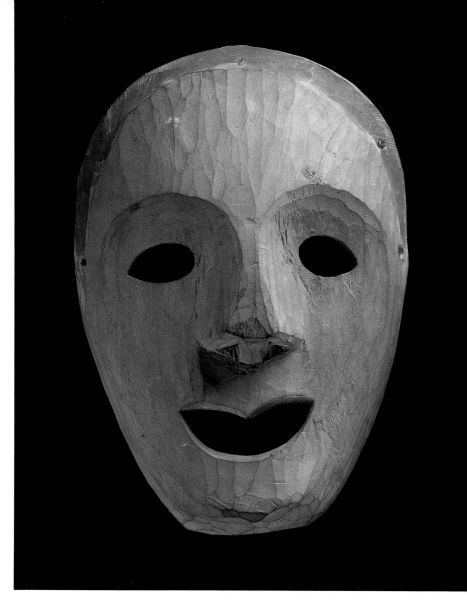

I don't know about the ones that belong to other people and what they stand for. I only saw some at my village representing different things. One would be a mask representing a fox, another would be a representation of an animal from the ocean, another one would be a representation of something else. Our ancestors decorated them with things that were desirable to acquire. . . .

Those masks are like examples [representations] of things they can catch. It is similar to the way white people use things as examples nowadays.

And then the ones who see that scene and see that example, if they know the meaning of it, they will suddenly remember and say, "So that's what it is." . . .

They were meaningless masks, but they represented things they prayed for.

They say our ancestors were not religious, and they say they didn't know anything about God. But now that I am older, and I look back to how they lived and how they are today, I have come to understand that they were very religious. Not surrounded by different things from another culture, when they woke up and carried out the day according to the teachings, it was as if they were constantly praying.

But nowadays, when we get up, we don't think much about anything because we see so many different things. We don't pray to God.

Although among the most eloquent, Paul John is far

This simple face mask collected by Otto Geist at Old Hamilton in 1934 embodies a long and complicated story about a doll that causes seal hunters to disappear:

*A poor orphan boy had a doll which he put into a toy kayak. One day while playing along the water's edge the kayak and doll drifted out to sea. After this the seal hunters going out to hunt never again returned. The boy decided to borrow a kayak and went in search to find out why the hunters failed to return. When he went out to sea he came upon a great whirlpool. Nearing the whirlpool the boy spat upon it and out jumped his kayak and the doll sitting in it. Instantly the whirlpool was stilled. The boy wished to take the doll back to the village,*

*but the doll refused to go, so the boy promised to get him a wife from the village. The boy returned to the village for a boat and a wife for the doll. He put out to sea and went after the doll and put him into the boat by the wife. On the way back the doll began to shiver, and the boy gave him his bird skin parka. When they had returned home the doll and his wife went out hunting using a bow and arrows. But the toy doll did not know how to hunt so his wife took the bow and arrows and caught a swan. The next day they went out again to hunt caribou. The toy doll tried again but failed so his wife killed the caribou. On the third day they went out to hunt bears, but again it was the wife who killed a bear for him. After the return of the toy doll no more hunters ever disappeared again.*

*UAM, 64-7-30 (20.3 cm)*

6. Early Yup'ik converts to Christianity referred to the creator in a number of ways, most of which have been lost since the adoption of Agayun. Lavrentiy Zagoskin (Michael 1967:121) wrote in the 1840s, "The spirit of life, ilkhlyuagun [?], is called upon at all occasions, but particularly to effect cures. He is believed to appear in five different aspects, called nyukhta [*nayurta*, 'one who stays with you, is with you']. God, the Creator, is called on the coast nunalyukhta [*nunaliurta*, 'one who deals with land'], [and] on the Yukon and Kuskokwim nunalishta [*nunalista*, 'one who makes land'], which means 'the Creator of the world.'"

MAKING
THE UNSEEN
SEEN

61

from unique in his comparison between his forebears' use of masks to ask for what they hoped to harvest and Christian prayer; other elders in southwestern Alaska increasingly express a similar attitude, emphasizing the common motive underlying masked dances and Christian prayer rather than their distinctive sources of power. In a planning meeting for the mask exhibit, Yupiit members (April 15, 1994) gave an equally positive evaluation, describing the use of masks as a "petition to the animals to be available" to the people:

ANDY PAUKAN: When a shaman made a mask to be presented and composed a song about the mask, he would let a carver make a mask, telling him what to do. When the mask was done he would put the mask on and dance. . . . They would present the animal that people used to survive to honor it, hoping that more of it came to the people. . . . They were praying. They were communing.

ELSIE MATHER: Down on the coast they would say they were pretending to be something when they danced, hoping it would become true. The lyrics of their songs would name the thing that was desired.

PAUL JOHN: During this time now people in aspiration use prayer. They would make a plea to God and pray very hard. That's what it was. . . .

From a long time past they called a ceremonial mask an *agayu*. Before the priests introduced Christianity, when people told stories they would mention the *agayuyaraq* [the way or process of praying or requesting] that had been practiced by the people . . . from long, long ago. When they did a presentation with a mask they would say that they were praying, practicing the custom of *agayuyaraq*.

Paul John points out a critical etymology. In the past the verb base *agayu-* meant "to request" or "to participate in a ceremony." On Nunivak Island *agayu* translates simply as "mask." When Christian missionaries began arriving in the 1840s, the term *agayu* was applied to the newly introduced religious ceremonies and came to mean prayer, worship, and participation in the new religion. According to Nelson (1899:421–22),

Curiously enough, the great mask festival (A-gai-yu-nuk) [Agayuneq] of the Eskimo south of the Yukon mouth has supplied terms by which the natives speak of the Greek [Russian Orthodox] church and its services among themselves. When they saw the Russian priest in embroidered robes performing the complicated offices of the church, it was believed that they were witnessing the white man's method of celebrating a mask festival similar to their own.

Today in southwestern Alaska, Agayun means God, *agayulirta* means "priest" or "minister," and *agayu-* translates both as "to pray" and "to cross oneself."[6]

Elsie Mather (May 6, 1994) reiterated the close link between the past and present meanings of *agayu* in her explanation of the name of the mask exhibit, *Agayuliyararput:*

The word *agayu-* means "to pray." Or in some church groups, it means going to church and worshiping. But in the old times that term seems to have been used when they would dance, during the dances, especially the mask ceremony. It is a time of praying, hoping for things to be. People honoring the person or the animal are praying for things to come. It was a very important activity for people because this was honoring the providers. So we've come up with a translation like *agayuliyararput,* "our way of making prayer."

[The postbase] *-li* means "to make something." And there's a sense that people made these masks. The idea is making prayer. It includes making the masks, making the songs, the motions, the dance groups, just the whole way of making these prayers.

Yukon delta elders also emphasized the connection between their traditional masked dances and contemporary Christian prayer. Past dances and present prayer were "exactly the same" for Justina Mike (March 1, 1994) of St. Marys: "They would wear masks and pray and ask the creator for animal and plant productivity. . . . *Agayuniluteng* [they would say they were praying]—they would call it that. Then when they came here they began going to church and praying, finally knowing what it is. They learned that there was a God. Now these are exactly the same."

Not only contemporary Yup'ik elders identify the purpose of the masked dances as honoring the *yuit* of the animals and requesting their return. Zagoskin (Michael 1967:228) found the same true in the 1840s: "The dances . . . express petitions, vows, or expressions of gratitude offering to the spirits or apparitions which have appeared to the shamans." Nelson (1899:358–59) said that the primary purpose of the "Inviting-In" Feast was "to propitiate and do honor . . . to bring about plenty of game during the coming year and to ward off evil influences. The *inuas* or shades of the various animals are invited and are supposed to be present and enjoy the songs and dances." Although Nelson never personally observed these dances, he interpreted many of the masks he obtained as having this function. In his description of one thin, flattened mask, Nelson (1899:404) wrote, "This face represents the *inua* of some species of waterfowl, . . . but from the drawings of the various game animals upon the flaps attached to the sides, I judge that it was used in festivals connected with obtaining success in the hunt, which I learned to be the case with similar masks in the region."

### Agayuyaraq: "Of the *Angalkut*"

Along with their emphasis on continuity between the masked dances of the past and contemporary Christian prayer, most elders today emphasize the role of the *angalkuq* in the creation and performance of masked dances, primarily during the midwinter dance ceremony Agayuyaraq. People performed Agayuyaraq to interact with and influence the spirits of animals and other entities of the natural world to elicit successful hunting in the year to come.

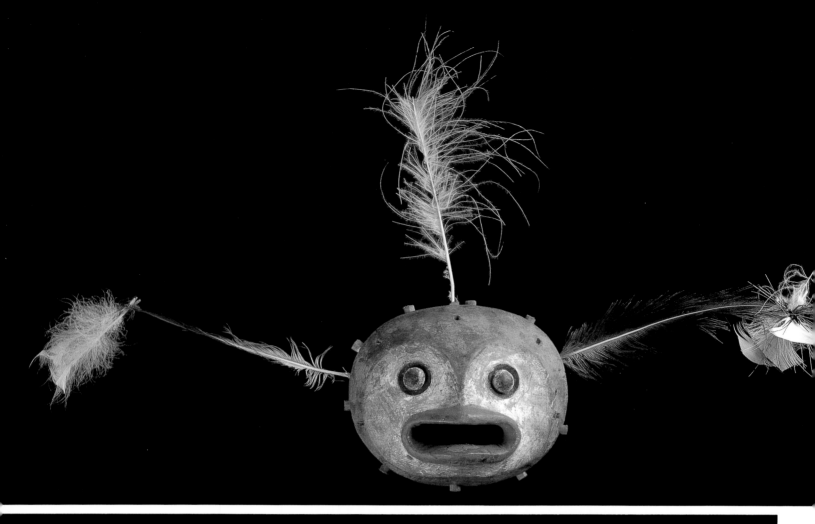
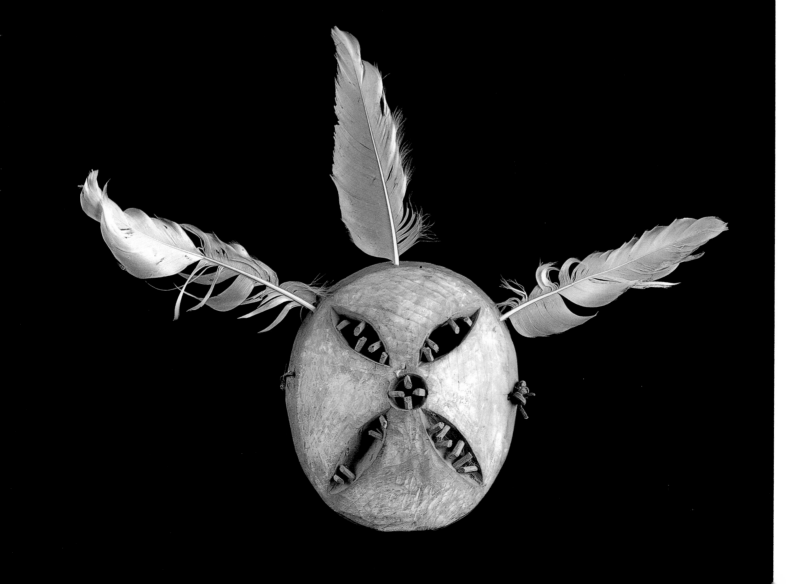

Owl forehead mask collected by Jacobsen on the Kuskokwim, 1883. The eyes protrude, and the mouth is the only opening. Like so many masks, the face was originally surrounded by a caribou ruff held in place by wooden pegs. The *angalquq*'s helping spirit often took the form of an owl. *MV, IVA5157 (11 cm)*

Yukon mask representing a jellyfish, "Iggarnekrak-Kinakok" (*kegginaquq,* "mask"), collected by Jacobsen in 1882. According to Jasper Louis, "Anything we have can become a mask" (see p. 67). The holes and deepenings are spiked with wooden "teeth" and show traces of red paint. Toothy mouths such as these occur on many masks and may relate to the predatory creature represented (see "The Monstrous Mouth," (pp. 175–80). *MV, IVA4416 (17.4 cm wide)*

MAKING
THE UNSEEN
SEEN

Whereas both the Bladder Festival and the Feast for the Dead supplied the needs of the dead (both human and nonhuman), people performed Agayuyaraq mainly to please the *yuit* of animals yet to be taken to supply the needs of the living.

Like the Bladder Festival and the Feast for the Dead, Agayuyaraq primarily concerned traversing boundaries between worlds. People also referred to it as Kelek (from *keleg-,* "to invite to one's home") or Itruka'ar (from *iter-,* "to enter or come into a habitation") on the Kuskokwim and lower Yukon (Morrow 1984:136) and the "Masquerade," "Inviting-In" Feast, or "A-gai'-yu-nuk" (Agayuneq) in the literature (Fienup-Riordan 1994:304; Hawkes 1913:1, 1914:40–41; Kilbuck in Fienup-Riordan 1988:23; Nelson 1899:358, 421–22). Paul John (February 22, 1994) said that Itruka'ar referred to the gifts people brought to gain admission to the dance: "Because they bring in things that are useful, not just anything, and then pass them to the other people, they call it *itruka'ar*" (lit., "thing to come in with").

In most places Agayuyaraq was the final feast of the winter ceremonial season and was an intervillage event that rotated among related communities. This complex ritual involved singing songs of supplication to the spirits and *yuit* of the animals, accompanied by the performance of masked dances under the direction of the *angalkuq.*

Like the Bladder Festival and the Feast for the Dead, Agayuyaraq was a legend as well as a rite. Nelson (1899:494–97) recorded the lower Yukon story of an *angalkuq* who journeyed up through the star holes to visit the "inuas" (persons or *yuit*) of the skyland in their heavenly *qasgiq.* From its roof hung wooden hoops decorated to represent the levels of the universe. Beside each person the *angalkuq* saw a small wooden image representing a different mammal, bird, or fish. The occupants of the skyhouse were the *inui* controlling the fish, birds, and land animals.

The *angalkuq* later returned to Earth, falling head first through the exit hole in the heavenly floor. When he awoke, he told the people to hold a festival during which they should decorate their *qasgiq* like the skyhouse he had visited. The people offered food to the *inui* of the skyland and sang songs in their honor to ensure the return of the animals. If satisfied with these offerings, the sky people would cause the images beside them to grow, endow them with life, and send them down to earth to replenish the supply.

### The *Angalkuq:* The One Who Could See

During the reenactment of the Agayuyaraq legend the *angalkuq* played a critical role as the intermediary between the human and spirit worlds. Just as the *angalkuq* in the legend advised his people to perform certain rites following his visit to the skyland, during Agayuyaraq *angalkut* were called on to direct the dramatic representation of these *yuit* as well as enactments of what was hoped would come from them in the future. The *angalkut*'s actions during Agayuyaraq reflected their role as mediators between worlds.

Their power emanated from their ability to look into places and times not accessible to ordinary humans. With this supernatural vision went the ability to travel to the skyland, the undersea home of the seals, and the underground land of the dead, where they could communicate with and pacify these nonhuman persons. This they did with the aid of their *tuunrat,* who were invisible to all but the clairvoyant *angalkut.* Paul John (February 22, 1994) described the *angalkut*'s journey to the ocean to increase the animals available for hunting: "Their *angalkut* . . . go to the ocean . . . using their *angalkuq* powers to increase the number of living things that are to be caught. Or to move the ones that are far down in the ocean closer to the shore, so . . . there would be plenty of them."

People called on the *angalkuq* in times of personal and community crisis, such as illness and famine, believed to result from transgressions of the rules for living. The *alerquutet* (admonitions) and *inerquutet* (prohibitions) defined clear boundaries between men and women, land and sea, and the living and the dead, and people crossed these boundaries at their peril. During the ritual process, however, the mediating activity of the *angalkuq* dramatically transcended these boundaries so scrupulously maintained during daily life.

Ordinarily, a rigorous separation between the sexes circumscribed everyday activity. The *angalkuq,* however, held an ambiguous position. Both men and women could wield shamanic power (Hawkes 1914:11; Weyer 1932:421–22), and *angalkut* presented themselves as male mothers in specific ceremonial contexts. Although an *angalkuq* might be a man, he was not a hunter. *Angalkut* were notorious for their lack of hunting prowess, and oral tradition often depicts them as physically weak and apparently defenseless.

During his travels between worlds the *angalkuq*'s movement was wrapped in images of biological reproduction. Prior to departure on a "spirit journey" he was carefully covered and sometimes tied in a fetal position in the *qasgiq.* His simultaneous exit from the human world and entry into the spirit world were represented as movement through a restricted passage—either an entryway, ice hole, or star hole. As during birth, a helper stood in attendance during the journey. Following his return the *angalkuq* gave away the clothing he had worn during his travels and rested for five days, actions comparable to those of a girl following her first menstruation or a woman following childbirth.

The *angalkuq*'s spiritual journey was clothed not only in images of birth and female reproduction, but also those of death. The binding of the *angalkuq* at the opening of a seance recalls the bound corpse as strongly as the unborn fetus. Likewise, shamanic initiations and cataleptic trances often involved the symbolic death of the *angalkuq,* after which he might travel to the land of the dead before returning to the land of the living. Conversely, the powerful *angalkuq*

was considered impossible to kill. Nelson (1899:434) described how an *angalkuq* was "burned alive" to attain additional power. He was bound hand and foot and

a large mask, covering his face and body to the waist, was put on him. . . . Immediately after the people went inside the assistants unbound the shaman and substituted a log of wood behind the mask, while the shaman concealed himself near by until the next morning. . . . This ordeal of fire was supposed to endow the person enduring it with the power to cast off or assume the bodily form at will and to greatly increase his power in other ways.

The *angalkuq* derived power from his paradoxical position as a person who had experienced death but did not die. In general, Yup'ik cosmology clothed death in images of birth, thereby transforming it from a final exit into a new beginning. By employing these contrasting images, the *angalkuq* transcended the apparent opposition between life and death, which was reconceptualized as a cyclical movement between birth and rebirth.

The *angalkuq*'s travels to other worlds served to expel evil spirits, uncover transgressions, and change the weather. One of the most important motivations of such travels was to request the *yuit* of the animals to give themselves to human hunters: "The trips that the shamans made are to the areas where the spirits of the animals are. . . . [A]ll living things and animals caught for food have spirit places where they will never die. During spring seasons, the shamans bring the spirits of the animals and fishes to the people so that starvation will not plague their villages" (Pingayak 1986).

Paul John (February 22, 1994) compared the *angalkuq*'s journey to the ocean to the work of a scientist who "fixed the path for the fish":

They talk about scientists nowadays. Those were the scientists of our ancestors. They would know the future through their invisible world. . . . And the white people mention biologists nowadays, the ones that keep an eye on the fish. Some of those *angalkut* worked on the path the fish were going to use so their people wouldn't lack for fish when summer arrived. . . . And then the [*angalkut*] who are able to would go down into the ocean in the winter to conjure up plenty of seals or any other sea mammals, so that in the spring when people started going hunting, there would be plenty of them to be caught.

Just as the *angalkuq* visited the seal world at the close of the Bladder Festival, during Agayuyaraq he journeyed to the moon to request animals. Paul John (January 13, 1977) described such a journey:

In those days, some of the *angalkut* said they went to the moon. . . . When an *angalkuq* was going to go to the moon, all the men and boys went to the *qasgiq*. . . . And out in the houses were the women with little boys who were not old enough to be in the *qasgiq*. Then

when [the *angalkuq*] was going to go he would have someone warn them not to go outside until he came back, or the *angalkuq* would not find his way back. (See also Nelson 1899:430; Fienup-Riordan 1994:260–62)

## Masked Dances

*Right now when they're dancing they don't even use masks, like in the old days. They used to wear these masks and to me it looks better that way. Because they're fancy when they're dancing with the fancy masks, painted good and all those feathers around the mask. . . . If you see that kind of dancing maybe you would never forget it.*—Jasper Joseph, *Emmonak (Kamerling and Elder 1989)*

In preparation for Agayuyaraq the *angalkuq* directed construction of elaborate masks, through which the spirits revealed themselves as simultaneously dangerous and potentially beneficial. On Nunivak these masks were known as *agayut* (from *agayu-*, "to participate in a ceremony") and on the lower Yukon as *avangcat* (sing., *avangcaq*) or *kegginaqut* (lit., "things that are like a face," from *kegginaq*, "face; blade of a knife," plus *-quq*, "one that is like"). These powerful masks were dangerous and had to be carefully handled at all times. Women, especially when menstruating, were forbidden to touch them: "They say something leaks out of her thyroids . . . that repels animals. . . . [These days] they have started to dance with women in their arms. As I thought about it, our food supply is getting smaller and smaller" (Jasper Louis, February 25, 1994).

Prior to performances, the masks were hidden under the benches of the *qasgiq* wrapped in grass mats, protected from human gaze, lest the animals be offended (Ray 1966:84). Masks were watched carefully when brought out for a performance, and were never left alone: "They would care for the masks and hang them. When they hung them they would never leave the *qasgiq* totally empty. They say that when they were left alone some of the masks would go outside. And they would rub against the other masks that were hanging" (Jasper Louis, February 25, 1994). Even when they let people see the faces of the masks, they always hid their backs. Some of the larger masks hung from the ceiling with cords during performances, while others were held up to the dancer's face with wooden mouthgrips, which the audience never saw, as they were the *angalkuq*'s secret (Ray 1967:20).

The masks, which were concealed both before and after Agayuyaraq, were believed to endow the performer with supernatural vision during the performance. According to Nelson (1899:395), "When [masks are] worn in any ceremonial, . . . the wearer is believed to become mysteriously and unconsciously imbued with the spirit of the being which his mask represents, just as the namesakes are entered into and possessed by the shades at certain parts of the Festival of the Dead." The use of masks during Agayuyaraq provides a concrete image of the contrast between

Backside of a mask, showing the wooden mouthgrip the performer used to support the mask during performance. At the 1989 Mountain Village exhibit, elders requested that masks hang against a mirror so that people could see the backs and learn for themselves that there were no strings attached. *ASM, MC, II A5404 (50.2 cm)*

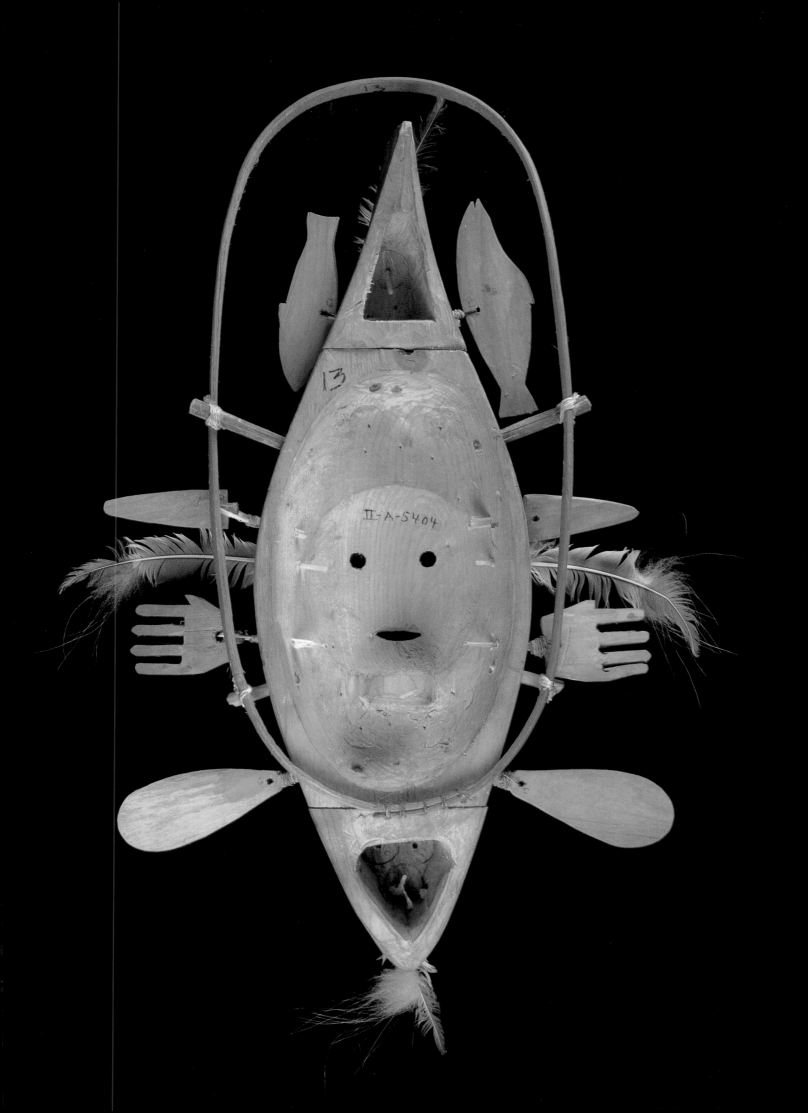

restricted vision and powerful supernatural sight. Masks simultaneously functioned as eyes into a world beyond the mundane and the visible sign of the *angalkuq*'s experience. Jasper Louis (May 28, 1993) reiterated this point:

They wore masks and would cry out sounds of the animals they have carved into masks. . . .

They would make a mask depicting something. The songs of the *angalkut*, the composition would illustrate the thing they were depicting. We ordinary people can't truly understand the essence of the mask the way an *angalkuq* did.

Did the masks belong to only the *angalkut* back then? They would carve the likeness of what they had seen. They would reveal the image. They have said they were the revelations of what they had experienced and seen.

### *Tuunraq:* The *Angalkuq*'s Helping Spirit

As people considered Agayuyaraq "of the *angalkuq*," they viewed the *angalkuq* as "the one with a *tuunraq*." In southwestern Alaska the shaman was originally known by two names—*angalkuq* and *tuunralek* (lit., "the one with a helping spirit"). After the arrival of the missionaries, *tuunraq* came to mean "devil," and Ray (1967:11) subsequently back-translated *tuunralek* as "demon intermediary." Contemporary elders rarely use the term *tuunralek* in connection with masks or masked dancing and instead use *angalkut* when talking about shamans of the past. Elders' statements, in which the word *tuunraq* comes up again and again, can help unravel the confusion surrounding the label "tunghat," which, following Nelson, has been applied to so many Yup'ik masks.

We know from historic accounts that *angalkuq* masks could represent mythological beings and beings encountered during supernatural journeys, as well as helping spirits. Of these masks, however, liv-ing elders most often recalled those depicting the *angalkuq*'s *tuunraq*. When asked the meaning of *agayu,* Kay Hendrickson (January 1, 1994) said, "The *angalkuq,* apparently, would depict his *tuunraq* in a mask."

Nelson (1899:428) gave the first and fullest definition of *tuunraq*, which he referred to as "tunghak," using an orthography that rendered the modern "r" with a "gh" and the modern "q" with a "k":

Every *tun-gha-lik* [*tuunralek*], as the name implies, is the owner or controller of shades or supernatural beings called *tun-ghak,* dual *tun-ghuk,* plural *tun-ghat.* These beings possess supernatural power, and the more of them the shaman subjects to his will the more power-ful he becomes. *Tun-ghat* are believed to be the personi-fications of various objects and natural forces, or may be wandering shades of men and animals, and are invis-ible to all except *angalkut* or people possessing clairvoy-ant powers, unless they become visible to ordinary people in order to accomplish some particular purpose. They have various strange forms, usually manlike, with grotesque or monstrous faces, such as are shown on many of the masks obtained in this region. They have the power of changing their form; in some instances becoming animals or assuming very terrifying shapes.

Nelson goes on to describe various "tunghat," noting that "a common form of *tunghak* is the *yu-a,* or spirit of the elements, places, and things."

In the literature (Ray 1967:11; Fitzhugh and Kaplan 1983:198, 204; Kaplan and Barsness 1986:116) "tunghat" are generally defined as power-ful spirits who lived in the skyland, especially on the moon, and acted as keepers of animal and human spirits. Some have interpreted Nelson as distinguish-ing between the "tunghat" as beings separate from the animals but which controlled them and the ani-mals' own spirit beings. They could be dangerous and needed constant appeasement to avoid disaster.

Dance ornament said to represent "Jarneelingak [Carniilngaq?], an evil spirit that tells medicine men to harm and kill people." Col-lected by A. H. Twitchell at Napakiak in the early 1900s. *NMAI, 9/3578 (30.5 cm)*

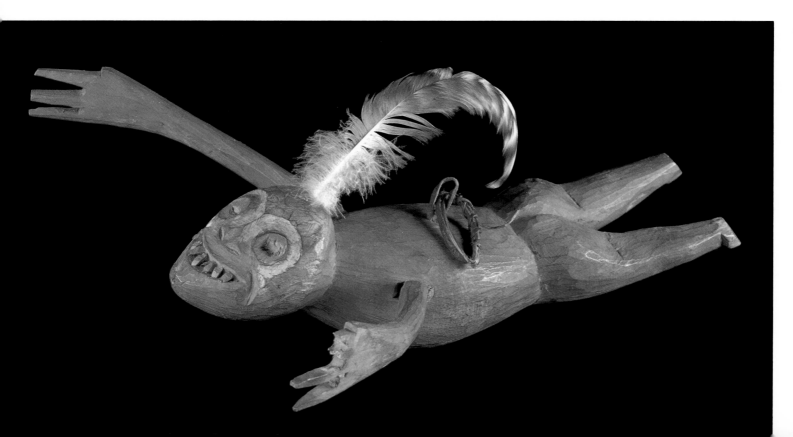

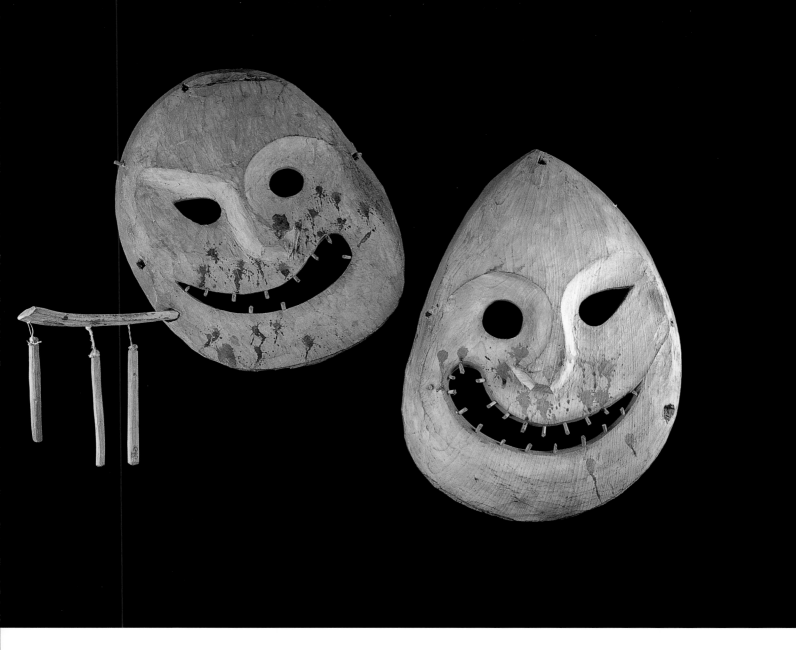

Paired asymmetrical masks collected from the lower Yukon in 1882 by Jacobsen, who said the "thunrak" (*tuunraq*) masks represented evil mountain-dwelling demons that pursue and devour hunters. Their mouths are always soiled with blood. They also plague people by causing things to break. The wooden projections represent labrets. *MV, IVA4402 (33 cm) and IVA4398 (37.5 cm)*

MAKING
THE UNSEEN
SEEN

The "tunghat" could cause disease and famine by withholding game. Ray (1967:11) called "tunghat" "malevolent beings" and "separate entities, not in any way connected with the spirits of objects or living creatures."

Contemporary Yup'ik accounts of *angalkut* and their *tuunrat* do not entirely correspond with these scholarly definitions. They deemphasize both the deitylike and malevolent aspects of *tuunrat* and often describe them as taking animal form. For example, Jasper Louis (February 25, 1994) said he had seen *angalkut* presenting many different kinds of masks depicting *tuunrat*:

The shaman could make masks of animals and beings known to the people in the village if the animal or being had become his/her *tuunraq*. When the people hear a song with two beings as *apalluk* ["verses," dual; sing., *apalluq*; pl., *apallut*] about these two beings, an *angalkuq* could actually see [the animals]. Some *angalkut* were revered by the poor ancestors. . . .

While we are alive anything we have can become a mask. The creature masks [such as] wolf masks were powerful when the *angalkuq* used them as *apallut*. . . . They say wolves were able to pursue things they want.

I think everything is handy to the wolves today. . . . But [bear masks] were scarce. Only a few presented the bear mask. . . .

The more powerful *angalkuq* had a loon mask as an *apalluq*, too. . . .

All the masks were made by *angalkut*. Looking at their *tuunraq* they created masks.

They even had masks of deceased humans. They would make masks of *angalkut* who had died.

The *tuunraq* was like their helper.

Bringing together Nelson's observations and the commentary of contemporary elders such as Jasper Louis helps disentangle the scholarly confusion. It is not that "shamans took as their spirit helpers both animal *yuas* and *tuunrat*" (Wallen 1990:15), but that myriad beings—including animal *yuit*, dead humans, or any creature an *angalkuq* encountered and overpowered—could act as *tuunrat*. The literature usually labels as "tunghat masks" the more surreal and elaborate masks, designating "animal masks" as a distinct mask category. In this scholars are probably mistaken. The *angalkut's tuunrat* represented on masks took myriad forms, some fantastic and some deceptively realistic.

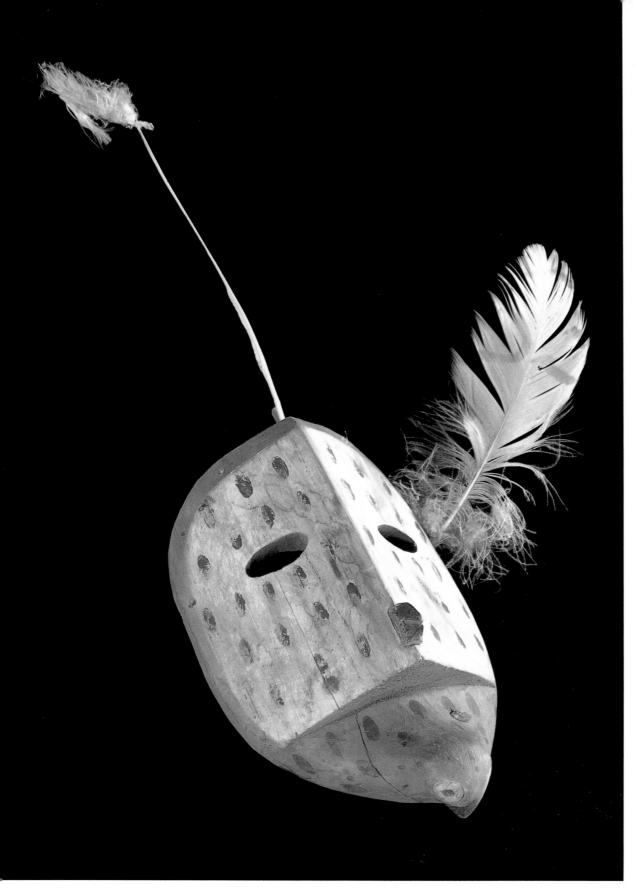

Delicate mask, both a bird and face, collected by J. H. Turner on the lower Yukon, 1891. Small, apparently insignificant creatures could act as helping spirits. According to Mary Mike (October 19, 1994),

*Different kinds of animals were their* tuunrat. *Some would present little birds and sound out their cries. They would present loons too. Some of the birds they presented and called out were not the kinds that were very big and powerful. There was an* angalkuq *who was very prominent who was approached by a little calling bird out in the ocean. While he was on ice early in the morning a little bird landed above him and began to sing. As he listened to it singing, he understood its call saying, "It is going to get stormy. Don't stay there, go up to the land." It was telling him that he would be in trouble if he remained there. When he understood what it was saying he went up to land. Shortly after that it got very stormy and pieces of ice began to break off and floated out to the ocean. That little bird was probably his little* tuunraq. *It was called* taituir *[from* taituk, *"fog"].*

A number of masks carved in this style were collected in the 1890s. *SI, 153628 (18.6 cm)*

Contemporary Yup'ik accounts also tend to be partial. Elders maintain that simple animal masks represented the *angalkut's tuunrat* and rarely mention the fearsome beings that *angalkut* traditionally employed as *tuunrat*. Although recent accounts emphasize the more benevolent aspects of *angalkut* (as "doctors" and "scientists") and "spirit helpers" who made food available to the people, less appealing *tuunrat* are not denied. Dick Andrew (August 16, 1992), originally from Nelson Island, recalled: "They say the apparitions were plenty back in those days. They say that those *angalkut's tuunrat* could be apparitions, shrouding themselves with those who had died. They would use the body though the person was dead."

Although Nelson's original discussion of "tunghat" emphasized their fantastic and unrealistic qualities, he closes his account by saying that "tunghat"

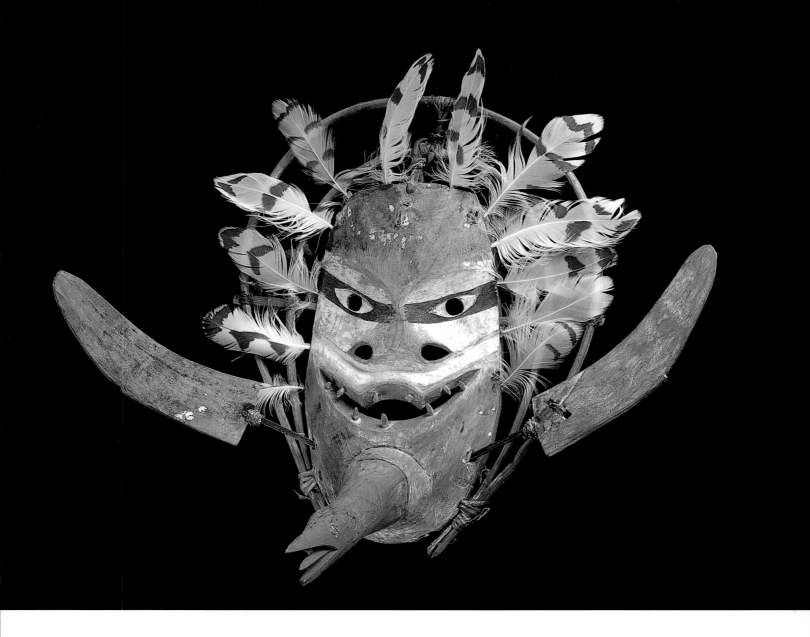

Loon mask collected by Jacobsen in 1883 along the coast below Cape Vancouver. According to Jacobsen, the *angalkuq*'s messenger took the shape of the loon when the *angalkuq* sent it out to reconnoiter; the face on the loon's back is that of the *angalkuq*'s *tuunraq*. The loon often figured as a *tuunraq*, probably due to its ability to move between worlds, as it is simultaneously a creature of the land, air, and water. Snowy owl feathers decorate the mask's rim. *MV, IVA5151 (32 cm)*

could take the form of *yuk*, which he defined as "a spirit of the elements, places, and things." In fact, *yua* is not different from *inua*, as Nelson believed. Rather, both mean "its person" in Yup'ik and Iñupiaq, respectively. Nelson was thus both accurate and mistaken. "Tunghat" could take the form of *yua*.

### *Yua:* Its Person

It is impossible to mention *yua* casually in relation to masks or anything else, as there is probably no concept more fundamental in Yup'ik cosmology. For Yupiit past and present, everything has personhood—every animal, every plant, every stone—and human thought and deed constantly take this shared personhood into account.

Simply stated by Paul John (April 15, 1994), everything has a *yuk:* "My wife's uncle, since they've said that he was almost an *angalkuq,* told me this more than once. He told me that everything has a *yuk.* He told me that he had seen them. He said that even a piece of wood that was split in half was half of a person. It was their life."

The concept of shared personhood is fundamental to masking. In the past, "when the earth was thin" (*nuna-gguq mamkitellruuq tamaani,* from *nuna,* "land,"

and *mamkite-,* "flat object that is thin"), when traffic between worlds was more common, an animal might reveal its personhood by pushing up its beak or muzzle to reveal the person beneath. According to Nelson (1899:394):

It is believed that in early days all animate beings had a dual existence, becoming at will either like man or the animal forms they now wear. In those early days there were but few people. If an animal wished to assume its human form, the forearm, a wing, or other limb was raised and pushed up the muzzle or beak as if it were a mask, and the creature became manlike in form and features. This idea is still held, and it is believed that many animals now possess this power. The manlike form thus appearing is called the *inua* and is supposed to represent the thinking part of the creature, and at death becomes its shade.

Nineteenth-century transformation masks play on this concealed character of an animal's person. Known as *patulget* (lit., "those with covers," from *patu,* "cover"), these masks had doors covering a human face. Dall (1884:123) wrote that opening this door signaled a change in the singing and dancing.

Himmelheber (1938:58) said that on the Kuskokwim a helping spirit showed his liking for the *angalkuq* by opening the doors and revealing his human image.

Writing about the multiple masks of both the Eskimos and the Kwakiutl, Claude Lévi-Strauss (1963:262) provided an eloquent reading of their double meaning: "Those masks with louvers . . . hold at the same time the function of masking and unmasking. But when it comes to unmasking, it is the mask which, by a kind of reverse splitting, opens up into two halves, while the actor himself is dissociated in the split representation, which aims at flattening out as well as displaying the mask at the expense of the individual wearing it."

Not all animal masks containing a human face, whether revealed or hidden, represented the animal's *yua*. Himmelheber (1993:37) wrote that in a "shaman mask" with double faces, the human face does not represent the animal spirit but the personal spirit of the *angalkuq*, which has slipped into the animal. Conversely, Hawkes (1913: plate 11) illustrated an "Inua" mask worn by an *angalkuq* carved as a simple human face devoid of animal features.

Nelson (1899:395) wrote that people believed *angalkut* had the power of seeing through the animal mask to the "manlike" features behind. Some contemporary elders support Nelson's gender-specific word choice, maintaining that the person of an animal always appeared as male (Kay Hendrickson, January 4, 1994).

Everything in nature, both animate and inanimate, possessed *yuk*, and the *angalkuq* was the most likely to perceive this personhood and direct its revelation through a mask. Traditional tales as well as dramatic performances describe the personhood of animals. Stories often tell how a human child lives among animals, perceiving them as human during his or her stay. When the child prepares to leave, however, he or she might glimpse their true animal nature: "The [host] would tell that person before leaving, 'When you go outside, after you have taken a few steps away from the house, look behind, if you are curious to know if I was a person.' . . . When they leave they would finally look back and discover they had gone inside an animal's den" (Pauline Akaran, February 27, 1993). Cecelia Foxie (May 31, 1993) of Kotlik said the same thing: "They are human sometimes. They let humans see them in human form. Now they let him talk like, 'What is one doing, suspecting that I am not human.' And when they tell him to glance at them, they would not be human but something else!"

In the past circumstances caused many animals to abandon their human form. Alma Keyes (February 27, 1993) of Kotlik told the story of how the fox became furry and red out of embarrassment when a tiny needlefish teased him about his stinky rectum. Other tales describe extraordinary animal *yuit* who change form when people encounter them. Bearded seals, for example, sometimes take human form. According to Paul John (February 21, 1994):

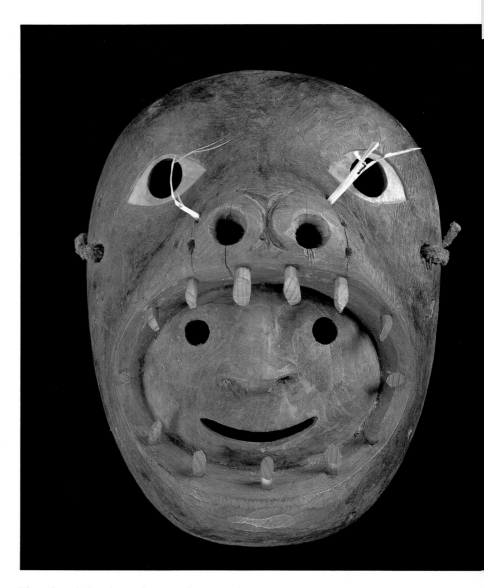

Those bearded seals are the ones that turned into human beings. In those days, people would see a human being sitting on the ice without a kayak. It would be staying [its legs tucked in] with a seal-gut rain parka on. The bearded seal that had turned into a human being is called a *qununiq*. And [people] would recognize them in those days because they didn't have a kayak—"It is a bearded seal." . . .

And then when that one suddenly became aware of the fact that a human being had come upon it and speared it through its seal-gut rain parka, it would fall into the water.

It is said that when it came up for the first time, it would have a bearded seal face. The second time it came up . . . more of it would have become a bearded seal. It would become more of a bearded seal when it came up for the third time. When it went down underwater for the fourth time, it would come up for the fifth time being totally a bearded seal.

Whether or not animals reveal their personhood, humans are admonished to treat them respectfully. All animals share with humans a mind meriting respect, and all are acutely aware of how they are treated. Some animals surpass humans in their sensitivity and ability to know human acts and intentions.

Small, finely carved seal mask, its *yua* peering out from its mouth. Thirteen small holes around the rim indicate that feathers or a caribou ruff framed the face, comparable to the ruff on a parka. Collected by Ellis Allen from Goodnews Bay in 1912. *Burke, 4516 (14.5 cm)*

Originally this entire mask, collected by Jacobsen on the Kuskokwim in 1883, was ringed with a bentwood hoop. Empty holes show that appendages are also missing. The mouth opens to reveal a second face frozen in a toothy grin. A tapered tail runs up from the forehead, and a small bird perches on its tip. The caribou ruff was added during restoration in 1994. *MV, IVA5196 (60 cm)*

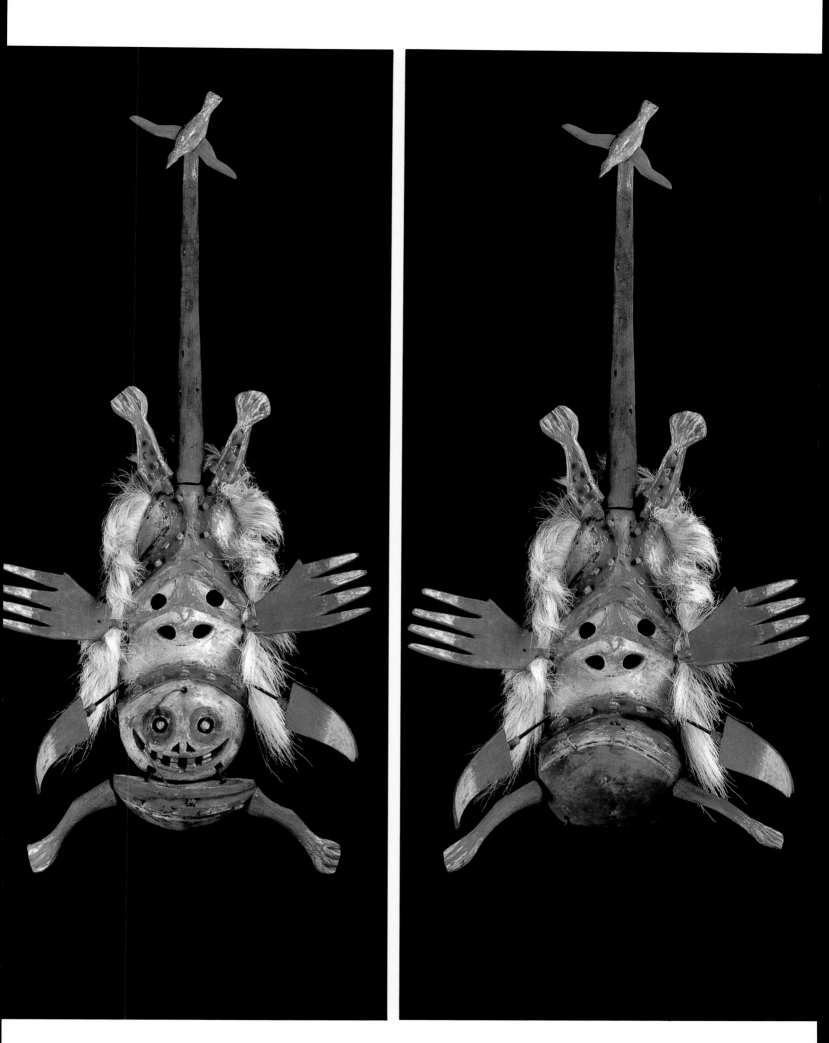

Alma Keyes (May 30, 1993) described the sensitivity of bears, which are referred to only indirectly as *ungungssiq* (quadruped), as "their ears are the ground":

It was a very important rule. My late father used to tell us not to call them by their names. . . . They say [bears] could hear you talk to them even though they were far in the distance. They would tell us not to make fun of them out there or in our homes. . . . They say they could hear your voice under the ground.

And also, they would say . . . the winter would approach and the bears would disappear. . . . They had a skylight up on top of their dens. And when [a bear] wished to take someone's food it would check out the person and check out their food. Then the person would begin looking for the food he had cached. . . . He would ask why [the food] was disappearing fast. They say the bears would just reach out and eat whatever they liked. . . .

They say they are actually human beings . . . to be respected and not criticized. A few times I've seen them at close range and I would always give them respect. . . . Evidently, the bear can reveal itself to a person if it wants to.

Not only large, powerful animals but also the apparently insignificant merit careful treatment and respect. For example, when people gather tender roots and tubers from the caches of tundra mice, they must always leave some "mousefood" in the animal's cache: "We take some, not all of it. But we offer a small compensation of a small amount of food. We just put it in and cover it over again, inside their cache, though it isn't much" (Cecelia Foxie, May 31, 1993). Justina Mike (March 1, 1994) described how swallows must be talked to if accidently injured, lest they strike back. All creatures merit careful treatment and respect, and woe to the person who ignores this prescription.

### Ircenrrat

Animal masks revealing a human face were not Yup'ik carvers' only expression of the dual nature of reality. Many a mask appears divided lengthwise, one side depicting a human male and the other an animal. In many cases, this divided countenance marks them as *ircenrrat,* also known as *ircit* on Nunivak Island. *Ircenrrat* were extraordinary persons who appeared alternately as small humans and as wolves, wolverines, foxes, or killer whales (Fienup-Riordan 1994:63–76; Lantis 1946:198–99). *Ircenrrat* are not human, although they may appear in semihuman form, with the divided face often found on masks. This dual character is revealed in tracks made of alternating human and animal footprints. Looking at photographs, Kay Hendrickson (January 5, 1994) identified a number of masks as depicting *ircit.* Each had a divided face, and color often accentuated the different features. In one case he recalled an *ircit* mask with the left side painted black and the right with red ocher. Himmelheber (1993:37) reported that *ircit*

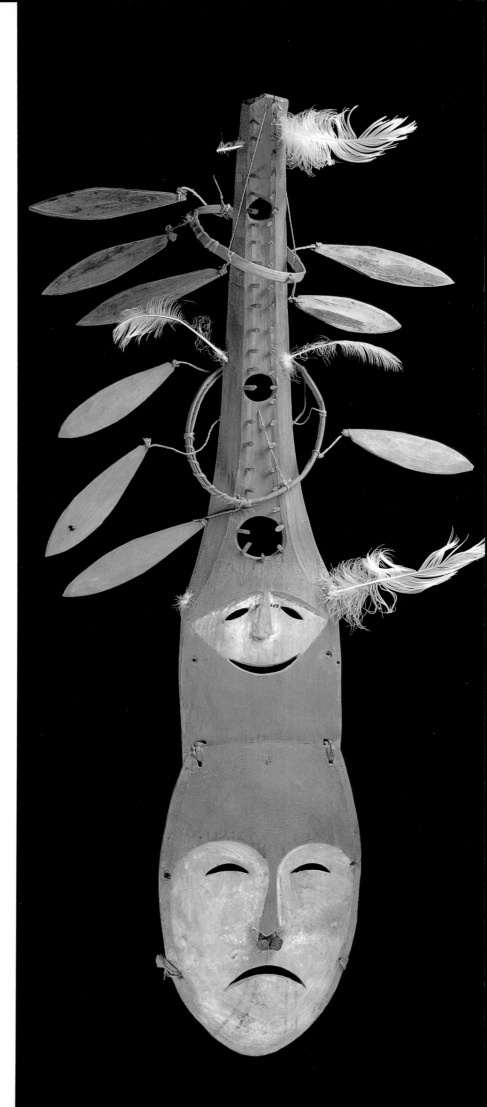

Elongated two-faced mask collected at Andreafski by Sheldon Jackson in 1893. The bottom, frowning face has the tatoos of a woman. A pegged "tail," from which hang hoops and thinly carved pieces of wood, rises into the air. Such clacking appendages added supernatural sounds to a mask's visual presentation. *SJM, IIB47 (72.7 cm)*

Seal mask collected by Sheldon Jackson, probably at Andreafski in the 1890s. Panels open to reveal eight eyes. *SJM, IIA53 (66.4 cm)*

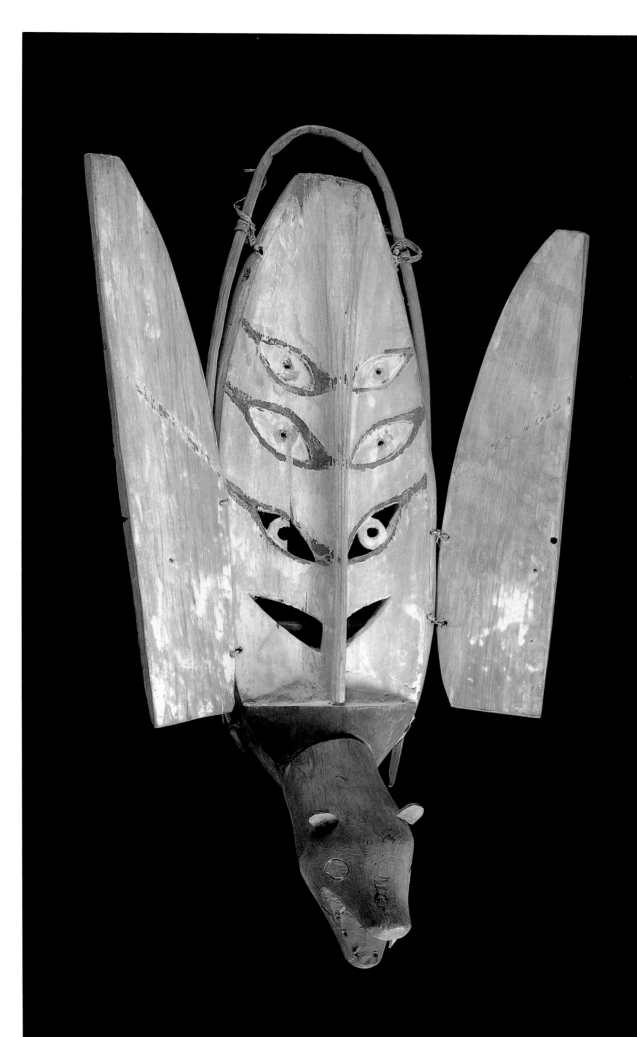

MAKING
THE UNSEEN
SEEN

73

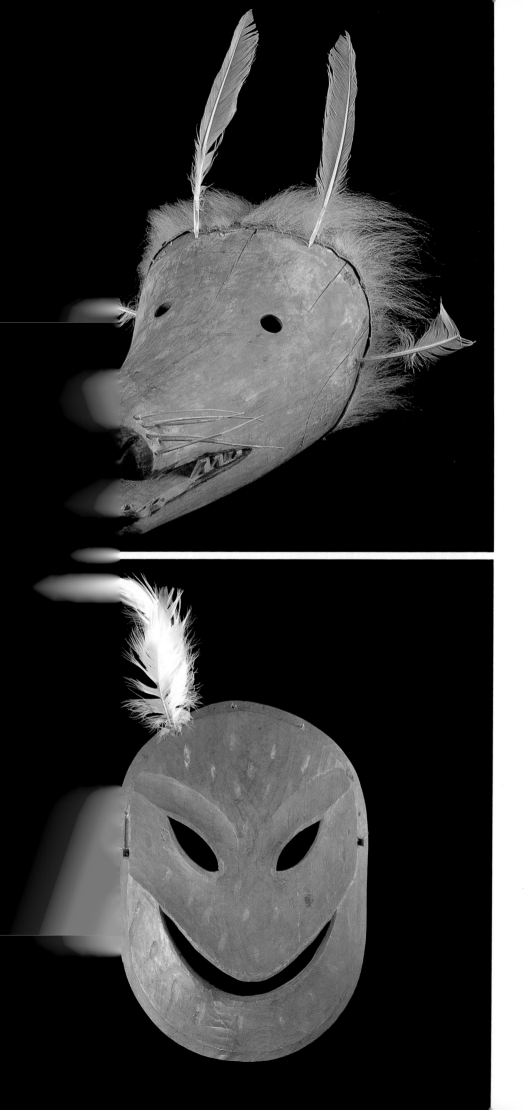

Lower Yukon polar bear mask collected by J. H. Turner, 1891. Although rare in southwestern Alaska, polar bears sometimes range as far south as Nunivak Island. It was thought that when a polar bear was after someone, it lay on its back with legs in the air and, by bending its legs inward, imitated four hunters gutting a seal—hence the saying that a person should be careful about approaching such hunters. *SI, 153639 (27.9 cm)*

Jacobsen said this Yukon "Ersinekat-Kinekut" (*ircenrrat kegginaqut,* "*ircenrrat* mask") represented "a feared mountain spirit who lives on the lower Yukon and does a lot of harm to people." The mask originally had six feathers along its upper rim. Square holes for attachment are on the sides. *MV, IVA4427 (28.2 cm)*

Unusual mask in which a face looks out from behind a half-human, half-caribou animal person. George Heye purchased this Goodnews Bay mask in 1923 and sold it to Julius Carlebach in 1944. The Metropolitan Museum of Art acquired it in 1978. *MMA, 1978.412.77 (12/926) (49 cm)*

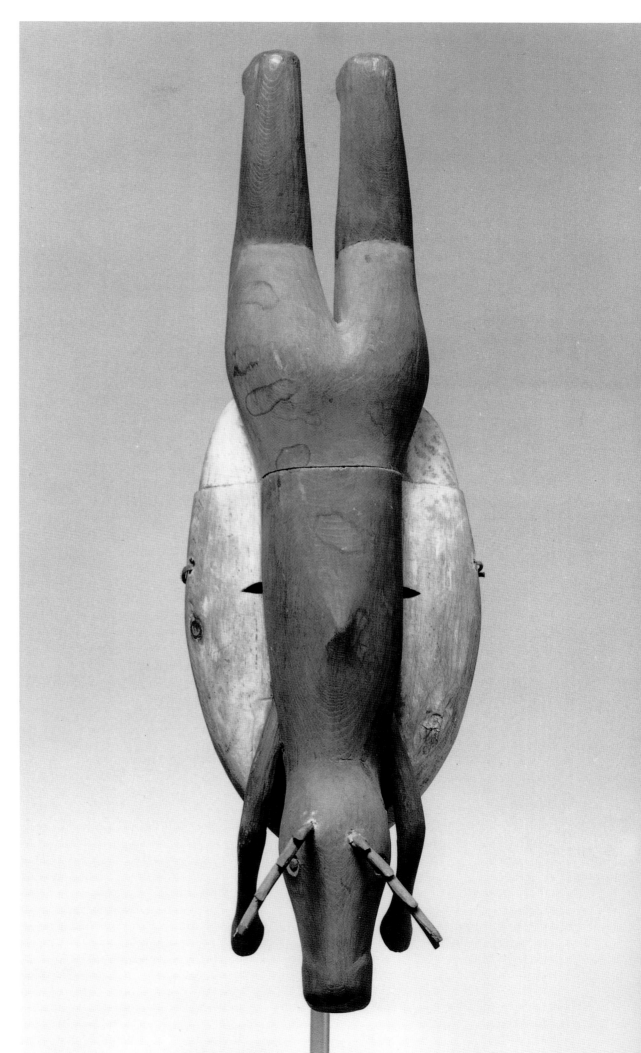

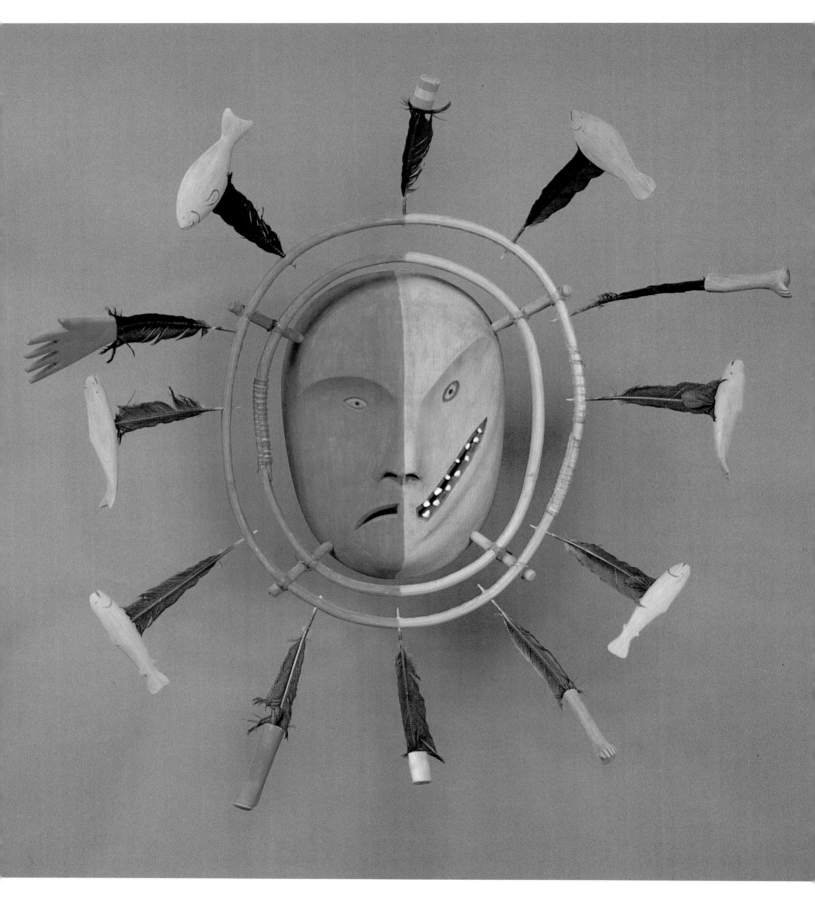

masks were sometimes made very small and then fastened on the forehead: "These small forehead-masks (Nunivak Gnachtach [*qanartar?*]) are the only art work which plays a small role at the great Feast of the Dead."

Like the smiling human faces embedded in animal masks, the divided countenance of many *ircenrrat* masks expressed the dual character of the beings represented. Appearances were often deceiving, in life as in art. Just as a human face had no single meaning on a mask, not all masks with divided countenance represented *ircenrrat*.

Human/fox mask made for a Messenger Feast, Nunivak, 1946. Many accounts depict *ircenrrat* as half human and half animal, and dance masks representing them

### *Nepcetat,* the Ones That Stick to the Face

*In all the classes of masks, the kind they called* nep-cetaq *was the most important and powerful. It ranked the highest in all the different kinds of masks. . . . Long ago when the* temainaunelnguut *[ones disembodied in some sense] used this type of mask, sometimes after five parkas were placed on the mask, he would bend over and put his head over the mask, and it would get fused to his face.*—Andy Kinzy, *St. Marys, February 28, 1993*

The *nepcetaq* (from *nepete-* "to stick, cling, or adhere"; pl., *nepcetat*) is a distinctive style of *angalkuq* mask described throughout southwestern Alaska, especially the lower Yukon. Elders distinguish *nepcetat* from *kegginaqut* (regular dance masks) and report that originally there were many kinds of *nepcetat*. All *nepcetat* were the property of *angalkut,* but not all *angalkut* had power enough to possess *nepcetat.*

Accounts of *nepcetat* are widespread. Kotlik's Willie Kamkoff (February 27, 1994) was too young to see *angalkut* using *nepcetat* in performance, but he did see such a mask:

I've seen a *nepcetaq* . . . after the owner had died there in Ngel'unguaq on the Pastuli River . . . when I was a child. . . .

When I saw the *nepcetaq* . . . and whenever I went near it to look, my grandfather would speak loudly and tell me to go away from it. The outside border of the mask was smooth and was big like this. And in the middle there was a round face. It was painted green here and white over here. And from the eyes, all the way down there were pictures of all the sea mammals. And from [the eyes] all the way up there were pictures of many land animals. And there were swan feathers here . . . They say the *nepcetat* always have swan feather quills. . . .

I saw a person who could use a *nepcetaq,* but I didn't see him perform with it. But our late son-in-law watched him. His name was Teryuuk. When he was using the *nepcetaq* his son was dancing. The mask didn't have a string or anything like that on it. Before he performed he asked for a seal-gut parka. Then he asked for a fancy squirrel parka. And he asked for two caribou-skin parkas with the skin inside. There were four of them. Since [our son-in-law] sat close to them he watched [Teryuuk's son] dance the song [Teryuuk] had taught him.

He placed the clothing on the *nepcetaq* [which lay face down on the ground]. The mask didn't have any strings. As [our son-in-law] watched he saw the mask fly up as [Teryuuk] stooped down about this high. The mask was loaded with parkas . . . no doubt, the caribou-skin ones were heavy. He wore it and moved to the rhythm. It wasn't tied to his head. When the song was over he *qasercaaqaa* [?]. He said the mask couldn't come off, for it had really sucked his face. When he pulled very hard it finally fell down. And his face left a perfect imprint on the caribou-skin parka. The mask down below the pile had really kissed him hard.

According to Yup'ik tradition, the *angalkuq*'s power source enabled the mask to stick to his face. A wooden mouthgrip inside may have helped him accomplish this feat; however, few *nepcetat* in museum collections have them. Noel Polty was one of the last to see an *angalkuq* perform with a *nepcetaq,* but the man's power was already waning and the mask did not stick to his face: "For the last time when Iggvicngaq sang the song, it did not have any effect. The mask did not stick to the face. At that moment Atall'eq used Uicimall'eq's T-shirt. . . . Because it was not his [it could not stick]. From then on that was the end of that because it could not work for them" (KYUK 1989, tape 2:2).

*Angalkut* used the *nepcetat* to influence the animals and enable people to get food, as well as to demonstrate their own power. The four or five holes in the plaque surrounding the face of the *nepcetat* signified the passages between worlds through which both land and sea animals came to inhabit the human world. Carved images perched on the holes' edges represented the animals. Noel Polty described the power contained in one of these carved images, a fish appendage attached to a *nepcetaq* from Holy Cross. According to his account, coastal people took the fish carving but before reaching the ocean realized that a snowy owl was following their progress. They then found themselves caught in an enormous fish trap placed facing the current as they continued downstream, but they were able to escape. Realizing the strength of that appendage, they brought the fish back to the rightful owner in Holy Cross, where it is today.

In his analysis of the *nepcetat* Jacobsen collected in the 1880s from Yukon communities, Hans Dietrich Disselhoff (1935) suggested that the mask's face is the "man in the moon" (controller of the animals), the backboard is the sky, and the holes starholes through which the animals move to earth below. Disselhoff cites Nelson's (1899:494) account of the origin of the Doll Festival, in which the *angalkuq* finds wooden images of various animals lying beside each of the skyland's inhabitants. The "maleness" of most *nepcetat* is reinforced by their wide, toothy grins and, sometimes, men's labrets. The Jacobsen collection also contains two small backboard masks called "Marsakoak" (*macaruaq,* "pretend sun"). Neither has appended animals or feathers, and each face is frowning. In fact, in Yup'ik oral tradition, the sun is a transformed woman pursued by the moon, her errant brother.

Johnny Thompson (February 27, 1994) of St. Marys told about a shaman who smeared feces across the face of a *nepcetaq* and was subsequently confronted by two bears, the *tuunrat* of the *angalkuq* whose *nepcetaq* he had desecrated. Although the bears attacked him, he later claimed them as his own *tuunrat.* The bears entered him when the *angalkuq* sang the *apalluq* of his power song, and he growled and began wrestling with himself like an animal. In this way he robbed his rival of his power and claimed the bears as his personal helpers.

When an *angalkuq* performed using a *nepcetaq,* he

often have human features running down one side and animal features down the other. Curtis (1930:38) wrote that on Nunivak ordinary people's masks were painted red and those of an *angalkuq* or spirit blue. Here the red half depicts a human and the blue half a fox. *Burke, 2-2128 (31.75 cm)*

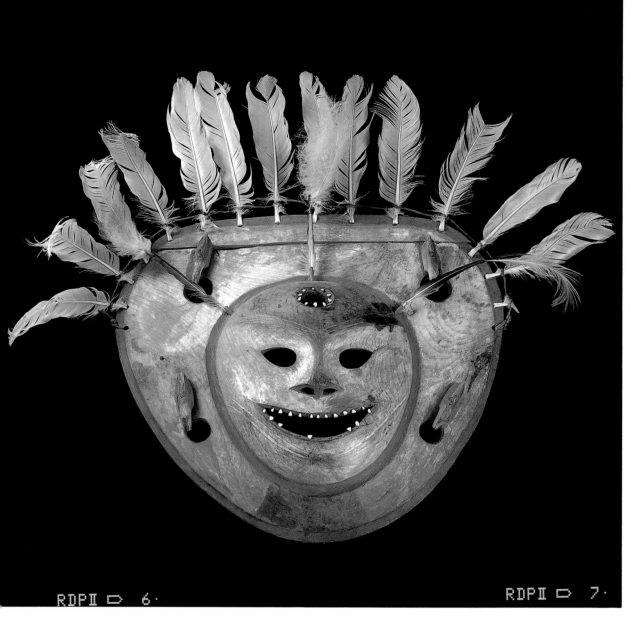

RDPI ▭ 6·

RDPI ▭ 7·

*Nepcetaq* mask collected at Andreafski by Sheldon Jackson in 1893. The plaque backboard typical of *nepcetat* represents variously the universe, water, air, and land, and the holes in the mask's surface represent the passages (sky-holes or ice holes) through which the animals move in their journey toward the human hunter. The mask's two-part construction is typical of *nepcetat* and may have had a special meaning. *SJM, IIB8 (61 cm high)*

One of a dozen *nepcetat* collected in southwestern Alaska by Jacobsen. He said *angalkut* used this mask for hunting in spring and that the outstretched feet and arms signified the power of *angalkut,* supported by *tuunrat* throughout the world. Above the forehead sits a *tuunraq* identified through special "totems," caribou (land animal) and white whale (sea mammal): "This means that the time is coming when game will soon come back, through the power of the shamans." Note the unusual five-fingered hands. *MV, IVA4422 (70 cm)*

was the main attraction and few, if any, dancers accompanied him. The drum beat fast during the performance. People viewed the *angalkuq*'s ability to lift the mask as evidence of his power. Only "true *angalkut,*" the "real ones," could make the *nepcetat* stick to their faces without aid (Paul John, April 15, 1994).

Wooden plaque masks were not the only objects used in this way. Accounts describe *angalkut* lifting a rock or other heavy object and holding it to their face (Himmelheber 1993:38). Johnny Thompson (February 27, 1994) told of an *angalkuq* using a kayak as a *nepcetaq.* Mary Mike (February 25, 1994) knew the same story: "And also, they say . . . that once he used a kayak as a *nepcetaq,* placing the mask on the kayak hole. I bet it was heavy. However, with his power source it probably was weightless for him. They say he would move his head from one side to the other making animal sounds. They've said the person they called Teggalquq was a powerful *angalkuq.*"

*Nepcetat,* like other *angalkuq* masks, were apparently carved following an *angalkuq*'s instructions. Willie Beans and Wassilie Evan made this clear when they discussed the *nepcetat* they saw during their 1989 visit to the Sheldon Jackson Museum: "If this is indeed [the *angalkuq*] Angulvak's [*nepcetaq*], these

were carved as he instructed and placed as he wanted. . . . When he wanted a tooth on it the carver placed a tooth. . . . If this is [the *angalkuq*] Irurpak's, it was made like that. But Angulvak had his own [self-]designed masks. . . . They each had their own" (KYUK 1989, tape 1:1–2).

A *nepcetaq* could also be used to predict the future. When parkas were put on the *nepcetaq,* if the owner of a parka was going to die soon, the mask would not stick to the *angalkuq*'s face. This may account for the variable number of parkas elders recall in their accounts of performances in which shamans used *nepcetat.* Although most describe five parkas, others mention three or four. According to Jasper Louis (February 25, 1994),

After the mask had come up [to his face] they would ask someone to place something on it. Then they would spread out a parka over it. . . . If the owner of the parka wasn't going to live for very long, it would not come up. . . . And if they placed a parka of a person who wasn't going to die soon, it would come up. Then he would ask for more. One more parka would be placed on top of the other. They probably weren't light in weight, being parkas. Again, as he lowered his head his mask would begin to rise. Perhaps the ones that

always get stuck on the face were called *mak'niituut* ["ones that could rise up," from *makete-*, "to rise, get up"].

You knew that those placed on it down there were obviously heavy for the *angalkuq*.

They couldn't add more than three. When they got stuck they would do this and make them go down. Using their hands like this [*pushing down and away from the face*].[7]

If that didn't work, they would use both hands like this outside the parka. . . . I saw them. But the people who owned those kinds [of masks] have been gone a long time now.

Alma Keyes (May 30, 1993) observed an *angalkuq* using a *nepcetaq* to foretell the future. The *angalkuq*

wearing the mask engaged in an unintelligible conversation with *apqarat* ("ones making brief utterances," from *aper-*, "to say, to pronounce," plus -*qar*, "briefly"; pl., *apqarat*). Only the *angalkuq* could understand and interpret the *apqarat* while he was using the *nepcetaq* as his power source:

They closed off the doorway. . . . The *qasgiq* had a skylight up on top. The firepit was covered up also, right after they had a firebath. It was warm inside the *qasgiq*. He got a seal-gut rain parka from one of the people there and put it on. He didn't even use his own, for he wasn't a rich person. . . .

He put on an *avangcaq*. . . . When he got up and pushed, it couldn't come off. They called those pieces

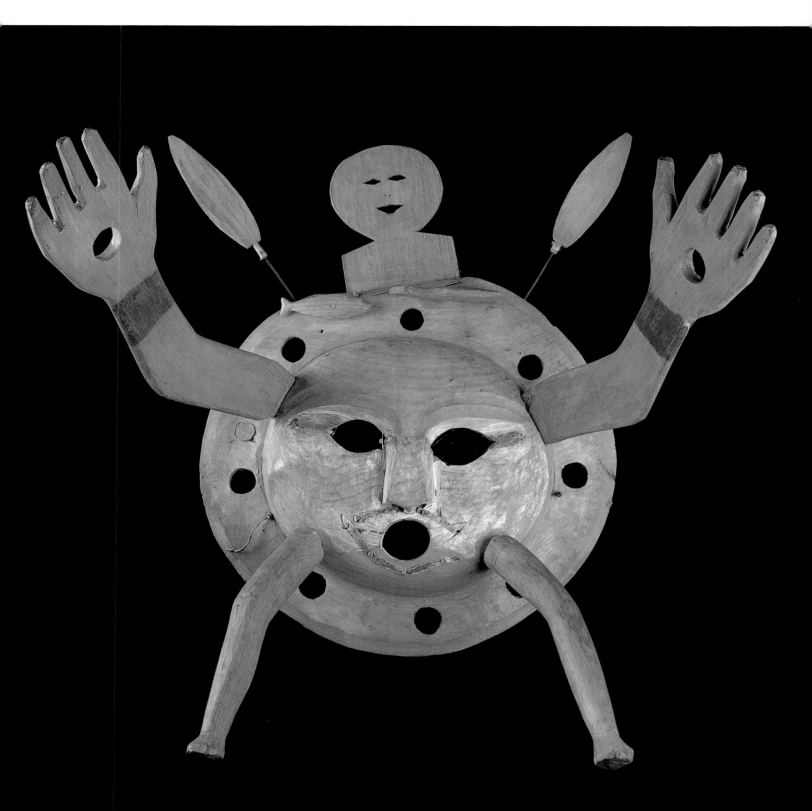

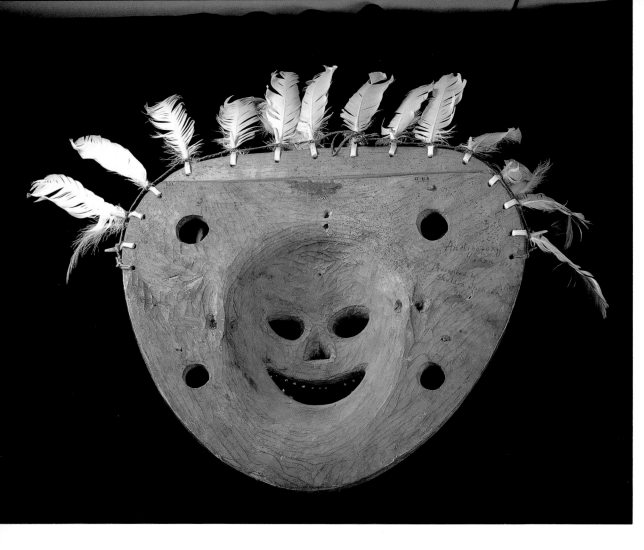

Back view of a *nepcetaq* collected by Sheldon Jackson at Andreafski. The *angalkuq* may have held the mask up to his face by cords tied through the double holes on each side of the face. Many *nepcetat,* however, show no obvious means of support. *SJM, IIB8 (32.7 cm)*

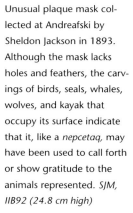

Unusual plaque mask collected at Andreafski by Sheldon Jackson in 1893. Although the mask lacks holes and feathers, the carvings of birds, seals, whales, wolves, and kayak that occupy its surface indicate that it, like a *nepcetaq,* may have been used to call forth or show gratitude to the animals represented. *SJM, IIB92 (24.8 cm high)*

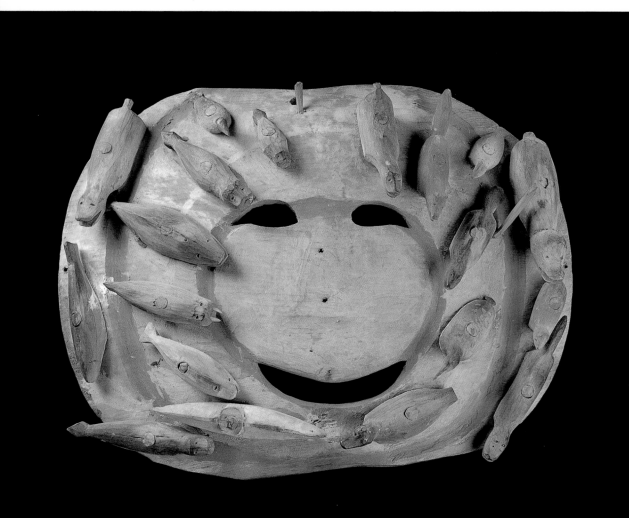

Jacobsen designated this massive *angalkuq* mask from the lower Kuskokwim and Cape Avinoff "Pogtettnoak, one travelling with a big boat" (*pugtatnguaq,* "thing you can float on") and said that an *angalkuq* had used it to show his power and wealth. The central face represented the *angalkuq's* "main spirit," while its outstretched arms showed his power, as in the mask illustrated on p. 78. Included are the bow and stern of a kayak. The lamp post beside the stern may signify people hosting a feast. *MV, IVA5145 (84 cm)*

*nepcetat.* . . . And when he somehow removed it he was very hot and sweaty. . . .

When he started making strange noises it seemed like something began to emerge from down under the house. They say it was asking him questions, but we couldn't understand it. That was why I got so frightened. When it asked him a question he would answer . . . and he would be the only one to understand its responses.

Those of us without masks couldn't understand it. He would talk to it. When it asked a question he would answer back. They called the ones with the muffled voice *apqarat* when they began making noise under the *qasgiq.*

Unlike most masks, which were routinely discarded or destroyed after use, the *angalkuq* kept the *nepcetaq* after the performance and used it again and again. According to Willie Kamkoff (February 27, 1994), "They used only new masks. And though they were repeating the song for it, they wouldn't use the masks from the year before. . . . However, the owner never changed the *nepcetat* . . . because they owned them through their *tuunraq.*" Kamkoff recalled the fate of one *nepcetaq* after its owner's death:

Their *nepcetat* were very sacred to them. My grandfather used to tell me not to bother the one that was there. But I saw that particular *nepcetaq* [when I was young]. . . . In our summer camp long ago, when I was a boy, we heard there was a doctor collecting bones. When we went back up I looked for it, but I think that person had taken it. It was gone. . . . It was on the food cache in Ngel'unguaq. . . .

I haven't seen it. I know it very well, and if I see a picture of it I will recognize it. I walked up to it and looked at it many times. If I had taken it, it probably would be with me now. [*Laughter*]

Although *nepcetat* were normally massive, Jacobsen collected several tiny ones, one measuring only 8.5 centimeters across. Whether these miniature masks had the same function as their larger relatives is difficult to say. Jacobsen described them as "imitation" *angalkuq* masks made for children to play with. These small masks lacked holes for thongs to attach them to the face.

How widely were *nepcetat* used? Erna Gunther (1976:123) wrote that the Andreafski "backboard masks" at the Sheldon Jackson Museum were a type of mask not found elsewhere. Although the majority of *nepcetat* come from the lower Yukon, collectors acquired them from all over southwestern Alaska. Jacobsen collected half-a-dozen, some from the lower Yukon and several from the Kuskokwim. Himmelheber (1993:38) reported hearing about "a trick in which a mask was used" and subsequently seeing a mask for such use on a house roof in Napaskiak, near Bethel. He bought the mask, and it is now in Switzerland's Basel Ethnographic Museum. Both a Bethel shaman and Himmelheber's informant, Charles, told him the story of laying the mask down, placing five parkas over it, and the mask then sticking to the *angalkuq*'s face. Ray (1967:20, 179) heard the same story in St. Michael, where the *angalkuq* used the mask for "weather medicine." Dick Andrew had heard about *nepcetat* but had never seen one used.

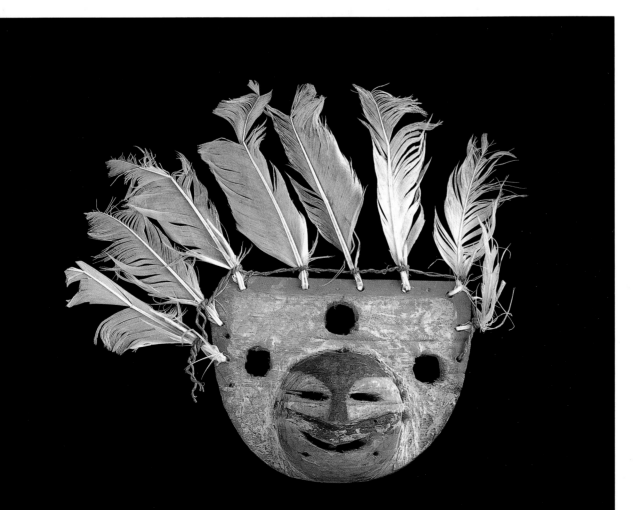

Jacobsen collected small as well as large *nepcetat,* such as this miniature lower Yukon mask representing a seagull. He labeled it "a true imitation of the so-called shaman masks of this area" and said that it was for children, as it had no holes for facial attachment. He recorded the name "Mekjeltingarorok" ("pretend child" from *mikelnguq,* "child") for another small *nepcetaq* (IVA5159, 17 cm high). *MV, IVA4466 (7 cm high)*

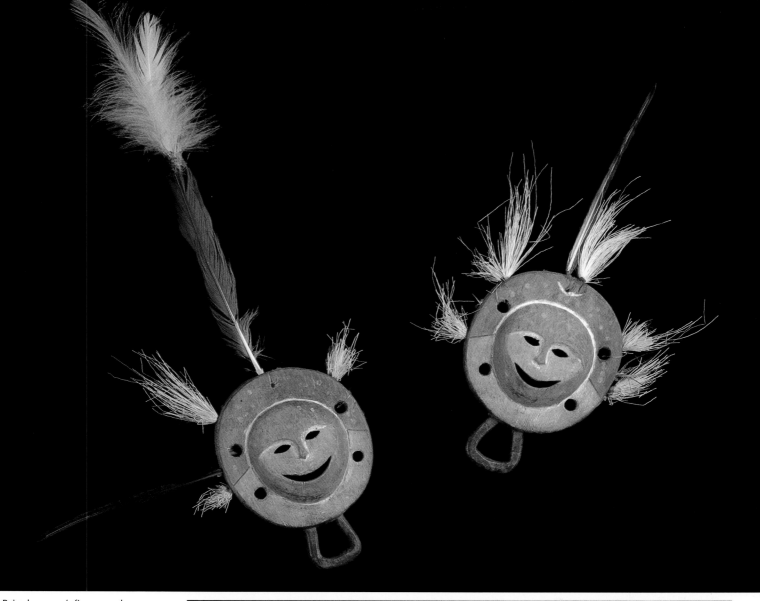

Paired women's finger masks collected by Jacobsen on the lower Yukon, miniatures of the larger *nepcetat* used by men during dances. According to Jacobsen, they "show spirit faces similar to the masks, probably the king of the salmon." *MV, IVA4372 (12.5 cm)*

*Nepcetaq* collected by I. G. Voznesenskii in the 1840s. *MAE, 571–13*

MAKING
THE UNSEEN
SEEN

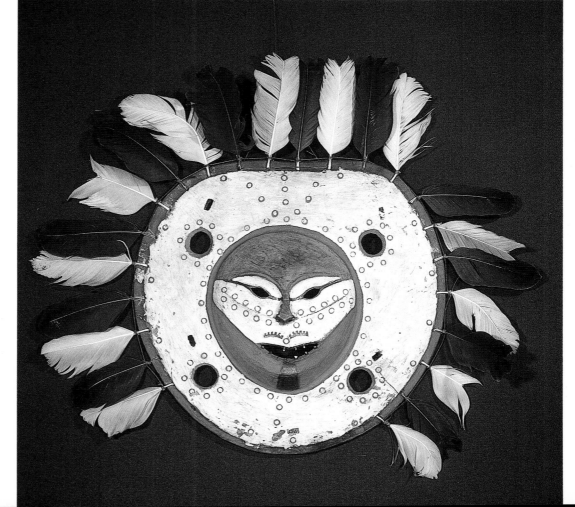

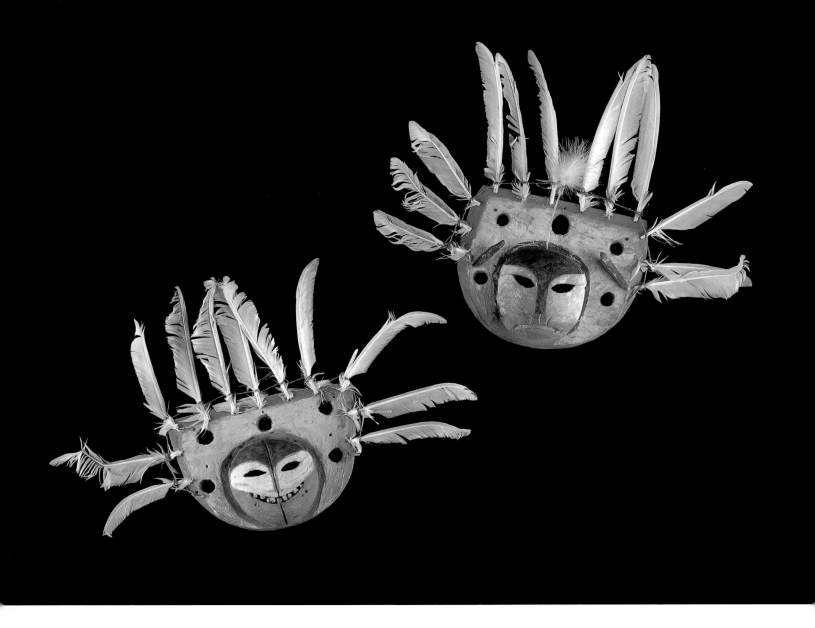

That knowledge—if not use—of *nepcetat* may have spread beyond southwestern Alaska is hinted at by the extraordinary *nepcetaq* collected by I. G. Voznesenskii. The huge *nepcetaq* is given a lower Yukon provenance; however, it is painted in a style identical to that of the dozen Alutiiq masks Voznesenskii collected following the "six-act mystery" he witnessed on Kodiak Island (Liapunova 1994). The mask's backboard is dotted with small painted circles identical in color and style to those on the Kodiak pieces and very different from the fingerprint spots found on Yukon and Kuskokwim masks. A Kodiak artist may have repainted a Yukon mask that Voznesenskii obtained elsewhere. Or, perhaps, the mask represents a Kodiak version of the *nepcetat* found all along Alaska's west coast from St. Michael to the Alaska Peninsula.

## Healing Masks

Masks were used not only in performances involving shamanic visions; *angalkut* also sometimes used them in acts of healing. Although elders often metaphorically compared the masked dances of the past to present prayer, they rarely compared their traditional *angalkut* to contemporary ministers or priests. Instead, the *angalkuq* was commonly compared to

the modern physician. According to Dick Andrew (August 16, 1992), *angalkut* were men and women with special songs: "They were like doctors. [The *angalkut*] would put their hands on a painful spot and would tell [the person] to touch it, then they would touch it. They would put their hands right on the skin of a person. And the spot where they had placed their hand would become well. That was the way our old ones operated."

*Angalkut* usually performed their acts of healing in the *qasgiq*, using a number of different techniques. During healing sessions grass mats covered the entrance and skylight, and the *angalkuq* wore a gut parka with the hood raised over the head. Devoid of the light required for normal vision, the *angalkuq* employed supernatural sight to determine the location and character of the patient's complaint. The *angalkuq* sometimes used a mask for this purpose:

It was put on, using it as a mask. Then [the *angalkuq*] would pretend to be examining this person. . . . And [the *angalkuq*] would be able to see that person's ailment. Or if that person did something, or had been mischievous, or had intercourse with a lady, [the *angalkuq*] would be able to see it with that device. . . .

These two small *nepcetat* from the Kuskokwim may have been children's masks or may have been given by an *angalkuq* to a patient. Jacobsen wrote that the larger mask depicts a seal, while the smaller has a distinctive split face with a toothy grin. On the back both have feathers bent over, ends connected by string. *MV, IVA5152 (9.4 cm high) and IVA5158 (12.5 cm)*

Two Kuskokwim masks Twitchell said represented the faces of spirits that help *angalkut* heal the sick. The larger mask's lower jaw and ear ornaments are attached with cotton string, and its countenance is divided lengthwise, light and dark. It has neither mouthgrip nor side holes, but does have a hole at the top to hang it. *NMAI, 9/3419 (41.9 cm) and 9/3420 (27.3 cm)*

When they became old, worn out, they made replacements of their likeness . . . that were identical, out of wood again. . . .

They said that back then no one tried any of the *angalkuq*'s weapons. They were afraid of them because belief makes all things come true. If a person believes that an *angalkuq* has helped him, [that person] will be helped through his belief. (Joshua Phillip, Tuluksak, July 1, 1988)

Sometimes an *angalkuq* might give a mask to a patient as an *iinruq* (amulet). A woman in Kongiganak told how her mother owned such an *iinruq* mask with both a man's and woman's face carved on it.

Margaret Lantis (1946:203) noted that Nunivak *angalkut* wore masks and called upon their spirit helpers to give them power to deal with sickness, and Jasper Louis (February 25, 1994) said his ancestors used masks to heal the sick. Paul John (April 15, 1994) described a healer's use of a fox mask on Nelson Island.

The people they called *yuunginaunrilnguut*, those who had dual lives—when they worked on something they would become that other person. They weren't normal people. And when they doctored people they would take something out from the inside of that person while s/he was looking. Since they were some other being, they immediately devoured [the person's] ailments as soon as they took them out. They would say that things they took out were very slippery when they ate them.

One of our village members told a story. He saw someone put a fox mask on when he was about to open up a patient while people there were watching. He was using an ivory storyknife [a knife used for illustrating stories in mud or snow]. He said that while he was looking the storyknife didn't touch the patient, but there was a cut in his abdomen. When the incision was big enough the man wearing the fox mask stooped down and cut and began chewing. He ate what had been hurting the patient. And when he was done eating he licked the cut from one end to the other. When he stood up the incision was all healed. The man's mouth was bloody. And the person they had carried in stood up and went home. He was done right away instead of waiting for days.

Many describe an *angalkuq*—with or without a mask—"devouring" illness with the help of a *tuunraq*. In 1841 Zagoskin (Michael 1967:226) observed a cur-

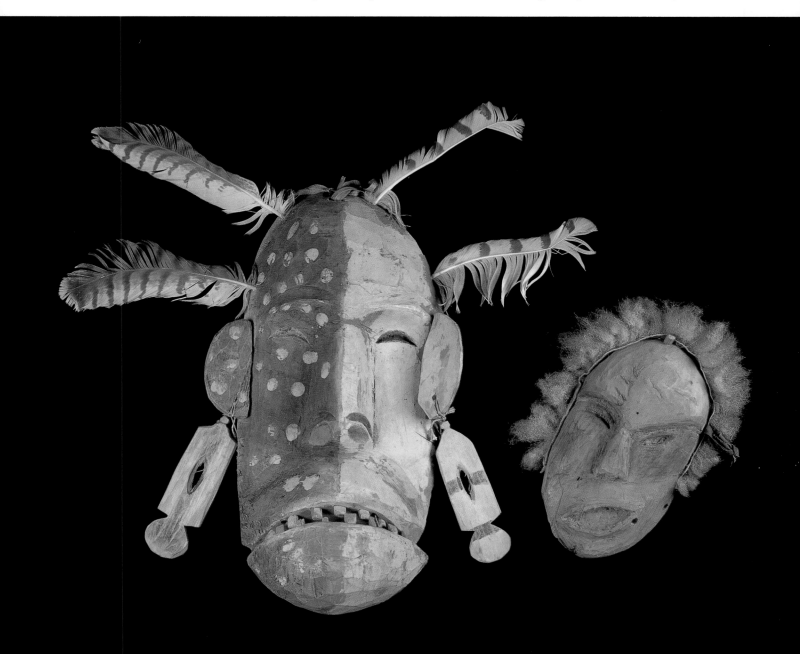

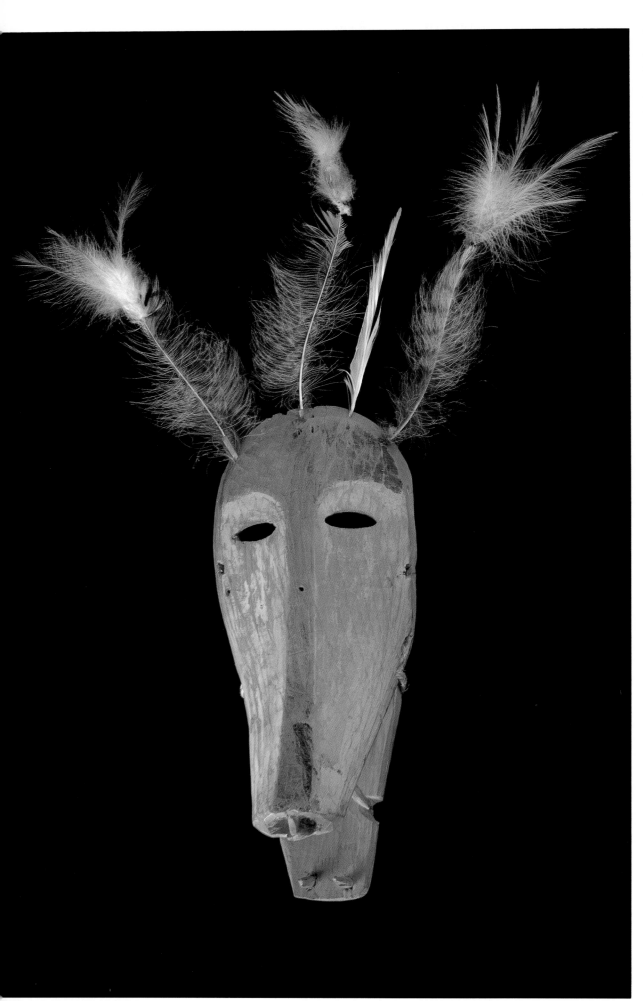

Wolf mask with moveable jaw collected by Sheldon Jackson at Andreafski in 1893. The mask is topped with three down-tipped feathers; one of two additional feathers between them remains. *SJM, IIB7 (32 cm high)*

Jacobsen described this lower Yukon piece as a "dance mask showing the spirit of a fox. On top of his head the spirit shows his face which has, like all spirits, a human likeness or can show itself as a human." Red fox masks were collected from the same area by both H. M. W. Edmonds (Ray 1967:188) and Ernest Hawkes (1913), and Dorothy Jean Ray (1967:189) was told the origin of the red fox dance, which was performed at the Messenger Feast from Seward Peninsula to the northern mouth of the Yukon. *MV, IVA4447 (21 cm)*

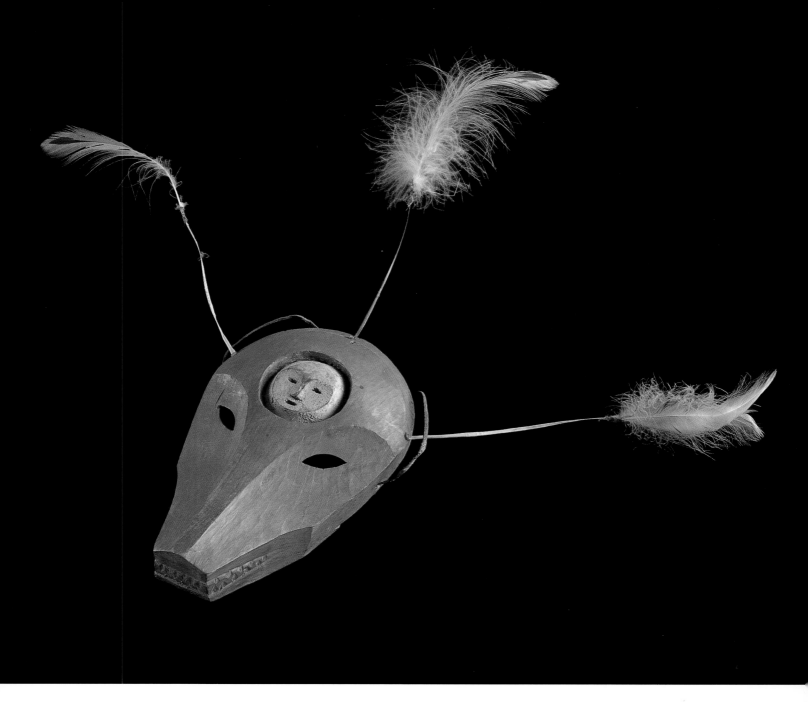

ing session in which the *angalkuq*, "howling like a wolf and attacking the sick man as though she were biting his back," devoured her patient's disease. One hundred fifty years later, Willie Kamkoff (February 27, 1994) described a similar incident in which a wolf entered an *angalkuq* as his helping spirit: "They say back in those days many had the wolf as their *tuunraq*. They also talked about a person named Nakacuk who used to operate on people before the doctors came. They say when he removed what was making the person ill he never threw it away. When his *tuunraq* the wolf entered him he would . . . eat what he had removed, with blood dripping down his mouth. . . . He personally didn't eat the part, but his *tuunraq* the wolf would eat it."

### Women's Masks

Men most often wore masks, both during Agayuyaraq and in healing ceremonies. Himmelheber (1993:31) wrote that only men could use masks along the Kuskokwim, and Ray (1967:73–74) agreed: "Women, except in certain secular dances, did not wear masks, and under no circumstances could they represent a spirit or interpret a male shaman's dream in a mask. Even a female shaman's experiences were interpreted by a male carver."

Although references to women wearing masks are few and scattered, they do occur, both in the literature and in contemporary accounts. Zagoskin (Michael 1967:227) described women giving an "evening party," dressed in men's clothes and wearing masks. In a recent account Johnny Thompson (February 27, 1994) stated that although lower Yukon women did not normally wear masks, they might occasionally use them in a teasing context "pretending to be men":

Within the village when the opposite sexes challenged each other, I saw women dressed as men and actually dancing with masks. . . . Their men would invite them to it. They did funny things up there. When they fin-

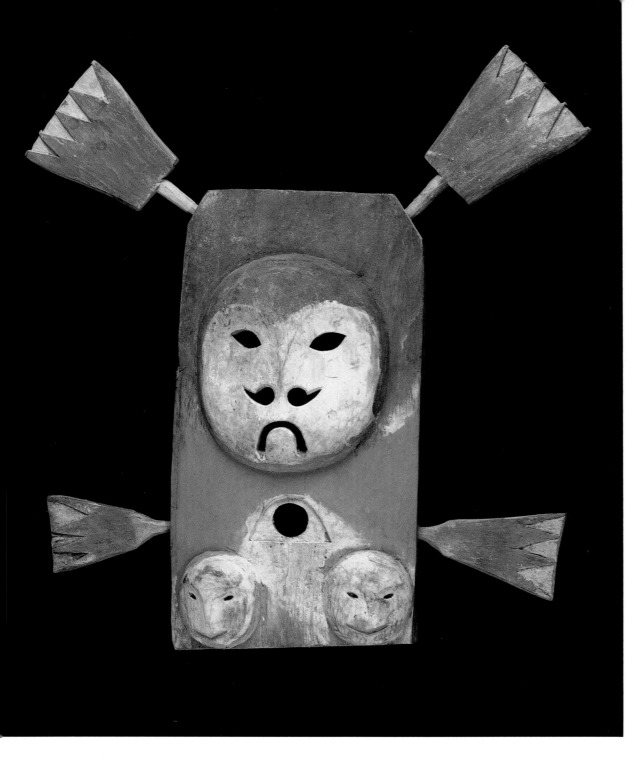

Seal-faced mask without rings. Mary Mike (March 1, 1994) commented on the seal's downturned mouth: "Masks of bearded seals, spotted seals, and hair seals—[masks] that have mouths like this seem to be those kinds of ocean animals [*imarmiutaat*]." This seal mask lacks a mouthgrip or side holes. A small hole on the mask's reverse side directly below the face may have been made by a nail or other sharp object held in the performer's teeth. Paul John recalled a Kuskokwim story about the presentation of a seal mask:

*When the woman's turn came she revealed a bearded seal mask. She was a woman. She said, since she was so thankful for the seafood she had received from the coastal people each time they came, she asked a carver to make a seal mask for her. She was grateful for their gifts and was presenting the mask so their good fortune would continue when they went out hunting.*

*She told them she was ready to make the mask call out. . . . As soon as the woman put on the mask she exited through the floor opening and disappeared down into the qasgiq's underground entrance and began to cry out. She cried out exactly like a bearded seal.*

*After the presentation the men said she sounded so much like a seal that they felt their foreheads open up and pull back from the experience. Some of them said that was how they felt, because she sounded so much like a bearded seal. When people talked about her they believed she was truly representing the animal.*

*Burke, 1.2E644 (16.1 cm)*

ished the main events with other villages they would continue to do activities in the village for recreation. Men and women would be partners.

They pretended to be men. They would wear men's clothing and dance with other women. They would respond to the [men's] actions. . . . They would have fun with their teasing cousins.

Teasing and comic events were not the only contexts in which women wore masks. Jasper Louis (February 25, 1994) recalled women wearing masks on the lower Yukon: "A woman would put on a mask used by her ancestors." Paul John (February 22, 1994) gave a detailed account of a female *angalkuq* who asked a man to make her a bearded-seal mask for a summer dance at Kwethluk attended by coastal people who had come to the Kuskokwim for fish camp. The woman presented the mask to the assembled guests,

saying that she had it made to express her gratitude to the coastal people for their gifts and to wish that they "would hunt in the ocean without lacking for something." Then she put on the mask and went down into the underground entrance, where she made the sound of a bearded seal underwater: "When she made that sound the coastal people felt as if their heads split open because she sounded so much like a bearded seal. They say she was a real one because she made the exact sound that a bearded seal made even though she was a woman and she had not gone to the ocean before and she had not heard a seal making a sound before." Paul John emphasized the exceptional character of the woman's performance. It was unusual for a woman to perform with a mask, and it was particularly impressive that she became a bearded seal.[8]

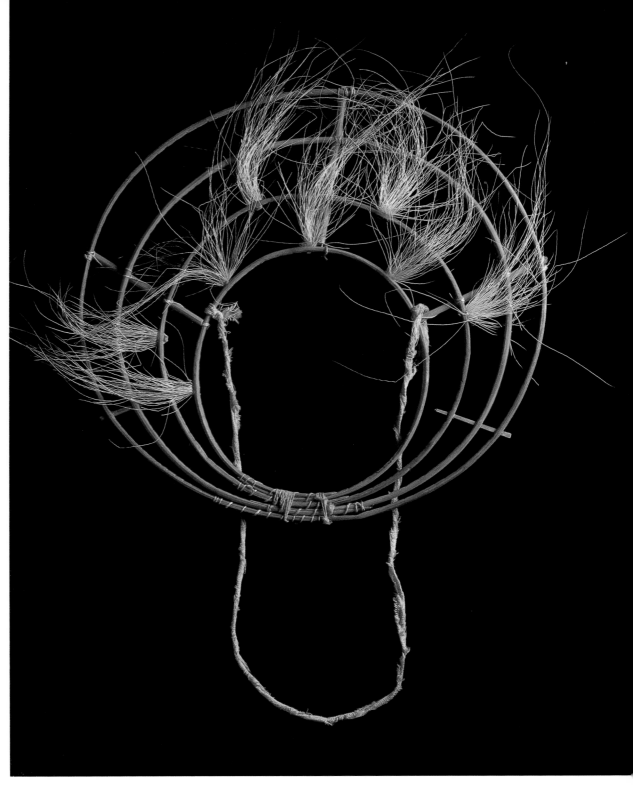

Woman's mask collected by A. H. Twitchell from the Kuskokwim, early 1900s. In Yup'ik each hoop is designated *ellanguaq* (pretend universe); the hoops are painted alternately red and blue. *NMAI, 9/3437 (66 cm)*

8. A powerful female *angalkuq* possessing hunting knowledge contrasts dramatically with the male *angalkuq*, who was typically a mediocre hunter.

Both the National Museum of the American Indian and the Smithsonian Institution contain a handful of objects that accession records specifically identify as "women's masks." Each consists of two to four concentric bentwood hoops decorated with tufts of caribou hair. Comparable hoops (*ellanquat*, lit. "pretend universes") surround animal and human faces in many masks worn throughout southwestern Alaska. These women's masks, however, feature the hoops without the central carved face. Instead, the dancer's face would appear rimmed by the wooden hoops.

J. W. Johnson collected a woman's mask with two small accompanying dance fans from Fort Alexander at Bristol Bay and sent them to the Smithsonian in 1886. The hooped mask was accompanied by a packet of whalebone and feather quills that originally decorated the concentric rings. Heye acquired three such masks for his museum, described in accession records as "women's dancing headgear." One is in the Twitchell collection, and the other two were purchased by G. B. Gordon in Bethel and subsequently acquired by Heye in an exchange with Philadelphia's Free Museum. Gordon met Twitchell in Bethel in 1907 and subsequently bought masks from him, so it is possible that Twitchell collected all three masks, perhaps from the same dance.

The use of such masks may have been ancient; or

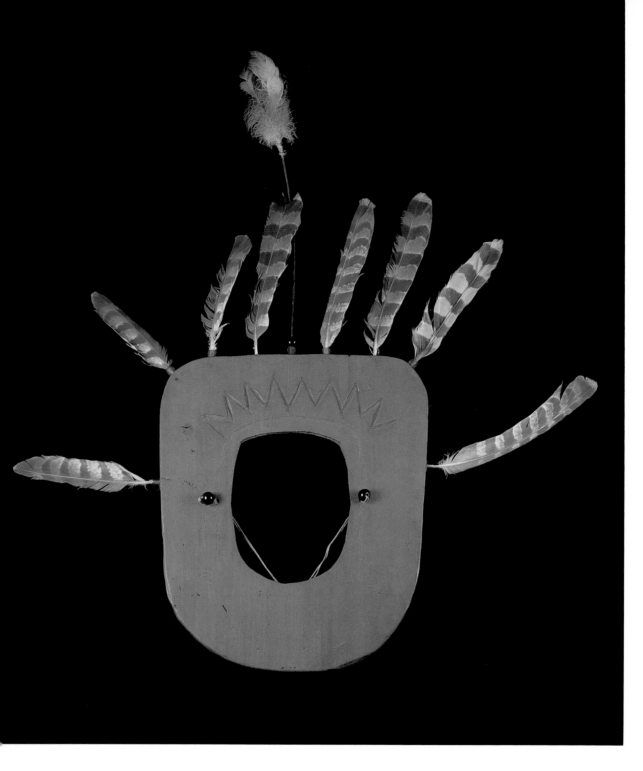

Paired women's masks collected by William Fisher at Ugashak in 1882. Note the bead ornaments opposite the ears and the red-painted "crown" that would have appeared over the woman's forehead. *SI, 72506 (78.7 cm) and 72507 (83. 8 cm)*

they may have originated in the 1800s after the introduction of Christianity, inspired by halos painted on icons and in the Bible pictures missionaries used to explain Christianity. Within Christianity the halo is a vivid symbol of spiritual possession and supernatural power, and Yup'ik performers, recognizing that power, may have made the halo their own by incorporating it into their dances. They may even have made these rare masks specifically to represent and incorporate Christian elements.

The halolike women's masks may also be related to the widespread, and possibly ancient, tradition of faceless, framelike masks found to the south among Alutiiq and Koniag people. In 1840 Voznesenskii collected four "hunters' masks" on Kodiak Island (Liapunova 1994). These elaborate, open-work construc-

tions surround the performer's face without directly covering it. Although bent and tangled, they have more in common with the relatively simple women's masks than with the carved wooden constructions covering the dancers' faces.

More recent, but equally intriguing, is the pair of flat board masks painted with commercial blue paint that William Fisher collected at Ugashak on the Alaska Peninsula in 1882. Fisher labeled them "China-chut" (probably *kegginaqut*) and said they were "worn by women at dances." Like the Kuskokwim women's masks, these frame the face rather than cover it.

Before he left Alaska in 1883, Jacobsen (1977:198) dug briefly at Soonroodna on the south shore of Kachemak Bay. At a nearby cave burial site he found

Women posing with masks at Akulurak Mission, early 1900s. The woman in the center—perhaps a nun, judging by her long dress—wears a large *nepcetaq,* while two girls hold concentric hoops similar to Kuskokwim women's masks. *Jesuit Archives, GU*

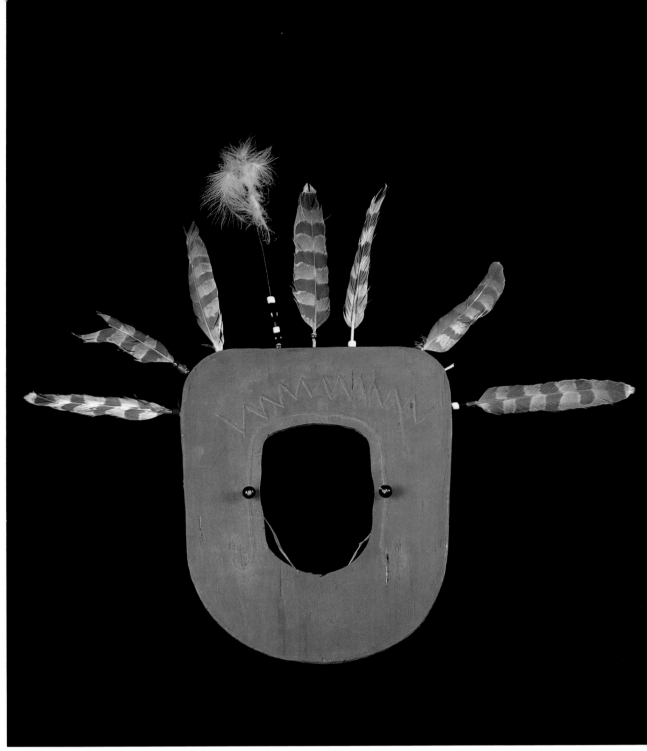
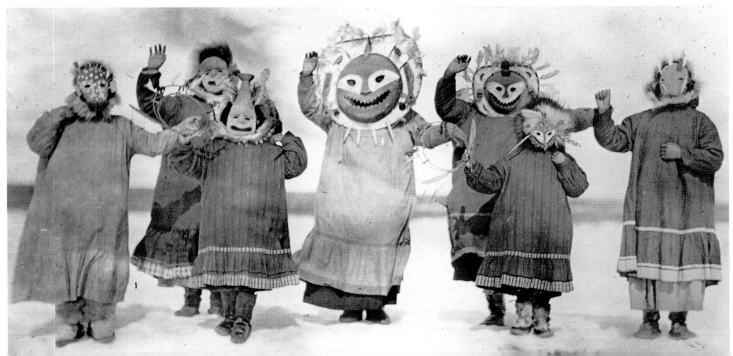

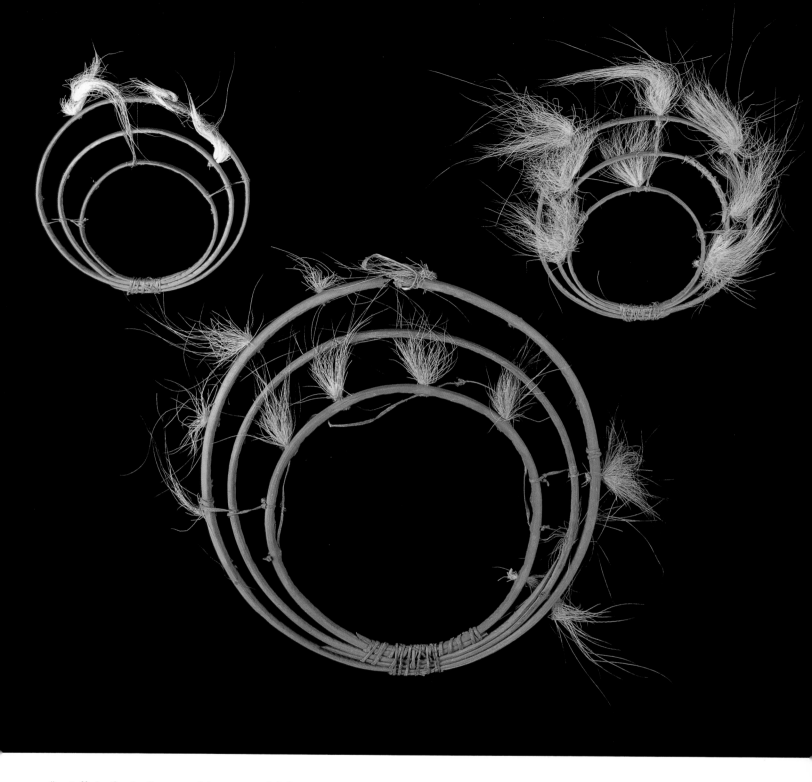

"a staff similar to those used in ceremonial dancing and also a figure of a woman and a square piece of wood with a hole in the center. Its use could not be determined." Although he tells little about them, Birket-Smith (1953:109) also maintained that Chugach Eskimo women wore masks. And Jacobsen collected a "woman's mask" from among the Ahtna of the Alaska Interior.

Until now, the literature has completely ignored these unusual pieces—masks that raise more questions than they answer. Their use may have been restricted to the Kuskokwim and Bristol Bay regions, where all of the Yup'ik women's masks located in museums originated. However, a photograph taken in the early 1900s at the Catholic mission of Akulurak on the lower Yukon shows seven women danc-

ing with masks, two of whom are holding dance ornaments smaller than, though similar in shape to, the women's masks collected along the Kuskokwim.

Contemporary elders gave no explanation of women's masks and how they might have been used. Perhaps men wore them after all, pretending to be women, just as women occasionally wore masks "pretending to be men." We may never know. We do know that it would be rash to say that Yup'ik women never wore masks.

### Teasing and Comic Masks

Yup'ik performers also used masks "just for dancing," to tease and make fun of their friends and neighbors, especially a "teasing cousin" from their own community or a distant cousin visiting from afar. Although

Woman's mask and accompanying dance fans collected by J. W. Johnson at Bristol Bay in 1886. A dozen baleen and feather plumes originally decorated the mask's concentric rings, painted alternately red, blue, and red like the woman's mask Twitchell collected. *SI, 127669 (outer hoop 30.5 cm diameter) and 127676 (quills 38 cm high)*

Comic mask made and worn by Cyril Chanar to tease his male cross-cousin. The chin is movable, wired through a hook in the upper lip. Paul John recalled, "They would try to entertain each other back when I first started observing them, and cousins would tease each other when they *tangertaingnaq-luku* [try to make them look away from the other]. They used the masks at that time. He would try to outdo his cousin by keeping the audience's attention longer than the other." UAM 70-53-31 (24.8 cm)

Chevak dancer performing with a plastic Halloween mask and sunglasses at the 1994 Cama-i Dance Festival in Bethel. *JHB*

people were expected to treat both their siblings and parallel cousins with respect, cross-cousins were fair game for all manner of joking and banter. The repartee between cross-sex cross-cousins was particularly loaded.

Wendell Oswalt purchased a teasing mask from Cyril Chanar at Toksook Bay in 1970. Chanar made the mask with a moveable jaw and distinctive goatee to represent his *iluraq* (male cross-cousin), and older Nelson Islanders remember seeing comparable masks used in village dances long after the use by *angalkut* of *tuunraq* masks had ceased. Paul John (May 6, 1994) recalled seeing masks used during such dances, in which each cousin would challenge the other and try to be the funniest or the best performer, upstaging his or her rival and making the people laugh.

Comic masks are sometimes designated "secular" in the literature (Ray 1967:44). Hawkes collected several such masks following the 1912 St. Michael "Inviting-In" Festival. He reported that the comic dances took place on the first day of the feast and that if the hosts could make their guests laugh, they gained the right to ask for anything they wanted. Hawkes (1913:12–14) described their lack of success until an old man "took his place in the center of the floor amid perfect silence. With head on his breast and hands at rest on his lap he seemed sunk in some deep reverie. Then he raised his hand to his head and cracked a louse audibly. This was too much for the Unalaklit, and they howled with laughter. Then, having won the day by this ruse, the old man began his dance."

Himmelheber (1993:35) mentioned similar performances on the Kuskokwim and noted a mask mimicking the distorted features of a local white trader. He also cited John Chapman's (1907) description of "actors' masks" used by Athapaskan performers on the middle Yukon. The trader Frank Waskey collected four face masks made in Qissunaq in the late 1940s, one of which caricatures Waskey himself (see p. 302).

Teasing with and without masks was a central part of both intra- and intervillage dances in the past, and it remains important today. Carved wooden masks, as well as plastic Halloween masks and creative cross-dressing often add to the hilarity of the situation. The dances provided opportunities to air grievances in a socially acceptable way. Cousins could mercilessly tease one another, exposing their foibles to the amusement of the assembled guests. Although shamed or embarrassed, the butt of the joke was prohibited from getting angry. According to Anatole Bogeyaktuk (Eskimo Heritage Project 1985), from Stebbins, "If a faithful participant has sat down and he wants to *kasmurraq* [lit., "push, exert pressure on"] anyone, he can do so even to a respected hunter and one of higher rank. And if that person has something like *maklak* [bearded seal] material or an iron trap, he would open it up and give it to that person and let it snap on him. And if he has a rope he would let them pull him . . . all the way to the porch." Charlie Steve described a man throwing a rope around the body of his teasing cousin Ciimaq and pulling him out the door: "When [Ciimaq] got to the door and got up, he

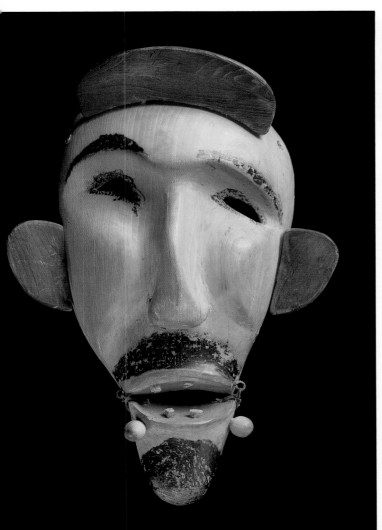

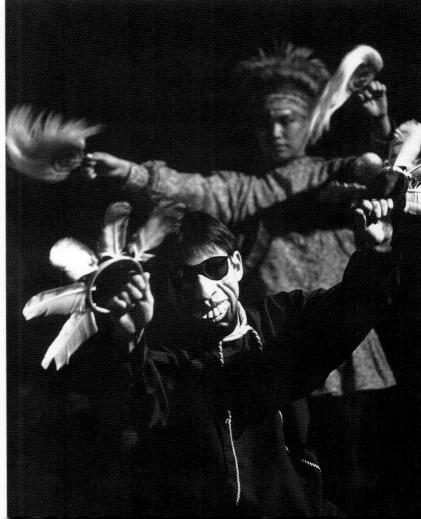

scolded them without anger! And those in the porch were just laughing! . . . And they didn't cause any hard feelings. . . . When he got up he was in a good mood, as if nothing had happened, because if he had done anything they would have thrown him out."

## Masks Made for Sale

Times have changed, and masks are rarely made for use in dance performances in southwestern Alaska today; however, a number of carvers make masks for sale. Kay Hendrickson (January 1, 1994), a well-known maskmaker, has sold many masks in Alaska and beyond. When asked about one of these, he said, "This is a *kass'artaq* [white person's piece]. It's made for sale. It's just a musk ox mask with no meaning. . . . It's a modern piece for selling. It has no story."

Hendrickson's observation is both correct and mistaken. Although the masks' meaning and context of use have changed radically, many design elements are traditional. Also, many continue to illustrate both old and new stories and, in some cases, the Christian carvers' former guardian spirits. Made to hang on walls rather than move to the rhythms of the dance, these new "presentation" masks tell their own stories, simultaneously rooted in the past and branching into the future.

## "Putting Away" the Masks

Like other forms of representational art in southwestern Alaska, including drum painting and storyknife designs in the mud, most masks were destroyed soon after their presentation during a dance performance.

Preservation was neither the artist's nor the audience's goal, and the Yupiit regularly "curated" their masks by "putting them away"—either burning them or leaving them on the tundra to decay. Both Nelson (1899:359) and Hawkes (1913:4) witnessed the burning of masks after use. Himmelheber (1993:11) said that masks were burned without exception: "If one asks for the reason, one will always hear, 'Because they are nothing. We want to see something new next year.'"

Kay Hendrickson (January 4, 1994) described the disposal of masks on Nunivak Island, where people either burned them or placed them together out on the tundra just beyond the village. People in other areas also sometimes hung masks in trees. Willie Beans talked about this last practice: "When they were done with the masks they hung them up in the trees. They're all rotted away, . . . except these that the white people collected and preserved" (KYUK 1989).

Willie Kamkoff and Johnny Thompson (February 27, 1994) said that lower Yukon people put the important masks out on the tundra and gave away the smaller ones, "such as fox masks," to children. It appears that important masks associated with *agayu* dances might be burned after use, but *uigturcuutet* ("practice masks," from *uigtur-,* "to try") could be given to children to play with. Paul John (April 15, 1994) explained the use of *uigturcuutet,* saying that when they were done with them someone would have them as toys: "When people practiced dancing . . . they would say *uigturluteng* [they were trying]. . . . They would use them for teaching."

Jasper Louis (February 25, 1994) described children getting dance masks to play with following a performance: "They gave me some, too. We would have fun with them in the house. . . . I don't know about playing with them with others. They would just amuse themselves with them." Someone who was ill might also receive a mask. Louis concluded, "They didn't give them away to just anybody and everyone. They would pick and choose whom to give the masks to."

The powerful *nepcetat* were neither destroyed nor given away, but rather retained by their owners. According to Willie Kamkoff (February 27, 1994), "They didn't keep the masks of things. However, they never changed the *nepcetat,* those *tuunrissuuteteng* [those they used with spirit powers]. I think they kept them until they died. . . . They kept the ones they have called *an'uralriit* ['the ones that keep going out (for presentation),' from *ane-,* 'to go out']. I've seen that kind more than once."

Masks in museum collections testify to the long life masks occasionally enjoyed. Some show the marks of repair work done to ready them for another year's performance. The backs of others are marked with soot and dirt, indicating storage and repeated use. Mary Mike (February 25, 1994) talked about masks she had seen:

One of twenty masks left on the tundra to rot outside Sheldon's Point, probably in the late 1920s. Villagers found them in 1980 and sold them to the Anchorage Museum of History and Art. Note the lunar-shaped eyes and mouth. *AMHA 80.85.3 (26.4 cm)*

Dog forehead mask used during the Nunivak Messenger Feast, purchased by Margaret Lantis in 1946. *Burke, 2-2129 (32 cm)*

Those two who had masks in Amigtuli never discarded them. We thought they had thrown them away, but they weren't actually gone. They would put them all together. My stepmother and I happened upon such a stash—I actually found them first. They weren't casually thrown away but neatly arranged on the ground near a lake ringed by a wide marsh. The masks sat side by side on the marsh below the tundra edge. Different masks were all together, including powerful ones. I don't think those two men let the children play with them. But they would give the ones of unimportant beings and little masks and bird masks to the children. . . .

But I saw the *nepcetaq* that belonged to Teggalquq in Amigtuli. It was nailed to a short post outside the *qasgiq*. . . . It was a square mask with a face in the middle. It was always there in its place . . . long after Teggalquq, the *angalkuq*, died. . . . It was there until it rotted.

### Masking and the Traditional Ceremonial Cycle

Although Agayuyaraq comprised the main context in which people performed masked dances, masking figured to some extent in all parts of the Yup'ik ceremonial cycle. There was, however, wide variation throughout the region in when and how masking occurred. On Nunivak and Nelson islands, for example, masked dancing was an important feature of the Messenger Feast, whereas in other regions it was not. In some places, such as St. Michael, masks may have been used as part of the Bladder Festival, although in other areas elders do not recall the use of masks during this event. Broad generalizations on when masks were used are not possible and have often resulted in confusion. The best course is to take the ceremonies one by one, evaluating what different sources have described.

### Masks and the Messenger Feast

More argument surrounds the use of masks during the Messenger Feast than any other event. Ray (1967:34), writing about both Iñupiaq and Yup'ik masks, generally stated that masks were used for all occasions except outdoor dancing in the summer and

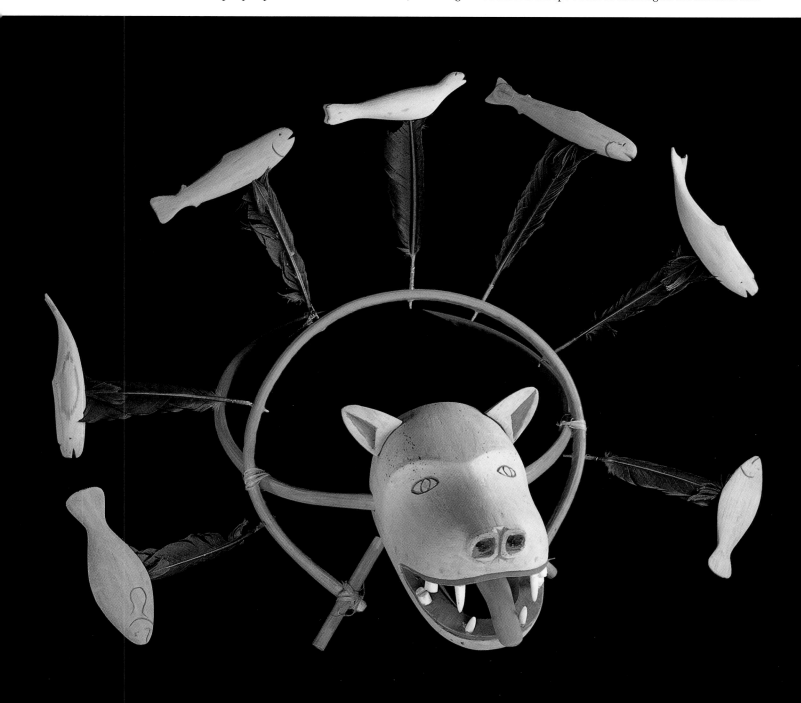

the memorial feasts for the dead, and that they were used most frequently in the Messenger Feast. Yup'ik elders interviewed by Elsie Mather (1985) in the early 1980s denied that masks were used during the Messenger Feast and insisted that Kelek (her sources' designation of Agayuyaraq) was the only context in which their ancestors used masks. Interviews with additional elders in the early 1990s indicate that masks were probably more widely used in the past than Mather was told, but were not as prominent a part of the Yup'ik Messenger Feast as they were in its Iñupiaq counterpart.

Nunivak informants make it clear that their Messenger Feast, held every two or three years, did feature masks (Lantis 1946:188, 192, 200, 201; 1960: 11, 12, 23; Curtis 1930:69). Not only were *angalkut* active during the feast, but ordinary people also danced with masks. Rasmussen's notes, published by Sonne in 1988 and unavailable to Mather and Morrow, confirm the importance of a variety of masks, worn during the feast both in the *qasgiq* and outside. In 1946 the elderly Nunivaker Daniel described to Lantis (1960:12) the masks he had seen during a Messenger Feast, including "ordinary masks," *angalkuq* masks, and masks used "to get animals from the sea." In 1994 Kay Hendrickson described the use of masks by the *angalkuq* during the Messenger Feast:

These masks didn't belong to just ordinary people. They come from *angalkut*. They belong to the *angalkut*. In preparation for the Messenger Feast, they sent out messengers to another village to invite them. After the messengers were sent the *angalkut* would have the carvers make masks they would use when the invited guests came. The *angalkut* themselves didn't actually use them to perform. They would appoint people of their choice and have them perform with them. . . .

When the other village was invited . . . the masks were worn with respect and honor. When they sent messengers to invite the other village, they would send either one or two people. After [the messengers] left, the *angalkut* would make the masks to be worn when the guests came.

Nunivak informants told Lantis (1960:67) that the same kind of dances, songs, and masks were used in the summer on Nelson Island as on Nunivak. Paul John (April 15, 1994) confirmed that Nelson Islanders used masks during their Messenger Feast. He described guests bringing masks with them to the feast, a practice that also varied from place to place:

When a village was invited to a certain village and they came to participate in the event, they called it *curukaryaraq* [process of challenging].

When some of the invited guests wanted to present masks in the event called *curukaryaraq* or Kevgiryaraq [the Messenger Feast], they would bring their usual masks with them to the host village.

It was just during the time they invited guests. When the *angalkut* made masks they would say they were making *agayu*. And when they danced with the masks they would say they were praying. They would

say they were doing Agayuyaraq.

They would bring them to another village if they had planned to use them in the event. This is what they have said. It was *mumigaruciiqngamegteki* ["because they plan to reciprocate or reverse the action," from *mumigte-*, "turned over, inverted"] before they came home. If the guests remained in the host village and did it, they called that *mumigarulluteng*. They would dance at that time.

Or they may choose instead to return to their own village and invite them [*kelegluki*, "they would invite them," from *keleg-*, "to invite"].

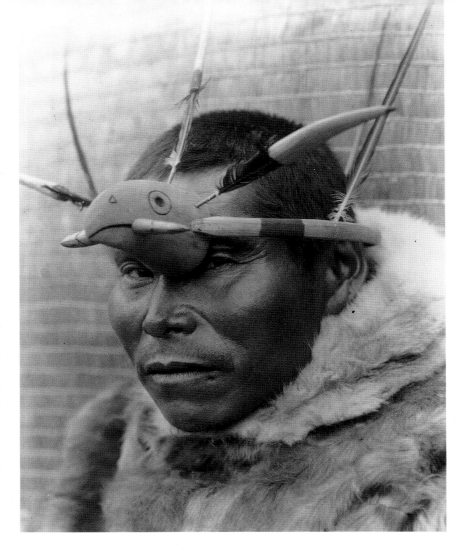

Man wearing a forehead mask of a predatory bird carrying a fish in its mouth. Carved wings are mounted on three-inch feathers stuck into the hoop. "A miniature spear, feather-mounted, was stuck in the top of the bird's head" (Curtis 1930:39). *EC, 1927, SI, Dibner Library, 83-3665*

Paul John's comment helps us understand the distinction between the Messenger Feast and Agayuyaraq. Masked dancing might take place as part of either event. The difference was the focus during the Messenger Feast on gift giving between host and guest and giving away products of past harvests, whereas Agayuyaraq emphasized masked dancing to request future abundance. Guests attended, but the focus of the event was on the relationship between humans and the spirit world—members of which also attended as guests—not intervillage competition and exchange.

Jasper Louis (February 25, 1994) also described seeing guests wearing masks while dancing at a village on the lower Yukon: "I saw them in the village when I first became aware [*ellangellemni*]. And some guests would bring their masks if they were planning to reciprocate immediately. If the guests danced we

Dance ornament representing a bird with human legs meant to hang in the *qasgiq*. The bird's stomach opens to reveal a toothy cavity from which projects the blade of a woman's semilunar knife. Collected by A. H. Twitchell on the Kuskokwim, early 1900s. *NMAI, 9/3440 (47 cm)*

called it *akinauq* [reciprocating, paying them back]."

Stebbins elders described a formal ending of their "potlatch" (combining elements of the Messenger Feast and other ceremonies) in which they "tricked" spirit guests into leaving:

We close the Potlatch with a different style of dancing, with three or four Hand Motion songs. We do this to keep the spirits of dead people and animals from floating around.

They make songs and make motions that mean to step on the Potlatch, or end it. They might sing and take a month to make songs and make the motions that mean they are stepping on the potlatch to end it.

Men dance and sing for two nights and the women do the drumming, they change roles and let the women drum to trick the spirits and make them leave. . . .

At this time they make masks and show them to their teasing cousins and say, "This is what my grandfather has used and I'm using it. Shaman walrus mask, teasing cousins, I would show you. This is what my Grandfather has used and I have used them." Showing the masks puts the Potlatch down, stops it from moving, as the Potlatch travels by mask and dance. (Eskimo Heritage Project 1985:109–10)

### Masks and the Bladder Festival

The men's use of carved, wooden noses as disguises during Qengarpak preceded the Bladder Festival in some areas. Lantis (1946:239–40) mentioned small, wooden mask-images and real animal heads worn on the forehead during the Nunivak Bladder Festival: "One inogo [*iinruq*] of a certain man was Crane. He owned a frayed specimen of a crane head, which he wore in a certain part of the Bladder Feast. Also, at various points during the Feast, he imitated his inogo; as he burst the seal bladders and put them down under the ice, he cried like a crane. At the end of the ceremonial, this little forehead image was carefully put away, not to be used until the next Bladder Feast."

Daniel Neuman reported that masks he collected at Hooper Bay between 1910 and 1920 had been used at a Bladder Festival and Feast for the Dead (Wallen 1990:19). Ray (1967:39) cited H. M. W. Edmonds's description of what was probably a Bladder Festival at St. Michael in the 1890s, during which men wore masks representing hawks, foxes, wolverines, and other animals. A carved, mechanical hawk suspended from the roof swooped down on these masked dancers, while from behind lamps came other men "rigged up in devil masks." Nelson (1899:382–83) also described hanging images in the *qasgiq* during a Bladder Festival that he witnessed at "Kashunak" (Qissunaq) and men wearing their hunting hats making the cries of various birds. One hundred years later Joseph Tuluk (February 1995), born and raised at Qissunaq, confirmed Nelson's account.

In all these events—on Nunivak and at St. Michael and Qissunaq—the hunters (whether masked or not) probably imitated their personal helping spirits, which often took bird form. The association between the bird and the hunter was strong. Whereas hunters viewed seals as sharing with them an essential personhood, they also believed seals perceived human hunters as birds (and possibly other

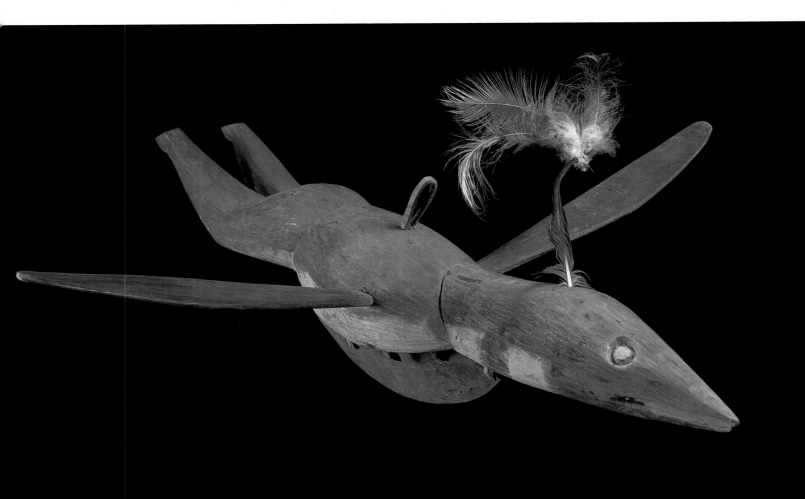

animals) during the hunt (Fienup-Riordan 1990b). The Bladder Festival was primarily an opportunity to host the *yuit* of the animals killed during the preceding year. Not surprisingly, each hunter dressed himself for the occasion as his personal animal helper (sometimes with the help of masks) to present a form in which the animals knew him.

### Masks and the Dead

Few contemporary elders associate masks of any kind with the Feast for the Dead, and none recalled any details of masking during the ceremony. Only a handful of references exists in the literature to masks used during memorial feasts. As with the Bladder Festival, masking probably did occur during the Feast for the Dead, but may not have been common or widespread. Himmelheber (1993:31) reported the use of "ichzit [*ircit*] forehead masks" in the Feast for the Dead on Nunivak. Nelson collected a mask from Askinak (modern-day Hooper Bay) in 1878 and commented that it had been worn at a Feast for the Dead.

Although masks were not a regular feature of the Feast for the Dead, throughout northern Alaska a person's mask might be hung on a frame over a grave (Ray 1981:37). Faces also appeared on the board monuments Yup'ik men and women sometimes used as grave markers, but these faces were probably not used as masks during any ceremony.

Jacobsen provides a compelling description of half-masks (*inglupiat kegginaqut*) used during a lower Yukon feast for the dead. During the memorial rites, a dancer wearing such a mask reported from the land of the dead how the deceased was faring, how often he or she thought of living relatives, and how many caribou and fish he or she had sent to them during the past year. Jacobsen said people believed that the spirit of the dead was really before them. The mask symbolized the wearer's oneness with the namesake from the otherworld. It is of interest that a Kodiak tale describes stars as halved people, while Knud Rasmussen (1931:209) reported that the Netsilik people considered stars to be deceased humans (Disselhoff 1935).

### Masking during Petugtaq

Neither elders nor scholars generally associate the use of masks with Petugtaq; however, several accounts indicate that humorous masks were occasionally part of this event. As one focus of Petugtaq was teasing, people sometimes used disguise, including masks, to heighten the humor. Men dressed as women and women pretended to be men. John Pingayak (1986)

Wooden *alailutak* (grave monuments) at the mouth of the Kuskokwim, early 1900s. The central feature of the monument is a simple carved wooden face with ivory eyes sheltered by a wooden visor. Surrounding the face are the clothing, ornaments, and tools of the deceased, including bird spears, paddles, and snowshoes. *MA (Pa.)*

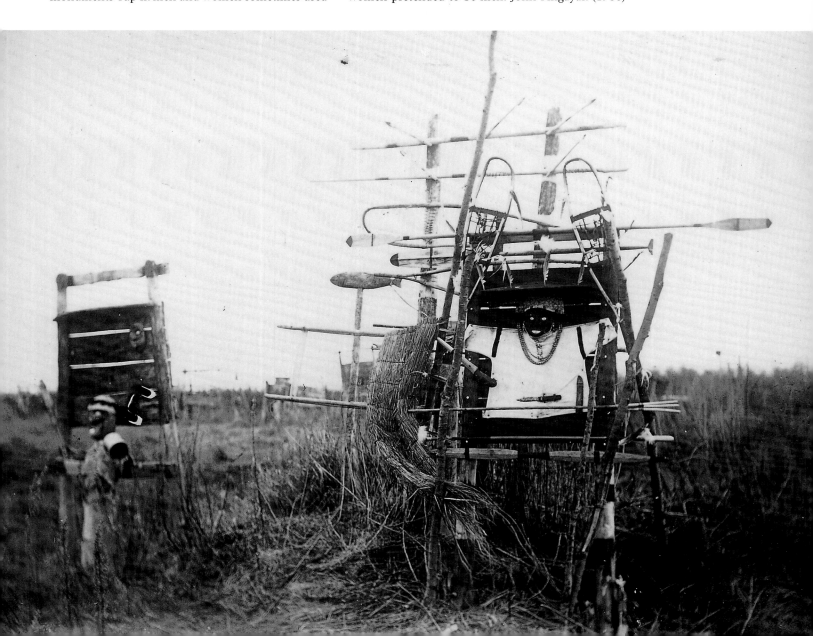

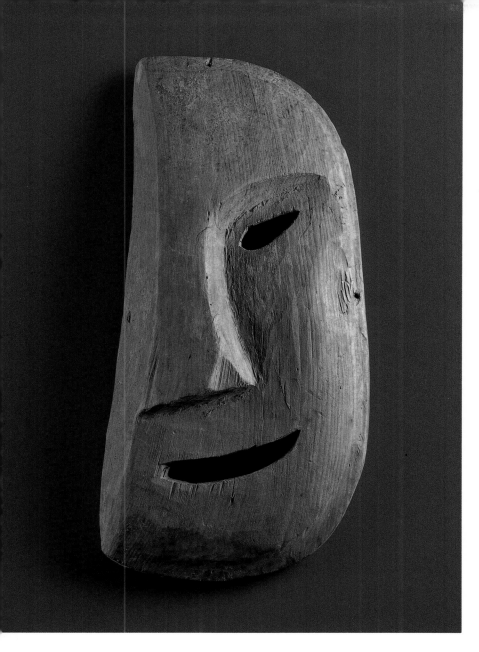

One of several half-masks collected by J. A. Jacobsen on the lower Yukon. The mask, covering part of the face while leaving a portion uncovered, symbolized the wearer's oneness with the dead. *MV, IVA 4390 (26.5 cm)*

historian of Eskimo masks, wrote that only in Alaska, where ceremonialism reached its highest development, did Eskimos use wooden dance masks: "Skin masks were used to some extent in all Eskimo areas east of Alaska, but they were generally employed to amuse or frighten children, or in connection with sexual play." In Alaska in general, however, and in southwestern Alaska in particular, abundant resources provided the impetus for the unprecedented development of ceremonial life—and the equally unprecedented creation of masks.

Not only was the use of masks restricted in geographic range, in some areas it may have been a relatively recent development (Ray 1967:72). The practice of burning masks after use may in part account for their scarcity in archaeological sites. The efflorescence of maskmaking may have been nurtured by the introduction of more efficient carving tools with intensified European contact and trade as well as by improved transportation, permitting greater interaction between different native groups (Ray 1967:75). Ray (1967:76–77) attests to the relative youth throughout northern and western Alaska of the Messenger Feast, which spread only after the introduction of dog traction within the last three centuries:

The new kind of transportation not only facilitated the getting of food to feed the many guests, but fostered a new kind of winter ceremony in the comparatively rich subsistence areas of the Bering Sea and Bering Strait. The Messenger Feast undoubtedly developed its kit of ceremonial regalia and wooden masks for both the spirits and the people within its framework of intervillage competition and rivalry.

Another factor contributing to ceremonial elaboration in southwestern Alaska was the decline of bow-and-arrow warfare after the Russians arrived in the early 1800s. Although few Russians settled in the region and were never numerous enough to force changes in traditional practices, the diseases they brought devastated the Yupiit. For those who survived, time and tools became available. According to Yup'ik oral tradition, intervillage dancing in general and the Messenger Feast in particular began where interregional bow-and-arrow warfare left off. Brentina Chanar concluded her account of the origin of the Messenger Feast, "So from then on, warfare was terminated. But they competed with each other with a Messenger Feast. That was the reason for the end of warfare" (Fienup-Riordan 1994:325–26).

Masks were an important part of the Iñupiaq Messenger Feast into the early twentieth century. In southwestern Alaska, however, masked dances occurred during the Messenger Feast only in some areas, such as Nunivak and Nelson islands. Along the Yukon and Kuskokwim the use of masks was more often associated with Agayuyaraq. The masked dances embedded within Agayuyaraq appear to be both older than the Messenger Feast and of more fundamental importance. Along with the Bladder Festi-

described the use of masks as part of such cross-dressing during Petugtaq in the Chevak area. After the women give gifts to the men and make requests for return gifts,

the men start practicing Eskimo dance songs that they will be singing for the women to dance to. The women disguise themselves as men. Some wear humorous masks and others paint their faces with black soot. They all [wear] old clothing so they look unrecognizable. . . . The women start practicing Eskimo dance songs. When they are done, the men are gathered into the *qaygiq*. The men bring the gifts that the women wanted. Then the men dress up in the porch as women but with humorous masks or painted faces of black soot. Their roles reverse during the Eskimo dances, the women sing and drum, and the men [dance]. Everyone [has] a lot of fun, especially the cousins exchanging humorous remarks to one another.

### The Uniqueness of Alaska Eskimo Masks

Though both Yupiit and Iñupiat in Alaska share many features with their Inuit relatives to the east in Canada and Greenland, dance masks are not among them. Dorothy Jean Ray (1967:2), the preeminent

val and the Feast for the Dead, Agayuyaraq helped maintain proper relations between the human and nonhuman worlds. Both the Bladder Festival and Feast for the Dead drew the spirits of dead animals and humans, respectively, into the world of the living, where they were hosted and sent away satisfied. Agayuyaraq, in contrast, called forth the animal *yuit* and spirits responsible for the people's future wellbeing. The masks used in this ceremony were primarily created to embody these animal *yuit* and helping spirits, and these were the masks that were ordinarily destroyed after use. Although scant physical evidence remains of these ancient masked dances, it may be that the use of masks during Agayuyaraq is much older in southwestern Alaska than the masked performances that occurred during the Messenger Feast.

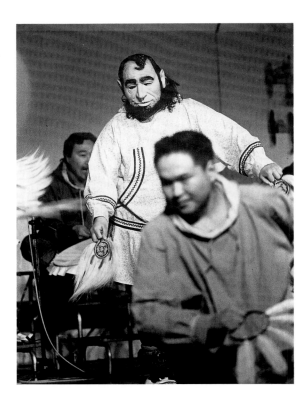

Chevak woman wearing a man's mask at the 1994 Cama-i Dance Festival in Bethel. *JHB*

# Masks and the Stories They Tell

9. Himmelheber (1993:11) noted in a discussion of Yup'ik art that the "attitude of the onlooker corresponds to the aim of the representation. He sees above all the content, not the aesthetic qualities of the work of art." When he asked Lame Jacob of Bethel to evaluate a group of paintings, Jacob told him, "Those are all good paintings, but they don't tell me much as such because I don't know the stories which go with them."

Nick Charles, Sr., presenting John Kusauyuq's snowy owl mask (held by Joe Chief, Jr.) in Bethel, 1982, at the first masked dance held there in more than fifty years. According to Mary Mike, "The owner of the mask would select the dancers to present the mask. And when the song ended, the owner would explain the mask's meaning. He would say the animal depicted in the mask was the one who would help him in time of need in the wilderness." *JHB*

### Presenting the Mask: Telling Its Story, Providing Its Call, Singing Its Song

*They would explain what the masks were about. This happened when many guests had arrived for the event. When the song ended and they removed the masks, the owner of the mask would come forward and explain the story behind it.*—Mary Mike, *St. Marys, May 29, 1993*

The mask was the visible sign of the *angalkuq*'s experience, but it was far from the only sign. The presentation of the mask involved much more, including stories and songs that both explained and embodied the special circumstances surrounding the mask's creation.

Mary Mike (February 28, 1994) spoke at length about *angalkut* using different kinds of masks to present their power sources, the beings that helped them survive. In doing so she emphasized a central feature of these presentations—the *angalkut*'s explanation to the people of what the masks meant: "When they were done with the presentation they would stand up and tell the story of the mask to the people. They would tell what the two [masks] were about. They would explain what they had done . . . and how they had been helped by them."

When William Tyson (February 27, 1993) described masks, one of the first things he mentioned was the explanation that routinely accompanied their presentation: "When they talked about their mask they explained what it was to be used for. It wasn't just for one purpose. . . . They would make an image of something . . . and some would reveal themselves after they had created the mask." Sonne (1988:37) expressed surprise that Rasmussen's notes and drawings on Nunivak masks were so detailed, considering that none of the Nunivakers who gave him the information were shamans, the ones who presumably knew the most about the masks. In fact, everyone who attended the masked dances heard the stories, as *angalkut* presented their masks with full explanations.

Johnny Thompson (February 27, 1994), who saw masked dancing twice when he was young, described the presentation of the masks: "They didn't present too many masks at one time. However, when they did, they would add things they knew about at that time." He stated that the men preceded this presenta-

tion with a northern-style *pualla* dance that they performed standing and moving their arms.

Jasper Louis (February 25, 1994) also mentioned the *angalkuq*'s sharing special knowledge with the people when he presented the mask. Ordinary people could see only the mask, not the *angalkuq*'s *tuunrat*, as only he knew about them and could explain the story behind the mask: "He would explain if it had a purpose." In Yup'ik life the mask was not decorative, but essential.[9]

The symbiotic relationship between Yup'ik art and story is perhaps most striking in the storyknife tales of young girls (Oswalt 1964), which, like the masked dances, are performances in which neither the picture nor the story is meant to stand alone. In most cases, keeping a mask was no more essential than keeping the design made in the mud. Painting on seal-gut windows was equally ephemeral, as the wind and weather would quickly erase this visual reminder of a tale once told. The only such paintings that remain today are the handful that nonnatives such as Himmelheber purchased and put in museums.

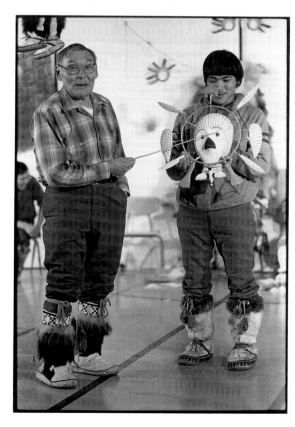

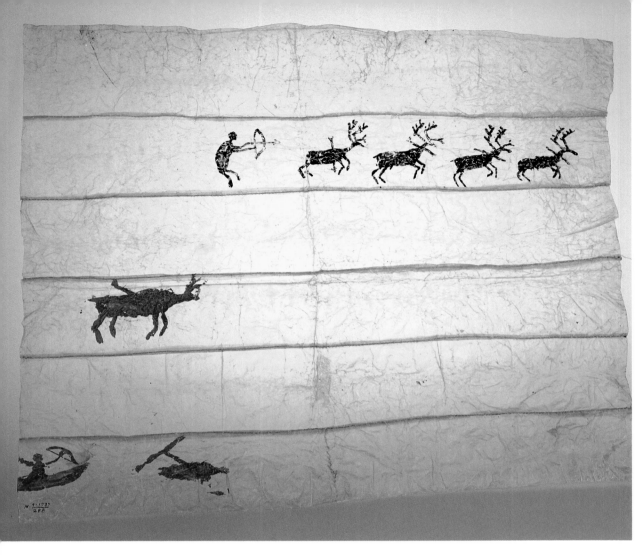

Nunivak gut skylight collected by Himmelheber in 1936-1937. It tells the story of an old hunter who surprisingly killed four caribou in a single day. *UAM, 67-0287 (43.2 cm by 52 cm)*

The *angalkuq*'s explanations were not the only sounds that accompanied the masks' presentation and called forth their power source. Mary Mike (February 28, 1994) described the presentation of a wolf mask in which the wolf was said to enter the performer: "When Leggleq [the *angalkuq*] had presented a wolf mask that time . . . the wolf entered him. Though he wasn't actually fighting another person he was ferociously growling and carrying on down there and he was also barking. . . . I think that wolf mask was a genuine power. It would come to those certain people. Perhaps it was able to see people who were clean and pure."

Paul John (April 15, 1994) described men striking the masks and making the sounds of what they were presenting: "They would say they were providing the sound for the mask. When they cried out, that person would suddenly change. It was when their power source penetrated them, when they were empowered by it . . . they would change." Paul John applied the term *tuka'arluteng* ("kicking or knocking on something," from *tukar-*, "to kick") to this act of hitting the mask and eliciting the entrance of the being the mask represented: "The *tuka'aryaraq* seems to originate from the *ircenrrat*. When the *ircenrrat* kick, one would hear the thundering sound."

The masked dances were not the only context in which a person might hit an object, eliciting its cry as well as its aid. Paul John told the story of a man

who painted drawings of loons on the sides of his kayak. When the man patted on the drawings, he would hear a loon cry and his kayak would move faster. The unseen loon was the power source that gave his kayak extraordinary speed.

Martha Mann (July 8, 1994) of Kwigillingok spoke of masks called *tukarautet* (things that you hit with your feet), which, when tapped, sounded like the animal being presented:

When they made *tukarautet* they would make huge masks and put carved things around them. And when two people left to get the invited guests, they would cover the masks and hang them up. They would use woven grass . . . or cover them with cloth. Then after they arrived and did something, they would dance and rehearse. At that time they would uncover some of them. Then right before the dance in the evening, when they got ready to cry out the sounds of the masks, they would take them out. It actually sounded like the cry of the beings presented. They would tap [the masks] when going by them. (See also Morrow 1984:137)

After making these sounds they sang a slow song, a *tukaraun*, while men danced with the masks. Here, too, the act of striking apparently elicited both the mask's "call" and the entry into the performer of the spirit the mask represented.

Dick Andrew (January 5, 1994) saw masked danc-

ing at Kayalivik, north of Nelson Island near present-day Newtok. Here again, some of the masked dancers would make the sounds of the animals represented:

They would put on seal-gut parkas and paint red ocher on them and put on masks and dance. I saw them. Ones that had walrus masks would make sounds like walrus. . . .

They would wear [masks] and dance. And when they were done using them they would let them go. They would let children have them or throw them away. . . .

They would talk about the fish mask and say they were presenting it hoping to receive it. Or they would present a seal mask and say they were hoping to receive it. . . . They would talk about their masks like that. . . .

They would use their *tuunrat* like that. They would make masks that represent their *tuunrat*. . . .

And in the spring there would be lots of walrus if one of them had presented a walrus mask.

Justina Mike (March 1, 1994) also described masked dancers making the sounds of the animals they were presenting, "asking that these animals be abundant. They would dance. . . . If someone had on a sea mammal mask he would sound like one. And if he had on a fox mask he would cry out like a fox. They would all do that. When they were done they would leave and another presenter would appear from behind the curtain. They would continually change like that."

The *angalkuq*'s explanation of the mask and the animal cries made by the performers were not the only clues the audience had to the meaning of the mask. Each mask's story was presented in the form of a song with accompanying dance motions. The *yuarun* (song) was a highly structured composition, including both an *agenra* (chorus), which was repeated during the performance, and two (or sometimes three) related *apalluk* ("verses," dual). Each *apalluq* depicted an action requiring the dancer to portray its content. Singing these songs, particularly the *apalluk,* had an effective as well as a rhetorical function. Participants performed these songs to draw the *yuit* of the animals as well as *tuunrat* into the human world. Some songs depicted hoped-for future events, which their creators intended their performance to produce. Others depicted past encounters in which *tuunrat* had provided aid.

Just as the singing of special songs accompanied the use of masks, carefully performed dance motions (*arulaluteng*) accompanied the songs. According to Theresa Moses (October 26, 1987), "*Arulat* are the dance motions that they perform holding on to dance fans. They call that *ciuqiluteng* [doing the first one] and it takes the form of *agayuliluteng* [requesting]." These dances were precisely choreographed. In the same way that the masked performer became enlivened with the spirit of the being represented, the song (especially its *apallut*), if properly performed, had the power to realize that which the motions of the dance depicted.

According to Mary Mike (February 25, 1994),

In the fall they would do the *yurapiat* [real or genuine dances; sing., *yurapiaq*] first. They say they would begin in the month of Cauyarvik [November, lit., "time/place for drumming," from *cauyaq,* "drum"]. I suppose they were drumming. They would begin singing. And when they were done with that . . . about [February] they would begin the *arula* [motion dance] presentation there in Amigtuli. Then they would *arula* [until] the following month would come. . . . They would be working on wood, too, making masks. They would *arula* for a long time. They would *arula* in the evening every day.

Before the last part of the event they would summon their guests to come. Anybody who wanted to come would come in great numbers. They would all come like they do nowadays.

The [guests] didn't bring masks. It would be just the host village that presented them. They would *arula* with the masks.

These dance motions were more than mere imitations of animals. During Agayuyaraq, men and women actually performed the dances of the animals whose presence they hoped to elicit in the year to come.

Agayuyaraq participants viewed the masked dances in the context of an all-encompassing dramatic display, including word and song, sight and sound. The boundaries between worlds were temporarily breached. The spirits entered into the center of the human community, into the masked dancers themselves, and the unseen was partially revealed.

## Pairs of Masks

*The masks would be the* apallut *of the songs. Images of different beings would have* apallut. *The songs would be about the different images of beings presented.*—Mary Mike, *St. Marys, February 25, 1994*

An essential feature of Yup'ik masked performance was that masks were often danced in twos and threes. More than a quarter of the Yup'ik masks in museum collections today form recognizable pairs, yet museum exhibits and art history books almost exclusively feature the single evocative image. A close look at museum collections and attention to contemporary elders' memories indicate that these one-of-a-kind masterpieces were the exception rather than the rule.

Elders from all over the region use the terms *aipaq* (partner, companion, mate, spouse, other of two) or *paatnaq* (partner) to talk about the pairs of masks they observed in performance when they were young. As early as the 1840s, Lavrentiy Zagoskin (Michael 1967:227) associated pairs and threesomes of masks with *angalkut*'s performances: "No matter how many performers there are, they all wear masks. In the shaman's performances, however, there are never more than three persons." Elders in the 1990s said the same thing.

Several scholars recognized pairing in masks. Nelson (1899:396) mentions a pair of bear masks but did not illustrate them together: "A mask from

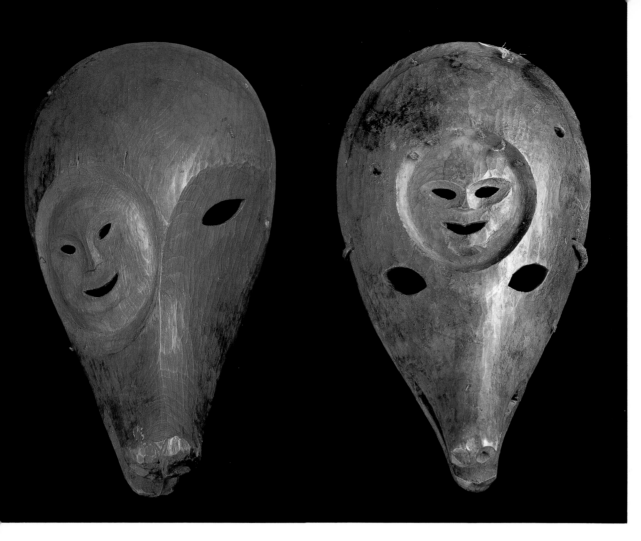

Paired red (grizzly) and black bear masks collected by Nelson at Sabotnisky. Each bear's *yua* peers out; feathers originally decorated the mask's upper rim. *SI, 48986 (22 cm) and 48985 (19.6 cm).*

Complementary masks collected at Cape Vancouver on the northwest side of Nelson Island by Sheldon Jackson. One has a round eye on the left, the other on the right. The crescent-shaped eyes and spots on a black background may represent the moon and stars. Each mask has a feather coming out of its mouth, is fringed around the forehead with caribou hair, and has three trimmed quills with downy tips. Masks in this style were collected elsewhere along the coast in the 1880s and 1890s, and they likely relate to a widely known story or experience. Nelson (1899:396) says a similar mask from Cape Vancouver portrays a *tuunraq*. *SJM, IIH1 (20.8 cm high) and IIH2 (20.8 cm)*

Sabotnisky . . . represents the features of a black bear. On one side, covering the area of the right eye and cheek, is a round, human face overhung by five tufts of human hair, which represents the *inua* of the bear. Another mask from the same locality, and very much like the preceding, represents a red bear and has a human face on the right side, painted red." In the 1950s Edmund Carpenter (1991:16) had been impressed by the "duplicate" masks in the Twitchell collection and spoke of them often to fellow anthropologists. But other than Sonne's 1988 exhibit of Rasmussen's twenty-eight Nunivak masks at the Danish National Museum, pairs of Yup'ik masks have never hung side by side.

In *Eskimo Artists* Himmelheber (1993:32) wrote that masks, often in pairs of male and female, displayed the animals and plants that seem so essential to the people. He cited John Chapman's (1907) description of Athapaskan masked dancing along the middle Yukon. The forty-four masks from Anvik that Chapman sent to the American Museum of Natural History included six pairs and one threesome.

Many other collectors brought home pairs of masks. Hawkes (1913: plate 7) collected a pair of red fox masks used during St. Michael's 1912 "Inviting-In" Feast. Twitchell acquired at least thirty-four paired masks along the Kuskokwim in the early 1900s. Jacobsen, Jackson, Edmonds, Neuman, Gierke, Geist, and the Milottes—almost everyone collecting masks in southwestern Alaska—acquired from one to a dozen pairs. Additional pairs may have been split

by collectors reluctant to take home two of a kind or by Yup'ik traders uneasy about letting them go.[10]

A number of different collections contain similar pieces, and it is unlikely that these are all divided pairs, as these collections come from different times and places. Perhaps, like the *nepcetat* that occur repeatedly in different collections, similar pieces were made to illustrate the same stories. Thus, along with new creations, carvers needed to create many of the same masks year after year to retell particularly dramatic events and perform the more important dances.

The majority of mask pairs that nonnatives collected and elders describe today are not duplicates, and they come from the same time and place. Usually they appear as fraternal—not identical—twins. They are similar but with a difference. In some cases the colors oppose each other, as in the Nelson bear masks. What is red on one mask is black on the other, and vice versa. In some cases the asymmetrical features of a mask are inverted in its twin. For example, Gierke collected a pair of masks in which the right side of one and the left side of the other are covered by a crescent-shaped creature.

Many individual masks, including those depicting *ircenrrat* and some of the more fearsome *tuunrat*, were asymmetrical with divided countenance. This asymmetry is partially explained by the divided character of the creatures represented: half-wolf/half-human or half-natural/half-supernatural. This asymmetry, however, was balanced during performances in which a

10. Ray (1967:181) studied a pair of large plaque masks from St. Michael at the Hearst Museum but separated them in her text, showing one in color (plate II) and one in black-and-white (plate 2). As the Alaska Commercial Company records had been destroyed, she could say nothing about the masks' possible relation to each other. She did, however, note that the masks in plates III and 3 were painted with the same paint by the same person. The masks in plates 2, I, and II also appeared to have been painted out of the same pot. And plates 2 and II match a mask originally from the Heye Foundation and now

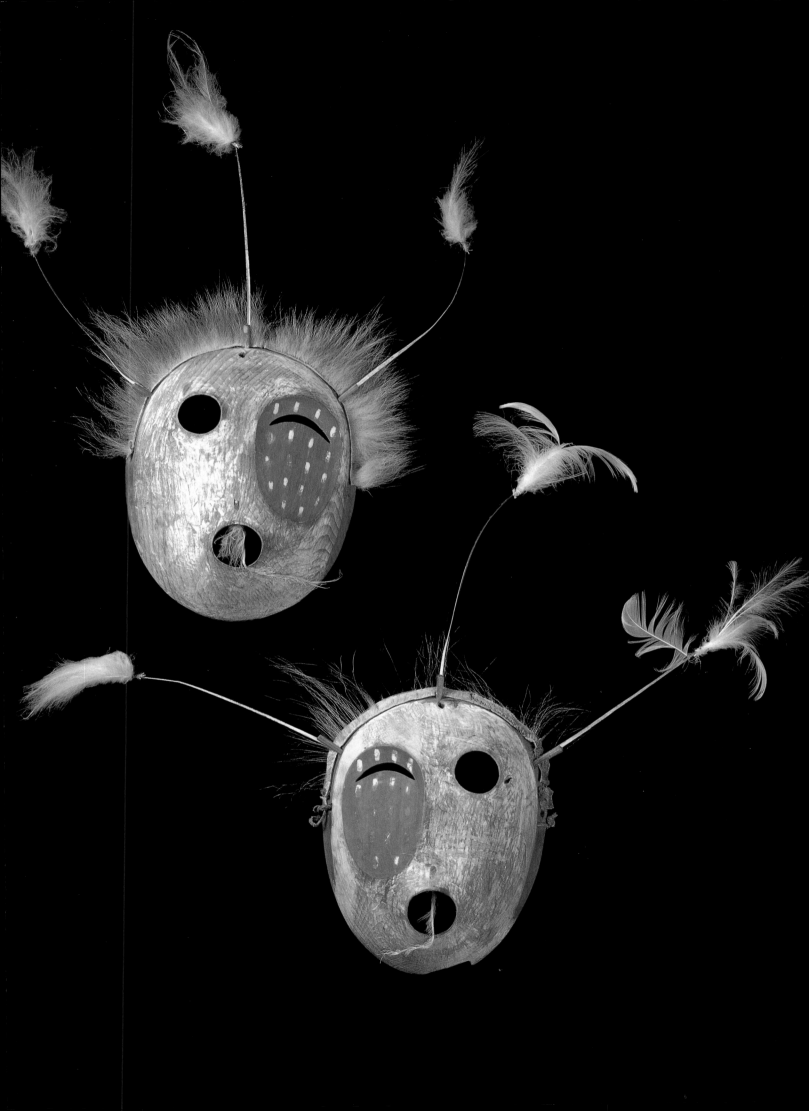

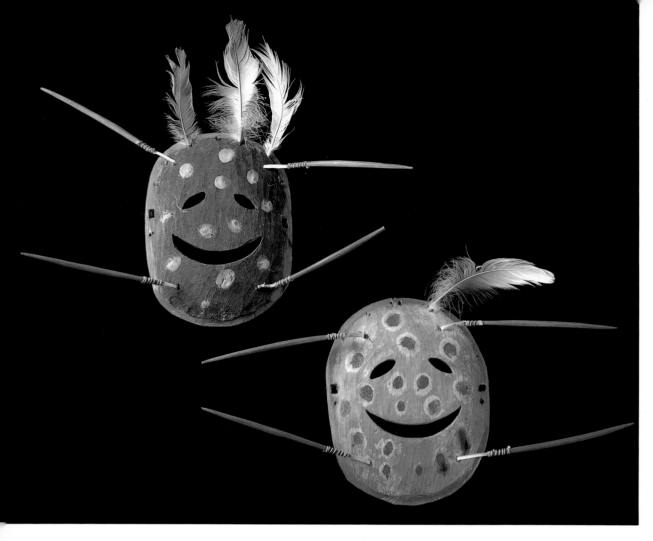

in Jean-Jacques Lebel's private collection in Paris. Is this a related threesome separated by space and time?

Pair of delicate red-rimmed masks Sheldon Jackson collected at Andreafski in 1893. Wooden rods are tied with string to quill supports, which move in time to the dancers' motions. The back of the eyes are painted red. Nelson (1899:406) collected a similar mask from Sabotnisky said to represent a moon-dwelling *tuunraq* that regulates the supply of game. The white marks and red finger spots are comparable to those painted on bladders during the Bladder Festival, when the seals are likewise requested to return in abundance. *SJM, IIB86 (17.8 cm) and IIB87 (17.8 cm)*

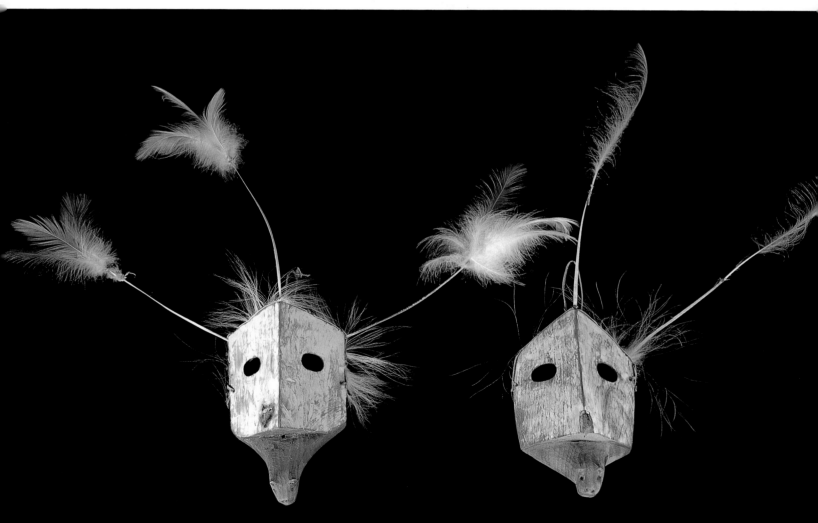

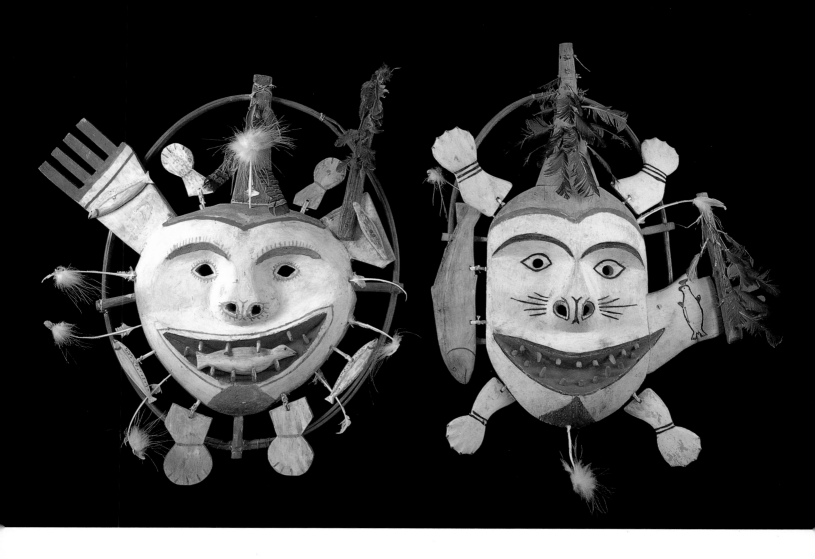

Pair of elegant masks that appear as an abstract face from one angle and a small animal from another, collected by Henry Neumann in 1890 at St. Michael. Dorothy Jean Ray's (1967:195) informants identified a similar mask as a seal. *SJM, IIG5a and b (24.8 cm high)*

George Bunyan carved this pair of beaver masks at Hooper Bay in 1946 for a dance performed during the filming of the Disney movie *Alaskan Eskimo*. The feathered "trees" the beavers hold represent their food. These and a third mask (II-A-5393, see p. 291) made by Sam Hunter told the same story. *ASM, IIA5395 (63.5 cm) and IIA5396 (61 cm)*

MASKS
AND THE
STORIES
THEY TELL

mask appeared alongside or opposite another that inverted its features. These performances recall the Yup'ik linguistic device that allows a speaker to use a single word to refer to two parts of a pair. *Maurluqell-riik* translates as "grandmother-related ones" and refers to a grandmother and her grandchild, and *nu-lirqellriik* as "wife-related ones," for a husband and wife. Like the dance, these terms unified difference in a single context.

A single mask often displayed paired features. For example, Nelson (1899:409–10) collected a mask south of the Yukon mouth featuring a pair of wolves—one black, one white. On each side above the eyes are the head and shoulders of a wolf in relief. Nelson believed that the wolves signified day and night.

Himmelheber (1993:44) described paired kayak carvings balancing the craft: "Both figures always form a pair, for instance a man's and a woman's face or a woman's breast on either side. These pairs are supposed since they are mutually supplementary, to hold the swaying kayak in balance." Himmelheber (1993:27) also described the creatures men painted on the outside skins of their kayaks to make the kayak faster, or one on either side to balance the craft: "The figure is painted with outspread hands under the kayak as if it is clinging to it with arms and legs to prevent it from tipping over." This symmetrical painting recalls the symmetrical masks with matching appendages. Similarly, pairing of asymmetrical

kayak carvings to create balance resembles the pairing of asymmetrical masks.

Although almost invisible in the literature, pairing of masks throughout the Yukon-Kuskokwim delta is still recalled by elders. Jasper Louis (February 25, 1994) saw a performance in which a red fox mask was presented with a white fox mask. He said that *tuullek* (common loon) and *tunutellek* (Arctic loon) masks were also presented together. Mike Angaiak (November 30, 1989) described the joint presentation of a bearded-seal mask and one representing ice: "Specific mask images worked together with the others. For example, the mask of the *amirkaq* [baby bearded seal] is really round and small and it represents the seal, so that would be like praying for many seals to come in the springtime. And another mask would represent a symbol saying, 'We want lots of ice,' because without ice there is no hunting for seals. So the group of men would work together so as to pray for lots of seals."

Justina Mike (March 1, 1994) saw two masked dancers during *agayu* dances "asking that these animals be abundant." In such performances they would make the sounds of the animals they were presenting:

There were two masks. They were standing across from each other. They took turns presenting the masks. The [canvas] curtain back there would close. . . . They would say what they were requesting and pray. I think the [two masks] were alike when I saw them at that

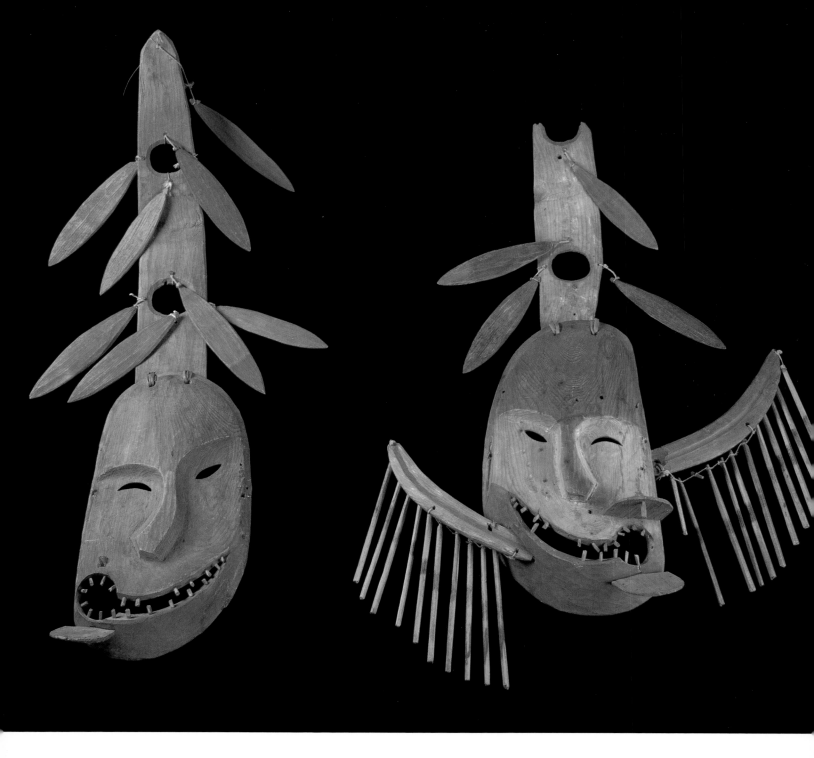

time. . . . They used the masks as *apallut*. They wanted [the animals] to be plentiful in the summer. It was on the last day that they would speak and do that.

Mary Mike (February 28, 1994) also described pairs of masked dancers calling out the cries of the animals represented. Two dancers representing "powerful animals" would go outside the *qasgiq* for this part of the performance and call down from the skylight. Pairs of dancers representing smaller animals would remain inside.

When they perform the *agayu* pieces they would . . . let us sit on the *ingleq* [bench] on the side. . . . There would be two men moving down there with two women moving behind them. The drummers would accompany their movements.

They always danced in pairs. Two men and two

women. And they would always begin the performance very slowly. They didn't move quickly when the song began. They would begin very properly. Then when they sang the two *apalluk* they would finally begin moving. They would let some of them dance for a long time. . . .

The two would be wearing masks. Perhaps it was at the time they were doing the *arula* dances that they would put them on and go outside. Then they would climb to the edge of the skylight up there . . . and cry out the sounds of the masks. And since they probably stooped down toward the skylight, they would be very loud. . . . They would depict different kinds of animals. And when they had wolf masks you could hear them howling out there. . . .

When they presented the powerful animals they would go out. However, when they presented the little animals they would stay inside and call out their cries.[11]

11. Knud Rasmussen (Sonne 1988:31) recorded the same thing on Nunivak—masked dancing both inside and outside the *qasgiq*.

Sheldon Jackson collected this asymmetrical pair of masks at Andreafski in 1893. Their distorted faces with round mouth corners, toothy grins, and wooden appendages are reminiscent of the pair of *tuunraq* masks Jacobson collected from the same area ten years earlier (see p. 67). The crescent-shaped eye, distorted "man-in-the-moon" face, and toothy orbs recall celestial imagery found on many *tuunraq* masks. *SJM, IIB45 (52. 8 cm) and IIB46 (61.3 cm)*

Jacobsen collected this pair of carvings at Cape Vancouver. He wrote that such "Thunnerasut" (*tuunrissuutet,* "things of the helping spirits") were "kept in the house to keep happiness and blessings. It is possible that the spirit of a dead person lives in this object." Nelson collected similar paired smiling-male and frowning-female charm images that the hunter lashed inside his kayak's cockpit to spiritually "balance" his craft between sea (the frowning face of a seal) and sky (the moon's smiling face). (See "The Monstrous Mouth," p. 175.) *MV, IVA5169 (12.5 cm) and IVA5182 (12.5 cm)*

When Mary Mike (October 19, 1994) observed masked dancing, the masks were hidden before their presentation.

I used to go with my uncle's daughter when she went to the *qasgiq* to bring food. When we went in I used to see a cloth spread out in the back of the *qasgiq*. It was a white canvas called *cingyaak*. They also had the kind they called *tiik* [mattress ticking]. . . .

The area under the *ingleq* would be covered up. Apparently, it was filled with masks. They would keep them covered before the guests arrived.

After they ate they would begin in the evening. . . . They would place two huge split logs across from each other down on the floor. The men would sit all the way around the floor and the women would sit on the *ingleq* up there.

The singers would be down there. And the visitors would sit on the *ingleq*. . . .

A group of masks belonging to one person would be covered together and another group belonging to another person would be covered together.

They would take them when they were ready to present them and the two dancers would put them on across from each other, and the owner would talk about them. And some would *arula*.

Mary Mike (May 29, 1993) saw a variety of paired masks used during the winter *agayu* dances (see stories, this chapter). Year after year her uncle presented a pair of loon masks and retold the story of his encounter with two loons that came to his aid when he and his brother were lost on the ocean. She (October 1994) saw another pair of masks representing a jaeger and an *amikuk* (a creature believed to help women having difficulty during childbirth):

[My uncle Leggleq, the shaman] presented many kinds of masks, including an *amikuk* mask and a jaeger mask . . . .The figure of a jaeger was hanging up there attached with a string. Two people on either side kept pulling the strings to flap its wings, giving the appearance of flight. [Leggleq] held the jaeger and *amikuk*

together while he told the story about them. The two animals depicted provided the two *apalluk* of the song he composed for the masks. . . .

I think the first *apallaq* was about the *amikuk*. I think the second *apalluq* was about the jaeger, a species that resides on land.

People used pairs of masks in a range of contexts to tell many different stories. Dick Andrew (January 5, 1994) described the creation of pairs of masks under the direction of the *angalkuq*: "That animal mask was the protection and safeguard of the *angalkuq*. Those masks were made by *angalkut* . . . who instructed the carvers to make pairs of masks." He then told several stories of partnerships between different animal species, including grebe and muskrat, and lushfish and blackfish. Andrew described grebe and muskrat as *qatngun* (half-siblings through a traditional spouse-borrowing relationship), making it clear how varied "partnerships" might be.

Men and women from all over the delta mentioned that when they danced with masks, the song would have two *apalluk*, the first about an ocean animal and the second about a land animal. Willie Kamkoff (February 27, 1994) both stated this rule and described its exceptions—songs with three and sometimes four *apallut*:

The masks belong to the *apallut* in the song. . . .

It was the object that came with the song. It was back in those times when they would request things through a song. . . .

There were many different kinds of masks with songs. One song would present an animal from the ocean and an animal from the land. . . .

In every song they would sing about the ocean animal in the first *apalluq*. And the following *apalluq* would be about the land animal. . . .

They would present the two masks with a song. When I observed them closely in Emmonak, the day before they presented the masks they all cried out with the sounds of the animals. First they placed all the

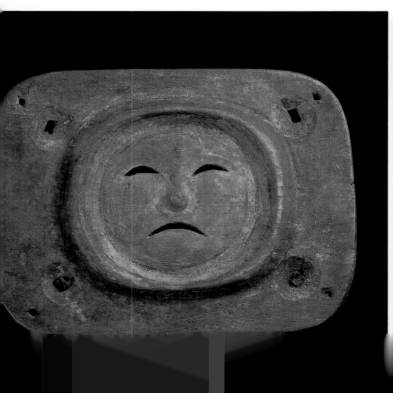

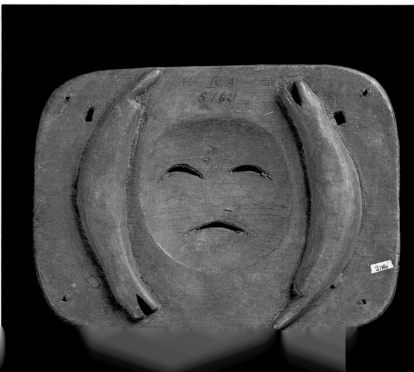

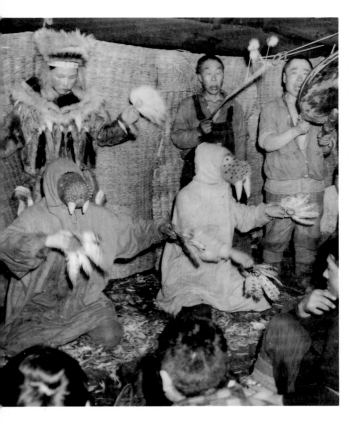

ocean animal masks out in the porch. And they put all the land animals in the back wall of the *qasgiq* behind a *negcuar* [?] curtain. Then they danced, making the animals' sounds. They would put on the mask and make the sounds of the image. That's what they would do the day before they presented the masks. . . . They explained their masks before they presented them.

The composer of the song took care of those masks. And when he was done he would explain the full meaning behind it. He would explain the source of the masks.

They say that for many songs there are two *apalluk*. However, the *tuunrissuutet* [doctoring songs] of the *angalkut* and the songs sung in the *ellanguaryaraq* [presentation of the model universe] always had three *apallut*. Some *tuunrissuutet*, too, can have four *apallut*. But mostly two, about the ocean and about the land.

Jasper Louis (February 25, 1994) stated, "Traditionally, the first *apalluq* was about the ocean animal. . . . The *apallut* being in threes doesn't happen very often. A song normally has two *apalluk*. When people dance with masks the masks are in pairs."

Kay Hendrickson (January 4, 1994) described a pair of masked dancers on Nunivak who also reflected the opposition between land and sea:

Pair of masked dancers performing in Qissunaq, photographed by Alfred Milotte during the filming of *Alaskan Eskimo,* 1946. ASM, MC, neg. no. 1103

Mated pair of red fox masks collected by Jacobsen on the Kuskokwim. The male is slightly larger than the female, and forehead pegs show that they were caught in a trap. These are possibly forehead masks, as neither has attachment holes. *MV, IVA5163 (25 cm) and IVA5165 (27 cm)*

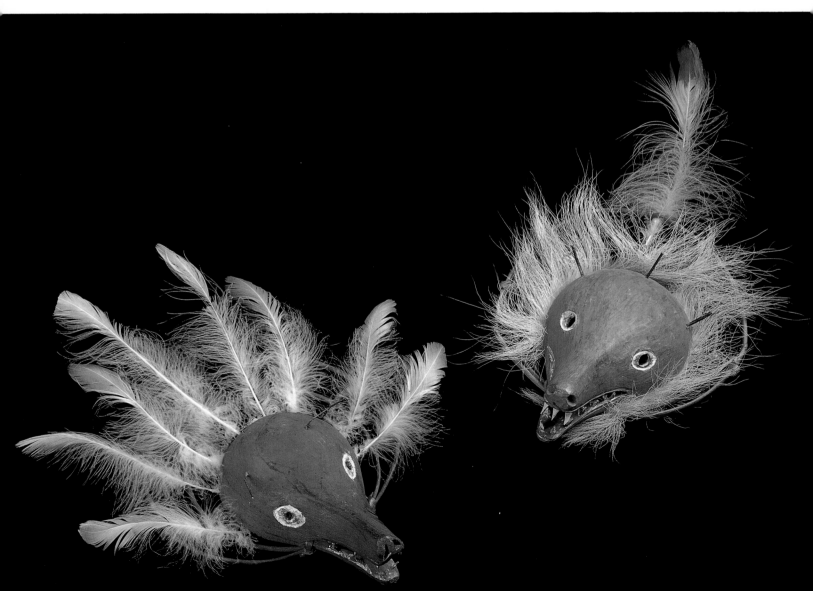

Whimsical threesome of clam masks Jacobsen collected on the lower Yukon in 1882 and called "Yualle Resak Kinakok" (*uilurusak kegginaquq*, "pretend clam mask"). Red paint appears around the openings on the backside of all three. Note the crescent-shaped eyes and double faces, A red furrow in which feathers were originally fastened circles the mask. Rasmussen was among the first to suggest that the edge of the mask is the universe through which the creature sticks its head to look in on the human world (Ray 1967: 190). We know that each clam originally had at least two legs. Missing arms and legs were added during restoration in Berlin in 1994. See p. 245 for another image of a clam, perhaps a more recent telling of the same story. *MV, IVA4418 (17.5 cm), IVA4407 (17.5 cm), and IVA7237 (17 cm)*

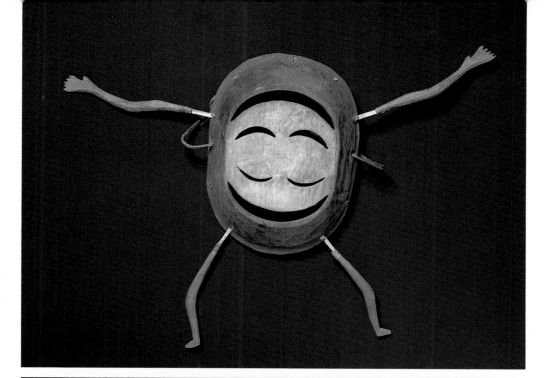

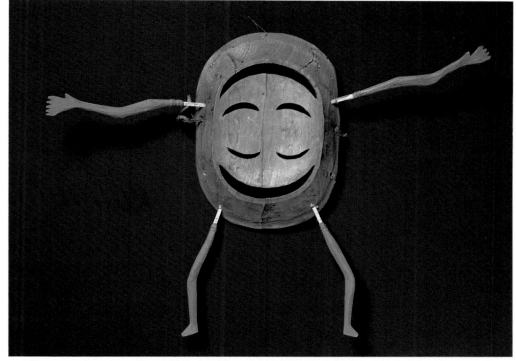

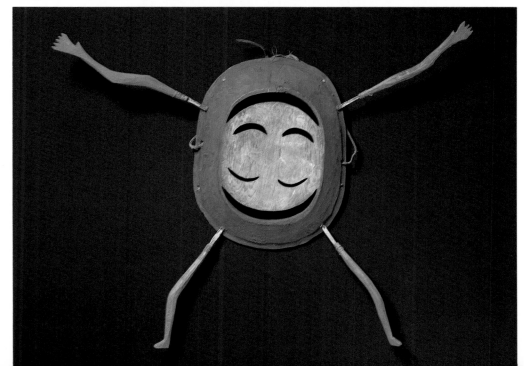

I used to see masked dances. . . . The *angalkuq* would ask two people to perform. . . . [who] would put on the masks belonging to the *angalkuq* and dance. . . . They would only dance and perform for the visitors [not telling a story]. One time as the two performers put the masks on and knelt down, one of them said something about his mask, according to the instructions of the *angalkuq*. He said that he was located at the crest of the daylight [*erenret qauratni*] just coming up in the early morning. . . . The other person said that he was located below the ocean. Then they danced after they said that.

Mary Mike's and Kay Hendrickson's accounts, like those recorded from other elders, provide the key to understanding the significance of the pairs of masks found in museum collections today. As described above, a dance song consisted of both a chorus, which was repeated during the performance, and two or three *apallut* (verses), which the dancers enacted. Kay Hendrickson (January 1994) recalled, "The *angalkuq* would compose a song for it. The two *apalluk* to the song would be different. And if he wanted to make a third *apalluq* he would do so." The masks dramatized these related *apallut*. Masks appeared in pairs and trios because the songs they dramatized had two or three verses. As Mary Mike (February 25, 1994) said so well, "The mask was the *apalluq* of the song."

Understanding the relationship between the masks and the songs they dramatized also helps us visualize what a pair of masks might look like. To dance the story of the partnership between grebe and muskrat, or the story of the crest of the daylight and the ocean bottom, performers would have worn two very different masks. Most of the masks in museums today probably were once paired, but we no longer know their songs and stories and so cannot recognize their partners.

No single meaning seems to underlie the pairing of Yup'ik masks. Some pairs highlight oppositions—land and sea, male and female, day and night. The masks carved to represent the crest of the daylight and the ocean floor are such a pair. Some *agayu* dances requesting abundance may have involved masks depicting the male and female of the species. But other pairs, such as the two wolf masks and two loon masks Mary Mike observed, may have been more a matched than an opposing set. Pairing was an all-pervasive feature of Yup'ik masks and masked dances, and it probably had as many meanings and took as many forms as the myriad songs and stories of the dances themselves.

### Finger Masks

Pairing was not restricted to the masks that covered the dancers' faces. No dancer, male or female, ever performed *agayu* dances bare-handed. Both men and women used paired dance fans called *tegumiak* (dual, "two things held in the hand," from *tegu-*, "to take in the hand") or, south of Hooper Bay, *taruyamaarutek* (an untranslatable word derived from *taru*, "human being"). Men's fans were relatively simple, made from

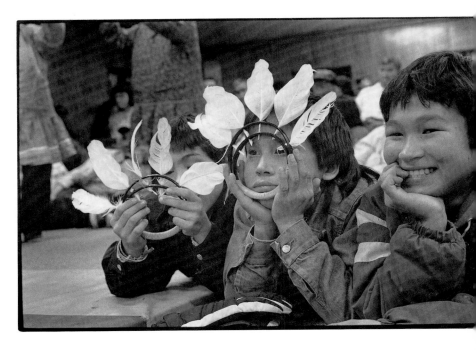

Boys watching the dancing at the 1989 Mountain Village Dance Festival through the bentwood rings of a pair of men's dance fans. *JHB*

a circle or several joined circles of split willow roots to which were attached the feathers of a snowy owl.

Women's dance fans, often referred to as "finger masks," were more complex and delicate, and in the past were usually carved from wood. They might be circular or square, with three to six down-tipped quills or old-squaw duck tailfeathers inserted around the border. Lucien Turner collected a pair of circular wooden dance fans from Norton Sound on which the central disk represented a star, and the feathers the twinkling of its light (Nelson 1899:413).

Often the body of the finger mask depicted an animal, such as a bear or fox, or the distorted features of an *ircenrraq* or *tuunraq*. Like the pairs of masks presented during the dance, paired finger masks were not usually identical, but were complementary. The distorted features of the *ircenrraq* face might occupy the left side of one finger mask and the right side of the other. Or the rim of one would be painted red, while its partner's might be white. In small ways and large, the pairs both balanced and complemented each other. Finger masks held by women inverted the male-dominated masked dancing. While two men presented a pair of large masks, each woman held two finger masks.

More recently, women have made their own dance fans of coiled rye grass (*taperrnaq*), which is also used to make baskets. As in the wooden dance fans, they attach a fringe of reindeer neck hair or feathers to the circular woven frame—a fringe reminiscent of the furry border on many masks. In the past people used grass in myriad ways in daily life to make everything from mats and pack baskets to fish braids and grass socks. In the 1970s Cecelia Foxie performed during the Stebbins potlatch wearing a grass headdress, grass belt, and holding grass dance fans. Before she performed she told the people that she had made these ornaments to impress upon the younger generation the importance of grass in the past, present, and future.

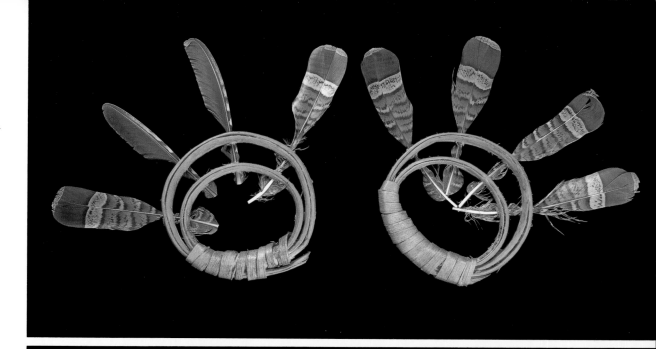

Pair of men's dance fans used at the 1946 masked dance at Hooper Bay. Note the four fingers on this feather hand. *ASM, IIA5417 (10.2 cm)*

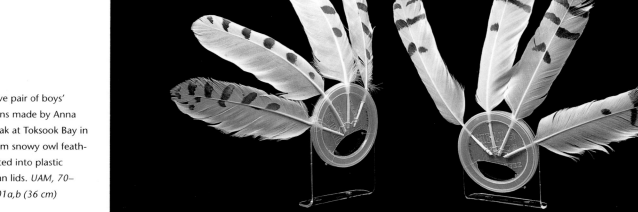

Innovative pair of boys' dance fans made by Anna Kungurkak at Toksook Bay in 1970 from snowy owl feathers inserted into plastic coffee-can lids. *UAM, 70–056–0001a,b (36 cm)*

Pair of finely carved *taruya-maarutek* (dance fans) from Cape Vancouver, held with two fingers of each hand. According to Jacobsen, one side depicts the spirit of a seal, the other a beast with a mouth going from ear to ear. The representation of opposing figures may express the spirits' dual nature or, like the kayak boards (see p. 109), a balance between elements—male and female, sky and sea. *MV, IVA5209 (10.1 cm)*

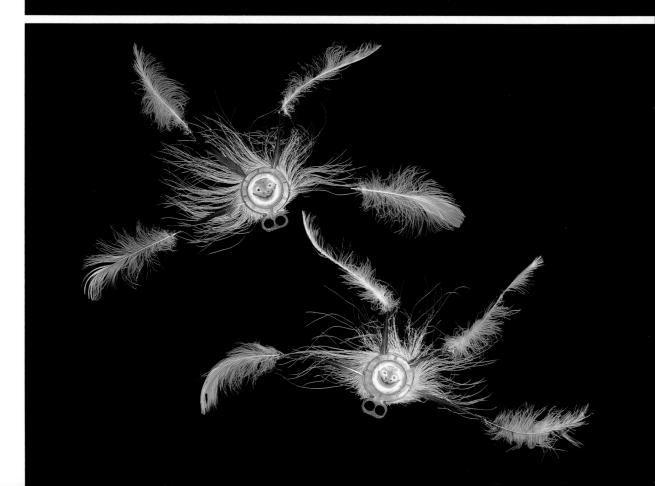

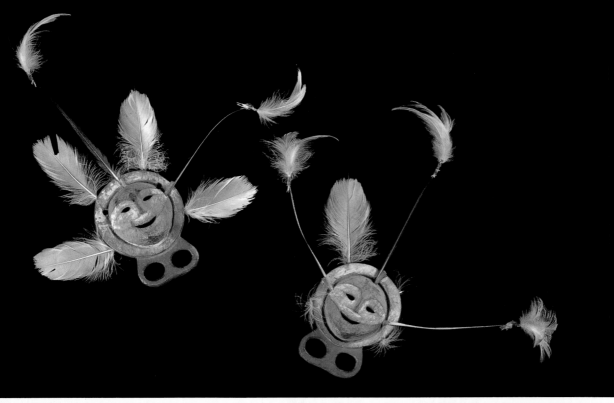

Jacobsen reports that the faces on these lower Kusko-kwim paired dance fans may depict a reindeer or seagull spirit. As in other dance fans, the spirit faces peer out from feather frames representing holes in the sky world. The eyes and mouth are pierced, and the backside carved out and painted red. The edge, in natural color, is grooved. *MV, IVA5213 (12.2 cm high)*

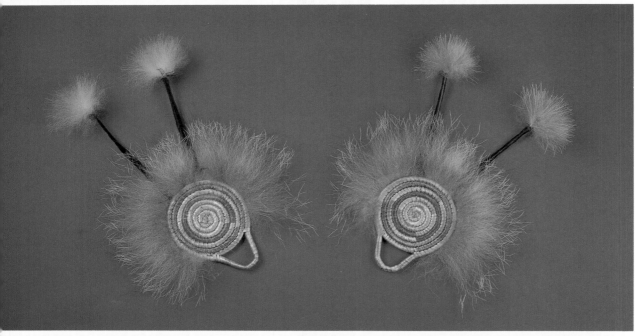

Contemporary dance fans made in Kipnuk in 1965. Grass dance fans, woven in concentric designs and decorated with fur and feathers, are common along the coast south of Hooper Bay. Although the spirit face is absent, its circular "window" into the human world remains. *ASM, 4225 (22 cm)*

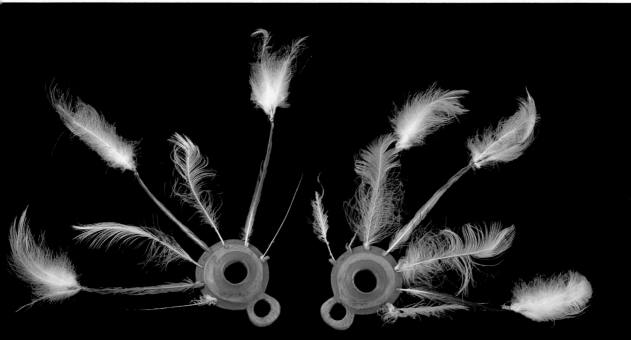

The ringed center featured on this pair of dance fans was a strong image in Yup'ik cosmology. Much ritual activity focused on clearing the paths of animals and spirits into and out of the human world. Movement between worlds through circular or square holes was a constant theme in daily and ceremonial life. Collected by Sheldon Jackson at Andreafski in 1893. *SJM, IIB161a,b (33.5 cm and 32.3 cm high with feathers)*

Pair of "finger ornaments" carried by women in dancing, supposedly depicting the walrus spirit. Jacobsen collected these from the lower Kuskokwim and designated them "Tarrojararotitt" (taruyamaarutet). The wooden face is encircled with feathers that have been stripped on one side and augmented at the tips with light-colored feathers. *MV, IVA5215 (13.2 cm high)*

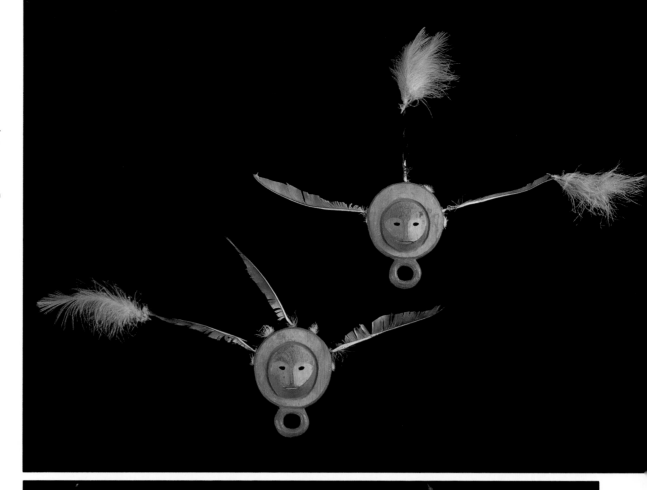

The five holes in these paired finger masks from Andreafski recall numerous ritual acts, such as pouring water at each corner and the center of the square hole in the ice before the bladders are sent away at the close of the Bladder Festival. Four and five steps separated men and women respectively from the land of the dead. *SJM, IIB33 (8.4 cm)*

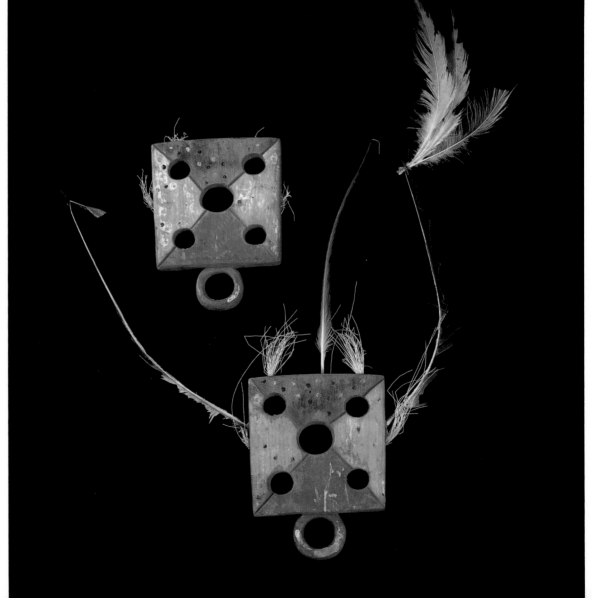

William Tyson (February 1993) reported that a woman said she wore a dance fan with a bear face that had belonged to her grandfather "so that everybody would know what is behind her." Agnes Waskie of Emmonak told the story of her dance fans:

The face on this is what our ancestors are famous for catching. . . . My dance fan has the face of a bear. My great-grandfather used to catch bears without shooting them. He would provoke the bear, and when it attacked, he would dodge out of its way. . . . He would plant his heel and keep turning away. When the bear got tired and was facing away from him, using his spear, he would poke him through the asshole and twist the spear around. That's the way my great-grandfather killed them. He hunted bears and he wasn't afraid of them. (Kamerling and Elder 1989)

While viewing dance fans at the Sheldon Jackson Museum, Wassilie Evan (KYUK 1989, tape 2) commented, "The designs [of finger masks] are fashioned by using [people's] ancestors' ideas, and they continue today. . . . My father instructed me in the family design and that is what I use today." The designs carved or woven into finger masks and dance fans reflect the performer's family history.

### "The Stories behind Them"

Qaneryarangqerrsaaqut-am taukut. Carrait qaneryar-angqerrlaryaaqut.
*There are stories behind those [masks]. There is something of significance to say about every little thing about them.*—Mary Mike, *February 25, 1994*

Many elders, especially those living in Yukon River communities, still remember seeing masks and masked dances in the early 1900s. Most of these men and women speak no English, and tell their stories in Yup'ik. In May 1993 Mary Mike of St. Marys gave Marie Meade one of the most detailed accounts. We translate it in full here to give non-Yup'ik readers an opportunity to listen to a story eloquently told in traditional Yup'ik style.

Mary Mike's stories may seem unnecessarily repetitious. Repetitions, common to all oral literature and used to enhance memory, are a standard feature of Yup'ik oratory and often occur in threes. Ellipses mask such repetitions in quoted statements elsewhere in this book, to conform to written English style, but here we retain them, for readers interested not only in what elders say but how they say it.

### *Mask Stories*
*Told by Mary Mike of St. Marys, May 29, 1993*

*Murilkellukek malrurqugnek kegginaqurluteng pillrat. Avaken tua-i ayagluteng piuratullrullinilriit. Taukugnek taugaam malrurqugnek allrakugni murilkeqapiggluki tua-i tangvallruanka. Kegginaqunek-ll' nalqigciaqluteng. Tamakut-wa tua-i allanret tekirqellratni yuut, yuarun tamana iquklitaqan, kegginaqut taq'aqata, yuugaqateki, pikestiin taum ullagluki nalqigtaqluki-gguq tamakut*

*kegginaqut. Qaillun tua-i nalqiggluki callrat. Murilkeqa-pigcuitanka-am tamakut. Alingnarqut ilait keglunruat, amikuguat—cat-ll' imkut amikugnek pilartatki—cat tua-i tuntut-llu. Unguvalriit-w' tua-i unkumiutaat-ll' mermiutaat alingnarqaqluteng ilait. . . .*

I paid attention twice when they danced with masks. Evidently, it was a custom that was practiced from generation to generation. I seriously paid attention only during those two years. They would explain the stories behind the masks. When the song and mask performance ended and the dancers had taken the masks off, the owners of the masks would come forward and tell the stories about them to the many guests present for the event. Previous to the two years I mentioned, I didn't pay close attention when they explained the stories about them. Some masks depicting wolves and *amikuk* were quite frightening. I'm not sure what an *amikuk* is exactly.[12] There were also caribou masks. Some of the masks depicting sea mammals and other creatures were very frightening.

### Nulirruaq, the Wife-Woman

There was a man we called Quscuar who explained the mask depicting a woman he said had saved him and his brother Atakirraller when they almost died of hypothermia. They say it was at Qip'ngayak, on the Black River, perhaps in March. I say it was March. The people who ran out of food for themselves and their dogs would go down to Qip'ngayak. The river had a lot of needlefish. They would go there to harvest needlefish. When there were a lot of needlefish, some were given to the dogs. People from different places would come to that river and gather the little fish.

At that time they moved down to Qip'ngayak. However, he said the water there was not good to drink, having gotten dark and murky. But they would melt ice and snow for drinking water. There was also a lake on the tundra where they would get some. They would get ice from there, too. One day during a blizzard some women went to get water from that tundra back there. The tundra was quite a distance from Qip'ngayak. I don't know how far it was. The *ingigun* [topographical indication of a natural feature] was pretty far out. They were going to go with sleds. Quscuar and Atakirraller had an older sister who was Mike's uncle's mother. Mike lives down in Emmonak now. Their sister had gone to fetch some water with some other women. Her two younger brothers fussed and cried, wanting to go with them. With the wind blowing from the north causing a blizzard, the weather had been bad, but it had begun to ease up. Crying, the younger brothers followed them in the early evening.

As they were going, the two became confused about their direction. They couldn't see the others up ahead anymore, for the drifting snow had obscured their view. When they became disoriented, they began to go with the wind. To their chagrin, they found they had headed upstream. On their way they approached a black object. When they got to it

12. Edward Nelson (1899:442) heard about *amikuk* one hundred years before. He wrote: "The *ă-mi'-kuk* is said to be a large, slimy, leathery-skin sea animal with four long arms; it is very fierce and seizes a hunter in his kaiak at sea, dragging both under the water. When it pursues a man it is useless for him to try to escape, for if he gets upon the ice the beast will swim below and burst up under his feet; should he reach the shore the creature will swim through the earth in pursuit as easily as through the water."

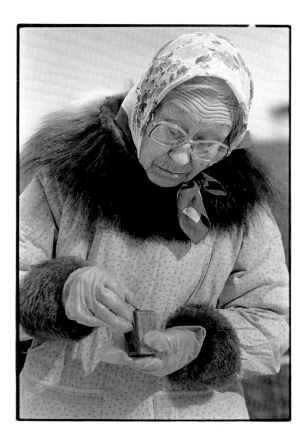

Mary Mike examining a tobacco box at the Mountain Village exhibit, 1989. *JHB*

they saw it was a huge uprooted tree with massive roots. Being unsure what to do or where to go, the older brother, being wiser, had his younger brother nestle in front of him as they crouched down and huddled together on the lee side of those huge roots. There they remained and fell asleep when it got dark. Before they had fallen asleep they had gotten very cold, for it was quite cold then. So both of them had fallen asleep. Soon Quscuar became aware, perhaps awakening to the realization that he wasn't cold anymore! But he could feel heat emanating from somewhere, feeling it on his back, too. He awoke feeling suffocated. And because he had been sleeping he didn't even remember that he was outside in the cold!

Then, trying to focus his mind, Quscuar realized that a person was holding them in her arms, one on each side. Then he realized the person was breastfeeding them. She had presented a breast to each of them. Making an effort to identify the person, he looked and saw a woman there. She began to speak to him and said that since they were experiencing a life-and-death situation, she was protecting them from freezing to death.

They remained there. When daylight came, they could no longer see that woman; she had vanished. Their search party found them there. They took them home.

Quscuar presented a mask of the woman who had come to their aid and given them breast milk. He explained that she was the one who saved them. He said it was Nulirruaq [Wife-Woman]. He said it was the face of Nulirruaq.

He called her Nulirruaq. You know, a long time

ago, young men at a vulnerable age, before they were properly married, could become possessed by Nulirruaq and become obsessed with sexual fantasies. They would actually believe and begin to act as if they were with a woman. Nulirruaq [from *nulirruar-*, "to have delusions about wife-possession, to act as if one has a wife"] was the source of such obsessions.

She came to them and saved them, coming to them while they were sleeping. Since he probably wasn't an ordinary human but an *angalkuq*, she became his *tuunraq*. He would regularly reveal her in a mask. He presented other masks as well, explaining the background for each, but I have forgotten those explanations.

## Ocean-Bird Mask

He also presented a little ocean-bird mask, representing a bird they say liked to land on ice pile-ups on the ocean and sing. I can't remember the name of the bird. I would like to be able to tell some of these stories from the beginning, but I have forgotten them. Anyway Quscuar said that when he was out seal-hunting he woke up one morning and heard a bird singing outside, telling him to go up on land because it was going to get stormy on the ocean. Being curious about what kind of bird it was, he looked out from among the ice pile-ups where they were sleeping, and he saw that it was a cute little bird that had been talking. Then when he said, "Please fly in the direction from which the wind will be blowing," it flew away toward the south. He believed what the little bird had said and told the others that a storm was likely to come.

## Two Loon Masks

And also some time back my late uncle, Tommy's late father [Leggleq], would tell people stories about his own masks. He would tell stories about the wolf masks, *amikuk* masks, and common loon masks. One particular story he told about masks I have not forgotten to this day.

One day when he accompanied his brother sealhunting out on the ocean, it was very calm. There wasn't any wind at all. It turned out that the ice they were on had broken away from the area behind them. Once they realized that, they quickly got ready and rushed toward the shore. But lo and behold, the crack in the ice was already too wide for the sled runners. They ran to check the other end and discovered they were actually on an ice floe drifting away. But it wasn't even windy! The ocean moved in huge rolls even though the wind wasn't blowing. It was a condition called *qairvaaq*.

Then, since everybody had their own kayaks with them and they had no alternative but to use them, he and his brother doubled up in their one kayak. One let the other crawl inside the kayak. And even though it wasn't windy, he put on his *imarnin* [seal-gut raincoat] and secured the spray-cover to the coaming of the kayak hole. I remember they made that cover by

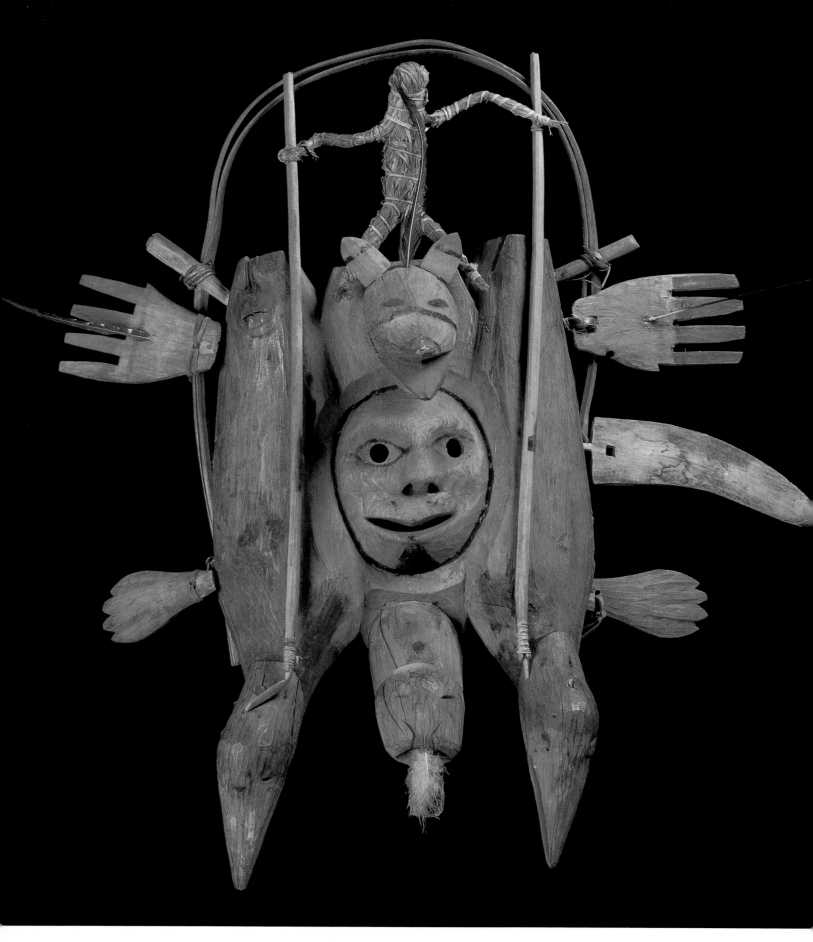

sewing spawned chum salmon skins together. But I can't remember what they called that piece. It looked like a short flared skirt with drawstrings on the top and bottom. They would sew the spawned chum salmon skins together, finishing them so that they would fit securely around the kayak-hole coaming.

They made drawstrings for both the top and bottom of the piece, tying this part around the coaming and fitting the top part over the *imarnin,* tying the strings tightly around the waist to keep the water from coming in. What was it called now? I know the name of that piece, but it has slipped my mind.

Large, powerful mask showing two birds moving side-by-side, reminiscent of Mary Mike's uncle's encounter with loons. A grass figure rides on their backs. Col-

lected by Ellis Allen at Goodnews Bay in 1912. *Burke, 4530 (57 cm)*

Mated pair of wolf masks collected by Henry Neumann at St. Michael in 1890. The smaller, red wolf has a birchbark tongue showing on one side of the mouth, while the larger, blue wolf has a bladder tongue. Wolf masks were common all along the Bering Sea coast, especially north of St. Michael, where they were prominently featured in the Messenger Feast. These are similar to masks collected at St. Michael by H. M. W. Edmonds in the 1890s and by J. H. Turner in 1891. *SJM, IIG12 (19.7 cm) and IIG2 (27.4 cm)*

So, he had the other crawl inside the kayak, or perhaps it was Leggleq himself who had crawled in. The brother was paddling. They began paddling up toward the shore. The ice floe they had been on was drifting alongside them. Way up in the distance they could see land. Goodness, they had drifted way out! The tide going out had caused them to drift out faster than they realized. The ocean current had gotten stronger with the tide. The one inside the kayak, Leggleq, had begun to doze off. And the other person who was paddling had tied the paddle to the kayak in case he dropped it into the water if he dozed off. He tied a line from the paddle to the side of the kayak and continued to paddle. Perhaps it was because the paddler got weary that he fell asleep. Inside the kayak Leggleq was also asleep. Then he slowly awoke from his sleep to a loud, swishing, gurgling sound. He heard the loud swishing sound, and yet their kayak wasn't making a rocking motion. He could feel the kayak moving along swiftly, and yet his brother was sitting still and it didn't sound as if he were paddling out there. He asked his brother what was going on and asked him if he had fallen asleep, too.

And when he found a way to move his head up and look around outside, he saw two common loons swimming, one on each side of the kayak, propelling

it to the shore. Then he suddenly felt their presence at the sides of the kayak. They were bringing it up toward the land. And when his brother woke up, the two loons suddenly vanished. He looked around, and they found themselves already at the shore where the ice had broken away. So there they were. They came out of the kayak. The other hunters had also arrived.

So that was the explanation for the mask. He would bring out those two common loon masks for presentation to the people. He told them that when he and his brother had drifted out on the ice floe, those two had saved them. He said that they helped them. The common loons probably intentionally cast a spell on them so they could move them to shore. They gave them sleep, during which they could propel them to shore. The loons brought them to the shore, and he woke up right before they reached their destination. That was his explanation for the mask.

## Two Wolf Masks

Although they told stories behind the masks, including the wolf masks, I have forgotten the stories behind those that looked frightening. At that time they were frightening. And I do remember the two wolf masks being put on by two men who were across

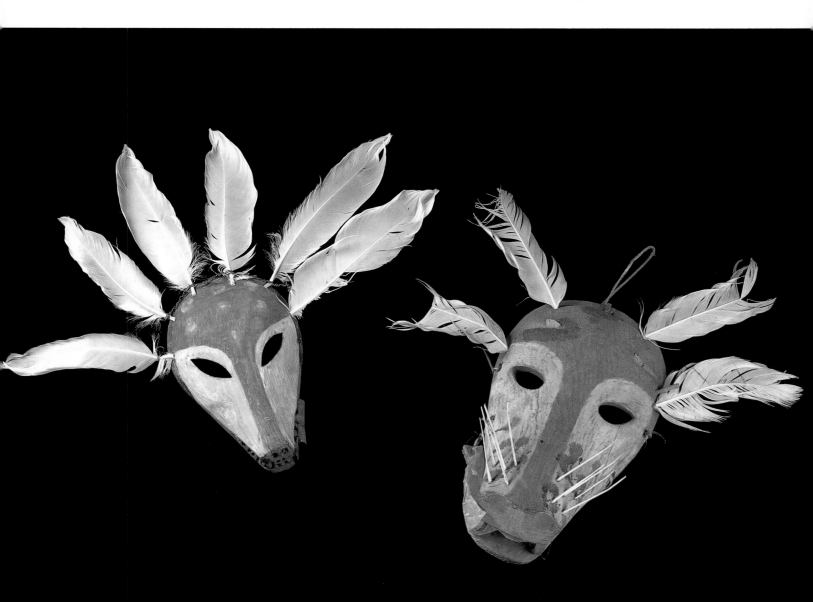

from each other, Atakirraller being one of them. The other person died, and I don't remember his name.

They went outside on top of the *qasgiq* and began howling. It sounded as if the two of them were next to the smokehole on top of the *qasgiq*. They sounded exactly like dogs howling. They entered crawling, hands flat on the floor. They would suddenly howl as they continued to crawl to their place. Howling intermittently, they were not quiet at all. They danced for a while, and probably after the *apallut* were sung, they fought like wolves. They danced bare-chested when they did this. As they were fighting like wolves, their bodies appeared to get all bloody.

They were fighting down there, fighting each other viciously. I didn't watch anymore after I saw blood on one of them. It was real blood. I didn't watch the rest of their fight. Then the owner of the masks, Leggleq, who was quite young at the time, did something to stop them from fighting. They had begun to bleed. I thought they had actually wounded each other. The other people there also thought that one of them had been wounded. They had really fought each other ferociously. Unexpectedly, neither had received cuts from the fight. Yet we had seen blood on them while they were fighting. Leggleq went up to them and stopped the fight. I don't know what he did to them. Actually he talked about it, but I don't remember what he said. Many of us were scared when they were fighting so ferociously.

## Two *Amikuk* Masks

And also I think his companion, the late Quscuar, owned an *amikuk* mask. He had his daughter stand at the back of the *qasgiq*, and had her mother stand on the opposite side. The two women were [biologically] mother and daughter. They both wore long, tattered full-length cloth *qasperek* [*ciqay'allraak*] over their fancy fur parkas. I asked myself why they had done that to their beautiful parkas. I wondered why they had covered their gorgeous parkas with tattered cloth garments. Apparently, they had done that because someone was going to tear up the outer cover during the presentation.

The babies the daughter bore had not been able to survive. That was why they were making the presentation. And her mother, having had the same problem, had successfully raised only that daughter standing with her. While they were dancing, perhaps during the *apalluq*, a dancer wearing an *amikuk* mask approached her. Starting from the hood of the *qaspeq*, the person with the mask began to tear the *qaspeq*, shredding it apart until it fell to the floor. He did this again to the other woman. He shredded the old *qaspeq* down to the floor. Their beautiful parkas were exposed for all to see. Freed at last from those old coverings, the two of them began to dance.

There were two men wearing *amikuk* masks. Then one of them stood up and tore up the *qasperek* the two women were wearing. He tore them all the way down to the floor. That ritual signified the removal from the women of the negative aura that caused

them their great affliction. They were undergoing the ritual because their babies always died. When his daughter's husband died, she remarried and bore several children. Only one of her children is still alive, down at Sheldon's Point. His/her name is Aqumgaurluq. They say that his/her father's grandfather, an *angalkuq*, named her/him Aqumgaurluq, which is a *tuunraq* name. Her other two children are already dead.

What is an *amikuk*, anyway? It's an animal. It's a living creature. I wonder what an *amikuk* is. He used his *tuunraq*, the *amikuk*, on mothers-to-be during delivery. That *amikuk* is associated with childbirth. You know, some women hemorrhage when they deliver babies, to the point of near-death or even actual death. That person who owned the mask would use it to help these women. And indeed there is a ritual song that goes with it. I've heard him sing a song that mentions the *amikuk* in the lyrics. The verse would include mention of the *amikuk* in one line, and in another line he would be telling the *amikuk* to suck it [the placenta?] out even though it was deep inside the person who was hemorrhaging. So there's a song like that about the *amikuk*.

The *apalluq* of the song mentioned the *amikuk*:

*Use it on the one who is bleeding.*
*Though it is deep, would you suck it out?*

These were the words in the *apalluq*. He always changed the words in the *apalluq*. When he sang it the next time, the following year or whenever, he would sing it the new way. The only line he ever changed in the *apalluq* of the song would be the one that goes, "Though it is deep, would you pull it out?" He would make a new *apalluq* for it that way.

They say the *amikuk* was used for women delivering babies. As mentioned before, some women die of complications during delivery. It was the one that would save women who were having such complications while giving birth. That was why the words to the song say, "Would you suck or pull it out even though it's deep?" *Mikelnguum kingunra*, the placenta . . . you know, some women die after hemorrhaging. It's probably that. You know, they say sometimes a woman died from bleeding too much. That's probably what it was. That's probably what it would be. So he would sing that way. The song they sang was like that. They would sing that song all the time during those presentations. However, they would change the words in the *apalluq* of the song. But actually the song didn't change very much.

No doubt they wished intensely that the generation that followed them, including their own relatives, would learn some of the songs. After they had departed this world, they would want those songs that were used for healing and general well-being to be passed on so that they would be carried forward from generation to generation.

One of three *amikuk* masks collected in the early 1900s by A. H. Twitchell, who wrote, "Mask representing Amekak, a spirit that lives in the ground. He comes out at times but leaves no hole in the ground. He sometimes dislikes men and will jump through them, but leaves no mark. The man then lies down and dies."

More recently, Joseph Evan (July 12, 1994) recalled:

*It is said that some people hear* amikuk *out in the wilderness as they move about in the spring. It's hard to tell where the sound is coming from. And though it sounds like it's coming from the land, there's nothing there. It isn't visible.*

*When a person hears the sound it gets louder and louder. They keep hearing the sound. . . . When the creature swims around in the earth near the person, the ground they're walking on becomes like quicksand. And if a person is holding an* ayaruq *[walking stick] when an* amikuk *comes, they begin to feel very different. They become weak. It is said that this happens when the creature begins entering inside them and begins to swim in their body.*

*NMAI 9/3421 (26.9 cm)*

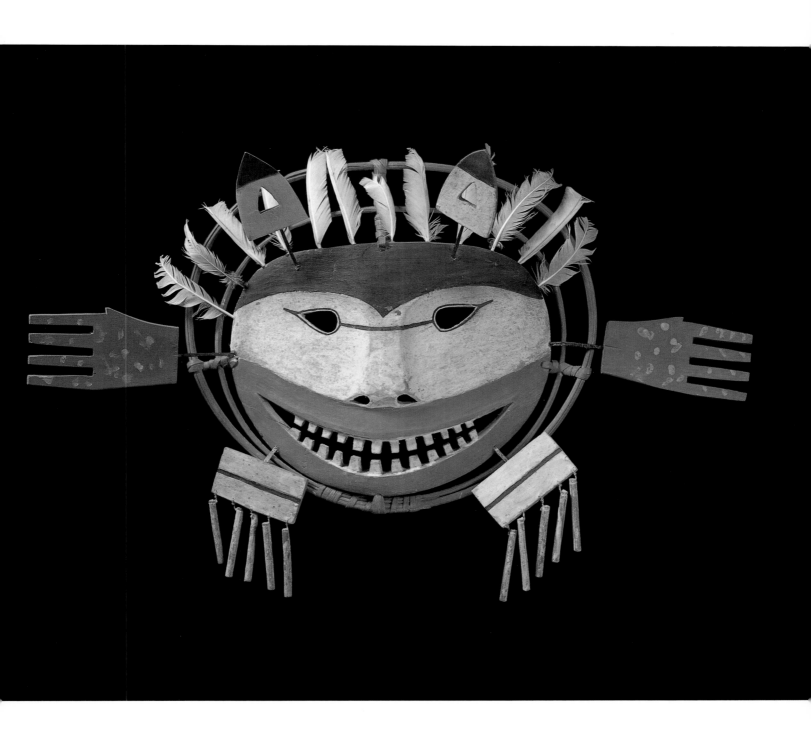

# In the *Qasgiq*

The elaborate, dramatic context of masked dancing—its theater—was the *qasgiq*. Masks were a central feature in the representation of and communication with the spirit world, but their effect depended on many other things. The backdrop included heavenly hoops hung from the ceiling, the underground entranceway was transformed into a watery passage between land and sea, and dancers employed a plethora of carved figures, dance wands, and elaborate ceremonial regalia to communicate the essentials of the story.

*Qasgiq* is usually translated "men's house," but "community house" perhaps better represents its function. Although the *qasgiq* was the place where men worked, slept, ate, and bathed, just as important was its use as the main meeting place for all members of the community for both formal and informal gatherings.

Each winter village had at least one *qasgiq,* and larger communities had two or three. Like the villages they served, some were modest structures, while others could accommodate as many as three hundred people during an intervillage dance. In many parts of southwestern Alaska it has been only in the last fifty years that men abandoned the *qasgiq,* encouraged by missionaries to build frame houses and live with their wives in a nuclear family setting.

The oldest men today came of age in the *qasgiq* and still remember how it looked and how it was made. Joseph Tuluk (July 14, 1994) of Chevak described the construction of this semisubterranean building:

When they made a *qasgiq,* they dug in the ground. And then they used wood to make a wall, covered with dirt. When they were putting up the rafters, they put up posts in the corners. Then they put a long log on the roof just the right size. . . . They put up other logs on the door side. If they were about to put up another rafter log, they would put a small piece of log at a 45 degree angle and put up another log on top of it. Then they put another long log on it. That is how they gradually made it go up until it was quite high. When it got so high, on the outside they put a long log as an outer layer. When they finished they would cover it with a thin layer of dirt from the surrounding area . . . overlapping the sod they were putting on. They did that upwards . . . covering it all. . . . They made it well insulated.

They made a firepit down there . . . and an entrance all the way to the outside. That door had about three posts. So they would come in through the underground entrance. They made a door outside so one could come up and go out into the porch. And they covered the top of that with sod. They also made a door that could be used instead of going down. When they came in from outside, they went down at the porch. And they came in from underground; and inside the *qasgiq* the floor door was in the middle of the interior. And so one came up.

That was their step inside the *qasgiq* by the firepit under the floorboards. They stepped on that and went up. Short people would lean on the side, swing their legs up and, lying down, they would go up. [*Laughs*] But when children put their hands on the side of the entrance, [adults] would go down to them and hoist them up.

Jasper Louis (May 29, 1993) remembered the wooden handles on each side of the underground entrance hole to help people swing themselves up into the *qasgiq:* "We call them *ayaperyarak* [dual, from *ayaper-,* "to lean on one's hands"]. The entrance to the *qasgiq* was traditionally a hole. And when you came up through the hole you would find *pall'itak* [two handrails] here on the sides. You would place your hands on them and come up into the *qasgiq.*"

Inside the *qasgiq* each man had his accustomed place. The rear of the *qasgiq,* the warmest and driest spot, was reserved as the place of honor, while older men and inactive hunters occupied the corners to the sides of the door: "The elders, especially, would stay closer to the entrance hole. An elder was called *uaqsigilria* [one who is nearing the exit]. . . . And the others stayed further inside. They would have *ingleret*

Ivory dance house collected on the Kuskokwim in 1890 by Adolph Neumann and labeled "Potlatch Dance." A fully dressed figure stands beside a man holding up a skin, as in the presentation of gifts during the Messenger Feast. To his left is a figure holding up a saw. Facing these three is a male performer. Behind him a man pulls a cord attached to the ceiling, raising and lowering a carved image. Men sit on surrounding benches in ritually significant groups— three sets of five—observing four presenters. *SJM, IIS1 (37.5 cm high)*

Drawing of *qasgiq* after E. W. Nelson, 1899. *Fitzhugh and Kaplan (1982:163)*

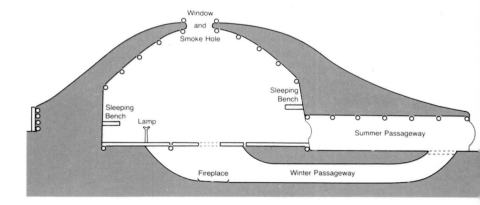

[benches] . . . all the way around the wall. Some of them would sit there and sleep there also" (Jasper Louis, May 29, 1993).

Mary Mike (February 28, 1994) described the interior of the *qasgiq* when guests arrived for *agayu* masked dancing:

When they arrived their men would go to the *qasgiq*. And their women would go to the homes of their hosts. Not long after, the *qasgiq* would begin to smoke. They always got the wood ready before their guests arrived. It was when they had fire baths. Some of the places would have huge *qasgit* . . . for community gatherings. There would be a huge firepit down in the middle. Then after [the men] took a bath, the young girls who were just turning into adults would bring them food in dishes.

Oh my, just when [the guests] arrived they brought them a little bit of food such as dried fish. They would

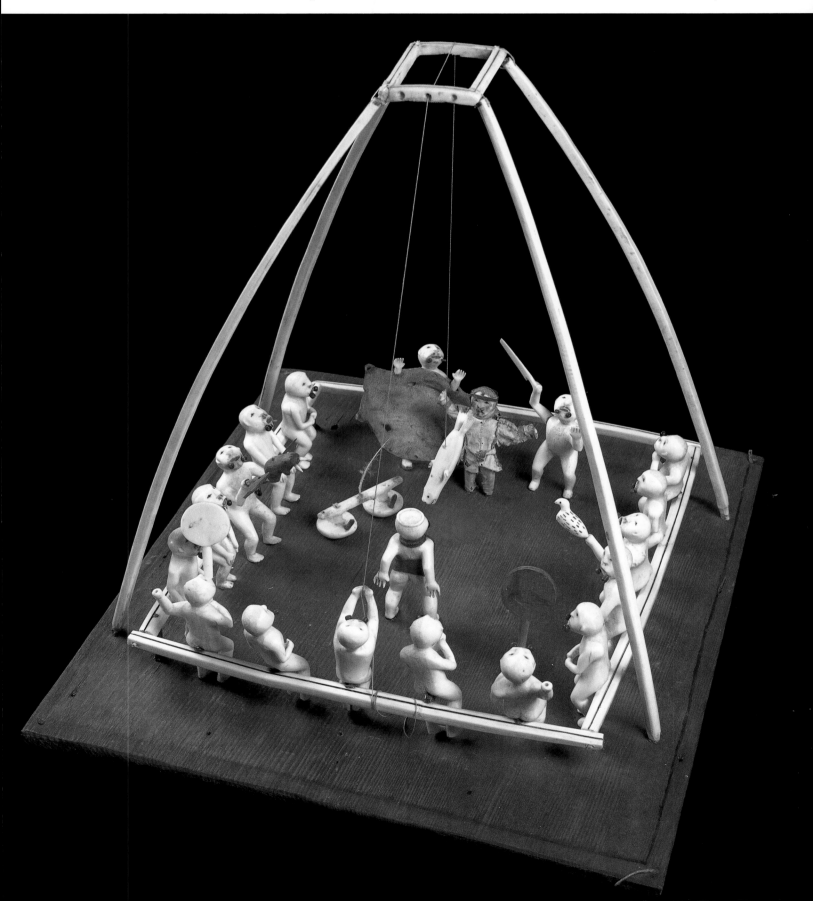

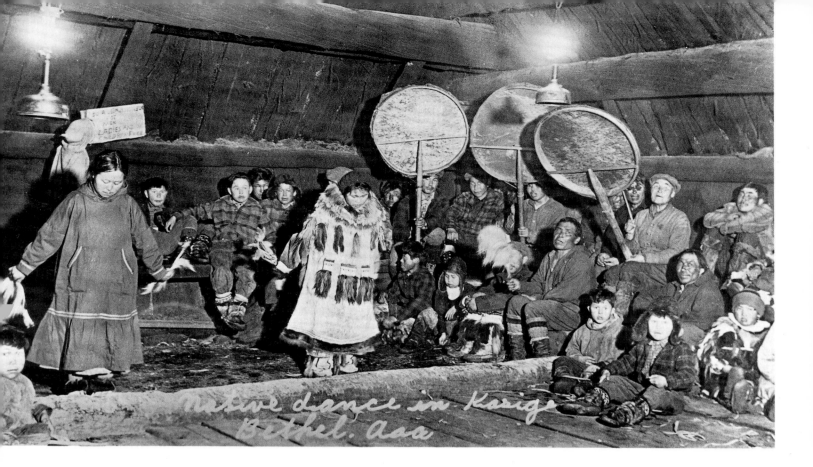

*Native dance in Kasige Bethel. Aaa*

call it *payugarciyaraq* [presenting food to a friend or relative]. . . . They would say they were making them feel welcome—the guests that had arrived.

The food carriers would wait until [the men] had eaten, and when their bowls were empty they would leave. After they left smoke would start coming out of the *qasgiq*. [The men] would start the fire and bathe. Then as soon as they were done bathing [the women] would bring them a full meal. . . .

After they bathed and ate they would invite all the guests, including the women, to the *qasgiq*. They didn't bring in the gifts at the beginning. . . . Then, after all the guests assembled in the *qasgiq,* the hosts would finally go across and join them. Then they would sing. Since they did the dances they called *yurat* in the fall, when the days got longer like now they would say they were making songs and dances they called *agayut*. . . .

The back of the *qasgiq* . . . would have benches all the way around . . . called *ingleret* . . . high enough so that a person could sit underneath. People would be sitting up there all the way around. And the space under the bench would be filled with people all the way around. And those down there would have a wooden bench in the back too. [During *agayu* dances people were not allowed to sit on the bare floor.] They would sing and drum sitting across from each other. And there would be a [long] board on which their lamp was lit. . . . There would be candles lit up across it. And there would be two more hanging lights on the bench, or they would put strings on them and hang them. Or they would let some of them sit on the surface. You never saw gasoline lights. In our opinion it was very bright in there . . . since there were many candles lit. There would be a row of them under the people sitting up there.

The hosts would sit across from each other and drum. They would be sitting on a piece of wood about so high. And the dancers would dance down there in pairs. There would always be two men dancers down there with two women standing and dancing. . . . And when they finally finished presenting their dances, those giving away food would begin bringing it in. They would gather different kinds of food ahead of time for the event.

Ordinarily the *qasgiq* was a sod and wood structure devoid of decoration. During dances, however, it came to life in myriad ways. Stories were everywhere, carved into the masks and dance fans, woven into the clothing, painted on drumheads. Even the skylight covers, constructed of strips of dried seal gut sewn together, told a story. Himmelheber (1993:23), who collected several of these delicate, translucent works of art when he visited southwestern Alaska in 1936–37, associated window painting exclusively with the "Inviting-In" Festival before which guests painted a window and gave it to the messenger to show accep-

Women dancing in the *qasgiq* in Bethel, 1932. Two gasoline lanterns light the room. *FD, MA (Pa.)*

Painted gut skylight (*ega-leq*), collected by Hans Himmelheber in southwestern Alaska in 1936–1937, which tells the story of the painter's ancestor who, when paddling down the Kuskokwim, suddenly saw half a dozen graveposts running toward him. They had carved faces but human arms and legs. When he shot an arrow at one, they transformed into wolves and ran away.

Newly painted windows were often given to the *yua* of the *qasgiq* during the Messenger Feast, as well as on other occasions. Had Himmelheber not purchased the window, the wind and weather would have quickly erased the painting. *UAM, 67–0286 (40.6 cm by 49.5 cm)*

Jacobsen identified this small Yukon mask as "a village spirit whose name is unknown. Each village, even each house, has its spirit." This may be the representation of the *yua* of a *qasgiq* reported by Hawkes (1913:4), who gave gifts to village leaders so that the "kazgi inua—the spirit which sits in the posts and presides over the kazgi—might not be offended." *MV, IVA4400 (15.3 cm high)*

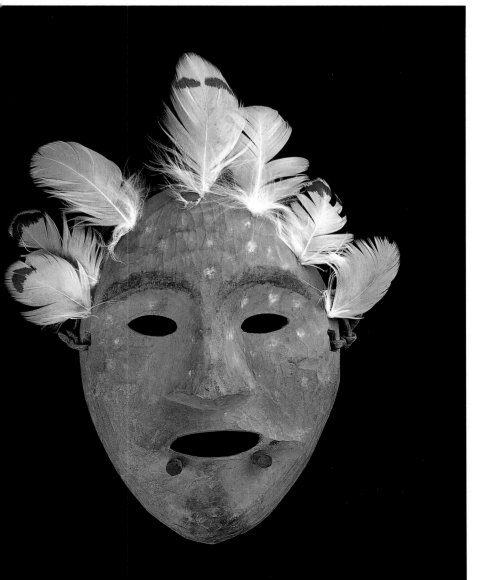

tance of the invitation. Contemporary elders remember various times when painted windows were presented. According to Joseph Tuluk (July 14, 1994), "A long time ago, when they wanted to have *ineqsuyuk* [honoring of a dear child] when a child got his first game, they had a feast. And they included a *qasgiq* window of seal gut that was painted. They had all kinds of designs such as reindeer or anything—those windows that were given out along with other things during *ineqsuyuk*."

Jasper Louis (February 25, 1994) described the significance of the designs themselves as visible markers of events passed down from generation to generation: "In the *qasgiq* they had some designs too. Before I knew about them, they stopped having designs. . . . The skylight cover had designs about things their ancestors had done. When the visitors saw the designs on them they figured out who their ancestors were. And if one of the guests recognized a certain design they would find out who their relatives were."

Paul John (February 22, 1994) stated, "They would make a design on anything, and they would especially make a design on the window of the *qasgiq*. . . . A man would make a design on the window about the [animal] he caught the most while he was trying to make a living." The artist painted only what happened within his own family. When people heard one of their family stories or saw a familiar painting

in another village, they knew that the artist must be their relative (Himmelheber 1993:23).

In many ways people treated the *qasgiq* like a respected person, and they gave those in the larger communities proper names. According to Billy Lincoln of Toksook Bay (January 5, 1991), if a village had two *qasgit*, they had independent names, such as Qasgirpak (Big *Qasgiq*) or Angulvik (Place of *Angun* [Man]). Running and unruly behavior were ordinarily prohibited in its vicinity. Men regularly purified their abode by vigorously sweeping the floor and emptying the urine and water buckets, accompanying this action with noise and drumming to drive off evil influences. During ceremonial distributions, the *qasgiq* might receive gifts in its name, such as a new gut window or clay lamp. Through deferential treatment, naming, purification, and gifting, the men honored the *yua* of the *qasgiq*. In some cases they even carved masks to represent and celebrate this respected "person."

### Ellanguaq

One of the most impressive and memorable ornaments accompanying masked dancing was the *ellanguaq* (pretend or model universe), which consisted of a number of large wooden rings suspended from the *qasgiq* ceiling, connected to each other by wooden rods. This entire contraption was decorated with feathers and down, as well as numerous carved figures. During a performance the *ellanguaq* was moved up and down with cords. Many contemporary elders describe the excitement the *ellanguaq* evoked. Ivan Hamilton of Emmonak recalled,

Long ago they made the dance house a happy and exciting place. They hung a hoop from the ceiling and hung feathers from it which they called snowflakes. From the center of the sky they hung the pretend hawk, held together with string. When the song ended, the hawk would fall and break into pieces. It was breathtaking to see, like a movie. It lifted one's spirits. They shook this pretend universe in rhythm as they sang, and the whole dance house moved with excitement. At the same time masked dancers would call out in the voices of animals they represented . . . like bearded seals, foxes, ravens, and seagulls. It was something to behold. (Kamerling and Elder 1989)

One hundred years ago, Nelson (1899:496) described a comparable *ellanguaq*—the one that the *angalkuq* in the origin story of the "Inviting-In" Feast saw hanging from the roof of the heavenly *qasgiq*. It consisted of enormous wooden hoops representing the heavens, decorated with tufts of down and feathers signifying snowflakes and stars. A cord raised and lowered the hoops in time to the beating of the drum, symbolizing the approach and retreat of the heavens. On his return to earth, the *angalkuq* instructed the people to hold a great festival every February and to decorate their *qasgiq* to look like its heavenly counterpart. He and his companion taught the people all necessary

ceremonies, during which people made offerings to the *yuit* of the animals and sang songs in their honor: "If these instructions were properly followed, game and food would be plentiful on the earth, for the people in the sky house were the shades or *inuas* controlling all kinds of birds and fish and other game animals on the earth."

In the late 1800s the *ellanguaq* was used in the Yukon "Doll Festival," which Nelson (1899:494) said originated at Paimiut. It spread to the coast as well as upriver into Athapaskan territory (see also Osgood 1958:100, cited in Ray 1967). The use of the *ellanguaq* was not restricted to the Yukon area, but occurred in coastal villages as well. Himmelheber (Fienup-Riordan 1996) observed a variation on the coastal *ellanguaq* during the Bladder Festival he attended on Nunivak in 1936:

In the midst of the room, hanging from the ceiling, was a type of globe-frame consisting of three wooden hoops the diameter of a large children's hoop. They were placed together so that they looked like the equator and two vertical meridians. Within the structure burned a small oil lamp. The whole was decorated with some feathers and a bundle of a plant. The strange object is called Kokakmamguach [*qukaq*, "middle, center," lit., "model center"], the very center. Nothing more was known about it. When I asked, half in fun, if it could mean "the world," it was accepted as an enlightening suggestion. The Nunivak natives indeed have a similar perception of the cosmos.

One St. Marys elder (February 15, 1993) described the use of the *ellanguaq* following direct communication between the people and the spirit world:

Before they shook the *ellanguaq,* they used to invite the *ircenrrat.* The people in the *qasgiq* could hear them when they responded. The residents of the *qasgiq* stamped their feet on the plank flooring and made thunderous sounds at intervals. After they did that those people would stop momentarily and sit on the floor. Then . . . a thundering sound would strike from down below. They say that was [the *ircenrrat*'s] way of affirmation. Then after they got their endorsement from them they would gather to celebrate [*kassiyurluteng*] and would use the *ellanguaq.*

Willie Kamkoff (February 27, 1994) emphasized the importance of performing the event properly and accompanying the *ellanguaq* with appropriate songs. A modern presentation he witnessed did not meet these high standards: "When I listened I didn't hear the song of *ellanguaq.* And I don't think some things were presented. Nowadays kids are too wild, and you cannot place things on the floor [because] there would be too many children." Kamkoff described the *ellanguaq* as a "long, involved work" requiring months of preparation. People only rarely presented the *ellanguaq,* and not every village hosted such a presentation. Kamkoff's grandmother had lived in Pastuli and saw the *ellanguaq* presented only twice in her lifetime.

Mary Mike (February 25, 1994) saw the *ellanguaq* used once at Pilot Station as recently as the 1970s. As with masks, each hanging figure had its own meaning, which a respected elder explained to the people:

It was hanging up there in the *qasgiq*. . . . The huge bird, here, and also a figure of a woman were hanging. . . . Apparently, when a woman fetched some water in the evening that eagle flew away with her. Then it landed with her on a tall mountain up there along the Yukon River. She disappeared from her family, but they found her bucket by the hole in the ice. . . .

There were little animals such as ptarmigans and rabbits hanging from [the *ellanguaq*]. They say those were the kinds of animals the eagle caught.

That was the *ellanguaq.* The late Noel Polty told the story about it. He said that the old man Uicimalleq had given the village permission to present the *ellanguaq.*

Pilot Station elders (February 27, 1994) recalled:

The *ellanguaq* did not actually originate from up there. Long ago they gathered for the Messenger Feast. . . . When they took part in the event *taitnauryaraq* [asking songs] up at Russian Mission, that *ellanguaq* was used there, and Pilot Station stole it from them. [*Laughter*] . . . They say when they shook the *ellanguaq,* the people from Russian Mission separated and fled to the site of Pilot Station.

Dancers performed with a *ellanguaq* in Bethel in 1982. And as recently as the 1993 Cama-i Dance Festival[13] in Bethel, decorations were hung from a net (rather than carved wooden hoops) in the center of the high school gymnasium where the dances were held. A male *yuguaq* ("human figure," lit., "pretend person") hung from the center of this *ellanguaq,* and a person on the side made the figure move up and down.

Justina Mike (March 1, 1994) suggested that, like individual masks used to request particular species

13. The greeting *Cama-i* translates "Hello" and is usually accompanied by a handshake and a smile.

Joe Friday of Chevak pulling the rope attached to a *yuguaq* (human figure), making it move during the 1982 masked dances in Bethel. The masks used during the performance lie on the floor in front of the drummers. A grass mat hangs against the back wall. *JHB*

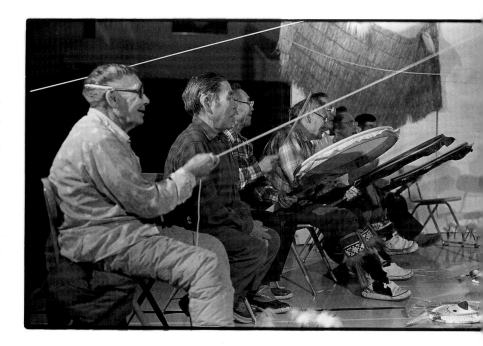

and the *agayu* dances performed to request a bounteous harvest in the coming year, the *ellanguaq* was used to elicit the good weather necessary to make such a harvest possible:

They would really decorate the ceiling for the presentation of the *ellanguaq*. . . . Perhaps they did that to make sure *ella* [weather, universe, world, awareness] remains good to them. They would call it *ellanguaryaraq* [the way of doing *ellanguaq*]. Or was it to make sure *ella* would not be disgusted, and the people begin to run out of food? The adage was "*ella agniluku*" ["*ella* is going over," implying uncooperative weather].

The movement of the *ellanguaq* to promote well-being is in keeping with the concept of *ella,* which was central to Yup'ik cosmology (see Fienup-Riordan 1994:355–62). At many points in the traditional ritual process, men and women moved *ella maliggluku* ("following the universe" clockwise, east to west) to create a boundary against evil and promote a successful future. Andy Kinzy (February 28, 1993) said, "I understand that expression *ella maliggluku* like this. A person will follow the *ella* and travel the same path if he wants to lead a good life. However, if he goes against it . . . he will reject the very thing that would

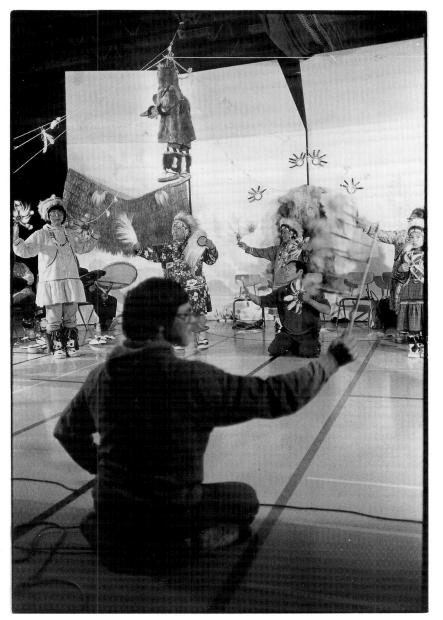

*Yuguaq* hanging in the center of a rope *ellanguaq* created for the 1982 masked dances in Bethel. A young man moves a dance wand to the drum's rhythm in the foreground. Men's dance fans hang on the back wall. *JHB*

help him in his life. But if he goes with it he will experience compassion and solace in his life along the way." The use of the *ellanguaq* and movement *ella maliggluku* still have meaning in southwestern Alaska, embodying a view of the world in which individual acts have the power to affect a person's future.

## Moving Images of the Sky

The *ellanguaq* was decorated with all manner of wooden figures, which also appeared on their own. Along with models of birds and human puppet figures, they included various mechanical animals. Just as some masks had movable parts, bird images flapped their wings, fish swam through the air, and human figures appeared to run across the room. Some people referred to these hanging images as "things of the *qilak* [ceiling, sky, heaven]." Martha Mann (July 8, 1994) of Kwigillingok recalled, "The *angalkut* would use *pekcetaat* [things to move around] and make them move. They would stretch out the skin rope up there and let them run around up there."

In the 1840s Zagoskin (Michael 1967:129) described carved figures, including an owl, a human head, a seagull and two ptarmigan hanging in the *qasgiq* during a Bladder Festival and put in motion during the evening dance performances: "The owl could flap its wings and turn its head, activated by strings and a clever mechanism; the gull, pecking the floor with its iron beak, appeared to be catching a fish, and the partridges [ptarmigan], coming together, kissed each other. During the holiday the natives never left their toys all day, and in the evening they danced for our entertainment."

In 1879 Nelson (1899:382–83) observed a carved seagull that could be made to glide up and down during the Qissunaq Bladder Festival. In the other *qasgiq* in the same village hung an image of a person wrapped in an eider duck skin, illustrating an important relationship between humans and seabirds such as the eider and the gull. Just as humans viewed seals as honored "persons" during the Bladder Festival, they believed seals perceived successful hunters as seabirds during the hunt. The birds hanging in the *qasgiq* along with the bladders during the Bladder Festival vividly recalled this relationship (Fienup-Riordan 1990b).

Jasper Louis (February 25, 1994) remembered things hanging in the *qasgiq*. People used these images, like the paintings on gut windows, to make their past actions known to others: "Those who were knowledgeable about them could identify who the ancestors were. They were used to identify themselves to others."

An object might also be hung in the *qasgiq* to signify a village's sentiments toward its rival. Commenting on a wooden fish-egg smasher they saw at the Sheldon Jackson Museum, Wassilie Evan recalled one such episode: "At one time, when we had an exchange dance (*curukaq*) at Cuukvagtuli they hung two egg smashers in the *qasgiq* across from each

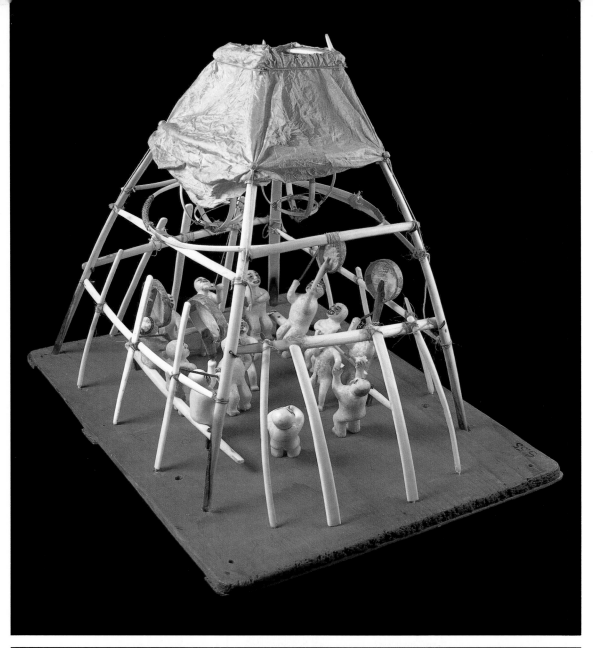

Ivory *qasgiq* model, probably made for the infant souvenir market and collected on the Kuskokwim in the 1890s. Four ivory drummers beat time while five men dance, recalling both the hand (four fingers and thumb) and square hole (four corners and a center). One of the dancers holds a dance stick with a bird at its tip. Suspended from the *qasgiq* roof are two global lamp frames and a small ivory bird such as those hung from the *qasgiq* ceiling during the presentation of the *ellanguaq*. ASM, IIA5350 (28.3 cm high)

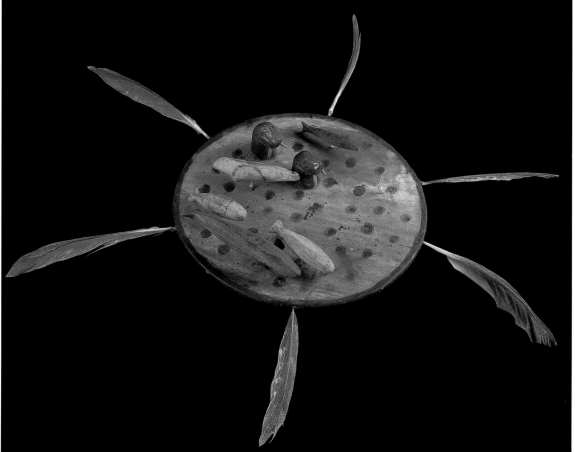

Hanging dance ornament with carved animal attachments supported on feather quills including two walrus, one whale, one ringed seal, one fish, and holes for three additional figures now lost. Black feathers around the rim are held in place with wooden plugs. J. H. Turner collected this unusual piece on the lower Yukon in 1891. Like the *ellanguaq,* it was probably made to rise and fall during performance. SI, 153674 (54.6 cm)

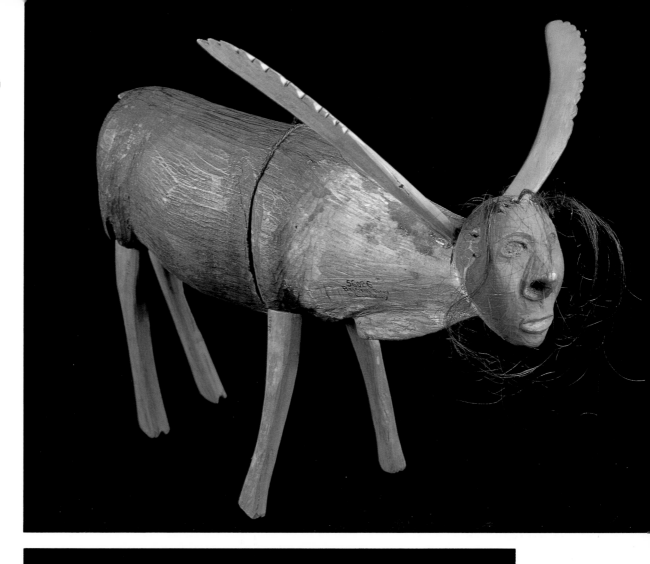

Caribou person from Bristol Bay, probably made to hang in the *qasgiq* during winter ceremonies. Collected by Charles L. McKay in 1882. *SI, 56026 (27.3 cm)*

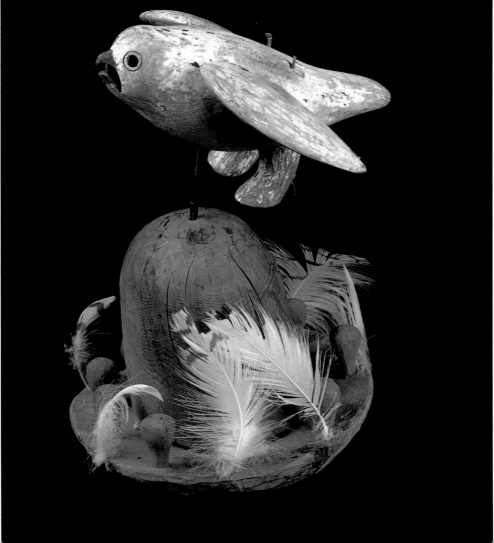

Owl perched on a mountain, collected on the lower Yukon by Jacobsen, who labeled this unusual figure a "shaman's mask," noting that many such objects were found in *qasgit.* The owl was often associated with *angalkut,* in part because of its extraordinary vision. *MV, IVA5429 (28 cm)*

IN THE
*QASGIQ*

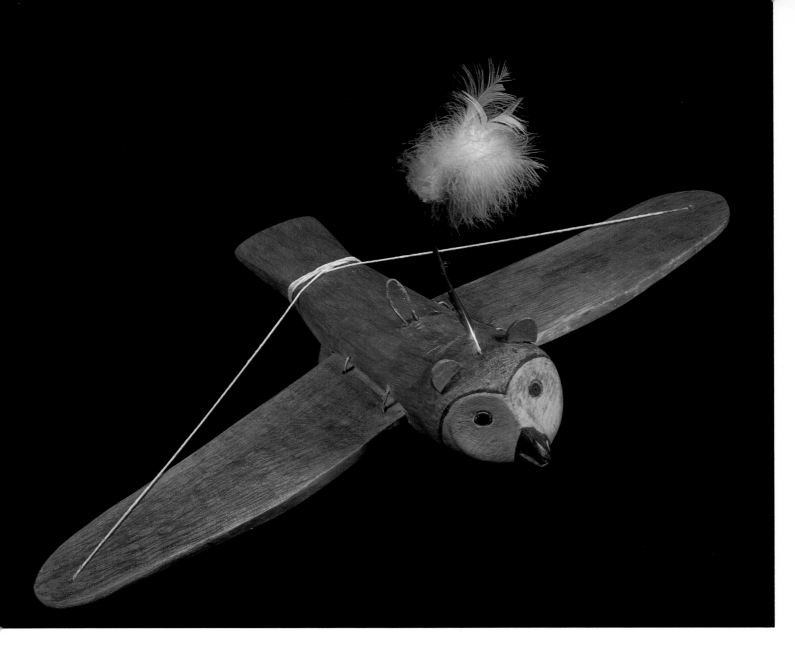

other. . . . The host village elders did not think highly of the men of the other village that they had invited [and they doubted their accomplishments] so they hung the fish-egg smashers . . . in the *qasgiq*" (KYUK 1989, tape 4).

Martha Mann (July 8, 1994) mentioned puppets dressed in gut parkas that dashed across the room. She also recalled *ellanguaq* decorated with *qilaamruyaat* (hanging lamps) and *qirussit* ("wooden decorations or appendages"; sing., *qirussiq*) and a parka-clad doll, which she called *neviaq* (from *neviarcaq*, "young woman"), running through the air. Both puppets were created to tell a story about someone's past experience.

The *angalkut* were the ones that did *ellanguaq*. . . . They would call them . . . *qilaamruyaat*, wooden pieces with lights in them that hung from the *qasgiq* ceiling when they danced. . . . They would light the lamps. They would be bright. When they did the Agayuyaraq, some of the *angalkut* would make a figure of a person move up there—it looked just like a person. And when they called it, it would run across the ceiling. . . . It was a movable object with a skin rope tied to it for pulling. . . . It looked like an actual person.

That movable object would be called *neviaq*. [They would call out,] "Is the *neviaq* coming to check on them?"

Carvings of animals were *qirussit* around [the masks]. They were decorated. It would be beautiful inside the *qasgiq* with bird down feathers everywhere. The boys who were dancing would also dance with cute masks on. The drums were also decorated with old-squaw duck feathers with white down feathers on the tips. And their *enirarautet* [dance sticks, "pointers"] would have long bird quills with soft down feathers on the tips. They would be beautiful.

Chevak elders Joseph Tuluk and David Boyscout (July 14, 1994) describe the variety of *qirussit*. Like the masks, the hanging figures told particular stories and were never the same. They noted especially the use of replicas of Arctic loons on the top of the "model of the firmament" because "they were such good food catchers . . . never without a fish in their beaks, they catch fish underwater."

Paul John (February 22, 1994) spoke of wooden images hung so that things would be abundant in the future: "They used to call them *pinguarcuutait* [replicas]. . . . While making them, one's thought is that

Dance object representing a short-eared owl with movable wings and leather loop at the top to hang it from the *qasgiq* ceiling. According to A. H. Twitchell, who collected it near Bethel in the early 1900s, "the owl represents a good hunter in the night, and so some men can find game in the dark." *NMAI, 9/3435 (37.5 cm)*

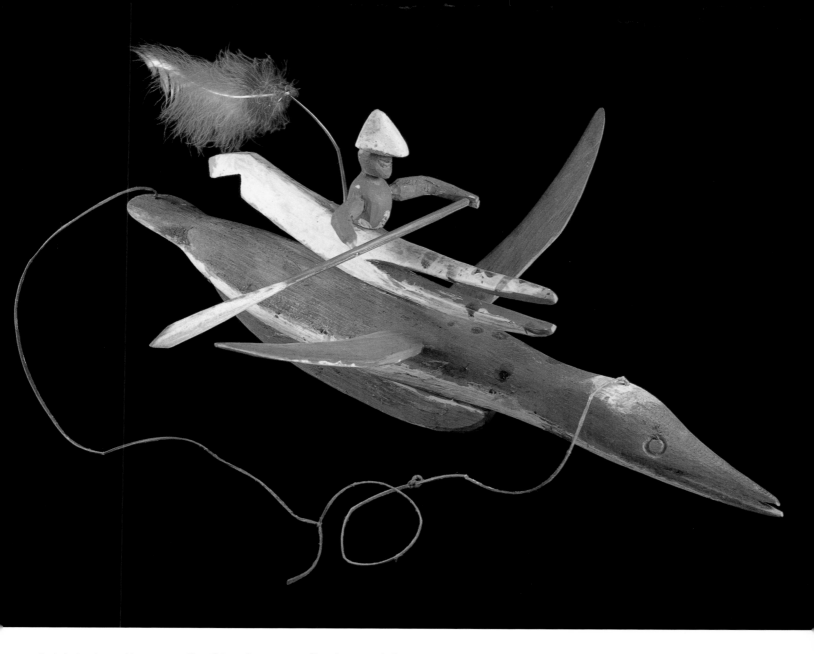

Kuskokwim dance object
designed to hang from the
ceiling with a leather cord,
representing a hunter in his
kayak riding on the back
of a thresher shark "that
catches anything it wants
to." The kayak also has a
sharklike mouth. Twitchell
obtained four thresher shark
dance ornaments in the
early 1900s, but this is the
only one still in the National
Museum of the American
Indian's collection. *NMAI,
9/3442 (48.9 cm)*

the thing they are replicating won't be so scarce. They are made to encourage that item it represents to become more abundant, just like the woman [who presented the bearded-seal mask] who wanted the coastal people to be good catchers."

Mary Mike (February 28, 1994) recounted a "hunt" enacted between a mechanical owl and ptarmigan:

A carving of a snowy owl would hang up there with a string attached to it. They would make it fly continuously. And below it was a little bird. Perhaps it was a ptarmigan. The talons of the snowy owl would be protruding. It looked like it was about to grab the ptarmigan. There would be two people on both sides pulling the string making it . . . flap its wings and appear to be actually flying. This would go on while they were dancing. One of the makers of the masks would be presenting [the snowy owl].

Sometimes the figure takes the form of a mask, transforming the performer into a mechanical creature. Peter Lupie (June 18, 1985) of Tuntutuliak described a performance involving an enormous wooden loon:

The head was in the front and the wings stretched out on the side about five feet. . . . It had a tail at the back and it had a hole in the center where a man stood inside. . . . If I were in one of these loons it would be about five feet by five feet. The strings would come up around my shoulders. If I wore one of those, and a wooden mask, and I were dancing, the wooden loon would be loosely dangling around my waist. . . . There are lots of things like that the people danced with.

Fannie Waski (January 15, 1994) described a masked dance at Qinaq, during which a model bird hung in the *qasgiq:* "They used masks and they had *enirarautet.* Old men wearing strange masks 'pointed' [with dance sticks]. And up there were two small birds, looking like loons, continually making noise. My word! . . . They kept making bird noises up there."

Joshua Phillip (July 1, 1988) described human figures used along the Kuskokwim above Bethel that spoke, walked, ate, and wore out their clothes:

The *angalkuq* would make replicas of humans, and make them able to move and also make them speak. . . . At Kwethluk and at Akiachak there were ones of that type. And the witnesses to those are alive

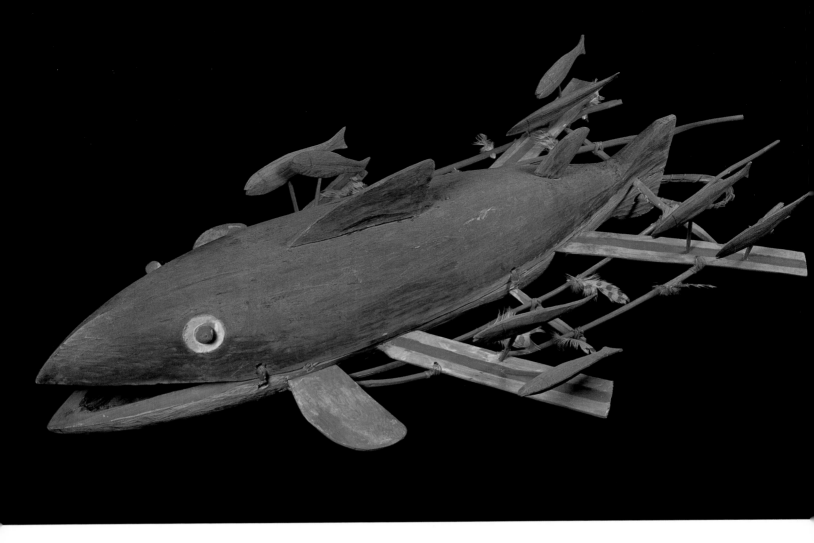

today. . . . At Akiachak [there was] a puppet that walked and also spoke, which had the name of Qetunrall'er [Bad Son]. But then at Kwethluk, the one was named Yugauyuk, his name was Yugaq [Doll]. . . . The ones that could talk and walk were powerful. They would also leave fingerprints . . . and they would leave footprints in newly fallen snow. And they would wear out the soles of their mukluks and their parkas would become worn out, and food and water that was set out for them would be gone.

Nelson (1899:379, 494), Zagoskin (Michael 1967: 228–29), and Moravian missionary Ernest Weber (Fienup-Riordan 1991:188) described doll festivals of the people of the middle Kuskokwim and lower Yukon from Ikogmiut to the coast. They placed a wooden image of a human being in the center of the *qasgiq* and after the festivities wrapped it in birch bark and hung it in a tree until the following year. Zagoskin said that masks covered the faces of these figures. Nelson stated that the festival was called "I-ti-ka-tah" (Itruka'ar) from "i-tukh-tok" (*itertuq,* "he comes in") and "Yu-gi-yhik," from "yu-guk" (*yugaq*)—the name Joshua Phillip remembered one hundred years later.

### *Ayaruq:* Walking Stick

Another important item of ceremonial regalia was the *ayaruq* (walking stick or cane). Nelson (1899:360) mentions that at the St. Michael "Asking Festival" (Petugtaq), they used this slender wand, called "ai-ya-g-uk," with three hanging globes at the outer end. In the evening the men gathered in the *qasgiq* and the women in their houses. A man holding the "asking stick" stood in the center of the *qasgiq,* while the men told him what they wanted from a particular woman. The wand-bearer then went to each woman's house and stood before her, swinging the globes on the wand and telling her what was asked of her. He then returned to the *qasgiq* and stood before the one who sent him, telling him what was desired of him in turn. Nelson concluded, "After the wand has been used while conveying the messages of the different people, it is hung in a conspicuous place in the kashim [*qasgiq*] and kept there until the festival is ended. This instrument is much respected by the community, and it is considered shameful to refuse the requests made with it." Nelson also noted that people on the lower Yukon and in villages to the south along the coast communicated their requests with small carved images of the desired object, which they hung on the messenger's wand.

Hawkes (1913:7) described the use of an identical "asking stick" with three hanging globes hung over the *qasgiq* entrance at St. Michael, but he associated it with messenger requests between villages rather than between the men and women of a single community. According to Himmelheber (Fienup-Riordan 1996), the people of Nunivak perceive the cosmos as a row of hollow globes hung one over the other, the lowest one representing our Earth with the firmament. The globes suspended from the "asking stick" pictured in Nelson (1899:359) may have embodied this concept.

Large mask representing "Takiokook" (*taryaqvak,* "king salmon"), said to drive the fish—as important as sea mammals to coastal people—into the Kuskokwim River. Collected by Twitchell at Napaskiak, near Bethel, it may have hung from the ceiling in front of the dancer. Spruce root connects the upper and lower halves. The eyes are protruding wooden plugs. *NMAI, 9/3574 (112 cm)*

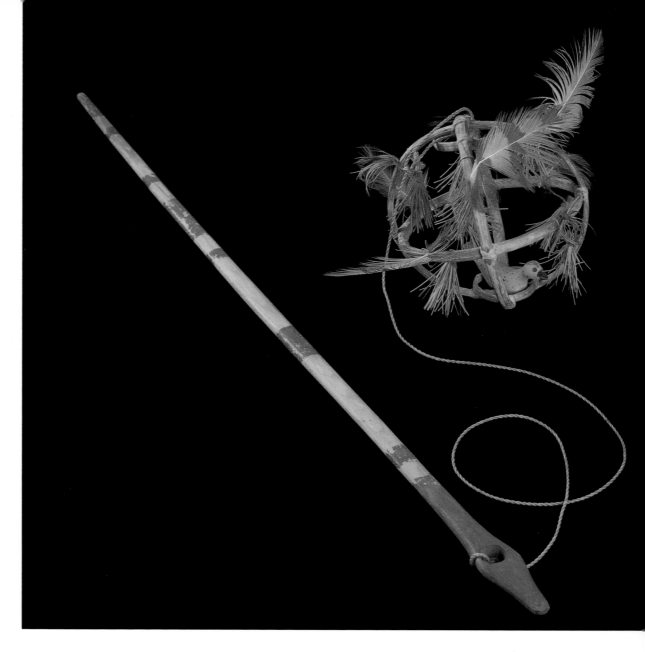

"Asking stick" consisting of a painted staff from which a bentwood globe is suspended. A small carved bird rests inside the feathery globe. *ASM, IIA7377 (stick 54.6 cm long, globe 11.4 cm by 9.5 cm diameter)*

### *Yuut Aturait:* The People's Clothing

Along with decorating the *qasgiq,* the people dressed themselves in their finest clothing when entertaining animal-persons and members of the spirit world. Men and women donned elaborate festival clothing, including exquisitely sewn seal-gut and fur parkas, bead necklaces and earrings, headdresses and armlets, and feather wands and dance fans. Women tied valuable caribou-teeth belts over their parkas, while men wore plainer belts with wolf or wolverine tails hanging behind (Michael 1967:212). Many covered their hands with gloves, and men sometimes donned elbow-length gauntlets decorated with the bills of horned puffins, which rattled dramatically as they performed.

A newly married woman might appear wearing a fancy heirloom parka, an *atkupiaq* (lit., "real parka"). Such a finely sewn garment demonstrated the skill of the woman's relatives—both the women who stitched it and the men who procured the many animal furs used in its construction. Like the window paintings, the designs of each parka told a story of an important family event. The gift of such a parka by the groom's family represented not just material wealth, but a gift of history.

Dancers sometimes wore seal-gut rain parkas during performances. Practical protection from wind and rain during daily life, they were also worn as spiritual protection by an *angalkuq* healing the sick or by a woman working on a sealskin kayak cover. The crackly noise emitted when someone performed with a dry or semidry gut parka simultaneously accompanied and disguised the performer's interaction with the spirit world. Peter Lupie (June 18, 1985) described an *angalkuq*'s use of a gut parka as a means of divination:

The *angalkuq* would ask the seal-gut rain parka, "What is this person like?" or "What did she do?" The gut parka would answer that this woman did that, this woman did this. The *angalkuq* would understand what that raincoat said, but the rest of the people didn't understand it. . . . The *angalkuq* would ask a question out loud to the gut parka and then he would listen for an answer, although there was nobody in the rain parka. . . . The spirit of the *angalkuq* would answer.

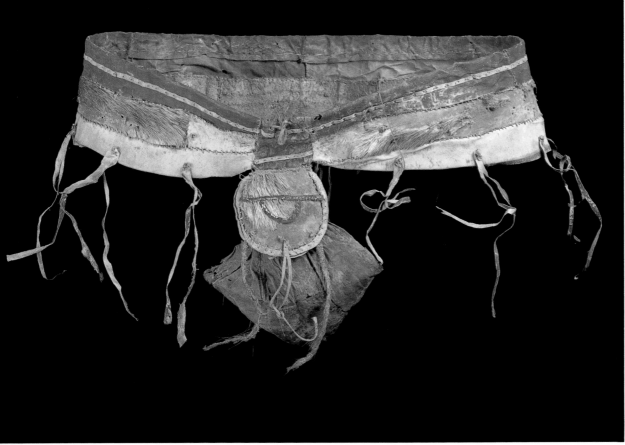

*Naqugun* (skin breach cloth) for dancing, collected by Charles L. McKay at Bristol Bay in 1882 and described as a "band worn around the waist when a man dances naked." Red-dyed skin decorates the upper border. *SI, 56036 (35.5 cm)*

Armlets from the lower Yukon, consisting of wooden feathers with downy tips fastened together on a roll of straw wrapped in sealskin. In the Chevak area these *pugnguaryat* hung from the *qasgiq* center during the Messenger Feast after the loss of a family member. Hunters portrayed birds during the festival; the wooden arrows may represent figurative hunting of the hunter. *SJM, IIH24 (57.4 cm)*

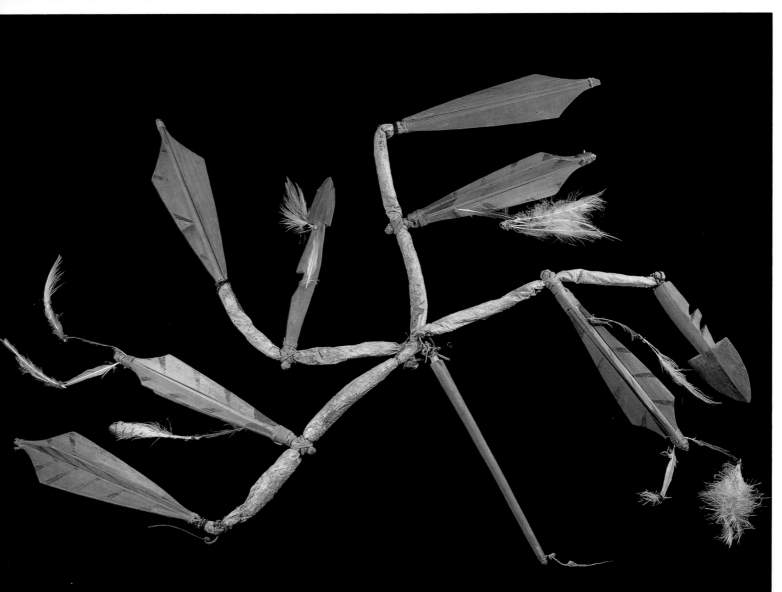

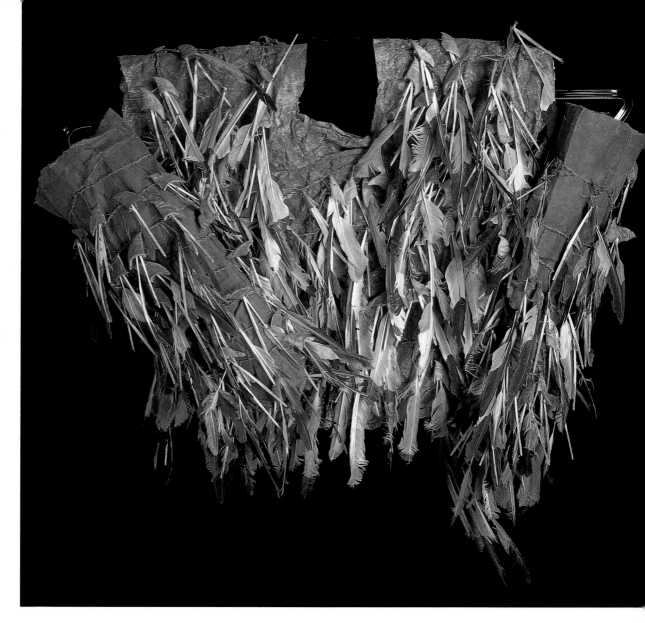

Sleeveless ceremonial shirt from Andreafski, made of fishskin partially tanned and dyed a brownish red. Gull feathers strung with "sea parrot" (puffin) beaks are sewn on it in horizontal bands. Accession records say that the shirt, with its rattling attachments, was used in the dance "The Cooing of the Birds in Spring." The same performer wore ceremonial gauntlets that were fingerless (but had holes through which the fingers were put) and were decorated with puffin beaks. Since puffins are coastal birds, either the beaks were obtained through trade or the shirt was made elsewhere and traded upriver. *SJM, IIB73 (60 cm long)*

14. *Nasqurrun* is the term used for "headdress," even in areas where *qamiquq* rather than *nasquq* is the word for "head."

Zagoskin (Michael 1967:212) collected a ceremonial gut parka from the lower Yukon in the 1840s. He wrote,

The women's parka covers for dancing which they wear for the important winter festivals are sewn of the very finest seal and bear intestines. No additional decorations are sewn onto them[;] as with the Maleygmyut [Norton Sound Iñupiaq] parkas the pattern is sewn directly into them. As they are worn with nothing under them, they are translucent at first when perfectly dry, but when the warmth outside, the perspiration inside, and the continuous dancing soften the parka cover it clings to the dancer and sometimes to such a degree that it tears apart and occasions general merriment.

The *nasqurrun* ("dance headdress," from *nasquq,* "head, crown")[14] was another important article of dance attire. *Nasqurrutet* (pl.) varied considerably, and again distinctive ancestral designs reflected particular stories. According to Jasper Louis (February 25, 1994), "This *nasqurrun* [is] what her ancestors had caught. *Nasqurrutet* are not the same, either. If their grandfather or a relative had used a bow and arrow they would make a *nasqurrun* like this. That is the story behind it." *Nasqurrutet* were most often created from skin and beads, bordered by wolf or wolverine fur. The halolike effect of the headdress recalled the fur halo found on many masks. Women still often wear *nasqurrutet* when they dance, as do men when they act as dance directors.

Pairs of masked men were routinely framed by dancing women, each holding a pair of finger masks. Women also sometimes performed with pairs of eagle-feather dance wands called *tengmiarpak* (lit., "big bird, eagle," from *tengmiaq,* "bird"). These wands were made from large flight feathers with downy plumes at their base, and women used them during both informal dance performances and important ceremonies such as the Feast for the Dead (Nelson 1899:353, 369). W. H. Dall (Ray 1967:31) saw women with such wands during the opening of a Messenger Feast at Unalakleet in 1867: "In each hand they held long eagle feathers, to the edges of which tufts of swan's down were attached. The opening chant was slow and measured. The motions of the dancers were modest and pleasing; the extreme gracefulness of the women, especially, would have excited admiration anywhere."

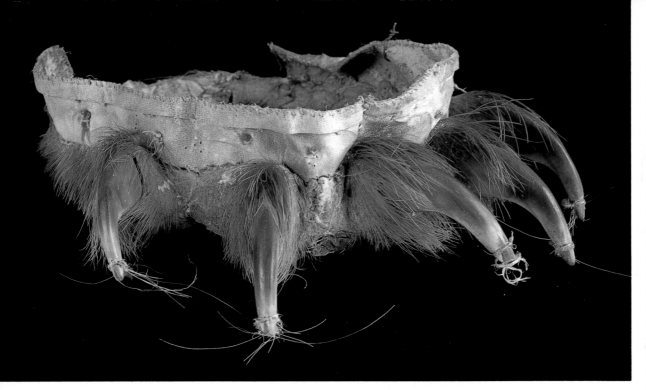

Bear-claw headdress collected by Charles L. McKay at Bristol Bay in 1882. Something originally hung from the tips of the claws, and eleven patches of red string have been sewn into the skin. Alma Keyes recalled wearing a similar headdress when her mother brought her into the *qasgiq* in Kotlik during the Feast for the Dead to receive gifts: "It had four bear claws and then some big, blue beads and seal gut. And then they named me after their relative who had died. After naming me, they said to me, 'When you go outside, go to the north.' I pretended to do it when I went out, breathing while facing north and then taking off. I really got ready. It was as if I were going out to the wilderness." *SI, 56035 (24 cm)*

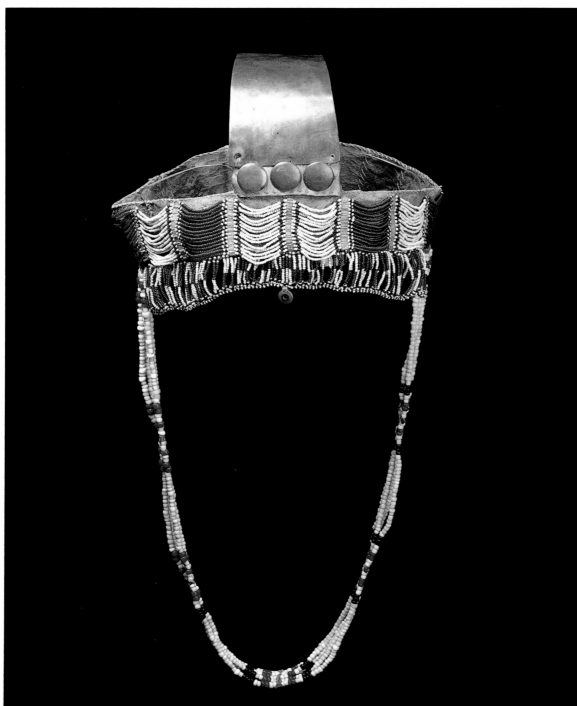

Rare *camataq* (metal and bead dance headdress) from Nunapitchuk, near Bethel, collected in 1947. *UAM, 0366–0001 (41 cm high, including beads)*

Eagle-feather dance wands Nelson collected at Rasboinsky in 1879. Zagoskin (Michael 1967:230) saw women carrying wands such as these and men wearing puffin-beak mittens during the Feast for the Dead on the lower Yukon. *SI, 38870 (77.5 cm and 63. 5 cm long)*

of the drummers, pushing their dance sticks back and forth to the beat of the drum. Peter Lupie (June 18, 1985) described the use of the sticks:

Some men would hold a stick with feathers at the tip to make them look good. I saw people use those sticks to conduct the beating of the drums. The men who had those were the head people. The sticks were called *enirararcuutet* [sticks for conducting]. The men who were beating the seal-gut drums would beat the drums once when the man who had the stick waved it a certain way.

Henry Bighead of Stebbins described three "pointers" he made in 1971 and sold to the University of Alaska Museum in Fairbanks:

These, when translated from Eskimo to English, are called "pointers." Pointers like these have been used by my people at Eskimo dances that were held every winter, up until 1919 or 1920. That is about the time potlatches stopped. These pointers are like those old ones in appearance. Whenever pointers were made for a potlatch, they were made the same every time. . . .

We had a potlatch last year, like the ones our ancestors used to have. One hasn't been held for a long time. . . .

The figures on these [pointers] have stories. The one with the man and walrus tell that long ago a man harpooned a walrus, sending the harpoon through the walrus.

The other one tells that there was once a man who was able to kill any living thing with a bow and arrow.

The stains on these are not a man-made paint. It came from the earth. Such have been used before the white man came. . . .

There has always been either a fox or sometimes a wolf tail, depending on how good hunting was at the time, used on one of the pointers. . . .

The feathers are duck tail feathers. The ducks usually can be got only before ice breakup, but after that they can't stay. The white ones are owl feathers, and usually are . . . available only in winter. . . .

The three bands are identification marks of our village. Whenever a potlatch was about to be held, a person was sent to invite a village and the village invited knew what village was holding the potlatches by the marks on the staff carried by the person. Each village had its own marks or bands. The three bands were put on kayaks, or whatever weapons they had and whoever saw those knew what village a person belonged to.

The pointers were used by men only, never by women.

I've made the pointers as those I used to see the old people use. The pointers were a necessary part of the potlatch, which in this area died out a long while ago, and only recently were used in a potlatch similar to that of old.

Nelson Island dance sticks were straight, but wands in other areas were sometimes made with a wooden crosspiece at one end. The central wand was straight with a wolf or fox tail attached to it, referring to the story of a man who was injured when wolves encircled him and beat him with their tails (Fienup-

## The Dance Stick or "Pointer"

Another important piece of equipment was the dance stick, known as *eniraraun* (from *enir-*, "to point"; pl., *enirarautet*) on the Yukon, and *apallirturcuun* (lit., "device for making the verse," from *apalluq*) on the coast. Dance sticks were used only on special occasions. According to Jasper Louis (February 25, 1994), the *apallirturta* (song director) wielded the device while performing the *yurapiaq* during the Messenger Feast. Two or three such directors sit in a row in view

"Apatlersun" (*apallirturcuun*, "dance stick"), made by Aglurmiut from the Iliamna Lake area northeast of Nushagak, featuring a bear. J. A. Jacobsen collected the piece in 1883 and wrote, "Object is carried in the hands while dancing. Probably used only by those men who had success in bear hunting." Like the bear-claw dance headdress (see p. 136), this unusual piece is an indication of the respect these four-legged creatures commanded. *MV, IVA6370 (60 cm long)*

Set of three *enirarautet* (dance sticks or "pointers") made by Henry Bighead of Stebbins, 1971. Grass figures, bound with string and painted with red ochre, recall successful hunting. *UAM, UA71–033–0001, 0002, 0003 (27.8 cm each)*

Riordan 1994:67–74). A man on each side of the central figure held a dance stick with a wooden crosspiece at the end (Eskimo Heritage Project 1985:76, 78).

Nunivak people used huge wooden dance "trays" (Lantis 1946:91–92; Ray 1981:29) called *keniraraun* ("pointer," from *kenir-*, "to point") decorated with downy plumes and small wooden animal carvings like the coastal pointers. Both pointers and dance trays were stained red with a mixture of *uiteraq* (red clay or ocher) and seal oil. Kay Hendrickson (January 4, 1994) explained the use of dance trays during the Messenger Feast: "When they sent messengers to invite another village they used these [dance sticks/ trays]. They didn't use them any other time. When the guests arrived the host would use it first and the next day the guests would use it. . . . And when they were done using it and the guests left they would break it into pieces and use it for steambath wood."

Both dance sticks and dance trays were proprietary and commemorated extraordinary hunting feats and personal experiences. They recalled remarkable encounters between human and nonhuman persons, often representing the same stories year after year. Stebbins elders reported that the dance wands represented travelers' sticks or ice testers, without which hunters would never journey onto the ice. Nelson (1899:495–96) stated in his account of the origin of the "Inviting-In" Feast that dance sticks represented the outspread wings of Raven, who made the world. Brentina Chanar (June 16, 1989) described how wands sometimes depicted notable recent events:

*Enirarautet* designs depict real-life things that have happened. They have all kinds of designs. When we first were going to have a Messenger Feast at Toksook, having moved there the first time [in 1964], our *enirarautet* had miniature designs of houses that were being moved. . . . Miniature kayaks and boats—that is what we had when we sang, when we moved by putting

houses on the rafts and moved them down to Toksook. . . .

While they sang those songs they said, "All those houses, across there at Toksook River, are all coming over!" And then its reply was "Even though there is a south wind, bring them all up on land!"

And then they hit the drum hard with gusto!

The three holding the wands stood up and danced a "stick dance" at the beginning of the performance of the asking songs. Standing in place with eyes lowered and knees bent, each placing one hand on his hip and holding the dance wand in the free hand, they alternately moved the wand in and out and from side to side. Their postures represented travelers on a long journey, and the standing dance signified the formal request for gifts that had likewise "traveled the path" from one village to another.

After the men took their seats, gift presentations commenced. The central dance director led by singing the words of the asking songs. According to Stebbins elders, "The singers behind the Pointers [men holding the wands] then repeat the first verse of the song as they keep time to the beat of the music with their bodies. Then as they [get] warm the Pointers begin to strip between the dances. This represents walkers getting warm as they walk with their stick. Wearing their shirts while they dance equals walking cold." It was customary for them to wear new clothing, and the dancers presented them with new gloves and other small presents when they performed (Eskimo Heritage Project 1985:72, 79, 80; Fienup-Riordan 1994:324–47).

Participants handled the dance sticks carefully and respectfully during the feast. Damage to the stick required the person responsible to pay compensation. In the past sticks were never handled or displayed after their use during the Messenger Feast and were burned following the event.

Paul John, Billy Lincoln, and John Jumbo of Toksook Bay holding *enirarautet* during 1987 dance festival in Bethel. Note the large Nunivak dance tray against the wall to Billy Lincoln's right. *JHB*

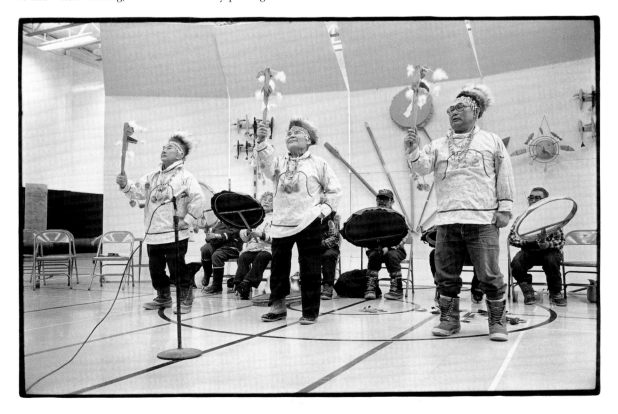

# Suppression and Revival of Masked Dancing

## The Missionary View of Masks

**M**asks and masked dancing came under early scrutiny by missionaries when they arrived in southwestern Alaska in the mid-1800s. Father Iakov Netsvetov, a Russian Orthodox priest who worked in the Yukon-Kuskokwim delta between 1845 and 1863, often referred to the great dances and "divvying-up" that characterized the winter ceremonial round (Black 1984). Although he forbade his followers to hold "festivals" on the Sabbath and other holy days, he did not reject the masked dances and frequently attended as an invited guest. Had he forbidden them, people likely would have ignored his command, as he was the only priest in the entire Yukon/Kuskokwim region and visited his thousands of parishioners once a year at best.

Arriving fifteen years after Netsvetov left, Nelson (1899:358) noted that although masked dancing had been abandoned by 1880 at St. Michael and the adjacent parts of Norton Sound, masks were still used by the Yup'ik people to the south. He added,

During the time of my residence in Alaska the Eskimo of the mainland were still firm believers in their ancient religion. . . . The sole effect of the priestly efforts have been to cause the Eskimo to become more secretive than formerly about practicing their religious rites when in the vicinity of white men. . . . In some districts, notably between [the] lower Kuskokwim and lower Yukon rivers, the ancient rites and beliefs were still practiced in their aboriginal purity. (Nelson 1899:421).

Not until the mid-1880s did Catholic and Protestant churches send missionaries to work among the Yupiit. For Moravian missionaries John Kilbuck and William Weinland, who with their wives established the Bethel mission in 1885, native ceremonies initially appeared "like a fair." In 1890, however, Kilbuck wrote to his coworker, "You remember the *masquerades?* At the time [1885–88] we could not condemn them, because we were unacquainted with their nature. Now, however, that we know that they are no more than heathen rites, the one grand religious ceremony of the year, we have condemned them, and seek to suppress them." The Moravians and Catholics were much less tolerant of masked ceremonies than their Russian Orthodox predecessors,

and referred to them alternately as "heathen idol worship," "devil's frolic," and "black art" (Drebert 1959:42; Society for Propagating the Gospel 1916:41).

As the missionaries began to win converts, they continually debated the subject of masked dancing. Edith Kilbuck (February 1889) wrote in her private journal:

It was first discussed and settled whether or not our members might attend their masquerade dances. After a good deal of arguing and explaining they said they would let it go. . . . [During the feast] shamans are entreating the different spirits of the game and fish to send a plentiful supply for the coming year's food and the natives dance with masks of the different animals on their faces. . . . We were somewhat surprised to see how willingly they did give it up.

A year later John Kilbuck (January 24, 1890) wrote to his wife: "We had a big meeting last night and a good one too. These people say, Shamaning and masquerading must go, because they want to follow Jesus Christ. Edith, this is good news, something to brace the heart."

Eradication of masked dancing, however, was not so easily accomplished. Upriver from Bethel at the Ougavig (Uuravik) mission, Ernest Weber saw masks in use in February 1893 when he attended a "give away play." He wrote in his journal:

Today some of the folks have gone to attend the masquerade and idol worship which is connected with it, this time it is at Kalchkachamute [Kalskag], last week it took place at Quichaluk [Kuigurluq], and on that occasion it pained us when we heard that some of our members had also attended it. In one of our evening meetings I had spoken to the people of the sin of idol worship into which sin Solomon had fallen for these people also have such a custom. They have quite a number of false faces hung up on a tree in the timber, to these masks there is attached a roll of birchwood, and in the rolls there is a wooden doll.

Weber described how the doll was cared for and used to foretell the future. He continued: "They also bring presents to their pieces of wood while they are in the kashima [*qasgiq*], but I suppose that if anyone handles these objects that the one that touches them will die. . . . I want to burn them if I can get the consent

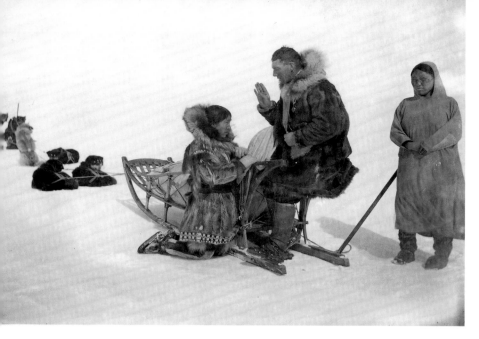

Father John Fox hearing confession on the trail, early 1930s. The photograph was posed after a real event. *OPA*

Acrylic painting by Tim Troll, 1989, entitled "Sheldon Jackson," showing the Presbyterian educator holding a *nepcetaq,* one of more than four hundred masks he collected for his Sitka museum. In 1879 Jackson was invited to the house of Toy-a-att, a leading chief and Christian at Fort Wrangell in southeastern Alaska, to witness traditional masked dances. After the chief performed, he apologized for the feebleness of his representations: "When I was a young man, I danced vigorously; now, since I have become a Christian, I have almost forgotten how. . . . Christianity has changed us. Formerly we thought the crow made us. . . . Now we know God made it. . . . My brothers, I thank you. You come into this house to see how we used to do. You laugh at what we used to do. We were foolish. Now we know better" (Jackson 1880:104–6). *SJM, VD3 (99 cm sq.)*

SUPPRESSION
AND REVIVAL
OF MASKED
DANCING

of the people for I think it is a sin for Christians to have anything to do with them."

Weber succeeded in confiscating the masks, and on a visit to the region the following year, John Kilbuck heard complaints about the way the images had been taken (Fienup-Riordan 1991:188–89). The masks appeared in a 1903 photo of "curios" taken in Bethel by Kilbuck's brother-in-law, Dr. Joseph Herman Romig. Romig noted on the back of the print: "The masks are from the mythological Ougavig Deity or legend of the missing child. These I hold in trust from the people of Ougavig." The "legend of the missing child" concerns a boy who would not mind his parents and was subsequently transformed into a cottonwood tree: "When people cut the tree down, it bled and they made powerful masks and charms from the wood" (Anderson 1942:101).

By 1894 the Moravians happily announced that there were "no mask festivals from Bethel to Ougavig, that is in six of the prominent villages" they served. Nevertheless, that same year a nearby tundra village held a masked dance. The older men said that the surrounding settlements were making so much fun of them for abandoning their traditional practices that they decided to go ahead with the festival (Society for Propagating the Gospel 1894:26–27).

In 1910 a handful of Moravian converts attended a play at Painghak (Paingaq), where an estimated thousand people gathered and several thousand dollars' worth of goods were given away: "The temptation consisted not only of the call of a heathen past, but also of the attractiveness of something unusual and large." Another Moravian missionary, Arthur Butzin, found work in the tundra villages southwest of Bethel particularly discouraging because there "the shamans are still strong and by their wiles and mask plays succeed in keeping the people in an indifferent attitude to everything that scents of progress in any sphere" (Society for Propagating the Gospel 1910:45; 1915:44).

Masked dances continued to be held away from the Bethel mission center. The missionaries, although disappointed, reported slow but steady progress in winning the Yupiit to Christian ways. But much to the Moravians' distress, during the winter of 1916 the Bethel natives had one of their "old heathen plays." Worse yet, they chose to celebrate with the most "benighted of the tundra villages,—villages where almost half the population are shamans. . . . When we have inquired why they should choose such a village with which to share their amusements, the reply was given, 'Well, the messengers came. Long Andrew received them, and, of course, when once the invitation was accepted, we could no longer refuse'" (Society for Propagating the Gospel 1916:40–41).

That same year, in the coastal village of Kwigillingok, Moravian missionary Ferdinand Drebert (1959:68) observed, "The people had already given up the mask dance, or Itruka'ar, as irreconcilable with their new faith. However it was still practiced farther down the coast . . . in the spring, preceding the seal hunting season. . . . Each mask had eyes, indicating that the spirits could see, and that they knew everything that was going on." Although masked dancing no longer took place at Kwigillingok, Drebert (1930s:7–8) attended other "heathen festivals," including the Feast for the Dead and Aaniryaraq, which he persuaded them to give up: "They continued to hold their potlatch, however, the Kivigek [Messenger Feast], since this festival was a purely social affair. We did not say anything against it as such, although we did try to discourage some of the extravagances and the social evils connected with it."

Throughout southwestern Alaska, missionaries raised their voices against what they saw as profligate Yup'ik giving—"no one ever hordes anything"—and corrupt banqueting. The enormous gift distributions that accompanied both the Messenger Feast and the Feast for the Dead were incomprehensible to the thrifty Moravians. Ella Romig complained, "But of course they are not like white people to look out for the future, they simply live for today, and let tomorrow take care of itself, and are always the worse for it" (journal, January 6, 1903). From the Yup'ik point of view the gifts given were far from spurious, as they

ensured support in the future from both the human and animal guests attending the feast. The Yup'ik injunction to give was firmly grounded in the knowledge that only then would they receive in their turn.

This critical attitude toward traditional Yup'ik give-aways runs like a broken record in missionary accounts, Catholic as well as Protestant. In April 1920 Father Anthony Keyes wrote to Kilbuck, then superintendent of the Bureau of Education, seeking his support in forbidding the Feast for the Dead:

In my experience of 21 years among these Natives of the Delta I noticed that such a feast is most dangerous to them, and now I beg you to consider my reasons for forbidding it.

Number one . . . the time lost. Every winter women are gathered from the surrounding village to begin preparation. The nights are passed playing. The children do not follow school teaching. Two . . . the goods are lost. People who have give everything away. Three . . . health loss. The people gather in cabins or kashims for hours and hours consumptively infecting each other while they relax. They live in dirty houses all packed indecently with the freedom and immorality of animals. Four . . . back to savagery. This kind of feast is carried on mostly by the instruction of their medicine doctor.

Half-a-century later Ivan Hamilton of Emmonak spoke about why the church tried to stop the traditional give-aways:

Because the people were giving away their food. That's what the priest told me. We should keep what we catch, and eat it ourselves, like the white people. . . . And I answered him, "Why do you object when we give our things away? Why do you have Thanksgiving and Christmas? Why do you do those things? It's the same for the Yup'iks." . . . When white people have Thanksgiving and Christmas they are giving to others. (Kamerling and Elder 1989)

While the missionaries continued to suppress "idolatry" (as embodied in the midwinter plays), they increased the purview of Christian replacements. For example, the 1904 Moravian Church conference in Bethel decided to encourage amusements on holy days. They would "make merry" on Christmas, and have target shooting on Thanksgiving, Washington's birthday, and the Fourth of July. They also planned to use magic lantern shows and arrange social gatherings to "gradually root out the old heathen plays." Card playing, however, was denounced.

The debate on the value of the ceremonies was not just between the missionaries and their potential converts, but within the Yup'ik community itself. In 1908 the Moravian *Proceedings* reported, "Concerning their plays, there is more and more division among them; while some wish to have them according to their customs, . . . others want them modified, so that they may be an amusement which they can thankfully have before God" (Society for Propagating the Gospel 1908:73). In Akiachak the "younger element"

took a stand against the traditional dances, which they maintained were wasteful of their time. This was not accomplished without a struggle:

Some feeling was generated between the young men and the old men, but as the young men were in the majority, they carried the day. But a serious question is whether they will be able to get along without something to replace these old customs? Their own suggestion is that they invite a neighboring village to unite with them for a Mission Festival and Love Feast. It holds possibilities for good if carefully planned. (Society for Propagating the Gospel 1927:27)

Although the ceremonies declined, debate continued. In 1928 Bishop Gapp wrote, "Some Christians claim that as now celebrated in the more advanced sections of the Eskimoworld, there is nothing intrinsically wrong in them, old superstitious ideas and disgusting practices having been eliminated. . . . Other and more strict Christians fear that participation in any of these festivals might weaken their testimony for Christian life" (Gapp 1928:60). By 1931 Yup'ik dances were increasingly "scheduled" around the Christian calendar: "The services of Holy Week are becoming quite general in all of our congregations along the river and out on the tundra. . . . [S]uch native dances as they still have they try to be well over with before that season of memory of our Savior's Passion" (Society for Propagating the Gospel 1931:54).

Not all nonnatives living in southwestern Alaska opposed the masked dances and traditional ceremonies. Hawkes (1913:3) actively supported the natives against the local missionary when they wished to hold a masked dance at St. Michael. He went so far as to convince the local military commander not to interfere with "a peaceful native celebration, which had lost most of its religious significance." The last day of the dance the natives invited the captain to attend, and a Unalakleet chief made a speech summing up the native attitude toward the event: "To stop the Eskimo singing and dancing . . . was like cutting the tongue out of a bird. They did not dance for pleasure alone, but to attract the game, so that their families might be fed." If they did not dance, the animal spirits and the shades of their ancestors would go hungry: "There was nothing bad about the dances; which made their hearts good toward each other, the tribe friendly with tribe. If the dances were stopped, the ties between them would be broken, and the Eskimo would cease to be strong." Paul John said the same thing eighty years later.

Along the Yukon River and the coast as far south as Nelson Island, Catholic missionaries labored just as zealously to abolish the traditional ceremonies. Justina Mike (March 1, 1994) of St. Marys is old enough to remember the first priests and their message: "When [the priest] understood what [a *tuunraq*] was he told us to stop believing that. The dancing stopped quickly. The people in the village danced

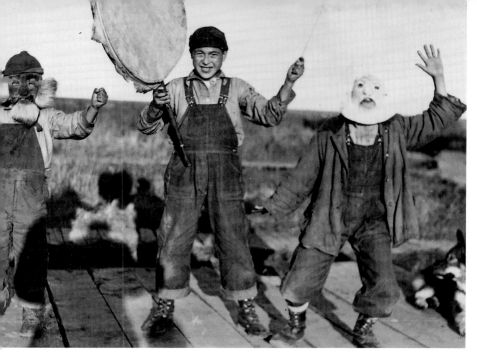

some of the things they had done. And though they made *arula* songs they did not wear masks anymore. . . . I wonder why they didn't wear masks? . . . It was because they had no *angalkut*. The *angalkut* that were around had gotten old. They didn't make masks and did not join in much. And they were not replaced.

Contemporary elders remember this period of rapid social change and cultural suppression with more sorrow than hatred. One Emmonak elder recalled,

It was our belief that there's a spirit that has power over all. Nobody knows what it is—and there's a spirit for everything. And when the priests and Christians came they condemned our way of living. They said . . . everything is from the devil, everything's wrong. We thought we were doing all right. . . . But when they start condemning us something deep in our hearts, they tried to pull it out, they're trying to take it away, and we were kind of hurt. We lived by what we believed and what we thought was true. (Kamerling and Elder 1989)

William Tyson was born on the lower Yukon in 1916, orphaned by an epidemic, and raised at Akulurak Mission. He returned home as a young man, later becoming one of the first Yup'ik Catholic deacons. His attitude toward the changes he lived through is both clear-sighted and compassionate:

The priests and the nuns were saying that everything that we did was evil because . . . it came from the devil. We could not follow them. And the teachers said, "You cannot listen to your parents because they give you

Men dancing with masks, Akulurak Mission, circa 1910. The bearded mask on the left may be a comic piece. *OPA*

"Eskimo Medicine Man" at Nushagak, photographed by John E. Thwaites, between 1906 and 1908. Another photograph shows the same man without the mask and describes him as a Togiak *angalkuq*. The mask is similar to those collected by the Alaska Commercial Company—probably from Nushagak—with its massiveness, chevron forehead, and elongated, inward-bending hands. Once part of George Heye's private collection, it is now in the Lebel collection in Paris (see p. 267). *UWL, Thwaites Collection, neg. NA3153.*

once in a while and stopped inviting other villages for dances." Unlike the Moravians, however, the Jesuits were not opposed to what they viewed as "recreational dancing," and they allowed some "purely secular dances" (without masks) to continue. Justina Mike remembered that Father Martin Lonneux, who worked out of St. Michael from 1927 to 1952, not only allowed small dances to take place within the village, but participated: "In our home they danced without masks. . . . Father Lunum [Lonneux] would let them do that . . . but during Lent they would stop. . . . and they stopped doing the Messenger Feast. He liked dancing in our village. He would join us when we danced. He actually learned how to dance."

The last of the major masked dances along the Yukon were held between 1900 and 1920. According to Mary Mike (February 28, 1994),

Anagcirmiut did that for the last time. Then several years later—perhaps it was three years later—the Feast for the Dead was celebrated in Uksuqalleq. Apparently, just like the other village, they also stopped doing it. . . . The priests didn't agree and said it was satanic. [The people] couldn't do it, though they wanted to. [The priests] told them not to give away clothes to other people . . . [and] to keep the clothing themselves. I had never heard people saying they had to keep the clothing themselves.

Intense missionary suppression was not the only factor in the ceremonies' decline. When disastrous epidemics at the turn of the century cut the region's population in half, the very young and very old were particularly hard hit, and those left behind were both leaderless and demoralized. As Mary Mike (February 28, 1994) pointed out, masked dancing declined because of both the priests' appearance and the disappearance of the *angalkut*, the traditional religious leaders:

When I got to be a big girl, that village began to lose

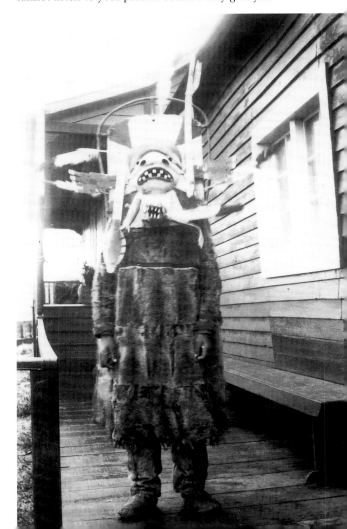

SUPPRESSION
AND REVIVAL
OF MASKED
DANCING

wrong direction. You have to listen to us." And that's where after [my generation], children started drifting away from their parents. But then if you look at it, I cannot blame them. They work for Christ and, remembering the first commandment of God—"Thou shall not have strange Gods before me"—well, they had to obey that. And everything else was not right. They had to tell us to obey that one. So were they wrong or what? So now what I've been thinking is that they should have studied our belief before condemning it. Because those old medicine men, some of them were amazing in what they could do. . . .

In my mind I want to blame them, but at the same time I can't. But I wish they had studied our way first. And then we might have been together. (August 1, 1991)

## Bringing the Past into the Present

Since the early 1980s more and more respected village elders and regional leaders, especially in the Catholic communities on the lower Yukon and Bering Sea coast, have spoken out in support of their past. Many now say that the rapid conversion to Christianity devalued their beliefs. They are reevaluating aspects of the traditional ceremonial cycle, highlighting the similarities between their pre-Christian past and a present they hope to enrich. Paul John (April 15, 1994) is among the most vocal in this debate:

*Aviukaqsaraq* [making a food offering to the dead] was a custom that we should not have abandoned. And also *tarvaryaraq* [cleansing or purifying with smoke]. Those were powerful ways that our old ones had. . . . They actually did baptisms by offering water. Our ancestors truly led and carried out their lives according to the design.

*Eyagyarat* [traditional abstinence practices associated with birth, death, illness, or puberty] were ways that we should not have abandoned. However, the first Catholic priests that came to us told us that our ways were evil. That was why they abandoned them.

The old ones actually prayed like they were bowing to God in their world, especially the hunters. . . . They would cleanse themselves. They wanted to be pure and clean when they left the village to hunt. . . . This *tarvaryaraq*, which was powerful, should not have been abandoned.

Commenting on what was lost, Paul John (April 15, 1994) does not ignore the importance of dancing—the one custom that has carried into the present: "I'm beginning to understand more and more that we [humans] had not been created by ourselves. When God made people, each group was designed with its own ways. . . . When you consider our dancing, which is the only custom remaining in our culture, every group in this world has their own style of dancing."

By the 1930s most Yup'ik communities had abandoned all of their most important ceremonies. Himmelheber was still able to work with expert carvers in the late 1930s; however, the elaborate multivillage masked performances were a thing of the past.

When Father René Astruc began his tenure in southwestern Alaska in 1956, no one danced. His predecessor had forbidden it, but Father Astruc represented a new generation of Jesuits committed to reclaiming selected indigenous activities as building blocks for a new Catholicism. When he became Superior of St. Marys Mission in 1964, he let it be known that he had no objection to Yup'ik dancing:

When I first arrived in the villages there was no more dancing. It was very hard to find a drum, even. And over the years, somehow I have seen it start again. And there is no stopping it now, that's for sure.

The dancing today is something which is a way of expressing one's own spirituality. And it is definitely part of the Yup'ik spirituality, a way into the world of prayer. When people dance today, there comes a time . . . when the dance becomes something very personal, a way of showing what's going on in their heart. . . . When you reach those moments, the dance is really something special.

It becomes somewhat intemporal. You are not in any one place . . . or time, you are just completely coming out of yourself and at some time you may even wonder is it me doing that. There's nothing holding you back, you just let go completely. And of course there's a fantastic inner feeling. I don't think we would have the words to express it, you have to have felt it yourself to really understand what it is.

Recently I was at a potlatch and I was dancing for a friend of mine who had died and who really was a very good friend. And I really didn't know the dance. . . . But when I danced it I thought of him, and I thought of his son who was here and his wife who was standing behind me . . . and even though at first I didn't know the dance very well I was so taken by what was taking place that I just let go and felt terrific at the end of the dance. And really I think he was there, and he was happy we were dancing for him. I remembered how he danced, he too was able so often to let go, and so I was just thinking of him. I had asked his widow if I could dance for him because I felt that way about him, and he was there with us dancing. (Kamerling and Elder 1989)

People also are reclaiming other traditional practices. Mary Mike (February 28, 1994) commented enthusiastically on the recent incorporation of the traditional Yup'ik naming ritual into the Catholic baptismal ceremony:

Back then when someone was born they used to do the naming ritual. They would sprinkle water on them and give them names of the deceased. . . . [Missionaries] also made them stop doing that custom. . . . Since last year the priest has been telling us to begin . . . giving food and water offerings when people are baptized. Before they baptize them the priests let their grandmothers give water offerings . . . and say they are giving them the name of a certain deceased individual.

The same men and women who witnessed the last major masked dances have lived to see the time when

dances are again performed, albeit without masks. Understandably some hesitate. Father Astruc recalled a dance practice in the St. Marys chapel in the late 1960s. One man asked, "Should we cover the crucifix?" Another responded, "Would Jesus be ashamed of what we are doing?" The first man answered, "No." The second concluded, "Then we should leave it as it is."

William Tyson, who passed away in December 1993, was both a devout deacon and an expert dancer. During the last deacons' retreat he attended in October 1992, he and his wife drummed and danced during the closing mass. Tyson, who came late to dancing, recalled,

When I was in school, I heard [about dances]. But when I went back, I had to see them, when they danced. I enjoyed looking at them. But I never took part in them, because I was told I could watch them but couldn't take part in them. I never took part until the late 1960s in St. Marys, and I was in my late fifties when I first danced. And it was only after I saw Father Astruc and the other priests start dancing that I started joining in, too. (August 1, 1991)

The Jesuits now view the revived Yup'ik dancing as a spiritual activity, a legitimate way of "making prayer." Paul John's daughter Teresa, a fine dancer in her own right, observed,

I thought it was funny when priests would say that you could only sing [Yup'ik] songs that were not spiritual, but they did not know the language. They didn't know how much was traditional or spiritual. Today we're being encouraged by the Catholic religion to bring back singing and dancing in the church services, if you can believe that. In the middle of their altar right before they do their communion services. It's very spiritual. (March 1993)

Willie Beans (KYUK 1989, tape 1) summed up a century of change: "When the missionaries arrived, they almost totally stopped the Yup'ik dancing. At the time dances included shaman songs. But today dancing is revived again. Dancing to any song. No *angalkuq* songs. One can make a song and dance, having a lot of fun. We did not lose our way of dancing."

As remarkable as the revival of Yup'ik dancing in Catholic communities has been the transmission of enthusiasm for dance to some Moravian and Russian Orthodox communities along the Kuskokwim. Even along the Yukon, the revival of dancing built gradually from small intravillage get-togethers to the enormous dance festivals that occur throughout southwestern Alaska in the 1990s. Beginning in the 1960s men and women carved new drum handles, made new dance fans, and began practicing a combination of old songs and new ones composed according to traditional patterns, but highlighting contemporary activities such as basketball and bingo games. Within a few years intervillage potlatches reemerged as a regular midwinter activity. Villages took turns inviting each other to two- and three-day dances, including elaborate gift distributions, feasting, and the sort of

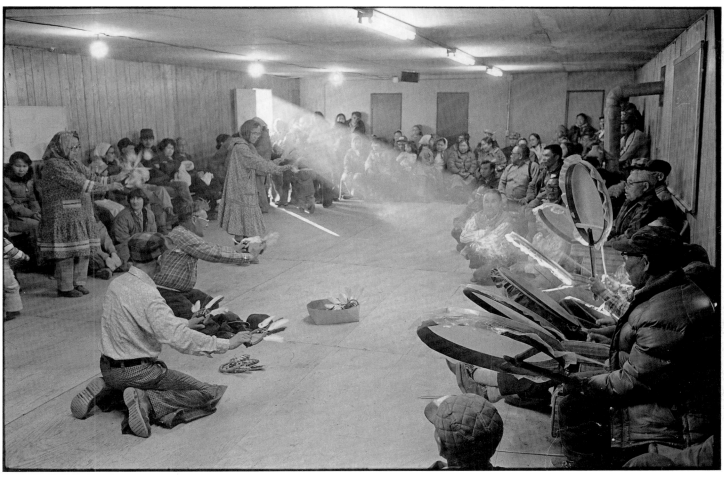

rivalry and banter that characterized the traditional Messenger Feast. Guests arrived in the early days by dogsled and later by snowmobile, waiting outside the village until dusk, when they entered en mass, sometimes numbering three hundred or more. Their hosts fed them, teased them, and sent them away satisfied, to reciprocate in their turn. Pairs of villages exchanged dances year after year—Kotlik and Stebbins, St. Marys and Pilot Station, Alakanuk and Emmonak, Hooper Bay and Chevak, Toksook Bay and Tununak.

In the early 1980s Alaska was flush with oil revenues, and many villages took the opportunity to expand community facilities. One of the first things lower Yukon villages did was build larger community halls. Finally, a number of dance groups could gather at one place and time. St. Marys was among the first to build a new hall. Construction was completed in 1980, and in 1981 the village invited three other dance groups to help them celebrate—Toksook Bay, Pilot Station, and Kotlik. In October 1982 St. Marys hosted an even bigger festival, Yupiit Yuraryarait (Yup'ik Ways of Dancing), with dance groups from seven villages, and in fall 1985 a third dance festival. In 1987 Yukon villages joined together to form the Coastal-Yukon Mayors' Association, which has continued to organize dance festivals at three-year intervals—often enough to ensure continuity without overwhelming the smaller annual intervillage potlatches. So far the Mayors' Association has sponsored two more festivals, each bigger than the last—in 1989 at Mountain Village and in 1992 at Emmonak. More than twenty dance groups were invited to the 1996 Toksook Bay festival.

The five dance festivals differed in character as well as size. The 1989 Mountain Village Dance Festival hosted the Sheldon Jackson exhibit, precursor of the 1996 mask exhibit in Toksook. At Emmonak in 1992 the King Island Dancers and the Naukan Siberian Yup'ik dancers were enthusiastically received as the guests of honor by their Central Yup'ik hosts. Emmonak hosted fourteen groups at the first downriver festival, to which even tiny Sheldon's Point, which until then had no formal dance group, sent dancers.

Lower Yukon villages have not been the only ones creating and enjoying midwinter dance festivals. Chevak has hosted an annual Tundra Fest every August at the close of the summer harvest season for the last ten years. Combining Yup'ik dancing with cake-walks and a crafts fair, Tundra Fest draws visitors from throughout the delta. Chevak's neighbor, Hooper Bay, has recently joined in, hosting a three-day "Bladder Festival" dance in early March, including Yup'ik dancing, fiddling, and storytelling.

Teresa John, then working for Kuskokwim Community College in Bethel, was so impressed by the 1982 St. Marys festival that she encouraged the college to help organize one in Bethel in 1985, which has since become the annual three-day Cama-i Dance Festival in late March. Like the Yukon festivals,

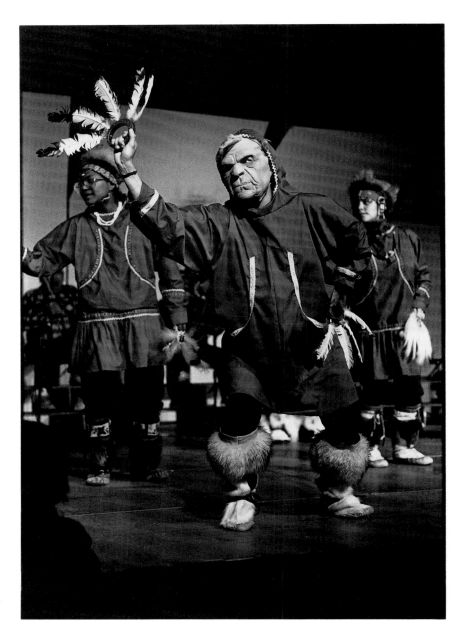

Cama-i includes increasing numbers of dance groups, filling to overflowing Bethel Regional High School's huge gymnasium. In 1994 twenty-four groups—including Sioux, Tlingit, and Siberian dancers—performed.

Planning and participating in large dance festivals requires enormous amounts of time, energy, and money (mostly for transportation). Bethel organizations work with local community councils to get funding to fly dance groups into Bethel, arrange food and lodging, and plan workshops to accompany the dances. Less visible and even more impressive is the effort that local groups devote to "practice" dances. To perform at Mountain Village or Bethel, a village group (usually consisting of a core group of elderly "expert" drummers and singers and two to three dozen younger performers) practices several times a week for two to three hours at a time. Each practice is a dance in its own right, giving intense enjoyment and satisfaction to those involved.

Moravian communities generally are less involved in dancing than their Catholic counterparts, a reti-

Kalskag dancer performing with a rubber mask at the 1991 Cama-i Dance Festival. *JHB*

cence rooted in their unique conversion experience. Beginning in the late 1800s Moravian missionaries encouraged Yup'ik helpers to assume primary responsibility for community church life. These native helpers were required to internalize the church view that traditional Yup'ik religious acts—both public ceremony and personal rituals—were morally wrong. Under the firm guidance of such strict and pious men as Ferdinand Drebert and Frederic Schwalbe, Yup'ik helpers preached the sinfulness of dancing of any kind. They condemned as superstition the burning of *ayuq* (Labrador tea) and the act of giving water to the dead, soon to be replaced by proper Christian candle services and burials.

Coming straight from the mouths, and hearts, of respected members of their own communities, these condemnations carried considerable weight among the people. Dancing disappeared in Moravian communities to the south of Nelson Island and along the Kuskokwim River until the 1980s. Since then, several villages have shown renewed interest in bringing dancing back into their lives. Still, the communities' respect for the handful of elderly Yup'ik pastors, raised to believe dancing is the work of the devil, prevents them from wholeheartedly bringing Yup'ik traditional acts into their church services. Catholic communities, on the other hand, can more easily disown, and put behind them, past damage by well-meaning priests preaching foreign values of a different era.

In spite of these differences, an impressive cross-pollination already has occurred. In 1983 Elena and Nick Charles, Sr., both members of the Bethel dance group, taught dancing to youngsters in Kasigluk (Elena Charles's hometown), a community including members of both the Moravian and Russian Orthodox churches. Within only a few years, the Kasigluk dancers gained statewide recognition for their fine dancing and traveled to perform in Anchorage at the annual Alaska Federation of Natives convention. Yup'ik dance groups today not only travel within the state on a regular basis, but dancers are invited to perform in cities all over the world, including Washington, D.C., New York, Boston, San Francisco, Paris, and Moscow. Ironically, when filmmakers Leonard Kamerling and Sarah Elder filmed Emmonak's annual potlatch in 1977 and interviewed local elders, many predicted the end of dancing, as so few young people participated. In fact, as more and more young people participate, some elders have turned their original observation on its head, lamenting now that so many of the dancers are so young.

Many people in southwestern Alaska, such as Teresa John, find Yup'ik dancing and the renewed interest in Yup'ik ceremony both personally meaningful and culturally important:

The sad thing is that when the missionaries came a lot of people had to burn a lot of their masks, and their regalia that had a lot to do with spiritual matters. . . . But today we're asking elders, and saying, "Why don't you make this anymore?" . . . We're trying to revive a

lot of the items that were lost. Like the dance sticks or the different masks that had a very big significance, too. (March 23, 1993)

Some older villagers who experienced the transforming power of the *angalkut* at close range, however, do not casually embrace this revival. Though they encourage the increasing awareness of the old ways, they also feel uncomfortable seeing these once-vital ritual acts taking place in totally different contexts. Dances once performed by men in the *qasgiq* to influence the unseen spirit world are now performed by children—often oblivious to their movements' original intent—under the bright lights of the high school gym.

One instance of this conflict can be seen in the composition and presentation of a dance song by Brentina Chanar, the oldest woman living in Toksook Bay in the late 1980s. Her song concerned *tarvaryaraq*, or purifying with smoke. The village dance group at first downplayed the song because of its past associations. But some elders gradually came to appreciate the song's reference to a distinctly Yup'ik act that they felt reaffirmed the spirituality of their ancestors. According to Teresa John (March 23, 1993):

I remember in my own village a few years back, when some of the drummers or singers were hesitant to sing it because it was part of a shaman's song. Or it has that connotation of healing. Traditional words like *tarvaq* [are] to heal someone. Like from the word *tarneq*, spirit, so that word, *tarvarnauramken* [means] "let me work my spirits into you." So that song had one very old word in it that the composers were saying, "Well, I don't feel too comfortable singing." But then me and my dad said "No, it's a really good song, it's a healing song."

The Toksook dancers learned the song and performed it at the Cama-i Festival in 1991 and the next year were asked to close the festival with it. In 1994, two years after Brentina's death, Paul John, his wife Martina, and daughter Teresa performed the song "Tarvarnauramken" as the festival's closing "prayer." That same year several people slowly danced to Brentina's song at the graveside during William Tyson's funeral. He was buried dressed in the *qaspeq* he used as a deacon, with dance fans resting on his coffin. As the last generation to see the old ceremonies passes away, a new Yup'ik tradition is born.

Toksook is far from the only community to experience this conflict and ongoing debate. In nearby Tununak people hung a drum above the altar in the local Catholic church as a symbol of peace. Some of the younger villagers later removed it, as its presence made them uncomfortable. In another village a leading elder did not participate in the performance of a song because in the past an *angalkuq* had directed it. He did not attempt to stop the dance, but he personally would have nothing to do with this specific performance because of its traditional religious character.

Teresa John commented that sometimes when she attends dances she is approached by elders who want to share their memories of dancing or other traditional ways, although some ask not to reveal who told her. While carrying out interviews in preparation for the *Agayuliyararput* exhibit, Marie Meade encountered willingness to elaborate on traditional beliefs much more often than reluctance. She and Teresa John and others of their generation find the elders' generosity and willingness to explain deeply moving. Many elders are as eager to teach as their descendants are to learn.

## Contemporary Maskmakers: The Invocation of Tradition

By 1916 Bethel natives had held their last major masked dance, and the coastal residents of Kwigillingok no longer celebrated Agayuyaraq. But occasional masked dances still took place in many parts of southwestern Alaska, as evidenced by the twenty-six masks given to Kuskokwim trader Robert Gierke in the 1920s and the fifteen masks Otto Geist purchased at Old Hamilton in 1934. In 1936 Hans Himmelheber was able to observe expert carvers at work making masks in Kuskokwim communities around Bethel, as well as on Nunivak Island, where they danced with masks until Covenant Church missionaries settled on the island in 1940. By the mid-1930s masked dancing had ceased in Catholic communities to the north. Yet when the Milottes arrived at Hooper Bay in 1946 to film *Alaskan Eskimo,* villagers enthusiastically carved masks and performed for the filmmakers' benefit.

Dancing in lower Yukon and coastal communities in the 1960s was primarily without masks. Paul John (April 15, 1994) joked about the power still invested in "teasing" or comic masks, recalling a small mask that hung on the wall in the city office and that was sometimes used for dancing: "Then an attorney came and when he was done talking, I said, 'You see, my computer up there will know if you are actually telling the truth.' He stared at it up there with a straight face. Then without smiling he said that he thought he was telling the truth, but that some of the things he said probably aren't true."

Well before the decline of masked dancing, carvers in southwestern Alaska began making masks for sale. As early as the 1880s collectors purchased masks at trade centers such as St. Michael that were made for the then-infant "tourist" trade. In 1927 Rasmussen commissioned Nunivak carvers to make him masks. During her fieldwork on Nunivak in 1939–40 Margaret Lantis purchased a number of masks, as did Oswalt in the 1950s in Napaskiak. Although the intent of production changed over time, carvers continued to make masks, but more often as wall decorations than as face coverings. The eyes of such masks, no longer essential, appear as painted marks rather than carved holes, rendering them functionally blind (Fienup-Riordan 1987).

Production of masks for sale has steadily increased. Expert carvers such as Nick Charles, Sr., of

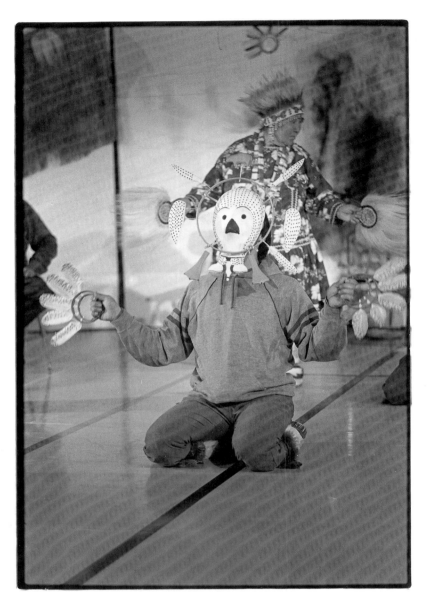

Joe Chief, Jr., performing during the 1982 Bethel masked dance with John Kusauyuq's snowy owl mask, which he held in his teeth with a mouthgrip. *JHB*

Bethel, Joe Friday of Chevak, Henry Bighead of Stebbins, and numerous Nunivak carvers—including Kay Hendrickson, Andrew Noatak, Peter Smith, Edward Kiokan, Dick Jones, Harry Shavings, Larry Float, Sr., Ben Whitman, Walter Amos, Harold Westin, Ollie Olrun, Harry Westly, and Harry Mike—have found wide audiences for their masks as art objects. Working in both wood and ivory in a variety of styles, each has his trademark pieces, such as the large dance sticks Kay Hendrickson created, Andrew Noatak's musk-ox masks, and Nick Charles's owl and double-eagle masks. Noel Polty created elaborate mask-sculptures to which he attached tape recordings of the stories the masks represented (Ken Pratt, personal communication; Ray 1981:182).

Most carvers worked in coastal and Yukon communities removed from Moravian activity, but a number relocated to the regional center of Bethel, including Nick Charles, Sr., from Nelson Island, and Kay Hendrickson and John Kusauyuq from Nunivak. In fall 1982, as lower Yukon villagers were gathering for their first big dance revival, these three carvers (along with Joe Friday) gathered at Kuskokwim Community College to teach a weeklong maskmaking

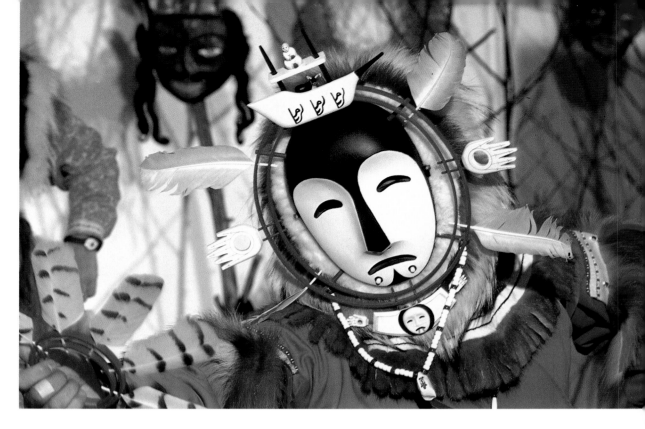

John McIntyre of the Nunamta Dancers performing with the Issiisaayuq "contact" mask, which tells the story of the *angalkuq* Issiisaayuq, who foretold the coming of the first white people. He predicted that they would come in ships, represented on the mask by the carving atop the *angalkuq*'s head. The ship did come, and the men traded with the people, but when it left all the goods the strangers had brought disappeared. *Bill Roth, 1994, Anchorage Daily News*

Marie Charles, one of a number of women carving masks in southwestern Alaska today. *JHB*

workshop. Following the workshop was a dance featuring the masks—the first masked performance in Bethel in more than sixty years (Fienup-Riordan 1990:49–67). Although the presentation of pairs of masks is no longer the focus of either village or intervillage dances, individual performers still occasionally perform with masks.

Ray (1981:70) wrote that in 1976 most carvers were more than sixty years old, but that this did not necessarily mean that maskmaking was dying out. Typically men did not begin serious carving until after they retired from hunting and fishing and regular wage employment. In fact, as these expert carvers of the 1980s end production, it is younger men and some women who are taking their place. This marks an ironic return to nineteenth-century tradition, when *angalkut* called talented younger men into service to prepare for a performance (Himmelheber 1993:56).

Nunivak Island still produces the majority of maskmakers in southwestern Alaska. A number of younger carvers live in Tununak, Chevak, Hooper Bay, Bethel, and Anchorage. Both Susan and Bob Charles of Bethel are following in the footsteps of their father, Nick Charles, Sr. Along with recrafting some of his father's images, Bob Charles is also creating masks to dramatize stories his father told him and his siblings as he was growing up. Like the stories Noel Polty attached to his masks, legends and stories are provided by Bob Charles to heighten the buyer's awareness of the masks' meaning.

Younger carvers in southwestern Alaska include John Kailukiak, John Oscar, and Charlie Post in Tununak, and Alexie Isaac, Earl Atchak, and John McIntyre in Bethel. Charlie Kairaiuak and Jack Abraham, both from the region, work in Anchorage. John Kailukiak and Jack Abraham have had formal art training, and both use new material to re-create old forms. Charlie

Kairaiuak's mask "Time Caretaker" represents his interpretation of the Yup'ik worldview. He carved the mask in 1990 of yellow cedar and the posts from Douglas fir. The rings are alder, while the appendages are made from a variety of materials, including clear pine, spruce roots, seal skin, whale bone, and raven feathers.

Jack Abraham, a well-known Anchorage carver born on Nelson Island in the 1950s and raised in Bethel, also employs new materials to re-create old forms. His masks are both contemporary and eclectic, reflecting his past and present, mixing wood with bicycle parts, feathers, and metal knobs. In a recent interview he talked about the masks' meaning:

I never knew what those [mask symbols] meant. . . .
I learned a lot of things on my own just by being curious. . . . I just started making them and expressing my own feelings about them. . . . A lot of those things were just hidden from us deliberately. It bothers me a lot when people ask me those things and I don't know. Like some dumb Eskimo or something. I've reacted to that. People expect me to carve traditionally. (McDaniel 1994b)

Joe Senungetuk, an Iñupiaq artist living and working in Anchorage, also carves masks, sometimes improvising on a Yup'ik style. In an editorial written for the *Anchorage Daily News,* Senungetuk (1990) captures the conundrum of many of the younger native artists working in the state today—how to be taken seriously as artists who happen to be native rather than natives who happen to be artists:

Noun, (Nai-tiv arrt): works in wood, stone, bone, ivory, skins of animals, cloth, metal and/or other materials for sale to mainly nonnative buyers who would like to possess something from a place and time which they only have a vague notion about.

People call me a Native artist more times than I care to hear. . . .

My BFA degree came from San Francisco Art Institute in 1970 and I'd like to nurture the idea that I'm just as universal as . . . say, Pablo Picasso. But that old thinking just keeps working like a giant vise grip, wanting to put me in my place.

On the other end of the spectrum are carvers such as Patrick Matchian, who teaches in the wood workshop in Chevak's Cultural Heritage Program. There he directs students in carving the masks that the Chevak dance group uses when they perform locally as well as in Bethel, Anchorage, Canada, and beyond. The masks Matchian carves are "funny masks" (his term) and are made as half-masks covering the upper half of the face or as full face masks without mouth or with only the upper row of teeth (Madsen 1990:125). In Chevak—the only Yup'ik community that regularly uses masks as part of dance performances, not as objects to sell or hang on a wall—the masks retain their original place as part of the performance and always draw enthusiastic applause.

John Pingayak, the dynamic director of the Chevak program, also sometimes carves masks. When a young student at the Catholic boarding school at St. Marys, Pingayak gave the first mask he carved to Father Astruc. Father Astruc treasured his gift through the years. Until recently it hung on the wall at Jesuit House in Anchorage, along with two Hooper Bay masks that Father Astruc purchased and, on occasion, danced with. Following a 1994 retreat, Father Astruc gave Pingayak's mask to a fellow Jesuit as a parting gift, both to communicate his deep regard for his coworker and to divest himself of a material object he truly valued. An enormous change has occurred in the meaning masks can have, for Yup'ik and missionary alike.

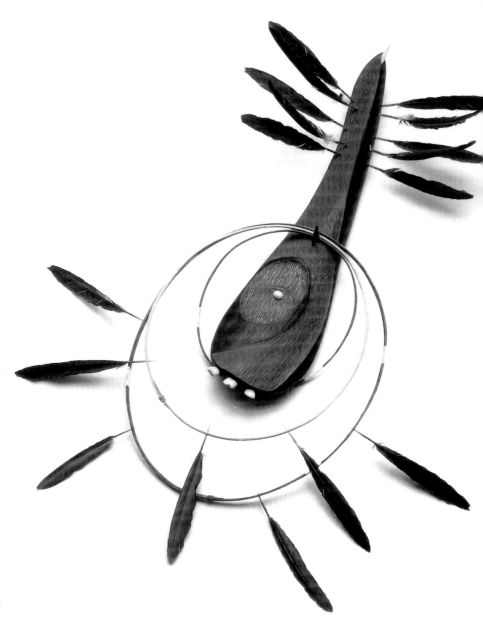

Modern mask made for sale by John Kailukiak, Toksook Bay. *Chris Arend*

Youngster at work in the Chevak Cultural Heritage Program, 1995. *JHB*

# Making a Mask

Carvers made masks to tell stories, and they greatly valued the representational dimension of their work. Their view was the counterpoint of art for art's sake (Himmelheber 1993:50). Maskmaking, like drum painting and story-knife drawing, was representation for the sake of representation. The masks were meaningless without knowledge of the stories they embodied.

Representation was the core meaning of the mask. At the same time, the masks' place in *agayu* dances performed to elicit the goodwill of members of the spirit world made it imperative that the masks be well made. So important was this requirement that an *angalkuq* commissioned a recognized expert to carve his masks. All men carved, but some better than others, and those with the skill to make masks were considered the finest among them.

A unique division of labor thus characterized the maskmaking process—between the *angalkuq* whose vision the mask embodied and the carver who made the mask. In the past this division was perhaps not as sharp as one might think. Even if not an expert carver, the *angalkuq* knew the tools and materials with which the master carver worked from first-hand experience, and the *angalkuq* oversaw the mask's construction, giving instructions and telling the carver how to realize his vision.

## Learning to Carve

Until recently, carving was a skill as fundamental to a man's life on the delta as eating and breathing. To eat one must hunt, and to hunt one must carve. Men were constantly working on wood. If they were not hunting or fishing, they were making or mending the tools, kayaks, and sleds that enabled them to harvest food. Nick Charles, Sr., an outstanding carver and maskmaker born on Nelson Island in 1912, recalled his early years, when men were always busy carving:

In the winter and spring the men would carve in the community house. In the summer, when the weather is nice, they would carve anywhere, even outside the community house. During the fall months people would travel to their fish camps. There they would carve anywhere—outside or in their tents. They would work on big things outside, and small ones inside the tent. Men were always busily carving something. We never saw anyone who wasn't carving. (KYUK 1985)

Like others of his generation, Charles learned to carve by watching and imitating the men working in the *qasgiq*:

Whenever my late father wasn't using his curved knife, I would pick it up and carve. Sometimes I would get scolded because it got dull. So he made me a curved knife just for my use. I began carving just by watching the carvers and trying to match what they made. . . . As long as you tried, that was the important thing. Things would begin to take shape as they neared completion.

I used to see the elders carving all the time. They used to advise us and tell us to carve as much as we could on our own, even though it didn't come out looking perfect. A person doesn't learn by being idle. . . . If a person just watches, and hasn't tried the carving, when he goes to carve it, it won't be done the right way. But if he tries, even though it's done poorly, the carving will just get better and better. If the hands learn how to do it, it will get better. . . . That's how we were told. We were never helped while we made something. They would watch us, but wouldn't help us. Even when it wasn't done correctly, or perfectly, they didn't say so. We just tried ourselves, thinking of how we would try to make it better. (KYUK 1985)

## Gathering the Wood

That the treeless delta at the mouths of the Yukon and Kuskokwim rivers supported such a rich carving tradition may seem ironic, but the lowland coast annually received a wealth of driftwood from upriver. Men sought stumps of both cottonwood and white and black spruce for carving masks, as the lower part of the trunk had a higher resin content and was less likely to crack and break under the carver's knife. The wood had to be soft and light so that the carver could easily shape it and the performer could comfortably wear the finished mask. Carvers often used the curve of the wood to help form the mask's face, and they could make more than one mask out of a good stump. Kay Hendrickson (January 5, 1994) detailed the wood-gathering criteria on his native Nunivak Island:

The bottom part of a tree has a stump. . . . They used that part cutting off the roots. They never used just any kind of wood. They used wood that had drifted onto the shores. . . .

They call stumps *qamiqunar* [from *qamiquq*, "head"] around [Bethel]. . . . [On Nunivak] they call them

*mimernat* [stumps]. And the ones deep in the ground are called *talliruat* ["roots," lit., "pretend arms"; also *acilquq*, from *aci-*, "area below"]. . . .

You don't use the rest of the wood in the tree. If there are no branches on the wood, they would make other things such as fishtraps, handles for tools, and paddles. They made a lot of things out of driftwood.

Martha Mann (July 7, 1994) remembered the first step in the maskmaking process—gathering the wood: "Perhaps they made new masks every time they had a ceremony. . . . And when they prepared to make them again two men would go out and get wood for the masks." Charlie David (July 7, 1994) described the same immediate relationship between wood-gathering and maskmaking:

When they were getting ready for the event Agayu-yaraq, they would send men out to gather driftwood. They would go out and gather material for masks. And when enough stumps had been gathered and piled up next to the *qasgiq* they would begin making masks. Some of them would make huge masks . . . to be presented to the people. They would try to make the same images of things they cherished.

Jasper Louis (May 29, 1993) recalled the rules surrounding wood-gathering on the lower Yukon, where men searched for driftwood and cut alder and willow along the riverbank. They did not view wood as an object, but as a sentient being deserving their respect: "In those days, when we went to get willow sticks, we had prescriptions . . . [such as] 'When you pick up a dried willow stick, snap it and put the cut end in your mouth and inhale it.' What you are inhaling is its light. They say dried willow sticks have light in

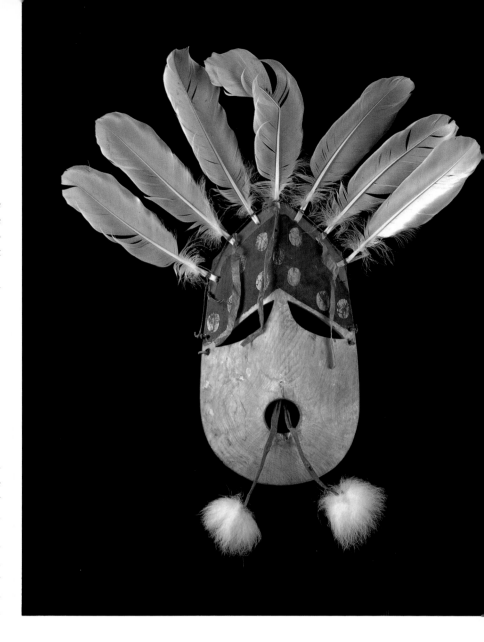

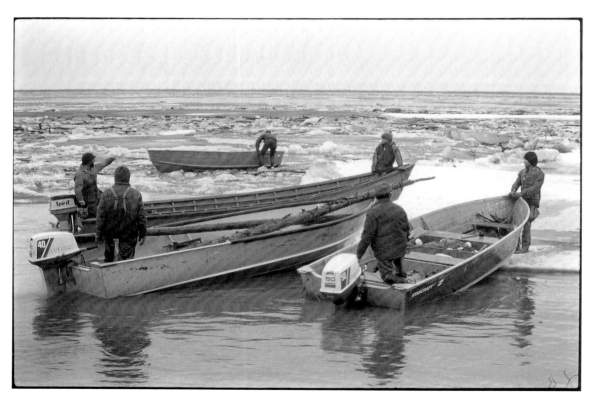

Men gathering driftwood in spring at the mouth of the Yukon River. *JHB*

Fine threesome of masks collected at St. Michael by Henry Neumann in 1890. H. M. W. Edmonds collected a similar mask there between 1890 and 1899, which he labeled "the spirit of the driftwood." Each mask's forehead is painted black with white dots and the lower half white, perhaps representing the upper world (with star-holes to the next universe) and the lower human world into which it is hoped the driftwood will come. According to Willie Kamkoff of Kotlik (February 27, 1994),

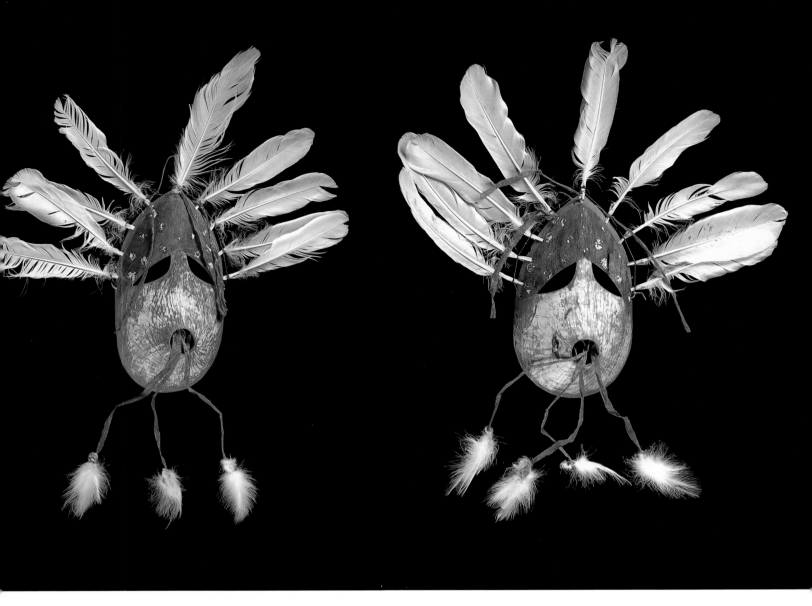

*The* angalkut *composed lyrics to accompany masks and presented them to people. These masks represented the wood they wanted to acquire for the people. . . . Since they used wood for everything they always presented the* equk *mask. They made kayaks out of wood and made their homes out of it and used wood tools to acquire food. They used wood for everything.*

SJM, IIG6 (30.7 cm high), IIG7 (28 cm), and IIG8 (26.6 cm)

them. They say that this dry dead wood has brightness."

One of the most detailed tales Himmelheber collected during his winter on Nunivak related the experiences of a tree, told from the tree's point of view. A man noticed the tree along the riverbank and stopped to cut it down. While he was splitting the wood, the tree tried with difficulty to prevent itself from laughing. As the man worked on the wood, transforming it into a kayak, the wood was happy, but it felt pain when someone else carved it. When the man finished the kayak and covered it with skins, the kayak became very hungry and was satisfied only when the man rode it out hunting, killed a seal, and filled it to the top with meat. Later the man gave the kayak away during a feast. The new owner was not like the first, and the kayak was poorly cared for and unhappy. The kayak then returned to its original owner in human form, refusing the owner's hospitality and eventually taking the man's wife. Throughout the tale, the personhood of the wood/kayak/man is explicit (Fienup-Riordan 1996).

Far from an insentient object, wood is viewed as a feeling, knowing being, capable of both gratitude and retaliation. Men carved masks to represent the *yua* of

the driftwood, which required as much attention as any other living creature. Henry Neumann gave three such masks to the Sheldon Jackson Museum in 1890 and the three masks are not unique. Just as people performed *agayu* dances to request that animals and fish return in abundance, they also danced to coax the precious driftwood to return when the rivers thawed in spring. According to Willie Kamkoff (February 27, 1994):

When they had the last dance with masks in Emmonak, the maker of this mask said that it was an image of *equk* [driftwood]. . . . When people danced in the winter with *equk* masks and received their plea lots of driftwood would come out the Yukon River. When they used driftwood for everything they relied on it. The equipment they used to acquire food was made mostly out of driftwood. That was why the *equk* masks were always presented. I heard that from my mentor.

## Tools of the Trade

Yup'ik carvers made an extraordinary variety of masks with the help of only a handful of tools. Carvers used both the *kepun* (metal-edged adze) and *mellgar* or *caviggaq* (curved knife) for working wood,

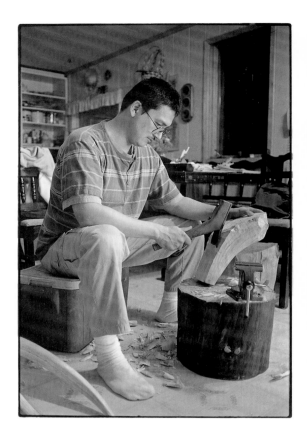

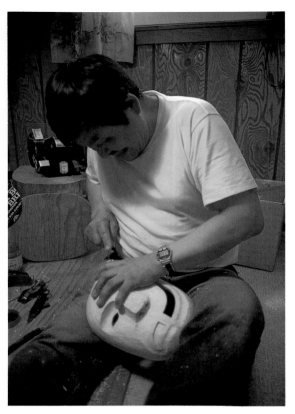

John McIntyre of Bethel using an adze to shape wood. *JHB*

Larry Float, Sr., carving a mask using a *mellgar* (curved knife), the Yup'ik carver's single most important tool. *JHB*

whether for large kayaks and sleds or small tobacco boxes and bentwood bowls. Carvers made their first rough cuts with the adze and the finer shaping with the curved knife. Wassilie Evan recalled,

These are the tools used to make things such as kayaks. We use the *kepun* first to chop as an axe. We make the wood smaller. When it is small enough, we switch to a *mellgar* to smooth it. The knife acts as a carpenter's plane. We make the ribs and the hole, preparing them before assembling a kayak. . . . I still use my knife today, when I make fishtraps, ladles, and other things. (KYUK 1989, tape 5)

Men made all their own equipment by hand, including their carving tools. Nick Charles, Sr., said, "It is difficult to believe that just these two tools—the adze and the crooked knife—were used to make such different things, very big things, as well as small ones" (KYUK 1985). Men worked with skill and patience. Looking at the things his ancestors had carved, Jimmy Paukan (KYUK 1989, tape 1) commented, "You can tell these were worked on with patience in the old days, chopping a little at a time."

For contemporary carvers such as Nick Charles, Sr., the curved knife is the most important tool. He uses some modern tools, including a pocket knife and small plane, but he still relies on the curved knife to finish his work: "I never left it behind when I went somewhere, like the tundra. Out there men would stop and work on something they were carving. Even though they had other tools, the carver was the one most used. They would use it to finish almost anything, following the shape of the object" (KYUK 1985).

Wassilie Evan also talked about the importance

and versatility of the crooked knife, explaining why the tip is curved: "If the tip of the knife is not curved, it could not carve out the inside of the bowl. The curved end is used to make wooden bowls." Carvers use the other end of the knife, called *kakinqutii*, for splitting wood to make traps for catching fish in small streams. Wassilie Evan continued:

It is also used to work on kayak parts—mainly to split wood and use it as a handle for the knife. When I make strips for the fish trap I first use the splitter end and when they are thin enough I use my hands to make the strips. When you get good you can do it with your eyes closed.

You use the flat parts of the knife to work on the wood, to make smooth, flat cuts. The bone handle is also used as a sander to smooth the wood. When I became aware, all men had their own knives to work with.

When I first started making fish traps, I worked on the strips of wood first and saw the other men's work, noticing that they would bend the end of the fishtrap to tie it at the end. Before they instructed me I used to cry, not knowing how to make the ends meet, wanting to make a perfect tip on the end of the fish trap. The men used to laugh at me. But then they instructed me. If you want to make a perfect tip of the trap you start tying two strips and sometimes four until they meet at the end. When I learned I realized they were very good. (KYUK 1989, tape 5)

## Maskmaking Today

Contemporary carvers on the delta use the same basic techniques, materials, and tools to create masks as their ancestors did in the past. Nick Charles, Sr., begins by roughing out a rectangular block of wood

(Fienup-Riordan 1986b). Sitting on the floor, he holds the wood between his thighs with his legs spread out before him. He can also rough the wood from a kneeling position. Holding the wood with his left hand and the adze with his right, he turns the block clockwise four turns, giving it a new face at each turn. He varies the dimension of the block depending on the size of the piece of wood and the mask's intended shape. The rough wood rectangle often seems small compared to a finished mask. But with the addition of bentwood rings and appendages, it will grow in size and stature.

After Charles has formed a narrow rectangle, he quickly and deftly cuts away its edges with the adze or sometimes a small metal-edged saw. Then, rotating the rough-edged rectangle, he uses the adze to trim away the angles and shape the oval or circular form of the mask's face. He then places the flat oval on the floor or on another piece of wood, using the adze to transform the flat face into a curved one. Next he turns the mask over and roughly hollows out the back of the face with the same tool, to make it light enough for a performer to wear and open enough to breathe through. Finally, he roughly planes the face and gives the edges the desired curve.

This completes the basic roughing out. He then exchanges the adze for the smaller, hand-held curved knife. In an expert's hands this simple tool moves as smoothly over the wood face as water, seeming to wash off the rough crust covering the finished form below. He sometimes sings a soft *arra rra rranga yura-raa* as he works. The emerging form is clear in his mind's eye, and his strokes are steady and precise. As he works, he cradles the rounded form to his chest. One hand pulls the crooked knife toward him, while the other alternates between holding the form close and holding and turning it at a distance so that he can judge its progress.

After Charles has carved the features of the mask's face, he scours the entire surface of the mask with fine-grade sandpaper for a more finished look. Past carvers sometimes polished the mask's surface with pumice (*keggalrun*) found washed up along the shore. Delicate knife marks remain on many masks. Others display jagged cuts, probably made intentionally to catch the light for dramatic effect during performance. The insides of many masks show the marks of rodent-tooth tools used to finish them.

Charles uses his curved knife to cut out the beak of a bird or the mouth of a human face to open up either a breathing hole for the performer or a hole in which he can later attach a carved fish or animal. He also opens eye holes in the face. If the mask is to be worn, he bores small holes in the back to hold two thick posts, which the dancer can grip in his teeth to hold the mask up to his face. This mouth grip enabled the dancer to manipulate the mask, performing tricks and transformations in front of the audience inside the steamy *qasgiq*. For this reason the backside of the mask was never open to public view. It is appropriate that today we view masks head on,

hanging on a wall. Although wall masks have been deprived of their motion and sight, at least they continue to show us their proper face.

Charles next will rim the face with four or more three- to four-inch *napartaruat* (lit., "pretend posts; pegs") that will support the ring or rings encircling the mask. He first whittles a thin piece of driftwood down to the diameter of a lead pencil by holding it in his left hand against his outstretched left arm and pulling the curved knife toward his chest. (In the past carvers applied this same technique in making kayak ribs or the slats of a fishtrap.) He then planes the rod by pushing the knife out and away while holding the wood firmly between his knees and cuts it into equal lengths, measuring the first piece against his hand and each succeeding piece against the first. He inserts these pieces into holes that he has drilled equidistant from each other around the circumference of the mask's face. To insert a peg, he puts it in the hole and pounds it gently with a smooth stone. Sometimes he reinforces the pegs with wood glue.

After Charles has completed and temporarily inserted the posts, he measures the first wooden ring against the mask and bends it to the proper diameter. Like the rod from which he cut the posts, the wooden ring is a long strip of wood that he has thinned with the help of the crooked knife. In the past the carver would have steamed the spruce strip to make it pliable. Instead, Charles moistens it under running water and gently bends it by working the wood through his mouth. As he grips the wet wood in his teeth, he exerts pressure on both sides of the thin strip. Finally, he closes the circle with strong string to bind the two ends together and runs the string across to the opposite side of the ring, back to a point just below the bound connection, and across to the opposite side. He then hangs the bound ring on a peg to dry, leaving the cross-binding in place until the wood sets. When he cuts it away, only a single tight knot connects the two ends of the closed circle.

After the rings have dried, he attaches them to the mask's face. Holding the ring firmly in place against the post closest to the mask's base, he binds it to the post with strong black thread (instead of the fine sinew string used in the past.) He first loops the thread around the post and ring, then brings the end of the thread through the loop, forming a neat closure. Holding the loose ends together, he winds the thread around the juncture several times, and finally brings the tail of the string up between the post and ring. He pulls it tight and completes the binding. After the initial bind is made, he holds the ringed mask at a distance away from his body and checks the fit. He then attaches the ring to a post at the top of the mask, ties the remaining posts, and completes the connection.

Having tied the ring to the posts, Charles attaches appendages called—like those decorating the *ellanguaq* hanging from the *qasgiq* ceiling—*qirussit*. He has made these small carvings from scraps of wood, which he holds cradled tight in his hand while mov-

ing the curved-knife blade in toward the base of his thumb. He makes them in many shapes and sizes, often stylized representations of animal parts, such as a bird's tail, wings, and feet surrounding the central head. He attaches each piece to the blunt tip of a bird or duck feather quill inserted into the mask's outer ring. Unlike the wooden posts that support the ring, these feather posts are flexible and allow the appendages to bob up and down, emphasizing the dancer's movements. The appendages thus add both detail and motion to the mask. Charles prefers the tail feathers of old-squaw duck (*aarraangiiq*), but he also uses quill feathers of birds such as common eider (*metraq*), common scoter (*kukumyar*), and snowy owl (*anipaq*).

## Painting a Mask

After Nick Charles, Sr., has carved all of the mask's parts, he is ready to paint and assemble the finished piece. He uses white, red, black, and blue—the four colors originally derived from natural mineral pigments available in the coastal environment. The base color, *urasquq*, is a flat white made from clay that he mixes with water and applies by hand. He often uses this clay coat to cover the mask before applying designs in blue, red, and black. *Qesurliq*, the blue color, probably derived from vivianite (Ray 1981:20), was also used to decorate kayak paddles and hunting equipment. *Uiteraq* (red clay or ocher) is ground to produce red paint. Women also use red ocher to dye the tanned side of wolverine tassels that decorate fancy parkas.

Past carvers often mixed red ocher with nose blood (on the Kuskokwim) and seal blood (on Nunivak Island) to ensure the color's permanence (Himmelheber 1993:62, 70). Sitting in the *qasgiq* painting his mask, the carver would prick the inside of his nose, mixing drops of blood with the clay (Fienup-Riordan 1996). Other paints, especially red, were mixed with seal oil to make them darker and more durable.

Historically, carvers made black paint (*tungulria*, lit., "black thing") by mixing charcoal or ashes with oil and water or blood. Zagoskin (Michael 1967:121) observed men painting designs on each other's backs using powdered coal dissolved in fermented urine. Charles uses India ink or felt-tip marker as a contemporary replacement.

Nelson Island was traditionally and continues today to be the source of white clay, blue vivianite, and a bright red goethite clay (Ray 1981:20) used throughout the delta to decorate carvings. Red and blue colors came from mineral lumps that could be easily ground to a fine powder and were sometimes used in healing rituals. Carvers from other areas acquired these materials through trade or as a gift from Nelson Island friends and relatives, storing the highly valued pigments in finely carved wooden paint boxes (Nelson 1899:199). Men traded for paints but never for finished masks.

People know the general location of these deposits but say that they reveal themselves only to seekers worthy of the find. Even more elusive is the location of a pool of wet white clay located near the island's center. This pool, which is covered by a slate slab, on which lies a bone spoon, is an old and well-kept secret. Carvers gather blue vivianite from rocky cliffs along the coast west of Tununak. The deposits are high out of reach, and people dislodge them with gunshots. At low tide one can walk out on the mudflats below Toksook Bay, where streaks of white clay just below the surface reveal scattered caches of kaolin. The red clay that carvers covet is found in a remote spot in the center of Nelson Island, where Raven's daughter was said to have had her first menstruation: "Crow's daughter went above Tununak, on this side of Ngel'ullugaq, to make story pictures. . . . When she was ready for her menses, she hid it on the top of a mountain. . . . This is where people get red coloring from, in the place where she had her menses. Lots of red coloring, very red. The name of the place where she had her menses is called Qilengpak" (Fienup-Riordan 1983:248; see also Himmelheber 1993:61; Ray 1981:20).

Kay Hendrickson (January 5, 1994) described traveling to Nelson Island from Nunivak to gather paint pigments:

Since Nunivak did not have any, they went to Nelson Island to get red ocher paint . . . and also white paint, which they used on the masks. . . . We went to Nelson Island crossing Akulurar [Etolin Strait], . . . we would paddle and go after [the pigments]. . . . You have to look for them. The white clay was found on the beach. And the red paint between the rocks on the shore. Those who know where to find them would dig around and find them. I, myself, would look where people had dug and find some.

Like Nick Charles, Sr., Kay Hendrickson made black paint from coal, which was available on Nunivak. Mary Mike (October 19, 1994) said that coal to make black paint was also available near Ingrill'er, the mountain located at the head of the Black River.

Carvers rarely mixed colors on Yup'ik masks, but they used them in recurrent combinations. Many carvers from all over the region painted their masks with a distinctive three-color scheme: red on the bottom over the mouth, white across the nose and cheeks, and blue-green or black across the forehead. No one has ever recorded an explanation for this triumvirate.

We know very little about Yup'ik color symbolism. Although no overarching system is apparent today, local meanings still exist. In his account of the end of warfare and the beginning of dancing, Mike Angaiak (November 16, 1989) described the protagonist's interpretation of the three colors he used to decorate the dance stick he presented as a peace offering to an enemy village:

"This [stick] is the way we live today on this land." He mentioned the red paint on it and said, "This is what

Finger masks collected at Andreafski in 1893 by Sheldon Jackson, displaying the color triumvirate so common on Yup'ik masks and dance fans. Each has a single finger hole, and feathers tipped with down alternate with four tufts of reindeer hair. As with so many larger masks, the back of the eyes and mouth are painted red. The forehead design is designated *nuusaarpak*. SJM, IIB32 (10.2 cm)

Back of a mask, painted with red ocher around the eyes and mouth, collected by J. H. Turner in 1891. Red paint could protect, empower, or transform, depending on its context of use. SI, 153619 (38.7 cm)

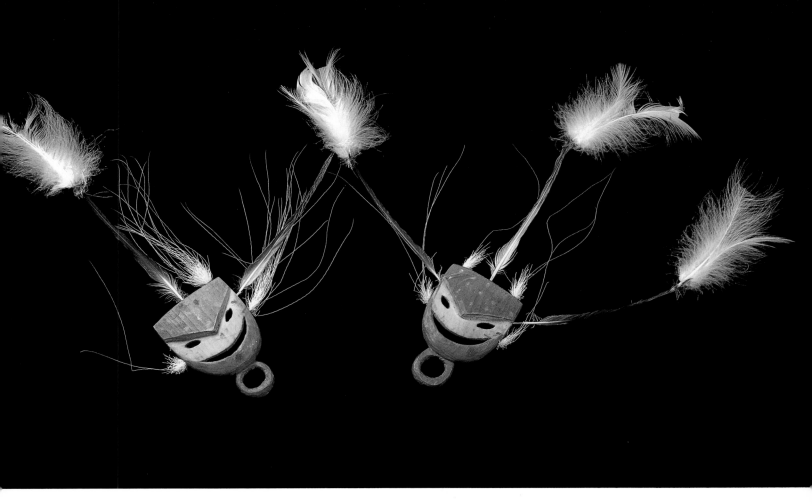

15. Yup'ik interpretations of the meaning of colors and color combinations resonate with the color symbolism of the people of Northeast Asia. Sergei Serov (1988:245) noted that among the Chukchi, black was the color of the other world and death, while red was the color of life: "Face and hand painting with red ocher or the blood of a sacrificed animal was an important element in Chukchi wedding and funeral rituals. Ceremonial and shamanistic garments were ornamented with red tassels of twisted wool or fur. Red and black were conflicting colors, whereas white played a neutral role. A combination of three colors was used on divination sticks."

we are like today. This red color is the blood. We are such sorry people. . . . We have been fighting for so long now. Our blood is scattered all over the land." He talked about this piece like that.

Then he pointed to the white part and said it was winter. And the other parts were the animals. All the caribou that roam on the land and the other animals that swim out in the ocean. That is the meaning behind the white color. He said the black color was the earth.

Alma Keyes (February 27, 1993) of Kotlik associated the contrast between black and white with that between life and death: "They have said when some-

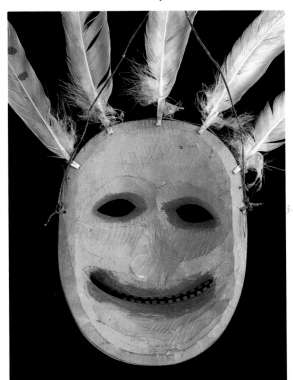

thing is painted with black color it meant that it was going to die ultimately. Apparently, that is what it is. . . . Perhaps they live when they use the color white."

Red appears on many hunting tools and articles of clothing. Curtis (1930:38) noted that on Nunivak ordinary people's masks were painted red, while *angalkut*'s spirit masks were blue. Moreover, the eye, mouth, and nose areas on the back of many masks were rimmed in red, possibly to protect the performer, bounding him off from the spirit represented by the mask. Peter Lupie (June 18, 1985) described how the powerful *angalkuq* Apangtak vomited colors. Yup'ik people may have viewed all colors as magical in some sense, as they were associated with the representation of an other-than-human reality during the ceremonial season.[15]

To color the finished mask, Nick Charles, Sr., rubs the mask's face with a mixture of white clay and water, applying it as paint with his palm. Other mask-makers use wolf or fox fur to apply the paint. He gently rotates the mask over the flame of a Coleman stove to ensure even and complete drying and then rubs the face again to dust off excess paint. Next he rubs the posts and rings surrounding the face of the mask with red clay, chunks of which he blends with water to produce a thick paste. He mixes by hand, breaking up the lumps through slow and careful stirring. After Charles has applied the red paint with a cloth, he lets it dry and rubs away the excess. As a final step, he uses a black marker or a stick dipped in black paint to draw the designs on the mask's face.

Kay Hendrickson (January 5, 1994) described the

painting process on Nunivak, which included use of a squirrel's-tail brush to apply black paint to a wooden bowl and "setting" the paint with heat:

They would mix [red ocher] with water very well. And when it was ready they would use it. . . . When the paint dried you would press it and rub it very hard. You would rub it until you were sure the paint would not run anymore. You would finish it when you knew the paint was all set firmly. The paint would stay when you used the piece for anything. And if you used it in water, the paint would not rub off.

After they added blood to the coal, they would take a piece of wood and they would carve it and put the end of a squirrel tail at the tip. And after they dipped the squirrel tail in the mixture they would paint the wood, and when they brought the painted wood near the fire it would begin sweating. And after they brushed the paint again and brought it near the fire it would look very good.

Before attaching the appendages, Nick Charles, Sr., coats each one with white clay paint and details many with the same black paint (or marker) that he used to paint the mask. Next he presses the blunt tips of ocean bird or owl feathers into their bases, and the basal ends of the feathers through evenly spaced holes in the ring. After he has fitted the feathers and their attachments, he removes them from their slots. In the past he might have dipped them into a glue made from nose blood rubbed until it turned white. Today he dips them in store-bought wood glue and puts them in place.

### Qirussit: "The Things We Put on the Mask"

Carvers finished their masks in a variety of ways, making use of almost every imaginable material, including feathers, grass, caribou hair, animal fur and teeth, willow root, dyed pieces of dried seal intestine, beads, bells, and buttons (see Ray 1981:58). Like many Yup'ik carvers, Nick Charles, Sr., encircles his masks with *ellanguat,* to which he attaches numerous *qirussit. Qirussit,* defined by Charles simply as "the things we put on the mask," may include carved body parts or objects related to the mask's story. For example, the mask he made to represent the story of the *angalkuq* who predicted the coming of the first white people was the face of the *angalkuq* Issiisaayuq with a single *qirussiq* perched on his head—a boat representing the ship in which the strangers arrived (see p. 149).

Masks from southwestern Alaska often consisted of dozens of parts attached either directly to the body of the mask or balanced gracefully on feather quills or baleen pieces attached to an encircling ring. A common style from the coast between the mouths of the Yukon and Kuskokwim rivers is a face surrounded by one or two *ellanguat* with feet at bottom, hands at the side, and a person or animal head on the top. Alternately, the wings and feet of a bird or paws of a land animal might be attached. Thus, the living being was disintegrated into its component parts and

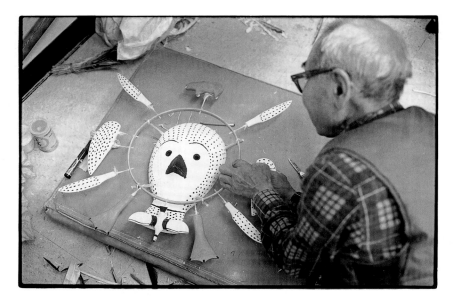

then reassembled, providing a new and unique way of viewing the "person" represented—whether animal or human. Commenting on this process of decomposition, Himmelheber (1993:77) wrote, "The face as most expressive part gains in expression at the cost of the parts which are weaker and the least expressive part, the body, is totally omitted."

On some masks the appendages are small models representing whole objects, such as animals or hunting implements. Nick Charles, Sr., remarked that this area of the mask can be an outlet for the imagination. For example, a young woman at a carving workshop in Kasigluk carved the face of a woman, complete with downturned mouth, to which she attached small carved mukluks, mittens, and other "women's things."

John Kusauyuq adding appendages to the *ellanguaq* surrounding his snowy owl mask during the Bethel maskmaking workshop, 1982. Each appendage balances on a feather shaft, allowing it to move rhythmically during the dance. *JHB*

Kay Hendrickson drilling holes in the *ellanguaq* of his seal mask before adding appendages during the 1982 Bethel maskmaking workshop. *JHB*

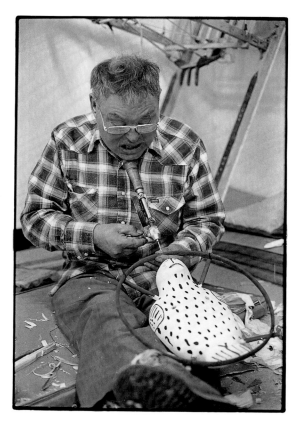

Jacobsen collected this sea-gull mask at Cape Vancouver in 1883. Bird masks with the bird's *yua* carved into its back were made throughout southwestern Alaska in a wide variety of forms. Ray (1967:195) notes that every collection of Eskimo masks contains a unique example. *MV, IVA5171 (30 cm)*

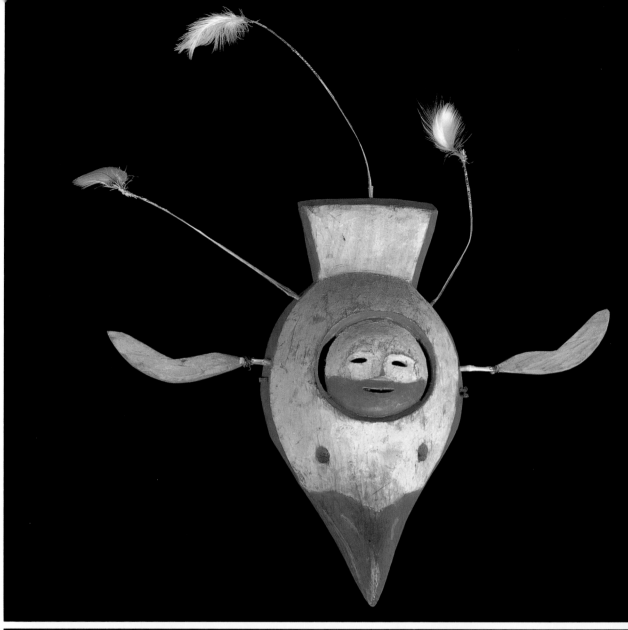

Wooden bird with a human face collected by Jacobsen, in 1883, either from Golovin Bay on the north shore of Norton Sound or Ekusak near Goodnews Bay. Jacobsen wrote that the image "probably represented the spirit of an ancestor. During the Feast for the Dead, the bird was lowered from the roof of the *qasgiq* by a rope as soon as a new guest entered through the opening located in the middle of the floor as if to greet the new guest." A wing and leg have been restored. *MV, IVA3119 (26 cm)*

MAKING
A MASK

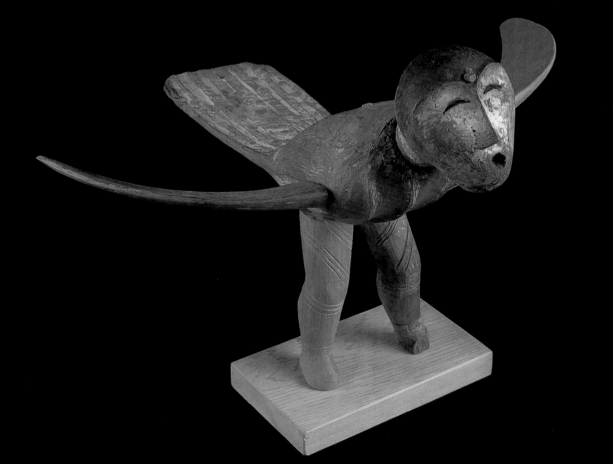

The owner of a mask explained the meaning of the *qirussit* when the mask was presented. Asked about the significance of those around a mask made by the *angalkuq* Irurpak, Wassilie Evan demurred, saying that only the owner could give a full account: "These appendages are made to look like what they are. Like the kayak there . . . was placed as he wanted it to be to his own interpretation. The other attachments have meanings, but I do not know what they might be. . . . The other appendages each have their own meaning that only Irurpak's *tuunraq* knows. If this is Irurpak's, only he would know" (KYUK 1989, tape 1).

Mary Mike (February 25, 1994) remembered how the masks came to life as the performer moved and the *qirussit* rattled against each other, giving the mask its own voice:

Some of them had *qirussit* like this one. . . . A piece of wood would be circle shaped. It would have feathers on it. And there would be little hands hanging on one of the *qirussit.* . . . When they explained to the audience what the masks were about, the owners of the masks would call out the sound of the animal depicted. The hanging objects would hit the *qirussit* and make a rattling sound as they did this. They would put it on and cry out the call . . . of the image they were presenting.

Willie Kamkoff (February 27, 1994) recalled that, like the mask, these carved images were sometimes made wishing for an animal to be plentiful. Thus, a single mask might embody requests made through myriad voices.

In northern Alaska the unadorned human face made a regular appearance in masked performances. This was not true in southwestern Alaska, where masks only infrequently appeared without something circling their outer edges. A halo of caribou hair fitted into a groove carved around the mask's edge rivaled in frequency the wooden *ellanguat* encircling so many coastal masks. But caribou hair is hollow and easily broken. Thus, museum collections today contain many deceptively plain masks that were originally generously rimmed with fur. Nelson (1899:397) noted that these halos represented the parka's fur ruff, and *The Eskimo about Bering Strait* illustrates many masks in their original glory. Perhaps it is appropriate that representations of the animal's *yua* appear clothed in a human garment.

Feathers of all kinds were omnipresent on masks. Commonly used feathers included swan, snowy owl, old-squaw duck, goose, eagle, gull, tern, and ptarmigan. In some cases these feathers represented snow, in others stars (Nelson 1899:496). Their meanings, like those of the wooden *qirussit,* were various, depending on the story the mask presented. Flexible quill feathers were used to balance the wooden *qirussit,* adding emphasis to the dancer's undulating movements. Feathers often appeared in threes, fives, and sevens over a mask's forehead, balanced right and left with a single feather at the top. The number of feathers varied widely, up to as many as two

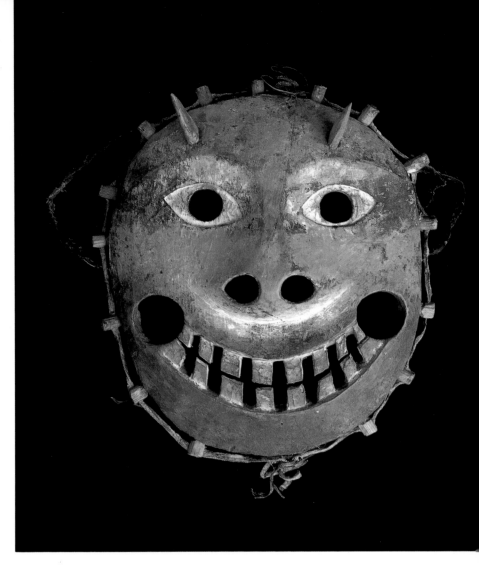

dozen. Masks made along the lower Yukon and north towards St. Michael, such as those collected by J. H. Turner and Sheldon Jackson, often appeared topped with three down-tipped old-squaw duck quill feathers. The *nepcetat* masks so common on the Yukon typically had a line of a dozen or more swan feathers running along the upper rim.

The general use of feathers simultaneously relates to the natural abundance of birds in southwestern Alaska and their cultural importance. Bird images were central to many Yup'ik ceremonies (Fienup-Riordan 1990b). In coastal communities the hunter and his wife played the part of seabirds during the Bladder Festival and other ritual acts associated with seal hunting. Faced with the contradiction between an ideology that emphasized the seal as honored guest and the reality of the animal's death in the hunt, Yup'ik hunters were both protected and empowered by a birdlike identity. Lantis (1947:93) noted that everyone on Nunivak had their own bird spirit. Though the enhancement of ability was part of what was represented in some ceremonies, in the Bladder Festival the hunter not only took on birdlike qualities but became a seabird, such as a murrelet or an eider duck, in the eyes of the seals he sought. The wooden birds hung from the *ellanguaq* as well as the bird feathers and figures on many animal masks provide a vivid image of this relationship—hunter and hunted side by side.

Finely carved Kuskokwim mask originally surrounded by a caribou ruff. Jacobsen labeled it "demon mask showing a bad spirit." *MV, IVA5176 (17.5 cm)*

# Human Senses in Yup'ik
# Iconography and Oral Tradition

A number of features appear regularly on Yup'ik masks and other objects of ritual and daily life, such as wooden hoops, painted rings, thumbless hands, goggled eyes, and nucleated circles. Attempts to interpret these features, however, pose more mysteries than solutions. Ethnographers have described the iconography, and historians have analyzed it feature by feature (Nelson 1899:393–415; Ray 1967:65–71; Fitzhugh and Kaplan 1982:198–203). Recently, Wallen (1990:17–19) related selected aspects of mask iconography to the natural world, showing ways in which art imitates life. These writings tell us a great deal about what features commonly appear on masks and where some of these images may have originated.

Instead of beginning with the masks and relating them back to what they might represent, the approach taken here begins with the Yup'ik understanding of the senses of human and nonhuman persons and then shows how the features of the masks both express and expand upon their meanings in everyday life. According to Yup'ik cosmology, both humans and animals possessed a mutual awareness of each other's activities and were constantly admonished not to injure one another's "mind" (*umyuaq*). The Yup'ik concepts of "mind" and "awareness" encompassed the ability to see, touch, hear, taste, and speak as well as to know.[16]

16. Robin Barker (1994) develops this idea in great detail as it relates to learning and socialization of Yup'ik children.

The Yupiit performed many ritual acts, especially the extraordinary masked dances, to influence animals, who, as nonhuman persons, were cognizant beings, capable of responding to the thoughts and deeds of their human companions. In these dances they acted out the opposition between their own limited vision and the supernatural senses they attributed to their spirit guests. The dances opposed restricted human sight to powerful vision, the gloved human hand to supernatural touch, polluted human odor to cleansing smoke and transforming breath, restricted human speech to powerful songs, and the closed lips of attentive listeners to the spirits' wide, toothy mouths. Masked dances combined movement, sound, light, song, smoke, and food to attract, influence, and often to embody the members of the spirit world on whom the Yupiit depended.

## Ella

The concept of *ella* is among the most important in Yup'ik cosmology. *Ella* translates variously as "weather," "world," "universe," "air," "awareness," or "sense." "*Ella assirtuq*" means "the weather is good," while "*ellanguaq*" translates as "model or pretend cosmos." *Ellange-* means "to gain awareness" (from *ella*, "awareness," plus *-nge*, "to begin"). Many oral accounts begin "*Ellangellemni . . . ,*" translating "When I became aware." Very young children lack awareness or lasting memory of experience. As they mature, however, they gain awareness, recognize their surroundings, and remember their experiences.

Animals and humans share this awareness. From the powerful bear to the small, apparently insignificant tundra lemming, each is a thinking, sentient being and must be treated with respect. Animals are often depicted as more sensitive and aware than humans. According to Charlie David (July 7, 1994), "That was the way the old ones operated when they totally respected the *ella*. . . . The land animals, like the ocean beings, are very, very keen. Even the fish are aware of people who are in trouble or in a predicament. During this time now you have heard of talk that fish are swimming very deep. Truly, they are keenly aware of everything." Conversely, those who disobeyed the rules were warned, "Someday *ellam yua* [the person of the universe] will make you become aware. *Ellam yua* will make us come to our senses. It is the truth."

The minds of respected elders were believed to be particularly strong, and young people were admonished to help them whenever possible. The efficacy of daily tasks and ritual acts alike were compromised if performed thoughtlessly. For example, young boys were admonished to keep their minds focused on the animals they sought as they prepared to hunt, or the animals would not approach them. Not only was a person's mind powerful, it was also considered vulnerable, and people learned to take care and control their words and actions so as not to injure another's mind.

Attitude was as important as action in daily life. Nick Charles, Sr., emphasized the connection between thinking and carving: "Anything made without an idea won't be anything when done. . . . You're always thinking of how best to complete whatever it is you're working on. . . . If an idea turns out not to look like what you want, you stop and try it another way. That is how it is to work on these. You

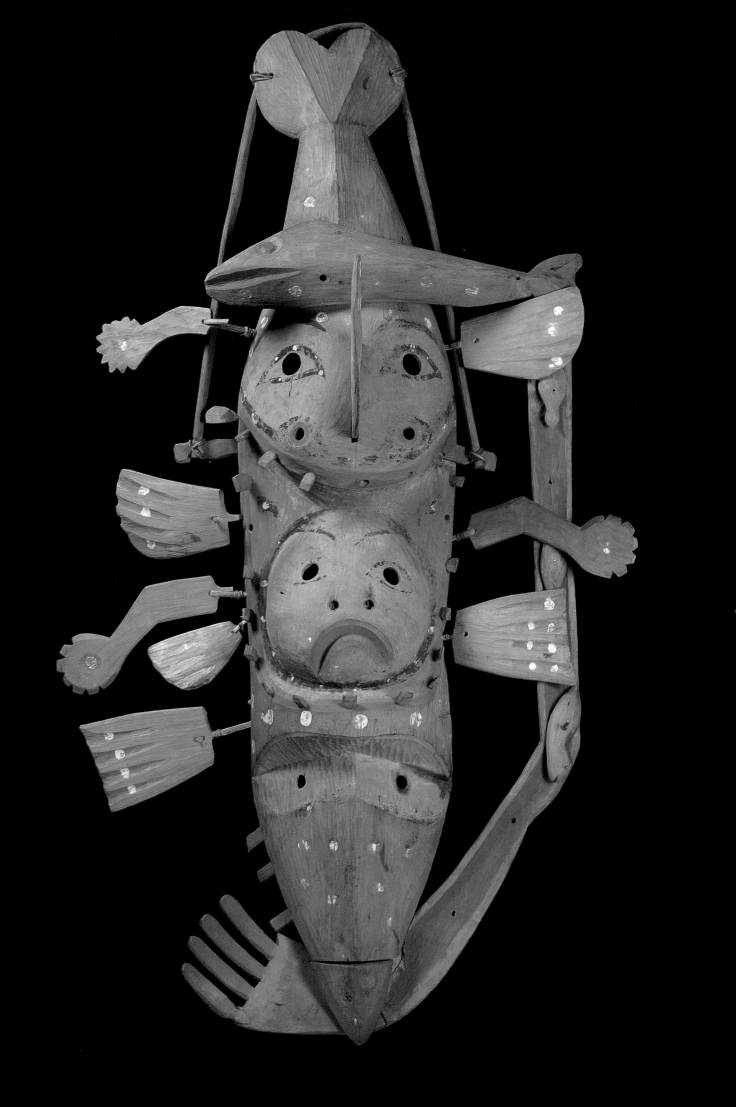

Enormous and complex Goodnews Bay mask, including forty-four detachable pieces. It is too heavy for the dancer to have held, and probably hung on a rope in front of his face. The body of the mask is a long fish, perhaps a pike, with a toothy mouth. A long arm ending in a four-fingered hand runs down one side of the fish, reaching below the mouth.

Looking out from its back are two faces—a smiling land animal on top and a frowning sea mammal on the bottom. Here, as in kayak charm plaques, dance fans, and other two-faced masks, the opposing faces may relate to the complementary relationship between sea and land or sky as well as between female and male (see p. 109). Collected by Ellis Allen, 1912. *Burke, 4528 (129.5 cm long)*

make as much as you want, using your ideas" (KYUK 1985).

## Restricted Human Senses

From their earliest years, children were taught myriad rules for the proper living of life—rules that guided them in their relations with both humans and animals. After they gained awareness, both young girls and boys spent countless hours listening to their elders. The words of their mentors simultaneously recalled past experiences and foreshadowed listeners' futures. Charlie David (July 7, 1994) remembered, "When I entered the *qasgiq* my late grandfather used to sit me next to his place and say, 'Listen to the speakers in here. They are talking about things you will utilize while you are alive. You will experience them someday. . . . If you always listen with your ears you will hear words of how a person would have a proper journey in his life.'"

While attending to these life-lessons, young listeners in coastal villages were told to look at the speaker's mouth, thus listening with their eyes as well as their ears. Martha Mann (July 7, 1994) described listening to her grandfather in the *qasgiq* and looking down from embarrassment. Another man told her, "'Pay attention to his mouth. When someone looks away when spoken to it means that they are not going to listen to advice.' Then I tried to look at him while he spoke even though my eyes were uncomfortable."

Jasper Louis (May 28, 1993) spoke of knowledge as something that one swallowed, emphasizing in yet another way the strong connection between thought and the senses through which one attained awareness:

It has been said that when a boy joined a man in a meal, the man was to tell the boy things that would help him do well in his life. They say that while the boy was literally eating, the words he heard were ones he could remember and keep. Both girls and boys could take and remember the things they heard as they were eating. They say at this time they would swallow the words. The combination of actually consuming food and swallowing words was the time people could hear things they could remember.

Parents and other adults taught an attitude toward life and work as important to their children's future as specialized skills. Young people used all their senses to attend to instructions as they prepared for adult life. In other contexts, however, their senses were rigorously controlled and activity circumscribed. Gaining "awareness" involved much more than thinking or acquiring ideas. Learning centered around the control of one's senses. Children learned both by listening to the experiences of their elders and by increasingly learning to control their own actions (Barker 1994; Briggs 1991).

Regardless of their technical knowledge, if young people failed to perform certain acts "to prepare the path for the animals," they put their future in jeop-

ardy. Getting up and out early in the morning were important cleansing actions that children performed from their earliest years. Young people were also trained to willingly embrace even the most distasteful chores. Caring for the refuse of the people created a "walktrail" for assistance in their future life. Joshua Phillip (June 1988) told how a young girl looked back across a river she had just crossed and saw that her way had been paved by the refuse she had cleaned from the houses. The same applied to young men: "Down there in the ocean, a person was also rescued by those things. He would step on those ice chunks in the water. After he had stepped on them, he would look back to them, and they would be ashes and grass. Those people who were grateful for his past deeds helped him in his time of great need. They rescued him from his inevitable death by using those ashes and grass." The powerful minds of the people he had helped and the power inherent in the refuse provided at once a pathway in time of need and a barrier to misfortune.

Removing snow from passageways was an endless task in winter. Wind and weather filled them in again as quickly as they were cleared. Young boys' work included clearing all manner of pathways—shoveling house entries, clearing the *qasgiq* skylight of snow, tending waterholes to keep them free of ice. According to Billy Lincoln (July 13, 1985), "One of the boys . . . who uses his mind would take a shovel and go out and go from house to house . . . through the whole village, clearing their porches, shoveling them. He would think like this, that when he begins to do things, he hopes that his catch will come to him." By performing these actions while keeping their minds focused on the animals, boys cleared the way for the animals they would someday hunt.

Ideally, all children's activities were carefully regulated, including sleeping, eating, drinking, talking, and movement in the performance of daily tasks. A child awoke early, immediately checked the weather, worked hard without fear of dirt, and ate carefully and in moderation. Through all these acts, one worked to simultaneously create a boundary between oneself and illness or ill will, while clearing a path to good hunting and a good life in the future. Regardless of one's technical skill, if one failed to live by the rules, illness and death, rather than animals and offspring, would come.

As they came of age, both men and women continued to carefully control their actions. For example, at first menstruation a young girl's senses were severely restricted. She sat inside the house, hooded and belted and wearing mittens. This covering both protected her from unseen influences and protected hunters from inadvertent contact with her "bad air." According to Mary Mike (May 29, 1993):

They wouldn't let her touch and cut freshly caught fish and game . . . or newly caught live things from the ocean. They wouldn't let her do some things. And they told her to always remember not to come face to

face with boys and talk idly with them. . . . This was during the time after she had been sitting down. She fasted. . . . Her mother didn't want her to look up in the sky, so that her eyesight would be keen and strong for a very long time.

A woman's activity was restricted not only during her menstrual period. In most contexts young women were admonished from direct eye contact with hunters. Also, the air of sexually mature women was considered polluting to young hunters, who were advised to pass a woman on the windward side to avoid her bad air and to breathe out when passing her so as not to dull their senses. Conversely, women were told not to walk upwind of a man, but to pass him on his lee side if it was windy. A man had to pull his mouth down under the neck of his parka and look down when he met a woman in the doorway. According to Paul John, a man's breath (*anerneq*) was particularly vulnerable to contamination from such contacts, with potentially disastrous effects. If a man breathed a woman's vapor, his breath soul would be weakened and his mind would become fuzzy and lose its power to focus on the hunt.

Both the menstrual and postpartum seclusions stand out as parallel attempts to temporarily contain a woman's reproductive power. During these ritually charged times, social relations, food intake, and daily activity were severely restricted. A woman was not allowed to cook for other people, handle fresh meat, or work fresh skins. All a hunter's senses were at risk, and all a woman's senses were bound off to protect his power to attract animals. A woman restricted her sight, smell, taste, and movement to empower the men in her community.

Rather than constituting a boundary between the sexes or between women and animals, these restrictions served to separate a person from the universe when the spiritual counterparts of human and non-human bodies were in transition. Moreover, these seclusions were not restricted to women. A woman shared her postpartum and menstrual seclusions with her husband. A mother shared with her son the restrictions following his first seal kill, just as she had shared restrictions surrounding seal hunting with her husband. Rather than suffering an opposition between sacred male and polluted female, men and women alike were bound off at these times to promote future well-being. It was neither man nor woman alone, but the married couple "acting with like minds" and sharing the animals that came to them who were responsible for the production and reproduction of life.

## Restricted Human Vision and Powerful Supernatural Sight

Human sight was restricted in many contexts. In all social and ritual situations direct eye contact was, and continues to be, considered rude. Downcast eyes signify humility and respect. Sight is the prerogative of age, of knowledge, and of power. The shades of the dead were traditionally said to hear and see nothing at first; however, by the time they reached the grave they had attained clairvoyance (Nelson 1899:425). Powerful images and hunting fetishes were supposed to watch for game and, by clairvoyant powers, see it at a great distance (Nelson 1899:436).

During masked performances, however, the *angalkut*'s supernatural visions turn these restrictions on their heads. Joseph Evan (July 12, 1994) was among the last to see such dances along the coast: "Those were masks belonging to *angalkut*. They made masks revealing the extraordinary sights they had envisioned. [An *angalkuq*] would create masks of things he had seen through his *tuunraq*." Joshua Phillip (July 1, 1988) described an *angalkuq*'s use of a mask for supernatural vision: "Some of those masks used for viewing were real. If he put this one on and was looking around, he would say, 'There is another *angalkuq* who is casting a spell on you. He is going to kill you. It is he who is sending it to you. It is connected to both you and the *angalkuq*. It is the *angalkuq*'s weapon.' He used that mask to see that."

Vision was an act constituting knowledge, and witnessing was a potentially creative act. According to Joe Beaver of Goodnews Bay (June 1988), "A speaker will not scold you for looking at him too much. But looking all the time while someone is teaching is how one must keep listening." Watching a person's face, masked or otherwise, was particularly revealing: "And they keep saying this: 'The mind of each individual is known by the middle of the face.' And I also know that. I know how people think even though they may pretend to be happy—it is easy to see!" (Nastasia Kassel, Kasigluk, May 25, 1988).

Whereas participants carefully hid dance masks before a performance, they believed that masks endowed performers with supernatural vision during the dance. According to Hawkes (1914:17), "When the actor puts on the mask, he is supposed to become imbued with the spirit of the being represented." The use of masks during Agayuyaraq provides a concrete image of the contrast between restricted vision and powerful the universe. In the case of the animal spirit masks, attention to the center of the face was particularly important. There, embedded in the carving of the supernatural being, a small, human form often represented the *yua*, or "thinking part" of the creature, which at death became its shade (Nelson 1899:394). Alternately, the carved face of the mask is raised up to reveal the face of the performer representing the *yua* of the animal.

A material manifestation of vision imagery is seen in the nucleated circle that decorates many hunting charms as well as objects of everyday use. The circle-dot motif, so common in Yup'ik iconography, is specifically designated *ellam iinga* (eye of awareness) in the Central Yup'ik language. In the literature the nucleated circle has been designated as a marker of joints and, as such, part of a skeletal motif. Alternately, the circle-dot has been labeled a stylized woman's breast that might then be substituted for a

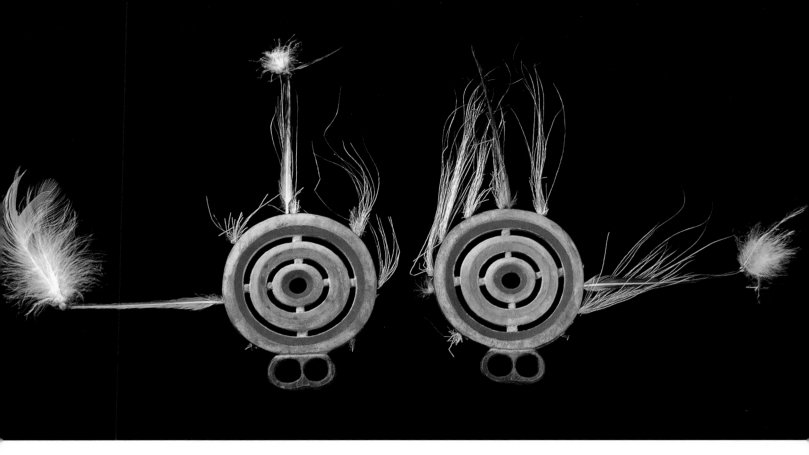

Dance fans featuring the circle-dot motif designated *ellam iinga*, from either the lower Yukon or tundra village area. The three concentric circles each have white edges and alternate red and blue inside, and each is divided into four quadrants. Like so many other finger masks and larger masks from the Yukon area, these are decorated with caribou hair and three jaeger feathers trimmed with downy tufts at the tips. *SJM, IIH45 (12 cm)*

woman's face (Himmelheber 1938:62; Ray 1981:25). Joints also were marked with circular eyes (Fienup-Riordan 1987; Phyllis Morrow, personal communication). William Thalbitzer (1908:447) observed that, "According to Eskimo notions, in every part of the human body (particularly in every joint, as for instance, in every finger joint) there resides a little soul." Though he spoke of Greenland Inuit, his observation seems to apply to Yup'ik concepts as well.

Joint marking was associated with social transformation in various contexts throughout the Arctic. For example, in southwestern Alaska the wrists of young men and women were tattooed with dots on the occasion of their first kill or first menstruation, respectively. Ritual scarification has also been observed among the Siberian Yupiit and maritime Chukchi (Bogoras 1904:408). Considered along with the custom of applying eye-shaped markings to the joints, the tattooed joint mark could well be the rudiment of the eye motif (Schuster 1951:18).

As in the circle-dot motif as applied to material objects, the puberty tattoo denoted enhanced vision. In the performance tradition, black circles around the eyes are one mark of a transformed character. Dark circles also appear as "goggles" or "spectacles" on many Yup'ik masks and other carved objects. These goggles identify a state of transformation. One contemporary Chefornak hunter recalled his mother circling his eyes with soot when, at age nine, he returned to the village after killing his first bearded seal.

Mike Angaiak's (November 30, 1989) description of wooden snow goggles provides a possible link to these black-painted spectacles: "On the inside liner of these snow goggles there is a black mark. That is the soot from the stove to color it dark inside so that sun doesn't reflect that much inside there." Black around the eyes helped a person—like a contemporary football player—to see. Goggling on masks may indicate the possession of or desire for clear vision.

Joints were not only marked with eyes as a sign of social transformation. Actually cutting an animal or human on the joints was associated with spiritual transformation, as when the joints of dangerous animals were cut to prevent the animal's spirit from reanimating its body. In the same way, an *angalkuq* might be figuratively dismembered prior to his journey to the spirit world. Traveling up through the smoke hole or down through a hole in the ice, he would visit the *yuit* of the animals to entreat them to return the coming year. The nucleated circle, both an eye and a hole, thus recalls the ability to pass from one world to another or to see into another world.

A particularly eloquent example of the relationship between socially restricted sight and powerful supernatural vision is contained in the story related by Paul John (February 1977) of the boy who lived and traveled with the seals for one year, thereby acquiring extraordinary hunting knowledge and power:

*And his host [the bearded seal] said to him,*
*"Watch him [the good hunter], watch his eyes,*
*see what good vision he has.*
*When his eyes see us, see how strong his vision is.*
*When he sights us, our whole being will quake,*
*and this is from his powerful gaze.*

*"When you go back to your village,*
*some will see the women, not looking sideways,*
*but looking directly at their eyes.*
*The ones who live like that, looking like that,*
*looking at the eye of women,*

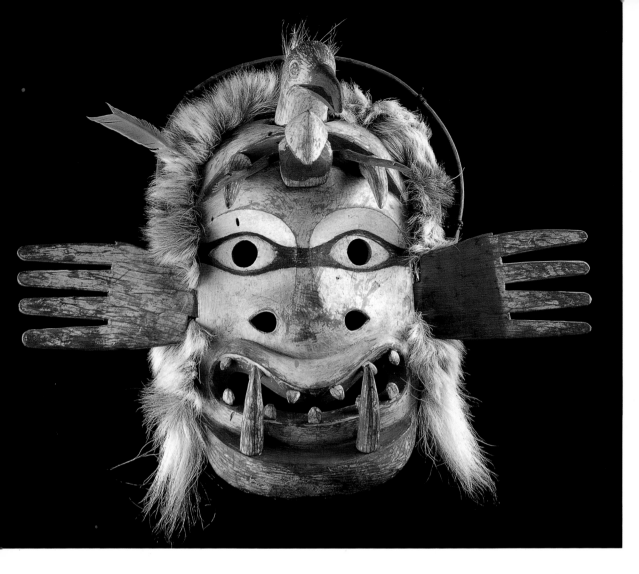

Kuskokwim mask designated "Narojaugoak" (*naruyaruaq*, "pretend seagull") with goggled eyes. Jacobsen wrote, "Shaman mask showing the main spirit of the shaman. The figure has black rings around the eyes nearly like glasses, a sign of a higher descent to the Indian [sic]. The face is enclosed by a walrus mouth with teeth from below and above. The outstretched hands (one of which is black, one white) show the shaman's power, his hands reaching across the world to draw the animals to the area. The seagull head is the messenger of the shaman which finds out for him where the walrus are located. On the forehead sits a hunter which shows the public that after the shaman conjures the walrus to the coast he can go on a walrus hunt. Like all such masks this was put on by the shaman during the last feast of the winter and usually ended the festivities." This was similar in use to the "pretend swan" mask illustrated on p. 56. The caribou ruff was restored in 1994. *MV, IVA5146 (52 cm)*

*their vision will become less strong.*
*When you look at women your vision will lose its power.*

*"Your sight gets weakened.*
*But the ones who do not look at people,*
*at the center of the face,*
*ones who use their sight sparingly,*
*as when you have little food, and use it little by little.*
*So, too, your vision—you must be stingy with your*
*   vision,*
*using it little by little, conserving it always.*

*"These, then, when they start to go hunting,*
*and use their eyes only for looking at their quarry,*
*their eyes truly are strong."*

A hunter's vision, like his thought and breath, must not be squandered, lest he be left wanting in his relations both within and beyond the natural world. A man's ability to harvest animals as an infinitely renewable resource was contingent on his careful use of his own finite personal resources.

Not only did the motif of the ringed center connote spiritual vision and movement between worlds, but people also performed the act of encircling in various contexts to produce enhanced spiritual vision or as protection from spiritual invasion. For example, during the Bladder Festival young men ran *ella maliggluku* (lit., "following the universe" with the sun

from east to west) around the village before entering the *qasgiq* bearing bunches of wild celery needed to purify the bladders and "let them see" the gifts of the people. Likewise, when a man hunted sea mammals at certain times of the year, before retrieving his kill, he circled it in the direction of the sun's course. He and his wife also ritually circled the boat before launching in the spring. Similarly, when on the third or fifth day after the birth of a child in southwestern Alaska, the new mother traditionally emerged from her confinement, she marked her return to social visibility by circling the house in the direction of the sun's course. On the fifth day after a human death, the bereaved circled the grave in the direction of the sun's circuit to send away the spirit of the deceased. These ritual acts recall the magic circle noted in the Netsilik region by Rasmussen (1927:129; 1931:60), whereby married women circled around strangers who approached their camp so that their footprints would contain any evil spirits that might have accompanied the newcomers (Fienup-Riordan 1994:355–62).

In the oral tradition the large hooped masks are themselves equated with the circle-dot motif, and their powerful supernatural gaze directly contrasts with the performers' restricted sight. Like the circle-dot motif, the hooped masks functioned as eyes into a world beyond the mundane. The masks were structurally ringed centers, their faces often framed

"Elgialik" (*elqialek*, "one with a visor") collected at Cape Vancouver in 1883. Jacobsen wrote, "Mask depicts the face of a shaman's helping spirit, a crabdiver [puffin?]. The Eskimos use the meat of this bird as food and its feathers as decorations. This bird arrives along with the schools of herring in the summer. The mask was used by a shaman." The chevron forehead is common on Kuskokwim and Nushagak masks and may represent the visors ocean hunters wore as practical protection and to appear more "bird-like" to the seals. *MV, IVA5179 (48 cm)*

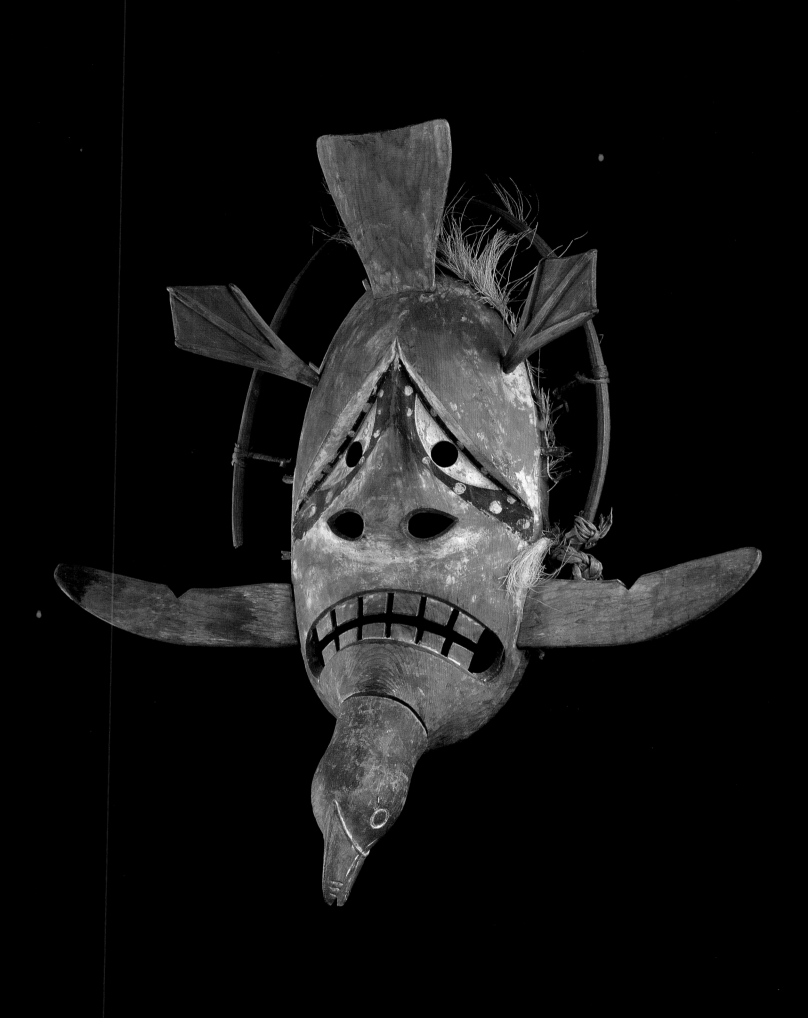

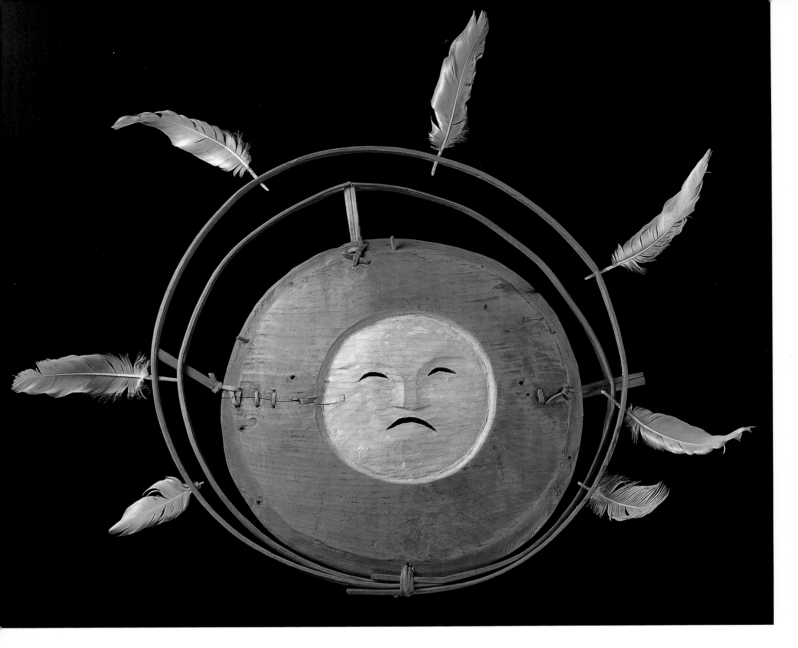

in multiple wooden *ellanguat,* which represented the Earth and the five upper worlds of the universe (Ray 1967:66). This same heavenly symbolism was repeated in ceremonial activity in which the masked dancer was a key participant, when the enormous *ellanguaq* rings were raised and lowered inside the *qasgiq* to represent the retreat and approach of the heavens.

We can also see the image of the encircling ring in the rounded dance fans fringed in fur and feathers. These paired fans were often miniatures of the paired masks worn by the central performers. Even today women appear with studiously downcast eyes, the fan's eye seeing for them while they dance. At the same time their heads are encircled with beaded wolverine crowns, which simultaneously restrict their view and protect them from supernatural powers.

The efficacy of the mask's supernatural sight contrasts to the lowered gaze of the human performers who dance so that they truly "see" and that the spirits see them. According to one elder, the traditional application of a white clay base and colored finger spots to the seal bladders inflated for the Bladder Festival was likewise an attempt to promote spiritual

vision for the souls of the seals. The painting of the wooden masks and the body of the dancer had a similar effect, allowing the dancer to become visible to the spirit world—to embody the spirit while the performer's identity was hidden from the human world.

The image of the universe that dominates the hooped mask can be seen in the rounded lamp, the ringed bowl, the hole in the kayak float-board, the decorative geometry of traditional ivory earrings, the central gut skylight opening in the *qasgiq,* and the decorative celestial rings suspended from its ceiling for a dance performance.[17] The world was bound, the circle closed, yet within it was the passageway leading from the human to the spirit world. Rimmed by *ellanguat* and transformed by paint and feathers, the eyes of the mask (themselves often ringed) looked beyond this world into another.

## Supernatural Sound

A contrast similar to that between restricted human sight and powerful supernatural vision exists between controlled human speech and supernatural sound. In the *qasgiq* young boys listened while men spoke to them on how to live. According to Dennis

Elegantly hooped mask with a red rim, blue body, and central face washed in white. Labeled "Moon Mask, Andreafski" by Sheldon Jackson. Note the crescent-shaped eyes and mouth. *SJM, IIB13 (30.7 cm diameter)*

17. Fitzhugh and Kaplan (1982:202) view encircling rings as endowing objects with spiritual life. Yupiit designate the painted rings on bowls as *ellam menglii* (lit., "the edge of the universe, the horizon").

Panruk (December 17, 1987) of Chefornak, "They learned that way of life before they were fully able to hunt. . . . These young boys were talked to by one man on the way of life. And while he was talking one could not even hear anyone whispering. That one particular speaker who was giving the instructions of life talked alone." Young people ideally were quietly attentive, while their elders sat down and spoke. Those who failed to pay attention would "live with recognition" later in life when they encountered situations that their mentors had described (Fienup-Riordan 1994:149).

A child used all senses in this process. One listened with one's ears, while watching the speaker's mouth with one's eyes and "swallowing" valuable instructions. Especially at night children were instructed not to make noise, lest they attract *nepengyat* (from *nepa*, "noise"; sing., *nepengyaq*), ghosts believed to present themselves accompanied by noise and a cold mist. Mary Mike (May 29, 1993) remembered, "Back in those days when strange things were more available, there was a group of children in the house who were visited by the *nepengyaq*. They were playing and making a lot of noise. Then the *nepengyaq* silenced them. They became quiet."

Many tales mention supernatural voices. Elsie Tommy (June 9, 1992) described hearing the voices of the dead grieving for their relatives back home. Once, while she was playing outside on a bright summer night, she heard a human voice crying. It approached from the direction of a wooden grave marker and continued on below her before ceasing. She ran home and told her grandfather, who had also heard the apparition: "He used his *tuunraq* and went and checked it out. When he was done he shook his seal-gut parka, brushing the stuff off of them. When he shook it for the fifth time he said, 'You will be okay. The apparition you heard will not touch you. He was only grieving for his people back home.'"

Jasper Louis (May 28, 1993) described how the laments of a living child woke its dead mother, causing her to haunt the living. Billy Lincoln told a similar story of a woman who died and was buried along with her living child. The child's cries woke her from death, and she returned to haunt the living until an *angalkuq* was able to show her the path that the cries of her child had caused her to miss (Fienup-Riordan 1994:237–38; Morrow 1984:129).

Although quiet attention was the general rule, noise was not always proscribed. Men intentionally

Finger masks from Andreafski. Two wheels with a hub and four spokes joined together by a small wooden bar top a single finger hold. Caribou hair in tufts and one jaeger feather, trimmed with a downy tip, decorate each wheel. *SJM, IIB48 (9.4 cm high)*

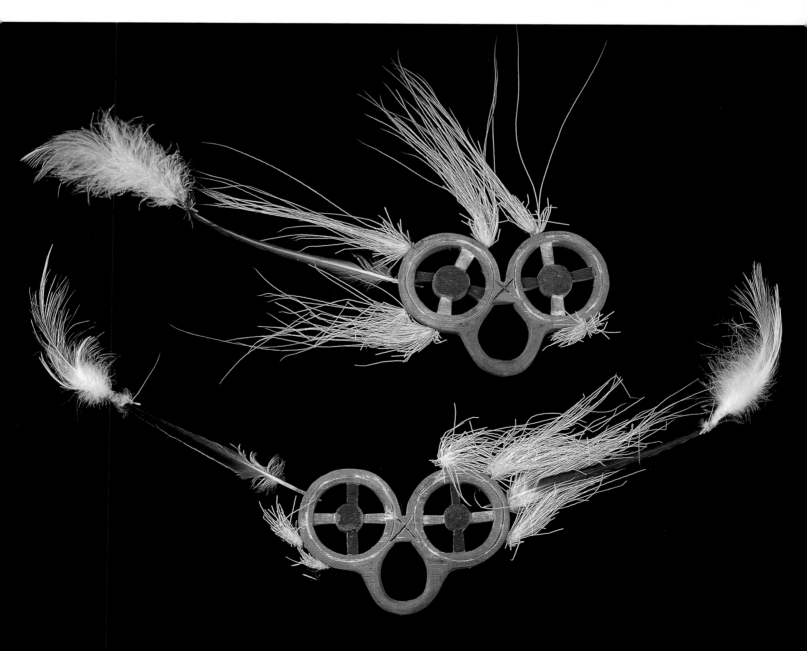

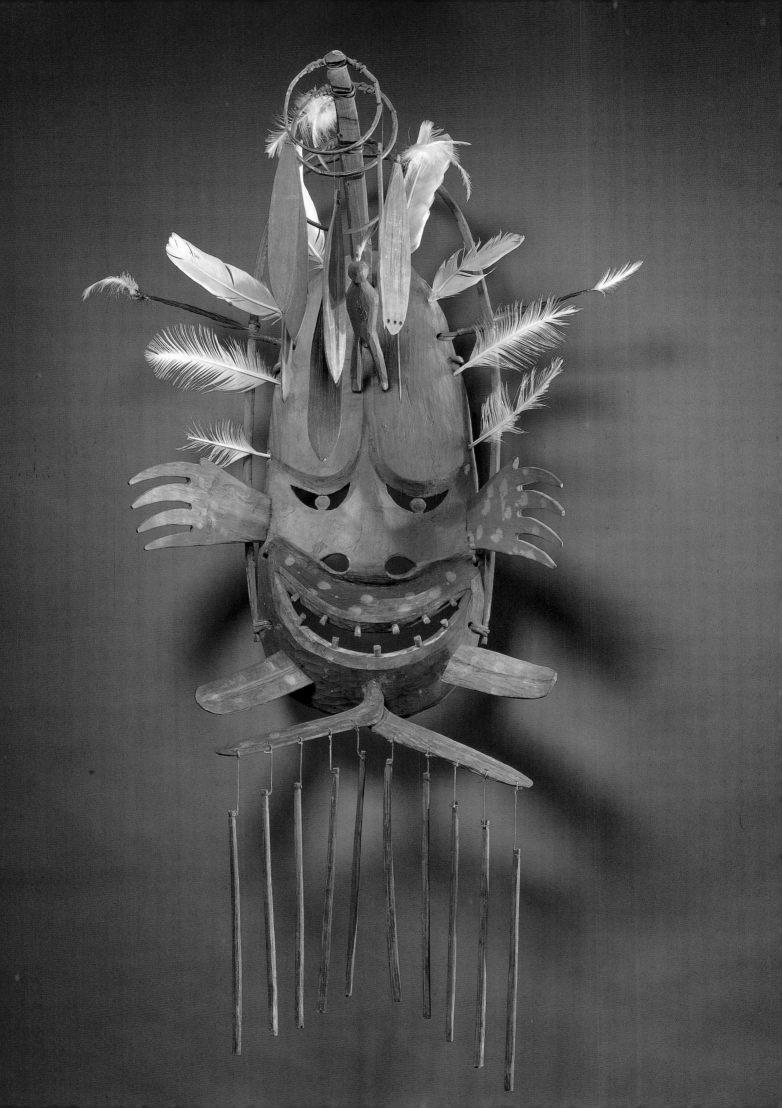

Kuskokwim mask represent-
ing "Negakfok" (*negaqvaq*,
"north" or "north wind"),
the "spirit who likes cold
and stormy weather." The
mask not only made visible
the unseen spirit world but,
with its clattering append-
ages, gave them voice as
well. Collected at Napaskiak
by A. H. Twitchell, who
wrote that the white spots
represented snowflakes, the
mask was one of a pair sold
out of the Museum of the
American Indian in 1944;
the other remains in private
hands. Along with four
"Negakfok" masks, Twitchell
collected masks representing
the south and east winds,
probably from a single event
in the early 1900s (see pp.
158–62). *MMA, Michael C.
Rockefeller Memorial Collec-
tion, Nelson A. Rockefeller gift,
1961, 1978.417.76 (9/3393)
(115 cm)*

made noise during the ritual cleaning of the *qasgiq* to drive away evil. Nunivak hunters beat on their kayaks to drive away bad weather (Lantis 1946:196). Healers often used loud noises, especially drumming and singing, to chase illness out of a patient's body. According to Brentina Chanar (June 30, 1989), "If they cannot cure someone, they use *tuunrat* in the *qasgiq*. They bring [the sick person] in, and let [the sick person] sit on the floorboards. They sing for [the sick person] like they do when they dance. . . . They would really start to jump around; that is when they find what the person's sickness is, when they are able to take it away."

Speaking out carelessly could be dangerous, as animals had keen senses and could hear what was said about them. Nick Charles, Sr. (December 17, 1985), told a story demonstrating the combined consequences of unrestrained speech and touch. He described how a woman touched a bear carcass, complaining about how little sinew it had: "When she was about to cut up the animal, she told the animal that it was too old and she placed her hand on it and said, 'These sure don't have any sinew. If you had sinew you would provide me with sinew.' Then the spot where her hand was began quivering. . . . It was jerking violently." Soon after she said that, a bear tore the woman to pieces. People believed bears knew what was said about them, and thus hunters never liked to say exactly what they intended to hunt.

The power of spoken words to evoke that which they describe appears repeatedly in Yup'ik oral tradition. Elders today are sometimes reticent about certain aspects of the past for this reason. Jasper Louis (May 28, 1993) said simply, "I'm afraid to just speak freely on my own, for I might bring out the reality." Conversely, the power associated with speech stands behind the injunction for elders to share their knowledge with the younger generation and for young people to listen closely to what they say.

Oral accounts often describe words, songs, and even thoughts producing dramatic effects. Nicholai Berlin (January 13, 1994) recounted a well-known story of a disappointed grandchild who used a song to kill her faithless suitor:

There is a story about a grandchild who was promised by a *nukalpiaq* [good hunter] that he would have her as a wife after he caught two young caribou, but when he got home he went to another girl. . . . The grandchild was very sad and was crying. The hunter had gone to get the animals for her new [wedding] parka. Her grandmother composed an *ingulaun* [song to accompany an *ingula* dance; pl., *ingulautet*] that she was to sing for him in the *qasgiq*. When she learned the song she brought food for the *nukalpiaq* in the *qasgiq* and stood right in front of him and danced. Then, apparently, that *nukalpiaq* . . . just lay back and died.

Justina Mike (March 1, 1994) told of an unhappy grandchild from whom the village children always fled. One day she saw her reflection in the water and found that she had stones stuck to her face. She told her grandmother that she now knew why the children ran from her. Her grandmother used her *uluaq* to pry the stones from the girl's face, and dressed her in beautiful clothing. .

Then the grandmother said to her, "Climb up on our old house." . . . She taught her the song to sing when she got up there. She told her to face the dawn and sing. . . .

[The girl] went up and sang. . . . The men and boys who stayed in the *qasgiq* always went outside to pee. The son of a *nukalpiaq* went outside to urinate. As he was peeing he heard someone singing. He looked around and saw a beautiful girl singing on top of the grandmother's house. She was very gorgeous. Her clothes were very beautiful. He took a gaff and walked up to her and tried to hook her with it, but she was difficult to reach. He couldn't reach her. . . . She had beautiful clothes on. . . . As he watched she disappeared into the dawn. Her grandmother had told her that she would go to the dawn. She told her that people would see her there right before the sun came up. She told her that she would go there and taught her a song. She sang the song and disappeared into it.

*Angalkut* had especially powerful songs, intended sometimes to heal, sometimes to harm. They might sing themselves or have attendants who sang. Willie Kamkoff (February 27, 1994) described how an *angalkuq* used song to gain extraordinary power:

He had two helpers and one was his grandchild. He told them to burn his body until it disappeared. He said that later when they sang for him, he would enter the *qasgiq*. . . . They began burning his body in the morning. . . .

Then when it was time people went to the *qasgiq* again. Perhaps since it was the first time he did that, many people stayed with him in the *qasgiq* . . . to sing his song. And when they started singing the second verse, the person whom they had seen disappear in flames walked in through the entrance . . . to the back and sat down. Perhaps he would do that to stay alive the following year at the same time.

At the end of the account, Johnny Thompson added, "They say that is what they did to improve themselves."

Along with the transforming power of song went the power to hear and interpret extraordinary sounds. In Peter Lupie's story about the seal-gut parka (see pp. 133–34) the *angalkuq* queried the parka and listened for an answer. The audience could neither understand his words nor interpret the raincoat's supernatural response.

## Powerful Breath, Dangerous Air

The power of song, speech, and sound generally is related to that ascribed to air and breath. Humans possessed no single spiritual entity translatable as "soul." Rather the human body was animated by, among other things, breath (*anerneq*), warmth or heat (*puqla*), and mind (*umyuaq*), qualities without which

it could not sustain life (Morrow 1984:128). Some people held that a person's mind, heat, and breath did not survive death. Others identified a person's breath or living spirit (*yuucian unguvii*) as capable of rebirth when a newborn received that person's name (*ateq*). But all agreed that loss of either one's breath or heat brought death, just as their possession was essential to living.

People believed that aspects of their being (mind, breath, heat, vision, voice, and visible image) possessed properties essential for life, both in the present and the future. Although the human person could not live without these attributes of being, they might exist separately from and independent of the human body (Fienup-Riordan 1994:211–13).

Each animal's *yua* had an anatomical locus—the bladder—to which it retracted at death to await rebirth. According to coastal oral tradition, seals saw approaching hunters as little seabirds who breathed a soporific mist that put the seals to sleep. The seal's *yua* then moved to its bladder, where it remained until the midwinter Bladder Festival. The hunter's breath, which then inflated the bladder, escaping as bubbles only when he punctured the bladder and pushed it under the ice at the ceremony's end, played an essential role in the process of guaranteeing the seal's return.

Nineteenth-century masks depict the importance of human and superhuman breath in myriad ways. A number of the elaborate Kuskokwim masks that Twitchell collected display a wind tunnel or tunnels on the masks' chins and foreheads, signifying the winds' power over hunting success. On a pair of small muskrat masks, also collected by Twitchell, tiny wooden bubbles ascend a wooden rod, representing the air bubbles that escape as the small mammals emerge from their holes.

Nelson (1899:440) noted the belief that certain kinds of contamination produced bad luck in hunting. When people came into contact with something unclean, a vapor attached to them that made them abnormally visible to game. Women emitted such a vapor during menstruation, but even when not menstruating, they were forbidden to step over people who were lying down, as that might cause them to bleed. According to Joseph Evan (July 12, 1994),

Back in those days they commanded us boys not to have close contact with a girl who had menstruated. They would tell us not to talk face to face at close range. Back then they had many rules of precaution. And they would say that when a boy inhaled the aura of a girl who had menstruated, he would become sick. . . . Since the boys were continually instructed

Delicately carved "duck" mask collected by Jacobsen on the Kuskokwim in 1883. The lower half of the body is painted white and the upper half black with white spots. This may reflect the markings of a particular bird or, like the masks representing the "spirit of the driftwood" (see pp. 152–53), an upper skyworld and lower human world between which the bird moved. The bird's mouth, eyes, and backside of the eyeholes are red. *MV, IVA5181 (20 cm)*

Kuskokwim mask representing "Walaunuk," or bubbles as they rise through the water, which are related to the spiritually potent breath of humans and animals and to the bubbles expelled from deflated bladders at the close of the Bladder Festi-

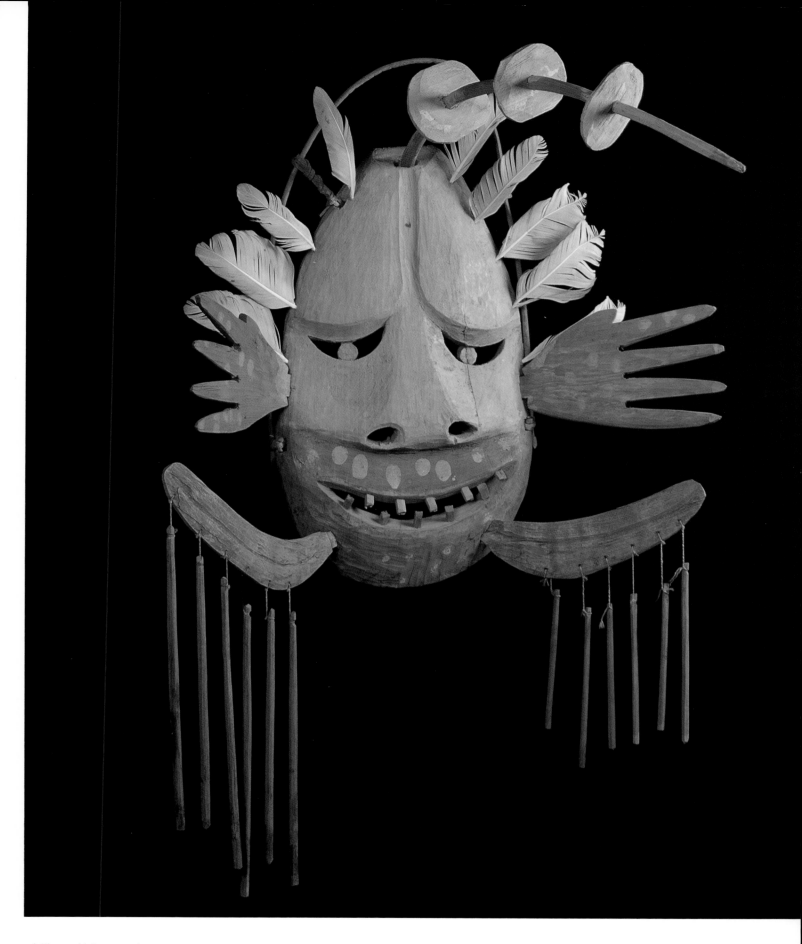

val. The mask's iconography reverses that of the previous mask, with the light half on top. Collected by A. H. Twitchell, early 1900s. *NMAI, 9/ 3432 (42 cm)*

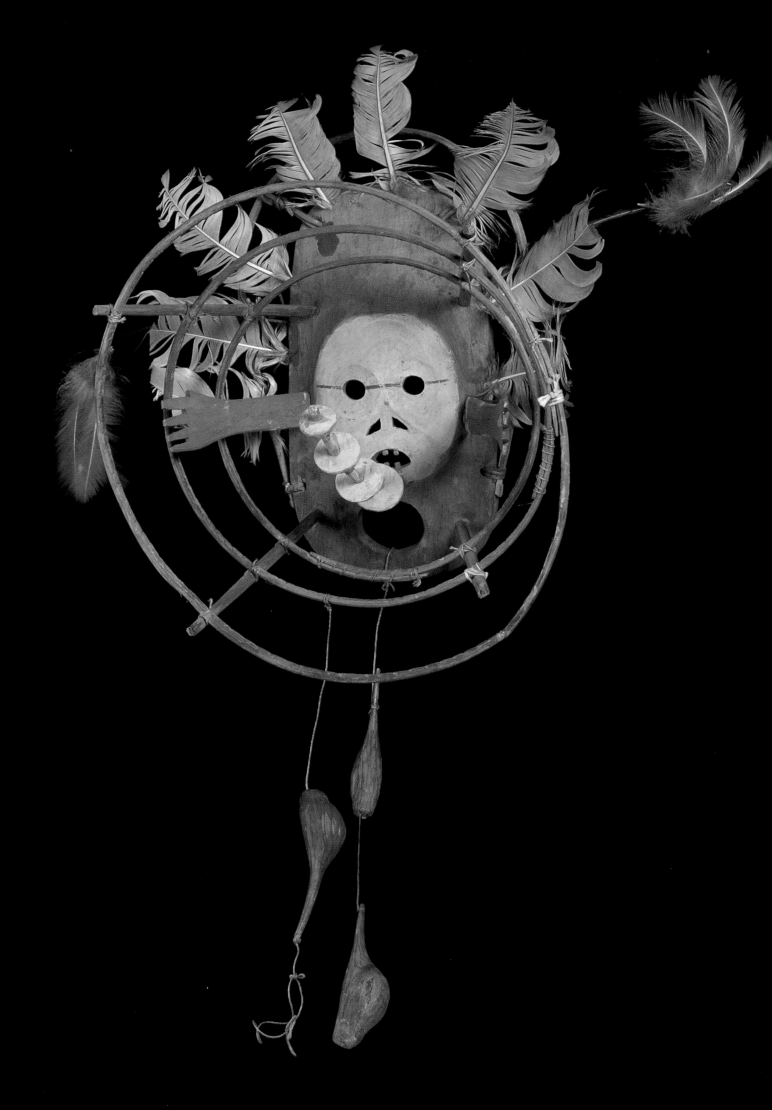

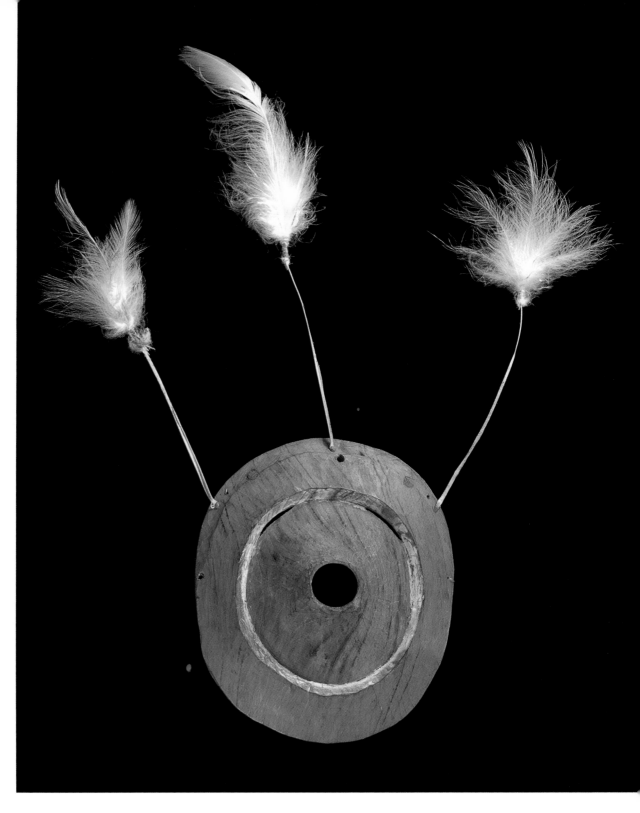

One of two muskrat masks collected by A. H. Twitchell at Napaskiak representing the "muskrat god, Andlu" (probably *anlu*, "the hole through which the muskrat emerged from its den," from *ane-*, "go out"). Twitchell wrote, "When turned face downward the mask represents a muskrat house. When face upward the rats can be pulled through the hole in the house, the way they come out in the spring. The white discs on the stick represent bubbles. The white face has four teeth, the same as muskrats and is a member of the same family. He furnishes plenty of rats in the spring, so their skins may be used for clothing." The hanging pieces at the bottom may be *uquutvaguaq* (water hemlock), which muskrats eat. *NMAI, 9/3403 (70.5 cm)*

Mask collected by Sheldon Jackson on the lower Yukon, similar to one Edward Nelson (1899:403) collected at Sabotnisky. According to Chapman (1907:15), it represents a bubble in the ice (Ray 1967:217). *SJM, IIH3 (52 cm)*

about it in the homes and the *qasgiq* they would fear the woman very much. It was back at the time when everyone had great respect for themselves and others. From their parents they would continually hear the warning against polluting oneself. It was back when acquiring good hunting skills was important to all the boys. . . .

And they would tell him not to pass a girl on the leeward side when he passed her outside. They would tell him to pass her on the windward side. This warning was to keep him from inhaling her vapor.

Breath was alternately powerful and dangerous. Human female air, particularly that associated with fertility, had to be controlled so that powerful supernatural breath could overcome animals in the ritual of the hunt. Conversely, the smell of the land was believed to attract animals. For this reason hunters fumigated themselves with the smoke of plants such as wild celery, Labrador tea, and blackberry to prepare for the hunt.

### The Monstrous Mouth

Nonhuman persons possessed extraordinary sight, hearing, and smell, so that humans had to control their own vision, noise, and odor when dealing with them. The Yupiit also marshaled the forms and functions of the human mouth in their conceptualization

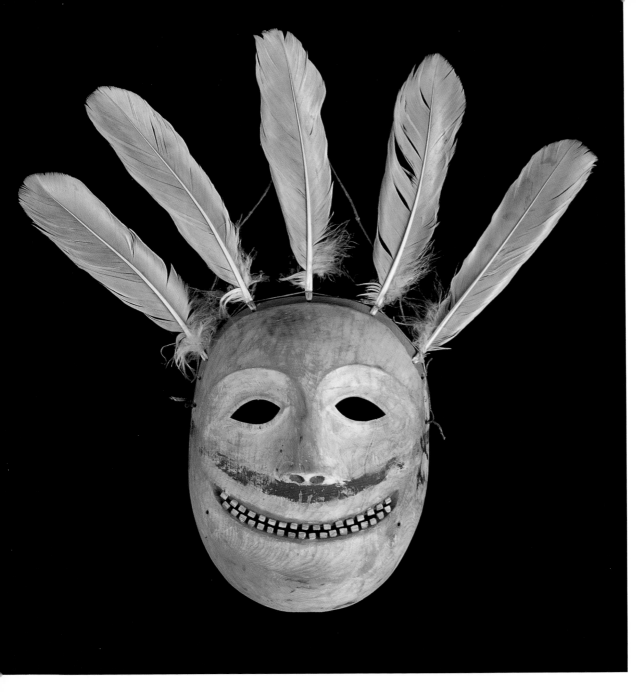

Mask having a wide toothy mouth. Viewing photographs of such masks, Justina Mike (March 1, 1994) recalled the well-known story of the child with a mouth from ear to ear that ate its mother and then went from house to house eating people. She also described a game the children in her village played pretending to be that creature, Ap'apaa:

*They would let us play right after the snowfall in the river. They would let us entertain ourselves saying ap'ap'-ap'. . . . When that person who was called Ap'apaa came out, he would come running after us. And the person he touched would become one of those kind.*

*We would play a game out of it. We would pretend we were it. They would say it would go into a house saying ap'apaa. Right after the snowfall they would let the children play the game, and at the other end they would make the place for Ap'apaa. When a person came out it would run after him or her. Then we would run across and try to go inside. We would always do that right after the snowfall. We would make a trail for it. It would only go on that trail. We would do the same thing that creature had done in the story. It would go into a house and come out and go to another house. It would eat the people.*

*SI, 153619 (38.7 cm high)*

of their spirit world. A small carved animal appears in the mouth of many masks, representing the hope for abundant game in the future. Other masks possess a twisted or distorted mouth, often associated with *ircenrrat.* Many accounts depict these supernatural beings as half human and half animal, or alternately human and animal. Dance masks representing *ircenrrat* show human features on one side of the face and animal features on the other.

Downturned mouths occur on many masks and tend to be associated with representation of a female (Fitzhugh and Kaplan 1982:198; Himmelheber 1993:77). Ray (1967:68) remarked that this association is not universal. Many masks that definitely represent males, including lower Yukon masks of the "man in the moon," also have downturned mouths. Another explanation is that the downturned mouth represents the hermaphroditic features embodied by many *angalkut* (Fienup-Riordan 1994:307).

Among the most distinctive and intriguing mask features are wide, toothy mouths and teeth running along great open cavities in the body or down the arm or leg. Nelson (1899:406) noted that the toothy grooves on one lower Kuskokwim mask indicated that the being represented had mouths all along those portions of its body. This may be a reference to the creature's predatory, carnivorous nature. Lantis (1990:173–76) contended that these toothy mouths symbolize animals' revenge on their human hunters. Jasper Louis (February 25, 1994) said simply, "If the being they were creating had many teeth, they would make the mask look like it, too."

Lantis (1990:170–76) related the masks' toothy mouths to the traditional tale of the "hammer child," a deformed baby with a mouth stretching from ear to ear that consumes its mother and other community members in retaliation for breaking taboos. The story of the hammer child is not the only traditional tale featuring a creature with a monstrous mouth. Cecelia Foxie (May 30, 1993) gave a detailed account of a boy who disobeyed his grandmother and went to explore a nearby knoll, which he discovered was a house.

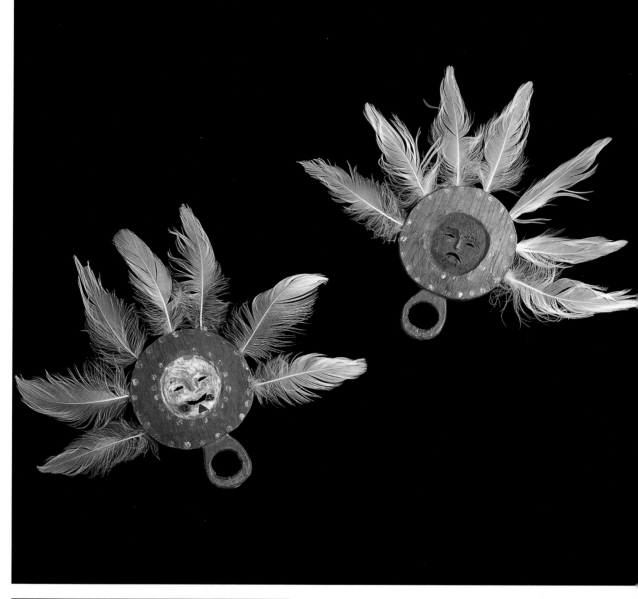

Kuskokwim finger masks collected by Jacobsen in 1883. One has a dark female face, with downturned mouth and tatoos on the chin. The light, male face, with labrets and a beard, is smiling. Like the unification of light and dark on a single mask, the contrasting relationship between the faces is enhanced by reversing the colors (see also p. 163). *MV, IVA7195 (9.2 cm)*

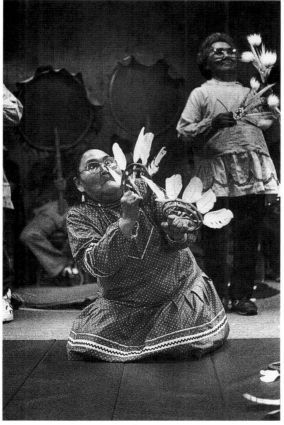

Woman with a downturned mouth: Agnes Polty dancing with men's fans at the 1989 Mountain Village Dance Festival. *JHB*

Inside lived a hunter lying on his belly. A woman then served the boy a bowl. When she turned around, the boy saw a baby in the dish with its stomach slashed open, revealing canine teeth (see also Nelson 1899:496).

The acts of eating and biting were fraught with associations for a people whose day-to-day lives depended on killing and eating animals, and they were often featured in scary stories of supernatural retaliation. Licking, however, was considered a healing act in many contexts, and saliva was often associated with long life. Jasper Louis's (May 28, 1993) story of the creature *qamulek* is one such account:

The *qamulek* was a huge insectlike creature that dragged part of its body behind it. . . . They say that at times someone would run in front of it and lie down removing all of his/her clothes. Then the creature would lick him/her all over his/her body. They say when you did that you could live . . . four lifetimes. . . .

After the person died s/he would come back as a child. That was why the children were told to consume food offered by the elder. This was done so a person could have a long life. They would tell people to always eat the leftover foods. They followed and adhered to instructions that guaranteed longer life. (See also Fienup-Riordan 1994:80–82)

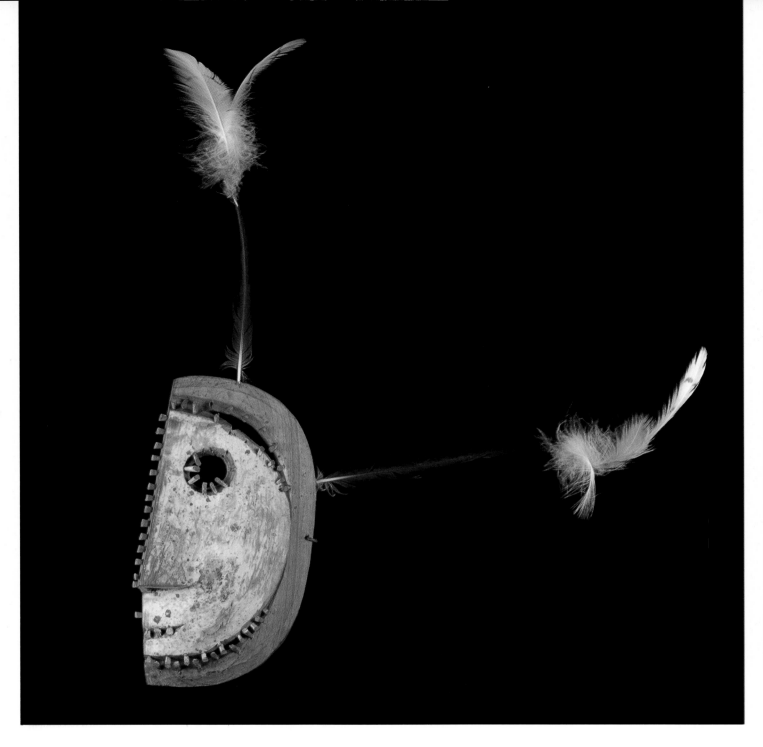

Alma Keyes (February 27, 1993) described another extraordinary creature, the *uilurusak*, which was capable of licking people all over and giving them four lives:

They say if a person is shining within their realm, if [the *uilurusak*] likes him it will come to him when he goes down to the ocean in the springtime. . . . They say the *uilurusak* has four ice holes. When a person comes to them, one hole will be in the middle. . . . When the mouse [shrew], the *uilurusak*, comes up on the ice it will get bigger and bigger. . . .

As the person stands, the mouse will climb up on him and lick and slurp every aperture, scuff, and blemish on his body. He will stand still, though he is petrified when the mouse comes to him. Then it will enter him through his big toe and again in there. The person will remain, though he is frightened. The *uilurusak* turns into a mouse with a long snout. It will enter and

lick and lap every scuff and blister. It will come out, slowly, totally cleaning the person . . . of dirt and grime. Then it will turn into a person and ask him, "So, what do you wish for in your life? Would you like to become a great hunter? What do you want?" A person who is energetic will wish to become a great hunter. He will want to become powerful through hunting. However, if a person has sense, he should wish for a long life, realizing that he has already been cleansed by [the *uilurusak*]. (See also Nelson [1899:442] on Wi-lu-gho-yuk)

The act of licking can, like the healing touch, mend injuries and restore a person's senses. Wassilie Evan (KYUK 1989, tape 1) described his own experience when the lower Yukon *angalkuq* Irurpak (Long Legs) licked his eyes, restoring his sight:

I was going blind. I could not open my eyes. My father

Half-face mask with wooden teeth pegged into its mouth, eye, and down and around its face. Like all twenty-three of the masks J. H. Turner collected in 1891, the piece is delicately carved and beautifully balanced, with the reverse side of the eye and mouth rimmed in red. H. M. W. Edmonds collected a similar mask at St. Michael in the 1890s, and Ray (1967:187) identifies it as the mythical half-man found all along the Bering Sea coast. *SI, 153623 (19.7 cm)*

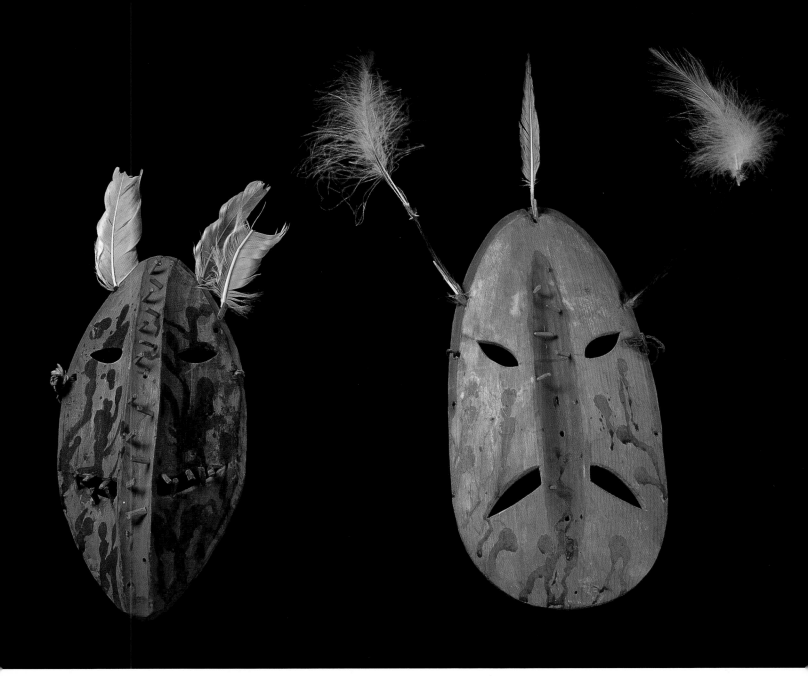

Paired masks collected by Sheldon Jackson in 1893 at Andreafski, with a toothy cavity running the length of each. The faces are splashed with paint, as are other masks from this area, perhaps representing the blood of the creatures' victims. Beneath the spatters, one is smiling and the other frowning. *SJM, IIB10 (31.3 cm) and IIB14 (29.2 cm)*

18. Events often occur in threes in Yup'ik oral tradition.

HUMAN
SENSES IN
ICONOGRAPHY

had summoned Irurpak. When he arrived I thought he would chant for me. After he ate he told me to go to him so he could lick my eyes. . . . As he proceeded to lick my eyes I noticed that his tongue felt like a file. After a while he told me, "Go outside and, after you come in, tell me what you have seen." When I first went out I did not see anything. It was still like a fog. I told him, "My sight did not improve."

He went on to lick my eyes a second time. Again he told me to go outside and look around. As I went out and looked around, I noticed that across the river the Qissunaq shoreline was almost visible, but the trees were not. I told him that when I went back in. "I saw a little. I noticed the shoreline across the river."

Before he did it the third time he told me, "The next time you will see it as it is." I went back outside as he told me. I then noticed that the shoreline of the Qissunaq River was visible—even the trees were very clear. Everything was good. When I went back inside I told him, "I can see . . . the trees on the other side of the river just the way they are." He told me that was enough. He stopped after the third time.[18] He saved my sight and made my eyes open again.

When Wassilie Evan and Willie Beans visited the Sheldon Jackson Museum, they identified an extraordinary drum as identical to one belonging to Irurpak. The handle is a human figure with the body cut open to expose the internal organs, and the opening is lined with fox teeth. Inside the rim are wormlike figures said to represent the *tuunrat*.

Willie Beans remembered Irurpak's using his drum in a healing session. He also recalled, "One time when we were traveling in a boat, at Kuigglualek I heard him drumming. We could hear his drum and him singing. He was on one side of the Yukon River, and we were on the other, but we heard him very clearly. When he finished a song he would make a sound."

George Heye collected a similar drum from the Kuskokwim area in the 1920s. The dramatic toothy mouths inscribed on *angalkut's* drums recall the supernatural senses of the *angalkuq's tuunraq* and the hammer child of oral tradition—senses one dismissed at one's peril. The monstrous mouth was

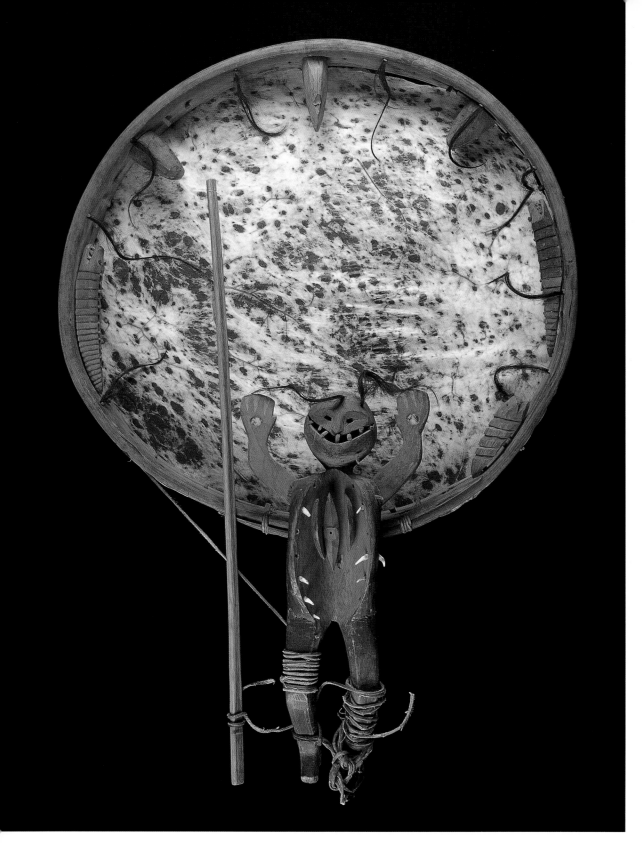

Drum like one that belonged to the shaman Irurpak, collected by Jackson on Nelson Island in the 1890s. Both Jacobsen (IVA5428) and Nelson (1899:442) collected wooden figures with a broad toothy mouth running down the chest, and Nelson (1899:406) wrote that these toothy cavities showed that "the being represented was supposed to be provided with mouths all along these portions of its figure." *SJM, IIS171 (49.5 cm diameter)*

Goodnews Bay mask collected by Ellis Allen in 1912, simultaneously a bird in flight and its powerful *yua*. The back of the bird reveals a human face, with its wings the outstretched hands of the *yua*. The large mask is too heavy for a performer to use without external support. Two of the appendages are attached by wire, and a repair with nails indicates that the mask may have been used more than once. Masks of this type were made along the coast as far north as Hooper Bay. *Burke, 4539 (62.5 cm wide)*

important both in *angalkut*'s actions and in the objects they created.

## The Human Hand

Along with the monstrous mouth, wooden bubbles, and bentwood *ellanguat*, a common mask appendage is the human hand, usually thumbless or with a truncated thumb and with a hole in its center. Yup'ik oral tradition identifies this hole as the source of the animals that humans hunt. Describing the masks he collected, Nelson (1899:395) wrote:

A number of them have wooden models of thumbless hands attached to their sides, the palms of the hands being pierced with large circular holes; these are usually found on masks representing birds, beasts, and spirits, having some connection with making game more or less plentiful. I am inclined to think that the holes in the palms indicate that the being will not hold the game, but will let it pass through to the earth.

Like the holes surrounding the spirit face in the *nepcetat* plaque masks, the hole in the hand may represent the hole in the sky that animals pass through to

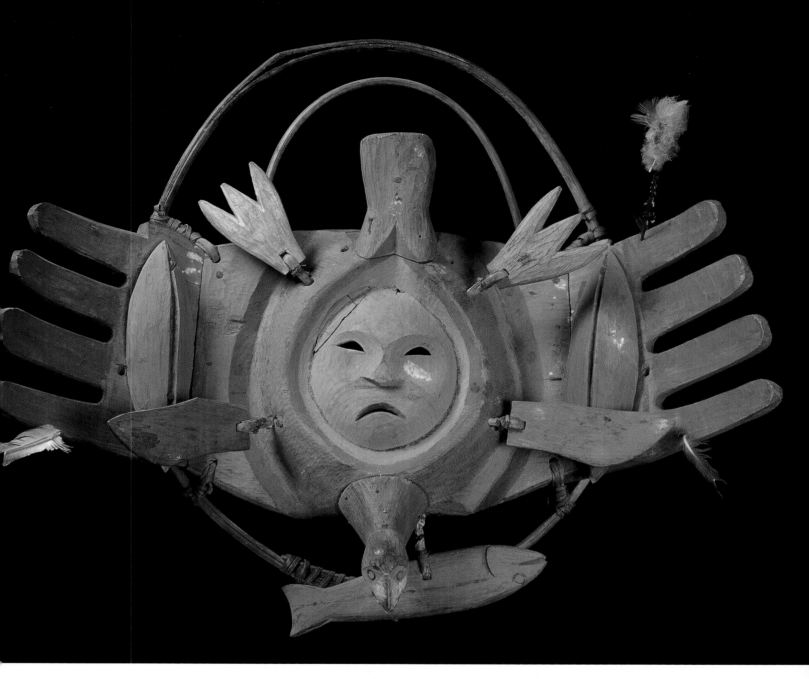

replenish Earth. Along with functioning as a passage between worlds, the hole may also represent a window or eye through which the *tuunrat* or the animal *yua* can see into the human world.

Kaj Birket-Smith (1953:121–22) recorded eloquent evidence of the belief among the Chugach Eskimos of south central Alaska that a hole in the human hand provided animals with a passageway to the good hunter. One story recalls a sleeping hunter who awoke to find a spirit-woman standing by his feet. The woman took him by the wrist and asked him if he wanted more animals. He answered yes, and the woman told him to take any kind of little animal from her clothes. The man wondered how the woman could read his mind, and she replied, "You talk to me in your wrist"—by which she was still holding him.

Then she turned his hand around, palm down, and wet her finger and drew a circle on the back of his hand, saying: "There is where the animals you are going to get are staying." The circle was full of animals.

She told him that he would always make money and again asked him to take some of the animals from her clothes, but he declined. Then she took something resembling two blue eggs from her breast and gave them to him. Just as he was keeping them in his hand they were gone—disappeared into himself. "The two things I gave you are in your body already." . . . She added that it was difficult for any people to see her and that she was *nunam-yua* [the land's person], but where she came from she would not tell him.

On most Central Yup'ik masks, the hands appear in pairs, one projecting from each side of the face of an animal *yua* or spirit person. The mouth, hoops, and hands (sometimes excepting the fingertips) often are painted red. The paired hands belong to this spirit-person and mark the wished-for willingness of that species to approach its human hosts. Although other wooden appendages may represent animal paws, bird wings, or the fins of fish, the hands of the *yua*, like its face, are always human.

Paired wooden hands also appear in other contexts. Joshua Phillip (1988:14) reported wooden

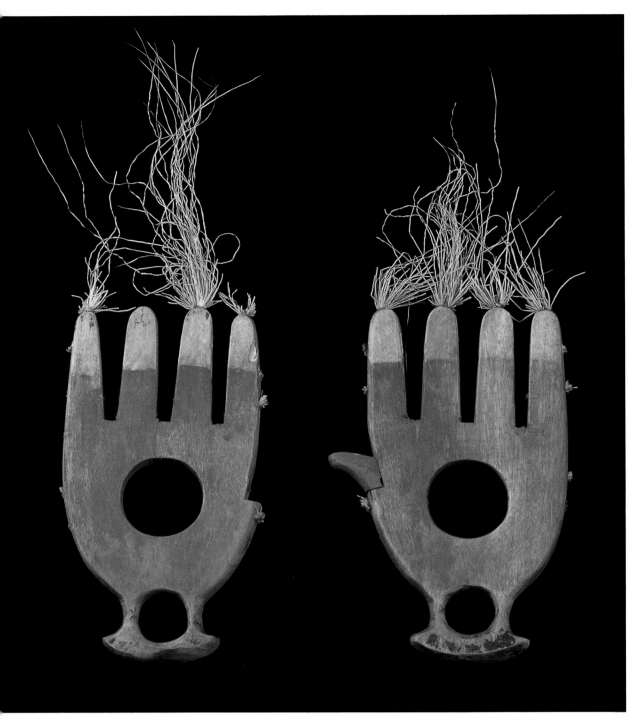

Finger masks in the shape of hands, each with a hole in its palm and a truncated thumb. Tufts of caribou hair decorate each fingertip. *SJM, IIX765a, b (12.8 cm)*

Unique Kuskokwim animal mask, collected by Robert Gierke in the 1920s, in which the body of the animal is transformed into a human hand. The animal's "tail" consists of four finger projections at the top. The back of the animal/hand has a stylized human face with one central eye. An area representing the mouth has a semicircular depression into which a carved animal figure is pegged. On its side, the mask looks like an animal (mink or muskrat) swimming through water, the hand's thumb becoming a hind leg. Thus the mask is three-in-one: hand, human face, and animal. *Burke, 1.2E634 (31.5 cm high)*

hands attached to a food cache, which, local people explained, were capable of identifying anyone who bothered its contents: "I used to see a cache back near the Akulmiut area [west of Bethel] which had these big simulated hands which were stretched out like so, with centers which had holes. It was said that should anyone take anything from that cache, the owner would be able to tell who took it by feeling around with those hands. And they would be able to identify the person and name who he is."

Three Kuskokwim masks collected by Robert Gierke in the 1920s vary significantly from the theme of the thumbless hand with central hole. Only one of the masks is ringed, and none has hands appended. Instead, the masks themselves form the shape of complete human hands. Two made from single blocks of wood have immovable thumbs attached with inset pegs. In both cases the fingers are colored and the thumb is painted white. The third mask has the fingers attached as well as the thumb, and all five appendages are painted red. Moreover, one hand is decorated with a single central eye, a nose, and an animal head projecting from the base. The other two hand masks have complete faces with toothy mouths and black-rimmed eyes. A wooden cover opens and closes over the mask's face during performance to indicate its concealed character—the hand's *yua*.

The mask with the single eye is particularly striking. The mask face ringed by *ellanguat* is iconographically comparable to *ellam iinga*, the eye of the universe. The Gierke mask is not ringed to represent a supernatural eye; rather, the mask itself frames a

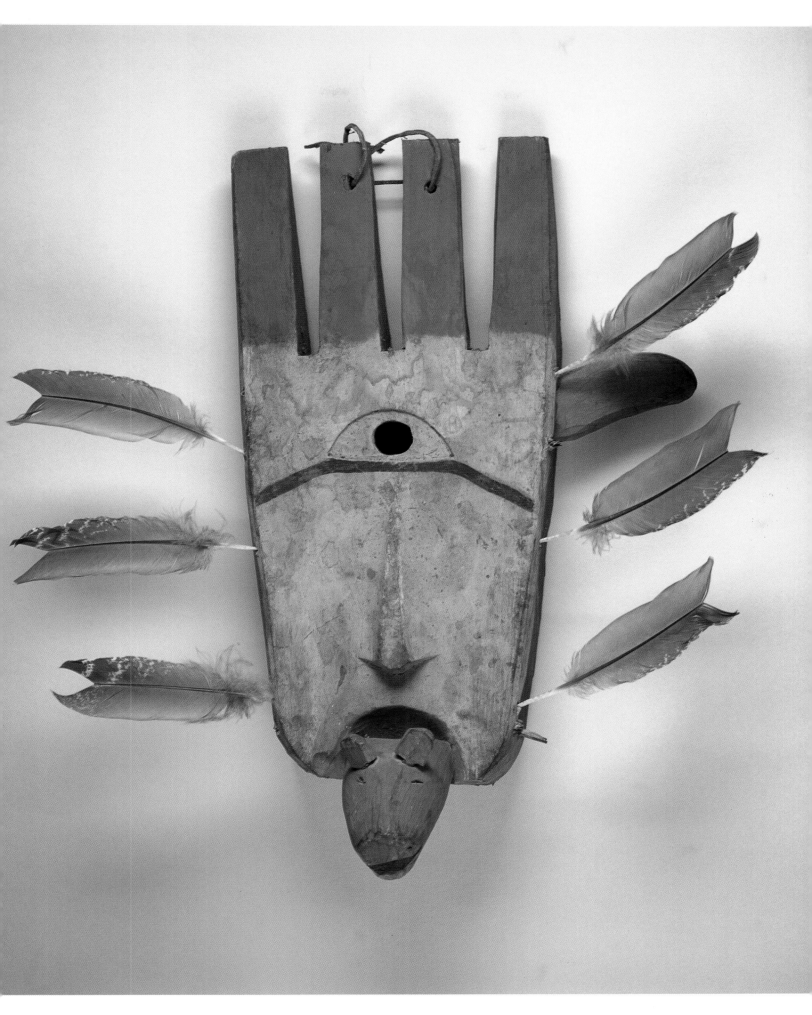

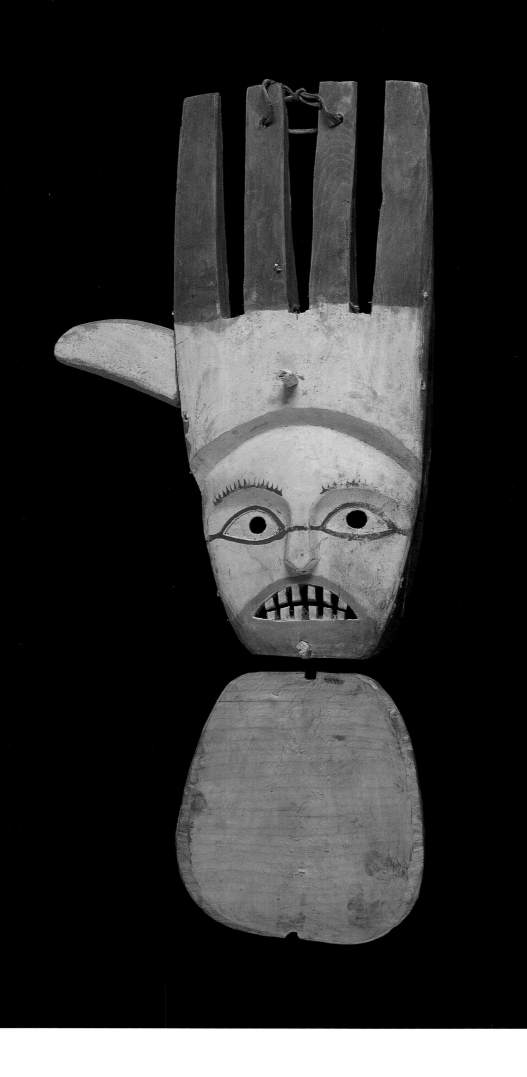

Another Kuskokwim hand mask collected by Gierke. Again the hand's back or palm contains a stylized human face, this time with two black-rimmed eyes and a large, toothy mouth, reminiscent of the creature Itqiirpak, the enormous hand that came from the ocean and devoured unruly children. A wooden cover with a second red-stained mouth engraved on its surface closes over the hand's face. Eight holes on the edge of the hand indicate that originally it had feather and wood attachments. *Burke, 1.2E635a,b (33 cm)*

Also collected by Gierke on the lower Kuskokwim, this hand mask has a crescent-shaped cover attached to the mask's edge by two pieces of baleen. The palm opens to reveal a grinning mouth, goggled eyes, and a hand holding a small carved seal as though offering it to human hunters. The fingers and thumb project from the bottom edge, all painted red, and a sea creature is painted in black on the inside of the mask cover. Although rough-hewn and heavy, the mask is a creative tour de force. A close-up shows the attachment of fingers with willow root. Note the wooden mouth grip used along with a cord tied around the head to hold the mask to the dancer's face. *Burke, 1.2E637 (35 cm high)*

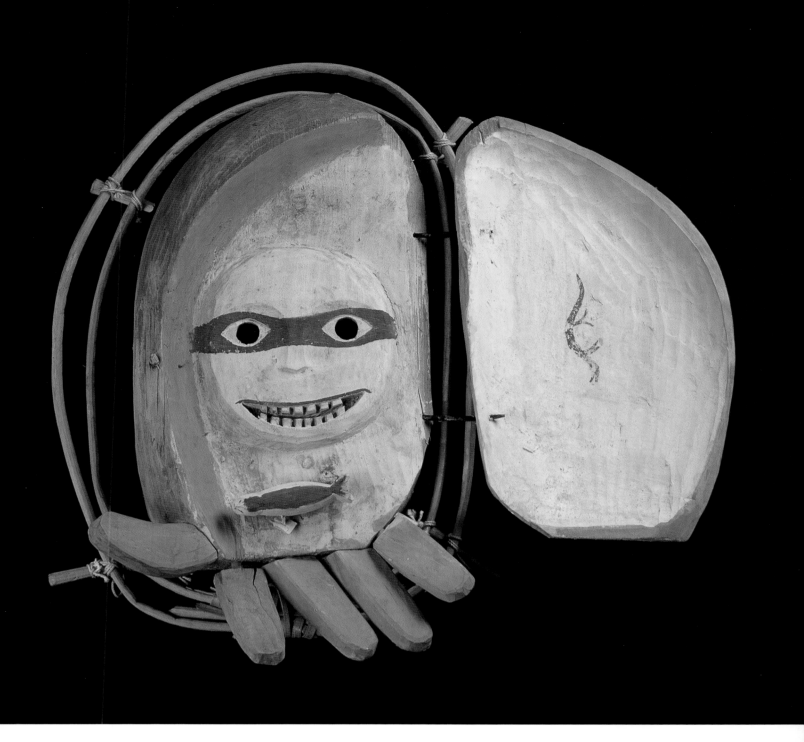

single eye, which takes the place regularly occupied in a *yua* mask by a complete human face.

The hands of the dancers also receive special treatment during both traditional and contemporary dance performances. Yup'ik dancers never perform without either covering their hands with gloves or holding a pair of dance fans. The fans simultaneously protect the performer and transform the human hand into a supernatural one. Many fans have a central hole, and most have either three, five, or seven feather "fingers." If the dance involves the distribution of gifts, a common offering to the drummers and singers before or after the dance is a means of covering the hands—a simple pair of cotton gloves.

People covered their hands in other contexts as well. At first menses a girl wore thumbless mittens and, until menopause, she limited the use of her hands during menstruation. According to Elsie

Paired masks collected by Gierke displaying simultaneously an animal, a face, and a hand. The projection from the mask's chin is both a human hand and an animal head. A single spike projects down from the hand's palm. One mask's visorlike forehead and the birdlike appearance of the projecting head may refer once again to the goggled and visored human hunter transformed into a seabird in the eyes of the seals he seeks. On the other mask two carved hunters perch atop the head. Both masks originally had numerous feather and wood attachments. This pair was probably part of a threesome, as the Gierke collection includes a third hand/bird chin appendage (1.2.873a) for a mask since lost. *Burke, 1.2E653 (30 cm high) and 1.2E654 (35.5 cm high)*

Tommy (June 9, 1992), "The girls who are menstruating back in those days would sit without moving. Then just before they stood up they would put on mittens with the thumb cut off." Alma Keyes (May 30, 1993) observed girls sitting with their fingers tied together following their first menstruation. People believed that joint pain in women's old age derived from picking berries during menstruation years before. A woman also wore mittens during her five-day postpartum seclusion, and both she and her son wore mittens after he caught his first bearded seal, even in summer. At the end of life, men and women alike went to their grave wearing mittens (Fienup-Riordan 1994:164–65, 182, 186, 214).

Just as dancing was one of several contexts in which people covered their hands, gloves were not the only covering used. People might paint their hands or, more commonly, rub them with dirt or soot before undertaking certain actions. This covering acted as a protective boundary and, simultaneously, enabled them to act as a conduit, literally "reaching between worlds." For example, Morrow (1984:130) described the efforts of a young boy to bring a dead woman into the world of the living. He was unable to grasp her until he had rubbed his arms with food scraps from the floor of the cache in which he found her (see also Fienup-Riordan 1994:240–41). In a more mundane context, Agnes Tony of Alakanuk advised young people to cover their hands with the "walking dirt" found in the doorway of a house and to rub the dirt on their bare stomachs. This, she said, created a pathway for disease to walk out of the body.

The human hand also sometimes represents a fearsome threat in Yup'ik oral tradition. One well-known and still widely told story recounts the misbehavior of a group of children playing in the *qasgiq*. Although one boy warns them to be still, they continue their antics long after dark. Because of the commotion they are causing, all save the one wary child fail to hear something approaching from the ocean. The boy hides under a large wooden bowl and, from his hiding place, sees Itqiirpak, a huge human hand with a mouth at the end of each finger. It enters the *qasgiq* and devours all his companions. After the hand leaves, the boy runs to the houses and tells the people what has happened. They set to work making a huge *uluaq* (woman's knife), which they poise over the door of the *qasgiq*. Then they begin to drum and make noise. Sure enough, the hand crawls slowly out of the ocean toward the *qasgiq*. As it enters, the people let the *uluaq* fall, killing the hand. Then, looking out toward the ocean, they see two smaller hands swimming away, presumably the huge hand's offspring. In Chevak people saw another big hand in later years as a huge red glow in the sea, and they say that the hand is looking for its mate. The implication is that these hands await to punish future generations of miscreants (see also Fienup-Riordan 1994:147).

Curtis (1930:56) explicitly connects the five days of the Nunivak Bladder Festival to five fingers of a supernatural hand: "After the short days had come and winter was upon them, the man brought out these bladders and inflated them. That night, as the couple were sitting by the fire, they were startled to see a hand with outstretched fingers appear above the entrance hole. It ordered, 'You must use these five days for your Bladder Feast.' No sooner were the words spoken than the hand disappeared."

Yup'ik oral tradition also portrays the human hand as an instrument of healing. If a healer (often an *angalkuq*) determined the locus of disease was within a person's body, he or she might remove the sickness through a "laying on of hands."[19] The healer either firmly held or gently massaged the affected area, drawing illness out of the patient's body into the healer's own. Lantis (1946:306) described a Nunivak *angalkuq* who was retained by a war party for his and his wife's ability to care for the wounded. The *angalkuq* would remove a spearhead or other cause of injury from the injured person's body, and his wife would wipe it with her hand, restoring the wounded flesh to wholeness.

A person might acquire healing hands through an encounter with magical worms. According to John Pingayak (1986),

When a person opens a mouse's food supply and finds a ball of squirming worms, do not fear—this might be a challenge of your life. The worms are the size of a soft ball, squirming without falling all over the place. The ball of worms is called *melqurripsaq* ["one without *melquq* (fur)"; pl., *melqurripsiit*].[20] The worms will stay together in a ball. It might startle you because they are

awful to look at. The colors of the worms are darkish, black, gray.

What you must do to become a healer is cover the worms with some part of your clothing with both of your hands. Your hands will feel like little spines are going in. When you uncover the cloth, the worms will disappear. After this experience you have become a healer. To see if you really are a healer, you must try out your healing powers on a broken stick of wood. When the broken part is back to its place after you placed your hands on it, then you have powers to heal any broken bones or other ailments.

Brentina Chanar reported the same phenomenon on Nelson Island, adding, "People who find healing worms put their hands on the part that has the pain. And the hands really stick to it. . . . So one keeps moving them, and when they are loosened, one takes off one's hands. And the pain of that person is gone." According to Mary Mike (February 25, 1994), "They would place [their hands] on a painful spot on a person and try to heal it. They call it *ayapercuun* ['device for putting pressure on with one's hand,' from *ayaper-*, 'to lean on one's hand']."

If the would-be healer allowed the worms to penetrate the hands, the hands lost their "stiff" or "rigid" quality and became "open" to the disease. The healer could then break down the boundary between individual bodies and acquire the power to draw out illness. Just as the boy in the food cache had used his hands to draw the woman into the land of the living, so the *unatelek* (one with hands) had the power to draw illness out of the human body and send it where it could do no harm. Elsie Tommy (June 9, 1992) experienced such a healing touch: "By holding me, and not speaking, beginning from my neck he touched me with his hands and slid them down to my feet. I did recover—he had healed me."

The potential healer's state of mind is critical to acquiring healing hands. As John Pingayak noted, the person must not be fearful, as "this might be a challenge of your life." Mouse caches replete with worms are relatively common, but few people are daring or knowledgeable enough to take advantage of them. Elsie Tommy (June 9, 1992) is one of many contemporary elders who missed her opportunity: "When we came up to our aunt, we were running out of breath. We told her we had found some insects. 'Oh my goodness. They probably escaped already. They would have given you magnificent hands. They would have assisted you greatly.' . . . We refused an opportune moment. But we were afraid of them."

Peter Lupie (June 18, 1985) emphasized that the would-be healer must have a strong, fearless mind. If one pulls back the tundra and finds a mouse cache full of insects, one must close it up, cover the cache with cloth, and put one's hands over it, palms up. One would feel a breeze go through the hands and must keep them in place until the breeze is gone. Dick Andrew (August 16, 1992) told how a woman found a mouse cache filled with *melqurripsiit*. She placed her hands on them, palms up, and subse-

19. Edith Turner (1990) reported a comparable practice in northern Alaska. Among the Chugach Eskimos, Birket-Smith (1953:128–29) described the power of the shaman's hands to heal and the power of a white man to affect the movement of fish by blowing on his hands.

20. Yup'ik speakers commonly use the English word "worms" to designate a variety of insects. Elsie Tommy of Newtok (June 9, 1992) notes that there are two kinds of healing worms, *melqurripsaq* and *uguguaq* (fuzzy caterpillar), and each imparts unique abilities to the healer's hand. The healer uses a different plant-helper depending on the variety of worm encountered: "They say that because those kinds of insects stay on those kinds of plants, they helped them in their work."

Martha Mann (July 8, 1994) said that the dens of mice might contain stones as well as insects. If a person covered the stones with his or her hands, like the worms, "they would go into the person's arms and become her or his hands." Those with "stone hands" could mend broken bones.

"Working to Beat the Devil: Eskimo Medicine Man, Alaska, Exorcising Evil Spirits from a Sick Boy." One of at least three photographs taken by John E. Thwaites of the same man posing with different masks (see photograph, p. 143, drawing of mask, p. 272; see also Fienup-Riordan 1994:306). A fourth photograph shows the man with face blackened, standing with the same boy (identified by Thwaites as a Togiak native) beside a sod house. Thwaites probably posed the photographs during one of his several visits to Nushagak between 1906 and 1908. *ASL, Thwaites Collection, neg. PCA-18-497*

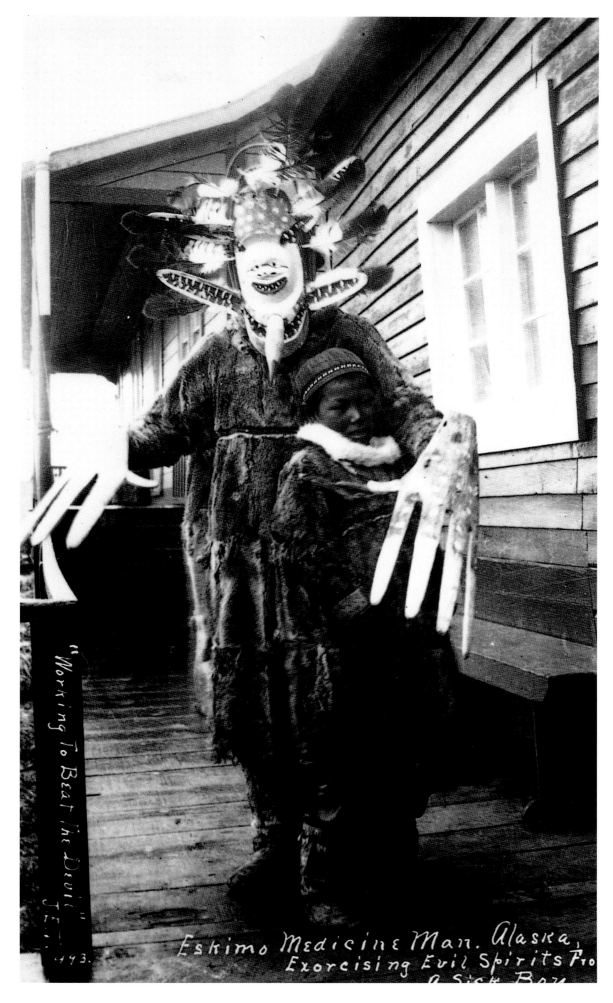

The pair of enormous wooden hands with truncated thumbs worn by the *angalkuq* in Thwaites's photograph entered the collection of the Museum of the American Indian in 1927. Wooden arm straps held each hand to the wearer's arms. The hands' backsides are painted black with white finger spots. Accession records say only that the hands are from Anvik, a questionable provenance. How widely such hands were used is unknown. *NMAI, 15/4345 (72.4 cm)*

quently became both a healer and a very fast worker and skin-sewer: "They say she used those [worms] as hands." John Active recalled that in the past, young girls were given bracelets and necklaces made of tiny mouse paws as charms to make them dexterous in their skin sewing or anything else they did with their hands (MacPherson 1992).

Like the connection between thought and powerful touch, that between supernatural touch and supernatural sight is an important and recurrent theme. Willie Kamkoff (February 27, 1994) suggested a connection between healing hands and the holes in the hands of mask appendages:

Perhaps the [hands] with the holes belong to the *cavtetulit* ["those who feel with their hands," from *cavte-*, "to feel or touch intentionally with one's hand"]. . . . [People] have talked about eyes of the hands. They say they had eyes. They say some people touched others with their hands and knew what was going on with them in those days. I, too, was poked by someone who could do that this winter when my back kept bothering me. There are some who could do that around today, but they are afraid to come out.

The hand mask with a single, central eye embodies these same relations.

The historic record provides another account of the Yup'ik belief in healing hands (Fienup-Riordan 1991:315). The healer Usviilnguq acquired his power by placing his hand palm down over the skeleton of a frog, saying, "Give me power to heal bruises." Then he went on his way and when he returned, the skeleton was gone. After that, when people came to him he was able to draw the bad blood from their wounds without lancing, simply by rubbing his hand over the bruise.[21]

Just as healers derived power from rubbing worms, so carvers rubbed wood worms into the palms of their apprentices' hands to enhance their talents. Mary Ann Lomack of Akiachak said that when she was young, her blind grandmother rubbed Mary Ann's hand, telling her that when she grew up she would be good at working with her hands. As with healers, elders used their hands as vehicles to impart their powerful thoughts for the future well-being of their young protégés.

Ordinary people combined thought and touch in important ritual actions in daily life. For example, a common cleansing act was to brush oneself off while thinking of making the way clear for animals to approach. This rid the person of any of the *caarrluk* ("bad stuff," dirt) that attached itself during daily life. Some people say that *arula* dance motions also push bad influences away from the dancer's body.

The powerful hands of a Nushagak *angalkuq* are vividly portrayed in a striking photograph taken between 1906 and 1908 by John E. Thwaites, a mail clerk on the *Dora* (Goforth 1995).[22] In it the *angalkuq* wears an elaborate mask, probably representing the *yua* of a bird, and his hands are covered with a pair of huge wooden hands encompassing a small boy, pre-

sumably in need of healing. On the steps of a frame building, the photograph's subjects posed with a rare example of complete, five-fingered carved hands. Yup'ik oral tradition describes powerful hands that detach themselves from the *angalkuq*'s body and travel independently, procuring valuable things such as animals or the *tuunrat* of another *angalkuq*. Looking at the huge wooden appendages in the photo, one can imagine them with a life of their own.

Healers' hands were not the only body part that could be strengthened by supernatural encounter. Eating any type of food found in a mouse cache enabled a person to become a healer, able to use saliva to heal cuts, sores, and other bodily ailments. As the incorporation of the magical worms gave the healer's hands the power to draw out illness, the ingestion of food gave the healer's saliva comparable power. Supernatural touch drew the disease out of the body in both cases.

Along with sucking or lifting illness out of the human body, the *angalkuq* might breathe on the affected area. People referred to a person with such power as someone with "strong breath." *Angalkut* might combine these healing techniques, drawing the sickness out of a patient's body with their hands and then breathing on their hands to dispel the illness from their own bodies (Brentina Chanar, June 30, 1989).[23]

Treatment of the body in times of illness was as much a spiritual as a physical enterprise. The Yup'ik people experienced a direct connection between physical problems and spiritual solutions. Conversely, physical ills directly reflected moral inadequacies. People brought on disease by transgressing the rules for living, and only through correcting or confessing their offenses could they hope to heal their bodies.

In case of serious illness the patient employed the *angalkuq* to cure both body and soul. Significantly, many curing techniques involved the reversal of the interpersonal boundaries of everyday life. A person's senses were carefully restricted under normal circumstances—eyes averted out of respect, a woman's bad air avoided, and direct address carefully controlled so as not to injure another's mind. But to draw an illness out of a patient's body, the *angalkuq* employed supernatural vision, powerful touch, "strong air," and confession, or "speaking out." By obviating the normal boundaries between persons and between the human and nonhuman worlds, the *angalkuq* opened a pathway for illness to leave the patient's body or for a lost spiritual essence to return. The human hand often played the part of conduit in this procedure.[24]

The ungloved hand, again acting as a potent extension of the human body to cross boundaries between the human and supernatural worlds, was a powerful persuader against unwanted apparitions. In the past, "when the earth was thin," people were said to encounter creatures rising through the ground. When a ghost is met on the tundra, a person must not deal with it socially (that is, by feeding it), but

21. Frogs, though rare in southwestern Alaska, do occur. They are associated with shamanism, as in the Tlingit area, as well as with other healing rituals (Phyllis Morrow, personal communication; see Fienup-Riordan 1994:201).

22. This photograph was later turned into a postcard, and the image was widely distributed. "How would you like to study 'Medicine' as here practiced?" Thwaites wrote to a friend on one card.

23. Writing about Baffinland Inuit of the Eastern Arctic, Boas (1907:530) provides a good example of the empowering combination of breath and touch: "In the hut was a partridge-skin which was drying. He asked his wife to hand it down, as he wanted to soften it. He softened the skin, fastened a string around the neck, and hung it up. Then he blew on it, and the partridge came to life and flew about. He called it, and it stayed on his hand. After he had shown it, he hung it up again to dry."

24. Nineteenth-century Yup'ik converts may have originally interpreted the hands-on blessings bestowed by both Catholic and Moravian missionaries in this light, seeing as removing evil an action that was intended to bestow God's grace.

must try to touch it (symbolic of capture), thus forcing it underground. One may feed a ghost, but, to avoid further confrontation, one must not flee.

James Lott (1989:2) of Tuluksak described what a person should do during such an encounter:

When one sees an *alangruq* [apparition or ghost, a thing that appears unexpectedly], one must put one's hand inside, even though it is cold, and take something away. To make the apparition go down, one must press it by its head slowly. Do not press fast—it will come back up again. And when it is under that ground, go like this [*rub your hand over the ground*]. And then that apparition will be gone. That is how they dealt with apparitions at that time.[25]

Dick Andrew (August 16, 1992) gave comparable advice: "If the apparition was a male, people were instructed to stick their hands in here [neck] and touch it on the skin. You would try to touch it there. They say their hands would get very cold . . . and sting after they stuck them in there briefly trying to touch [the ghost's] skin."

Describing Chugach practices, Birket-Smith (1953:175–76) recounted a meeting between a poor hunter and "Imam-shua" (Sea's Person), who appeared in the form of a woman. The spirit-woman told the man that his bad luck was due to his staying among menstruating women when he was a child. She then put her hand on his head two times in succession, and he saw first dirt and then bloody water coming out of his toenails. She again put her hand on his head, and he saw dried blood on his clothes. The man had contracted all of these impurities through his contact with women. Finally, the woman put her right hand on the man for a fourth and last time, and he felt better and "light." She then advised him to keep clean and not be lazy, and she told him that from then on he would be a good hunter and that the animals would come to him. In this case the spirit's hand pushed impurities out of the body, whereas the *angalkuq* pulled them out during ministrations to the sick. Also significant, the spirit's hand—possessing four fingers—touched the man four times, comparable to the four days of mourning and the four steps separating a man from the land of the dead. Just as the human body became gradually transparent as one journeyed in time and space toward the land of the dead, so the hunter became lighter following the spirit-woman's touch.

The traditional sign of peace was to stand in the open and greet newcomers by raising one's ungloved hand. Moistening both little fingers with saliva and beckoning someone would irresistibly draw him or her to oneself. A woman could make holes in the sky and let in good weather by touching her two little fingers to her mouth, blowing on the tips, and then turning her fingers outward and performing a tearing motion, moving them apart. Conversely, one was never to point an index finger at another person because of the damage it might do.

References to the creative power of the ungloved human hand abound in the ethnographic literature. In the creation story recorded by Nelson (1899:454), Raven animates the first woman by fashioning an image and holding it in his hands. Before they acquired tools, the first man and his son caught and killed animals with their bare hands (Nelson 1899:456). In the beginning, when there was no light, Raven would use his hand to hold up the sun for two days at a time so the people could hunt and get food (Nelson 1899:461). After the sun was released, Raven created the morning star by sticking a bunch of glowing grass that he held in his hand into the sky just before sunrise (Nelson 1899:462). Raven's touch might also engender life, as in the Nunivak tale in which he impregnates his wife by flattening his hands on her stomach (Lantis 1946:298).

Raven and his first creations were not the only ones with powerful hands. A story from Norton Sound tells how a woman fleeing from her cruel husband was cared for by a giant, who supplied her wants by reaching out his great hand and capturing deer, seals, and whatever she wished for food (Nelson 1899:471–72). A poor girl in a Nunivak story is approached by two terns, who transform into men and tell the girl to slap them on the head if she wants one of them for a husband. When the girl slaps one man on the head, he becomes a tern with a big head, and when she touches the other man with only her finger, he becomes a tern with a small head. Later the girl's grandmother rubs her hands along the girl's back, and the girl acquires beads in her ears, nose, and lips, becoming beautiful in her husband's eyes (Lantis 1946:291–92).

In a Sledge Island story a woman and her husband are confined to a house where they receive food daily in a wooden dish, pushed inside the door by the two hands of the *inua* who provides for them (Nelson 1899:512–13). In the story of the discontented grass plant, Chûñ-ûh'-lûk reveals his great strength to his brother by killing reindeer with his bare hands (Nelson 1899:509). In another tale a young traveler defends himself from a powerful *angalkuq* by raising both his hands and calling upon the thunder and lightening to come to his aid. When this ploy does not work, the young man strikes himself on the breast with his hand. A gyrfalcon and then an ermine spring from his mouth, visiting destruction on his enemy (Nelson 1899:492–93).

The Sledge Island hero Ak'-chĭk-chû'-gûk showed his prowess by the strength of his hands. Conversely, when his adversaries attacked him, his strong magic subdued them by forcing them to put their hands behind their backs. Before confronting his enemies, he disguised himself by smearing his hands and face with decayed fish roe. Finally, Ak'-chĭk-chû'-gûk destroyed an evil witch by catching her by both hands and crushing them to a shapeless mass (Nelson 1899:501–504).

A person's hands might also possess the power to

Large, complicated mask collected by Sheldon Jackson. Circular holes run down the back, as well as appearing on joints of three paw appendages projecting from each side. The face is partially surrounded by a bentwood ring. *SJM, IIX5 (84.7 cm)*

25. See "The Girl Who Saw a Ghost," told by Cyril Chanar of Toksook Bay (Fienup-Riordan 1983:246).

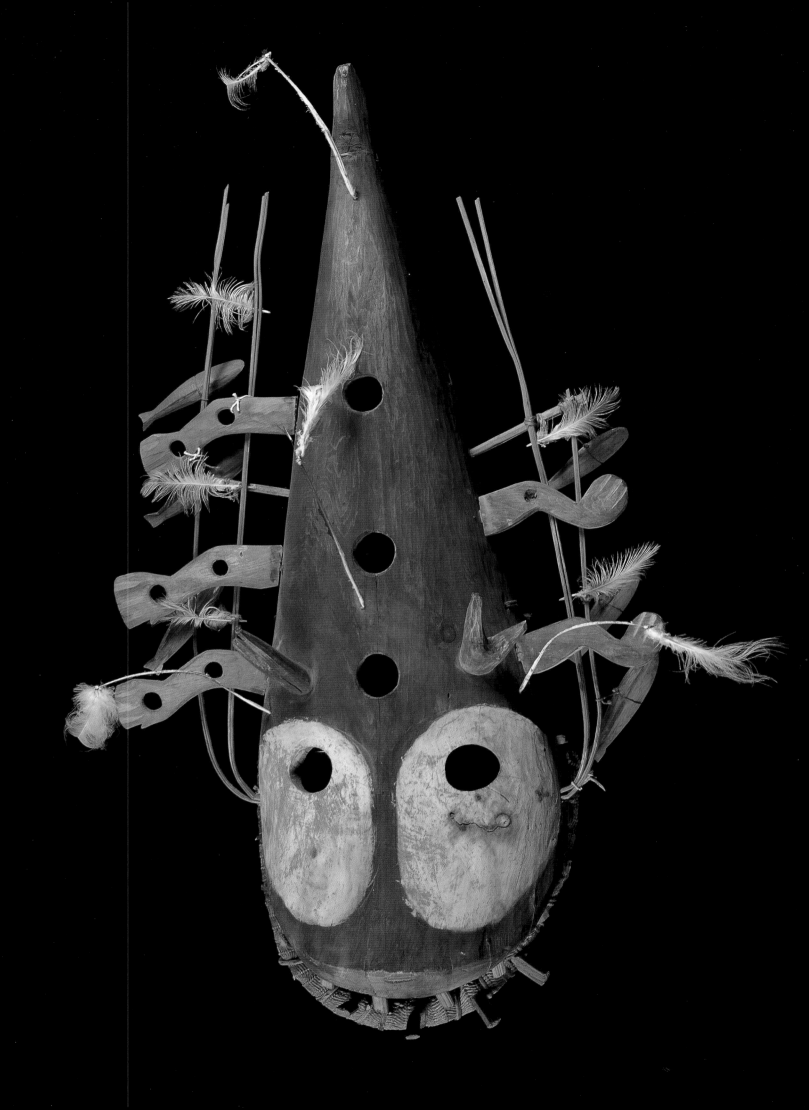

read another's mind, as in the story of the husband who put his hand on his wife's forehead and so learned that she was planning to kill him (Nelson 1899:493). The hand's movements often were potent and, consequently, restricted. For example, among the Chugach Eskimos hand games such as cat's cradle were typical summer pastimes, as people believed that they delayed the movement of the sun (Birket-Smith 1953:104). As in healing, the hands' power might combine with that of breath, as when an *angalkuq* blew through cupped hands to clear the weather.

Just as the ungloved hand could be a source of power, so power could be restricted by binding the hands and feet. Nelson (1899:481) recorded a story from St. Michael about a man who lost his children and subsequently became so gloomy that he traveled the world, scattering disease and eating his victims. *Angalkut* finally subdued him by binding him hand and foot: "To prevent evil spirits from wandering and taking possession of dead bodies and thus giving them a fictitious animation for evil purpose, and in memory of the binding of this evil one, the dead are no longer thrown out, but are tied hand and foot in the position in which the demon was bound and placed in the grave box." Conversely, the mark of an *angalkuq*'s power was his ability to magically escape his bonds when, like the demon and the dead, he was bound. Nelson (1899:434) described such a binding, as well as the *angalkuq*'s secret release by his assistants. The people afterwards pronounced him a great *angalkuq* (see also Boas 1888:592, 598).

People are, literally, the sum total of their hands and feet. The word for twenty is *yuinaq* (*yuk*, "person," plus +*nginaq*, "merely, nothing more"), reflecting that a person has no more than twenty digits (Jacobson 1984:515). The strength and dexterity of a person's hands were constantly challenged, not only in the routines of daily life, but in every conceivable occupation, from hand wrestling to string games. Loss of one's hands, like loss of sight, was considered devastating.

A person might use hand motion to enhance well-being. For example, after drinking from a bucket of water, one is supposed to move one's right hand back and forth across one's face, so as to clear vision and enhance visibility to animals. Those failing to do so will appear to the animals with buckets on their heads—persons not worth approaching.

In the Canadian Arctic, the human hand is the ultimate source of the sea mammals on which people rely for sustenance. A related series of myths reveals that whales, seals, and walrus derive from a woman's finger joints, which were severed by her father in his effort to push her into the sea. The woman subsequently sank to the ocean bottom, where she resides as the respected and feared protectress of its creatures. Inuit people across Canada and Greenland refer to her with a wide variety of names, including Sedna, Nerrivik (Food Dish), and Takanaluk Arnaluk (Woman down There). Whatever her name, her maimed hands from which sea mammals originate set her in sharp contrast to the ideal Inuit hunter and his wife who hunt and care for animals with whole, clean hands.

In Franz Boas's (1888:584–85) account from the Baffinland Inuit, Sedna took revenge on her father by letting her dogs gnaw off his feet and hands while he slept. Alternately, among the Iglulik of the eastern Canadian Arctic, the shaman wears nothing but mittens and boots when he journeys to the ocean floor to request Sea Woman to release the sea mammals. To incur her good will, he uses his hands to comb away the impurities that lodge in her hair, a task she is unable to perform for herself.

Sonne (1990:9) pointed out that hands connote the ability to work, which neither Sea Woman nor (temporarily) the human woman under taboo possesses. She described ways in which hands or, by substitution, mittens or even sea mammal flippers symbolize a meat-sharing partnership in areas of the Canadian Arctic. In southwestern Alaska, the seal flipper and human hand may have been comparable in certain contexts, but were contrasted in others. In Yup'ik masks the animal's appendages—flippers, wings, paws—are realistically represented, while the hand of the animal's *yua* is human.

The Yupiit gave the extremities of animals special treatment as the animals first entered the human world when hunters brought home their catch. A woman traditionally greeted sea mammals with pure snow or fresh, "sweet" water, a product of the land that they believed the animals craved. She placed this water in the sea mammal's mouth as well as over its back and front flippers. Conversely, people ritually anointed the extremities of land animals with seal oil, a product of the sea for which they supposedly yearned. This act both recalls and inverts the anointing of the seal's "hands" and "feet" (flippers) with fresh water. The offering of water to seals mirrors the five drinks of water given the *yuit* of the seals at the ice hole at the close of the Bladder Festival, as well as the placement of the bladders in each of the four corners and the middle of the hole before submerging them.

Perhaps these ritual acts, among others, are iconographically represented by the paws, flippers, heads, and tails appended to Yup'ik dance masks (Phyllis Morrow, personal communication). Often attached to hooped masks by means of flexible feather quills, the appendages came to life as the dancers moved, as the animals' *yuit* would come to life again if the human hunter and his wife "fed" their appendages and otherwise gave them proper treatment and respect.

Given the potential power of the human hand, like the power of direct supernatural sight, it is not surprising that people covered their hands in many ritual contexts. Just as dancers cast down their eyes during the dance, often covering them from view with the beaded fringe of their headdress, so they either gloved their hands or transformed them through the use of dance fans. Museum collections

contain numerous pairs of dance gloves, both small and large, including shoulder-length mittens, often without thumbs, trimmed with puffin beaks. The implication was that the uncovered hand, like the uncovered eye, was powerful and, therefore, potentially dangerous in certain contexts. A story from northern Alaska relates the origin of the use of gloves among Iñupiaq dancers:

One legend had it that one particular dance demonstrated an attack by a clan of Eskimos upon an evil supernatural being. This demon, it seems, had cast a spell over the sea, making it impossible to kill any walruses, seals, bears, or whales. Quite a clever demon, he nevertheless had one weakness which the Eskimos eventually discovered: He could detect the approach of a human being only by the sight of his skin.

Upon making this discovery, the Eskimos donned masks and gloves, and, by an ingenious plot, went forth and conquered the demon. So in the dance re-enacting this legend, the Eskimos wear gloves—both to make the dance accurate in detail, and to protect themselves against the demon's coming to life again and finding them in the act of boasting about their victory. (Blackman 1945:20)

Gloves were an essential part of a person's hunting paraphernalia, and performers wore gloves in the representation of hunting feats in dance. Edmonds reported that men hung a glove along with the bladders during the competitive games played during a St. Michael Bladder Festival, an event critical to future hunting success. A person took down and cared for the glove between contests (Ray 1967:30).

Performers also may have worn gloves as protection from more general supernatural danger. Just as the ungloved supernatural hand was powerful, the ungloved human hand was vulnerable. Teresa John (February 1993) commented, "The meaning behind having something either held in your hand, or covering your hand, is that you want to keep the human

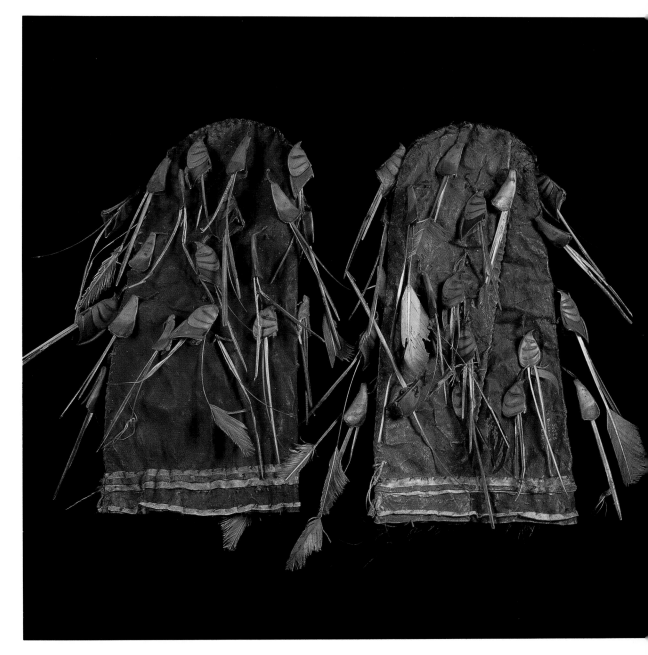

Ceremonial gloves such as these simultaneously provided a protective covering for the body and covered activity with the clattering noise of puffin beaks. Zagoskin (Michael 1967: 230) saw men wearing long sealskin mittens at a Feast for the Dead in the 1840s. Sheldon Jackson collected two pairs at Andreafski (SJM, IIB71 and IIB72). Charles L. McKay collected this pair at Bristol Bay in 1882. *SI, 56028 (51 cm)*

spirit within you. When you don't have either dance fans or gloves on, that means that your spirit can come out of you and leave you. People don't dance with just their hands." Some older women still pull their parka sleeves over their gloved hands or conceal them behind their backs when they walk abroad. As well as keeping them warm, this may keep them safe from harm.[26]

Robert Spencer (1959:312, 321) described magic mittens that helped Iñupiaq shamans in northern Alaska, often saving them from difficulties. Canadian Inuit shamans also used gloves and mittens to both protect and empower the human hand (Betty Issenman, personal communication). Birket-Smith (1971:189) witnessed a seance among Inuit of the Keewatin District of Canada's Northwest Territories in which the shaman, Igjugârjuk, reached his familiar spirit deep in the earth. Men, women, and children touched his covered hands. Then he placed a mitten in front of him and pressed on it with his wand. The presence underneath the ground made the wand more and more immovable. The spirit answered the shaman's questions by controlling his ability to raise the wand. The mitten thus became a surrogate hand, a link between the shaman and his helping spirit, a connection between the human and spirit worlds.

Boas (1888:184) described a Central Eskimo shamanic session to find out who was guilty of transgressions: "The lamps being lowered, the *angakok* strips off his outer jacket, pulls the hood over his head, and sits down in the back part of the hut facing the wall. He claps his hands, which are covered with mittens, and, shaking his whole body, utters sounds which one would hardly recognize as human."

Boas (1907:509–10) and Rasmussen (1929:204–206) tell the wonderful story of Qingailisaq, an Iglulik shaman, whom spirits instructed to wear a coat decorated with, among other things, two gloved hands made from white caribou hair. Boas says the hands were to ward off invisible spirits, while Rasmussen states that the hands show how the caribou spirit sought to overpower the shaman. Issenman points out that the hands are gloved, an appropriate procedure for shaman's hands during ceremonies (Issenman 1985:101–19; Rasmussen 1929:124, 123, 133, 145; Saladin d'Anglure 1983:67–83).

Some evidence exists that the three-part mitt or glove worn in ceremonies performed by Siberians, Alaskans, and Inuvialuit was based on Raven's foot. Finally, mention should be made of the thumbless mittens that Canadian Inuit bestowed on their enemies—mittens that tightened around the victims' wrists as they tried to remove them, preventing defense (Pitseolak 1993). Such mittens sharply contrast with the ungloved thumbless hand of the *yua*, which has supernatural power to bestow life, and with the properly gloved human hand, with its circumscribed human power to work and provide.

## Summary

We may never know the particulars of the three hand masks collected by Gierke or the exact function of the Nushagak *angalkuq*'s huge wooden hands. We can, however, recognize them as potent forms within the context of Yup'ik cosmology, in which control over the appearance and disappearance of animals was a central problem. At different points in the annual ceremonial cycle, participants made spirits visible in the present to ensure their ability to retain them in the future. Given the power associated with sight, sound, taste, and touch, the dramatic presence of the spirit world within the human world during masked dances was likely viewed as an act of empowerment affording human participants some control over the spirits represented. During masked dances the boundary of the human world was extended until it contained a visible, audible, tangible essence of the spirit world. Through the dances, men and women contrived to "hold" for the coming year the spirits they had drawn.

In some dances, human performers became the spirits they represented, and the *yuit* of the animals were depicted in human form. Just as the *angalkuq* had transcended the limits of gender, space, and time through powerful supernatural touch, sight, and sound, so the ceremonies most strongly associated with shamanic activity transcended the limits of human knowledge and experience in an effort to extend them.

As many masks make visible the unseen spirit world, the masks' features embody the spirits' senses through which they know the humans who call them forth. Conversely, in some contexts, humans restrict their own senses to simultaneously protect them from spiritual invasion and prevent them from leaving the body. In their dealings with the human and nonhuman worlds, men and women control their own components—their breath, sight, heat, mind. Masks embody the extraordinary senses of the nonhuman persons they rely upon.

26. Yup'ik carvers often made ivory and wooden dolls without hands and arms.

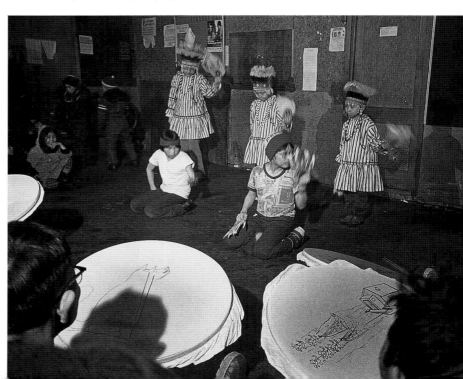

Teresa, Agatha, Agie, Freddy, and Willie John dancing a *tekiqata'ar* arrival dance at Toksook Bay in 1975. The girls cast their eyes down under beaded *nasqurrutet* (dance headdresses), and all the children hold dance fans. The girls' fans are woven grass with caribou ruff while the boys' are bentwood with snowy owl feathers. *JHB*

# Dance and Song: The Body and Breath of the Mask

*They say that every living thing dances. And my former sister-in-law told me that one morning when she was going to church, she saw a mouse. Because it was going to dance, it kept going out of its hole. It stood up and danced. I think everything dances, even ducks and geese. . . . And it is a fact that everything has dance connected to it. . . . And that is what the Yupiit did, they danced for everything.*—Theresa Moses, *October 26, 1987*

### "Everything Dances"

In Yup'ik oral tradition, dance began where war left off. Cyril Chanar of Toksook Bay gave a long account of the end of war and the beginning of dance. At the story's end,

Two men entered the open water in their kayaks with only a drum and a spear. They approached the village at night, waiting until morning to come close. Then they raised their paddles to make their presence visible. They approached slowly, saying, "We fight. Some are afraid of death, but still we fight. But spears are meant for killing animals." And they began to beat the drum, and the women came down to the river dancing. Then they said, "We want to come into the *qasgiq*." And they did, and took council there. And now they fight only with dancing. And the men who came went home to their old village and said, "No more war." (Fienup-Riordan 1983:247)

One of the first and most persistent battles Euro-Americans waged against the Yupiit was the suppression of their dance tradition, so that by the mid-1920s only memories remained of the elaborate midwinter ceremonies. Peter Lupie (June 18, 1985) described the pomp and ceremony that accompanied the last large dance on the lower Kuskokwim. As the upriver guests arrived, their hosts welcomed them with sealskin streamers:

This happened down in Anlleq in the summertime. I watched them when they did this. I was an adult already at that time. . . . They said they were gathering for the last dance. Then after that they stopped dancing.

We lived down in Cuukvalek. While we were in Cuukvalek they talked of the dance gathering they were going to have. Then when it was time to go, we left in the early evening in boats with sails. As we sailed out of Cuukvalek we saw many boats sailing down

the river. They were people from this area. They were people who lived on the Qinaq River. When we arrived at the mouth of Anlleq, the point was covered with many people. There were a lot of them holding children in their arms. . . .

When we got to the mouth of Anlleq the people up on land began throwing the sealskin twine to the boats down there. There were many boats there, but since they had many pieces of skin twine, they let the children [throw them]. I saw a child in someone's arms holding the end of a piece of twine. When they do this they call it *ukamarluni* [towing a boat while walking along the shore]. Though the current was strong, they were towing a train of boats upriver. They tied the many boats end to end.

When we got to the front of the village the people in the boats began to sing. We who had just arrived sang. And two women danced in one of the boats. They called it *tekiqata'arlutek* [two arriving slowly]. Many, many people were singing out in the open. The visitors arriving in the village were dancing. The two women in the boat were dancing while the others were drumming and singing.

And since the people in the village didn't have a *qasgiq*, they had a structure that was called a *qasgiarneq*. . . . It was a huge fence that was shaped like this. [*Motioning*] . . . It was a huge *qasgiq* without a roof. . . . But before it got dark they made a roof over it out of cloth.

The event they had that time was a big dance celebration. They were also doing the dance called *yuraulluteng* [dancing with something]. I watched them when they began the event. [The *qasgiarneq*] was huge, but they first put a cloth partition across the middle of the structure, leaving the top open. The drummers were sitting in the back and the cloth partition was stretched all the way across in front of them. They called it *capuciriluteng*.

Then after they removed the cloth partition they began to dance and danced all night long. A person would come into the arena holding up an object like a gun over his head, dancing and making dance movements like so, as the drummers began to sing. They called it "dancing with something."

It was the last dance I watched. And after that they never did anything like that again.

Nonnative observers saw little beauty and less value in Yup'ik dancing. In a 1945 article titled "The Mukluk Shuffle," Harold Blackman wrote, "When one first observes true Eskimo dancing, he has the feeling that time has, for the moment, whisked him back in

to an ancient primitive, almost savage era—so emotional and weird are the sounds of the drums and the voices, so intense and dramatic are the dancers." Later he refered to dancing as "this strange art." Thirty years later, Charlie Steve (1982) of Stebbins put Blackman in his place: "At the present time, we experience people talking back to us, 'That way of life is worthless, the modern way is all right!' This modern way, if our ancestors were around, those who want to would throw it away with a song."

Slowly, over the last quarter century, dance has returned to many parts of southwestern Alaska, and in lower Yukon and coastal villages today it is a major focus of winter activity. Along with multivillage potlatches, informal dancing and dance practices occur throughout the year. Although more common on stormy winter evenings than during light summer nights when the fish are running, informal dancing is a vital part of village life whenever an occasion presents itself.

Between one and two dozen participants, including the drummers, are enough to start off the evening, although the group often grows to ten times its original size as the dance progresses. The communities' older men and women are the expert dancers, along with a group of promising youngsters who have been taught some of the simpler dances by their grandparents. As the group assembles in the community hall, several of the middle-aged men take the drums from the storage closet and begin to play softly, waiting.

The shallow, tambourinelike drums are made of a rim of bent spruce, approximately two feet in diameter, over which is stretched a single piece of translucent plastic (formerly walrus stomach). The drums are the only instruments accompanying the dance, and the drummers strike their top surface with a thin willow wand. In contrast Iñupiaq drummers strike the drums' underside, aiming for the rim rather than the drum covering. Each dance calls for two to six drummers, who rotate during the evening as their voices weary and arms grow tired.

Skilled drummers are essential to any dance performance. Teresa John (March 23, 1993) spoke from experience:

Some assume that the drumming is very easy, but it's very difficult, especially when you want to be a perfect group. You don't want somebody who misses a little beat or misses a little break here and there. It just ruins the whole thing. I have observed some really picky drummers in villages where they say if one beat is off, everybody quits that song, because that's spiritually very important for them. They say once you mess up the song just a little bit, then you throw off the whole song. And it also throws off the dancers because the dancers go by the rhythm of the song, the beat.

Festival drums, like gut windows, are sometimes painted. During a performance men used blackfish skin to repair holes in the drumhead. Elders emphasize the careful treatment drums require. In the past

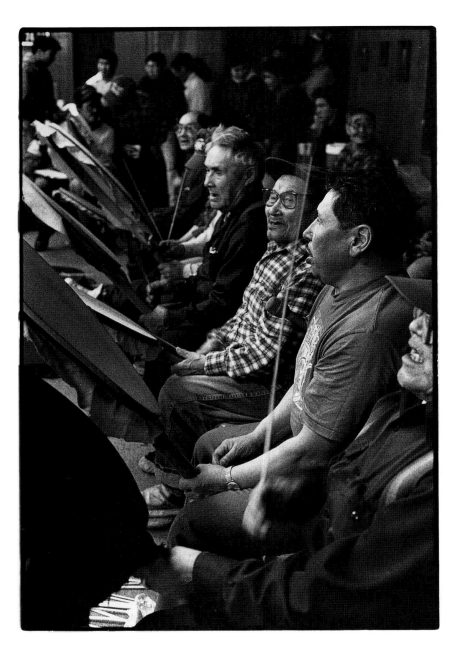

when someone died in the village, people disassembled their drums so as not to wake up the dead. Charlie Steve (1982) described the catastrophe that would result if someone broke a drumhead:

This drum is so sacred when they gather for a celebration (*kassiyurqata*). They try especially hard not to burst it. And they tell a person not to go out in a bad mood. If a person bursts a drum, it will be like bursting the whole village. If he does not exchange that drum, whether he may be rich or bad, they will treat him as one who has been rejected.

He will not watch it while he is drumming. And he will not be aware of how the drumstick is. Though he may burst it, it is all right. But if . . . you were drumming and you put it down awhile, if I rushed over and punctured it or burst it, I would shatter all the people's minds.

The generic term for Yup'ik dancing is *yuraq* (pl., *yurat*), a term that is also often used to refer to the *arula* dances consisting of both verses and a chorus.

Thomas Luke, Jimmy Paukan, Andy Paukan, and Andy Kinzy drumming during the 1989 Mountain Village Dance Festival. When a drummer wants to change his drum's tone, he rubs water over the drumskin, then pulls it further beneath the holding thong. *JHB*

In the past men and women performed six main styles of *yuraq* as well as a number of regional variations. They included *arula* dances; *yurapiat,* (lit., "real or genuine dances"), inherited "story" dances that told a tale from start to finish; slow, old-style *ingula* dances performed in the fall, following the berry harvest; northern-style *pualla* dances, sometimes performed outside before a feast; dances performed to *taitnauq* songs primarily during the Messenger Feast to bring in the gifts; and *tekiqata'arcutet,* proper entrance dances (lit., "things used to gradually arrive").

Only women perform *yurapiat,* and they dance without fans. A woman inherits her particular *yurapiaq* from her mother and passes it down to her daughter and granddaughters. Each *yurapiaq* tells the story of a single day, beginning in the early morning, progressing through the day's activities or adventure, and ending with the dancer recounting to the people what had occurred. Each part of the story is told in pantomime through the motions of the dance. The dance begins with the woman making the motions of *qavaruaq* (pretend sleep), indicating she is waking up. Dick Andrew (January 6, 1994) reminisced: "Long ago the women did the *yurapiat* and told stories with their arm movements. They would dance about something they did. . . . They've used their arms to tell stories from a very long time ago. One or two women would do one story dance. . . . They would bend their knees slightly in a rhythmic up-and-down motion as they danced. They would do the *qavaruaq* and do the motions of the story. Each movement would be different." Elsie Tommy (June 9, 1992) described the *yurapiat* performed after the Bladder Festival when she was young:

They would dance after they let the bladders go. During that time they did these dances. [*Chuckle*] They got very excited. Back in those days they would dance in the fall to these very, very old songs. Their performance would create motions for the stories. The motions would personify someone working on seal intestines. They would create motions of people battling in warfare. . . . They made motions of people picking berries. The people I saw performed those dances. They would make motions of playing ball. [*Laughter*] Their dances would be very picturesque. . . .

The dances now are somewhat like what they did in the past, but they were different back then. Back then only two dancers would dance a song. They would dance and stop when the drums stopped. They would be very bashful. . . . [*Laughter*]

They would be standing turned sideways. . . . Only two women at a time. And also during the Messenger Feast in Cuukvagtuli when they *tekiqata'arquneng* [slowly arrived], two of them would *tekiqata'ar* [do the arrival dance]. . . . The residents of Kayalivik would do that.

*Ingula* dances, too, were performed by women and told a story, but elders always carefully distinguished them. According to Dick Andrew (January 6, 1994),

The *ingula* dances were different, too. They would do movements telling a story. They would do movements of picking berries. The women would do the *ingula* dances wearing seal-gut *qaspeq.* I saw them doing *ingula* dances like that. . . .

[They would do *ingula* dances] in the fall. They would begin the events in the fall. Perhaps it was in November. They would do [*ingula* in the summer], too. . . . Down on the coast I personally didn't see people doing that in the summer. However, they say inland people did that.

Jasper Louis (February 25, 1994) described the *ingulautet,* the songs that accompanied the women's *ingula* dances:

*Ingulautet* were different from the regular songs. *Ingulautet* were old. *Ingula* dances were similar to *yurapiaq* dances. Some who performed the *ingula* dances used to bring food into the *qasgiq* for the people. A woman would do that. And after she presented the food she would dance. . . . It was a slow song with slow movement. They would call it *ingula.* The drummers would beat their drums slowly. The rhythmic bending of the knees would be slow following the beat of the drum.

Nicholai Berlin (January 13, 1994) described *ingulautet* as unique songs performed only in fall to accompany the *ingula* dances: "They were a little bit different from the other songs. They are very old songs passed down from generation to generation from long ago. The songs of the *qulirat* [ancient times and their tales] are like that too." Berlin went on to recount the story of the disappointed granddaughter who killed her faithless suitor when she stood in front of him and sang an *ingulaun.*

. . . . When he arrived from caribou hunting, he went to the home of another young girl. When the poor girl was heartbroken and crying, her grandmother told her not to cry and said she was going to compose an *ingulaun* for her to learn. She told her to dance the song for him when she brought food for him to the *qasgiq.* It began like this:

*In the land behind it back there*
*Look around and see*
*Two young caribou*
*The two you promised me*

Uu-uu-u iyaa-aa
Aagi-ii-iyaarangaa
Aa-angaa ggiyaa
Aagii-rriyaa

That song was an *ingulaun.* The *ingulautet* were not *angalkuq* songs. However, they were songs that . . . came from our real ancestors.

And there is another story about a porcupine. I think it was an *ingulaun.* A porcupine who was floating in the water. He could not swim.

It was when [the porcupine] and a *tunturyuaryuk* [legendary cariboulike creature, also known from Bristol Bay] were arguing. Though the *tunturyuaryuk* wanted to meet him, he refused. He began to float and

soon was floating out to the ocean . . . [where] he began to cry . . . , "May the water move me, so I can be with the killer whales." After he sang that, he dove into the water exactly like a killer whale. When he came back up he was a killer whale.

Whereas women performed both *yurapiat* and *ingula* dances, primarily men performed the *pualla*. They danced standing with their feet spread apart and arms moving energetically about their upper body. Justina Mike (March 1, 1994) gave a detailed account of *pualla* dancing during a lower Yukon Bladder Festival:

You have heard of people doing *pualla*. They would do the *pualla* songs all evening. And while they were doing that a person would come in . . . with a wooden bucket in his hands. He would have pants on. He had a seal-gut *qaspeq* on. As he entered through the doorway with a wooden bucket in his hand his *qaspeq* would crackle loudly. When he placed the bucket in the middle, the people doing the *pualla* would stop. Then a person on the side would walk down to him and begin talking, saying half of [his bucket] contained ice and the other half was land. . . . He would begin to talk. . . .

They would *pualla* with women. The men would *pualla* and down in the middle of them a woman would be dancing. They would be singing *pualla* songs. . . . Back then the men were doing something when they *pualla*. Perhaps they were demonstrating their strength. And a woman would be moving down in the middle *putuluni*. They would call it *putu*. Only one woman would be down there. While they were dancing like that, the man [with the bucket] entered the *qasgiq*.

When she finished, another woman would go down. When they sang another song, another would go down. The people here aren't accustomed to that kind of dancing. The *pualla* songs were fast. They would stand and dance.

And when someone from another place arrived, they would do the *pualla* song for him . . . all evening singing many different songs. . . . They would do that for visitors. They would do that too, even when only one visitor arrived.

Johnny Thompson (February 27, 1994), also from the lower Yukon, described men performing *pualla* dances while women performed *putu* before the masked dances. He also mentioned *talirluteng*, Iñupiaq-style bench dancing in which men and

Wooden *qasgiq* model from the lower Yukon showing four men performing a northern-style *pualla* dance while a single woman performs *putuluni* in their midst. Together the figures present a ritually correct configuration—four corners and a center. The underground entryway is visible in front of the woman, and she is flanked by two lamp stands. *SJM, IIH46 (42 cm × 37.5 cm)*

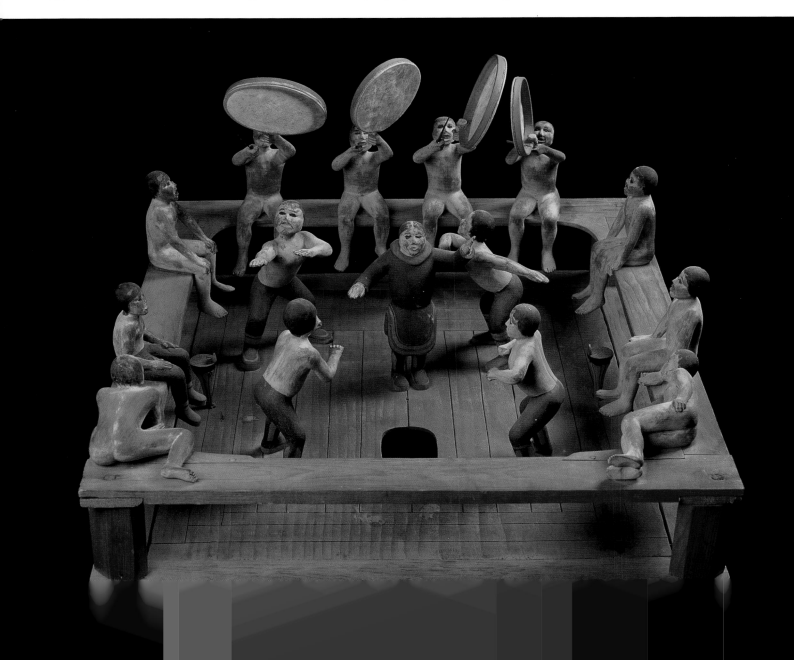

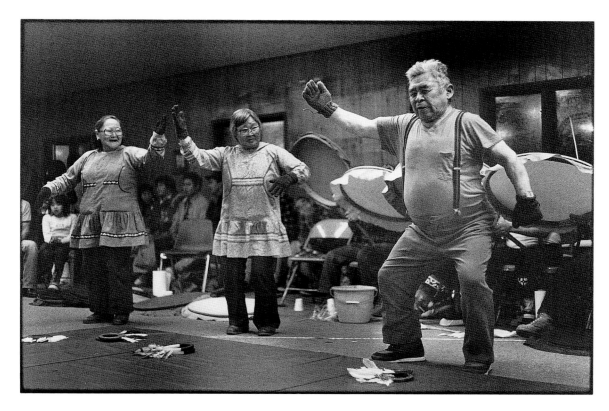

Ann Marie Yunak and Ann and Willie Kamkoff performing a *pualla* dance in 1989 at Mountain Village. All three cover their hands with gloves. *JHB*

women alternate in a straight line facing the drummers, keeping up a steady and exhausting beat:

Men would *pualla* . . . and women would come down and *putu*. . . . Those motions/songs come from the northern people. . . . When I became aware up there [in Pilot Station] some of the members were from the north. When they first learned it they would dance *pualla* songs all evening. And if not, they would sing *talircuutet* [line-dance songs]. . . . When those people up north sat in a line and danced, they would call that *talirluteng*. They would sit in a line and move together.

The most commonly performed dances today are the *arula*. Each has its own *yuarun* (song) consisting of three parts: two or more *apallut* (verses) sung to an increasingly rapid drumbeat, an *agenra* ("chorus," from *age-*, "to go from one place to another") repeated between verses, and a *cauyarialnguq* or *cauyaquciarun*, an irregular drum sequence accompanied by motions but without set words.

The verses and chorus contain both vocables of ancient origin and words descriptive of the actions or events the dance depicts. According to Teresa John (March 23, 1993), "Dancing had a specific vocabulary set aside for composing songs that we don't use in everyday life, such as chant words. And some of the endings of words are changed slightly when you sing a song. They are different from everyday words." Many ancient words, some associated with shamanism, still appear in songs today.

The verses and chorus elicit stylized dance motions, whereas the gestures accompanying the drum sequence are often realistic imitations of animal and human behavior described in the two verses and follow no set pattern. Pauline Haas (1990:31–32) noted that each dance song has fourteen parts. It begins with the chorus, which is sung a total of eight

times. The two verses make up the third and ninth parts of the song, while the drum sequence is performed every fifth, eighth, eleventh, and fourteenth part. The formal song structure is thus: A A B A C A A C B A C A A C. If the song has a third verse, it follows the third drum sequence and is, in turn, followed by an additional chorus and drum sequence, giving the song a total of seventeen parts.

Knowledgeable dancers and singers recognize this as the proper song sequence, but performances display considerable variation. Songs can be shortened by dropping parts and repetitions. They can also be considerably longer when an appreciative audience calls for an "encore." The singers and dancers respond by repeating the final verse, chorus, and drum sequence again and again, until sweat drips from their bodies and their teasing cousins in the audience are hoarse with laughter. People on the Yukon tend to call for more encores than do coastal or Kuskokwim audiences, drawing songs out to many times their formal length.

Tommy Moses lamented recent changes in song structure:

In every native song they always start off with the chorus, that's the main part they always start with. The two verses, the first verse and the second verse, are in between. And then at the end they make some type of motion like if a person is taking something and eating it, that's put in at the end of the song. But there are no words to it. Now there are many who are making up their new songs. It's not from the old timers. (Kamerling and Elder 1989)

Willie Kamkoff (February 27, 1994) recalled that songs traditionally had two verses, the first about an ocean animal and the second about a land animal.

His conclusions coincide with those of Moses: "Today our songs are about many different kinds of things and events, not really following the old tradition. [The dancers] could even operate machines during this time. But the old customs weren't performed carelessly and nonchalantly."

Contemporary songs containing both an ocean and a land verse are the exception rather than the rule. Still, many songs are composed of the traditional two verses, one describing hardship, followed by a happy resolution. Teresa John (March 23, 1993) stated, "In some songs—not all the songs I've studied—there will be a hardship verse and then the second verse will be happy. For example, there is a song about getting stuck in a blizzard or getting stuck in big ocean waves. The second verse is about being happy, being inside a warm place." Recent songs describing people playing basketball and winning the game, or getting lost in Anchorage and finding a friend, build on this pattern.

The performance begins slowly and quietly. One singer "begins to make sound" (or "reverberates," *mengluni*) singing the chorus while tapping the rim of the drum. As the singer finishes, the audience begins to generate the dancers, urging and calling them forth. The heads of older matrons turn, searching for the appropriate dancers—those who in years past have received particular dances as their prerogative from the older men and women who have written the songs. A husband and wife or two cousins come together from different parts of the seated mass and prepare to begin as the drummers tighten their drumheads. Women do the *ayakata'ar* ("gradually about to go," from *ayag-*, "to go away") when all the singers begin to sing together slowly. Standing with feet flat and looking demurely at the floor, they move their hands first to one side during the singing.

From two to a dozen individuals who have emerged from the audience perform each dance. The women dancers stand in a row toward the back, facing the audience, while the men kneel in front of the women. The drummers may sit in front, behind, or to one side. Then, with a loud drumbeat, the dance begins, slowly at first and gradually building to a dramatic crescendo. The dancers move with all-out energy as the song director (*apallirturta*) yells directions. The singers and dancers repeat the chorus, verses, and drum sequence again and again, becoming faster, louder, and more exaggerated with each repetition. The precise syncopation between the drumbeats and dance movements makes it seem as though the dancers themselves are making the sound. Members of the audience draw out the dances by calling out *pamyua!* (its tail!), *pamyuan nuuga!* (the tip of its tail!), or *pamyuan nuukacagii!* (the very tip of its tail!). The scene grows more and more raucous, with the audience shouting back and forth, pulling people off and onto the dance floor and calling for the dancers to begin again as the performers play up to an audience that continues to egg them on.

During the dances women stand feet flat, body swaying with an up and down motion, and knees bending to the beat, *uyungssuarluteng*. Their motions are spare, using mostly upper-body movements reflecting the confined quarters. Their eyes are cast downwards with solemn expressions. The motions of the men kneeling in front are sharper and more energetic. Sometimes, however, men stand during the dance's fast-paced finale, and women may kneel, as when dancing for a male relative. A mark of accomplishment, especially for men, is *ilgimcak* or *uyaqurra'arluni*, a distinctive rubber-neck movement. Both men and women hold fans or wear gloves while they dance. The flowing caribou hairs on the women's finger masks and the stiff feathers on the men's dance fans serve to accentuate arm and hand movements, rendering the women's movements more fluid and the men's more staccato.

Stanley Waska described the motions of the dance:

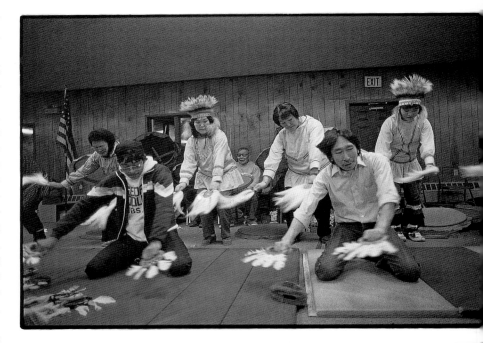

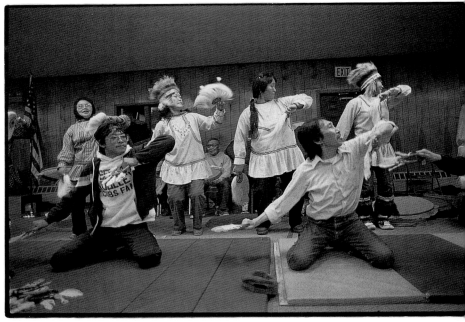

Four scenes from an *arula* dance, with verse and chorus, performed by Chevak dancers in 1989 at Mountain Village. *JHB*

David Bill of Toksook Bay and a woman from Chevak (dancing on her knees like a man) "get lively" during a dance's encore ("its tail") at the 1989 Mountain Village Festival. *JHB*

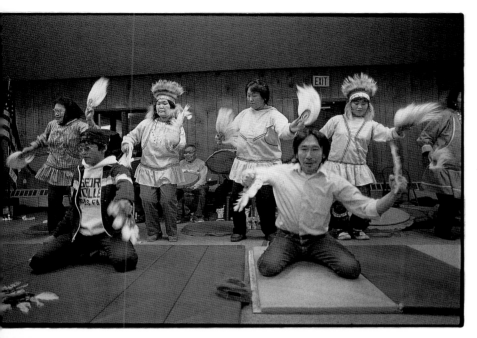

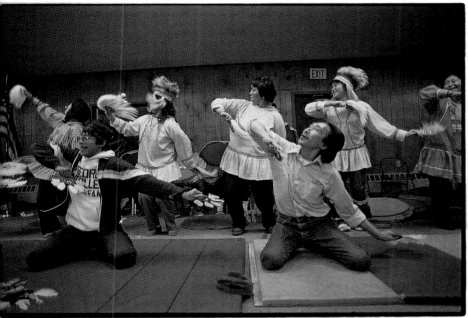

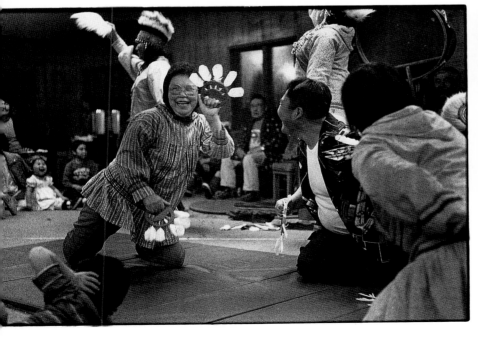

Dancers should stretch their arms out far. Not this way, making small motions. We want them to reach hard. The visitors like to see that. We tell the men to move their necks in rhythm with their bodies. When people are dancing really hard the audience really likes it. . . . On good nights . . . the drummers and singers are at their sharpest. Everyone is together and right on key. Those nights make you want to dance from way inside, to sing from way inside. (Kamerling and Elder 1989)

Today dance songs may be about winning at bingo, warfare, or escape from a ghost. Since all songs deal with daily experiences, both ordinary and extraordinary, a catalog of the changes that have come to the delta in the past twenty years can be read from Yup'ik dance songs—songs about basketball, guitar playing, taking a steambath, or playing on swings at school. Stanley Waska continued:

When they dance a song about hunting, they pretend to shoot a bow. If it's about leaving, they make walking motions. For going downriver, they make paddling motions. Recently I danced a song about blanket tossing. When the tossing part comes I raise my arms like this. I keep making raising motions like this. And in the song's chorus, I motion happiness lifting me up. (Kamerling and Elder 1989)

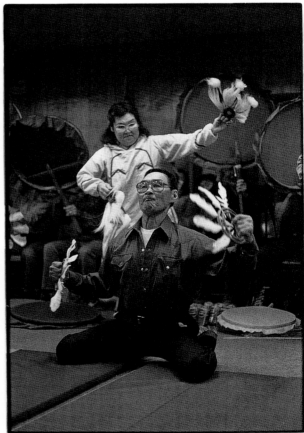

Paul and Agnes Tony in "classic" dance position, she standing behind with fur-decorated finger masks while he kneels in front holding bentwood dance fans decorated with owl feathers. Agnes dances gracefully while Paul moves his head and neck in a staccato *ilgimcak* motion. Men often use either their jacket or a gym mat (as shown) to cushion their knees in this strenuous position. *JHB*

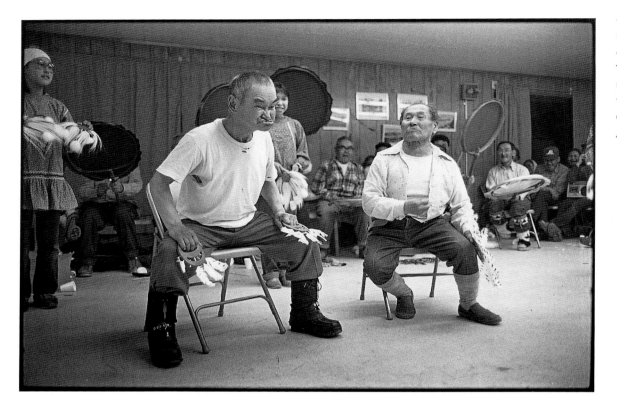

Charlie Steve and Jimmy Paukan entertaining the audience at the 1989 Mountain Village Festival with their rubber-faced antics during the closing *cauyarialnguq* (drum sequence) of a dance. *JHB*

### Nangertelluki: "Letting Them Stand"

Just as most men carved in the past, most people danced, and in dancing, as in carving, some people were known as experts. When Mary Mike (February 28, 1994) "became aware," she was already dancing: "I always loved to dance." Dick Andrew (August 8, 1992) said the same thing: "I fell in love with dancing. I became a dancer here in Bethel, and I always dance." A younger dancer, but an expert in her own right, Teresa John (1986) spoke about what dance means to her:

For me, dancing is something that's a great part of our life because it portrays the lifestyle of our ancestors. They tell stories of what they did—how they hunted, how they made clothing, how they preserved food, everything else. Listening to the songs, . . . the dances that I know word for word, line for line—they are so poetic! Once you really sit down and try to grasp what the composer was thinking, what the composer was imagining when they made it—they're wonderful songs! And the rhythm and the beat is so good it makes you want to dance!

The first time a person dances publicly is very special. Mary Mike (February 28, 1994) described this event: "It's a custom from long, long ago. When I became aware, they would let their young ones [and some adults] perform their first dances to the audience. . . . *Nangertelluki* [letting them stand] was the term they used when the young ones danced for the first time. . . . They would adorn them with clothes when they presented them. They would have on new dance regalia."

Charlie Steve (1982) remembered the importance of placing something on the floor for the first-time

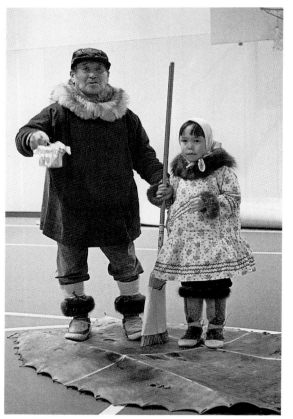

Jimmy Paukan presenting his granddaughter at a dance in St. Marys, 1979. *JHB*

dancers to stand on: "His grandmother or his aunt will help him dance while he is placed between them. They want [the first-time dancers] to stand proper because they could not do that [dance] without a cushion. They make [the dancers'] place of standing very good and let the people see that they let [the dancers] sit on a nice expensive thing. So when they reveal him, they do not want him standing bare." Johnny Thompson referred to the coming-out ceremony or formal public presentation of children as

*tukerceciluteng* (from *tuker-*, "to push or brace with one's feet; to hatch"), perhaps referring to the child's standing on this special gift.

Nicholai Berlin (January 13, 1994) described the presentation of the first-time dancers in the tundra villages:

They would take a bolt of cloth when a dancer stood up to dance. If the dancer was a girl, her father would let the people pass the rolled-up cloth around and make a big circle . . . with part of the cloth. And some people would put a line in the back of the room and hang bearded sealskins in a row. When a young dancer stood up they would do that and called it *nangrucirluku* [providing one something to stand with]. Or sometimes a dancer would hold a brand new rifle in position and would do the *ayakata'ar* as the song leader began to sound out the song at the beginning of the dance. And sometimes dancers would do the *ayakata'ar* standing on a bearded sealskin.

In an interview with Lenny Kamerling and Sarah Elder (1989), Lala Charles gave a moving account of her first dance:

When I first danced, I remember it was on a weekend, on a Friday. I was in school that day, and I was very excited. I felt really special because the older folks during that day would look at me and say, "You're going to be very nice tonight." I was nervous, I was excited, I couldn't wait for the night to come.

When our song started there were a whole bunch of gifts right in front of us dancers, and they placed a sealskin right in the place where I was supposed to stand. They set it up and everything, and I was all set to go. I had my headdress, my belt, my new dance fans, my new *qaspeq*. That was the first time I was going to face the whole crowd, you know, in the middle of attraction. I walked out. . . .

Dad brought me out there and he set me where he wanted me to stand. I felt really afraid. I almost couldn't remember what to do. I guess my uncle thought it was time for me to begin dancing in public. My father sort of explained it to me a little bit and he said that the first dancer is looked upon or recognized as a member of the community. I was afraid, . . . I couldn't look at anybody. I couldn't move my eyes, I just looked at one little . . . nail on the floor. I couldn't move my head . . . my uncle told me to move my head back and forth with my arms. But that was too much for a first dancer, I guess.

My father was handing out gloves and socks and mittens and brooms and shovels. The visitor can't accept that gift unless it's being touched by the dancer. Then towards the end of the potlatch there were sledloads of fish and sealskins. But mainly we gave a lot of fish, maybe five sledloads and the sleds are pretty big.

Good things come to us when we share with other people. It is believed that the things you give will return in large amounts. Like my father might catch a seal. We share the meat and oil and we find that later, the seal itself might not come to us, but we receive something big. Like fishing for us might be better. That's the way we live.

After the first dance that night I almost couldn't face anybody. . . . I was afraid to face especially the older folks because they might say that I did poor. You know they can come up and praise you and they can come up and try to kind of straighten you up. After the first dance I felt really good because they said that I can handle such a big thing because they said that I did very well. That made me feel good.

Usually there is some sort of competition in the dancing. All the people try to top each other, beat the other person, and the visitors ask for the dancers to dance over and over again. The parents, I wouldn't know how they feel, but I think they're just sitting there watching their children dancing. I guess if I was them, if my child was dancing, I would get up there and dance with them. My girlfriends were dancing, and their parents stood up and started dancing. I remember Mom . . . was dancing right behind me . . . as hard as she could.

It's a feeling that I would like to go through again. It's such a good feeling because you're being honored by the older folks. A special feeling that we don't get every day. I felt good about myself.

Often the grandparents or other relatives of the first-time dancers *ineqsuyugluteng*, that is, they are so moved that out of fondness they join the young person on the dance floor, swelling the ranks of the performers. Agnes Waskie recalled,

At my first dance, my dear grandfather was so moved that his cousins pushed him out to join me. I was scared, I thought they were fighting him, but they were only teasing. He came out with his arms already dancing, touched by how cute we were. They still do that today when their children dance. They run down to join them and dance with all their might. I myself do that when I am moved by how cute my own grandchildren are. (Kamerling and Elder 1989)

When people join the young dancers they are not only dancing out of fondness for the children, but also in honor of those departed elders for whom the children are named and who are believed to be reborn in those children. They are dancing both for and with the dead. Mary Mike (May 29, 1993) recalled the importance of joining in dancing:

When people were dancing, a person was told to join in and dance with the crowd instead of hiding under something. They say the departed ones would be sad because they were aware of our unhappiness. They did not like to see someone hiding or holding back. They say the departed ones do join the crowd in the *qasgiq* unseen. So, being aware of that when they dance, it has always been said that a person should stand up and dance. I've always stood up and danced. And at times I didn't feel like dancing, but [I would dance] believing what I had been told. But I didn't think it was true when I was young. It didn't really matter to me at the time. [*Chuckle*] . . .

It was the wife of Cakitelleq over there who told me. I never used to dance. It seemed like I was ashamed to dance. . . . She told me that I wasn't doing the right thing. She told me to stand up and dance even though

I didn't feel like dancing. She said that the departed ones become unhappy. She said when the departed ones see you unhappy they begin to weep with you. . . . I began forcing myself to dance. And soon I began to feel comfortable about it. So now that's what I do.

Not only did dancing honor the living and the dead, it was also the people's way of ensuring good health, of pushing disease away from their bodies. According to Jasper Louis (May 28, 1993), "Back then they told us to dance following the motions of a dancer. . . . They say when you dance you were rubbing off dirt from your body. They told us to do brushing-off motions when we danced. *Yuraq* wasn't the only term for this custom. . . . They told us to dance to push away disease and sickness. We older folks call that *ellugturturyaraq* [way of repeatedly brushing something off]."

Dancing, of course, was entertainment, but with poignant purpose. Especially during the years when epidemics swept the delta, killing so many friends and relatives, the evenings spent dancing comforted the bereaved, soothing them from thoughts of those who had passed away: "Dancing was our way of entertaining ourselves. . . . They called it the fun time. When you are by yourself and you reach this age your mind wanders off to unnecessary thoughts. You would think about dead people, too. For that reason they were very pleased when those poor people amused themselves and laughed. They were always mourning for loved ones who had passed on" (Jasper Louis, February 25, 1994). Teresa John (March 23, 1993) heard the same thing from her father: "He said that in the old days when people died, to heal the families they had dancing because dancing clears our mind of sadness. To focus on the happy content of songs, that's to reflect on life."

Dancing is still a deeply spiritual activity for many people, but today is perhaps more important in supporting relations among humans than between the human and animal worlds. Theresa Moses said that dances help neighbors and relatives resolve differences: "You might think you still hate somebody but you are in harmony with everyone in one building. You don't think of anything but harmony." Multivillage festivals are much like family reunions, where people reacquaint themselves with old friends and lost relatives. Lizzie Chimiugak said that it is "fortunate" to be invited to such an event where one can make new friends and see old ones (Humphrey 1994).

Shortly before his death in April 1994, Andy Kinzy (February 28, 1994) recalled the important sharing between generations that dances make possible:

Once in a great while, when an opportunity comes, when they have a dance, I make these sayings known to the ones who don't have an understanding of it. Because I don't see these people even though they are from the same village, when they see me during the dance, this person, this person, this person, they shake my hand. They act as if they were seeing someone who came to the village for the first time. Some of them

would be grateful . . . because of what little advice I give them.

Dancing, although changed, is as vital today as it has ever been in coastal and lower Yukon communities, and the drum continues a steady and meaningful beat.

## Powerful Songs, Past and Present

*The masks belong to the* apalluq *in the song. . . . It was an object that came with the song. Back in those times . . . they requested things through a song. . . .*

*When I observed them in Emmonak, when they were done presenting the song, they would explain to the people what it meant. They would reveal the meaning behind it with the mask.*—Willie Kamkoff, *February 27, 1994*

While looking at pictures of masks in museums, Jasper Louis said, "No doubt all these had songs." No doubt they did. The connection between mask and song was as strong as that between mask and story. When he viewed the masks at the Mountain Village Festival, Andy Kinzy explained,

The maker of the song for the mask thinks about the ending of the song for that particular mask. These are not "just masks" as we see them. The keeper of the song requests the master carver to make it as he instructed. I also noticed that each dance song had a mask . . . to complement it. Each [mask] has a name. Some are models of things that, as we see them, we know the maker of the song wanted as he instructed. (KYUK 1989)

For Dick Andrew (January 5, 1994) a picture of a snowy owl mask evoked memories of a snowy owl song that he danced in the past:

That owl [mask] was probably part of the story I had heard. How does the song go again? The owl had five babies. Then she sang,

Aa-ya-guu-ma-rraa-ya-guu-ma
A-ya-guu-ma-rraa-ya-guu-ma
*Flap your wings, flap your wings*
*Flap your wings, flap your wings*

*When your father comes*
*You all will eat*
*Five big mice*
Aa-ya-guu-maa
A-ya-guu-ma-rraa-yag-uu-mai
*Flap your wings, flap your wings*

The baby owls would start flapping their wings when their mother told them about their food. . . . You know the owls usually eat mice. . . .

That was the song I would sing with the story. . . . There are three parts to the song. The story is too short.

You sing it three times and each time a little bit different.

Owl mask Jacobsen collected on the Kuskokwim in 1883, probably worn on the forehead. Note the tin inlaid eyes. *MV, IVA5150 (20 cm)*

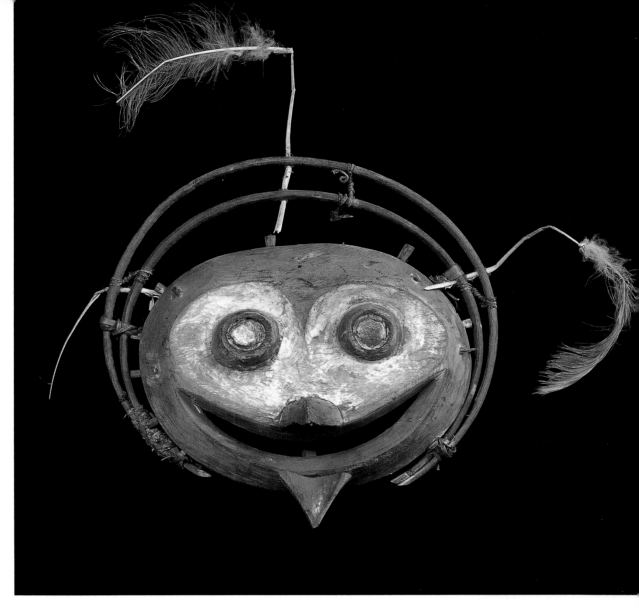

Aa-yag-uu-maar
A-yai-yai-aa
Aa-rraa

Aa-yag-uu-maar
A-yai-yaanga
A-yai-iyaa-aa-anga
Aya-yii-iyaa aya-rraa-ranga
*Flap your wings*

We used to dance it here long ago. I would think about the song of the story. The words that say, "When your father . . . ," you would sing faster.

There always are two verses to a song. The verses to the songs never change.

Songs were not only integral to the masks' presentation, but to their creation as well. Joshua Phillip (July 1, 1988) described the inaudible songs carvers chanted while they made the masks the *angalkuq* used to determine the cause of a person's illness:

They would chant as they worked on them—like *emm emm emmm*. They were inaudible as they chanted along, as they constructed the masks for viewing people. . . .

You couldn't hear what they were singing. You could just hear this *emm,* sort of like chanting, as they were making them. And then if you used these masks, you could see what was wrong with the person. The *angalkuq* could see if there was a hex on that person by another *angalkuq*. By looking at him [the *angalkuq*] would be able to tell that person who or what was causing him to feel that way.

The connection between mask and song was fundamental. In fact, the song was often the first expression of a person's experience that would subsequently find form in dance motions and a carved mask. Men and women alike composed such songs. For those who listened, songs were all around them. According to Paul John (April 15, 1994):

Our late parent [Billy Lincoln] always came to our house to see his grandchildren, and when he came my wife said to him, "Oh my, Apacuu [Little Grandfather], would you compose a song if you can?" He quickly said that he had a lot of songs with him. He said, "You see the grasses outside, the wind continuously makes them sing. I can hear their songs myself. I have their songs with me." That was what Billy Lincoln said to her. He said that when wind moves the grasses, they sing. And he said that he knew their songs very well.

Teresa John (March 23, 1993) talked at length about her own experience with song composition:

The composition of songs happened every day. The elders say that whatever they experienced, whatever they saw within their life, almost always became a song. The trait of being a composer is a very rich gift because not anybody can be a composer. You have to know the wisdom of being able to put together some words eloquently and descriptively so that you can sing them. . . .

A lot of the songs came from animal spirits. When people went out hunting, they would run into a bird that was singing and waving its arms and giving motion to the dance composer. And [the bird] would be singing a song, and it would be dancing. And they say that the strong composers acquire some of their songs from the spirit world.

One time I thought I heard a song in the wind. But it was the middle of the night, it was snowing out, and there was a little bit of whistling in the wind. But then I started to make this song. And every time the wind blew harder the sound would get [stronger]. . . . I tried really hard and I thought well, no, it's not happening to me. I've heard it happened to our people, but it's not happening—this is the eighties, you know, the late eighties! . . .

At that time I used to listen to my Yup'ik singing cassette tapes really loud, and then I would turn them off or go to bed, so I started thinking maybe I forgot to turn off my cassette player. But it was three in the morning. And I go, "I could not have—the tape should be done by now." I knew my sister was out dancing somewhere, and I thought maybe she [had come home and] turned the recorder on. But I knew she wouldn't listen to it at three o'clock in the morning. And then I felt really peaceful.

The next day I asked them, "Did you guys turn on the recorder last night?" And they said no. I knew I was awake, so I figured, gee, maybe it was happening to me. But then if I had been in the traditional days I would have learned [the song] even though I heard it [only] once. But I don't have that keen sense of learning a song after I listen to it once.

But a lot of composers used to acquire their songs through nature, through the wind, through the animals. And that's how they acquired them, especially the shaman. They said they would also feel the earth or travel under the earth and acquire them. They would start hearing some rhythm under the ground, like humming or singing. That's how they [met] their spirits.

Although songs originated in one person's experience, dancing a song was a community effort, requiring many people working together for many hours to perfect both the composition and its performance. Teresa John (March 13, 1993) continued:

They used to practice some songs over and over again, especially in fall and winter. Luckily there was no television back then, or any bingo or anything like that that was time consuming. So they spent many hours rehearsing. I would watch composers sit there together and say, "Well, these are the words that I would like to use in a song. But I need help in putting the rhythm into the song." So they would throw out several rhythms.

But more knowledgeable people would throw different samples and say, "How do you feel about this tone, the rhythm of this song?" And the composer would say, "Well, that sounds okay." . . .

Somebody would have the lyrics or the words. And then if they could not find the rhythm, they would present it to the group of people and say, "I need help putting the drum-part to this." And so after that came the drumming.

And then . . . [there are] rehearsals finalizing it, refining it. It has to be perfect. The drumming has to be down to the beat. Also, one thing you have to remember is that the dancers, especially the women that are going to be bending their knees and moving their arms, have to feel comfortable. So all that comes into account. They don't just compose songs. They have to think of the dancers. They have to think of the rhythm, the beat and everything.

What they would do is present it to the elders in the communities and say, "Well, what did you think of the song?" And if they say, "Well, I don't like this little bit because I know the dancers are going to feel uncomfortable about switching from that to that," they would modify it. So it's a lot of group effort, too.

There were many kinds of songs, and songs were sung on many different occasions. Songs were made to commemorate the dead, to tease the living, to rebuke, and to request. Andrew Noatak (August 25, 1986) of Nunivak reported hearing the songs of dead people at a gravesite: "The dead people from [these] graves actually sing. We have heard rumors about the singing but never believed them until we actually heard [the dead] ourselves. I have repeatedly heard the singing. When our daughter-in-law Cag'ar was about to die, [the people] heard singing from the graves. . . . All the graves sing in the evening." Dick Andrew (August 16, 1992) recorded one such song that belonged to the people of Cuukvagtuli:

Yaayiiyaangaar, *please give me a little tobacco*
Yaayiiyaangaar, *please give me a little tobacco*

*My people, please give me a little tobacco*
*from your tobacco pouch there*
*I'll give you something in return, I'll give you* pugugar[?]
Yaayiiyaangaar yaangayiiyaa yiirrii

*My people, would you give me a little water*
*from that pail down there*
*I'll give you something in return, I'll give you*
   pangalgar*[?]*
Yaayiiyaangaar yaangayiiyaa yiirrii-i.

As songs were all around, new dance songs emerged every year. After a composer presented a new song, it became public property. People performed favorite songs year after year. Tommy Moses described how songs passed down through the generations:

In the old days there would be people who were living before the schools were built. . . . These are the people that in their times . . . had their songs, and there's people around here who know many of these old time songs that have been passed on to us before we were

even born. And that song there, it keeps moving. Pretty soon there's songs from way back that you wouldn't even know who made that song. The guy is way underneath the ground, he's passed gone and his song is still going. (Kamerling and Elder 1989)

Dance and song required physical coordination, stamina, and mental energy. Especially when performing the verse section of a song, singers and dancers were to focus their thoughts on a hoped-for future, as words sung with concentration could produce what they described. Himmelheber (1993:51) was told along the Kuskokwim, "One who wants fishes must think and think about fishes during the dance and also must declare he is thinking about them." A person's state of mind as well as actions could and did affect his or her life. Song and dance did not merely represent a hoped-for future but created it.

Recalling the cleansing power of dance motions, Cecelia Foxie (May 30, 1993) described the cleansing power of song: "They would wash the bad stuff off a person with a song. The *angalkuq* used his special song. The *angalkut* composed songs for different circumstances, including the time when [people] went out to the ocean to hunt sea mammals."

Songs had the power to give a person strength as well as to promote a good harvest in the future. Sophie Lee remembered, "People are respectful of the old songs because the songs have power. They say some songs are good because their meanings are good. These songs give strength to our well-being and are helpful to our feelings. Other songs assure success in hunting, and some help in fishing" (Kamerling

and Elder 1989). According to Jasper Louis (February 29, 1993), songs, like dances, have the power to prolong life: "Our songs and those of our ancestors . . . really hope and push for people to live a while longer. . . . Those [older] people I caught up with sang songs to prolong life."

People considered some songs more powerful than others. Within a given song, however, the *apalluq* was considered the source of power. Paul John (April 15, 1994) recalled, "The motions are referred to as *arulat.* But the *apallut* are lyrics that represent the story. If the presentation was to bring more luck, the lyrics to the song would convey that."

## From Hardship to Fulfillment

The future of song and dance in village life is unclear. The precise rhythms of the dance are not learned overnight, nor can a single individual carry them on. If young people fail to follow in their parents' footsteps, the art of Yup'ik dancing will diminish. Teresa John (May 6, 1994) expressed her concern:

Today the main singers are very old, and I've seen many die in the last few years. If the younger generation doesn't maintain the language and the skills of drumming and singing and composing songs, then the dances will be done. And that's something that I push my students to do—to learn them and pass them on. Because it takes a lot of spirit, a lot of courage to continue it, to be able to drum and sing and compose and perform.

I mean some people can only drum. But they can't sing. Or they learn only how to sing but cannot drum or bend their knees at the same time. There are stories of some villagers who have tried all their lives to be performers, but they can't. So it's something that takes a lot of effort—many, many years of training. . . .

We're talking about the future of our culture. It's such a large component of the culture, which incorporates all the hunting, asking the spirits to bring food, asking for help, asking for the future of the kids—it all revolves around this. And that goes along with drumming and singing. And that's how it's been around through the years.

So that's something that I would like to see incorporated into the planning [for the *Agayuliyararput* exhibit]. Not just workshops of maskmakers but also workshops helping people learn to be a singer or a drummer or a dancer. Because it takes a lot of learning.

Ironically, perhaps, participation of the very young in some dances is a controversial innovation. For many, these young dancers are a point of pride, while others view their entrance onto the dance floor as premature. Elsie Tommy (June 9, 1992) complained mildly about the young, inexperienced dancers of today: "[During the Messenger Feast in the past] the dancers would be very radiant. . . . They would be dazzling. How sad it is nowadays, for the dancers are so young. . . . Back in those days they would turn sideways and look very shy. They would be very coy. . . . Traditionally young girls did not dance. Even though

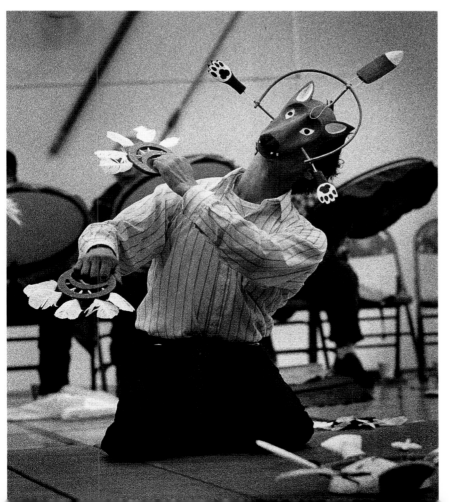

Joe Chief, Jr., gripping a fox mask in his teeth during a vigorous dance performance at the 1988 Cama-i Festival in Bethel. *JHB*

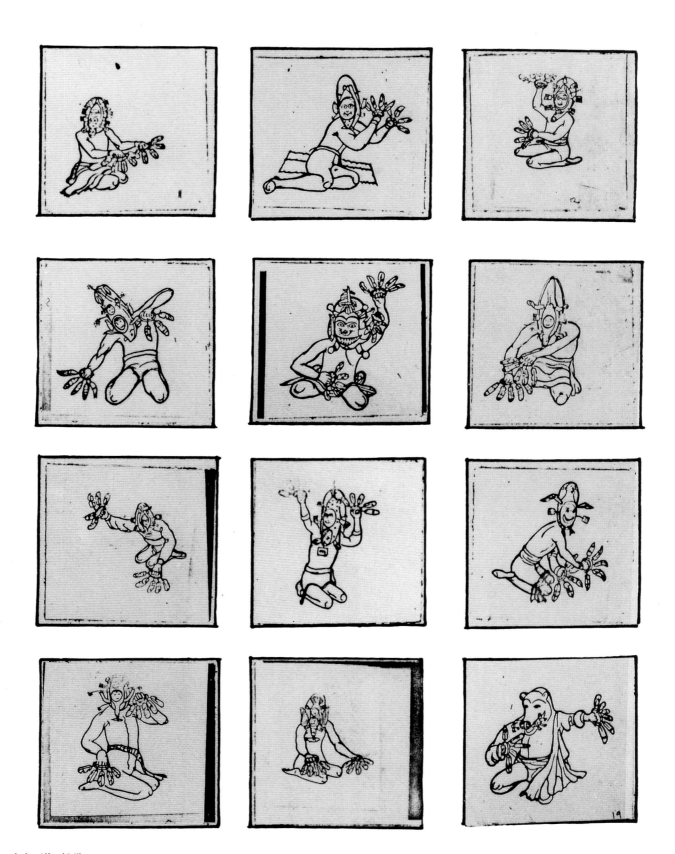

Line drawings made by Alfred Milotte
while filming *Alaskan Eskimo* at Hooper Bay
in 1946. Note the myriad poses dancers
can take, each of which has its own mean-
ing. *Alaska and Polar Regions Dept., MC, UA*

DANCE

AND

SONG

211

they wanted to join the dancing, [the people] would not let them."

Today masks are seldom part of dance in southwestern Alaska, but song and dance remain vital and changing. A fine example is the dance song composed by deacon William Tyson, who had seen dances in his youth and finally began to participate in the late 1960s, eventually gaining a reputation as a fine dancer. Several years before his death in 1993, he composed a song that he and his wife, Marie, performed as part of the Catholic mass:

[chorus]
*For I am quiet, I do not sing*
*For I am quiet, I do not sing*
*For I am quiet, I don't swing my arms*
Ayangaa-yii-yaar ayangaa-yii-yaa
*I don't have a drum*

[first verse]
*My spirit, when I bring you*
*The words of the Almighty*
*Through the reflection of the ocean down there*
Ayangaa-yii-yaar ayangaa-yii-yaa
*I don't have a drum*

[chorus]
*For I am quiet, I do not sing*
*For I am quiet, I do not swing my arms*
Ayangaa-yii-yaar ayangaa-yii-yaa
*I don't have a drum*

[second verse]
*My spirit, when I bring you*
*I bring you the word*
*Through the place where the mirage springs out back*
   *there*
Ayangaa-yii-yaar ayangaa-yii-yaa
*I don't have a drum*

[chorus]
*For I am quiet, I do not sing*
*For I am quiet, I do not swing my arms*
Ayangaa-yii-yaar ayangaa-yii-yaa
*I don't have a drum*

[third verse]
*My spirit, when I come to you*
*This important thing I bring you*
*Though lightning flashes with thunder up above*
Ayangaa-yii-yaar ayangaa-yii-yaa
*I don't have a drum*

[chorus]
*For I am quiet, I do not sing*
*For I am quiet, I do not swing my arms*
Ayangaa-yii-yaar ayangaa-yii-yaa
*I don't have a drum*

In traditional Yup'ik style, Tyson (December 1993) presented his song with a full explanation:

I made it for the deacons because the deacons are supposed to carry the word of the Lord to the people.

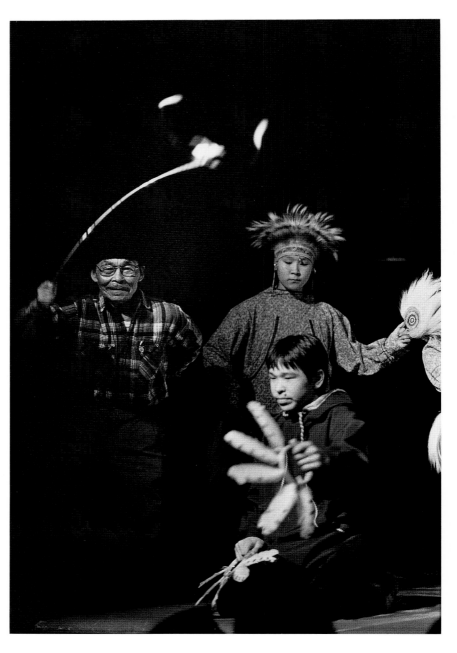

And then I tried to make it sound like in the old days, because we are talking to the spirits and we try to contact them, sounding like they do, humble and meaningful. Anyway, we humbly try to carry the word of God, but how?

The word *culugte-* is a noise from above—like the trees, the wind, the noise of the wind—and the old people without the gift of singing, they claim they don't know how to sing unless they have the gift, the singing power from above.... Without that gift I couldn't sing and without that gift of singing I cannot dance, but that's [the chorus]. You know all the Yup'ik songs—they always start with a chorus and they repeat the chorus over and over.

Most of the songs have only two verses. Some have only one verse and some have three, so this song I sang has three verses. [In] the first verse, *yugiyaamaa* [my spirit] is life in me, a life in you, my life, my spirit. "My spirit, when I bring you / The words of the Almighty / Through the reflection of the ocean down there" means that we go over by the water, we need a boat— that means that we came by water to bring the word to the people.

Albert Atchak holding a dance stick and acting as dance director while younger members of the Chevak dance group perform, Cama-i Festival, March 1994. *JHB*

And in the second verse: *Yugiyaamaa tekitaqamken* [My spirit, when I bring you]—I am bringing the word to you through the place where the mirage springs out . . . in the morning, you can see it—that's how I bring the word to the people over the land, so that way we have the transportation over land by cars, dog-team, walking, or whatever.

And [in] the third verse: *Yugiyaamaa ullagaqamken*— My spirit, when I come to you; *Nurnarli una taitaqaqa*— something very important that is really needed for the people, the word of God, I bring; *Kalluum pak'mun ken-erpallallrakun*—bring it though lightning flashes and thunder rolls up above.

That's what those three verses mean. The actual thing is "Because I don't have the gift of singing the noise, I cannot sing." The rest is just as it goes.

Like traditional dance songs, the verses of William Tyson's song move from ocean to land, and from hardship to fulfillment. For Tyson, singing and dancing had not only survived the introduction of Catholicism, they had joined it in meaningful union.

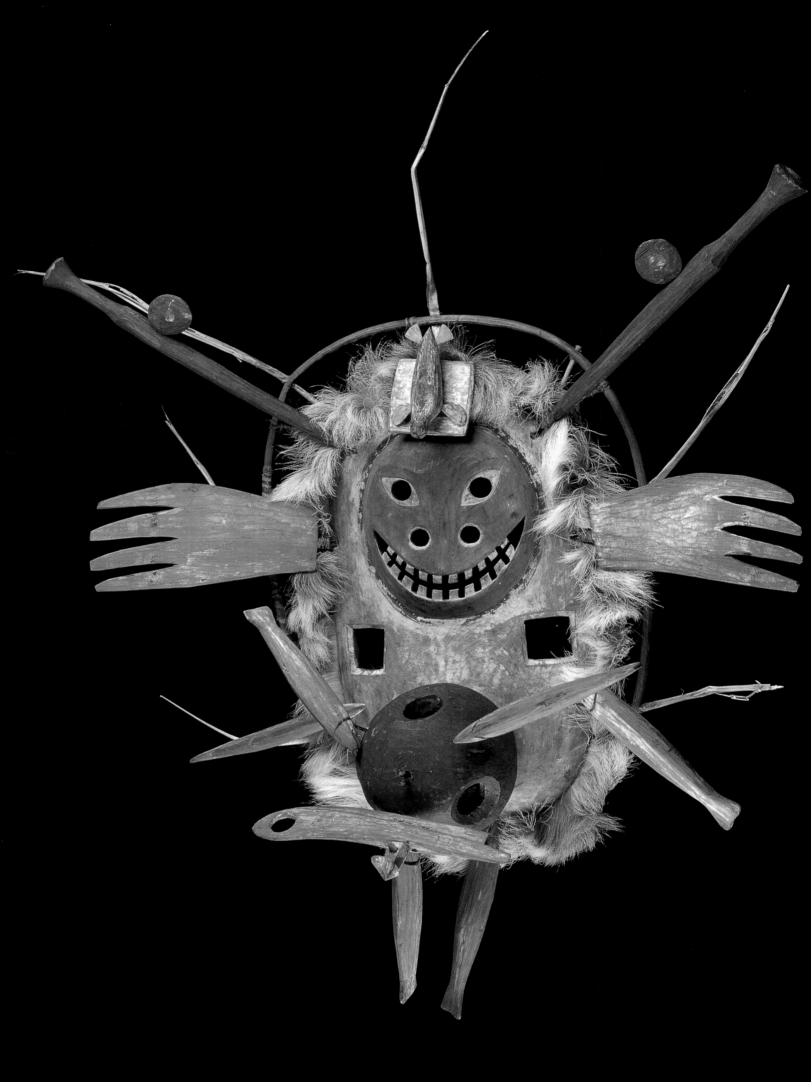

# COLLECTORS AND COLLECTIONS: NEW STORIES FOR OLD MASKS

*I was reluctant to become the owner of such fragile masterpieces and to feel responsible for their safekeeping to future generations. I even doubted that those masks belonged to the solid world of objects. I rather saw them as fleeting and almost immaterial embodiments of words, visions, and beliefs, eluding durable posses-sion.*—Claude Lévi-Strauss, *September 18, 1994*

Elaborate Kuskokwim mask Jacobsen designated "Amanguak" (pretend *amang*). See pp. 223–24 for Jacobsen's description of this piece. *MV, IVA5144 (55 cm)*

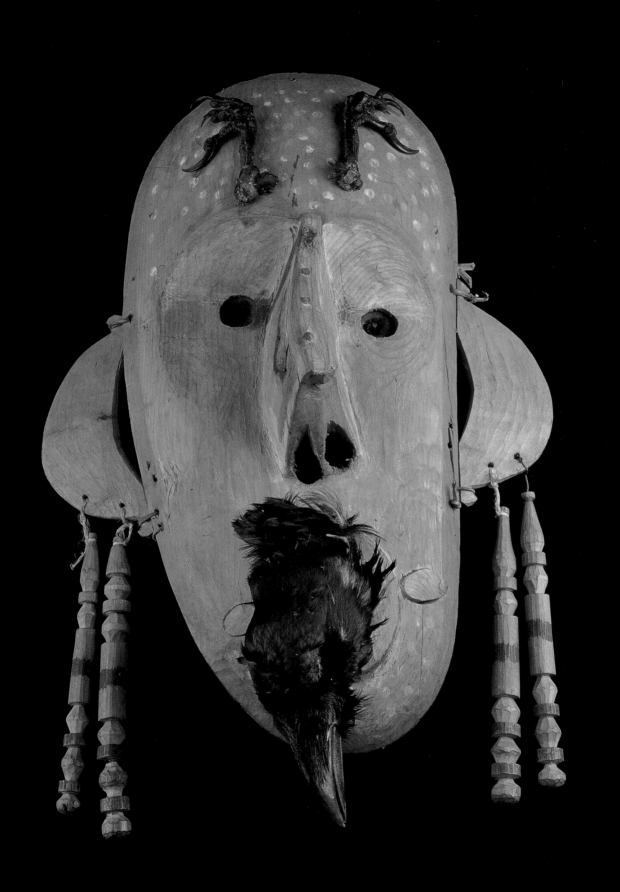

# Collectors Come to the Yukon

"Tullukarokaak Kinakut" (*tulukaruguaq kegginaquq,* "imitation raven mask") collected on the Yukon. Raven feet are nailed to the forehead while a real raven head sticks out of its thick funnel-shaped mouth. Jacobsen assumed that the raven theme was adopted from the "southern Chilcat Indians." In fact, its ear ornaments reflect Ingalik influence. Raven the Creator was known throughout Alaska, yet Yup'ik carvers did not frequently present raven masks. Seabirds, loons, and owls were the common embodiments of helping spirits. *MV, IVA4420 (47 cm)*

Johan Adrian Jacobsen in 1881, age 27, shortly before his collecting trip to North America for Berlin's Royal Ethnological Museum. Material collected by him in 1882–83 is featured in the following eight illustrations. *MV*

Thousands of Yup'ik masks have been transported from dance house to museum storehouse. The masks in each collection reflect the time and place of their origin and the circumstances of their acquisition. Some continue their travels through sale or trade by museum curators and collectors, extending their influence around the globe. The history of these masks, which continue to serve as cultural emissaries, is a medley of personalities, intentions, and unforeseen results, adding a new dimension to Yup'ik masks in the modern world.

The earliest and most prestigious collections of Yup'ik masks were acquired at the end of the 1800s by men trading and traveling out of St. Michael and along the lower Yukon, including Edward Nelson, Johan Adrian Jacobsen, J. Henry Turner, H. M. W. Edmonds, and Sheldon Jackson. Nelson's, Jackson's, and Edmonds's accomplishments are relatively well known, and their collections have been described and exhibited (Carlton 1992; Corey 1987; DeArmond 1987; Fitzhugh and Kaplan 1982; Gunther 1976; Nelson 1899; Ray 1966, 1967, 1981, 1987). Here we turn to the lesser-known Yukon masks—some once thought destroyed, others simply overlooked—bringing them into focus. We see how they simultaneously confirm what better-known collections of Yup'ik masks tell us and challenge longstanding assumptions.

## Johan Adrian Jacobsen: The Adventures of a Norwegian Collecting in Alaska

Johan Adrian Jacobsen was born October 9, 1853, on the island of Risø near Tromsø, Norway. Risø is north of St. Michael, and Jacobsen was reared in a wet and windy environment that prepared him well for his future travels. Although he had little formal education, he received his captain's certificate in 1870 at the age of 17. His travels abroad took him to South America and to Hamburg, where his brother owned a clothing business.

In Hamburg Jacobsen met Carl Hagenbeck, the owner of a zoological business that later became the Hamburg zoo. Hagenbeck also organized shows similar to American Wild West shows throughout Europe, featuring various indigenous groups. He contracted Jacobsen to engage Greenland Inuit and buy an ethnographic collection for a traveling Eskimo show. Jacobsen learned to speak some Inuit from the Green-

landers, whom he accompanied to such European bookings as Hamburg, Paris, Brussels, Berlin, Dresden, and Copenhagen. He (1977:220) wrote of the Paris engagement, "Here the Eskimo driving their dog sleds and small skin boats was new and wonderful. Never before had there been such a display of an ethnic culture."

On one of his trips, Jacobsen met Adolf Bastian, then director of the Royal Ethnological Museum (now the Museum für Völkerkunde) in Berlin. In 1881 Jacobsen offered to travel and make an ethnological collection for the museum, and Bastian readily accepted. Under Bastian's dynamic leadership, the museum's collections increased tremendously, and Jacobsen's contributions were among the most impressive. Many European museums have Yup'ik masks, but only Berlin's Royal Ethnological Museum sent out a collector. Altogether, Jacobsen gathered 6,720 objects, constituting the museum's most important collection of North American artifacts from the Northwest Coast and Alaska.

Like his contemporaries in the museum world, Bastian's goal was to acquire collections from Native

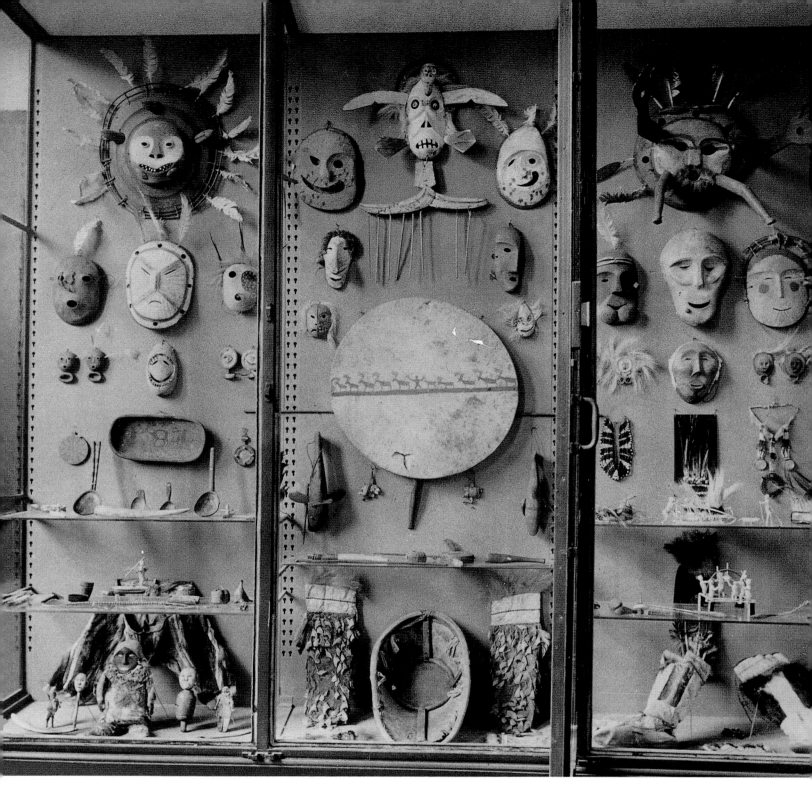

Americans not yet "tarnished" by contact with Euro-Americans, both to learn about these people's traditional lives and for comparison with other cultural groups. He considered the objects Jacobsen brought from Alaska "the documents for the future writing of the 'Book of Mankind'" (Jacobsen 1977:ix).

Jacobsen set out in July 1881 and collected for two years. He spent the fall of 1881 on Canada's northwest coast, returning to San Francisco for the winter. In July 1882 he arrived in St. Michael, just after Edward Nelson left. He traveled and collected along nine hundred miles of the Yukon River that summer and fall, north as far as Kotzebue Sound that winter, and then in March south past Nelson Island to the Kuskokwim and down the coast to Nushagak. From Bristol Bay he headed overland to Cook Inlet, Kachemak Bay, Prince William Sound, and Kodiak before returning to San Francisco. He crossed the continent by train, arriving back in Berlin in November 1883.

Jacobsen chose the northwest coastal area of Canada and Alaska because travel there was relatively cheap and because he could acquire many objects: "From Alaska I can bring back a hundred different things, and now there is more of a hunt for curiosities in Alaska than anywhere else, because now things still can be gotten, but in a few years the objects there—like everywhere else—will be picked out" (letter to Adolf Bastian, January 24, 1882). Hoping to beat collectors already working as far north as Bristol

Exhibition case in the old Museum für Völkerkunde, 1926, showing Jacobsen's Yup'ik and Iñupiaq material. Note the pair of *tuunraq* masks on either side of the large Kuskokwim swan mask at center top. *MV*

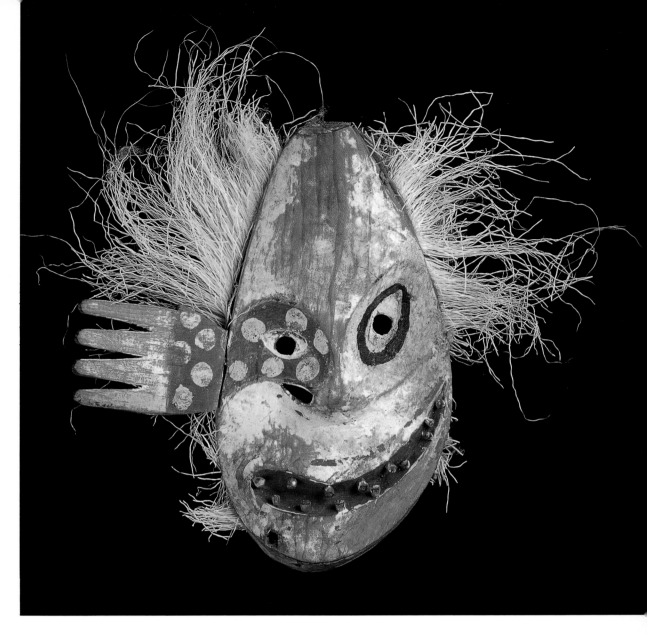

Miniature Kuskokwim mask Jacobsen said represents an evil spirit that "finds out about people's situations when they go hunting to kill and eat them. His mouth shows his longing for human flesh and blood." Jacobsen also said *angalkut* might use the mask against sickness. It has no holes for attachment. *MV, IVA5160 (13 cm)*

Bay, he determined to sail to St. Michael. He was ambitious to go where no collector had been before him and regretted the constraints that limited his mobility. In a May 27, 1882, letter to Bastian, he confided, "Too bad that I don't have our ship here—then I could go up the coast in Alaska and down in Siberia and could hit every hole just as thoroughly as I have searched the coast of British Columbia. . . . I plan to do everything possible to get down to Cook Inlet before winter, or maybe Kodiak and then Cook Inlet and Cooper River, which are the places in Alaska least visited by Europeans. The reason is that the Indians have been very wild until a few years ago."

Arriving in St. Michael with these high hopes, Jacobsen was disappointed to find that someone had been there before him. In his letters to Professor Bastian, he complained constantly that a young man from the Smithsonian, a Mr. "Nielsen," had already collected most of the interesting pieces. To his frustration, everybody, even the telegraph operators, was collecting for the Smithsonian: "Everywhere it is the same for me. Schmitzonia always has the first pick" (letter to Adolf Bastian, May 1883).

Throughout his tenure in Alaska, Jacobsen worked in Nelson's shadow. From 150 miles up the Kusko-

kwim, he wrote Bastian (April 17, 1883), "From the mouth of the Kuskokwim to here I have found only a few curiosities (Nielsen has been here) and at Cape Vancouver a little. Too bad that I cannot get across to Nunivak, because there is still a lot to be gotten according to all I hear." In the same letter he regretted having to travel down the coast by sled, as he could carry away only light things.

Jacobsen (1977:159) was also disappointed by the quality and quantity of goods available north of St. Michael: "The people were very aggressive and asked high prices and did not bring out as many ethnographic objects as I had been given to understand would be forthcoming. It seems that many of the objects of this type had already been purchased by Eskimo traders who took them to Fort Saint Michael, where Mr. Nelson bought them for the Smithsonian."

Nelson's head start notwithstanding, Jacobsen was able to amass a remarkable collection in the nine months he spent traveling in Alaska, particularly along the lower and middle Yukon. On his trip upriver, Jacobsen told people in every Yup'ik and Ingalik village where he landed that he would return and buy ethnographic artifacts they assembled, thus giving them time to create the objects he desired.

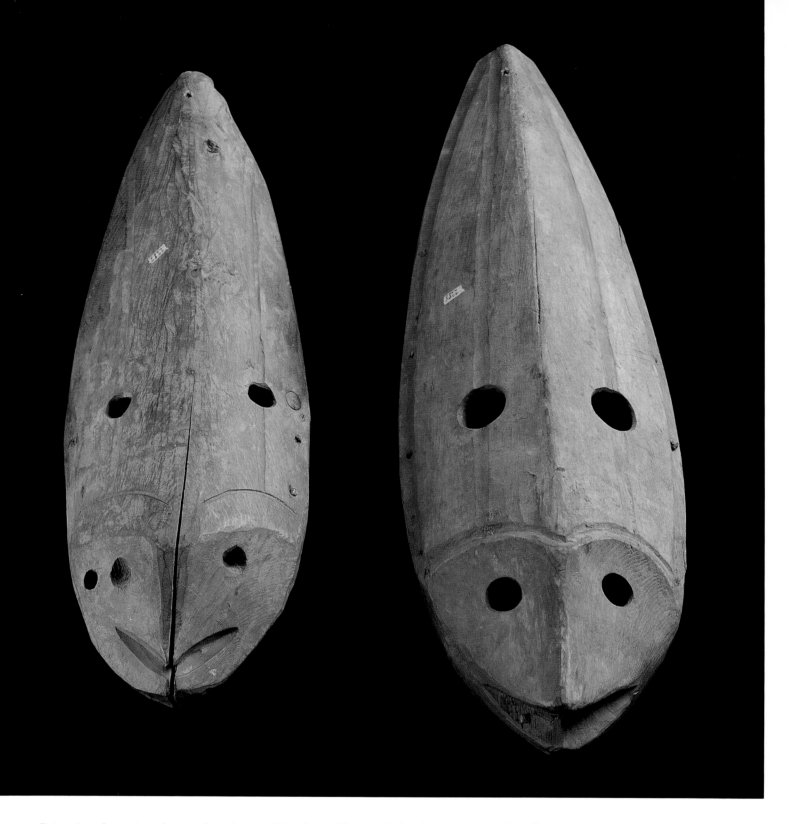

Returning downriver, he purchased everything he considered of ethnological significance. He noted that people did not wish to sell him anything from their burial sites: "On many of the Eskimo graves there were carved figures of the deceased, heavily decorated with beads, especially the female figures. . . . On the boxes were also masks of animals and spirits. It is distressing that these pieces could not be bought" (Jacobsen 1977:103, 109).

Jacobsen moved quickly through the country: "The next morning we started early and came to the village of Ka-krome, where my purchases took an hour. . . . I made a few purchases here and went on."

He noted that long visits in the villages were not profitable, "as the Eskimos take these only as occasions for the most shameless begging" (Jacobsen 1977:119).

On September 10, 1882, he landed at Dakketkjjeremiut (Takcarmiut) and his "lucky period of collecting began, for in the villages of the lower Yukon there was much more to be found. I especially bought stone knives and axes. It was here that I discovered the fake reproductions the Eskimo made by carving stone knives of soft stone and boiling them in oil to make them look old. But still I found a rich collection in . . . Rasboinsky" (Jacobsen 1977:111).

Paired Yukon masks Jacobsen said represent dog (chum) salmon just before death, having been in fresh water for so long that they have grown thin and their jaws are bent and hook-shaped. *MV, IVA4408 (36.5 cm long) and IVA4409 (44.5 cm long)*

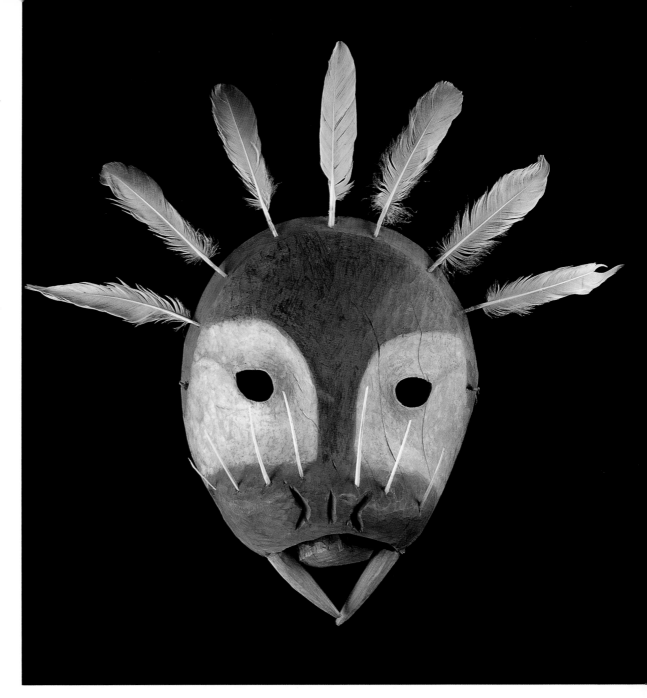

Yukon "walrus-spirit" mask. Jacobsen wrote, "This spirit creates much evil. In particular it causes the riverbank to collapse each year and sand to wash away. It is also responsible for landslides. The people who live on the river who have never seen a walrus and know about them only from stories describe the spirit as a monster." This description matches that of the legendary *quugaarpaq,* a tusked creature said to travel underground, turning to stone when it emerges and comes in contact with air. Yup'ik people find evidence of its existence in the mastodon tusks exposed on riverbanks each spring. *MV, IVA4406 (29.5 cm)*

Continuing downriver, on a channel of the Yukon just above Andreafski, Jacobsen "came upon a grave monument on which a hunting scene was carved with a bear pierced with an arrow, and beside it a post in imitation of a bow.... Since this monument would be admired by many more people in the newly completed Royal Ethnological Museum in Berlin than here on the banks of the Yukon, and since it was made to be seen, I took it with me" (Jacobsen 1977:122).

Returning to St. Michael, Jacobsen found his collection in bad shape and spent a week repairing it: "Although the pieces were made in the Alaskan climate, they were not expected to go through two shipwrecks when . . . I could not give them the conservator's care they deserved. . . . The friendly cooperation I received from the Alaska Commercial Company gave me an opportunity to unpack everything, dry and clean the items, and tag each piece with its use and provenance." A native named Petka (who had also been Nelson's interpreter) helped Jacobsen

(1977:116), providing him with the Yup'ik names of many objects. The general names Jacobsen recorded for animal face masks, such as "pretend seagull," "pretend walrus," and "pretend king salmon," point not so much to consistency in Yup'ik designations as to a single source of information—Petka.

Traveling as he did in late summer and early fall, Jacobsen did not see the festivals associated with the masks he collected. On his trip north he witnessed a shaman's seance, a Feast for the Dead, and other winter activities, which he described in journalistic style. In some places people received him joyfully—"They handled me as if I were a wonderful animal"—but in others his blatant disregard for taboos on work and travel that interfered with his plans earned him an unfriendly reception: "I began trading with the people, but without much success, and was quite annoyed at their begging and aggressive behavior, which included examining me physically" (Jacobsen 1977:143).

When he considered prices high, Jacobsen "made

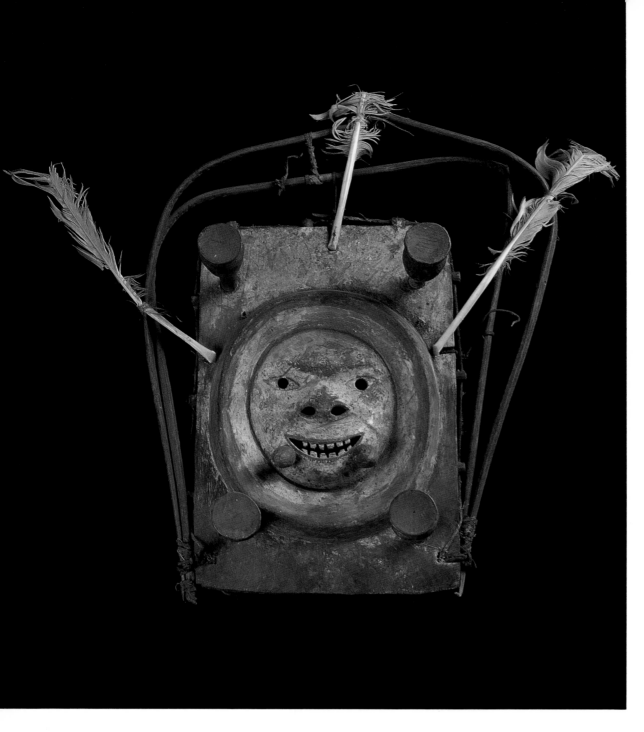

Plaque mask from Cape Vancouver, with model lamp posts in each corner and a central smiling face. According to Jacobsen, people kept such masks in the *qasgiq* to ensure good luck and blessings, and "similar masks were used by the young people to indicate that the time between the feasts was too long. To speed up the time they produced masks depicting bowls and other utensils used in the feasting." *MV, IVA5182 (39 cm)*

a speech in language they could understand that I would warn all white travelers of their prices—which I intended to do—but it did not have the least effect." Others he described as "importunate beggars." In the end he relied on a show of strength to get what he wanted: "The natives who believe that might makes right, take every opportunity to outdo a weaker white man. I often found that my energetic personality was my only protection from both the Eskimo and the Indians" (Jacobsen 1977:157–58, 164).

As his reception varied, so did his relations with Yup'ik and Iñupiaq people he employed. He remarked on the dismissal of an Iñupiaq guide who, among other things, took a sack of beans and hid it under frozen fish in his sled: "So, sorry as I was about this, I had to dismiss him, which did not seem to bother him because he was close to his home" (Jacobsen 1977:150).

On his return from Kotzebue Sound he received word that the Ingalik of the middle Yukon were angry over his collection of several human skulls during his September visit and that they had threatened the Alaska Commercial Company agent. A delegation of Ingalik confronted him at St. Michael. Mr. Lorenz purportedly showed them a medical book illustrating the human skeleton, explaining that the skulls of Caucasians were studied in the same way, and that they did not get angry but had great respect for the study of medicine. According to Jacobsen (1977:151, 167), the Ingalik went home satisfied.

Arriving at St. Michael, Jacobsen packed his collection for shipment, and on March 18, 1883, headed south along the coast with supplies and trade goods for a two-month collecting trip. At Pastoli he met friends from the previous season who sold him a number of dance masks, probably from that year's Agayuyaraq. Jacobsen had less luck obtaining masks and associated ceremonial regalia further south on

Two land-otter masks, designated "Anorallerek," collected by Jacobsen between Cape Vancouver and Cape Avinoff. The face on each otter's back shows its *yua,* which Jacobsen said was the "shaman's helping spirit." The eyes of the face are ringed in black with a small black line above the mouth. *MV, IVA5177 (27 cm long) and IVA5178 (49 cm)*

Nelson Island, as widespread sickness had circumscribed the annual midwinter dances there. Again, his purchasing was "very much curtailed by the previous visit of Mr. Nelson, who had bought extensively" (1977:170, 175–76).

An exhibition of his collection immediately followed Jacobsen's return to Germany, to the great satisfaction of those who had followed his journey through letters published in the local papers (Jacobsen 1977:212). Scholars praised his collection, although the anthropologist Franz Boas noted that his data were not always reliable (Thode-Arora 1989:52). Although not the scholar that Nelson was, Jacobsen documented his collection in considerable detail, and wrote the explanations for the masks himself. As German was his second language, his comments, which include numerous misspellings and unique grammatical constructions, are often difficult to translate. His tendency to generalize and project interpretation on objects is a more serious limitation. Yet he included much good information, often naming the animal or bird a particular mask depicted. Many masks are accompanied by long, rambling accounts that, while not entirely accurate, make clear how complex their stories were. Adrian Woldt, a scientific writer, assembled Jacobsen's notes, diaries, and lectures and published an account of his Northwest Coast and Alaska travels in 1884, which Erna Gunther translated into English (Jacobsen 1977:x). The scattered but valuable information Jacobsen recorded in accession records remains largely unmined.

Jacobsen's description for one Kuskokwim mask (p. 214, "Amanguak") was particularly detailed:

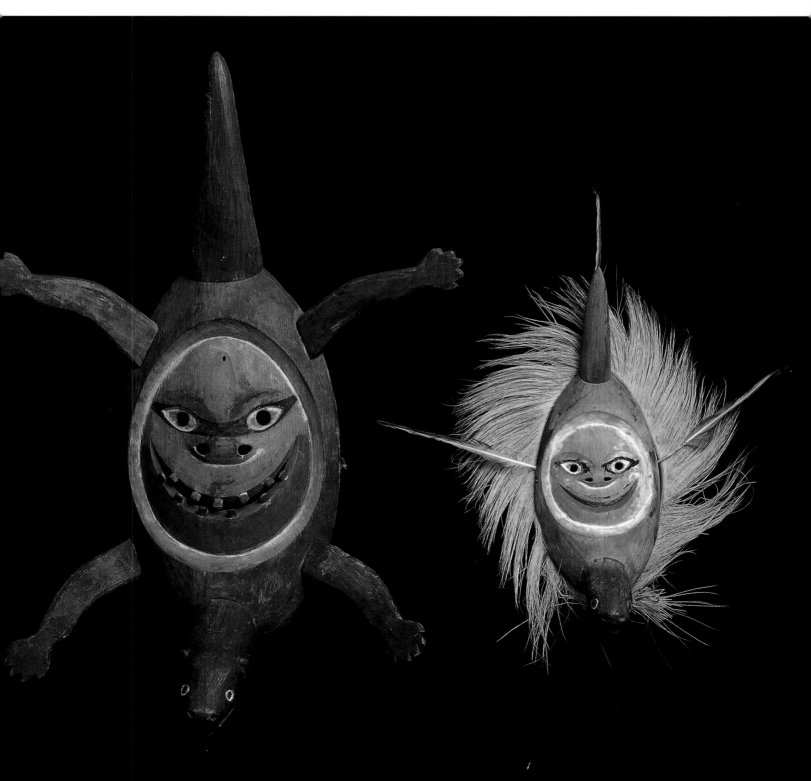

Shaman mask of the last dance in winter. The face shows the main spirit of the shaman. This is either, as here, a specific spirit of which the people know its name and merit or, as in most cases, a dead ancestor. It is remarkable that the eyes of a spirit which is not in an animal body are always crooked while a god who is the spirit of the animals or their king always has nearly round eyes. To the right and left of the face are two open arms with outstretched fingers which show the power of the shaman (through his spirit helpers) and that his arm reaches out over the entire world. On the forehead the spirit wears a piece of ice with a resting seal which means that the time is coming when the ice breaks up, a good hunting season for the Eskimo. The two sticks above the arms resemble the lamp posts used in the festival houses. The meaning of the two square holes beneath the arms was not checked. Maybe they symbolize the river mouths of the Yukon and the Kuskokwim because two salmon have turned their heads toward them. The red globe resting on the chin represents the earth, the holes three rivers (Yukon, Kuskokwim, and Nushagak) to which the power of the shaman forces the salmon to return every year. That the earth (the globe) is round probably is a coincidence or to save space. This mask is like others there on the coast decorated with caribou hair and seagull quills. The shaman puts this mask on to show the people how much good comes through his power and, perhaps, to show also that a lot of fish will be coming again to the coast through his power. Because they had just finished the feast when I arrived I was able to buy the mask.

Jacobsen also acquired a model ship from the Yukon for which he supplied detailed information. Used in dances, it tells the story of two monsters in the shape of women who lived along the lower Yukon and possessed a "devil's animal" that was half-monster, half-fish. This monster used the women as vehicles to roam the river killing and eating everything that came near, including people. Jacobsen suggests that this refers to the first Russians to sail upriver. The story goes on to say that a famous *angalkuq* brought the ship aground, splitting it in two. Its name is "Arnak Karak Tjukwagoak Angisok Taimani Pirtsaril-lerik," translated by Jacobsen as "Women old their animalboat big everything many people killed" (*arn-arkaraak cuukvaguaq angisuaq tamaani pitsarillerik*, "the two women's pike image that killed many people"). The people of St. Michael told Jacobsen the ship represented a vessel that once sailed the Yukon, half-ship and half-monster (perhaps the toothy pike referred to in the Yup'ik designation), the rear equipped as a lookout. It could have been the Russian vessel *Ladie*, which terrorized the inhabitants (especially the women) for a long time until a famous *angalkuq* used his powers to break it in two. The model ship was used in dances to commemorate this event.

Traveling to Siberia, Korea, and Southeast Asia, Jacobsen continued to collect for the Berlin Museum as well as for museums in Leipzig, Cologne, Lübeck, and his native Oslo. His lack of education prevented him from obtaining a curatorial position at a museum, so he continued to work for Carl Hagenbeck in commercial enterprises, returning to the

Model of a ship Jacobsen said terrorized the people of the Yukon in ancient times. *MV, IVA4195 (24 cm)*

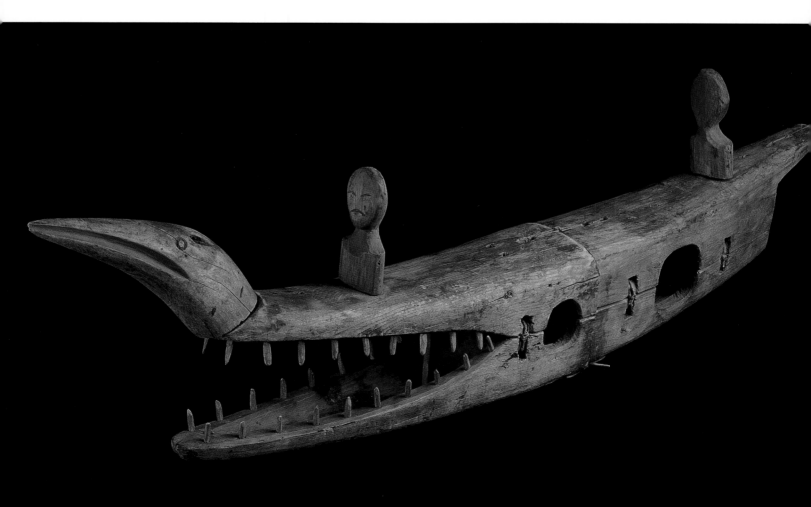

Northwest Coast to collect ethnographic objects to sell at the Chicago World's Fair.

Jacobsen also toured throughout Europe with various shows of Native Americans, catering to the European fascination with the New World's first people. In 1885 he brought a Bella Coola troupe for a year-long visit to Germany, where the natives not only danced but carved (Feest 1984:94; Haberland 1987). He and his wife also ran restaurants, first in the zoo in Dresden and later in Hamburg. When the latter zoo closed, he lost his restaurant and savings, but in 1926 was granted a pension from the German state. He returned to Norway during World War II, where he died in 1947 at the age of 94.

### Yup'ik Masks: The War Years

Under Bastian's dynamic leadership, the collections of the Museum für Völkerkunde grew rapidly from its establishment in 1873 through the end of the nineteenth century. The masks that Jacobsen obtained from Yup'ik villages in southwestern Alaska had a place of honor on exhibit in the museum's North American hall. The bulk of Jacobsen's collection, however, rested in obscurity for more than fifty years in the museum's research collection in Dahlem. This quiet existence was not to last.

In 1934, one year after Hitler came to power, the museum was ordered to divide its collections into three categories: irreplaceable objects, which would be removed from the museum if Berlin were to come under attack; valuable objects, which would be stored safely in the building; and everything else, which would be left to fate.

By 1939 packing was already in process. When bomb attacks started, museum personnel boarded up the windows and stored valuable objects in the anti-aircraft gun towers at the zoo and in Friedrichshain. When the military reclaimed the towers, soldiers moved most of these crates to the potassium mines of Grasleben in eastern Germany. Additional crates, packed under difficult conditions by a group of women students and French prisoners of war, were sent by small freight boat and train to the mines, where they were stored from July 1944 until almost the war's end. In all, about three thousand crates from the museum, including most of the North American collections, went to Grasleben (Höpfner 1993).

Other crates, including those containing the exhibited North American collection, remained at the museum in Dahlem. In May 1945 the Soviet army occupied Berlin, and until April 1946 they carried away the remaining museum contents to Leningrad. Like the French Impressionist paintings confiscated by the Soviets from Germany after the war and kept in hiding at the Hermitage for more than fifty years, Yup'ik masks (as well as many other things) were taken by train through Poland to Leningrad, where they were unpacked and inventoried. In 1977–78 these ethnographic collections, altogether 44,561 objects (including nearly nine thousand from America) were returned to the Leipzig Museum for Ethnology (Grassi Museum) in East Germany.

In fall 1946 the British military moved 175,000 objects from all sections of the museum—including those stored in the Grasleben mines—to the castle in Celle in northern Germany. One part-time ethnological curator looked after this enormous collection, and time and neglect began to take their toll. The museum was not notified of the collection's location until 1951, and by 1956 it was returned. The American military had also captured some crates, which returned in 1956 and 1958.

Concern and confusion about the fate of the lost Berlin pieces continued long after the end of the war. Many believed that the Alaska material had been destroyed (Ray 1987:33). An exhibition of Native American pieces in Leningrad and word-of-mouth reports from Americans who attended a conference of Americanists at the Grassi Museum in Leipzig in 1985 indicated that at least some of the Berlin pieces had survived. Not until the Berlin wall fell was the extent known.

In May 1990, nine months after the opening of the Wall, Berlin museum representatives went to Leipzig, where they found nearly forty-five thousand objects stored in the Grassi Museum. Most were still in the crates that had carried them to Leipzig twelve years before. They had been unpacked and inventoried in Leningrad, and when they finally returned to Berlin, they came with Russian inventory lists. Prewar pictures show that most of the returned masks had originally had more feathers and were more intact, but some were in as good or better shape than those in Berlin.

The return of collections from the Russians began in 1990 and lasted until July 1992. Eleven shipments carried 704 crates and 861 boxes and large objects back to Berlin. The first convoy arrived with much fanfare in August 1990 with spectacular pieces—a nine-meter Haida totem pole, a pair of Haida grizzly-bear houseposts, the renowned Benin bronzes, drums, boats, and bundles of spears and shields (Höpfner 1993). In 1995 museum departments were still busy reinventorying and making space for the new arrivals.

When I visited the museum in February 1994, the returned masks had only just been unpacked and laid on a table prior to reintegration into the collection. In the museum's wooden and glass storage cases I found one of a pair of finger masks returned to the museum from either Celle or Wiesbaden between 1956 and 1958, which had been sent to the potassium mines during the war. Its mate lay several yards away, newly arrived from Leipzig, probably taken from either the zoo towers or the museum storage in Dahlem. An impressive pair of *tuunrat* masks also was reunited. In all, forty Jacobsen masks have been returned, but three are still missing in action.

The Native American department received a total of nine thousand objects, including most of their missing South American items. Some of these had

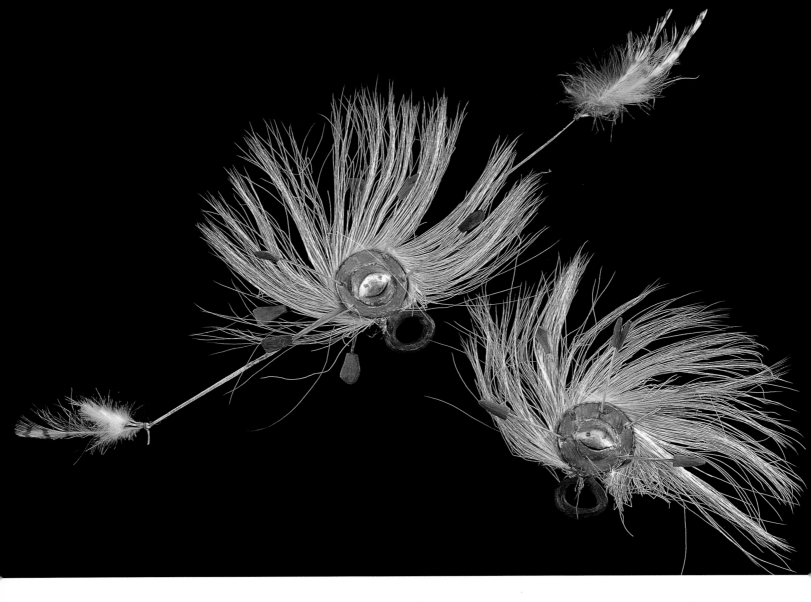

been in the museum's permanent exhibit. Remarks on the accession cards of most of the returned Eskimo masks indicate their position in the museum's display before the war.

An accurate account of which objects went where following the war is not possible. Pieces have returned from unexpected places, while others have not come back at all. Some objects moved out of the museum for safekeeping were destroyed, while others left in the museum basement survived. Where the objects went can often be determined only by their return route, as few records have surfaced.

Between 20,000 and 25,000 ethnographic objects are still missing, including 3,000 from the museum's North American section. Some that were looted at the war's end have been sold to collectors on the black market. Recently a collector's widow offered the museum a number of objects, including pieces Jacobsen collected, with their original accession numbers still on them. The museum bought them back. For nearly 50,000 objects, their fifty-year odyssey is at an end (Höpfner 1993).

## J. Henry Turner's "Sundry Household Articles"

At the same time collectors such as Jacobsen and Nelson were generating massive collections of Yup'ik and Iñupiaq material, other men were gathering more modest collections as an aside to their jobs as traders, miners, and federal agents. J. H. Turner was one such individual. He put together a striking mask collection in the last decade of the nineteenth century while working for the U.S. Coast Survey. Although several of his masks have been exhibited separately (Fitzhugh and Crowell 1988:266, 269), the masks have never been shown together nor details of their acquisition explored.

J. H. Turner worked in Alaska from the late 1880s through 1893, traveling the Yukon River and surveying the eastern international boundary between Alaska and Canada. This was a new field for ethnologists, as it was the mingling ground for Athapaskans and Eskimos. In November 1891 Turner sent to the Smithsonian one of two shipments of artifacts, including a kayak from St. Michael; a birchbark canoe from the Yukon River and two more from the Porcupine River; a sled, harness, and various articles of clothing from the Porcupine; and "sundry household articles" from the lower Yukon. Although his brief letter to Professor G. Goode at the National Museum mentioned no masks, the shipment included twenty-three elegant pieces, similar to those acquired by previous collectors in the vicinity of the lower Yukon and St. Michael.

Turner (November 12, 1891) wrote Goode:

Pair of delicate finger masks collected at Togiak by Jacobsen, who called them "Tarroyarrantitt" (*taruyamaarutet,* "dance fans") and stated that "one side shows a face with a mouth from ear to ear while the other represents the king of the walrus." Both originally contained "rattling stones," although only one still rattles. In his article on finger masks Disselhoff (1936) drew the inside of another rattle (IVA5437) filled with snail shells. A third rattle in the Jacobsen collection (IVA 5200b) contains three small coal pieces, and another (IVA5212) three crumbs of iron oxide, a substance believed to possess special protective properties in many contexts.

The end of World War II found one of these finger

masks traveling by train to Poland while the other remained behind in Berlin. In February 1992 when the museum's collections were returned, the pair was reunited. *MV, IVA5436a, b (10.5 cm)*

Owl mask rimmed with three immature eagle feathers. This and the following thirteen masks collected by J. H. Turner in 1891 probably came from a single dance. *SI, 153615 (15.2 cm)*

I am convinced that these articles will form a valuable addition to the "department of Alaska" in the National Museum. Many of the smaller things were purchased with trading goods delivered to me by Professor Russell of the Geological Survey who bought them in San Francisco with funds advanced by the Smithsonian Institution. Should the Museum desire these articles it will be necessary for it to bear the cost of transportation to Washington from San Francisco, and in addition reimburse me for certain expenses incurred personally.

Four days later Turner (November 16, 1891) wrote F. W. True, the curator in charge of the National Museum, asking $15 for the smaller articles—$10 to cover their freight, as they could be packed in two boxes, plus $5 reimbursement as "satisfactory to me and I am quite sure to you also inasmuch as the articles cost considerably more." Turner added that he was willing to have even this small payment

delayed until True had a chance to examine the collection, fearing that some objects might be taken from the boxes in San Francisco.

Turner sent two collections to the Smithsonian, the first received in April 1892 and the second in April 1893. The entire collection consisted of 235 objects from the northern part of the Yukon Peninsula. Shortly after making the second shipment, Turner died, and in August 1893 his father wrote Professor O. Mason seeking compensation for the "curios" his son had sent to the National Museum. He regretted having to charge the museum, but noted that creditors were banging at his door. Mason (January 7, 1894) in turn wrote True in support of the purchase:

Mr. Turner did us many favors, took trade goods and procured canoes and other things, and, also, bought

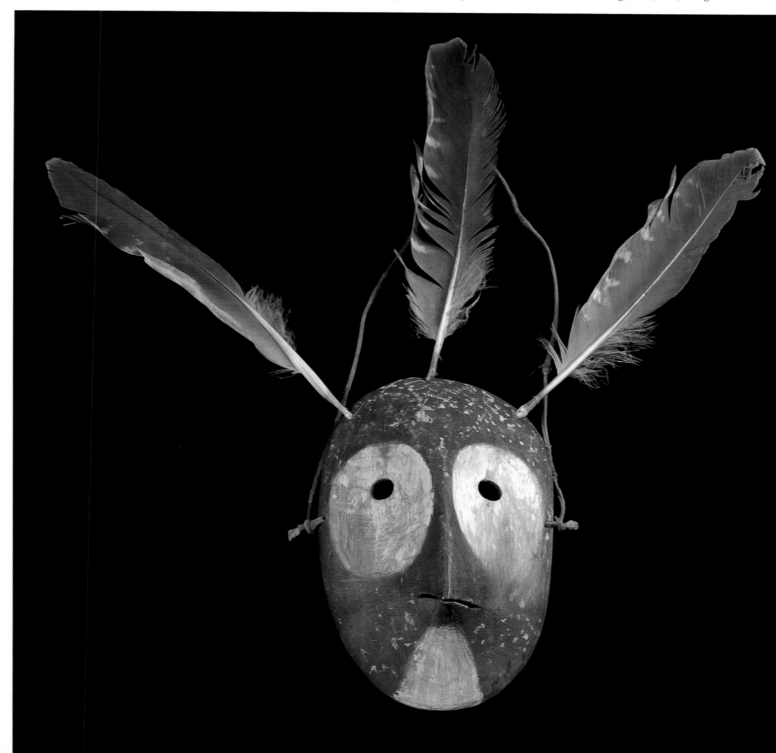

with his own means a lot of nice objects which he lent us. He has lately died, and his executor will sell the collection of about three hundred objects for $100. This is "dirt" cheap, and I earnestly request their purchase because their removal will leave a gap in our collection.

Although a tiny collection compared to Nelson's and Jacobsen's, Turner's masks form a unique set, bearing the mark of one man's vision. The masks were possibly used at a single event or made for sale by one or two carvers, modeled after masks used in local performances over the years. Unlike similar masks made for sale in the vicinity of St. Michael, such as those Lucien Turner collected for the Smithsonian in the 1870s, J. H. Turner's masks were crafted with care by expert carvers.

Exactly where the masks were made remains unclear, but they probably came from somewhere between St. Michael and the middle Yukon. They are similar in both conception and execution to another remarkable collection of Yup'ik masks from Nunapiggluugaq (Old Hamilton), near the northern mouth of the Yukon River.

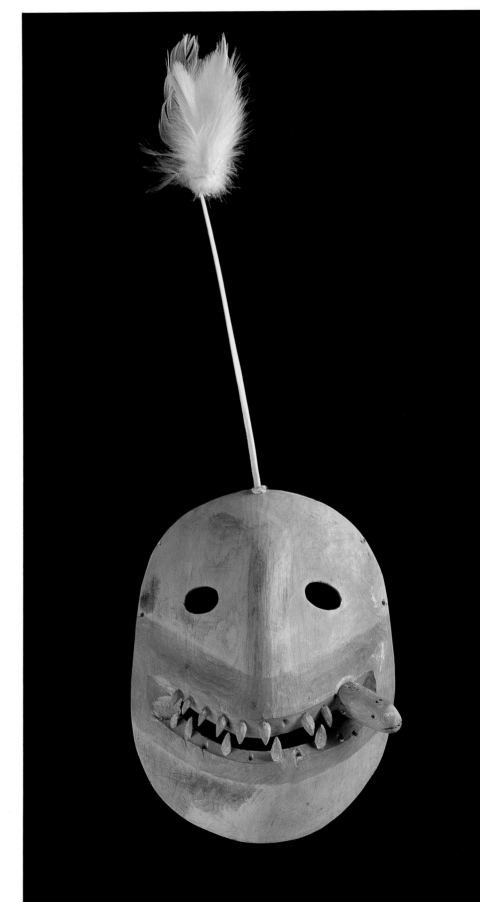

"Monster whale-eater mask," blue with a wide band of red about the mouth, and three long plumes. On the backside the eyes are painted red, as in the majority of masks Turner collected. *SI, 153620 (20.3 cm)*

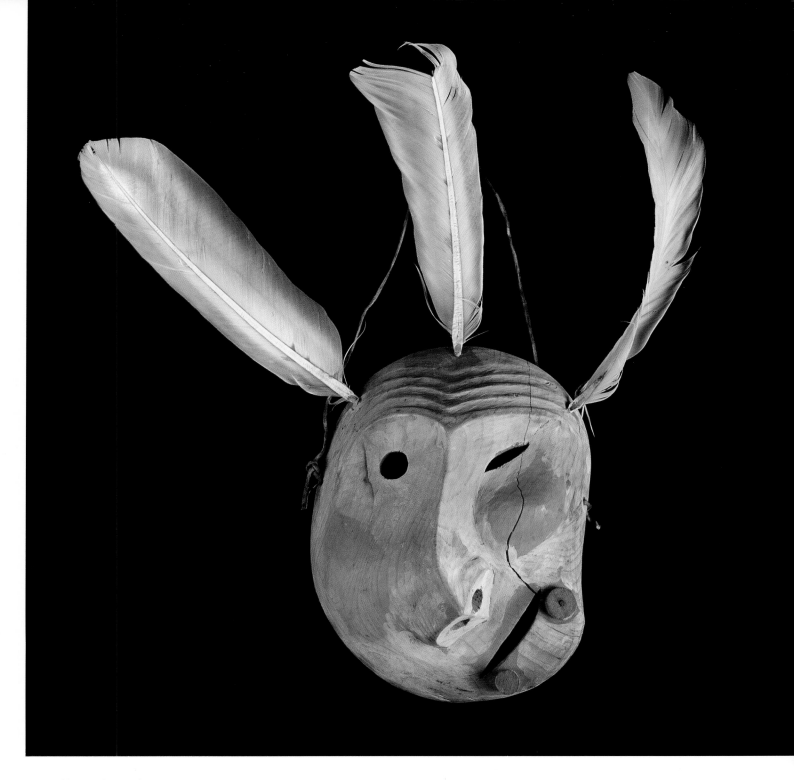

Distorted human face, with
one eye partly closed and
wrinkled forehead. Paul John
of Nelson Island recalled
stories about a strange noise
coming from outside the *qas-
giq*. When the people saw
the face of the creature that
had come to them, it would
have a bent face with a side-
ways mouth. *SI, 153621
(18.4 cm)*

COLLECTORS
COME TO
THE YUKON

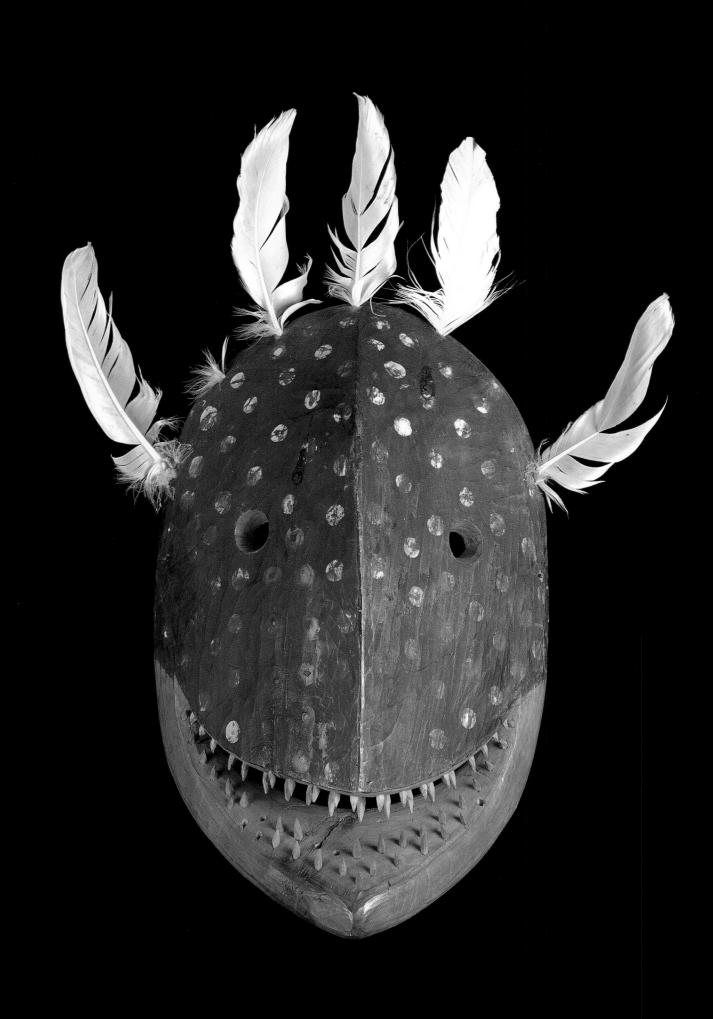

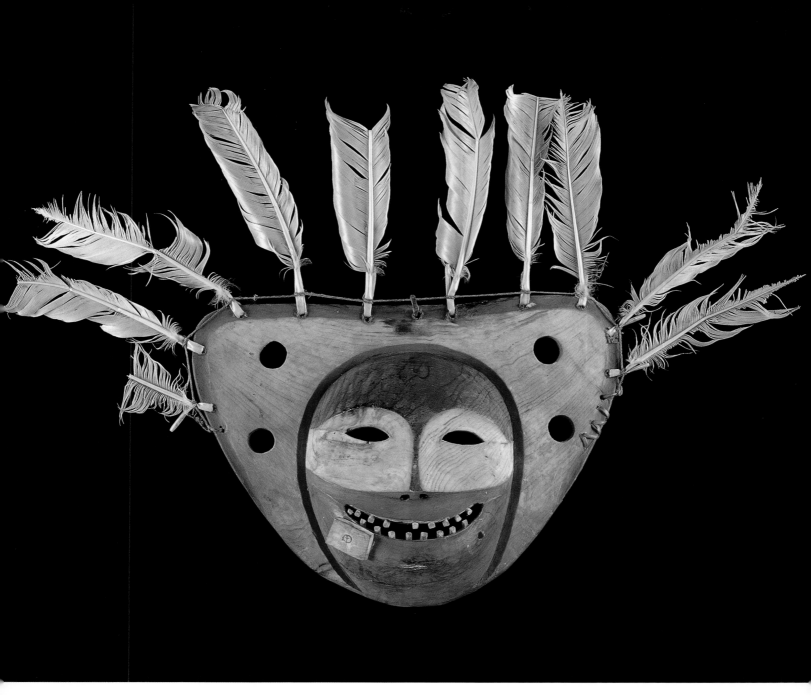

Labeled "black fish" by
Turner, this mask features
a red jaw and two rows of
teeth. Rather than the com-
mon blackfish found in tun-
dra lakes, this may represent
the many-toothed, ocean-
dwelling *qaculluut* (wolf
fish). *SI, 153622 (27.9 cm)*

*Nepcetaq* mask with face
peering through a triangular
shield, painted red, white,
and black. Ten feathers are
bent through holes in the
upper rim and sewn in
place. *SI, 153624 (35.6 cm)*

COLLECTORS
COME TO
THE YUKON

Dish-shaped mask with a
face carved on the convex
side, smeared with pipe clay,
rimmed with red ocher, and
ornamented with seven
feather tufts. *SI, 153625
(21.6 cm)*

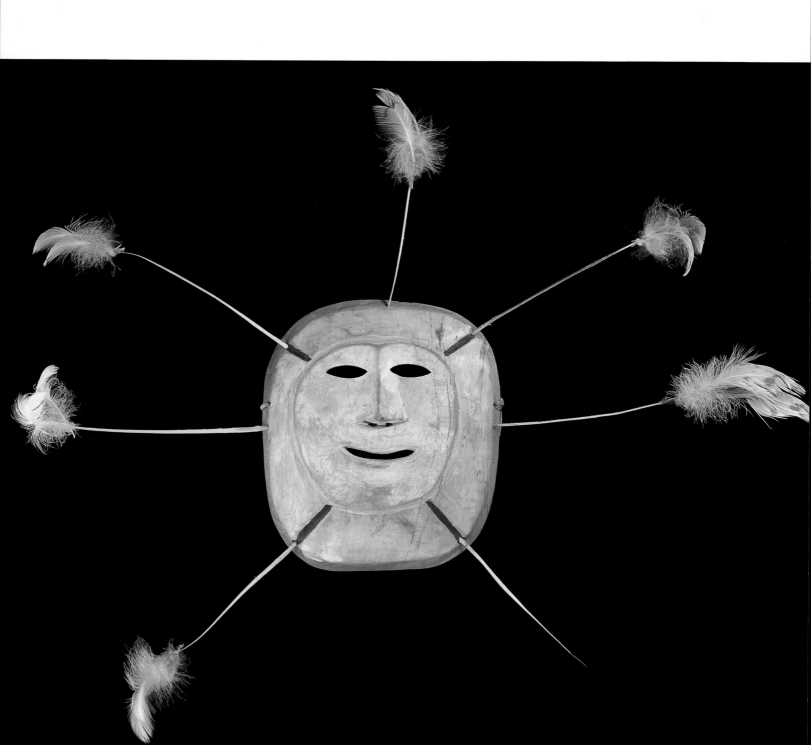

Elliptical mask with two sur-
faces sloping from a median
ridge, one painted red and
the other blue-green, both
spotted with white. Painted
spots appear on many
masks, as well as on the
bladders during the Bladder
Festival, and even on some
participants. They represent
snowflakes, stars, or eyes,
depending on the mask's
story. As in healing, the
painter's touch may have
been as significant as the
mark left behind. *SI, 153626
(34.3 cm)*

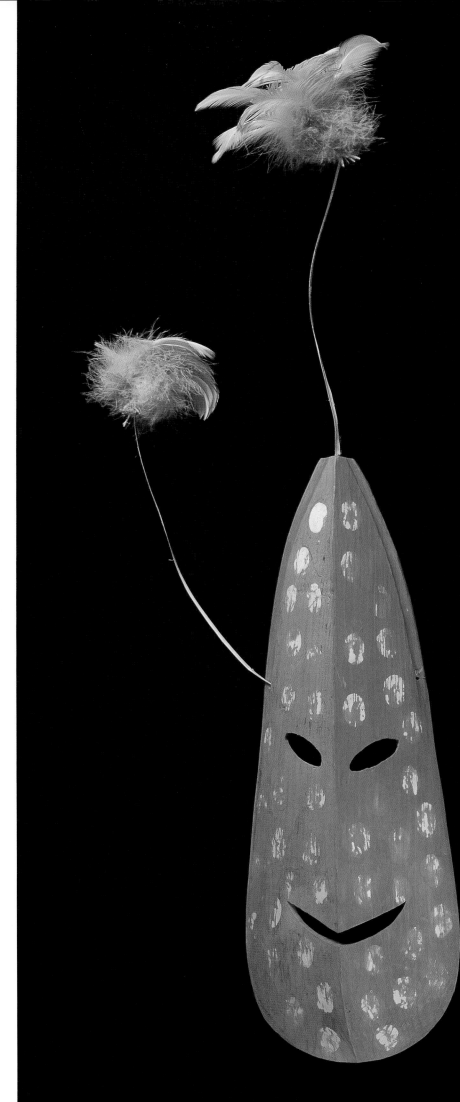

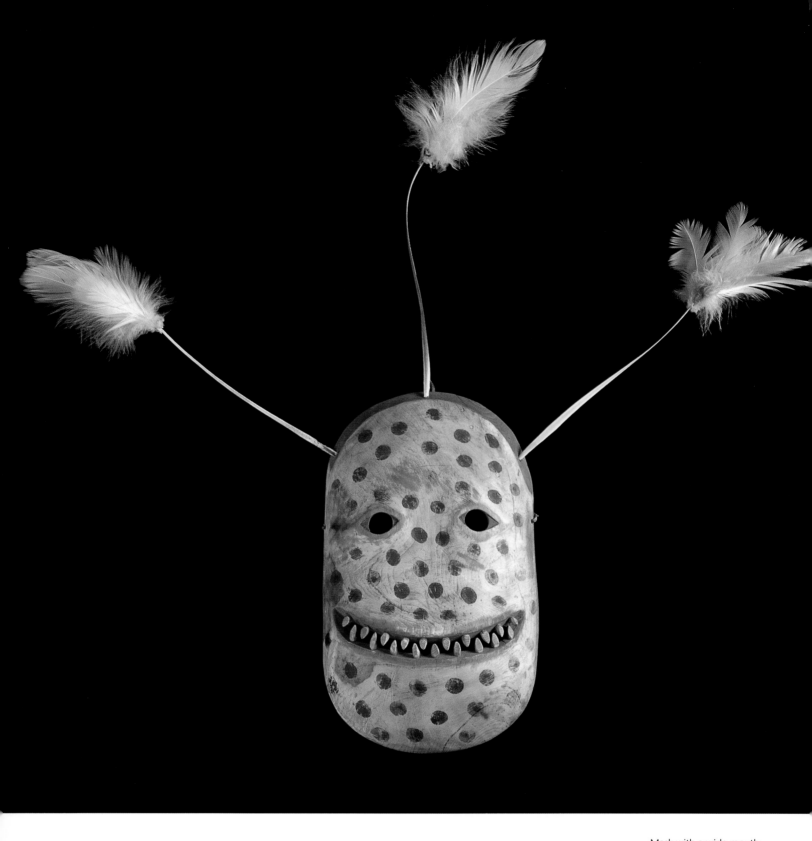

Mask with a wide mouth showing two rows of wooden teeth, a long face smeared with black spots, and three feather plumes. This is similar to a "sculpin mask" collected by H. M. W. Edmonds at St. Michael in the 1890s. *SI, 153627 (25.4 cm)*

Turner collected this delicate
mask in 1892, and similar
masks were obtained at St.
Michael by Henry Neumann
in 1890 (see p. 106),
Edmonds in the 1890s (Ray
1967:195), and Miner Bruce
at Port Clarence in 1890–91
(VanStone 1976:37). The
top portion shows a face
rimmed by three feather-
tipped quills, while the
lower portion is the head
of a seal, painted blue.
*SI, 153631 (22.9 cm)*

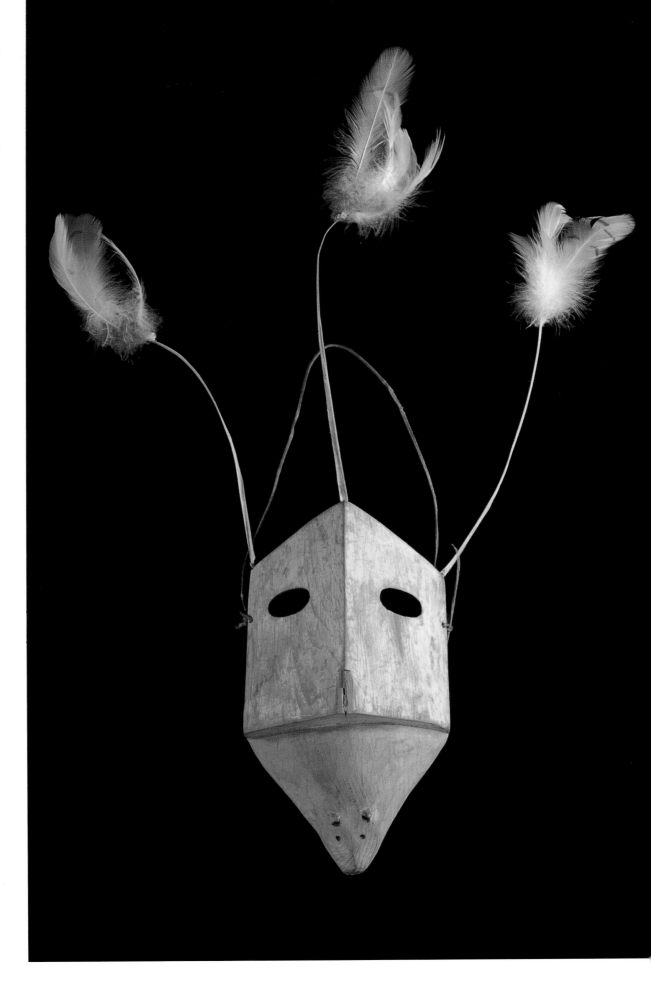

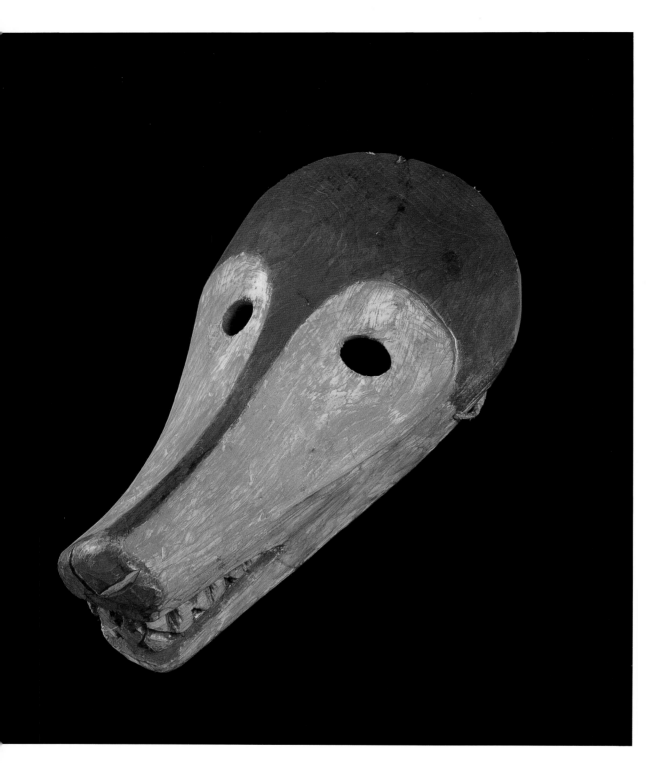

Finely carved wolf's head, with tongue protruding and (originally) three black feathers inserted in the upper rim. Men continued to carve similar wolf, fox, bear, and caribou head masks into the 1930s. Compare this mask to the fox mask collected by Otto Geist at Old Hamilton in 1934 (see p. 243), similar in style but heavier and less graceful in execution. *SI, 153632 (21.6 cm)*

Second wolf mask, crested with six white feathers, collected by Turner in 1891. The Smithsonian sold the mask in 1908 to George Heye, who misidentified it as a seal. An identical but slightly larger wolf mask, probably its mate, was collected at St. Michael by Henry Neumann in 1890 and given to Sheldon Jackson (IIG1, 25.4 cm). Compare with the pair of wolf masks, also collected by Neumann at St. Michael in 1890, illustrated on p. 119. *SI, 153633 (22.9 cm)*

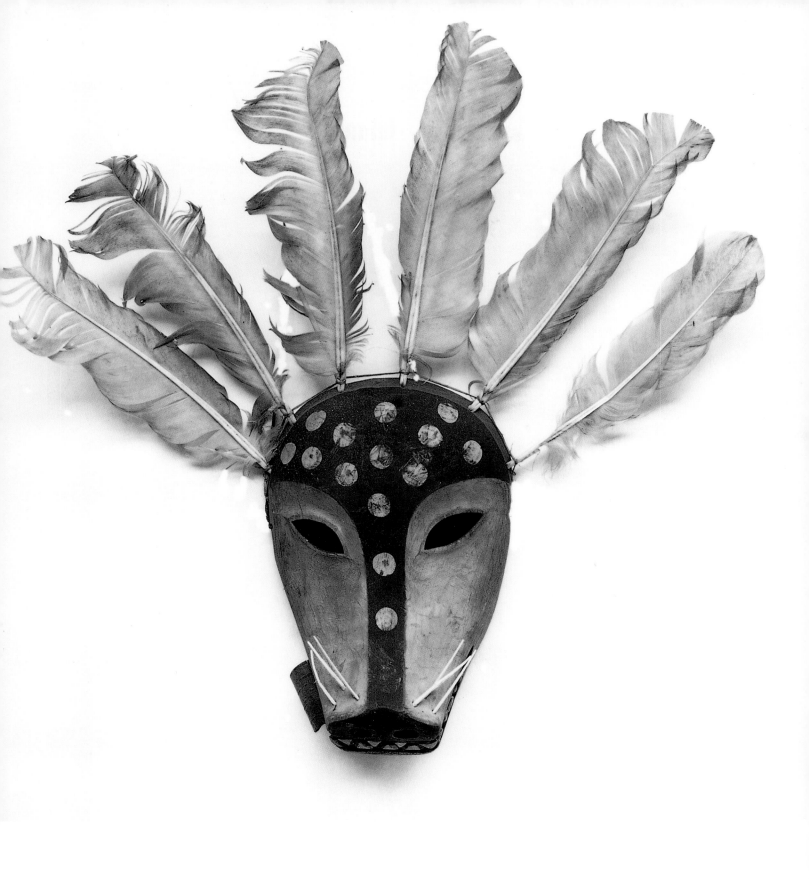

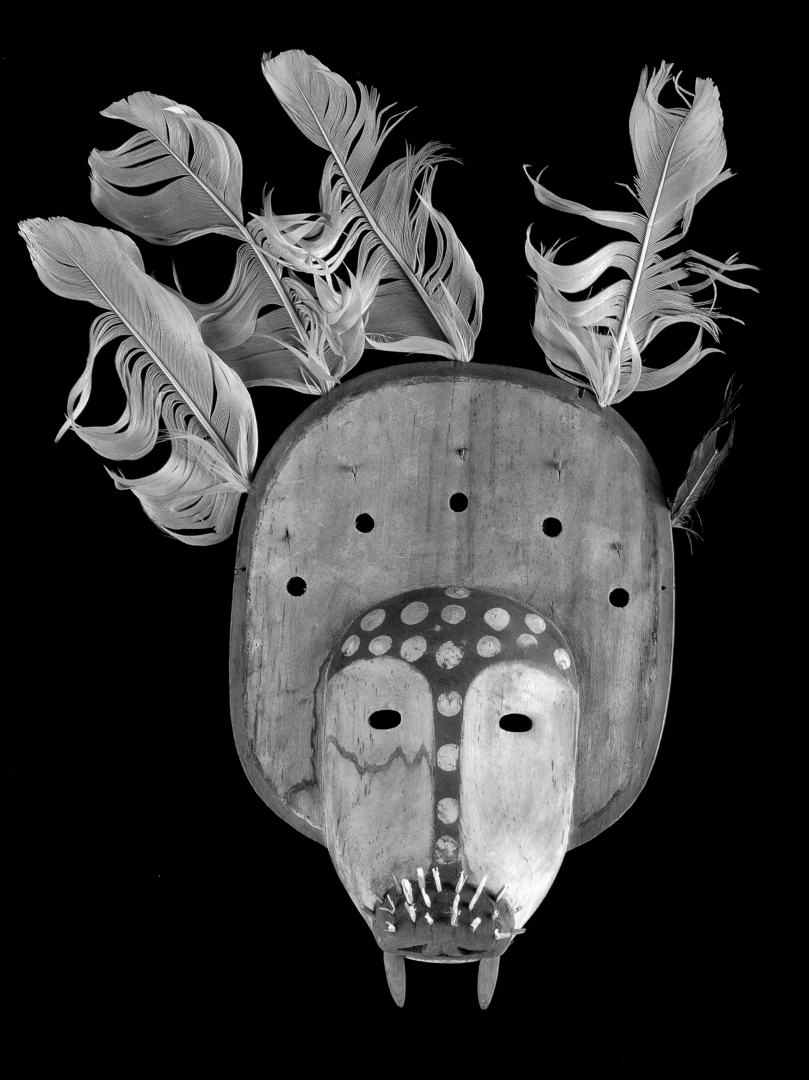

Like *nepcetat,* the plaque of this walrus mask has five holes beside which five carved animals originally sat. Five feathers decorate the rim. The mask is small and may have been worn as a forehead mask. *SI, 153635 (22.9 cm)*

A crescent-shaped slit in the blackened surface of this mask dotted with white spots may represent the moon and stars, and the round eye the sun. *SI, 153636 (16.5 cm)*

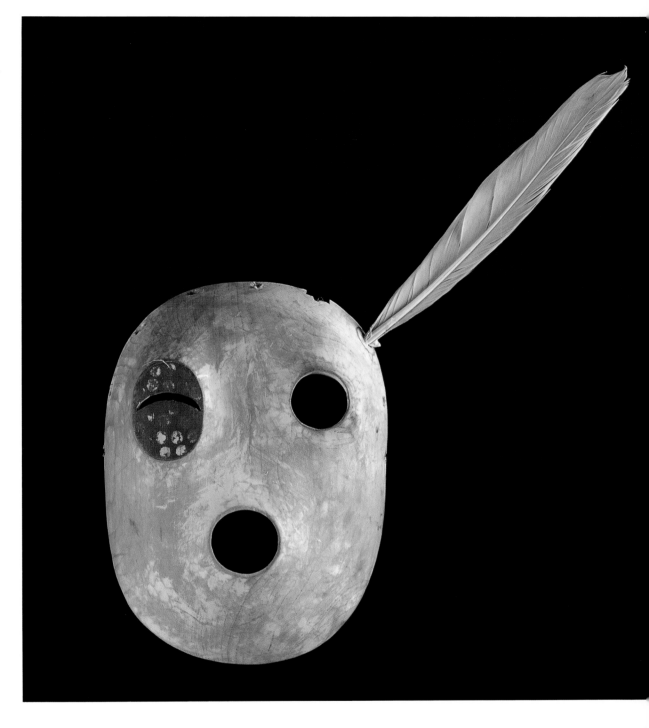

COLLECTORS
COME TO
THE YUKON

## Old Hamilton Masks and the Stories They Tell

Masks continued to be made and collected along the Yukon for half a century following Turner's death. A valuable group of fifteen was acquired from the lower Yukon village of Old Hamilton in 1934 by a notorious St. Lawrence Island collector.

Otto William Geist was born in Eiselfing, Bavaria, in 1888. There he earned a journeyman's diploma in metalwork before immigrating to the United States in 1910. He worked at a variety of jobs, including farming, truck driving, and enlisted service. In 1923, after yet another change of fortune, he wrote to his brother, then living in Alaska, "I was disappointed that I had to go out of business, but I still have my health and I am only 34 years old" (Keim 1969:42).

In Alaska Geist continued his peripatetic traveling. While working on a riverboat on the Yukon he made the acquaintance of the naturalist Olaus Murie, whom he impressed with his energy and interest in collecting. Murie wrote to Charles Bunnell, then president of the newly established University of Alaska in Fairbanks, about the young man, and when Geist was working as a dishwasher in Fairbanks in 1926 the two met. Both shared an avid interest in collecting and talked often about the great gathering work still to be done in Alaska. Out of this unlikely friendship between an ambitious dishwasher and a university president, the University of Alaska Museum emerged.

Unlike Bastian, Bunnell had no money to support a collecting expedition. Geist used the wages he saved through the winter to finance a trip north. When Geist returned, Bunnell not only purchased the collection for the university, he also agreed to support a second expedition to St. Lawrence Island. Over the next decade Geist continued to collect archaeological and ethnological specimens for the University of Alaska, primarily from St. Lawrence Island. Just as Jacobsen had provided Bastian with the Royal Ethnological Museum's largest North American collection, Geist's "vacuum-cleaner" approach to archaeology gave Bunnell and the University of Alaska one of the largest collections of Iñupiaq material in the world, including approximately fifty thousand specimens.

Geist's trips north sometimes allowed for stops in Yup'ik villages along Alaska's western coast. In 1934 he led a major expedition to St. Lawrence Island and on the way north acquired, almost as an aside, fifteen masks from Old Hamilton at the Yukon River's northern mouth. The set included a delicate threesome representing plants, but the rest—like the masks Turner collected fifty years before—were one-of-a-kind creations. Also, like Turner's masks, they lacked the elaborate appendages characteristic of coastal and Kuskokwim masks. Three empty holes on the upper rim of several masks indicated that down-tipped feathers were the only original attachments.

Unlike Turner, Geist acquired information along with the masks. What makes his collection extraordi-nary are the stories that he obtained from Pauline Kameroff, a former teacher at Old Hamilton (Nunapiggluugaq), who spoke with an older man in the village and wrote down what he said. In April 1935 Kameroff sent to Geist English summaries of what were certainly longer accounts. They constitute the most detailed stories accompanying a collection of Yup'ik masks anywhere in the world.

Photographs of the masks were shown to Yukon delta elders at St. Marys in February 1993 and the masks' stories briefly recounted, generating long and varied remembrances. Elders reported that the story of the loon mask (no. 12, see p. 246) is a *quliraq,* a traditional tale, variations of which are widely known throughout the Arctic (Morrow and Volkman 1975; Rink 1875:99–105; Spencer and Carter 1954). Walter Naneng summarized the tale:

When the wife got tired of working on the animals and fish [her husband] was bringing home, when he was sleeping she made him go blind. Then, since he knew

"Half Face Mask" (no. 8), one of fifteen masks Otto Geist collected at Old Hamilton in 1934. The local schoolteacher, Pauline Kameroff, wrote down the masks' stories.

*In a certain old village no one was allowed to enter under penalty of being devoured by people who had only half faces.*

Recall J. A. Jacobsen's association of the half masks he collected with memorial rites for the dead (see p. 99). *UAM, 64-7-25 (22.9 cm)*

Three small masks (possibly worn on the forehead) representing plants (no. 13), also from Old Hamilton.

*Out of the earth grass and other growing plants appeared. As they grew out from the earth they would spin a top. Whenever the top would stop spinning they would quarrel among themselves saying that the top had turned toward them.*

The jaws, held in place with cotton string, would open and close when the masks moved, perhaps representing the plants' periodic quarreling. Holes on the upper rims originally held feathers. *UAM, 2002 (20 cm), 64-64-11 (19.1 cm), 64-7-23 (17.8 cm)*

where the Arctic loons were, he crawled to them. And when he got to their place he sang his song, saying "Where is the voice coming from?" When he got to them he let them take him in the water. At first he did not get well, but after the second time his eyes could see again.

Yes, I've heard that story, too. They used to tell about the Arctic loon and about the person who went blind. His wife got tired of working and dropped ash in his eyes and made him go blind. (February 27, 1993)

The photographs of masks elicited more stories. Alma Keyes stated, "They say when someone is going to die, the loons stay around and continue to dive in and out of the water. . . . Loons are quite aware. And they know when things move around. They would tell us to be alert when we pick berries. When other animals are nearby the loons don't keep quiet. They scream out and sing." Keyes went on to describe her experience when loons came to her while she was sleeping in a tent on the tundra and would have flown away with her had her husband and children not returned.

When he saw the photograph of the half-face mask, William Tyson (February 27, 1993) reported:

I have seen this half-mask image once. When the owner sang about it, used the mask, and danced with it, he was holding a knife and making hitting motions all around himself when he told the story about it. They say that was the image of *cangarlak* [natural disaster, famine, epidemic], and if an *angalkuq* used it, he would let the half-mask help him with its weapon and scare away the *cangarlak*. That was how I understood this one here when he told the story.

Looking at pictures of the three plant masks, Justina Mike (February 27, 1993) commented:

They would *agayu*. The people in the village would ask the berries to be plentiful in the coming summer. Perhaps this is the person of those plants. They say sometimes many plants would grow. Perhaps that is the meaning behind [the mask].

They have painted this [mask] white. When there is lots of snow, we call it *aniuq*. When there is lots of snow on the ground, the berries and plants are plentiful the following summer.

In the privacy of her home, Alma Keyes (February 27, 1993) described the restrictions surrounding a girl's

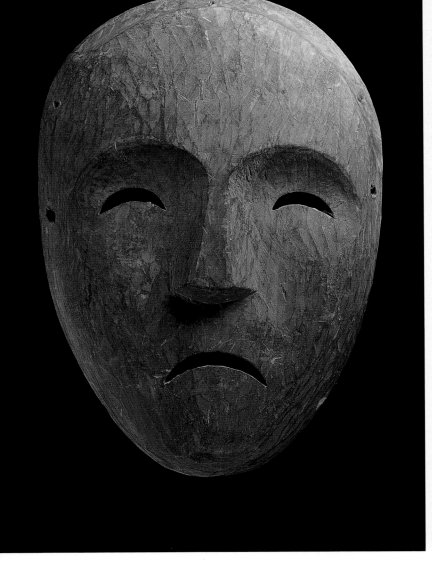

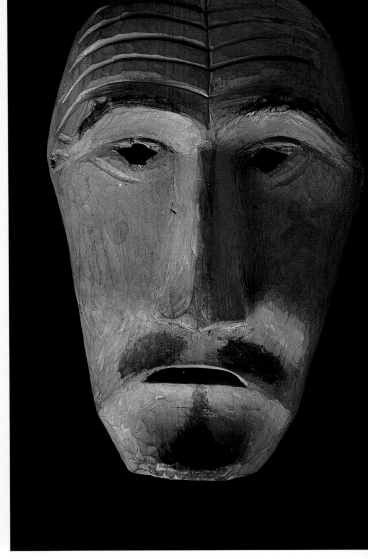

first menstruation as they related to the berry mask and berry harvest:

They absolutely will not let the girl pick berries during berry season if she is menstruating. They say if she picked a berry, the berries would disappear. That is why they would caution us girls and make us understand not to go toward the berries. . . . I'm speaking because that [mask] picture made me remember it. You see, though we are women, we have heard the traditional rules of proper living.

Some stories Kameroff recorded are short. For the half-face mask, all we are told is, "In a certain old village no one was allowed to enter under penalty of being devoured by people who had only half faces." The stories recorded for other masks are long and detailed. Moreover, the accounts' complexity is belied by the masks' apparent simplicity. A good example is the story behind the red fox mask:

A fox was out hunting for her young ones. By the seashore she came upon a bear who was also hungry. Then the fox took some snow and shaped it into a ptarmigan. After the fox had made several ptarmigans, she

barked at them and they were instantly living birds which she killed and fed to the bear. The bear was grateful and wished to repay the fox. The fox told the bear that only when he could get human beings to eat was his hunger satisfied. The bear answered after a pause that such things were not easy to get, but he went out to the sea thinking there would be some seal hunters nearby. Towards evening the bear was slowly returning from his hunting. As he came closer the fox saw that the bear was staggering. He had seen some seal hunters and had been struck by spears.

The fox said he would heal the wounds with some of his grandmother's medicine. He picked two pebbles from the shore and made a fire in which the pebbles were put to heat. When they were red, the fox took one pebble and put it in one of the spear wounds, which made the bear howl and snarl with pain. Then the fox took the next pebble and put it into the second wound which made the bear fall over dead. The cunning fox laughed at the dead bear and fed upon the bear meat for many days, forgetting her own young ones.

When the bear was finally devoured, the fox left the shore and soon met a starving wolf. She called the wolf her friend and told him how she always fished for tom cods in the open water holes. She told the wolf that if he began at dawn by putting his tail in the water he would catch many fish. The wolf was anxious to try,

"Salmon Berry Mask" (no. 9) from Old Hamilton.

*A salmon berry fell to the ground and arose in the form of a living person.*

*UAM, 64-7-26 (21.6 cm)*

Mask (no. 2) from Old Hamilton. No story was recorded for this mask. *UAM, 64-7-31 (21.6 cm.)*

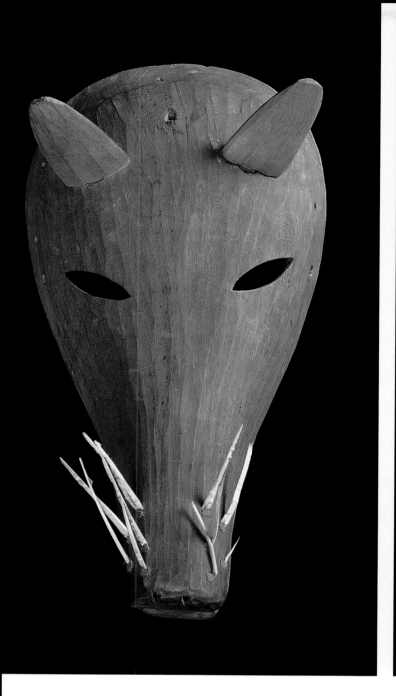

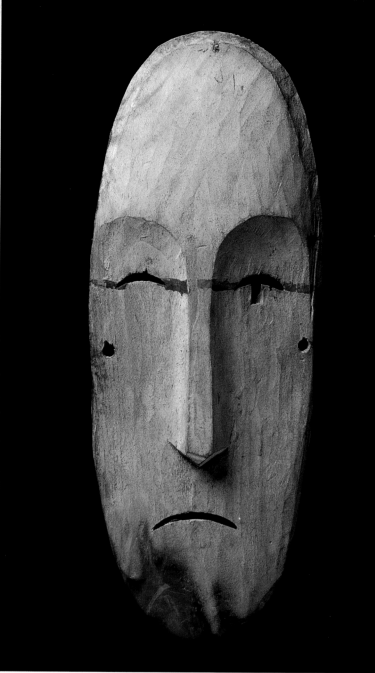

but the fox also warned him to have patience and to keep his tail in the water till the sun was high. The wolf did as he was bidden and when he tried to get up he found that his tail was frozen into the ice. He pulled and jerked till his tail came off. Howling with pain and dripping blood, he ran and ran until he dropped dead. Then the clever fox fed upon the dead wolf, and she suddenly remembered her young ones left behind. When the fox returned to her den she discovered that the young foxes had left to find food for themselves.

The story behind the "death mask" is even more complex:

An evil woman lived alone near a river. Whenever she desired a husband she would go to a village and under cover of darkness would select her victim and whirl him in the air. The surprised man would then find himself alone with this strange woman. She secured many husbands in this manner. After tiring of her various husbands she would kill and devour them. After a trip to a village she returned with another man for a husband. Later on this man became poor and thin. Being near

the berry season, the woman left him to go out picking berries. When the husband was alone a stranger came and looked in through the window. He saw the husband and asked him if his wife ever pinched him. The man replied that she had pinched him several times when he was sleeping. Then said the stranger, "That woman is going to kill you soon. I'll come and get you away tomorrow. Tell your wife that you would like to eat some king salmon."

That evening when the couple had gone to bed the husband tried to stay awake but fell asleep again. When he awoke the next morning his wife was gone. He looked up to the window to see the stranger peering down at him. This time he pulled the window cover off and lowered a king salmon net telling the husband to get inside the net. Then the stranger hauled him out through the window. Near by the side of the house was a canoe containing two paddles. One paddle was painted in red and the other in black. The husband was ordered to sit in the canoe but he feared that his wife would come after him. After much persuasion he got into the front of the canoe and took the red paddle while the stranger seated himself in the back with the

black paddle. Then the stranger shoved the canoe away from the house and the canoe glided through the air. Suddenly the two men heard a loud shouting and turned to see the woman coming after them. As the woman came closer her feet turned into a tongue and the edge of her parka became her lips, while her tassels changed into teeth. Nearer and nearer she came to the canoe, and what the men saw was a huge pike. The stranger told the husband to keep on paddling, and when the pike came near he raised his paddle and struck it with all his might, killing it instantly. Thus the man was saved by the stranger. After the canoe had landed on earth the man was directed to his own village. Going a short distance he turned to look back to the stranger only to see an old wolverine watching him. Near the wolverine were two logs. One log was

marked in red and the other bore black markings. The man returned safely to his home where he later became a great medicine man. One day while he was eating, a death mask appeared in the doorway and caused him to lose consciousness. When he came to himself the death mask became his spirit to aid him as a medicine man.

The Old Hamilton masks teach caution in assuming that identical or similar masks always tell the same stories. The group includes two "crow" masks that, without any additional information, a viewer might assume told the same tale. In fact, the Old Hamilton narrator made clear to Kameroff that each mask had its own story to tell.

Although these two raven masks look the same, each tells its own story:

"Crow Mask" (no. 5) from Old Hamilton.

*Long ago people lived in eternal darkness. Then a crow went in search of light with a pair of snow shoes. When he found light he put it into a seal bladder and as he traveled around, he opened the bladder and passed light along the way, thereby making the world light. When he reached the other end of the world he poured out all the light at that end.*

*UAM, 64-64-10 (25.4 cm)*

"Crow Mask" (no. 11) from Old Hamilton.

*A woman who was looking for her lost husband came upon a*

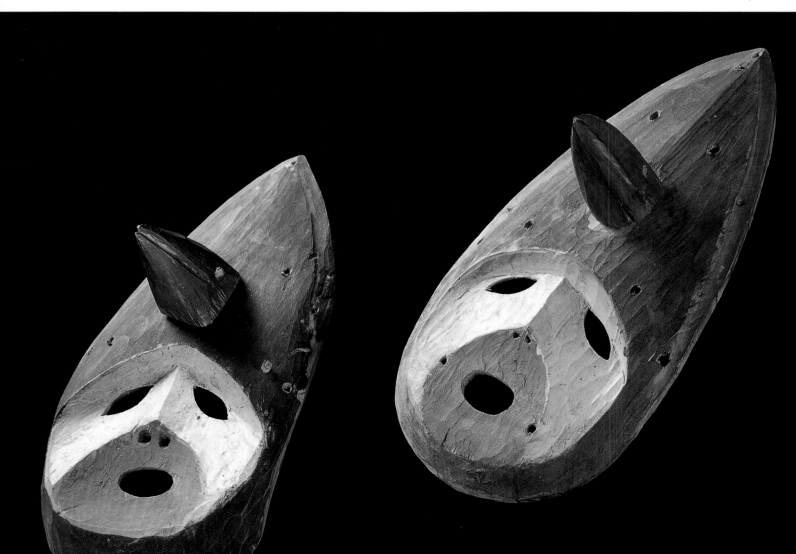

crow chopping wood near the bank of a river. As the chips flew from the wood they turned into fish and leaped into the river. The woman asked the crow about her husband but he refused to tell, so she gave him her husband's ax. Then the crow told the woman to go to his sister. The woman went to the crow's sister and gave her some beads for a present. The crow's sister told the woman that she would find her husband and then turned toward the river. A huge fish appeared in the water, and as his body opened wide the woman was told to enter it, and it closed again over her. The fish traveled along the river, and as they passed by the village the fish would rise to the surface and the woman would peep through his gills to see if her husband was there. They passed several villages before they sighted the husband. When at last they discovered him, the fish opened wide his body and the woman went ashore and took her husband. Then together they entered the body of the fish and returned to the crow's sister where they left the huge fish who had carried them and went back to their own village.

*UAM, 64-7-28 (25.4 cm)*

"Clam Mask" (no. 10) from Old Hamilton.

*A woman married a polar bear thinking he was a human being. One day they went out to the sea in a skin boat when a storm overtook them. The boat was overturned and they both sunk to the sea bottom, where the woman and the bear turned into a clam shell.*

Like the clam masks Jacobsen collected fifty years earlier (see p. 111), this mask originally had appendages. *UAM, 64-7-27 (20.3 cm)*

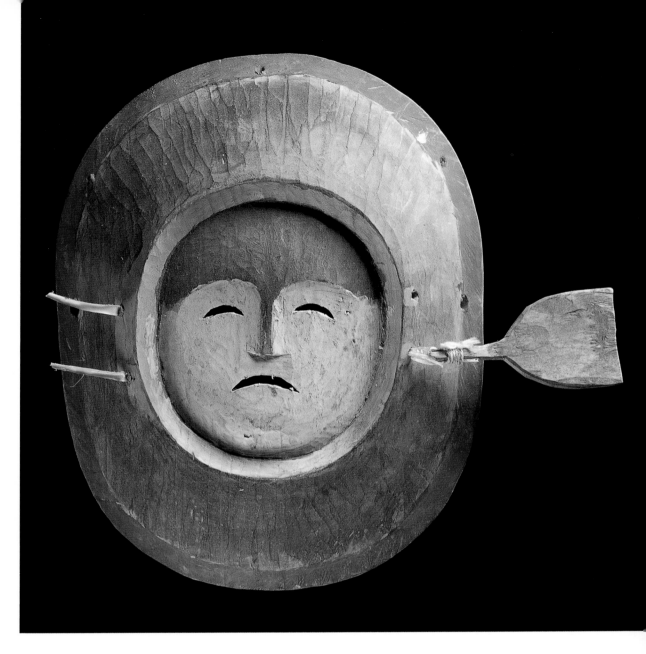

"Caribou Mask" (no. 3)
from Old Hamilton.

A young woman went out
to get some wood. Soon she
became tired and fell asleep.
Upon waking from her sleep
she felt a great change in her
life. Later on she discovered
she was to have a child. When
the time came she gave birth
to a caribou. When the cari-
bou was old enough, his
mother sent him away from
home to go and search for his
own kind. Finally he discov-
ered a large band of caribou
and he joined the herd.

UAM, 64-7-19 (30.5 cm)

"Loon Mask" (no. 12) from
Old Hamilton.

One day a woman took her
husband out to the tundra to
sleep. As soon as her husband
fell asleep she made her
breast drip into his eyes,
which caused him to become
blind. The woman had
become weary from skinning
many animals, as her hus-
band was a mighty hunter.
Now he would be unable to
hunt anymore.

When the husband awoke
he discovered to his horror
that he was blind. Unable to
see where he was going, he
crawled around on his hands
and knees until he came to a
lake. While he was resting he
heard a sound like someone
paddling a kayak, and he
shouted toward the direction
from which the sound came.
His call was answered by two
men, and when they came
near, the blind man was told
to get astride their kayaks.
Suddenly the kayaks sank
below the surface, almost
drowning the blind man, and
as suddenly rose to the top.
The blind man was asked if
he could see anything. He
answered that he was as blind
as before. Then the men dived
again in their kayaks, and
when they came up the blind
man saw a little light. They
dived a third time, and when
they arose they questioned
the blind man, who answered
that his vision was getting
stronger. The fourth dive
restored the man's full vision
and he was brought ashore.
Then the two strangers told
the hunter to turn his back to
them until they had gone a
short distance away. After a
moment the man turned to
look, but the strangers had dis-
appeared and all he saw were
two large loons in the lake.

Note how similar this story is
to Wassilie Evan's account of
how his eyesight was
restored (see pp. 178–79).
UAM, 64-7-22 (53.3 cm)

246

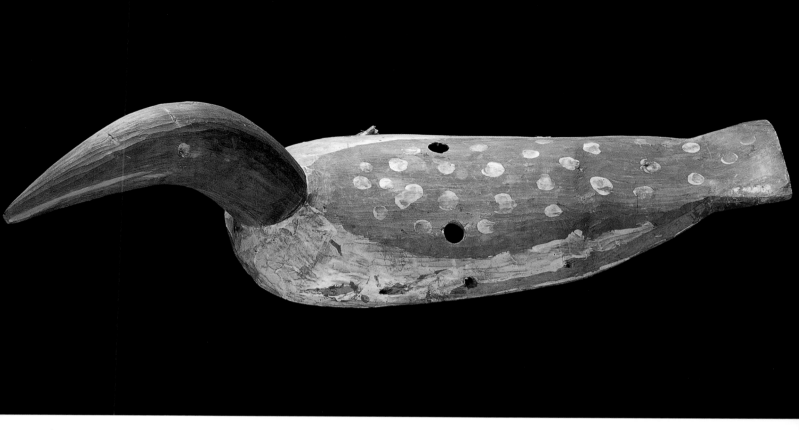

Mask (no. 15) from Old
Hamilton. This mask, too,
was collected without its
story. *UAM, 64-7-18*
*(43.2 cm)*

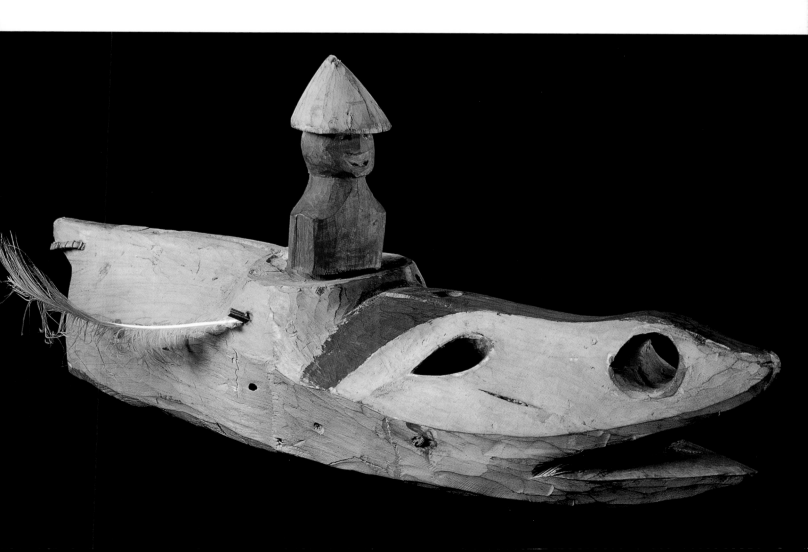

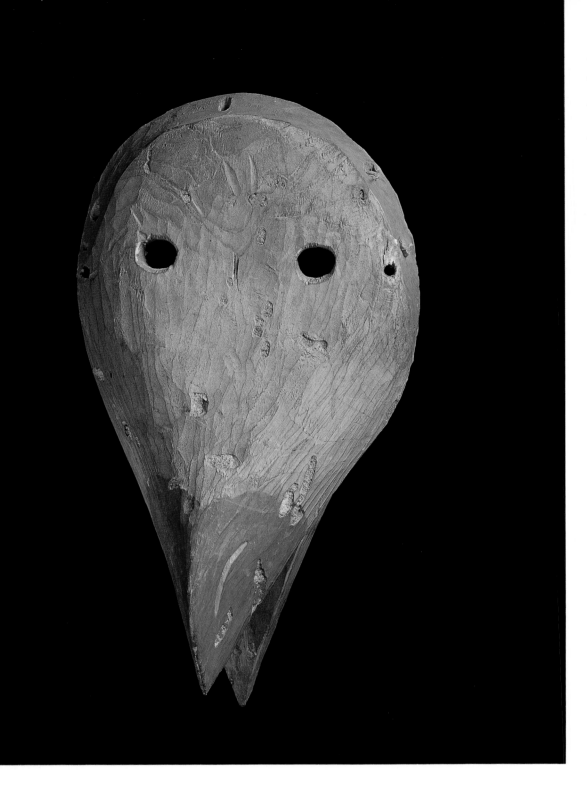

"Beetle Mask" (no. 4) from Old Hamilton.

*A beetle turned into a human being and wished to have a parka. She went to a village and entered one of the houses. The woman of the house was seated on the floor. The beetle wished to exchange her old skin for the woman's parka in order to get a husband. After the woman and the beetle had changed parkas the woman tried to walk, but her parka was too stiff, so she crawled on the floor. After a while she found that she had turned into a beetle. In the evening the woman crawled under the dripping oil lamp. When the oil dripped on her the beetle's skin sprang open and the woman stepped out. She grabbed her own parka from the beetle and pushed her out of the house.*

UAM, 64-15-4 (24.5 cm)

# Kuskokwim Collections and Collecting

## Masks Collected by A. H. Twitchell

*I remember Twitchell. They used to talk about a white man named Tuici who came to the area down there by dog-team. Since they didn't know how to pronounce Twitchell, they called that white man Tuici.*

*He traveled around here in the Kuskokwim area. Back in those days the white people traveled by dog-team trading in our area over there. It was when there were very few white people around. . . .*

*When people used masks in ceremonies he apparently traveled around. . . . He probably got them then.*—Dick Andrew, *January 5, 1994*

A. H. Twitchell with daughter Alice and son Ben, early 1900s. *Twitchell family*

The masks acquired by the Kuskokwim trader Adams Hollis Twitchell are among the most complex and elaborate ever collected. Born in Jamaica, Vermont, in 1872, Twitchell might have remained in New England, but according to family history his sister-in-law fell in love with him and, to avoid complications, the young Twitchell headed west. He arrived in Chilkat in 1898 and went on to Nome, where he and Charles Fowler tried their hands at gold mining in 1902. Both wanted to switch to a business that was less speculative than mining, and Twitchell put in a winter exploring the Yukon delta with the aim of establishing a fur trading and merchandising business.

Twitchell and Fowler, along with Frank Joaquin, bought out Bethel trader Edward Lind, and in 1905 Twitchell arrived in Bethel with his first load of trade goods. He had sailed eighty miles up the Kuskokwim on board the shallow-draft vessel *Zenith*, a major achievement at the time (Oswalt 1990:95). By 1909 the partnership was incorporated as the Kuskokwim Commercial Company, also known as Joaquin, Twitchell, and Fowler.

Twitchell and his partners had picked an opportune time to establish on the Kuskokwim. Fur prices were rising, along with demand for trade goods by native as well as nonnative customers. Margaret Felder Holland recalled, "[The Yupiit], too, wanted suits and ties, shirts and dresses, beds, rugs, chairs and table. The mission-educated natives wished to emulate the new culture. Instead of a kayak, they now wanted a fast boat and an outboard motor. The original Alaska trade goods of tea, beads, tobacco, and sugar evolved into a full scale offering of all the amenities enjoyed in any town in the States" (Lenz and Barker 1985:36).

By the time he settled in Bethel, Twitchell had married Irene Kocheck, a Yup'ik woman from a nearby tundra village. He worked as a trader in Bethel until 1916, when he moved upriver to Iditarod and Ophir to herd reindeer in the Kuskokwim Mountains. When herding declined he moved to Takotna, then a small riverboat landing and supply point on a tribu-

A. H. Twitchell and two of his children during the 1920s, when he herded reindeer along the Kuskokwim. *Twitchell family*

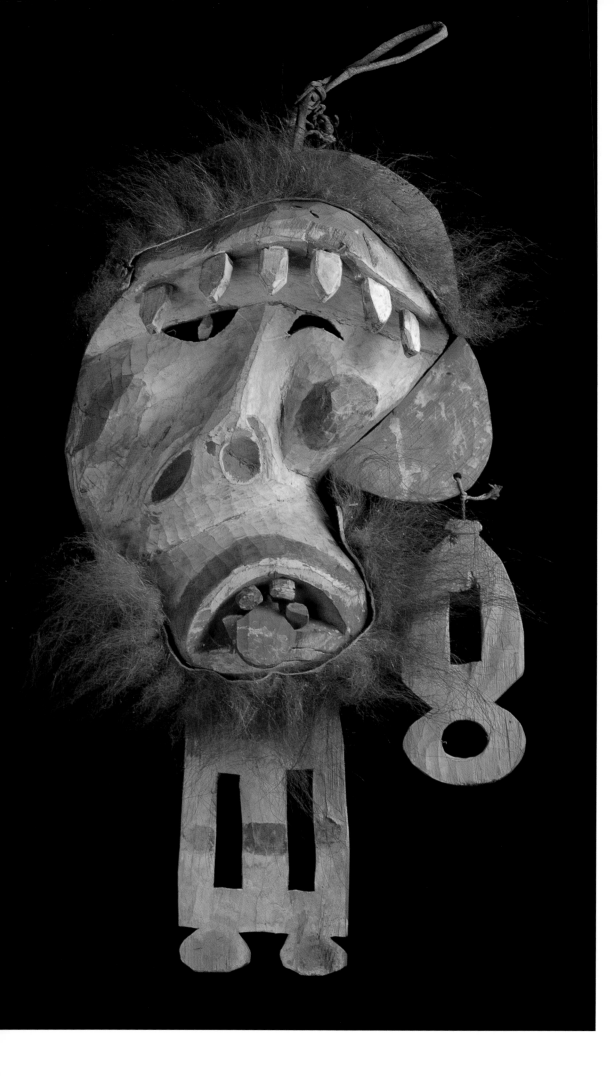

"Mask representing the watchman of the sky [perhaps *ellam yua* or *ellam iinga*]. His tongue is out and he is ready to tell if he sees anyone ready to, or trying to injure or kill another medicine man. If so, he warns the medicine man of his danger." This and the following twelve masks constitute a set collected by Twitchell below Bethel in the early 1900s. *NMAI, 9/3391 (51.4 cm)*

Napaskiak mask said by Twitchell to represent Avanak, a spirit of the dead who comes out of the ground to answer *angalkut*'s questions. The mask was sold to Julius Carlebach in 1944 and has since changed hands. Compare to the mask Jacobsen collected representing the dead and used in communication with them (see pp. 98–99). *PC, 9/3423 (24.1 cm high)*

tary of the Kuskokwim River. There he ran a general store until his death in 1949. The couple had five sons and three daughters, and many of their grandchildren still live in Bethel and Anchorage.[27]

Although he earned his living as a trader, Twitchell was a self-made scientist with an avid interest in natural history. He collected ornithological specimens for the Smithsonian and was a recognized authority on local flora and fauna. On Twitchell's collecting, his son Ben (1960s) wrote:

In latter years, when he had gone into the reindeer business and had to travel by foot between the reindeer range and the towns that were his market, he would not hesitate to let the pack horses go on alone or stop to feed while he unpacked his insect net and chased after a butterfly specimen that some museum or collector wanted. . . . He received orders . . . from as far away as England. Biologists and botanists sought him out.

Given the close connection between human and natural history at the turn of the century, it is not surprising that he also collected masks. George Byron Gordon, then director of Philadelphia's University Museum, met Twitchell in Bethel in 1907. A bill of sale dated September 7, 1907, indicates that Twitchell received $272 from Gordon for "1 lot specimens" and a dozen named objects, including a pair of grass socks, a birdskin parka, and several baskets. He apparently continued collecting after Gordon returned to Philadelphia. In a letter to Gordon dated March 4, 1908, Twitchell wrote:

In regard to the collecting of specimens I must say I have more trouble to get them than I expected. In beadwork I have nothing. We have offered two dollars for one headdress, but many of these things were given by relatives now dead and are strictly not for sale.

However, we have many masks that were made and used at the annual medicine dances and we have some of the stories that go with them. I attended one dance just to get the masks and information, and I went to another and stayed a week until it finished. I have written twenty three pages describing it which I will send you later.

In his reply of May 28, 1908, Gordon wrote, "I was very glad to know that you have succeeded so well in gathering masks and in getting information about them," but he was sorry Twitchell had acquired no beadwork or old ivory or pottery. No record of further correspondence between the two exists.

The third major player in the history of the Twitchell collection was George Gustav Heye, who had helped fund Gordon's 1907 Alaska trip. Heye was a New Yorker of inherited wealth who used his fortune and the better part of his eighty-two years to amass the premiere Native American collection of all time,

27. Twitchell's grandchildren were unaware of the legacy he had left in New York until Margie Brown, on a visit to the Museum of the American Indian, stood in front of a case of Kuskokwim masks and heard a curator say, "These [masks] were collected by some Kuskokwim trader, a man named Twitchell." Brown recalled, "You could have pushed me over with a feather."

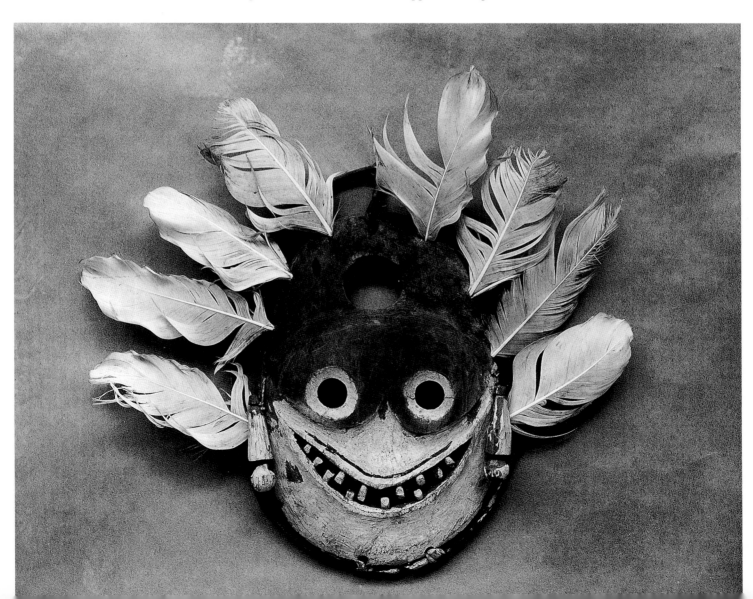

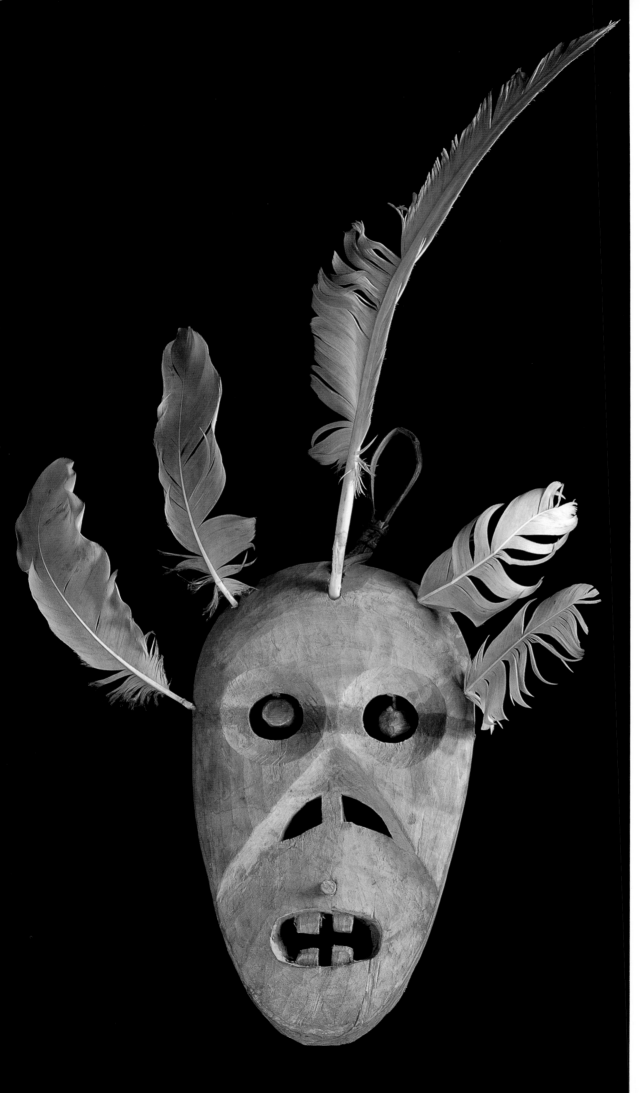

"Small mask representing young Avanak, the son of Avanak. This spirit is sent by his father to help and do errands for young medicine men." The eyeballs hang from string, and there is a mouthgrip on the mask's back. A black line runs across the eyes. Collected near Bethel. *NMAI, 9/3396 (50.8 cm)*

"Mask representing Isanuk [*asveq*], the walrus. This is the spirit that drives the walrus, sea-lions, and seals towards the shore so the hunter can get them." Twitchell collected three Isanuk masks near Bethel and sent them to Heye with identical descriptions, but the other two were sold out of the collection. *NMAI, 9/3398 (46.4 cm)*

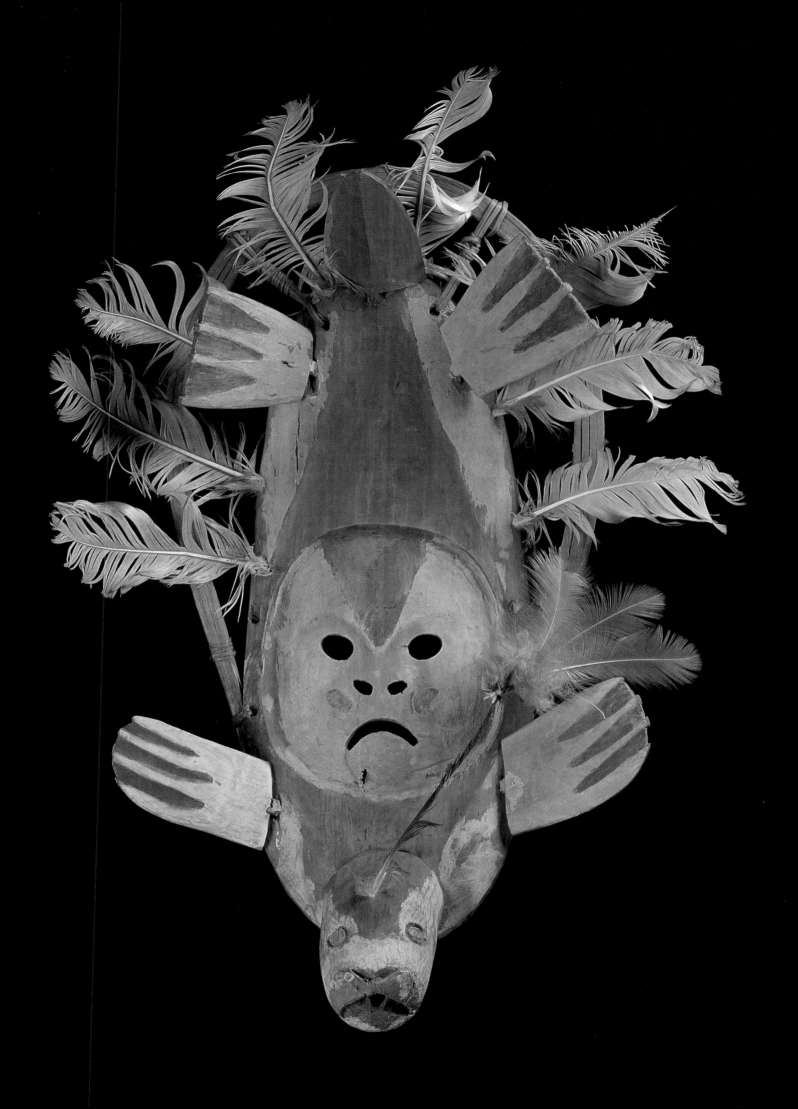

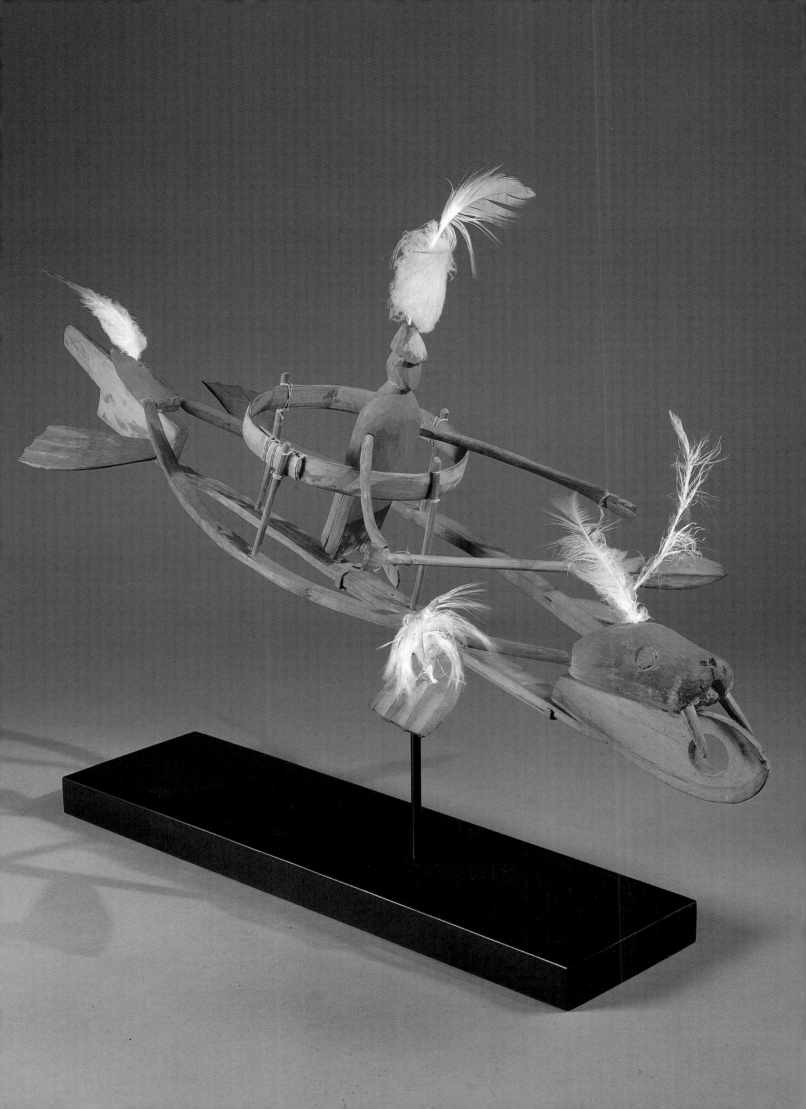

"Dance ornament representing a hunter with paddle, in boat, representing a combination of walrus (which he is hunting) and thresher shark, which catches anything it wants to." Collected and described by A. H. Twitchell along the Kuskokwim River in the early nineteen hundreds and sold to George Heye (NMAI 9/3445, 91.8 cm), who sold it out of his collection in 1957. The kayak was among a man's most prized possessions, as without it he could do no ocean hunting. The unusual feather attachments may relate to the bird form in which hunters were believed to appear in the eyes of the sea mammals they sought. *Property of the late Stanley R. Grant, New York, New York*

This dance object representing a small crane was stuck in the ground when the crane mask was used. *NMAI, 9/3436 (60.3 cm)*

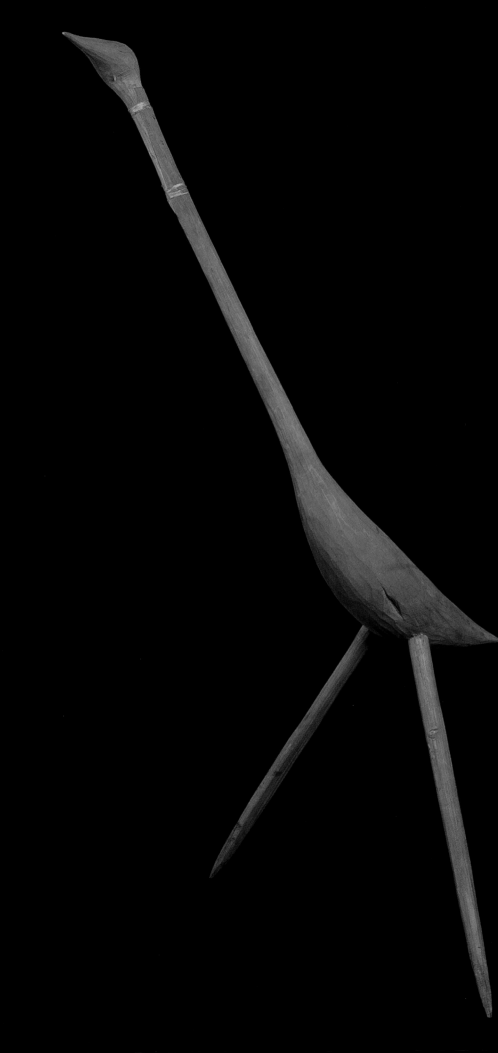

KUSKOKWIM
COLLECTIONS
AND
COLLECTING

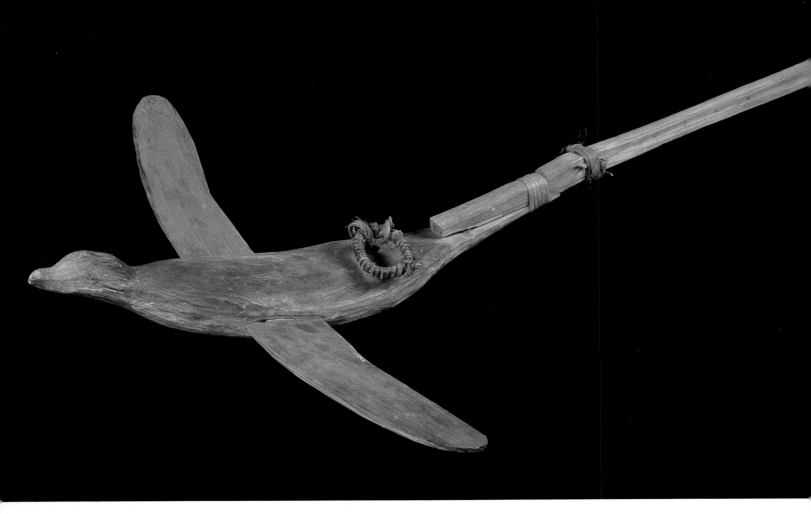

Kuskokwim dance ornament representing a goshawk, with the end of an arrow tied to its tail. *NMAI 9/3438 (69.2 cm)*

Drawing of one of the two "Amekak" (*amikuk*) masks sold out of Heye's collection in 1944. The three-color pattern on this mask (NMAI, 9/3400, 35.5 cm high) is the opposite of the "Amekak" mask remaining at the National Museum of the American Indian (9/3421; see p. 121). *RLN*

composed of 151,583 ethnological objects from virtually every state in the United States, Canada, Mexico, Greenland, and every country in Central and South America.

In 1908, the year Gordon acquired masks from Twitchell, Heye was looking for a place to house his already enormous and still-growing collection of North American holdings. Gordon offered Heye storage space, and the two men entered into an agreement. Gordon was justifiably delighted at acquiring Heye's extensive and valuable collections, which he believed Heye would one day bequeath to the University Museum. Heye not only had a place to store his specimens; the museum also provided him with exhibition space and the professional curatorial services he so badly needed (King and Little 1986:32–33).

Between 1908 and 1916 both the museum's and Heye's collections, which were cataloged separately, rapidly gathered artifacts from groups both men believed were vanishing. Their efforts were complementary, with Gordon focusing on Arctic and subarctic peoples, while Heye concentrated on the East Coast, Plains, and Northwest. Heye paid expenses for a small army of collectors and sponsored fieldwork for a number of young and promising anthropologists whose archeological and ethnographic finds added to his collection (King and Little 1986:39). Perhaps after Gordon's initial purchase from Twitchell, Heye contacted Twitchell independently to purchase his own exemplary Yup'ik specimens, but no trace of correspondence remains.

The collaborative collecting of Heye and Gordon was not to last. Railroad tycoon Archer Huntington designated sites in upper Manhattan for a cultural complex, including buildings for the new Hispanic Society of America and the American Geographic Society. Heye was a personal friend, and when Huntington offered him land for his own museum, he accepted. In 1916 he founded the Museum of the American Indian, Heye Foundation. Fifty-five Twitchell masks officially entered the books of the Museum in 1919, numbered, like every other specimen, in Heye's own hand. Heye may have acquired some of these masks directly from Twitchell, either before Twitchell left Bethel in 1916 or after his move upriver.

Heye moved his entire collection, as well as hundreds of specimens Gordon had collected, from Philadelphia to the new museum. Although Heye was careful to pay the natives from whom he collected artifacts, he was not above walking off with parts of collections with which he was associated, including those of both the American Museum of Natural History and the University Museum. The move left Gordon's systematically acquired collections in shambles (King and Little 1986:44; Mason 1958:14–17; Wallace 1960). Gordon lost records as well as artifacts, including the twenty-three pages of stories Twitchell sent down with the masks in 1908 and Heye entered into his accession records along with the date and place of

collection. Even these abbreviated "stories" add immeasurably to the masks' value.

In 1919 Heye logged 233 pieces of Kuskokwim material into his personal collection, sixty-four of which were masks and related dance objects. These grand mobiles, with moving parts, tinkling chips of wood, and hollow wind tunnels, were dramatically different from the smaller, more eloquent Yukon masks and the massive sculptural pieces from the lower coast. Heye would later refer to these elaborate, exaggerated masks as "jokes" (Carpenter 1975:10).

Many of the masks appear to be the creations of one or two carvers working together under someone's direction to produce masks for a single ceremony. And many are in pairs and threesomes. Accession records report thirty-four paired masks from "near Bethel," twelve specifically from twenty miles below Bethel at Napaskiak. They probably were used at the dances Twitchell wrote to Gordon that he had witnessed—among the last masked dances hosted along the Kuskokwim.

Besides pairing, the collection is remarkable for the Yup'ik names Twitchell recorded for each mask. Twitchell had the naturalist's penchant for recording detail, and in a number of cases he noted the masks' Yup'ik designations. This may seem a minor accomplishment, but of all the thousands of Yup'ik masks dating to the turn of the century, only those collected by Twitchell and, to a lesser extent, Jacobsen are accompanied by such information. Twitchell's years in Bethel and his Yup'ik wife likely gave him the necessary access and sensitivity, unparalleled even in Nelson's meticulous recordings. For example, one mask depicting an androgynous person with a downturned mouth under a heavy moustache and beard is said to represent "Kaarenta" (Qaariitaaq), the creature who licks clean the faces of painted children prior to the Bladder Festival. Younger Yup'ik men and women have heard of Qaariitaaq but never imagined that they might see its image.

Twitchell gave the name "Amekak" to another huge mask with toothy mouth, pointed ears, and wooden dangles that clatter when the mask moves. Twitchell's description of "Amekak . . . [which] lives in the ground and leaves no hole when it emerges," matches Yup'ik accounts of the creature *amikuk*, which sometimes appears in human form and can travel through land as if it were water (see Mary Mike's story, p. 120).

Had they remained together, the paired, named masks that Twitchell collected would constitute the premiere collection of Kuskokwim masks in the world today, but Heye's acquisition of the masks was but the first step in their journey into immortality.

### The Rape of the Heye, and Its Fine and Bright Progeny

In a biography of Heye published in the *New Yorker* several years after Heye's death, Kevin Wallace (1960:1) characterized the three-story brick research branch Heye built in the Bronx to store the diverse

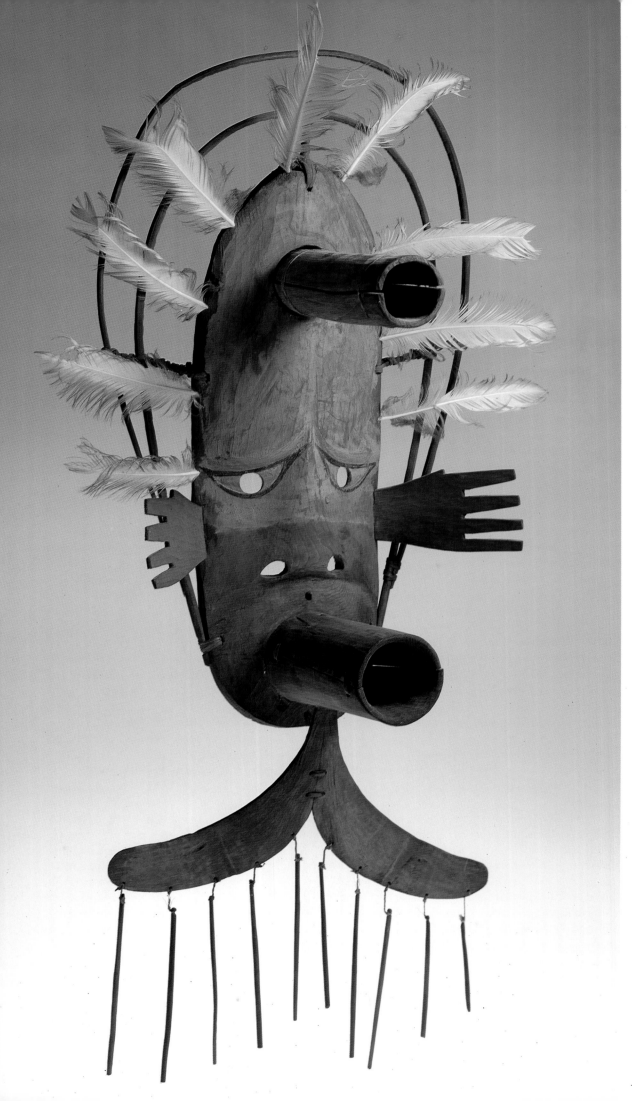

"Tomanik" mask from Napaskiak sold to Bernard Reis in 1944. Reis had two Twitchell masks occupying a prominent place in his living room. In the early 1940s the Surrealists regularly met and dined at his home, and it was there that André Breton staged his charades and riddles (Ted Carpenter, personal communication). *PC, formerly NMAI 9/3428*

Two Napaskiak masks representing "Tomanik" (Wind-maker). The white tube is for winter and the black for summer. *NMAI, 9/3427 (105.4 cm) and 9/3429 (78.7 cm)*

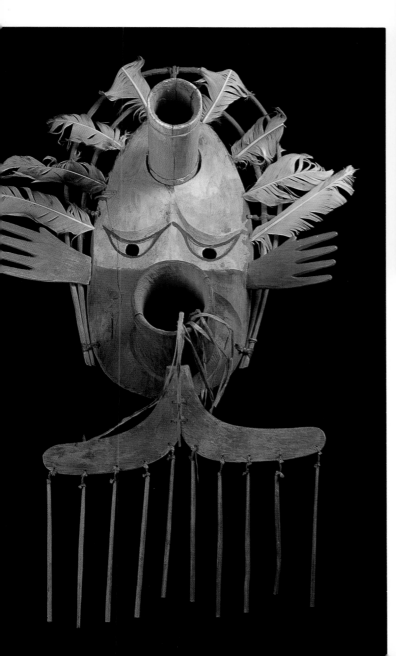
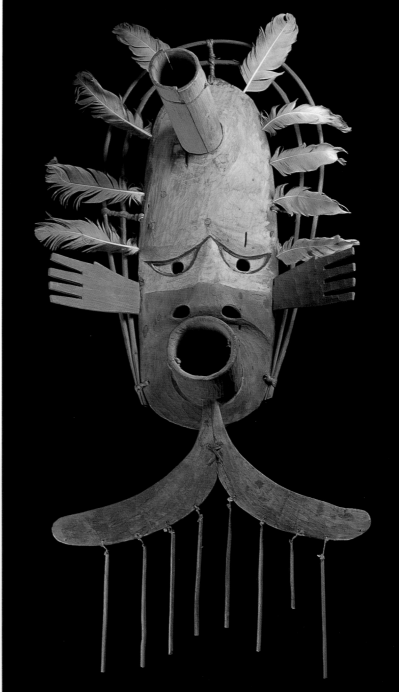

overflow from his collecting endeavors as a "Surrealist Macy's." During the 1940s this was quite literally the case, as artists and intellectuals visited the "Annex" and walked away with hundreds, if not thousands, of specimens.[28] Contributions from wealthy backers decreased during the Great Depression, and as Heye's own resources declined, he was forced to retrench. He cut back on expeditions and dispensed with his staff of anthropologists. He also sold or traded objects out of his collections to enable the museum to stay afloat.

Hard times, however, were not the only circumstance that undercut the integrity of Twitchell's unique collection. In the end its very strength—masks in pairs and threesomes—proved its downfall. Perhaps more significant than financial considerations was museum policy that viewed the marvelous pairing of masks as spurious repetition. Even today National Museum of American Indian policy reads: "When the Museum has duplicate material . . . [it] will consider disposition" (Carpenter 1991:16). Consider they did, and only a handful of mask pairs remain intact.

Between 1944 and 1969, thirty-two of the fifty-five masks Twitchell sent east from the Kuskokwim were "deaccessioned," sold for between $38 and $54 each. New York art dealer Julius Carlebach purchased twenty-six of these masks between 1944 and 1946. During the 1940s he purchased at least sixty-four masks from Heye's collection, including two masks Gordon had collected on the Kuskokwim, five from Goodnews Bay, and sixteen Athapaskan masks from Anvik.

Carlebach was not speculating—he was filling orders for clients passionately interested in acquiring the masks. They visited the Bronx with Carlebach and "shopped" in Heye's Annex, picking and choosing the best of the Twitchell material, which Carlebach later delivered to them in his Third Avenue gallery. Today, a collector must be wealthy to own a Yup'ik mask, which commands between $100,000 and $300,000 at auction. In 1944 this was not the case. Carlebach's clients mostly were expatriate intellectuals and artists, then of little means and uncertain futures, including such future luminaries as André Breton, Claude Lévi-Strauss, Roberto Matta, Max Ernst, Georges Duthuit, and Robert Lebel (Carpenter 1975:9–10; 1991:16).

Living out the war years in New York, this intense group scoured the city for grist for their mill and "discovered" Native American art in the American Museum of Natural History, the New York City Public Library, and, finally, in Carlebach's gallery. Max Ernst was the first to see the masks at Carlebach's, and he passed the word to Lebel, Breton, and others. Lévi-Strauss and Lebel were working on French radio at the time, making $100 a month. What they bought with their pennies changed history—both the masks' and their own.

Lévi-Strauss (1982:9–10) described the war years: "Max Ernst, André Breton, Georges Duthuit, and I did gather more modest collections, sharing among ourselves, according to the funds available, the pieces for sale at New York antique dealers. It was a time when these works did not arouse any interest, which, in itself, seems like a myth today." Lévi-Strauss was most impressed by Northwest Coast art, to which he admits an "almost carnal bond," but he saw and admired the Yup'ik masks:

Carlebach did not sell me any Yup'ik masks as I was concentrating on Northwest Coast. Of course I had many occasions to see the masks bought by Breton and Lebel (my acquaintance with Matta was slighter) and I greatly admired them. As a matter of fact, my interest in masks from the lower Kuskokwim had been already aroused by the plates in Nelson's *The Eskimo about Bering Strait* with which I was familiar. (Lévi-Strauss, personal communication, September 18, 1994).

28. Edmund Carpenter (1991:15), a former trustee of the museum, wrote that between 1940 and 1980 more than 91,000 specimens were traded, sold, stolen, or given away and that "these were not arrowheads."

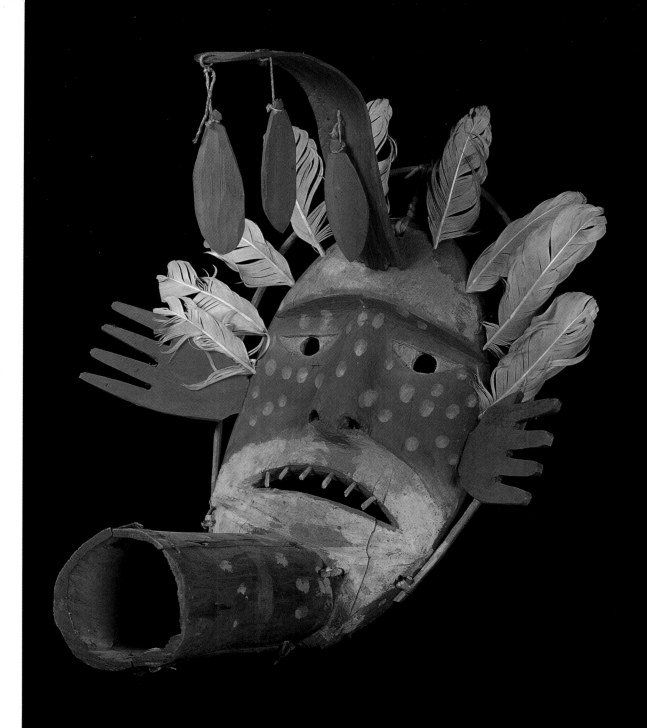

Robert Lebel made this drawing of Reis's "Tomanik" mask on a visit to his friend's New York apartment. Lebel's interest in Yup'ik masks was far from superficial and included careful cross-referencing and attention to Yup'ik iconography. Below the drawing he noted the story of the raven and whale recorded in Nelson's (1899:465) "18th Report": "From a tube that extended along the whale's backbone, oil was dropping slowly into the lamp." Lebel also drew two other masks he saw with comparable tubes and wooden "drips," one purchased by Enrico Donati (formerly NMAI, 9/3389) and one by Dolores Vanetti (formerly NMAI, 9/3393). *RLN*

One of four Kuskokwim masks representing "Negakfok" (*negeqvaq,* "north" or "north wind") collected by A. H. Twitchell near Bethel in the early 1900s. *NMAI, 9/3431 (50.8 cm)*

Lévi-Strauss's heady introduction to North American art and mythology deflected him from his work in the Amazon and marked the beginning of his development of structural anthropology. He saw in the masks evidence of the "deep structures" of the human mind, structures he spent the rest of his life elaborating.

The Yup'ik masks' impact on the Surrealists was even greater. Whereas Lévi-Strauss responded to the inherited traditions embodied in Native American "objects of bright pride," the Surrealists were struck with their ephemeral and strident individuality. They saw in them redemption from their own sullied heritage. The Surrealists approached Native American art in general, and Yup'ik masks in particular, with a sense of "raw wonder." In 1943 Adolph Gottlieb wrote,

That these demonic and brutal images fascinate us today is not because they are exotic nor do they make us nostalgic for a past which seems enchanting because of its remoteness. On the contrary, it is the immediacy of their images that draws us irresistibly to the fancies and superstitions, the fables of savages and the strange beliefs that were so vividly articulated by primitive man. (Varnedoe 1984:624)

Although European museum collections in Berlin, Basel, and Copenhagen included Yup'ik masks before the 1940s, the masks were exhibited only in Berlin and so were not widely known. Heye had sold some masks to Charles Ratton, a French dealer, who exhibited them in his Paris gallery in 1931–32 and again in 1936 (King 1992:13), but none of the Twitchell masks was included in these showings. The doors in Carle-

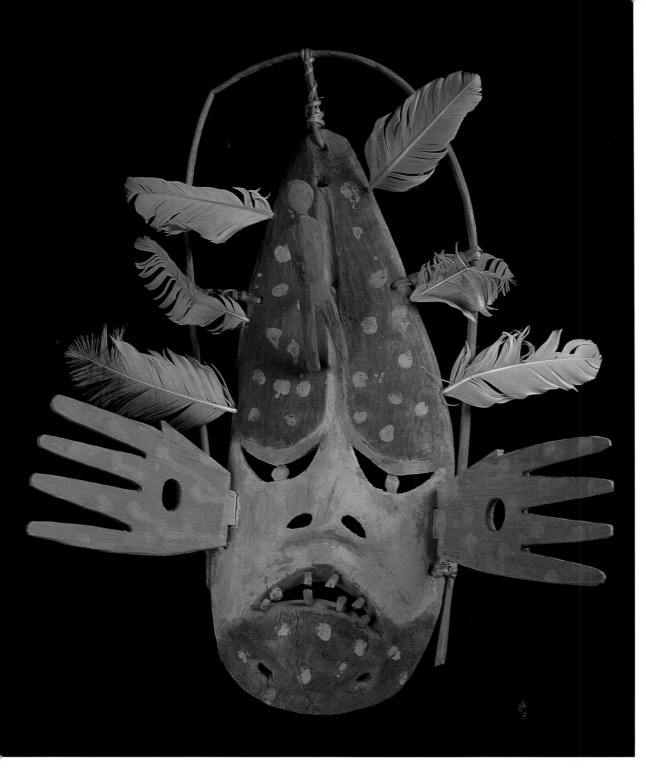

Mask representing "Cha-larok" (*calaraq*, "east" or "east wind") from Lomarvik (Luumarvik), near Bethel. Perhaps this and the nine related wind masks Twitchell collected were used to dramatize a story such as that recorded by Nelson (1899:497–99) on the origin of the winds. Good winds were critical to hunting, and weather masks were not uncommon. *NMAI, 9/3394 (54.6 cm)*

Lebel's drawing of another elaborate Twitchell mask Carlebach purchased in 1944 and sold to Donati. Lebel noted its accession number (NMAI, 9/3389), height, and length and wrote "tube-air hole in the ice, chimney of a kashim. whale and oil drops." This was shorthand for Twit-chell's original description: "Mask representing Oangi-luk [*ungalaq*, 'south' or 'south wind'], the rain spirit that brings warm weather. He is supposed to be in the South facing the Kuskokwim country. When the wind strikes him in the rear, he spreads out his hands, and as the wind and rain pass through him they become mild and warm. The wind passes through the large tube." *RLN*

bach's gallery opened wide on unimagined vistas. Almost overnight, Yup'ik masks won a place of distinction in the modern world.

The Surrealists were among the first to see Yup'ik masks as "primitive art" and to use them as inspiration for their own work. It was an exciting time in New York, with immigrant artists and writers gathered in Peggy Guggenheim's apartment to talk about and learn about Yup'ik masks. In his 1941 article on Cuban painter Wilfredo Lam, Breton emphasized the passionate relationship between the Surrealists and the objects of the Native Americans they so admired: "The modern eye has gradually taken in the endless variety of these objects of so-called 'savage' origin . . . and aware at last of the incomparable resources of the primitive vision, has fallen so in love with this vision

that it would wish to achieve the impossible and wed it" (Maurer 1984:578–80).

Men such as Breton, André Masson, Ernst, Yves Tanguy, Wolfgang R. Paalen, and Lam came to America seeking political refuge and went away with a new awareness of and appreciation for the importance of Native American cultures (Maurer 1984:578). During World War II they diverged from the Cubists' original focus on Africa in favor of South Seas, Northwest Coast, and Inuit art (Varnedoe 1984:621). The exaggerations and omissions of the Surrealist Map of the World reveal the Surrealists' sources of inspiration. Alaska looms large on this map, as do Labrador and Russia, while the United States, France, Britain, and Canada are almost nonexistent (King 1992:13).

"Eskimo Idiom" by Mark Tobey, 1946. Tempera on board, with splayed figures representing the Yup'ik masks that were his inspiration. *SAM (110.5 × 70.5 cm)*

In 1944 Robert Lebel created one of the most remarkable legacies of this intense period of interaction between Yup'ik masks and their Surrealist admirers. Lebel was deeply involved in the New York Surrealist movement and was especially impressed by the work of Breton. He purchased ten masks from Carlebach (two of which Twitchell had collected), and his son Jean-Jacques Lebel still caretakes these masterpieces in his Paris apartment. Studying alongside Breton and the others, Lebel carefully documented his own masks as well as those of his friends. In a small, lined notebook Lebel rendered color drawings of fifty-six masks, forty from Museum of the American Indian collections. At the upper right corner of each page he wrote the initials or surname of the artist or poet who purchased the mask—R. L. for himself, A. B. for André Breton, I. W. for Isabel Walberg, Donati for Enrico Donati, and Duthuit for Georges Duthuit. Many of the masks remain in the possession of the descendants of these individuals.

Lebel's notebook is invaluable for a reconstruction of the masks' history and influence. Not only does it identify owners, but in neat script Lebel recorded information concerning each mask. Carlebach supplied him with a list of the masks he had purchased from the Heye Annex, and Lebel copied some of this information as notes on each piece, including museum accession numbers and information on the masks' use. Lebel also included information on matching masks still at the Museum of the American Indian as well as information on similar masks pictured in Nelson's *Eskimo about Bering Strait*, which he simply referred to as the "18th Report." Nelson's richly illustrated five-hundred-page treatise was not a popular trade book but a government publication, and Lebel's references are only one indication of how thoroughly the Surrealists did their homework.

As Lebel's meticulous notebook documents the trajectory of each mask, the artistic creations of individual Surrealist artists testify to the enduring influence of individual pieces. Mark Tobey paid explicit homage to Yup'ik masks in his 1946 tempera painting "Eskimo Idiom," which splays flat the layered complexities of one of the Kuskokwim Wind-maker masks sold out of the Annex. In "Hearing with the Eye," Carpenter (1972:29, 31) wrote,

I don't regard as accidental the close parallels between Eskimo art and the work of Klee and Miro. In each a structuring of space by all the senses. . . . The [Kuskokwim] masks are complex mobiles with extensions and moving parts, like dissected Miros reassembled in three dimensions. No borders freeze, imprison. Instead, each mobile, obedient to an inner impulse, asserts its own identity, unhampered by external restraints.

Matta was another dedicated admirer of so-called "primitive art" and developed a large collection of tribal objects (Maurer 1984:577). Like many artists on both sides of the Atlantic, he borrowed freely from them.

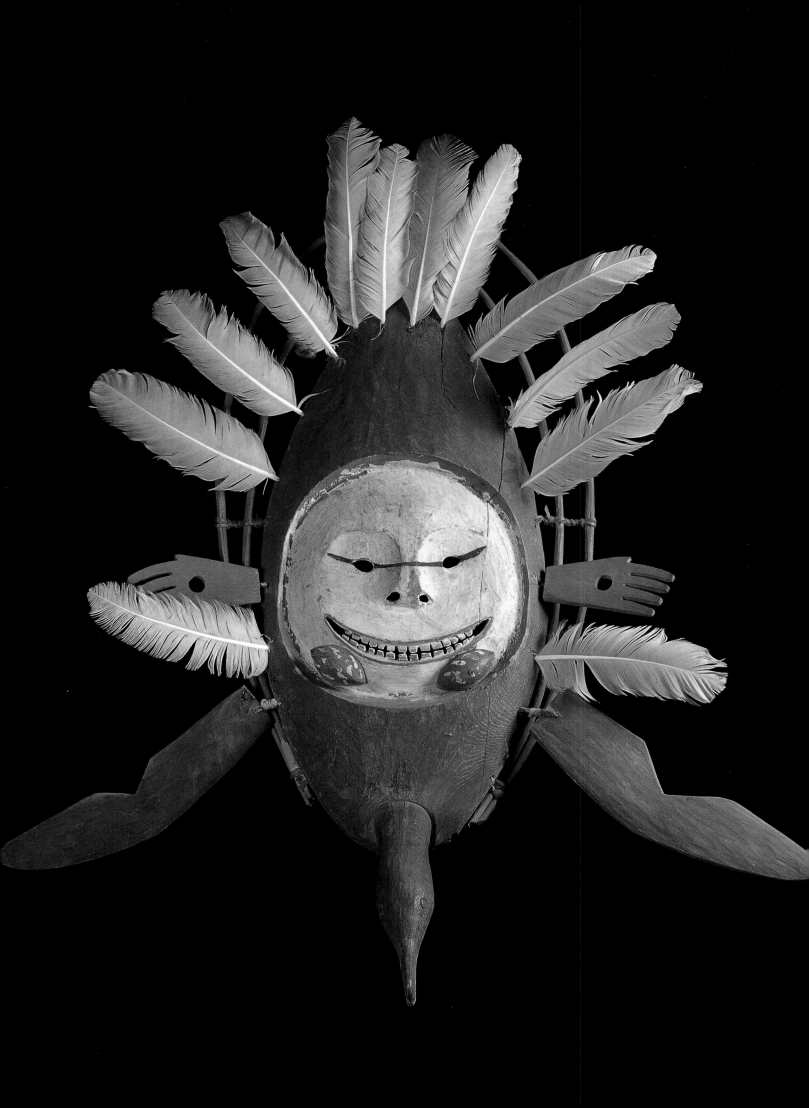

Twitchell mask representing a bird with a face carved on its back. Frederick J. Dockstader refurbished the mask during his tenure as director of the National Museum of the American Indian. *NMAI, 9/3388 (58 cm)*

Julius Carlebach purchased the bird mask's mate in 1944 and sold it to Robert Lebel, whose son, Jean-Jacques Lebel, now owns it. Under his sketch of the mask, Lebel wrote, "cf. 18th rep. [Nelson's *The Eskimo about Bering Strait*] Pl C No. 2. Cape Romanzof south of the mouth of the Yukon. Represents a guillemot swimming on the surface of the water. The head and neck are separated and fastened to the body by a peg. The face on the back represents its *inua*." Lebel also noted the mask's accession number (NMAI, 9/3415), identifying it as one of the Twitchell masks. *RLN*

One of a pair of raven masks, both sold to Carlebach in 1944. Lebel noted the mask's "mate" (formerly NMAI, 9/3433), purchased by Isabel Walberg. Both came from near Bethel, and Twitchell labeled them "Doologiak" (*tulukaruk,* "raven"). Although Yup'ik depictions of Raven the Creator are considered rare, both Twitchell and Geist collected pairs of such masks in the early 1900s. *RLN*

DONATI
9
3395

H 9½
L 11½

lune

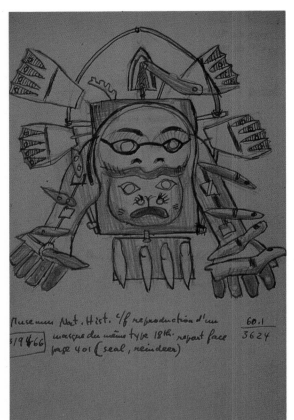

Musemum Nat. Hist. c/f reproduction d'un
masque du même type 18th. voyant face
page 401 (seal, reindeer)

60.1
3624

5/9466

Another small Kuskokwim mask collected by Twitchell in the early 1900s, sold to Carlebach in 1945, who in turn sold it to Donati. Twitchell recorded no information about this piece, but Lebel identified it as the moon. The mask is similar to the moon mask Sheldon Jackson acquired from Andreafski a dozen years before (see p. 168). *RLN*

The American Museum of Natural History, whose Northwest Coast collections so intrigued Lévi-Strauss, also exhibited Yup'ik masks, such as this elaborate piece sketched by Lebel, who noted a similar seal/reindeer mask illustrated in Nelson's (1899:401) "18th Report." *RLN*

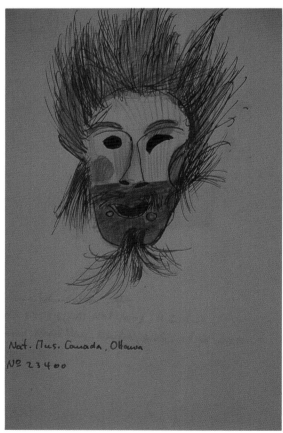

Nat. Mus. Canada, Ottawa
Nº 23400

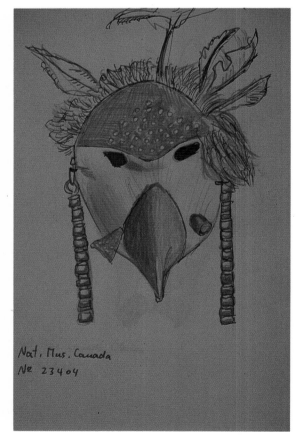

Nat. Mus. Canada
Nº 23404

Lebel studied masks in books as well as in museums. These masks at the National Museum of Canada in Ottawa were collected by Ernest Hawkes and illustrated in his 1913 publication on the St. Michael "Inviting-In" Feast. One is a comic mask. Hawkes designated the other a crow mask, but in fact it is Raven. *RLN*

The Surrealists also admired simple creations such as this small mask (top left) on display at the American Museum of Natural History (see p. 260). This style was common on the lower Yukon, and Edward Nelson, J. H. Turner, and Sheldon Jackson all collected examples. *RLN*

George Heye purchased twenty-nine masks with an Anvik provenance between 1916 and 1938, of which George Emmons had collected at least one, Joseph Chilberg at least two, and D. F. Tozier at least two. Although accession information is scanty, the masks—including several massive pairs—are striking. The Anvik masks impressed the Surrealists almost as much as did the Twitchell pieces, and they purchased at least twelve of the sixteen that Carlebach bought from Heye, including these three (top right, bottom left and right). Ironically, perhaps, this Anvik infatuation pays indirect homage to Yup'ik masks, as the Athapaskans borrowed their style of mask-making (as well as many other things) from their Yup'ik neighbors. Given the scanty and unreliable character of the masks' accession information, some of them may in fact be Yup'ik.

The half-walrus/half-caribou mask is similar to a pair of walrus/caribou masks still in the National Museum of the American Indian (11/3989 and 11/3991). The large plaque mask with appended thumbless hands and air bubbles is similar to two masks collected by the Alaska Commercial Company without date or provenance and assumed by Ray (1967:171, 180) to be from Nushagak (see p. 143). *RLN*

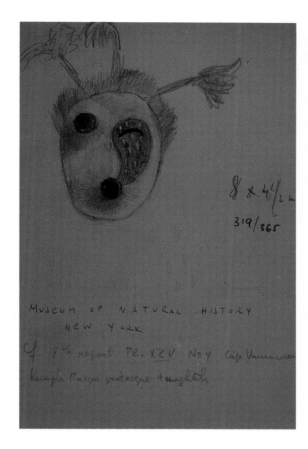

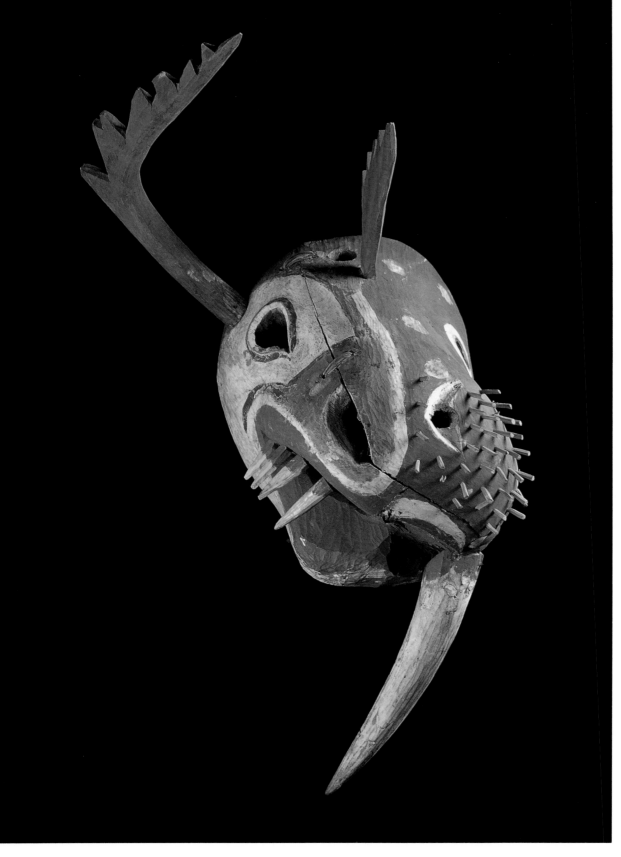

Pair of massive walrus/caribou masks from Anvik, sold to Heye in the early 1920s. As in so many masks, the countenance is divided—in this case between an important land animal and a sea mammal. *NMAI, 11/3989 (53 cm) and 11/3991 (36.8 cm)*

Mask representing "Uksoak," the "spirit of autumn" (*uksuaq,* "fall"). Twitchell sold a matching pair of "Uksoak" masks to Heye, who sold both in 1944 to different buyers. *RISD, formerly NMAI, 9/3425 (29.9 cm)*

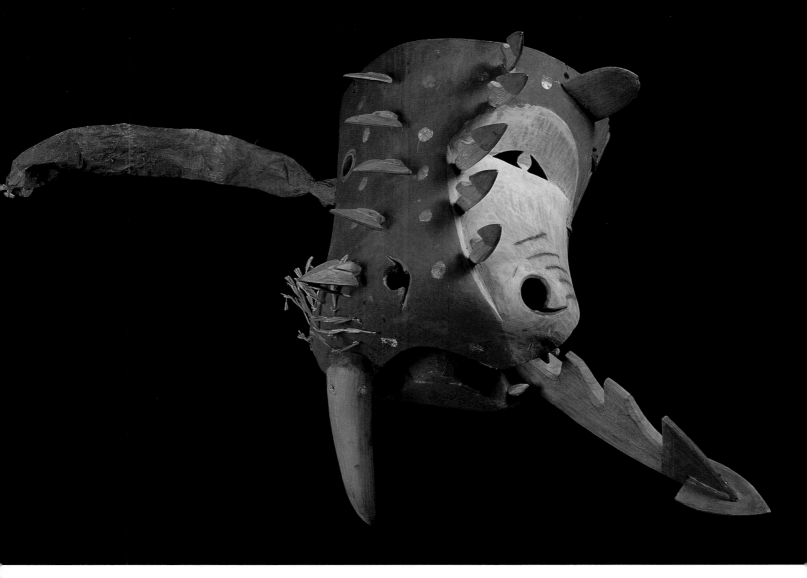

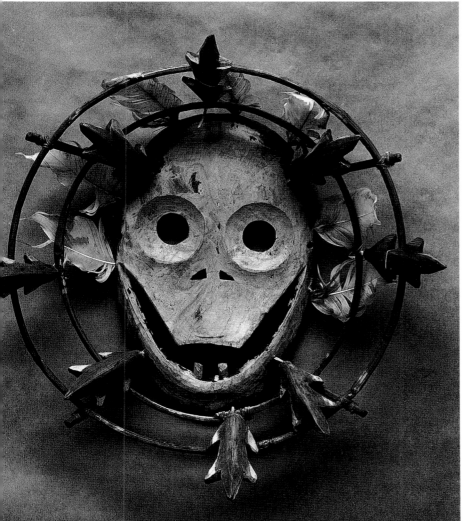

The masks deeply influenced artists both in New York and Paris where, after the war, many of the deaccessioned masks were taken. Breton's famous book *L'Art magique* (1957) reproduced in color the Kuskokwim masks he kept hanging on the walls of his Paris studio. Even the great Matisse fell under Yup'ik influence when he saw the masks (including one pair) that his son-in-law, the writer Georges Duthuit, brought home from New York.

A collection was dismembered in the 1940s but a future transformed. Heritage turned into parent in the tradition of the bricoleur. That the paired masks Twitchell appropriated were broken apart in the process of their "appreciation" is perhaps tragic, yet what a greater tragedy had the masks remained invisible. Heye's collection languished in the Annex for another fifty years, while those that circulated engendered an unparalleled enthusiasm and creative appropriation. Not that the masks left at the Heye went entirely unmarked by history—in the 1960s museum director Frederick Dockstader "refurbished" more than a dozen Kuskokwim masks, including some Twitchell pieces. Painted from the same pot, the masks acquired a false appearance of relationship, and their points of origin were obscured.

On the other hand, the masks that Heye sold or traded away continue to be shown both at home and abroad. As recently as 1991 Breton's masks, along

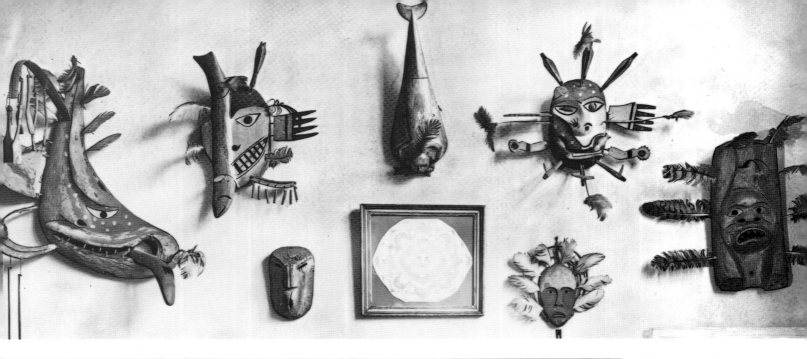

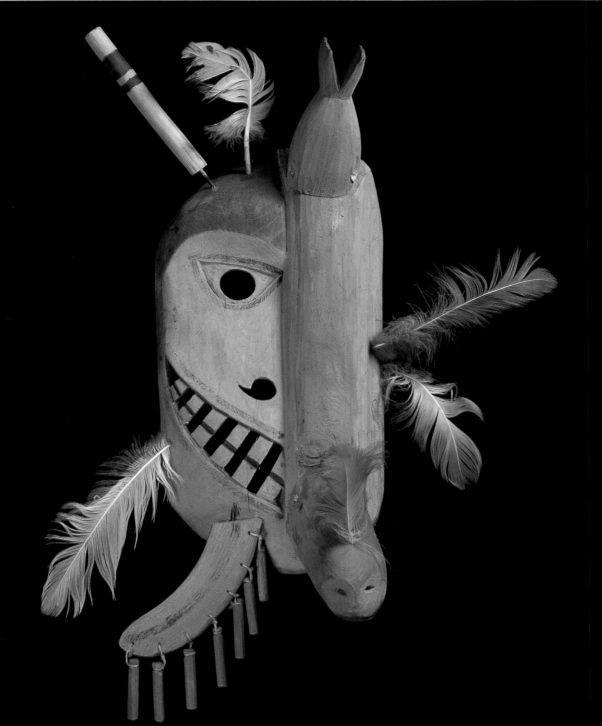

Eskimo masks in the collection of André Breton, Paris, 1955. The elaborate mask on the far left was one of a pair of swan masks in the Twitchell collection. *L'Oeil magazine international d'art, Paris*

Mate of the grinning mask with divided countenance that Breton took home to Paris. The pair was collected at Goodnews Bay in the early 1920s, and this one remains at the National Museum of the American Indian. *NMAI, 12/910 (49.5)*

Lebel's drawings of the elegant pair of swan masks Twitchell collected at Napaskiak and Carlebach purchased in 1944. André Breton acquired the red and white bird (NMAI, 9/3410), while Georges Duthuit took the blue one (NMAI, 9/3409, 54 cm). Lebel did not illustrate the pair side by side, but he did cross-reference his drawings, noting that Duthuit's mask was reproduced in Frederic H. Douglas and René d'Harncourt's *Indian Art of the United States* (see also Fienup-Riordan 1994:135).

Twitchell described the red and white mask as a swan that drives white whales to hunters in winter, and the blue mask as a swan that drives the whales in spring. *RLN*

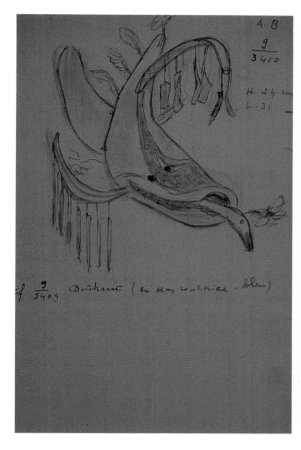

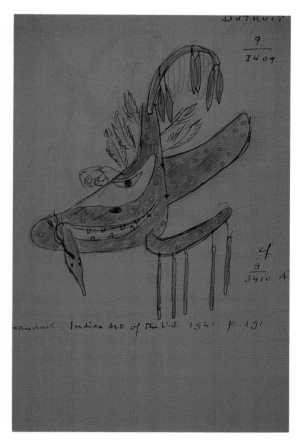

Small mask representing "Akasta" (*akerta,* "sun"), collected by Twitchell at Napaskiak (NMAI, 9/3411, 23 cm). Carlebach purchased it in 1945 and sold it to André Breton. Lebel made this drawing on a visit to Breton's New York apartment, cross-referencing the mask with a similar piece Nelson (1899:404) illustrated and noting that the labret indicates that it is a woman's face. This is important information, as in Yup'ik cosmology the sun is a woman pursued by her brother or nephew, the moon. *RLN*

Goodnews Bay mask purchased by Breton from the Heye collection (NMAI 12/921, 24.5 cm). Lebel noted in his sketch that the mask had a mate constructed in the opposite direction, and compared the mask to ones described by Nelson (1899:412): "Animal figures attached around the mouth. Represents the tunghak of some being which controls the supply of game. It is usually represented as living in the moon. The shaman pretends going to him to make offerings in order to return their luck to the unlucky hunter." *RLN*

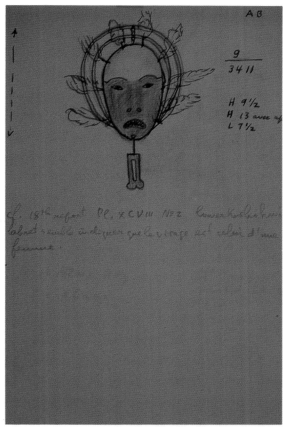

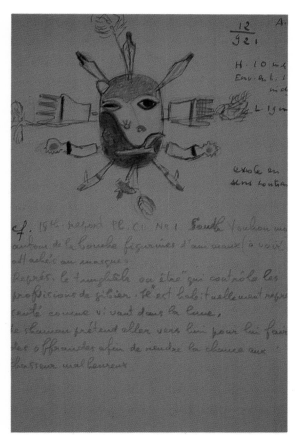

KUSKOKWIM
COLLECTIONS
AND
COLLECTING

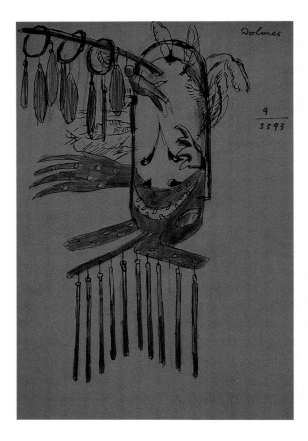

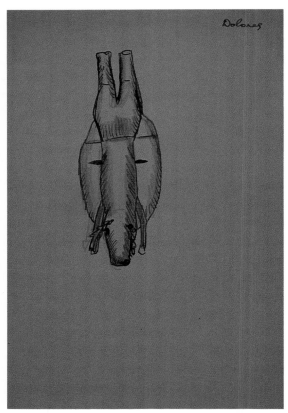

Lebel's drawings of two fine masks Carlebach sold to Dolores Vanetti in 1944. The masks subsequently passed through a number of hands and today are at the Metropolitan Museum of Art. Twitchell collected the "Negagfok" mask at Napaskiak (see p. 170), and the caribou-person is unattributed (see p. 75). *RLN*

The toothy-mouthed bird mask worn by the *angalkuq* in the photograph "Working to Beat the Devil" (see p. 189) made its way from Nushagak to New York after Thwaites's photography session. While the hands gathered dust in the Museum of the American Indian's Bronx annex, the mask attracted the attention of the Surrealists. Wolfgang Paalen purchased it in 1939, and it remains in private hands. Sotheby's auctioned it in 1995 for $51,000. *Formerly NMAI, 15/4344 (44.5 cm), Sotheby's photo*

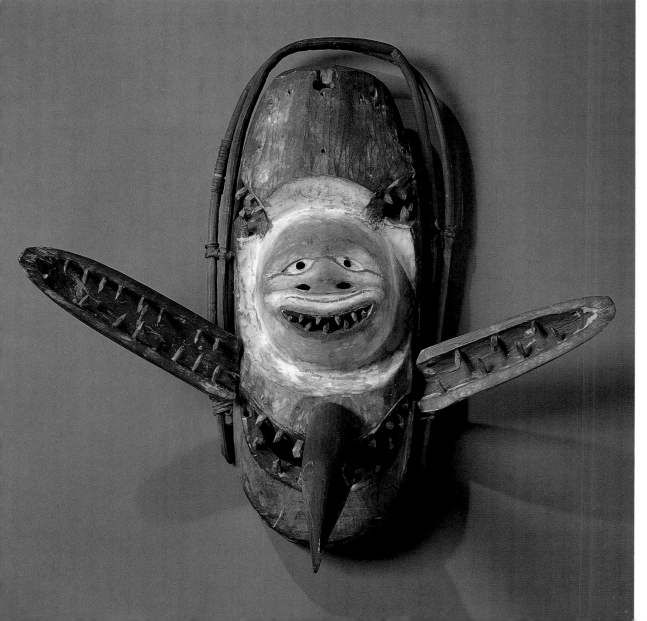

with several of Lebel's, were shown at the Pompidou Center, where they were the hit of the Paris art season (Breton 1991). The Metropolitan Museum of Art purchased a Twitchell mask in 1961. In 1952 Nelson Rockefeller acquired another fine Anvik mask Heye had sold to Wolfgang R. Paalen in 1939, and in 1979 Rockefeller bequeathed it to the Metropolitan (see p. 20). Today the masks hang side by side for all to see—"class 1" art objects divorced from any shred of Yup'ik context, but testimony to the place of Yup'ik art in "the West's incorporation of the rest." Taking our primacy for granted, many have commented on the surreal character of Yup'ik masks, with their exaggerated and distorted features, formal dispersal of parts, and incorporation of space. One might better speak of the Yup'ik character of the creations of the Surrealists, who carefully studied the Yup'ik masters and put what they learned to good use.

### Kuskokwim Masks Collected by Robert Gierke

The year A. H. Twitchell arrived in Bethel, Robert Gierke set out from San Francisco to make his fortune in the North. A twenty-three-year-old Wisconsin native, Gierke arrived in Bethel in 1905, and he, too, had trading on his mind. But unlike Twitchell, who established himself in Bethel, Gierke originally worked near the mouth of the Kuskokwim and along the coast between Bristol Bay and Nelson Island, operating through a network of native traders. Later he established a general mercantile store at Bethel, where he lived and worked until 1941, when he moved to Seattle.

Gierke married a Moravian schoolteacher in Bethel in 1920. The Reverend Ferdinand Drebert (1920) commented to Bishop Edmund de Schweinitz on the wedding:

Last night I had the honor of marrying Robert Gierke and Elizabeth Mewaldt here in the Bethel church. Practically all the white people were present. After the ceremony ice cream and cake were served to everybody. My wife and I cannot help but think that it is a strange union to have a missionary married to a fur trader. As far as the man is concerned we have not the least doubt of his integrity. He is a real gentleman as far as we can tell. But we are afraid that his calling cannot very well go hand in hand with missionary work if he uses the methods that practically all the traders do. However it is not impossible if he has the real welfare of the people at heart.

Over the years Gierke proved Drebert's fears unfounded. He acquired a reputation as a fair trader among the local population, and both he and his wife were well regarded by natives and nonnatives alike.[29]

Gierke had an opportunity to see and to purchase many things during his thirty-six years living along the Kuskokwim. Similar to Twitchell's acquaintance with Gordon, Gierke met and assisted the anthropologist Ales Hȓdlička during his fieldwork along the Kuskokwim in the early 1930s. Gierke subsequently donated specimens for the Smithsonian collections, which Hȓdlička took back with him to Washington, D.C. Although Gierke's interest in natural history and collecting may not have matched Twitchell's, he gathered a substantial collection over the years. Some items he purchased and others he received as gifts, including ivory carvings, household items, baskets, and wooden and stone weapons and tools. Along with these ethnographic objects, Gierke collected a number of souvenirs, including letter openers, napkin rings, baskets, and a cribbage board. Perhaps his most valuable acquisition was a group of twenty-six paired masks.

Years later, Gierke's son described how his father got the masks. It was late fall, and the people along the lower Kuskokwim had had a poor fishing season. Food shortages during the coming winter seemed imminent. Gierke and a Bethel missionary sailed downriver and helped in a beluga drive. They used their boat to drive the whales into a slough, where more than a dozen were stranded at low tide, providing thousands of pounds of fresh meat. The two men immediately returned to Bethel, and that night the river froze. Their aid had come none too soon and helped avert disaster.

Gierke had told people in the past that he wanted dance masks, but no one ever had any to sell. Later that winter, however, Gierke's daughter saw someone doing something near the steps of their Bethel store. She told her father, and he went to check. Outside he found a pile of masks, many disassembled. The trader collected the parts and put them in a box, where they remained for the next fifty years. Unlike Twitchell, who had bought and sold masks, Gierke's masks were a gift he would never sell.

When Gierke retired in 1941, he moved to Seattle, where he worked in the Ballard shipyards and, during the war, for Standard Oil. For the next thirty years the masks found on his store's steps remained packed away in boxes under his house. After his death in 1978 his children put the still-unopened boxes on someone else's steps—those of the University of Washington's Thomas Burke Memorial Washington State Museum, where the 350 objects constitute the Burke's largest single collection of Bering Sea material.

The masks are a particularly important part of the collection, examples of a period and style not well represented in any museum. These rough-cut masks provide sharp visual contrast to the finely crafted mobiles Twitchell acquired from the same area a decade earlier. The encircling rings are crooked, some more square than round, with broken rather than bent corners. Joints are not neatly spliced but crude and overlapping. This rough craftsmanship may reflect a decline in the fine art of carving as the masked dances came under persistent missionary attack, or it may reflect the masks' place in performance—as stage props rather than heirlooms. Yup'ik dances may have regularly involved masks of crude as well as elegant workmanship, but collectors probably

29. George Keene and Elena Charles of Kasigluk remember teasing Mrs. Gierke about her traveling, trader husband. As children they could make her blush when they sang, "Bobby Shafto's gone to sea, silver buckles on his knee, he'll come back to marry me, pretty Bobby Shafto."

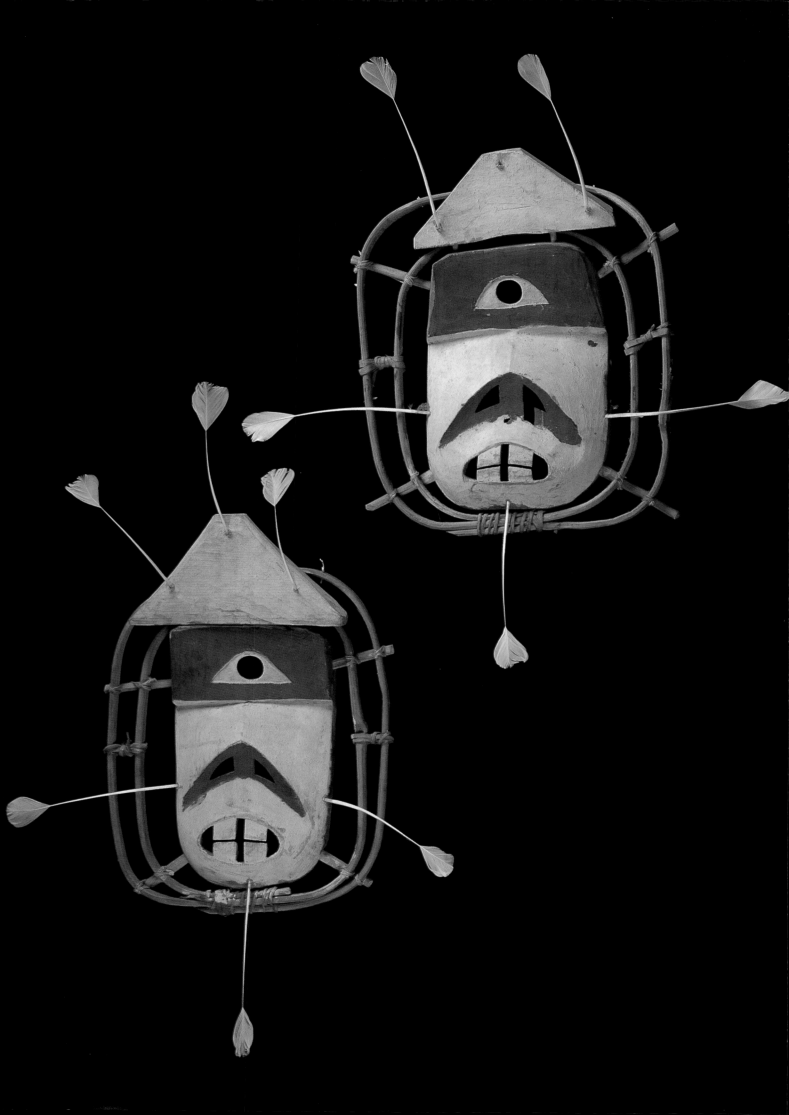

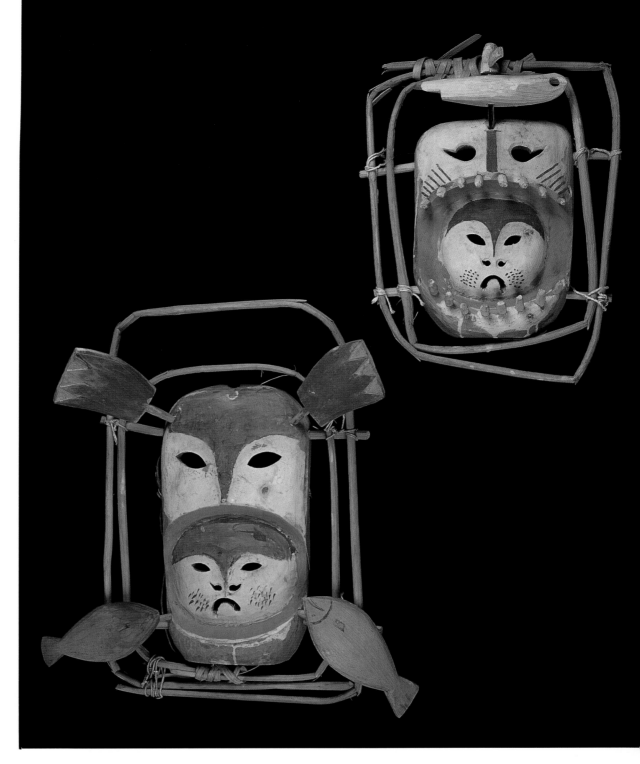

Pair of one-eyed masks collected, along with the masks in the following six illustrations, by Robert Gierke in the 1920s. Wooden appendages rather than feathers probably originally projected from the masks' rims. Empty holes with broken feather shafts around the bentwood *ellanguat* indicate that appendages are missing.

Mary Mike (February 25, 1994) told a story about a boy with one eye:

*This mask has one eye, a nose, and a mouth. Have you ever heard a story about something that had one eye?*

*I've heard a quliraq [traditional tale] about a creature with one eye. It is a story about [someone's] grandson arriving in a village. He hid himself and observed the village. While he was watching, a young boy about his age came out of a house. He probably was someone's grandson. He had one eye. It was his only eye.*

*His name was Inglupgayuk. After being curious for some time, [the other boy] asked him what he was. He told him he was Inglupgayuk. He would always hop around on one leg. His grandmother and he had a house at the end of the village. He had one eye. Perhaps the mask is an image of him.*

*Burke, 1.2E632 (31 cm) and 1.2E633 (34 cm)*

Pair of rectangular animal face masks, from the mouths of which seal faces emerge. The rings on both are rough and broken at the corners, without holes for attachments, and are held together with cotton string, as those on other masks Gierke acquired. The masks' similarity has diminished over time, as one has retained its flipper and fish appendages but lost the image attached to the top of

preferred the latter. Gierke, however, did not choose his masks. They were chosen for him.

As important as the shape and style of each individual mask in Gierke's collection is their unique relationship to each other. Unlike any other collection of Yup'ik masks, they appear to have been used as part of a single ceremony. Had the Twitchell collection remained intact, it, too, would have provided a material record of discrete events. Just as the spectacular character of Twitchell's masks led to their dispersal, the relatively plain appearance of Gierke's masks may have been their salvation.

Again, pairing of masks is the rule rather than the exception. Only three of the twenty-six masks appear unrelated, but this individuality may be more apparent than real since the masks were probably all related through the stories the dances told. Although the pairs and groups of masks remain intact, we know nothing about the stories they embodied. Unlike Twitchell, who saw the masks presented and wrote down their stories, Gierke never saw them in performance. Finding the masks partly disassembled only exacerbated his ignorance. Moreover, Gierke removed even more appendages when he packed the masks for shipping to Seattle. As the masks were not unpacked until after his death, he took what information he had on the position of particular parts with him to his grave. Thus, the Gierke masks presented museum curators with a monumental jigsaw puzzle when they arrived at the Burke, a puzzle that may never be entirely solved.

The Burke consulted a number of native and non-

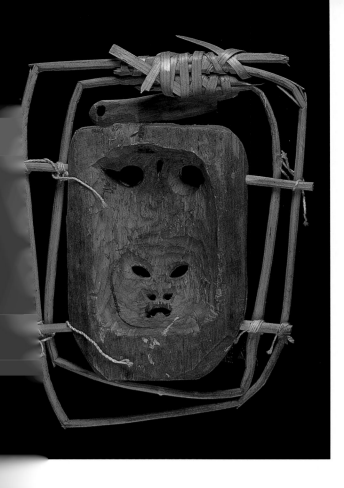

native experts during the masks' restoration. Some parts were relatively easy to replace, as they followed the cultural logic of Yup'ik iconography. For instance, feet were placed across from each other at a mask's base and hands and head were appended above them. Feathers proved among the harder parts to replace. It is not at all clear that their present location reflects their original position. In half a dozen cases feathers were stuck into holes in the body of the mask. Wooden appendages balanced on quills probably originally occupied these positions, and feathers likely decorated the encircling rings, not the masks' faces. Leftover parts indicate that the group originally included more than twenty-six masks. For example, the collection contains a pair of masks, each with a thick wooden hand protruding from its chin. A third hand appendage among the leftovers hints at the existence of a missing third mask.

Most of the masks Gierke acquired are surrounded by one or two crude wooden rings. Three of the masks, however, are unusual pieces carved in the shape of human hands, without encircling rings or wooden appendages. Though thumbless hands were regularly attached to many Yup'ik masks, these unusual masks are themselves hand-shaped, powerful extensions of Yup'ik iconography in a unique direction.

the head, whereas the other has a wooden hunter in a kayak on its top but has lost its four side appendages.

Seal heads received special treatment in coastal communities. Kay Hendrickson recalled that on Nunivak,

*All during the spring they would catch seals. They would cook the heads, and when they were done they would put them on the shelf in the house. And also the skin part of the face was cut at the nose below the whiskers. After the snow melted in the spring, in the evening each wife would put on a seal-gut parka and hold a lighted seal-oil lamp and take the bones that had sat back there away and leave them in the rocks by the shore. She would do this to the skull and face-part of her husband's first bearded-seal catch of the year.*

Burke, 1.2E642 (36.8 cm) and 1.2E643 (29.5 cm)

The back of the animal face mask on the right on the preceding page, showing the willowroot binding of the *ellanguat* and the cotton used to attach rings. The mask has no mouthgrip or sideholes for attachment. Burke, 1.2E643 (29.5 cm)

Asymmetrical pair of masks, each with a spiky-tailed creature covering one side of its face, similar to the Goodnews Bay pair collected by Heye, also during the 1920s (see p. 270). Each originally had beluga, seal, and caribou carvings emerging from the mask's face and feathers projecting from the outer ring. Two rings circle each mask, as on other pairs Gierke collected, and each has side holes. Burke, 1.2E649 (40 cm) and 1.2E650 (40 cm)

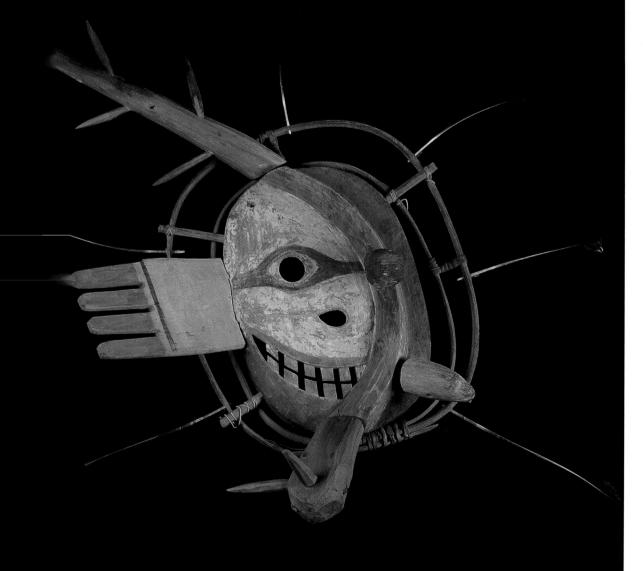

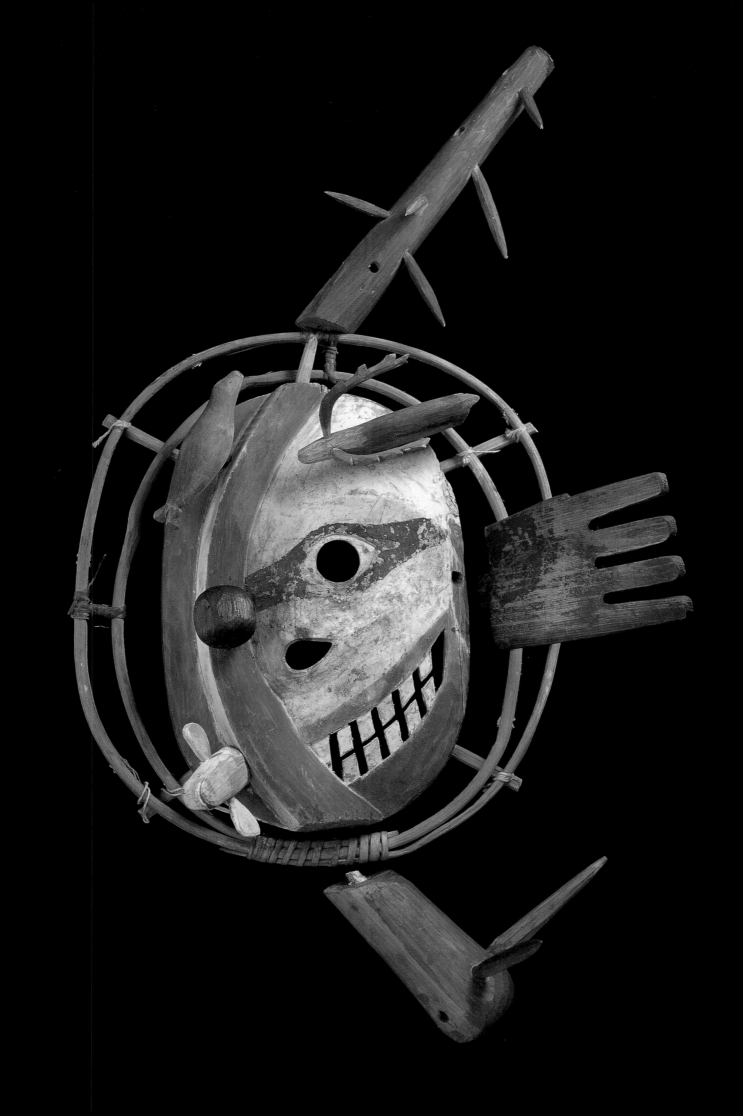

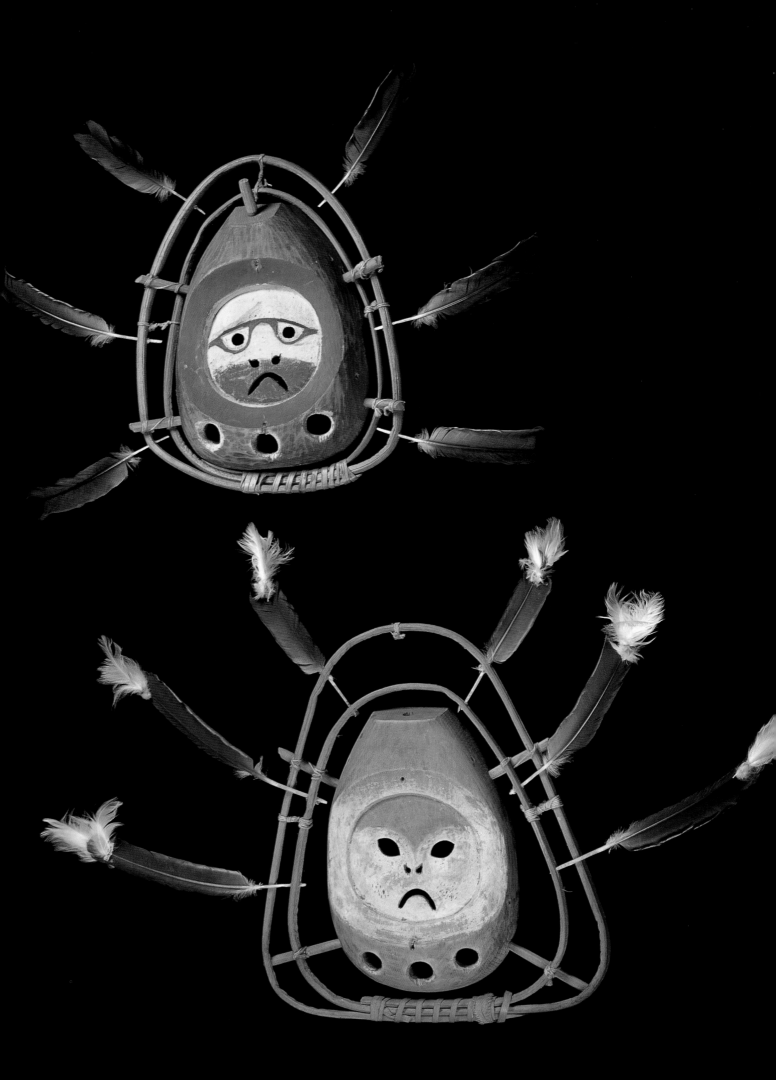

Each of the masks at left originally had an animal head on top and wooden appendages attached to the mask's body. Neither mask has side holes or a mouthgrip. The craftsmanship is similar to that of the other masks Gierke acquired. *Burke, 1.2E645 (29 cm) and 1.2E646 (33 cm)*

Rough-hewn mask with "platform" appendages on each side, showing human figures seated beside square holes. Dick Andrew (January 5, 1994) recalled the well-known story of Aanakalliiq:

*Perhaps that is the face of Aanakalliiq with a mouth reaching its ears. It is the story of a woman who could not conceive. Her parents were with her, too. Then an* angalkuq *worked on her and helped her to conceive and she had a baby. When the baby was born he had a mouth reaching his ears. The* angalkuq *told the mother not to be ashamed of him and to let other people see him, and he said the baby would become normal when he got bigger. However, the mother was very embarrassed about the baby. She hung a woven grass mat in front of their bed to hide him. Though the* angalkuq *had instructed her not to be ashamed, she was extremely embarrassed about him.*

*Once in the middle of the night her parents woke up to the sound of crunching and gnawing. One of them got up and looked behind the mat and saw that the baby had already chewed off one of his mother's breasts. He had killed her and was eating her. I think the mask is about him.*

*Burke, 1.2E655 (37.7 cm)*

KUSKOKWIM
COLLECTIONS
AND
COLLECTING

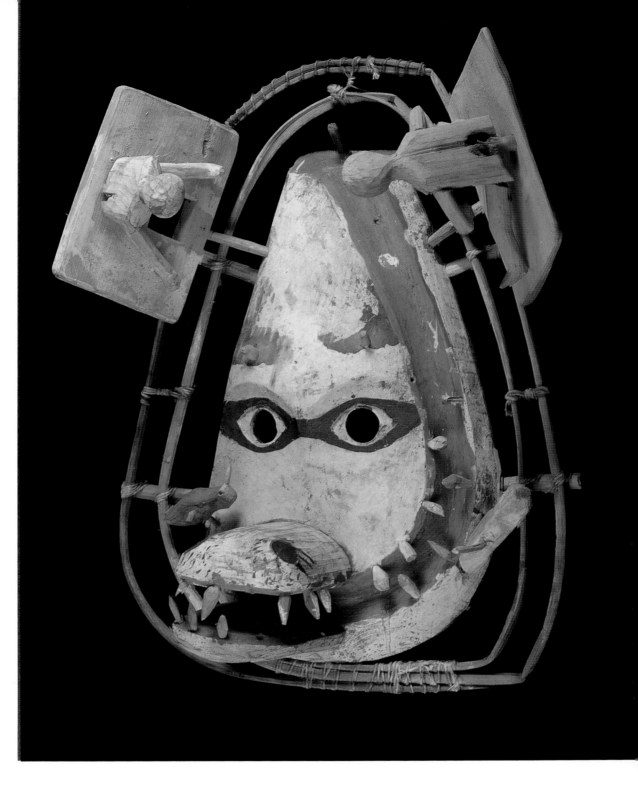

## Moravian Collecting on the Kuskokwim

Traders provided two outstanding collections of Kuskokwim masks, but they were not the only non-natives who acquired masks along the Kuskokwim. A number of Moravian missionaries working along the river took things home with them when they left the mission field, including a small number of masks.

Gierke's son remembered a group of masks displayed on the wall of his father's store, most of which a missionary later burned. This may have been the same group that the Reverend Drebert pictured in his photograph "Heathen Masks," taken in the 1920s. Drebert took a number of the masks home with him when he retired to Bethlehem, Pennsylvania, in 1954, donating some to the Moravian museum in Winston-Salem, North Carolina, and four to the Moravian Historical Society in Nazareth, Pennsylvania, where they still hang.

The masks Drebert brought to Pennsylvania have more in common with Gierke's masks than those Twitchell acquired. Half are encircled by a pair of wooden rings. Four have a series of three holes with carved animals at their base, comparable to the four or five holes surrounding the faces of lower Yukon

*nepcetat* masks. These holes likely represent the passages through which the animals moved on their journey toward human hunters.

Drebert's photograph shows most of the masks as paired sets. He did not bring any of these opposing sets home intact, but his photograph provides a unique historical image of a group of paired masks. One mask has a black semicircle painted on the right side of the face, another a black semicircle on the left. One has the lower half painted black; the other the lower half painted white. The two central masks show a pair of toothy mouthed, double-faced beings, again painted in opposite colors.

Other Moravian missionaries took masks home with them from Alaska, and today these are scattered in ones and twos in private collections in the Lower Forty-eight. In time, children and grandchildren may return some of these objects to Alaska. To date, at least two major collections of Yup'ik material have been donated to public institutions by Moravian missionaries. John and Edith Kilbuck gave their personal collection to Ottawa University in Ottawa, Kansas. Adolf Stecker willed three hundred Yup'ik artifacts to the Museum für Völkerkunde in Herrnhut, Germany. Although both of these collections contain valuable material, neither includes masks.

Photograph of Calitmiut "Heathen Masks," taken by Ferdinand Drebert in the 1920s. *MA (Pa.)*

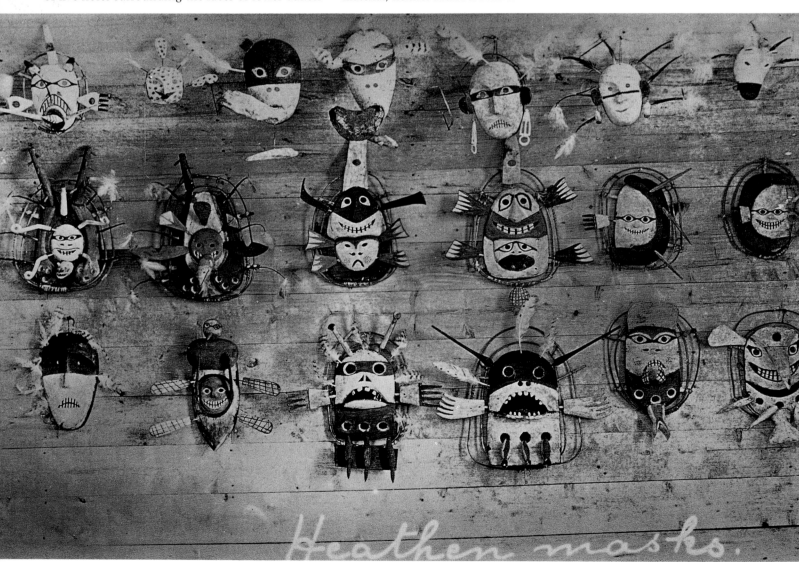

One of a pair of masks pictured in Drebert's "Heathen Masks," similar to the pairs of half-faced masks Gierke collected from the lower Kuskokwim several years later (see pp. 275–76) and Heye purchased from Goodnews Bay (see p. 270). Nelson (1899:410) wrote that a similar mask he collected represented a half-moon and was connected with winter ceremonies. *MHS, 469 (34.5 cm)*

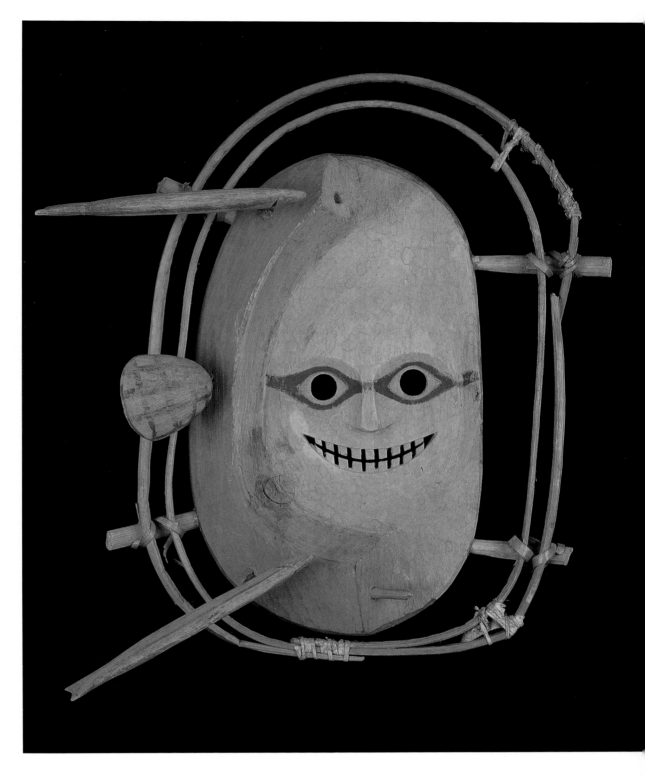

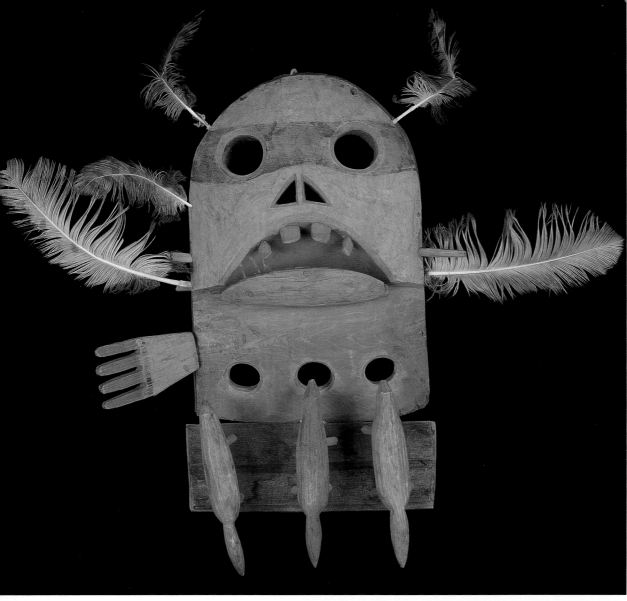

One of an asymmetrical pair of masks, also pictured in the bottom row of Drebert's "Heathen Masks." The three holes below the face resemble those on the pair of masks Gierke collected from the same area (see p. 278) and again recall the ice holes and star holes animals move through into the human world. *MHS, 472 (40.5 cm)*

Also appearing in "Heathen Masks," the mask below may have been paired with the one to its left in the photograph. Goggled eyes characterize most of the Calitmiut masks. *MHS, 471 (22 cm)*

Fourth remaining mask of those Drebert brought home to Pennsylvania in the 1950s. Others are unaccounted for. *MHS, 470 (44 cm)*

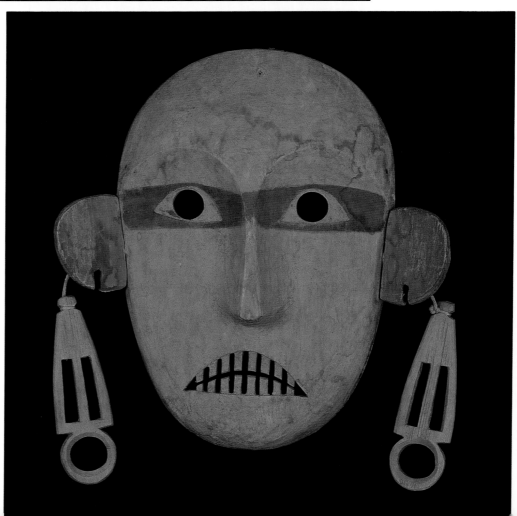

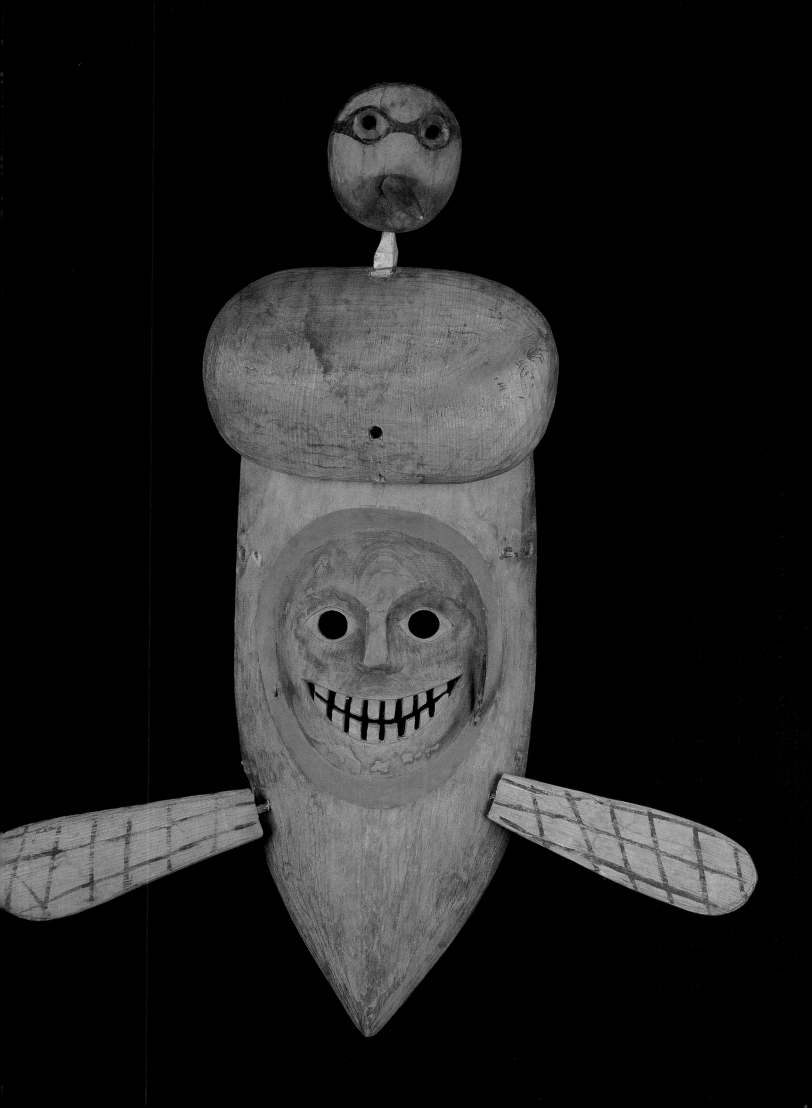

## Masks from Goodnews Bay

While Twitchell and Gierke gathered substantial collections of masks following important dance ceremonies in Kuskokwim villages, masked dances also took place to the south along the Bering Sea coast. A handful of masks from the region survive in the collections of the Burke Museum and the National Museum of the American Indian, as well as scattered pieces in other collections. Unfortunately, we know almost nothing about the circumstances surrounding the collection of these impressive masks.

Ellis Allen collected seven distinctive masks from Goodnews Bay in 1912, which E. W. Blackwell donated to the Burke Museum in 1913. The range in size is as remarkable as the individual pieces. One massive mask is in the form of a four-foot fish with two inner faces and an armlike appendage on one side (see p. 162). Another is a seal *yua* mask less than six inches tall (p. 70). Four are so heavy and large that they probably had to be hung from the ceiling while performers danced behind them. Himmelheber (1993:34) heard about such masks when he visited the Kuskokwim in 1936:

On the Togiak River south of the Kuskokwim estuary one dances, according to the [Moravian] missionary [Frederic] Schwalbe (Bethel), with heavy wooden reproductions of the entire animal, which one holds in one's mouth by a pivot and shakes back and forth. Schwalbe saw, for example, a wooden crane and a wooden, two feet long seal that the dancer, only through great labor, dripping with sweat, could keep in his mouth.

Charles can tell about masks which have movable limbs. They were hung from the ceiling and the limbs are made to flounder by means of a string, as with puppets. [Ivan] Petroff [1884:131] knew these masks.

In 1923 Heye acquired sixteen masks from Goodnews Bay from an unknown source. Like the masks Twitchell collected, these pieces attracted the Surrealists' interest, and Carlebach purchased six in the 1940s, selling three to Breton, two to Duthuit, and one to Dolores Vanetti. The original group of masks contained at least two pairs. One is a set of heavy, whiskered heads with jaws of rolled grass and seal-gut tongues. Down the length of each face is a two-foot wooden post to which three carved bees are attached. The second pair (one at the Museum of the American Indian and one in Breton's private collection) presents two opposing faces, one with a carved fish covering the left side of the face and the other with a fish covering the right. Like the massive fish mask collected by Ellis Allen, these two mask pairs appear heavy and formidable. Although some have appendages, they lack the airy, expansive quality of the Twitchell masks and the robust, almost playful character of the masks Gierke collected.

A third pair presents a puzzle. The masks depict killer whales (*arrluk*) with toothy mouths and wooden fins, each of which has strips of wood across the back that a dancer might hold in his hands while viewing the audience through eye holes carved in the mask's back. Both appear to have been made by the same carver, but documentation lists the larger mask as from Goodnews Bay and the smaller one from Anvik, an Athapaskan community two hundred miles up the Yukon that spawned a number of other masks the Surrealists admired. This may be an isolated error, but it is also possible that other so-called "Anvik" masks in the museum's collection are from Goodnews Bay, or vice versa. Given the influence both Goodnews Bay and Anvik masks had on the Surrealists, one would wish a ready answer to this intriguing riddle. None is forthcoming.

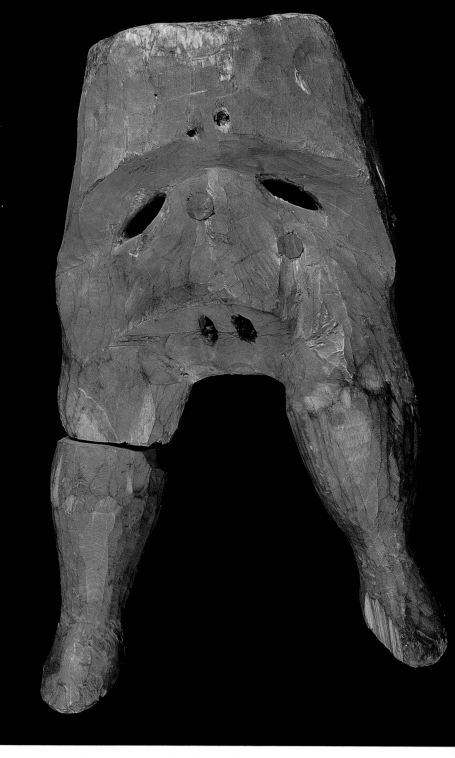

In this unusual mask, collected in 1912 by Ellis Allen at Goodnews Bay, the lower half of a person, with trunk and legs, doubles as a "tusked" face. A similar piece in the University of Alaska Museum in Fairbanks may have told the same story. *Burke, 4435 (26.7 cm)*

Asymmetrical pair of Good-news Bay masks acquired by George Heye in 1923. Both creatures have feather bristle whiskers, lower jaws of grass, and seal-gut tongues, which could be moved during performance with dramatic effect. An arrow or harpoon runs down the forehead of each, with three red bees placed along its length. Bees were potent creatures throughout the Arctic. Jasper Louis (May 29, 1993) said that in the days when there were *angalkut,* people were told to get rid of bad things by shaking their hands: "They told us that if a bee is near, to get rid of it like that. We pat our body, starting from the top all the way down. My bad stuff will come off. When a bee is there one shakes oneself [*ellugtuluni*]." *NMAI, 12/893 (66 cm) and 12/894 (59 cm)*

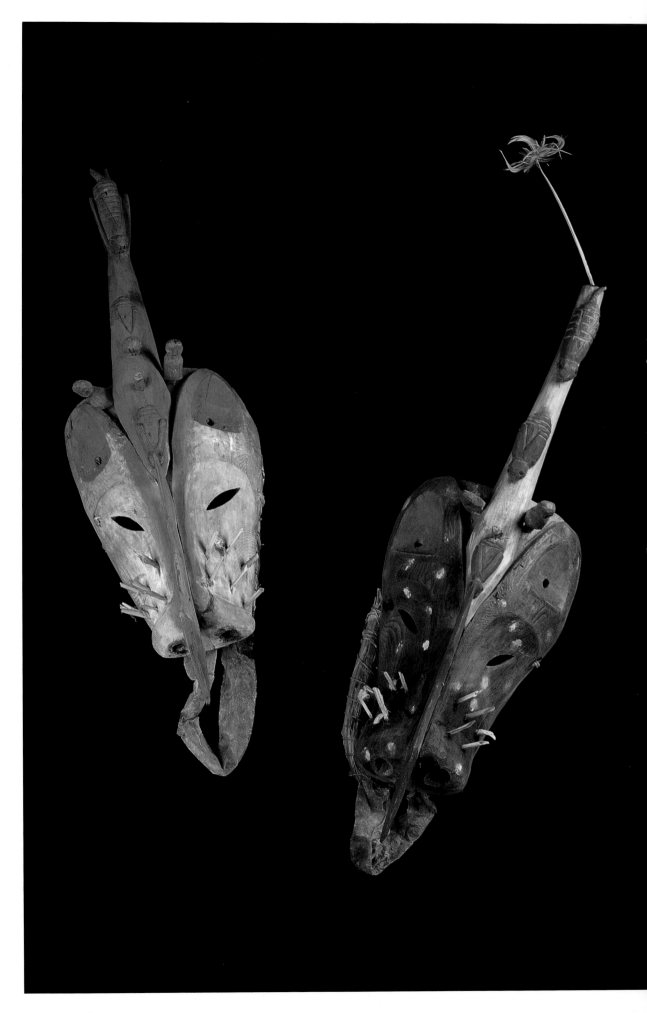

Pair of large killer whale (*arrluk*) masks, indicated by the many sharp teeth. The performer wore the mask vertically along his body, with the head pointed down. He looked through eyeholes carved in the mask's back. *NMAI, 12/916 (94 cm) and 19/8765 (87 cm)*

Massive paddle-shaped mask. Goodnews Bay carvers created masks so large and heavy that they had to be hung from the ceiling while performers danced behind them. *ASM, IIA 1454 (91 cm high)*

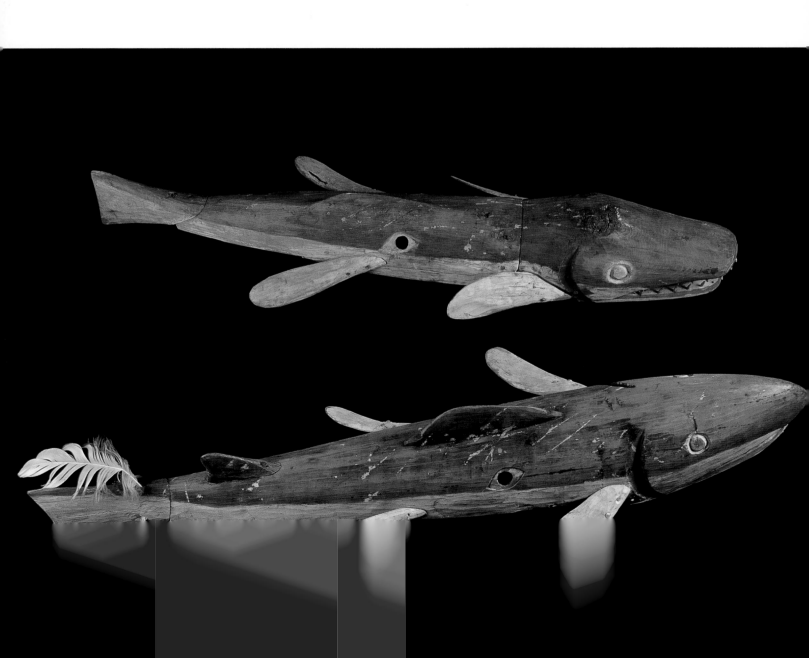

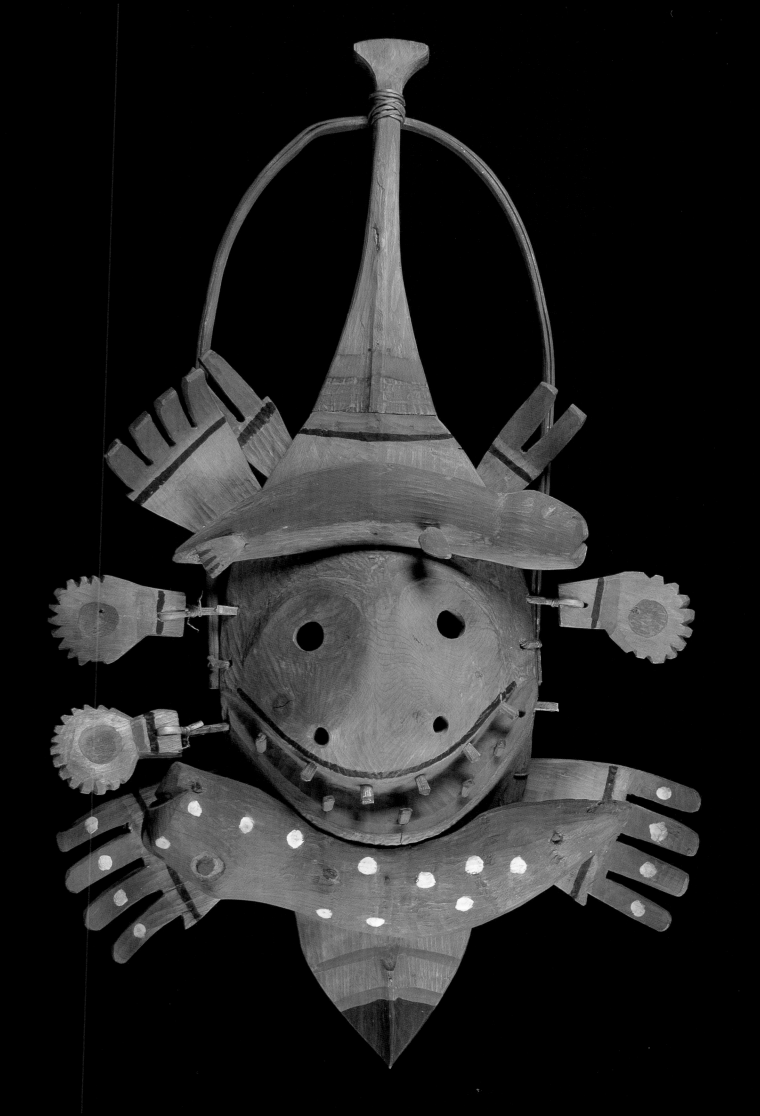

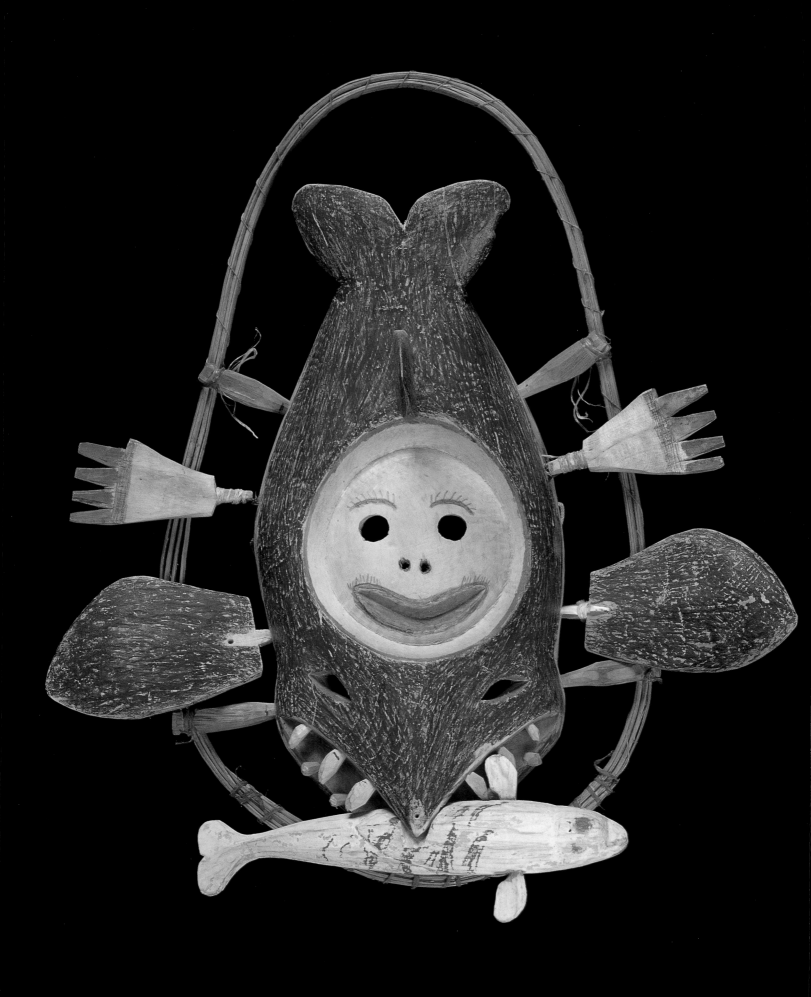

# Masks and Masked Dancing at Hooper Bay and Qissunaq

Blue killer-whale mask carved by Jim Lake. Jimmie Walker danced with it at the 1946 Hooper Bay dance. The mouth at the bottom has pegged teeth holding a small beluga whale or porpoise. The Milottes (1979) said the hoop encircling the mask "held the story in like a sky line around the world where, to quote an Eskimo, inside birds can fly around in the air.'" ASM, MC, IIA5413 (40.6 cm high)

**D**ancing was stopped. And then this photographer came to take pictures of an old dance in the *qasgiq*. . . . He let them dance a masked dance. . . . And starting from that, our dancing started again down at our village.—David Boyscout, *Chevak, July 14, 1994*

## The Milotte Collection:
## Walt Disney at Hooper Bay

Discouraged, even forbidden, by missionaries of every faith in the region, masked dancing was sliding into oblivion in coastal communities between the mouths of the Yukon and Kuskokwim rivers. Then, in 1946, an Alaska husband-wife team, Alfred and Elma Milotte, arrived at Hooper Bay to gather material for Walt Disney's True-Life series. Their interest in viewing and filming masked dancing came at a time when local whites, including the resident Jesuit priest, Father John Fox, were beginning to recognize that some traditional Yup'ik activities might coexist with Catholicism. As important, they came at a time when memories of masked dances remained vivid, and elders still remembered how to create masks for a dance.

The Milottes filmed *Alaskan Eskimo* at Hooper Bay during March-April and September-October 1946. They spent the rest of the year filming the northern fur seals of the Pribilof Islands for their Academy Award–winning *Seal Island* (1949). The Milottes, however, viewed their "Eskimo material" as more valuable: "We believe that Disney has a much greater picture in the Eskimos than in the seals. The people photographed very well and we are sure you will be pleased with the outcome" (Milotte 1949).

With permission to film from the Bureau of Indian Affairs, the couple moved into the old and drafty Hooper Bay teachers' quarters. Although they felt that they were "roughing it," they found the people friendly and genuinely seemed to enjoy their stay: "This has been a hard 7 weeks in this Eskimo village—we haven't had a bath for 2 months. . . . Have tried two kinds of seal meat—one good, one not so good—but it's fun trying. Seal oil is wonderful food, for these people have *beautiful* teeth" (Milotte 1946: May 4).

In many ways *Alaskan Eskimo* is typical of "real-life" documentaries of its day. From the opening shot, the didactic and often patronizing narrative points to the same themes that marked so many previous film depictions of Yup'ik and Iñupiaq people invariably "struggling against the elements." The narrator introduces the people of Hooper Bay as "a hardy, courageous people. Of all the primitive Americans, they have never felt the yoke of conquest." The film focuses on the hunter Koganak and his family. Reflecting the Milottes' belief in a common humanity, it encourages the viewer to identify with the lives of a family from another culture.

This period piece that tells us a great deal about how Americans viewed Alaska natives in the 1940s is a record that the people of Hooper Bay can also appreciate. In 1988, when they had a chance to view *Alaskan Eskimo,* they laughed at the narration and enjoyed photographs of friends and relatives taken more than forty years before. Many in the audience remembered the filming and, as schoolchildren, had written letters to the Milottes to practice their English. Some hoped the film could be made available on video so that they could see it more often. One villager commented, "This home life is exactly . . . the way my home life was when I was young" (Alaska State Film Library 1989).

For many, the film's high point was its closing scene—a dramatic masked dance. Shortly before the Milottes arrived, Father Fox had given the villagers permission to make masks and prepare dances for the benefit of the picture, the first such dance in twenty years: "There seemed to be an undercurrent of unseen activity. We learned that the older men were busy in the Kasga [*qasgiq*] carving masks and learning songs. In the evening from 8 to 10 they taught the dancers the motions to interpret the songs. Everyone seemed happy and excited over the coming event" (Milotte 1946: March).

In a short essay given to the Alaska State Museum the Milottes (1979) described the preparations that went into the dance. George Bunyan of Hooper Bay, a former *angalkuq*, acted as dance director. He not only envisioned how the masks were to be made, but composed the songs and taught the dancers their motions. Unlike a traditional *angalkuq*, Bunyan also carved some of the masks, working alongside carvers Sam Hunter, Andy Gump, Jim Lake, Billy Smith, and Jacob Night.

In 1946 these men were still living in the traditional sod and log *qasgiq*. The Milottes (1979) noted,

When not busy with hunting, fishing, gathering wood, ice or water, they occupied their time with a game similar to checkers. However, from shortly before we arrived on March 16, 1946, until the night of the dance, the six artists spent most of their days working on the masks. At night they trained eleven or more younger men and several women to interpret the songs with precise motions.

Bunyan described what he wanted to the other carvers, who carefully followed his instructions. He drew no pictures but simply explained verbally what to do—how large to make the mask, how many faces, hands, flippers, or feathers each should include. The Milottes noted that the decorations on the Hooper Bay masks were often the food of the animal represented. For example, "trees" made by sticking feathers into a tapered stick of wood adorned a pair of beaver masks.

Each carver used his fingers and hands as measuring tools. From fingertip to first or second joint was one unit. The distance from thumb tip to the tip of little finger with fingers extended was another. The tip of the middle finger to the elbow was yet another.

The Milottes described the natural materials Hooper Bay carvers used as paints: white clay from the nearby Askinuk Mountains, red rocks from Nelson Island, and green from another "mountain rock." The men mixed scrapings from the rock with seal oil to give the color permanency. They mixed the dust from imported coal with blood to make black. The men applied the paint with their fingers, a rag, or sometimes a squirrel's-tail brush.

Although the Milottes do not mention it, the carvers also used commercial colors. Jim Lake's killer whale mask is colored with blue crayon (he didn't have a black one), and Sam Hunter used commercial yellow and purple paint on his walrus mask. As in other parts of western Alaska, no one—not even a filmmaker—was allowed to view a mask's back, which was finely carved to fit the dancer's face.

The dance was performed in the *qasgiq* in April, when the snow was still deep. They hung woven grass mats from the ceiling in the back of the crowded room to provide a place for the performers to don their masks. One drummer sat on each side of the dancing area, and dance director George Bunyan stood beside one of them holding his dance stick. Each dance began when three masked men appeared from behind the screen. They took their places on their knees or sat on the floor with legs extended forward. Each dancer held wooden rings with six snowy owl feathers. When the men were in place, three women came out and stood behind them. Each wore a fancy fur parka and headdress and carried wooden finger masks. Unlike the women, the men did not wear fur, but dressed in cloth shirts or parka covers, sometimes stripping to the waist as they danced.

The Milottes commented on the comic character of one small mask that elicited general merriment and obviously poked fun at the Disney photographer:

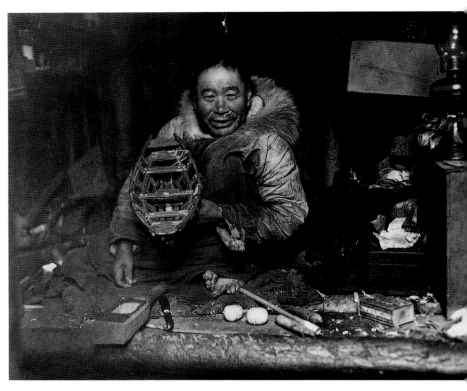

"One of the masks, number 21, is no doubt a caricature of Alfred. When questioned about this mask, laughter was the only response." Finally the people gave this explanation: "When they dance, they use a big mask, when they get tired they take it off and use small ones. Then the dancing changes to faster motions. It is more exciting when they have little masks on" (Milotte and Milotte 1979).

The caricature mask was not the only comic mask the Milottes (1979) observed during the dances: "Almost always the mask covered the whole face of the dancer. There was one exception. For a 'comic act' Ted Hunter wore a half mask (not in the collection) and used his own mouth and jaw for the other half." Carvers in the area today still make and use these comic half-masks.

The majority of the dances were, like the traditional *agayu* dances, performed to request abundance in the future: "Some dances began with grunts or barking sounds from behind the screen to indicate the creatures whose masks were represented. The songs were usually petitions for good fortune in hunting for food or fur." George Bunyan composed a special song for success in gathering wood: "With the light we go down the current of the Kuskokwim and chop wood and saw and pick it up—carry it and put it down" (Milotte and Milotte 1979).

Most of the songs had been handed down from the past. Only four men knew them, and they taught the others. Although their notes are skimpy in comparison to recent dance-song transcriptions and translations, the Milottes (1979) recorded more detail about the songs that went with individual carved masks than did any other collector, including Edward Nelson. Following is their record of the "mukluk (bearded seal) mask song," including both chorus (A) and verse (B):

George Bunyan, director of the 1946 masked dances at Hooper Bay, making a skin boat for the Milottes in his house. *AM, ASM*

Sam Hunter carved this "amakoot" beaver mask, and Joseph Smart danced with it. The mask is shaped like the body of a beaver and has a human face on its back. Appendages include two pairs of paws for the animal and one pair of hands belonging to its *yua*. *ASM, MC, IIA5393 (63.5 cm long)*

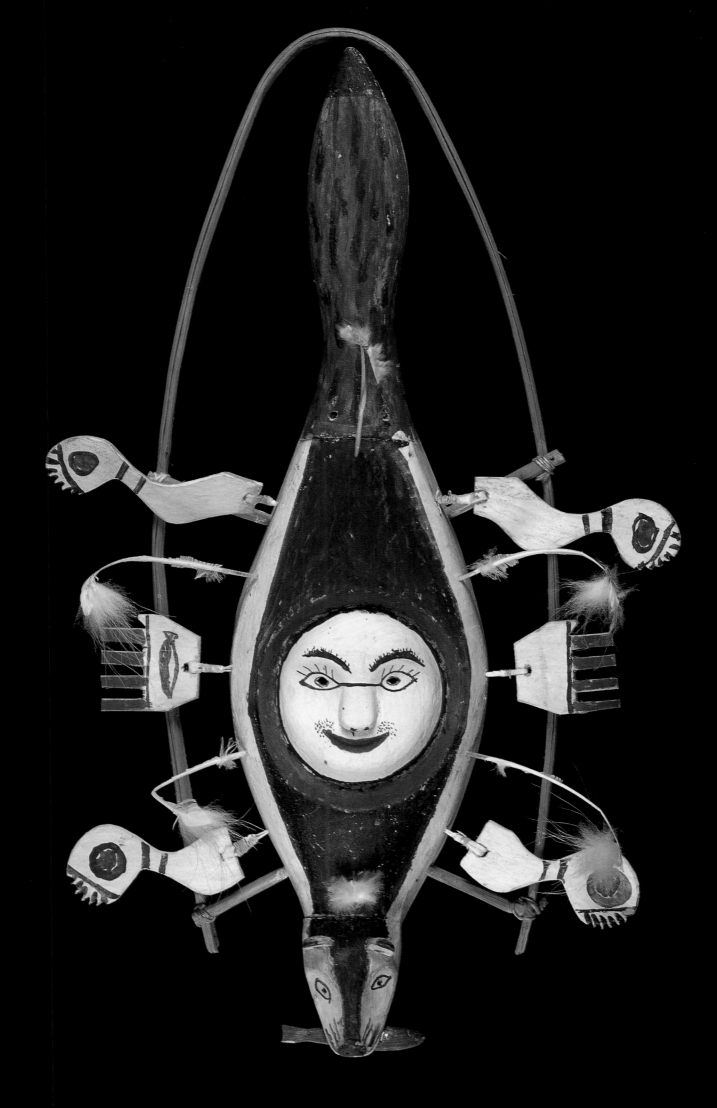

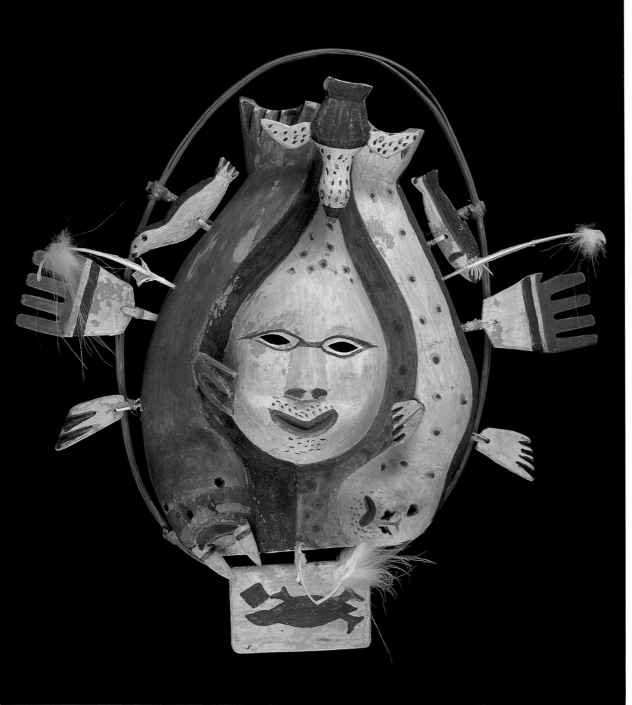

Billy Smith carved this mask and John Smith presented it during the dance. A seal curves around one side of a central face and a walrus around the other. This mask had the same song as the preceding "amakoot" beaver mask and a seal mask carved by Billy Smith. *ASM, MC, IIA5399 (50.8 cm long)*

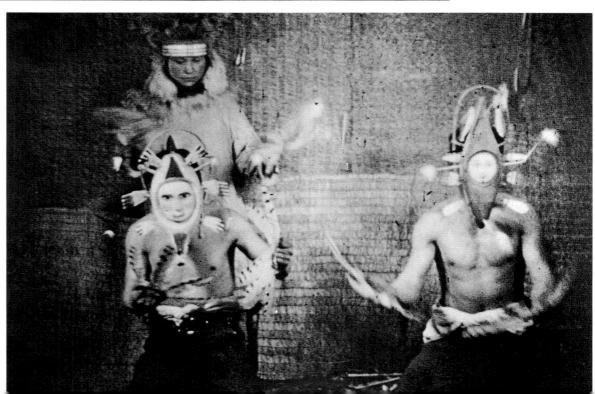

Whale mask carved by Andy Gump and danced by Robert Kaiser, held with a mouth-grip on its back. The head and tail were made separately and nailed in place. *ASM, MC, IIA5404 (50.2 cm long)*

Pair of masked dancers at Hooper Bay, 1946. The man on the right is probably Robert Kaiser, wearing the whale mask at right. Justina Mike (March 1, 1994) described similar masked dances she saw when she was young:

*In my village, on the last day when we went in the* qasgiq *we would see a wall covering in the back area. Someone with a mask on would peek out and say, "I'm peeking out"—from between the things that were hanging. Soon we would begin hearing someone singing quietly from behind. When the singer began to sing louder the curtain would open. There would be a woman dancer and a man dancer. The woman would be dressed up with a headdress and a belt. She would swing her dance fans. People from the side didn't come down when they did this. A man would dance with her. And sometimes there would be three dancers.*

*AM, ASM, MC*

MASKS AT
HOOPER BAY
AND
QISSUNAQ

293

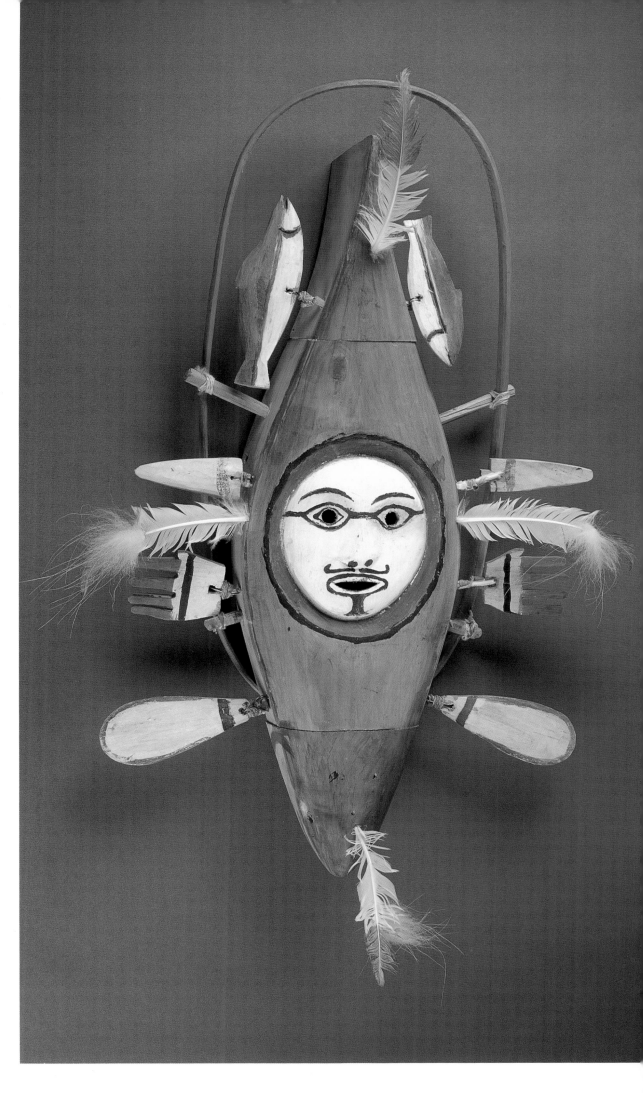

A  *North wind brings in the ice nine inches thick.*
   *Also brings seals sleeping on ice.*
B  *Wind from the west brings the thick ice.*
   *Fish follow under ice to hunting grounds.*
   *Wishing for good hunting and fishing.*

During the song that accompanied the "mukluk and fish mask dance," "seal sounds," such as that of bubbles coming up through the water, came from behind the curtain. Then the singers called out:

A  *For a person hunting, ice is starting to freeze,*
   *little seal under ice moving rapidly having fun.*
      *(gesture of goodwill),*
   *Hunters can have all these good things.*

While they sang, the dancers offered both hands in front, symbolic of having things. Then they sang:

B  *Thick ice coming from the North.*
   *Walrus like it and one right under ice.*
      *(hands behind—walrus)*
   *Sand from sea makes shallow water.*
   *When seagull has walrus in mouth,*
   *people will have walrus.*
      *(movements [probably the drum sequence]—*
      *paddle kayak, using hook, pull up, stuffing into*
      *kayak)*

The morning after the dance the Milottes spotted a mask on an ash heap, and they immediately asked if they could purchase the masks. First they were told that in the old days masks were destroyed after use. But the local storekeeper, Ted Hunter, sent out word of the couple's interest, and they took twenty-four masks with them when they left Hooper Bay several weeks later.

The Milottes numbered and photographed the masks before disassembling them and carefully packing them for shipping. Although the masks are relatively recent, the collection is unusually well documented, including photographs and written descriptions of the masks, the carvers who made them, and the dances in which they were used. The Hooper Bay masks are, in fact, the only group of Yup'ik dance masks for which the names of the carvers are known.

The masks remained packed for the next twenty-nine years, until they were exhibited in 1975 for a month at the Charles and Emma Frye Art Museum in Seattle. The Milottes had always hoped that the masks could someday return to Alaska, and in 1979 they sold them to the Alaska State Museum in Juneau, where a number have been on permanent exhibit ever since. Along with the masks, the Milotte collection included a dance drum and finger masks used during the 1946 performance, as well as tools, lamps, fish hooks, and clothing. One of the more memorable pieces is a tiny ivory Donald Duck, dressed in a parka and with arms raised as if he, too, were dancing. Jonathan Johnson had presented the

Milottes with two such carvings during their visit, one for them and one for Walt Disney.

Like the masks collected by Gierke and Twitchell, the Hooper Bay masks represent the vision of one man, George Bunyan. They might best be referred to as the Bunyan masks, as they form a distinct set bearing his personal stamp. The masks also show clear links to older coastal masks generally and Hooper Bay masks in particular. Compared to the delicate, finely carved masks collected from the lower Yukon and masks from the Hooper Bay area in the early 1900s, those the Milottes collected appear rough, less precisely carved, and generally heavier and thicker. Local trader Frank Waskey (1947) gave at least one explanation for this rough-hewn quality: "Formerly many weeks were spent in the manufacture of the very elaborate and large masks. Much less time is spent now and less pains taken."

Bunyan's masks in some respects demonstrate an antiseptic treatment of traditional themes. Excluding only the caricature mask of Alfred Milotte, all were animal request masks. Although a number displayed the traditional *yua* face, they included no fearsome *tuunrat* or creatures with wide, toothy grins, no *nepcetat* or powerful transformation masks. Although George Bunyan and his fellow carvers probably

Caricature mask carved by Sam Hunter and danced by Bob Smith. The name of the mask? "Al Milotte." *ASM, MC, IIA5412 (26.7 cm)*

Chevak dancer performing
with a comic half-mask
at the Mountain Village
Festival, 1989. *JHB*

remembered some of these dances from their youth,
they may have felt they conflicted with their Catholi-
cism. Animal masks requesting a hoped-for future,
though not "secular" to their makers, perhaps were
seen as more compatible with Christian ideas of
prayer. The carvers' choices of what to carry with
them into the future were certainly conscious ones
(Wallen 1987:8). Though the masks given to the
Milottes left some of the power and mystery of the
past behind, they do provide clear stylistic and
thematic links to the nineteenth-century masking
tradition.

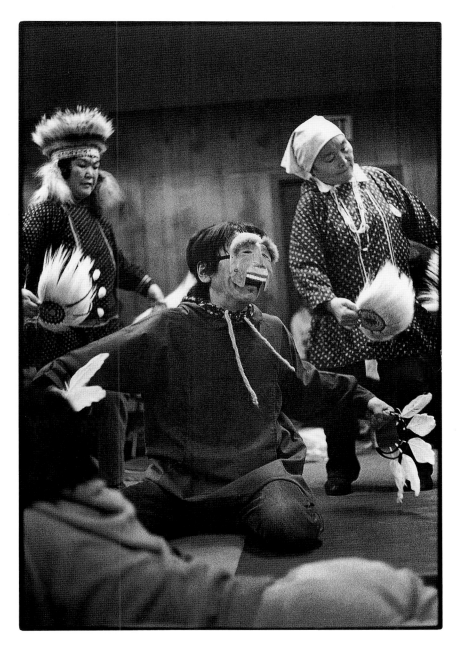

## The Hooper Bay Masks Collected by
## Anna and Ralph Sullivan

Other first-hand observations of masked dancing at
Hooper Bay aid in understanding their distinctive
style and putting the Milotte masks in context.
Between 1916 and 1918 Ralph and Anna Sullivan
worked for the Bureau of Education as schoolteachers
at Hooper Bay, and appear to have taken great inter-
est in the masked dances held there during their ten-
ure. Ralph Sullivan sketched detailed drawings of the
masks and their attached parts, and he took at least
one photograph of the masks in use in the village *qas-
giq*. Even so, by spring they were glad to see an end
to the "seemingly endless native dances." In a letter
home just before Christmas 1916, Ralph Sullivan
wrote,

I wish you could see the mask dance which we saw last
week. . . . The performers were hidden by a matting cur-
tain and made their appearance by crawling under it.
They danced in sets of three men and three women,
the men holding grotesque masks in their teeth. The
music consisted of four big drums and singing, the
dancers being directed by two men who shouted direc-
tions and guarded off the devils with sticks. The per-
formers danced until exhausted. The masks are very
interesting, no two being alike and all representing
something belonging to the country. The medicine
men direct the making of them, claiming that they
see them in visions while they sleep. Some of them
are nightmares all right.
  It is against their belief to sell them, but they will
give them to you and then expect a present in turn. We
have about six good ones and will probably pick up a
few more next year. (Wallen 1991:6)

When the Sullivans left Hooper Bay in 1918, they
took between thirty and forty masks with them (Lee
1990). Anna Sullivan echoed Yukon elder Mary Mike
when she stated that the masks had been handed
down over many years even though they were sup-
posed to have been destroyed after use. She might
have added that after the masks left Hooper Bay, they
would be handed down for many more.

  Ralph Sullivan died in the late 1920s, and Anna
remarried. Her second husband burned the bulk of
the collection, which he viewed as evidence of hea-
then superstition and not something a God-fearing
Christian should possess, even packed away in boxes.
Anna Sullivan saved ten masks and a few artifacts and
gave them to her son for safekeeping. Her daughter-
in-law decided that the masks, which the family
viewed as "curios," were dull, and she and her son
repainted them with housepaint. The masks were dis-
covered in this condition in 1976 in Seattle. Perhaps
the publicity surrounding the showing of the Milotte
masks the previous year was a factor in the Sullivans'
"discovery" of their own collection.

  When the repainted masks first came to light, Bill
Holm of Seattle's Burke Museum determined that
original paint existed underneath the commercial
housepaint, which was then carefully removed by

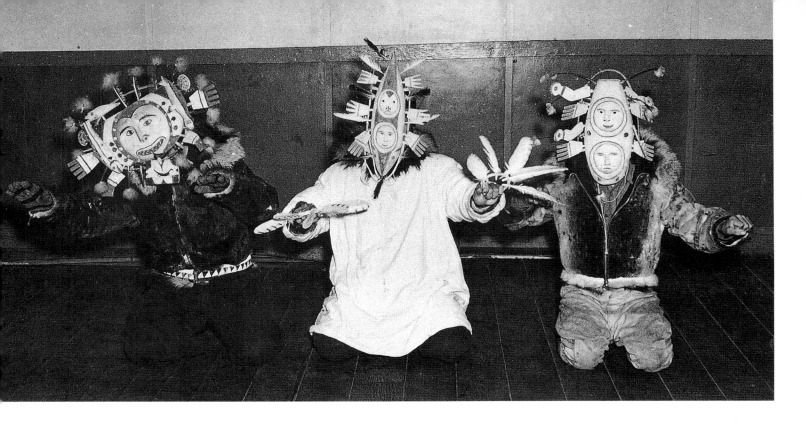

flaking. Over the years, the masks had lost more than half of their appendages. Those parts with matching elements were restored, using Ralph Sullivan's pencil drawings. In 1975 Anna Sullivan's son sold the masks to The Legacy Ltd. in Seattle, from which New York dealer George Terasaki purchased them. Terasaki subsequently sold all but one to Calgary's Glenbow Museum, where they were the subject of a fine exhibit in 1990 (Terasaki 1976; Wallen 1990).

Important similarities and differences exist between the observations of the Sullivans and the Milottes on the masked dances they witnessed, providing valuable information about how masked dancing in the Hooper Bay area was like and unlike

masked dancing elsewhere along the coast. Both the Milottes and the Sullivans commented on the grass mat from behind which the masked dancers emerged. Both mention the role of dance director, but the Sullivans reported two directors in 1916, while in 1946 the Milottes saw only one. Also, whereas the Sullivans saw a number of "grotesque" masks, the masks made at Hooper Bay thirty years later seem remarkably benign.

Neither the Milottes nor the Sullivans mentioned pairs of masks used in performance, reporting that three, not two, men performed each dance. Ralph Sullivan explicitly stated that no two masks were alike, although unmatched "sets" may have been pre-

Dancers posing with a "set" of three unmatched masks, probably made in the Hooper Bay area. The exact place and date of the photograph are not given. *ASM 202-E*

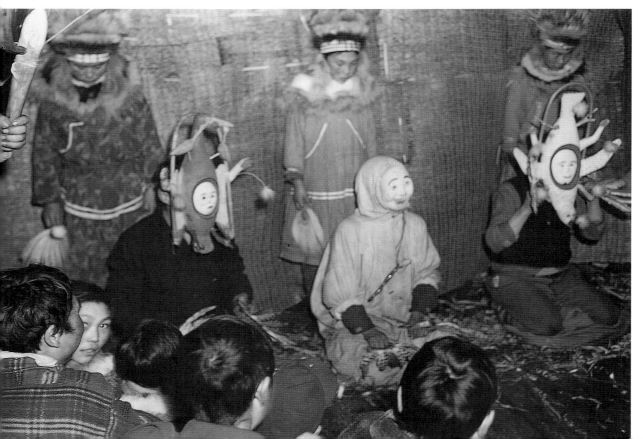

Group of three related masks photographed by Alfred Milotte during a performance at Qissunaq, 1946. *ASM, MC, neg. no. 1104*

sented that he did not recognize as "paired." At least one obvious pair occurs among the two dozen masks the Milottes collected—a pair of beaver masks. The Milottes sometimes noted which masks were used together. A white fox mask and a wolf mask were danced together to a fox song. An "amakoot" beaver mask had the same song as a seal mask and a walrus/seal mask. The Milottes also reported that this "amakoot" beaver mask had the same story as the two beaver masks, all three forming a related set. They recorded no information on the remaining seventeen masks that can help group them as they appeared in the dances. Possibly the three masked dancers performed old-style songs with three (as opposed to two) verses using three related, though dissimilar masks.

### Qissunaq Masks Collected by Frank Waskey

The Milottes and Sullivans merely visited Alaska and took masks home as souvenirs. Frank Hinman Waskey, in contrast, was a longtime Alaskan who gathered a collection of masks from the nearby village of Qissunaq. Waskey came to Alaska at age twenty-three in 1898. He first prospected and mined at Cook Inlet, moving on to the Seward Peninsula, where he lived from 1900 to 1909. In 1906 he was elected delegate from Alaska to the 59th Congress. Subsequently he served as U.S. Commissioner in western Alaska through World War I. Waskey was well known in the region as a man who took an active interest in old things. A self-described "peripatetic trader" along the Bering Sea coast, he ran a general store in Dillingham for many years. He was a self-made man with little formal schooling, thankful that "since coming to Alaska I have been in a measure exposed to what Henry Watterson so succinctly characterized as 'Men, Women, and Events'" (Waskey n.d.). When Wassilie Evan visited the Sheldon Jackson Museum and viewed the artifacts Waskey had sold to the museum, he commented:

When I first came in here I was amazed with what I saw, but knew that they would be . . . very old artifacts. . . . A man we called Neqyacagaq ["little fishy one," from *neqa*, "fish"], English name Waskey. . . . [At our village] he bought things like bowls and other [items], and we realized he had sent them here. He did not say where he was sending these things. Those things that were found in old sites that they dug up were also sent away. Those things that belonged to our ancestors who now are deep underground. Things they used for their survival. I'm most amazed at those. We realized he had sent them here after he bought and collected from our area. He would arrive. He spoke Yup'ik, though he was Caucasian. He would say he lived in Bethel. . . . Neqyacagaq was the first commissioner at Marshall. (KYUK 1989, tape 1:1)

Waskey's interest in masks was long-standing. In a 1947 letter to Ivar Skarland at the University of Alaska Museum in Fairbanks, Waskey wrote that in 1912 he had witnessed a masked dance called "Kenakuchuk" (*kegginaquq*), the "invitation or welcome to the spring." More than one hundred masked dancers took part in the ceremony in the village of Qissunaq, twenty miles inland from Hooper Bay. He also reported grass curtains stretched across the back of the *qasgiq* to hide the performers. He wrote, "At the conclusion of the several days festivities I tried to arrange to receive the entire collection of masks, some of which entirely covered the wearers from below the knees to above their heads. I was told this was . . . impossible, as to dispose of the masks would defeat the very purpose of the dance, i.e. to fix things up so that the geese, salmon, etc. would return."

Although Waskey failed to get masks in 1912, he

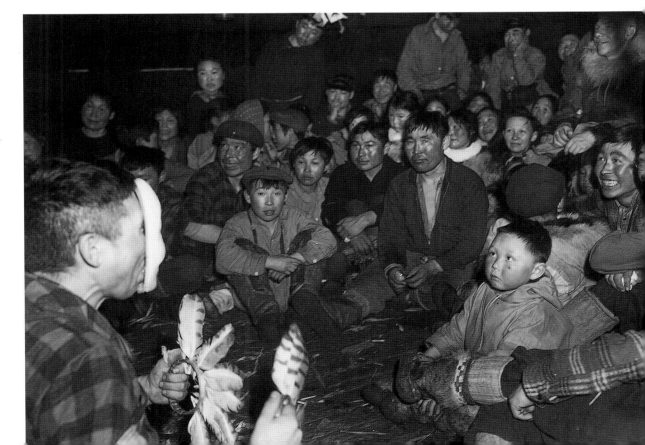

Men and women gathered in the *qasgiq* at Qissunaq for a masked dance, photographed by Alfred Milotte, 1946. Note the performer gripping the mouthpiece in his teeth. *ASM, MC, neg. no. 1102*

never lost interest. He watched as masked dancing first declined and then appeared to die out. Then, traveling on the coast in 1946, he noted that the people of Hooper Bay once again were making masks. He visited Qissunaq that year and remarked that Hooper Bay was not the only place enjoying a revival of masked dancing. Qissunaq villagers were also preparing a masked dance for the Disney filmmakers. Although Qissunaq film footage does not appear in *Alaskan Eskimo*, Alfred Milotte did visit Qissunaq in spring 1946 to make still photographs (often misidentified as from Hooper Bay) of their masked performances. From the perspective of Chevak resident David Boyscout (July 14, 1994), the revival of dancing throughout Alaska began when the Milottes came to the Qissunaq masked dances:

Dancing was stopped. And then this photographer came to take pictures of an old dance in the *qasgiq*. He came by sled, not by plane. . . . He was taking pictures. He let them dance a masked dance in the *qasgiq*, using a strong light. He didn't use an electric light like this. [*Laughs*] And starting from that, soon after that, our dancing started again down at our village.

So we initiated that as a fun activity between Christmas and Easter. After we started that, we would go to the village [of Hooper Bay] that is near and downriver from us. And they would do the same to us.

So we did that back and forth and soon it spread to take up a wider area. Now it covers all Alaska.

Following the Qissunaq dances, Waskey finally succeeded in acquiring ten masks, which he sold to the University of Alaska Museum in Fairbanks in 1947. He asked only that the museum cover his costs ("Unfortunately the point on my financial barometer at present indicates heavy weather") and offered to write about what he had gleaned on the significance of the larger masks. No such information appears in the museum's accession records, but the correspondence continued at least to the extent that Skarland sent Waskey a copy of Margaret Lantis's just-published "The Social Culture of the Nunivak Eskimo" in return for his contribution to the museum's collections.

The masks sent to Fairbanks included paired bird and fish masks, one of two walrus masks that appear in a photograph Alfred Milotte took of the dance, a white fox mask, and an owl mask. Joseph Tuluk (July 14, 1994) commented on these relatively small, unadorned pieces: "These small masks that were made with an *angalkuq* as a teacher, when one dances with them with vigor, they become heavy though they are small. They get . . . uncomfortable to wear, and the [dancers'] necks get tired." Viewing pictures of the walrus mask and fox mask, Tuluk continued, "Ingluilnguq . . . made it. His *tuunrat* were walruses. He was an *angalkuq*. So because he was an *angalkuq*, he let them make this. That was his support. . . . And this one also has a song. Songs depict them as their meaning. . . . When they make masks they tell about

them with their songs."

Waskey also acquired five humorous masks called *ketgaukaraat* (meaning unclear), one of which caricatures Waskey himself. In a July 1994 interview Chevak elders commented on this "ugly" mask:

JOSEPH TULUK: It is someone, a trader. They probably made a caricature of him. . . . It is so ugly.
MRS. BILLY ANDREWS: It looks like Uaskiq!
JOSEPH TULUK: It was probably Waskey. When he came he would buy fossil rocks. Waskey probably bought those masks.

The masks Waskey collected from Qissunaq were very different from those collected at nearby Hooper Bay both in 1916 and 1946. Only two of the ten masks have appendages or surrounding hoops. Instead, they are unadorned animal and human faces. Though Waskey did not give the names of the carvers or the dancers, the masks appear to have been made by two or three individuals. The craftsmanship is careful and exact. Milotte's photographs show that the performance featuring the walrus masks must have been indeed lifelike.

Waskey's letter to Skarland mentioned that in January 1947 he had seen the people of Qissunaq practicing for an upcoming dance. Masked dancing has continued on and off over the years both in the old village of Qissunaq and the new community of Chevak, to which most Qissunaq residents moved.

White fox mask collected at Qissunaq by Frank Waskey, 1946, featuring a mouthgrip on the inside rim, pegged-in ears and teeth, and quill whiskers. Page 53 above shows a man dancing with this mask. When Chevak elders saw a photograph of the mask, they commented that today in Chevak they still dance to songs about the white fox. *UAM, UA314-4353 (15.2 cm)*

Qissunaq bird mask used with the white fox mask, collected by Waskey, 1946. *UAM, UA314-4349 (55.9 cm)*

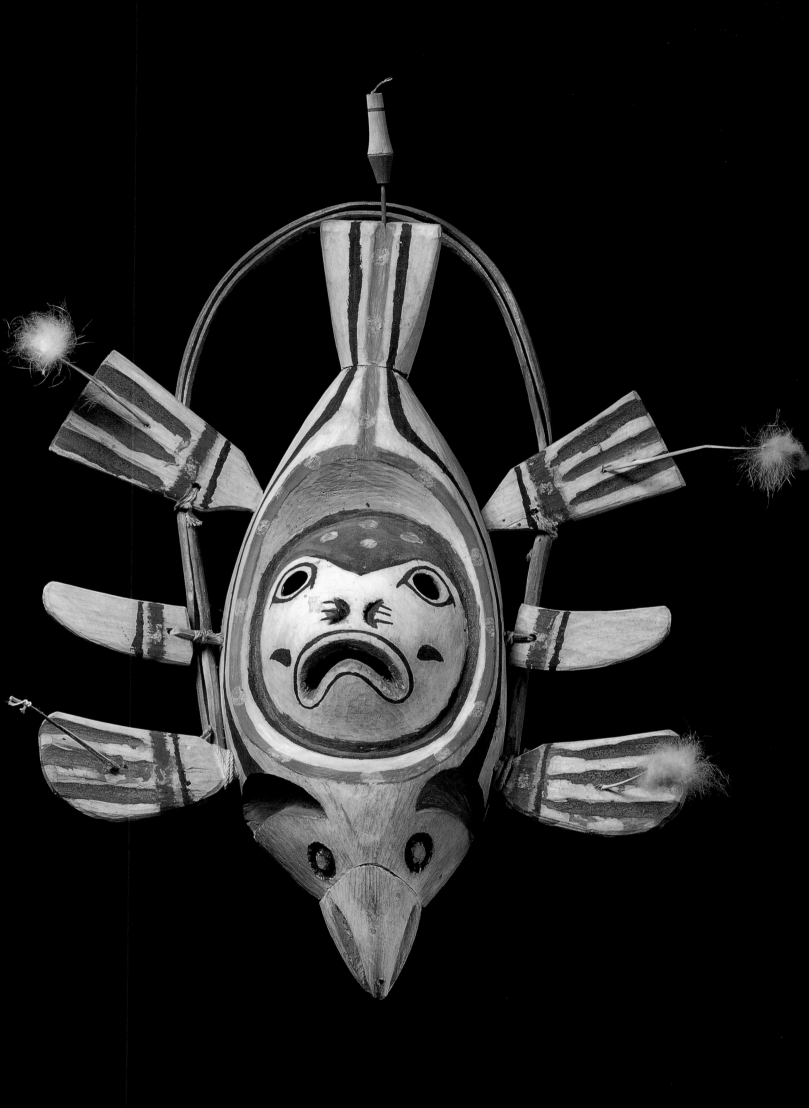

The coastal communities of Qissunaq, Chevak, and Hooper Bay were among the most isolated in the region. Perhaps this explains why masked dancing hung on into the 1920s and started up again so easily in the 1940s, forming an almost unbroken continuum. In places such as Nunivak Island and Bethel, commercial carvers make masks for sale. Only in Chevak and Hooper Bay do men still dance with the masks they make.

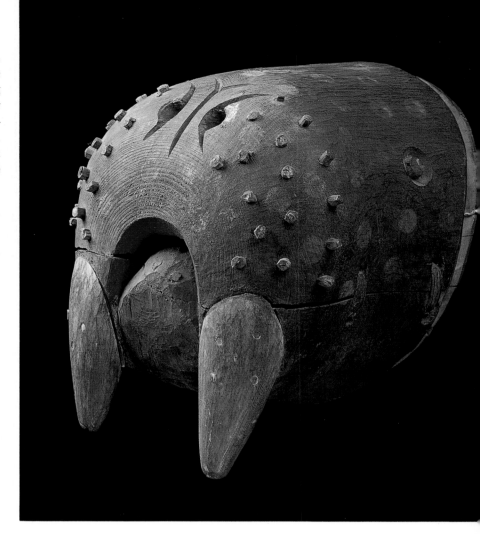

One of two identical walrus masks Alfred Milotte photographed in use in Qissunaq in 1946, collected by Waskey (see p. 110). *UAM, UA314-4351 (15.2 cm wide)*

Qissunaq owl mask, *yua* face peering from its back, collected by Waskey, 1946. *UAM, UA314-4354 (45.7 cm)*

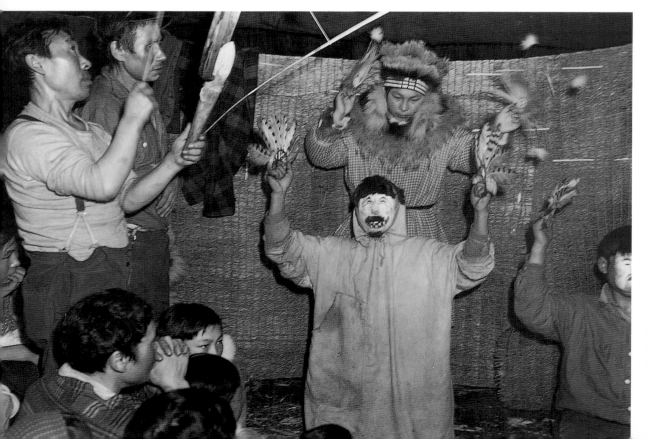

Dancing with caricature masks at Qissunaq, 1946. Note the hood pulled around the edge of the mask. *AM, UAM, MC, neg. no. 1101*

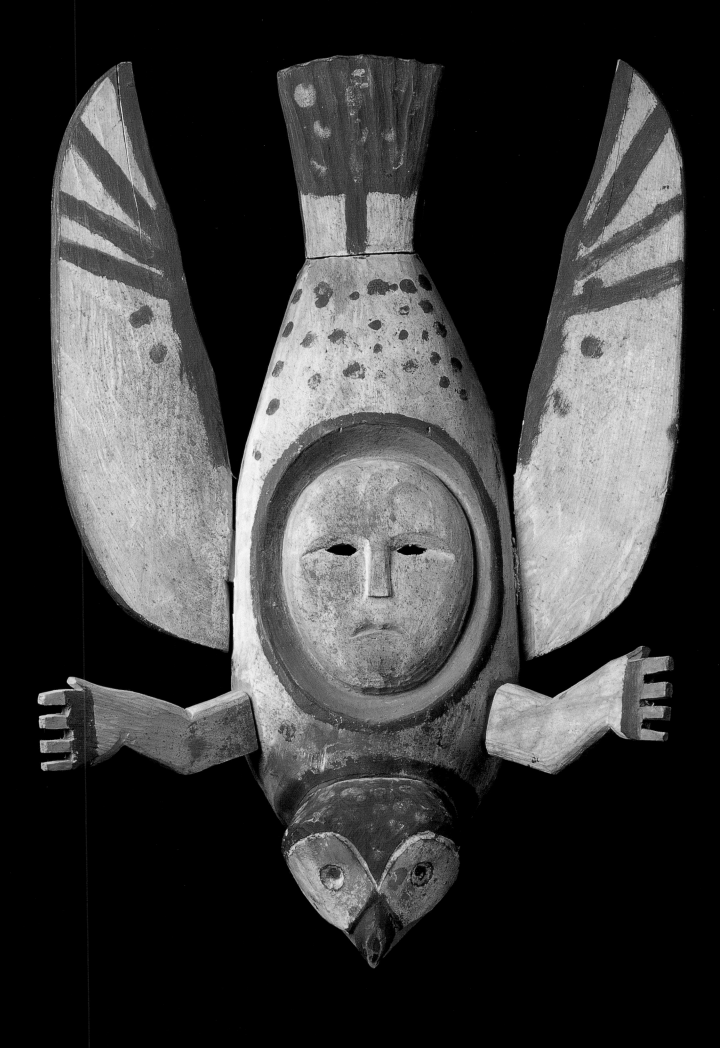

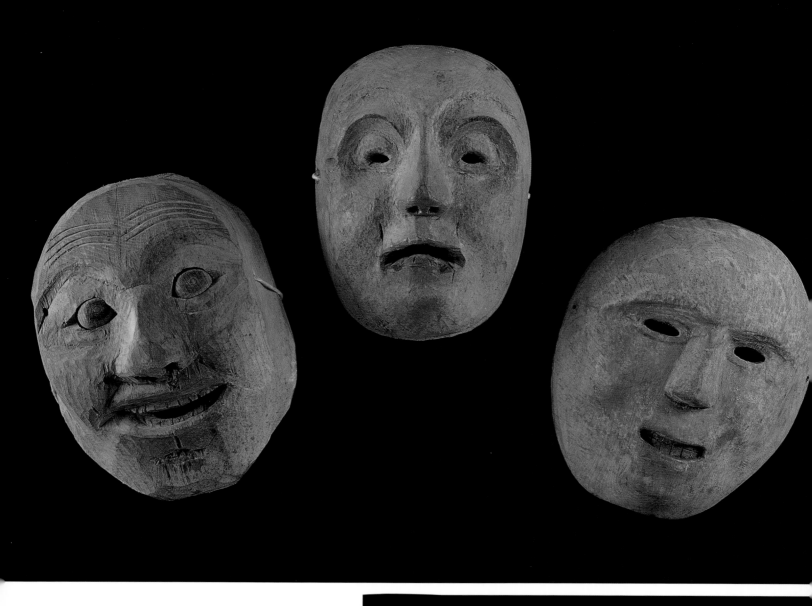
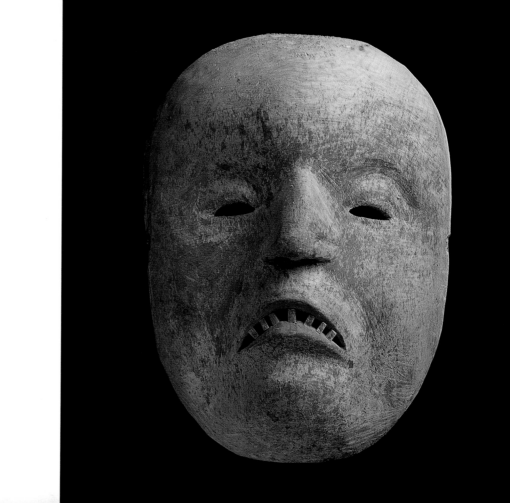

Three humorous caricature masks collected by Waskey at Qissunaq, 1946. All have inset rims so that parka hoods could be tied around the face, completely covering the performers. The eyes on the mask on the left are separate and can be made to move by means of a cotton string. Its forehead wrinkles are an unusual feature. *UAM, (left to right) UA314-4358 (18.4 cm), UA314-4357 (16.5 cm), and UA314-4355 (16.5 cm)*

Qissunaq caricature mask of Waskey, 1946. Traces of white paint, red-painted lips, and pegged teeth decorate the mask. *UAM, UA314-4356 (17.8 cm)*

Qissunaq caricature mask with hair, eyebrows, mustache, and beard done in graphite, and two pegged teeth, collected by Waskey, 1946. Paul John (February 1994) recalled,

*They say this about* ungalek *[one with a beard]. Suppose you admonish me but I do not heed your admonishment. I just do what I want to do. And then as I go on in life, I run into trouble. It is said that* ungalek *has finally admonished me, I cannot get away from it. Some of them used to say, "I do tell him but he doesn't listen to me. He doesn't pay attention to me because I don't have a beard."*

*UAM, UA314-4352 (22.9 cm)*

Men performing with caricature masks, Qissunaq, 1946. The dancer standing in the back may be a woman wearing a mask or a man dressed as a woman. *AM, UAM, MC, neg. no. 1103*

MASKS AT
HOOPER BAY
AND
QISSUNAQ

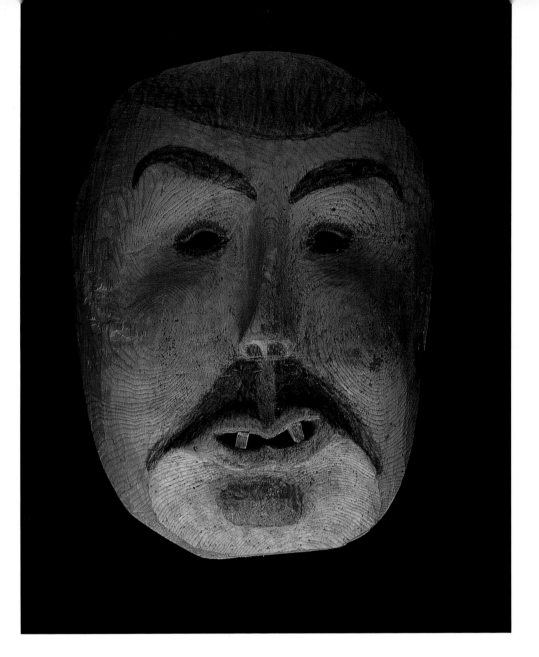

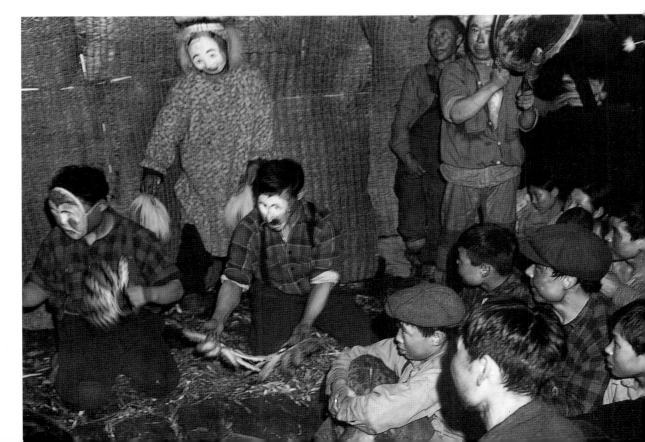

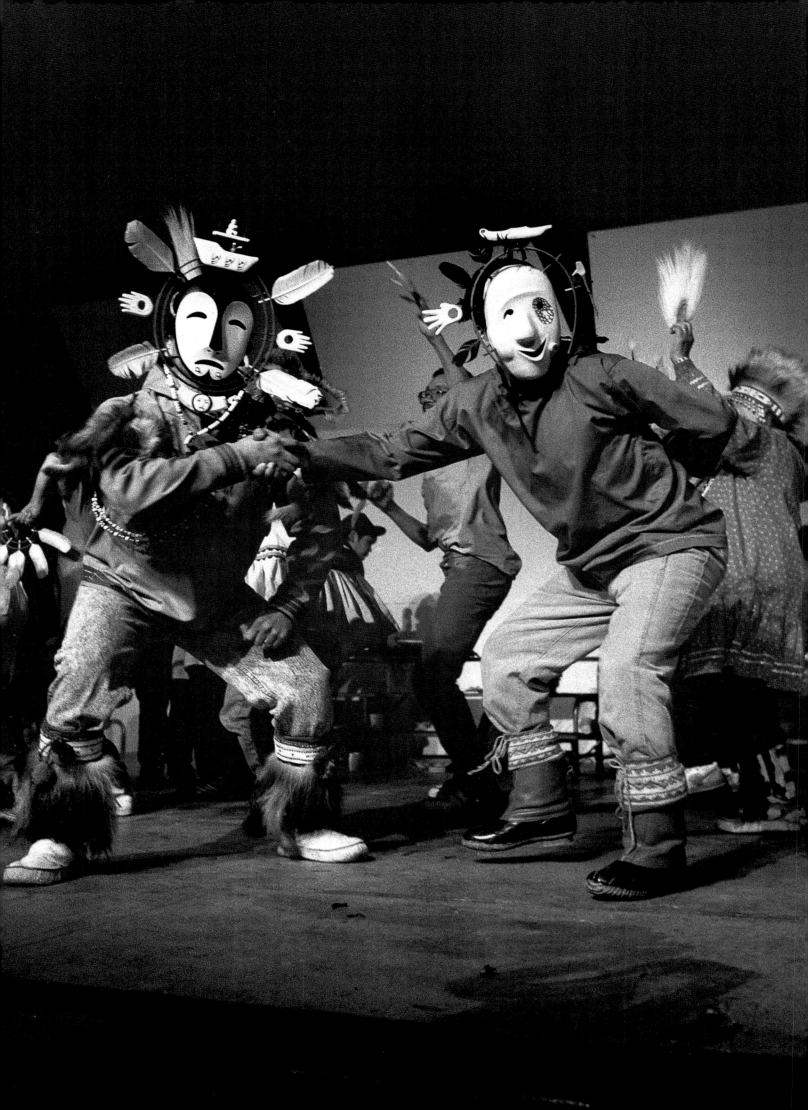

# Afterword

A masked pair, bringing the past into the present: John McIntyre (left) from Eek dances with Joe Chief, Jr., from Bethel. Joe's mask was made by Alexie Isaac, also from Bethel. John's mask tells the story of Issiisaayuq, the *angalkuq* who predicted the coming of the first white people. *JHB*

In the 1950s I was stationed at Caniliaq, located at the north mouth of the Yukon and later moved to Kotlik. In the rec hall there was an old wooden crate, and inside were all kinds of old masks, with the feathers gone and the paint all faded away. It appeared that they had been salvaged from some dances long ago. No one was using them for the occasional dance still held around Christmastime or for special feasts. In those days, none of the potlatch or traditional feasts was observed.

And then, in the 1960s the dances started again, and the potlatches, but without the masks. Jasper Joseph, an elder from Emmonak tells us what we missed:

They used to wear masks when they danced, made out of wood—wooden masks, that's what I like. They got different masks, like foxes, maybe seals, reindeer, fish, all kinds of birds. Now when they dance, they don't even use masks like in the old days. It looked better then, because they were fancy, painted good, all those feathers around the mask—it makes it look better. If you see that kind of dance, maybe you will never forget it. . . . They are good-looking when they are dancing with those masks.

A few years ago I came by two wooden masks carved more for entertainment than for traditional dances— no paint, no feathers. One looked very much like someone I knew. Some evenings when people were dancing for fun, I would put these masks on the floor where the men were going to perform. Timidly, after starting the dance, one of the men would put a mask on, then, not to be outdone, another man would put on the other. And then, hidden behind these masks, the men would act in very funny ways, to the delight of the crowd. For the same purpose I have seen some dancers put on a cloth mask with exaggerated features and achieve the same success with the spectators.

But I long for the day when, on the occasion of a potlatch, a dancer will appear and call for an abundant season of seals, salmon, or geese. This is "our way of making prayer," *agayuliyararput.*

Father René Astruc
*Anchorage and St. Marys*
*October 1994*

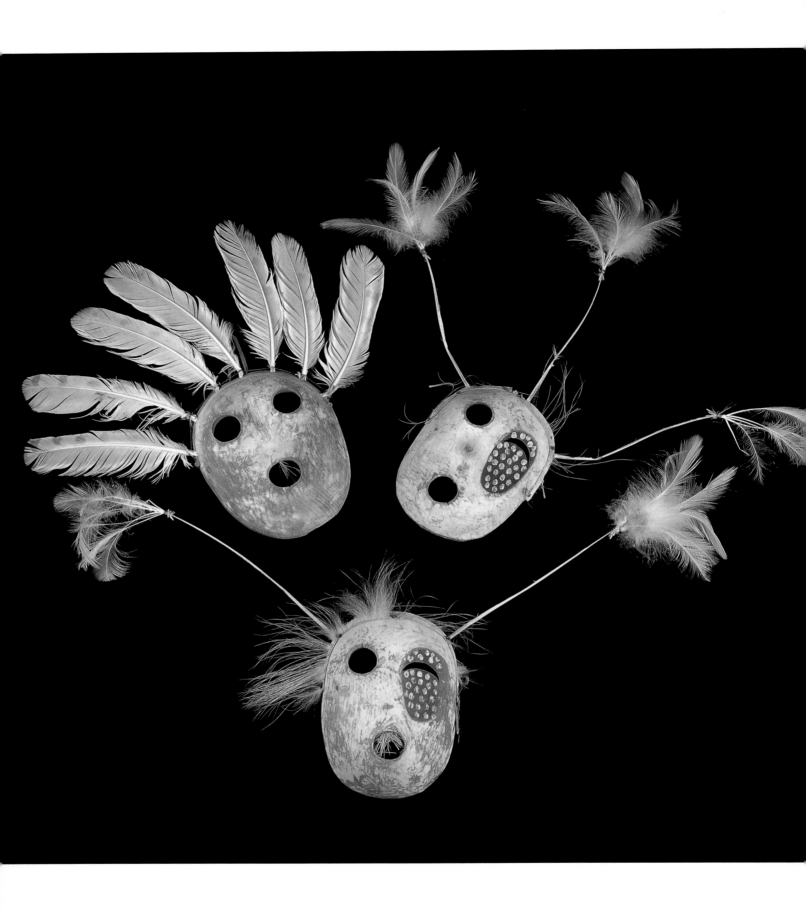

# Glossary

Generally, unpossessed nouns ending in "q" are singular, "k" dual, and "t" plural.

**agayu/agayut.** (Nunivak) mask/masks; religious representations to which or through which prayers or supplications are offered.

**agayu-.** To request, to participate in a ceremony, to pray.

**agayuyaraq.** The way or process of praying or requesting.

**agenra.** Chorus of a dance song, usually repeated during performance ("its result of going from one place to another without crossing a barrier," from *age-*, "to go from one place to another").

**akutaq.** Lit., "a mixture," including berries, seal oil, shortening, sugar, and, in some areas, boned fish.

**angalkuq/angalkuk/angalkut.** Shaman/shamans.

**apallirturcuun.** Dance stick (lit., "device for making the verse").

**apalluq/apalluk/apallut.** Song verse/verses and their lyrics.

**arula/arulat.** Dance motion/motions; motion dances with verses and a chorus.

**avangcaq/avangcat.** Mask/masks.

**curukaq/curukat.** Challenger/challengers; guests invited to a Messenger Feast.

**ella.** Weather, world, universe, air, awareness, sense.

**ellam iinga.** Eye of *ella,* eye of the universe, eye of awareness.

**ellam yua.** Person or owner of the universe.

**ellange-.** To become aware, to gain awareness (from *ella,* "awareness," plus *-nge* "to begin").

**ellanguaq/ellanguat.** Pretend or imitation universe/universes.

**eniraraun/enirarautet.** Dance stick/sticks, pointer (from *enir-,* "to point").

**iinruq/iinrut.** Amulet/amulets.

**ingleq/ingleret.** Wooden sleeping platform/platforms, bench/benches.

**ingula.** Dance performed by women to *ingulaun/ingulautet.*

**ingulaun/ingulautet.** Slow, old-style song/songs to accompany an *ingula* dance.

**ircenrrat, ircit.** Extraordinary persons who may appear in either animal or human form.

**kass'aq/kass'at.** White person/white people, Caucasian.

Henry Neumann collected this trio of masks at St. Michael in 1890. The eyes of two are identical. The sun, moon, and stars may be represented, with the wind signified by the feather emerging from the mouth. A caribou ruff was nailed in place on the two matching masks. The backside of all eyes and mouths is painted red, and brown dots are painted on the backside of the seven feathers on the rim of the mask lacking a caribou ruff. *SJM, IIG3 (19.2 cm high), IIG4 (19.2 cm high), and IIG10 (39.3 cm high)*

**kegginaquq/kegginaqut.** Mask/masks (lit., "thing that is like a face," from *kegginaq,* "face; blade of a knife").

**kepun.** Adze.

**mellgar.** Man's carving knife with a curved or bent blade, sometimes called a crooked knife.

**negeqvaq.** North wind.

**nepcetaq/nepcetat.** Shaman mask/masks (lit., "something that sticks," from *nepete-,* "to stick, cling, or adhere").

**nukalpiaq/nukalpiat.** Good hunter and provider, man in his prime.

**pamyua.** Word yelled out by members of the audience to request that dancers repeat the end of a song (lit., "its tail").

**pualla.** Fast-paced, northern-style standing dance performed by men.

**putu.** Standing dance performed by women while men perform *pualla.*

**qasgiq/qasgit.** Communal men's house or dwelling, community center.

**qaspeq/qasperet.** Cloth parka cover/covers.

**qirussiq/qirussit.** Wooden decoration/decorations or appendages.

**tarvaryaraq.** Cleansing or purifying with smoke.

**tuunraq/tuunrat.** Helping or familiar spirit/spirits.

**uluaq.** Traditional woman's semilunar knife.

**yua/yuit.** Its person/ their people (possessed form of *yuk,* "person"); its owner/their owners.

**yuguaq.** Effigy, human figure (lit., "pretend person").

**yuk/yuut.** Person/people, human being/human beings.

**Yup'ik/Yupiit.** Real or genuine person/people (from *yuk,* "person," plus the postbase *-pik,* "real" or "genuine").

**yurapiaq/yurapiat.** Long story dance/dances performed by women (lit., "real or genuine dance/dances").

**yuraq/yurat.** Generic term for Yup'ik dancing, also used to distinguish *arula* dances, consisting of both verses and a chorus.

**yuarun/yuarutet.** Dance song/songs.

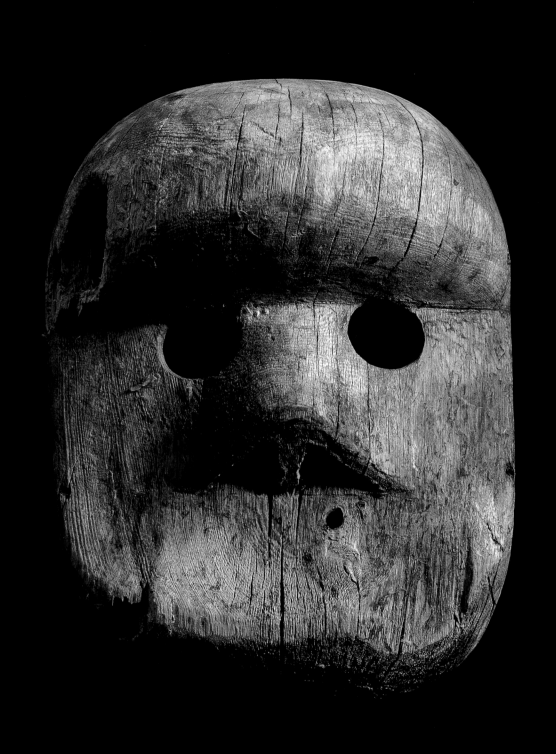

# References

Alaska State Film Library
    1989    Letter from Gordon Hills, Bethel, Ak., May 17. Anchorage.

American Museum of Natural History
    1909    "The Mural Decorations of the Eskimo Hall." *American Museum Journal* 9(7):211–27.

Anderson, Eva Greenslit
    1942    *Dog-team Doctor: The Story of Dr. Romig.* Caldwell, Id.: Caxton Printers.

Barker, Robin
    1994    "A Right Mind to Think With: Yup'ik Human Development Theory." Master's thesis, School of Education, University of Alaska, Fairbanks.

Barnum, Francis, S. J.
    1896    "Notes on Innuit Ethnography." *Woodstoock Letters* 25:47–51. Oregon Province Archives, Spokane, Wash.
    1901    *Grammatical Fundamentals of the Innuit Language as Spoken by the Eskimo of the Western Coast of Alaska.* Boston: Athenaeum Press.

Bethel Conference
    1904    Minutes of the General Conference of the Moravian Mission at Bethel. March 7–9, pp. 3–4. Alaska Collection box 3, no. 5. Moravian Archives, Bethlehem, Pa.

Birket-Smith, Kaj
    1953    *The Chugach Eskimo.* Nationalmuseets Skrifter, Etnografisk Raekke 6. Copenhagen.
    1971    *Eskimos.* New York: Crown Publishers.

Black, Lydia, ed.
    1984    *The Journals of Iakov Netsvetov: The Yukon Years, 1845–1863.* Kingston, Ont.: Limestone Press.

Blackman, Harold V.
    1945    "The Mukluk Shuffle." *Alaska Sportsman,* July.

Boas, Franz
    1888    "The Central Eskimo." pp. 399–669 in *6th Annual Report of the Bureau of American Ethnology for the Years 1884–1885.* Washington. Reprint, Lincoln: University of Nebraska Press, 1964.
    1907    "The Eskimo of Baffin Land and Hudson Bay." *Bulletin of the American Museum of Natural History* 15(2). New York.

Bogoras, Waldemar
    1904    "The Chukchee." In *Memoirs of the American Museum of Natural History,* edited by Franz Boas, vol. 11. Reprint, New York: AMS Press, 1975.

Breton, André
    1957    *L'Art magique.* Paris: Club Français du Livre, Forms de l'art, 1.
    1991    *André Breton, la beauté convulsive: Musée national d'art moderne, Centre Georges Pompidou.* Paris: Éditions du Centre Georges Pompidou.

Briggs, Jean
    1991    "Mazes of Meaning: The Exploration of Individuality in Culture and of Culture through Individual Constructs." In *The Psychoanalytic Study of Society,* edited by L. Bryce Boyer and Simon Grolnick, vol. 16. Hillsdale, N.J.: Analytic.

Carlton, Rosemary
    1992    "Sheldon Jackson, the Collector." Master's thesis, University of Oklahoma.

Carpenter, Edmund
    1972    *Oh, What a Blow that Phantom Gave Me!* New York: Holt, Rinehart and Winston.
    1975    "Introduction." In *Form and Freedom: A Dialogue on Northwest Coast Indian Art,* by Bill Holm and William Reid. Houston: Institute for the Arts, Rice University.
    1991    "Repatriation Policy and the Heye Collection." *Museum Anthropology* 15(3):15–18.

Chapman, John Wright
    1907    "Notes on the Tinneh Tribe of Anvik, Alaska." *Congrès International des Américanistes.* 15 Session 1906, p. 1–38. Quebec.

Clifford, James
    1988    *The Predicament of Culture: Twentieth-Century Ethnography, Literature, and Art.* Cambridge: Harvard University Press.
    1991    "Four Northwest Coast Museums: Travel Reflections." In *Exhibiting Cultures: The Poetics and Politics of Museum Display,* edited by Ivan Karp and Steven D. Lavine, pp. 212–54. Washington, D.C.: Smithsonian Institution Press.

Cole, David
    1975    *The Theatrical Event: A Mythos, a Vocabulary, a Perspective.* Middletown, Conn.: Wesleyan University Press.

Collins, Henry B., Frederica de Laguna, Edmund Carpenter, and Peter Stone
    1973    *The Far North: 2000 Years of American Eskimo and Indian Art.* Washington, D.C.: National Gallery of Art.

Corey, Peter, ed.
    1987    *Faces, Voices, and Dreams: A Celebration of the Centennial of the Sheldon Jackson Museum, Sitka, Alaska, 1888–1988.* Sitka: Alaska State Museum.
    1989    Trip Report, Mountain Village Dance Festival, November 6–15. Sheldon Jackson Museum, Sitka.

A mask abandoned on the tundra outside Sheldon's Point, probably in the late 1920s, along with the mask on page 94. *(AMHA 80.85.4 (26.4 cm)*

Curtis, Edward S.

1930 *The North American Indian, Being a Series of Volumes Picturing and Describing the Indians of the United States, the Dominion of Canada, and Alaska,* vol. 20. Norwood, Mass.: Plimpton Press. Reprint, New York: Johnson Reprint, 1970.

Dall, W. H.

1884 "On Masks, Labrets, and Certain Aboriginal Customs, with an Inquiry into the Bearing of Their Geographical Distribution." In *Bureau of American Ethnology Annual Report for 1881–1882, vol. 3.* Washington, D.C.: Smithsonian Institution Press.

DeArmond, R. N.

1987 "The History of the Sheldon Jackson Museum." In *Faces, Voices, and Dreams: A Celebration of the Centennial of the Sheldon Jackson Museum,* edited by Peter L. Corey, pp. 3–19. Sitka: Alaska State Museum.

Disselhoff, Hans Dietrich

1935 "Bemerkungen zu einegen Eskimo-masken der Sammlung Jacobsen des Berliner Museums für Völkerkunde [Observations on an Eskimo shaman mask in the Berlin Museum for Folklore]." *Baessler-Archiv* 18:130–37.

1936 "Bemerkungen zu Fingermasken der Beringmeer-Eskimo [Observations on finger masks of Bering Sea Eskimos]." *Baessler-Archiv* 19:181–87.

Douglas, Frederic H., and René d'Harnoncourt

1984 *Indian Art of the United States.* 1941. Reprint, New York: Museum of Modern Art.

Drebert, Ferdinand

1920 Letter to Edmund de Schweinitz. Bethel Mission correspondence. Moravian Archives, Bethlehem, Pa.

1930s "The History of Kwigillingok." Alaska Material, Moravian Archives, Bethlehem, Pa.

1959 *Alaska Missionary.* Bethlehem, Pa.: Moravian Book Shop.

Eskimo Heritage Project

1985 "The Stebbins Potlatch." Manuscript edited by Mary Alexander Wondzell, Introduction by Anatole Bogeyaktuk and Charlie Steve. Nome: Kawerak.

Feest, Christian F.

1984 "From North America: The Arrival of Tribal Objects in the West." In *"Primitivism" in 20th Century Art,* edited by William Rubin, pp. 85–98. New York: Museum of Modern Art.

Fienup-Riordan, Ann

1983 *The Nelson Island Eskimo.* Anchorage: Alaska Pacific University Press.

1984 "Regional Groups on the Yukon-Kuskokwim Delta." In *The Central Yupik Eskimos,* edited by Ernest Burch, Jr. Supplementary issue of *Études/Inuit/Studies* 8:63–93.

1986a "The Real People: The Concept of Personhood Among the Yup'ik of Western Alaska." *Études/Inuit/Studies* 10(1–2):261–70.

1986b "Nick Charles, Sr.: Worker in Wood." In *The Artist Behind the Work.* Fairbanks: University of Alaska Museum.

1987 "The Mask: The Eye of the Dance." *Arctic Anthropology* 24(2):40–55.

1988 "Eye of the Dance: Spiritual Life of the Bering Sea Eskimo." In *Crossroads of Continents,* edited by William Fitzhugh and Aron Crowell, pp. 256–70. Washington, D.C.: Smithsonian Institution Press.

1988 (ed.) *The Yup'ik Eskimos as Described in the Travel Journals and Ethnographic Accounts of John and Edith Kilbuck, 1885–1900.* Kingston, Ont.: Limestone Press.

1990a *Eskimo Essays: Yup'ik Lives and How We See Them.* New Brunswick, N.J.: Rutgers University Press.

1990b "The Bird and the Bladder: The Cosmology of Central Yup'ik Seal Hunting." In *Hunting, Sexes, and Symbolism,* edited by Ann Fienup-Riordan. *Études/Inuit/Studies* 14(1–2):23–38.

1991 *The Real People and the Children of Thunder: The Yup'ik Eskimo Encounter with Moravian Missionaries John and Edith Kilbuck.* Norman: University of Oklahoma Press.

1992 (ed.) "Social Status Among Yup'ik Eskimos of the Lower Kuskokwim as Told to Reverend Arthur Butzin by Alaskuk." *Anthropological Papers of the University of Alaska* 24(1–2):33–49.

1994 *Boundaries and Passages: Rule and Ritual in Central Yup'ik Oral Tradition.* Norman: University of Oklahoma Press.

1996 (ed.) *Hans Himmelheber's Ethnographic Accounts: A German Observer in Southwest Alaska, 1936–1937.* Fairbanks: University of Alaska Press.

Fitzhugh, William W.

1983 "Introduction to the 1983 Edition." In *The Eskimo about Bering Strait,* by Edward William Nelson. Washington, D.C.: Smithsonian Institution Press.

1988a "Eskimos: Hunters of the Frozen Coasts." In *Crossroads of Continents: Cultures of Siberia and Alaska,* edited by William Fitzhugh and Aron Crowell, pp. 42–51. Washington, D.C.: Smithsonian Institution Press.

1988b "Persistence and Change in Art and Ideology in Western Alaskan Eskimo Cultures." In *The Late Prehistoric Development of Alaska's Native Peoples,* edited by Robert D. Shaw, Roger Harritt, and Don E. Dumond. Alaska Anthropological Association Monograph 4. Anchorage: Aurora Press.

——, and Aron Crowell

1988 *Crossroads of Continents: Cultures of Siberia and Alaska.* Washington, D.C.: Smithsonian Institution Press.

——, and Susan A. Kaplan

1982 *Inua: Spirit World of the Bering Sea Eskimo.* Washington, D.C.: Smithsonian Institution Press.

Fox, John P., S. J.

1972 *Forty Years with the Eskimos.* Unpublished autobiography as told to Segundo Llorente. Oregon Province Archives, Spokane, Wash.

Gapp, S. H.

1928 *Where Polar Ice Begins: The Moravian Mission in Alaska.* Bethlehem, Pa.: Comenius Press.

Goforth, J. Penelope

1995 "Bristol Bay Views from the Deck of the *Dora.*" *Bristol Bay Times,* vol. 15, no. 11 (March 16).

Graburn, Nelson H., Molly Lee, and Jean-Loup Rousselot
1995 *Catalogue Raisonné of the Alaska Commercial Company Collection, Hearst Museum of Anthropology.* Berkeley: University of California Press.

Greenblatt, Stephen
1991 "Resonance and Wonder." In *Exhibiting Cultures: The Poetics and Politics of Museum Display,* edited by Ivan Karp and Steven D. Lavine, pp. 42–56. Washington, D.C.: Smithsonian Institution Press.

Gunther, Erna, et al.
1976 *A Catalogue of the Ethnological Collections in the Sheldon Jackson Museum.* Sitka: Sheldon Jackson College.

Haas, Pauline Natalia Walter
1990 "*Yuraryaraq Yugtun:* The Art of Yup'ik Dancing." In *The Face of Dance,* by Lynn Ager Wallen, pp. 31–33. Calgary: Glenbow Museum.

Haberland, Wolfgang
1987 "Nine Bella Coolas in Germany." In *Indians and Europe,* edited by Christian F. Feest, pp. 337–74. Aachen: Rader Verlag.

Hawkes, Ernest William
1913 *The "Inviting-In" Feast of the Alaskan Eskimo.* Canada Geological Survey, memoir 45. Anthropological Series no. 3.
1914 *The Dance Festivals of the Alaskan Eskimo.* University of Pennsylvania, Anthropological Publications 6(2).

Himmelheber, Hans
1938 *Eskimokünstler.* Stuttgart.
1993 *Eskimo Artists.* Fairbanks: University of Alaska Press.

Hipszer, Hermine
1971 "Les masques de chamans du Musée Ethnographique de Berlin [Shaman masks in the Berlin Museum of Ethnography]." *Baessler-Archiv* 19:421–50.

Höpfner, Gerd
1995 "Die Rückführung der 'Leningrad-Sammlung' des Museums für Völkerkunde [Return of the "Leningrad Collection" of the Museum for Folklore]." *Jahrbuch Preubischer Kulturbesitz.* Band 29. Berlin: Gebr. Mann Verlag.

Humphrey, Desiree
1994 "Competition Has No Place in Dance Fest." *Tundra Drums* (Bethel, Ak.) 21(48 [February 24]):1.

Institute of Alaska Native Arts
1993 *Arts from the Arctic: An Exhibition of Circumpolar Art by Indigenous Artists from Alaska, Canada, Greenland, Sapmi (Lapland), Russia.* Fairbanks: Institute of Alaska Native Arts and the Anchorage Museum of History and Art.

Issenman, Betty
1985 "Inuit Clothing: Construction and Motifs." *Études/Inuit/Studies* 9(2):101–19
1990 "Inuit and Museums: Allied to Preserve Arctic Patrimony." Paper presented at the Eighth Inuit Studies Conference, Quebec.
1991 "Inuit Power and Museums." *Information North: The Arctic Institute of North America* 17(3):1–7.

Jacknis, Ira
1985 "Franz Boas and Exhibits: On the Limitations of the Museum Method of Anthropology." In *Objects and Others,* edited by George W. Stocking, Jr. Madison: University of Wisconsin Press.

Jackson, Sheldon
1880 *Alaska and Missions of the North Pacific Coast.* New York: Dodd, Mead, and Company.

Jacobsen, Johan Adrian
1882 Letter to Prof. Adolf Bastian, written from Victoria, B.C., January 24. Jacobsen Collection, Museum für Völkerkunde, Berlin.
1882 Letter to Prof. Adolf Bastian, written from San Francisco, May 27. Jacobsen Collection, Museum für Völkerkunde, Berlin.
1883 Letter to Prof. Adolf Bastian, written from the Kuskokwim River, April 17. Jacobsen Collection, Museum für Völkerkunde, Berlin.
1883 Letter to Prof. Adolf Bastian, written from Fort Alexander on the Nushagak River, May. Jacobsen Collection, Museum für Völkerkunde, Berlin.
1977 *Alaskan Voyage 1881–1883: An Expedition to the Northwest Coast of America.* Translated by Erna Gunther from the German text of [edited by] Adrian Woldt. Chicago: University of Chicago Press.

Jacobson, Steven A.
1984 *Yup'ik Eskimo Dictionary.* Fairbanks: Alaska Native Language Center, University of Alaska.

John, Teresa
1986 "Interview: Yupik Dance and Theater." *Journal of Alaska Native Arts,* May–June.

Kamerling, Leonard, and Sarah Elder
1989 *Uksuum Cauyai: The Drums of Winter.* Alaska Native Heritage Film Project, Fairbanks.

Kaplan, Susan A., and Kristin Barsness
1986 *Raven's Journey: The World of Alaska's Native People.* Philadelphia: University Museum, University of Pennsylvania.

Karp, Ivan, and Steven D. Lavine
1991 *Exhibiting Cultures: The Poetics and Politics of Museum Display.* Washington, D.C.: Smithsonian Institution Press.

Keim, Charles J.
1969 *Aghvook, White Eskimo: Otto Geist and Alaskan Archaeology.* Fairbanks: University of Alaska Press.

Keyes, Anthony
1920 Letter to John Kilbuck, Superintendent of the Bureau of Education, April 15. Roll 35, frames 742–70. Oregon Province Archives of the Society of Jesus Alaska Mission Collection, Gonzaga University, Spokane, Wash.

Kilbuck, Edith
1889 Private journal, February. Kilbuck Collection, box 1, no. 13. Moravian Archives, Bethlehem, Pa.

Kilbuck, John Henry
1890 Letter to William Weinland. Kilbuck Collection. Moravian Archives, Bethlehem, Pa.
1890 Letter to Edith Kilbuck, January 24. Kilbuck Collection. Moravian Archives, Bethlehem, Pa.

King, Eleanor M., and Bryce P. Little
1986 "George Byron Gordon and the Early Development of the University Museum." In *Raven's Journey: The World of Alaska's Native People,*

edited by Susan A. Kaplan and Kristin J. Barsness, pp. 16–53. Philadelphia: University Museum, University of Pennsylvania.

King, Jonathan

1990 "Eskimos at Expos: The Development of an Enduring Stereotype at the Expositions in the United States 1893–1909." Paper presented at the Seventh Inuit Studies Conference, Fairbanks.

1992 "Surrealism, Structuralism and French Collecting of American Ethnography." In *Matisse: The Inuit Face,* by Michael Regan, curator. London: Canadian High Commission Cultural Centre.

Krupat, Arnold

1992 "On the Translation of Native American Song and Story: A Theorized History." In *On the Translation of Native American Literatures,* edited by Brian Swann. Washington, D.C.: Smithsonian Institution Press.

KYUK-TV

1985 "Nick Charles." *From Hand to Hand: Bethel Native Artist Profiles.* KYUK-TV video production. Bethel, Alaska.

1989 Interviews during the 1989 Mountain Village Festival and visit to Sheldon Jackson Museum. Translated by Alexie Isaac. Bethel, Alaska.

Lantis, Margaret

1946 "The Social Culture of the Nunivak Eskimo." *Transactions of the American Philosophical Society* 35:153–323.

1947 *Alaskan Eskimo Ceremonialism.* American Ethnological Society Monograph, no. 11. Seattle: University of Washington Press.

1950 "The Religion of the Eskimos." In *Forgotten Religions,* edited by Vergilius Ferm. Philadelphia: Philosophical Library.

1959 "Folk Medicine and Hygiene, Lower Kuskokwim and Nunivak-Nelson Island Area." *Anthropological Papers of the University of Alaska* 8(1):1–75.

1960 *Eskimo Childhood and Interpersonal Relations: Nunivak Biographies and Genealogies.* American Ethnological Society Monographs, no. 53. Seattle: University of Washington Press.

1990 "The Selection of Symbolic Meaning." In *Hunting, Sexes, and Symbolism,* edited by Ann Fienup-Riordan. *Études/Inuit/Studies* 14(1–2):169–89.

Lavine, Steven D., and Ivan Karp

1991 "Introduction: Museums and Multiculturalism." In *Exhibiting Cultures: The Poetics and Politics of Museum Display,* edited by Ivan Karp and Steven D. Lavine, pp. 1–9. Washington, D.C.: Smithsonian Institution Press.

Lee, Molly

1990 "Notes on the History of the Sullivan Masks." Manuscript. Glenbow Museum, Calgary, Alta.

Lenz, Mary

1986 "Alaska Native Teens Are Nation's Highest Risk Suicide Group." *Tundra Drums* (Bethel, Ak.) 14(50): 4,5.

———, and James H. Barker

1985 *Bethel: The First 100 Years 1885–1985.* Bethel, Ak.: City of Bethel Centennial History Project.

Lévi-Strauss, Claude

1963 *Structural Anthropology.* Translated by Claire Jacobson and Brooke Grundfest Schoepf. New York: Basic Books.

1982 *The Way of the Masks.* Translation of *La Voie des Masques* (1975) by Sylvia Modélski. Seattle: University of Washington Press.

Liapunova, Roza G.

1994 "Eskimo Masks from Kodiak Island in the Collections of the Peter the Great Museum of Anthropology and Ethnography in St. Petersburg." In *Anthropology of the North Pacific Rim,* edited by William W. Fitzhugh and Valérie Chaussonnet, pp. 175–204. Washington, D.C.: Smithsonian Institution Press.

Lot-Falck, Eveline

1957 "Les Masques Eskimo et Aleoutes de la Collection Pinart." *Journal de la Société des Américanistes* 46:5–43.

MacPherson, James

1992 "Mouse Caches Offer Treasured Delicacies for Some." *Tundra Drums* (Bethel, Ak.), October 29, p. 5.

Madsen, Mette

1990 "'To Have Weight so that Nobody Can Brush You Off the Top of this Earth': On the Cultural Construction of a Cultural Identity in Chevak, Alaska." Field report, Afdeling for Etnografi of Socialantropologi, Arhus Universitet, Moesgard, Denmark.

Mason, J. Alden

1958 "George G. Heye, 1874–1957." Leaflets of the Museum of the American Indian, no. 6, Heye Foundation, New York.

Mason, O.

1894 Letter to Prof. F. W. True, National Museum, January 7. Microfilm accession records. Smithsonian Institution, Washington, D.C.

Mather, Elsie P.

1985 *Cauyarnariuq [A Time for Drumming].* Alaska Historical Commission Studies in History, no. 184. Bethel, Ak.: Lower Kuskokwim School District Bilingual/Bicultural Department.

1986 "Preserving Our Culture Through Literacy." In *Report of the 1986 Bilingual Multicultural Education Conference.* Juneau: Department of Education.

Maurer, Evan

1984 "Dada and Surrealism." In *"Primitivism" in 20th Century Art,* edited by William Rubin, pp. 535–94. New York: Museum of Modern Art.

McDaniel, Sandi

1994a "An Era of Healing." *Anchorage Daily News,* January 2, section F, pp. 1–2.

1994b "Unveiling Ancestry." *Anchorage Daily News,* August 7, section M, pp. 1–2.

Menager, Francis, S. J.

1962 *The Kingdom of the Seal.* Chicago: Loyola University Press.

Michael, Henry N., ed.

1967 *Lieutenant Zagoskin's Travels in Russian America, 1842–1844.* Arctic Institute of North America. Anthropology of the North, Translations from Russian Sources, no. 7. Toronto: University of Toronto Press.

Milotte, Alfred

1946. Journal. Milotte Collection. Rasmuson

Library, Alaska and Polar Regions Department, University of Alaska, Fairbanks.

1949. Letter to Don Foster, Alaska Native Service, July 17. Box 3, Milotte Collection. Rasmuson Library, Alaska and Polar Regions Department, University of Alaska, Fairbanks.

Milotte, Elma, and Alfred Milotte

1979 "The Milotte Collection of Hooper Bay Dance Masks." Manuscript. Milotte Collection. Alaska State Museum, Juneau.

Miyaoka, Osahito, and Elsie Mather

1979 *Yup'ik Eskimo Orthography.* Bethel, Ak.: Kuskokwim Community College.

Miyaoka, Osahito, Elsie Mather, and Marie Meade

1991 *Survey of Yup'ik Grammar.* Anchorage: University of Alaska Anchorage.

Morrow, Phyllis

1984 "It Is Time for Drumming: A Summary of Recent Research on Yup'ik Ceremonialism." In *The Central Yupik Eskimos,* edited by Ernest S. Burch, Jr. Supplementary issue of *Études/Inuit/Studies* 8:113–40.

1990 "Symbolic Actions, Indirect Expressions: Limits to Interpretations of Yupik Society." In *Hunting, Sexes, and Symbolism,* edited by Ann Fienup-Riordan. *Études/Inuit/Studies* 14:141–58.

———, and Toby Alice Volkman

1975 "The Loon with the Ivory Eyes: A Study in Symbolic Anthropology." *The Journal of American Folklore* 88(348): 143–50.

Naske, Claus

1993 "Repatriation of Artifacts Threatens Valid Studies." *Anchorage Daily News,* September 3, section E, p. 10.

Nelson, Edward William

1899 *The Eskimo about Bering Strait.* Bureau of American Ethnology Annual Report for 1896–1897, vol. 18, pt. 1. Reprint, Washington, D.C.: Smithsonian Institution Press, 1983.

Osgood, Cornelius

1958 *Ingalik Social Culture.* Yale University Publications in Anthropology, no. 53.

Oswalt, Wendell

1964 "Traditional Storyknife Tales of Yuk Girls." *Proceedings of the American Philosophical Society* 108(4):310–66.

1990 *Bashful No Longer: An Alaskan Eskimo Ethnohistory, 1778–1988.* Norman: University of Oklahoma Press.

Petroff, Ivan

1884 *Report on the Population, Industries, and Resources of Alaska.* Washington, D.C.: U.S. Government Printing Office.

Phillip, Joshua

1988 Interview with Robert Drozda, July 1. Tuluksak 14(h)(1) Site Survey. Realty Office, Bureau of Indian Affairs, Anchorage.

Pingayak, John F.

1986 Cupik Eskimos. Cup'ik Cultural Heritage Project, Kashunamiut School District, Chevak, Alaska.

Pitseolak, Peter

1993 *People from Our Side: A Life Story with Photographs and Oral Biography.* Montreal and Kingston: McGill-Queen's University Press.

Rasmussen, Knud

1927 *Across Arctic America: Narrative of the Fifth Thule Expedition.* New York: Putnam's.

1929 "Intellectual Culture of the Iglulik Eskimos." *Report of the Fifth Thule Expedition 1921–24* 7(1). Copenhagen.

1931 "The Netsilik Eskimos: Social Life and Spiritual Culture." *Report of the Fifth Thule Expedition 1921–24* 8(1–2). Copenhagen.

Ray, Dorothy Jean

1966 "The Eskimo of St. Michael and Vicinity, as Related by H. M. W. Edmonds." *Anthropological Papers of the University of Alaska* 13(2).

1967 *Eskimo Masks: Art and Ceremony.* Seattle: University of Washington Press.

1981 *Aleut and Eskimo Art: Tradition and Innovation in South Alaska.* Seattle: University of Washington Press.

1982 "Mortuary Art of the Alaskan Eskimos." *American Indian Art Magazine* 7(2):50–57.

1987 "Eskimo Artifacts: Collectors, Collections, and Museums." In *Faces, Voices, and Dreams: A Celebration of the Centennial of the Sheldon Jackson Museum, Sitka, Alaska, 1888–1988,* edited by Peter Corey, pp. 29–43. Sitka: Alaska State Museum.

Reed, Irene, Osahito Miyaoka, Steven Jacobson, Pascal Afcan, and Michael Krauss.

1977 *Yup'ik Eskimo Grammar.* Fairbanks: Alaska Native Language Center, University of Alaska.

Rink, Henry

1875 *Tales and Traditions of the Eskimo.* Edinburgh and London: n.p.

Romig, Ella

1903 Journal, January 6. Romig papers, Alaska and Polar Regions Department, Rasmuson Library, University of Alaska, Fairbanks.

Rubin, William, ed.

1984 *"Primitivism" in 20th Century Art: Affinity of the Tribal and the Modern.* New York: Museum of Modern Art.

Saladin d'Anglure, Bernard

1983 "Ijiqqat: Voyage au pays de l'invisible Inuit." *Études/Inuit/Studies* 7(1):67–83.

Schuster, Carl

1951. "Joint Marks: A Possible Index of Cultural Contact between America, Oceania and the Far East." *Royal Tropical Institute* (Amsterdam) 39:4–51.

Senungetuk, Joe

1990 "Proposed Park Won't be Panacea for 'Native Artists.'" *Anchorage Daily News,* December 23, section E, p. 3.

Serov, Sergi

1988 "Guardians and Spirit-Masters of Siberia." In *Crossroads of Continents: Cultures of Siberia and Alaska,* edited by William W. Fitzhugh and Aron Crowell, pp. 241–55. Washington, D.C.: Smithsonian Institution Press.

Shaw, Robert D.

1982 "The Expansion and Survival of the Norton Tradition on the Yukon-Kuskokwim Delta." *Arctic Anthropology* 19:59–73.

Society for Propagating the Gospel

1885– *Proceedings of the Society for Propagating the*
1931 *Gospel Among the Heathen.* Moravian Archives,

Bethlehem, Pa.

Sonne, Birgitte

1988  *Agayut: Eskimo Masks from the 5th Thule Expedition* (Knud Rasmussens Samlinger fra Nunivak, Alaska). Report of the 5th Thule Expedition 10(4). Copenhagen: Gyldendal.

1990  "The Acculturative Role of Sea Woman." *Meddelelser om Grønland, Man and Society* 13:3–34.

Spencer, Robert

1959  *The North Alaskan Eskimo: A Study in Ecology and Society.* Bureau of American Ethnology Bulletin 171. Washington, D.C. (Reprinted 1976.)

———, and W. K. Carter

1954  "The Blind Man and the Loon: Barrow Eskimo Variants." *Journal of American Folklore* 67:65–72.

Stocking, George W., ed.

1985  *Objects and Others: Essays on Museums and Material Culture.* Madison: University of Wisconsin Press.

Sturtevant, W.

1969  "Does Anthropology Need Museums?" *Proceedings of the Biological Society of Washington* 82:619–50.

Terasaki, George

1976  Sullivan Collection. Personal communication to Sheldon Jackson Museum, Sitka, Alaska.

Thalbitzer, William

1908  "The Heathen Priests of East Greenland." In *Verhand Lungen des XVI Amerekanisten-Kongresses, Wien 1908,* pp. 447–64.

Thode-Arora, Hilke

1989  "Für funfzig Pfennig um die Welt." Campus Verlag, Frankfurt/Main, p. 52.

Troll, Timothy

1989  "Opening the Book: An Exhibit of Yup'ik Masks and Artifacts of Daily Life from the Lower Yukon River." *Frame of Reference: An Irregular Publication of the Alaska Humanities Forum* 1(2):11–12.

Turner, Edith

1990  "'Working on the Body': The Medical and Spiritual Implications of Iñupiaq Healing." Manuscript. University of Virginia, Charlottesville.

Turner, J. Henry

1891  Letter to Prof. G. Goode, National Museum, November 12. Microfilm accession records. Smithsonian Institution, Washington, D.C.

1891  Letter to Prof. F. W. True, National Museum, November 16. Microfilm accession records. Smithsonian Institution, Washington, D.C.

Twitchell, Benjamin F.

1960s  "The Character of My Father, Adams Hollis Twitchell: A Reminiscence." Manuscript. Twitchell family, Bethel and Anchorage.

VanStone, James

1976  "The Bruce Collection of Eskimo Material Culture from Port Clarence, Alaska." *Fieldiana Anthropology,* (Field Museum of Natural History), vol. 67

Van Valin, William

1941  *Eskimoland Speaks.* Caldwell, Id.: Caxton Printers.

Varnedoe, Kirk

1984  "Abstract Expressionism." In *"Primitivism" in 20th Century Art,* edited by William Rubin, pp. 615–60. New York: Museum of Modern Art.

Wallace, Kevin

1960  "A Reporter at Large: Slim-shin's Monument." *New Yorker,* November 19.

Wallen, Lynn Ager

1987  "The Milotte Mask Collection." *Concepts.* Division of State Museums Technical Papers, no. 2. July.

1990  *The Face of Dance: Yup'ik Eskimo Masks from Alaska.* Calgary: Glenbow Museum.

1991  "The Sullivan Mask Collection: Anna and Ralph Sullivan in Hooper Bay." *Glenbow* 11(1):4–7.

1994  "Dr. Daniel Neuman, Collector Extraordinare." Alaska State Museums Technical Papers, no. 6. March.

Waskey, Frank

1947  Letter to Ivar Skarland, February 4. Waskey Collection. University of Alaska Museum, Fairbanks.

n.d.  Autobiographical sketch. Waskey Collection. University of Alaska Museum, Fairbanks.

Weber, Ernest L.

1993  Ogavik journal, February 28, 1993. Alaska Material. Moravian Archives, Bethlehem, Pa.

West, W. Richard, Jr.

1993  "The New Inclusiveness." *Anthropology Newsletter* 34(2):1,39.

Westphal-Hellbusch, Sigrid, Gerd Koch, and Horst Hartmann

1973  *100 Jahre Museum für Völkerkunde* [*100 Years of the Museum for Folklife*]. Baessler Archiv Band 20. Beitrage zur Völkerkunde, Dietrich Reimer Verlag.

Weyer, Edward Moffat

1932  *The Eskimos: Their Environment and Folkways.* New Haven: Yale University Press.